THE
CHILDREN
OF THE SUN

A Study of the
Egyptian Settlement
of the Pacific

W. J. Perry, M.A.

THE
CHILDREN
OF THE SUN

A Study of the
Egyptian Settlement
of the Pacific

Adventures Unlimited Press

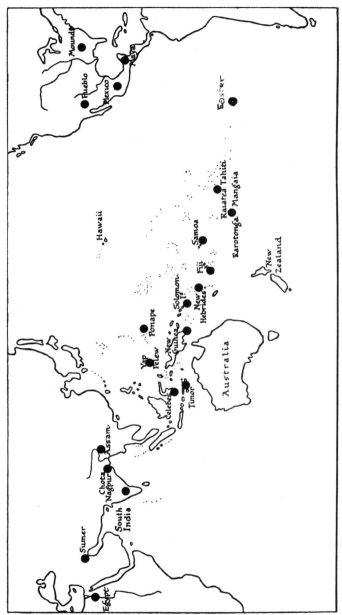

General Map of the Region, Showing Important Localities

THE
CHILDREN
OF THE SUN

A Study of the
Egyptian Settlement
of the Pacific

W. J. Perry, M.A.

The Children of the Sun

By W. J. Perry

Copyright 2004

Adventures Unlimited Press

Originally published by Methuen & Co., London, 1923

ISBN 1-931882-27-4

Published by Adventures Unlimited Press
One Adventure Place
Kempton, Illinois 60946 USA

Printed in the United States of America

10 9 8 7 6 5 4 3 2 1

To
GRAFTON ELLIOT SMITH
IN MEMORY OF MANY HAPPY HOURS

PREFACE

IN this, my second volume of researches into the early history of civilization, I have chosen a wider area, and a more extended investigation than in " The Megalithic Culture of Indonesia." As the inquiry proceeds, and general principles become clearer, it is easier to manipulate large masses of facts. This gives reason to hope that before long it will be possible to handle world-wide masses of facts with fair ease, and to set out the history of civilization in a limited number of general propositions capable of ready verification.

I have adopted, in this work, the device of sketch-maps to help the reader to appreciate the geographical distributions of culture. In " The Megalithic Culture of Indonesia " distribution tables were used, but they are not so very satisfactory at this stage of the science. Perhaps as time goes on it will be possible to use them with greater success. For the present, it seems to me that maps help the reader to a greater extent, enabling him to realize the manner of spread of culture over wide regions. Through the generosity of my publishers, I am able to include sixteen sketch maps, fourteen of which are in two colours, which show the reader at a glance the relationships between the different sorts of distributions that they depict. In the first map I have indicated the whole of the region under examination, and have marked some of the places that are important in the discussion.

I have to thank several kind helpers. Professor Unwin, of this University, suggested to me the scheme of the book, and I owe much to his kindly interest and criticism. Professor Canney, and Mr. J. Wilfrid Jackson of the Manchester Museum, have helped me in various ways. Miss Winifred M. Crompton, Assistant Keeper of Egyptian Antiquities in the Manchester Museum, has afforded me constant and untiring help, especially in the chapter on Egypt. She undertook for me the laborious task of searching the mastaba inscriptions for details of marriages, and has thereby supplied me with much valuable information.

I owe her a still greater debt for her able and unsparing criticisms with regard to style and exposition. My wife has helped me greatly in the laborious task of proof-reading. Heer Kruyt has supplied me with much information, and has allowed me to see some of his unpublished manuscripts. Mr. H. M. McKechnie, Secretary of the Manchester University Press, has given me much good advice. I owe much, also, to my colleague, Professor T. E. Peet.

My indebtedness to Professor Elliot Smith does not need emphasis. To him I owe the realization of the importance of Egypt in the history of civilization ; and it is a matter of gratification to all those who agree with his views to see that opinion is slowly, but surely, coming round to his point of view, so that the ultimate justification of his courageous and outspoken attitude is assured. If this book contributes in any way to that end, I shall feel myself well rewarded.

I cannot allow this opportunity to pass without adding my small contribution to what has already been said of the late Dr. Rivers. To him I owe everything as an anthropologist ; and for ten years I had the benefit of his unceasing advice and sympathy, as well as, what is equally important, of his unsparing and unerring criticism. Those who have come under the kindly lash of his tongue will well realize what I mean. He was to have seen this book in manuscript, and I was anxious to hear the verdict ; but he went from us just a month before it was to have been sent to him to read, so I shall never know what that verdict would have been. A great and good man has gone from the world, and his friends and pupils will never cease to mourn his untimely departure. I, for one, would sacrifice much to have him back.

MANCHESTER,
 February 22, 1923.

CONTENTS

(The numbers refer to pages)

CHAPTER VII
THE SEARCH FOR GOLD AND PEARLS

CHAPTER VIII
POLISHED STONE IMPLEMENTS

CHAPTER IX
THE SUCCESSION OF CULTURES

CHAPTER X
THE CHILDREN OF THE SUN

CHAPTER XI
THE COMING OF THE WARRIORS

CONTENTS xi

CONTENTS

CHAPTER XXII
THE TOTEMIC CLAN SYSTEM

CHAPTER XXIII
EXOGAMY

CHAPTER XXIV
GIVERS OF LIFE

CHAPTER XXV
THE ORIGIN OF THE ARCHAIC CIVILIZATION

CHAPTER XXVI
EGYPT

LIST OF MAPS

THE
CHILDREN OF THE SUN

CHAPTER I

INTRODUCTION

THE vast region stretching from Egypt by way of India, Indonesia and Oceania, to America, is important in the study of the early history of culture. It contains remains of civilizations rooted in the depths of time, whose ruins stand in the fever-haunted jungles of India, Cambodia, Java, Guatemala, on the islands of Micronesia, and elsewhere as silent witnesses to the frailty of human endeavour, arousing in the traveller wonder at the skill of their builders, and pity that such fair creations were doomed to ruin and decay. It contains, on the other hand, many communities of lowly culture, even so primitive in some instances as not to have learned to procure their food from agriculture or domesticated animals, who often live in countries that possess ruins of ancient civilizations, and show no signs of attempting to emulate the efforts of their predecessors.

What is the secret of the riddle of this vast mosaic, of this juxtaposition of peoples at the opposite ends of the cultural scale ? What have been the determining factors producing a certain form of culture in one place and at a definite time, in one place rather than another, and at one time rather than another ?

In seeking to grapple with this problem, we have to retain in mind the past existence of the great civilizations of Egypt, Sumer, India, Mexico, and Guatemala, extending thousands of miles across the earth's surface : we have to remember that while the civilization of Egypt can be reckoned back at least five thousand years, that of the Maya, the first to appear in the northern half of the American continent, originated somewhere about the beginning of our era. The bridging of these great gaps in time and space will necessitate the adoption of some very simple and general method of study, one that is purely objective and as independent as possible of the personality of its wielder. Some parts of the region, such as the area of the Plains of North America,[1] show no traces of the former existence

[1] Sketch Map No. 2.

of a highly developed civilization. On the other hand, it is usually found that behind existing communities there must have been others, whether related to them or not, whose culture was different. The existence of the study of archæology is itself witness of that fact. In many places comparisons can be instituted between two or more phases of culture. We may select one element belonging to the earlier phase, and inquire as to its presence or absence in the later phase. Whatever the answer may be, something of value has been learned. If such comparisons can be carried out on a sufficiently large scale, some rough knowledge will be gained as to the manner in which culture has been modified all through the region in the course of ages. If it be found that, wherever the inquiry be made, the answer is invariably the same in respect of any cultural element, then the first step will have been made to the foundation of a stable theory of the history of civilization in the region. This method possesses the merit of being as " fool-proof " as a method well can be : it is, moreover, capable of easy control, for the production of contrary instances will soon serve to jeopardize generalizations founded on surveys of culture sequences. I shall adopt this method of *Culture-Sequences*, and shall apply it to all manner of elements of culture, with the aim of reconstructing, so far as is possible, the past history of the region as a whole. In doing so, I shall take no account, for the present, of absolute chronology, but shall be content with the relative chronology of the sequences in any place. For instance, it will not matter that a culture-sequence in respect of irrigation, in which it is invariably found that the practice is dropped in the second phase of culture, may range over thousands of years in time when passing from Egypt to America. The essential fact is that irrigation tends to disappear in the later stage of culture.

The first application of the method of culture-sequences will be to the comparison of the remains of old stages of culture and those of existing peoples. Since this inquiry is largely concerned with vanished peoples, the elements studied by the method will have to be chosen from those available. The use of stone for purposes of construction, stone images, irrigation and so on, are objective facts that cannot be denied, and for this reason have been chosen out for study in the first instance. Since these elements have persisted in some regions and have disappeared in others, the knowledge gained forms a foundation on which to build a general theory.

When the region is surveyed for the elements just mentioned, it is possible to formulate a working hypothesis ; namely, that the earliest peoples in all parts, who had advanced beyond the food-gathering stage, were so similar in culture that they can be grouped together as constituting the *Archaic Civilization*. Not only does the survey reveal the essential similarity of the earliest stage of food-producing culture throughout the region,

it also shows that an important process was at work, that loss of culture was a constant feature of the history of the outlying parts of the region, the earliest communities in North America, Oceania and elsewhere being more advanced in the arts and crafts than those that followed.

Once in possession of the hypothesis of an archaic civilization, uniform in nature throughout the region as compared with its successors, several problems emerge, and the subsequent chapters are devoted to their examination. It is necessary to determine the relationships between the communities of the archaic civilization and those that followed, to account for the distribution of the communities of the archaic civilization, and to inquire into the origin of the archaic civilization itself. In order to solve these problems a thoroughgoing investigation is made to determine the political, social and religious organizations of the archaic civilization, and as the inquiry proceeds it becomes increasingly clear that the preliminary hypothesis fits the facts. The evidence shows, also, that the later communities of the region have acquired their culture from that of the archaic civilization, and that the variations that they display are due to the manner of derivation.

What of the archaic civilization itself ? Given that the later civilizations originated from it, where and how did it come into being ? The solution of this problem is, I contend, to be sought in Egypt : for, as I have tried to show, the assemblage of the elements of that culture could be watched there and nowhere else. It is in the Sixth Dynasty, the culminating point of the Pyramid Age, that this process seems to have been complete. The reason for its spread was, I maintain, the search for various substances, principally those prized for their assumed life-giving properties ; for the settlements of the archaic civilization are situated near sources of the very materials that the Egyptians themselves took so much trouble to seek in neighbouring countries. Further consequences of this search are discussed in Chapter XXIV, where it is argued that the native tribes all through the region use, for their magical practice, substances that attracted the men of the archaic civilization from place to place.

It is obvious that the inquiry just outlined must go to the roots of civilization. The reader will find that several fundamental problems are discussed. For instance, in dealing with the problem of the distribution of the various forms of culture, and particularly with the settlements of the archaic civilization itself, I urge that the important factor is the human mind with its desires and aims. Men in the past have imposed their will on their surroundings, and have not been forced by them into any line of action. Given certain desires, men will do their utmost to satisfy them, and it is to this dynamic attitude that is attributed the development and spread of the archaic civilization. This will hardly tally with the commonly accepted doctrines of the modern school of geographers, who appear, explicitly or

implicitly, to ascribe such importance to "Geographical Control" as a causative factor in the development of various forms of human culture, instead of looking at these phenomena as the outcome of processes at work in society itself. The views advanced here, if correct, serve to establish a continuity in human society from the very earliest stages, so that, from the days of paleolithic man settlement has been made in certain localities because men chose to live there, and not because they were forced so to do by the climate or some other geographical cause.

The investigation has led to the examination into the way by which early men built up civilization. It is found that early thought was originally based on experience, without, apparently, any element of speculation or symbolism. Early men thought directly of the world around them and expressed their thought in concrete ideas. I have tried to show briefly how this process worked—how, as the result of one discovery after another, the attention of men was directed to new phenomena, and thus an organized body of thought was fashioned.

A further development is that concerned with the influence of social institutions on the behaviour of men. I have ventured a little along this path, especially with regard to the important topic of warfare, which, as I hope to have shown, began in a highly organized condition of society, and thus is not a fundamental mode of behaviour common to mankind. If the arguments advanced here be correct, it follows that warfare is the outcome of social institutions that can be modified, and thus the problem of its abolition is ultimately soluble.

The investigation of this book is, strictly speaking, a continuation of that carried on in *The Megalithic Culture of Indonesia*, but its scope is much wider. I have, as is obvious would be the case, made great use of the work of Rivers and Elliot Smith, the first in regard to Oceania, the second in regard to Egypt. In such a great movement of thought as that opened up by these two pioneers, it is imperative that each worker, while constantly bearing in mind the studies of his colleagues, and using them for his own guidance, should mark out for himself a line of study to pursue, so as to avoid the risk of being overwhelmed with detail. Consequently I have followed my own line of thought, and have tried to produce a picture of some aspects of the rise and spread of early civilization as they appear to me. Thus the reader will find that many topics dealt with by Rivers and Elliot Smith have been ignored, while others that they have not treated are discussed in detail. At the same time I must freely acknowledge my great indebtedness to Elliot Smith, particularly as regards Egypt, for his pioneer work in that country has opened up the way for those who choose to follow, and I hope to have made clear the magnitude of his contribution to the study of the beginnings of civilization.

CHAPTER II

FOOD-GATHERERS AND FOOD-PRODUCERS

THE greatest stride forward ever taken by man was when he devised the craft of agriculture. Previously to that he had been in the *food-gathering* stage of culture, dependent on nature for his sustenance, and unable to control its production. The ability to regulate the food supply brought the power to increase the population indefinitely, and this has entirely changed the face of the earth. How did early men, after thousands of years of the food-gathering life, acquire the practice of agriculture and the domestication of animals ? Did these practices arise independently in different countries, or were they spread abroad throughout the world from one centre ? The answer to this question is of momentous importance, for on it depends the whole theory of civilization.

The region now to be studied contains peoples in all stages of culture, among them communities of food-gatherers, who still remain hidden in the depths of the jungles and on the outskirts of civilization : such are the Veddas of Ceylon, and other pre-Dravidian jungle tribes of South India ; the Kubu of Sumatra ; the Punan of Borneo, the Semang and Sakai of the Malay Peninsula ; the Indians of California, the Ute and Paiute of Utah, the Dene of the Mackenzie basin of Canada ; the Australians, and others, who, when what they have learned from other peoples is subtracted, are practically devoid of the arts and crafts.

In trying to account for the presence of agriculture in the region under survey, it is just as important to know why some people do not possess that craft as why others do : the one question is the complement of the other. If, therefore, it is possible to study, in any part of the region, food-gathering peoples and food-producing peoples in close proximity, some useful information may be forthcoming with regard to the manner in which native tribes have taken the first step upward to civilization.

Unfortunately this can only be done in three places : the United States of North America ; the region between New Guinea and Australia ; and in Borneo ; but the results obtained agree with one another.

Sketch Map Number 2 shows that North America can be

divided into several cultural areas. The Pueblo area is occupied by Indians who live in settled communities, building houses of adobe or stone, cultivating the soil by means of irrigation, and altogether presenting a relatively high stage of civilization.[1] The region between the Mississippi, the Great Lakes and the Atlantic Ocean can, for various reasons, be regarded as a whole. The third region comprises the great plains westward from the Mississippi to the feet of the Rockies. The region running up the west coast, although of great importance, will be ignored, as well as that of the Eskimo. The culture of the peoples living there shows signs of affinity with that of the peoples of the north-east coast of Siberia, and doubtless the two groups are culturally related. The Californian Indians will be considered, as will be those of Canada, outside British Columbia. Towards the south the region to be considered reaches to Honduras, and includes Mexico and Yucatan.[2]

In later chapters attention will be paid to other features of this distribution of culture. For the present it is only necessary to think of the boundary that can be constructed between food-gathering and food-producing peoples in the United States and Canada.

Before comparing food-gatherers and food-producers in North America one serious difficulty must be removed. In the area of the plains there live a large number of tribes, of various linguistic stocks, such as the Sioux, the Pawnee, the Arapaho, Cheyenne, and others, who rank above the food-gathering stage of culture of the Indians of California and other western states. These tribes can be eliminated from the present discussion, for it is known that they migrated into the plains after the introduction of the horse by the Spaniards.[3] The result of their migration was to cause profound alterations in their mode of life, which will be discussed later. If the conditions be considered at about the time of the arrival of Columbus, the United States would be tenanted by two groups of peoples. Within the boundaries marked out on the map would be agriculturists, and without the boundary would be food-gatherers, as still live in California and other states.

The distinction between the cultures of the food-gatherers outside the boundary and the food-producers within is abrupt. For a line drawn to mark the limits of agriculture would coincide with that already drawn, and this line would also denote the limits of pottery-making, house-building, and other cultural elements unknown to the food-gatherers.[4] It is curious to think that, when the boundary between the Pueblo Indians and the Californian Indians is crossed, we have gone from a region where

[1] They derive their name from the Spanish word for " Village."
[2] Cf. Clark Wissler (i), (iv) for fuller details with regard to Culture Areas. Sketch Map No. 2 is based on those given by him. [3] Wissler ii. 1 e.s.
[4] Wissler i. 474, 487, 490 : Spinden ii. 269 : Powell ii. 41.

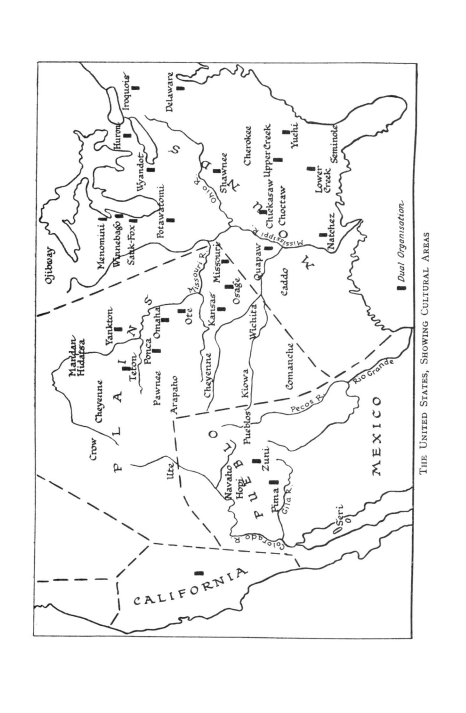

THE UNITED STATES, SHOWING CULTURAL AREAS

stone and brick houses are built, irrigation is practised, elaborate pottery is made, and metals are worked to some extent, into one where the people are devoid of these arts and crafts, being among the lowest in culture of the United States.

How is it that this abrupt boundary exists between the two sorts of culture ? Is it the result of natural conditions, of local features of climate and so forth ? If so, what is the essential difference between Arizona and California, that the one should have produced so high a form of civilization, while the other is devoid of it in practically every particular, in so far as the native tribes are concerned ? In this particular instance the differences, if any, in local circumstances, do not seem to offer the remotest chance of solving the problem.

In the second instance of the proximity of food-gatherers to food-producers, the boundary runs between Australia and New Guinea by way of the Torres Straits, and cuts off Australia from the rest of the world. On one side of this line is British New Guinea, with a relatively high form of civilization, with tribes that sometimes practise irrigation for their taro plantations ; while on the other is Australia with no native agriculture at all. It seems hard to understand what natural differences between Queensland and British New Guinea could have brought about this remarkable cultural difference. In New Caledonia again much irrigation is carried on, and the level of culture is relatively high. Certain cultural resemblances exist between Australia and Melanesia, as will be seen, but in the fundamental craft of agriculture a profound gulf divides the two regions. Why should this great continent be ringed by islands with relatively high civilizations, and yet have little itself, especially on the material side ? This problem, like that of North America, does not seem capable of solution in terms of environment.

Further to the west is a cultural boundary between hunters and food-producers that is not apparently more or less fixed as in the case of North America, and Torres Straits, but is continually advancing. We owe to Messrs. Hose and McDougall an illuminating account of the spread of culture across the island of Borneo, and the consequent conversion of nomadic hunters into settled agricultural tribes of varying degrees of civilization. It will be necessary to consider once more in a subsequent chapter the cultural history of this island, but for the present it will be enough to confine attention to the less civilized tribes of the interior. One group of these tribes, the Kayan and their kindred Bahau, have spread across the island from the south and south-western parts, and, after reaching the central highlands, are now travelling down the rivers into Sarawak. This migration is partly caused by their method of farming rice, which consists in burning tracts of jungle and then planting the seed in the ground so fertilized. This method is wasteful, and after a few years it is necessary to move on. This the Kayan are able to

do on account of their superior strength and organization.[1] It is to these migrating Kayan that is ascribed the culture of the non-Kayan tribes of the interior of Sarawak. In the same regions as the Kayan live other fairly well-civilized groups of tribes, called Kenyah and Klemantan, the Kenyah being the more highly civilized. The authors state that the culture of these peoples differs from that of the Kayan " chiefly in lacking some of its more advanced features, in having less sharply defined outlines, in its greater variability from one community to another, and in the less strict observance of custom. Thus the Kayans in general live in larger communities, each of their villages generally consisting of several long houses ; whereas a single long house generally constitutes the whole of a Kenyah or Klemantan village. The Kayans excel in iron-working, in padi-culture, in boat-making and in house-building. Their customs and beliefs are more elaborate, more definite, more uniform, and more strictly observed. Their social grades are more clearly marked. They hang together more strongly, with a stronger tribal sentiment, and, while the distinction between them and other tribes is everywhere clearly marked and recognized by themselves and others, the Klemantans and Kenyahs everywhere shade off into one another and into Punans "—that is, into nomadic hunters.[2] I will venture to quote more of these remarks, for they throw an illuminating light upon the early history of civilization. The authors are convinced that the Kenyah and Klemantan have assimilated their culture from the Kayan ; that they in fact are food-gatherers who have adopted part of the civilization of the strangers. The Kenyah seem to have assimilated more than the rest : they grow enough rice to last the year round, while the Klemantan do not. In fact " it seems that most of the present Kenyahs first began to plant padi not more than two, or at most three, centuries ago. Some of the Kenyahs also preserve the tradition of a time when they constructed their houses mainly of bamboo ; this was probably their practice for some few generations after they began to acquire the Kayan culture. At the present day those Punans (nomadic hunters), who have only recently taken to the settled mode of life, generally make large use of the bamboo in building their small and relatively fragile houses." [3] Moreover, the process of conversion of Punans into settled communities that assimilate more or less freely the Kayan culture is still proceeding. " We are acquainted," say the authors, " with settled communities which still admit their Punan origin ; and these exhibit very various grades of assimilation of the Kayan culture. Some, which still build very poor houses and boats, cultivate padi very

[1] Hose and McDougall, II. 232. It is possible that the iron-working activities of the Kayan have led them on to fresh sources of that metal in the beds of the rivers (see p. 122).
[2] *Id.* II. 243–4. [3] *Id.* II. 243–5.

imperfectly, and generally exhibit the Kayan culture in a very imperfect state." [1]

This is certainly one of the most valuable known facts concerning the development of culture. It shows that a people with a fairly high type of civilization, who build large houses, displaying thereby much skill in carpentry, who work iron, who have large boats, and display a high degree of social solidarity, can come into a region peopled only by food-gatherers, and, by contact of varying degrees, produce a whole series of cultures varying from their own level down to that of the food-gatherers. It is unfortunate that the possibilities of observing such experiments are so limited, for thereby much light can be thrown on the development of civilization. Such an example as this at once drives a breach into the defences of those who hold that peoples have, in all parts of the world, under certain climatic and racial influences, come to raise themselves in cultural level. The case of Borneo shows, on the contrary, that cultural uplift can be shown to result from contact between peoples of varying cultural level, whereby the people of lower degree borrow some of the arts and crafts of the others, and it offers a satisfactory explanation of the abrupt differences in North America and Torres Straits. This makes the development of civilization quite a different matter. It is now a case of movement of culture, and not of spontaneous generation.

As the argument proceeds it will be seen that growth is the chief feature of the development of early civilization. Signs exist, not of a general and independent uplift of culture in all parts of the region, but rather of the acquisition by communities of elements of culture from other communities that possessed these elements.

The food-gatherers will play but little part in the general discussion of this book, but their existence on the boundaries must not be forgotten. It will often be necessary to use them as a sort of " control " for the argument, in order to elucidate the points involved. But with the realization that their hunting-grounds have, in more than one place, been encroached on by peoples with the fundamental arts and crafts of civilization, the food-gatherers pass out of the scene to take their place in the background.

[1] *Id.* II. 244.

CHAPTER III

CULTURE-SEQUENCE, NORTH AMERICA

IN the last chapter it was said that a definite boundary includes the food-producing peoples of the United States; and that this boundary also marks the limits of pottery-making, house-building and so forth; allowing, always, for the fact that the time chosen is in a period prior to the introduction of the horse by the Spaniards. The next question is : How did these people come by their agriculture, pottery-making and the rest of their arts and crafts ? I shall now try to answer that question.

In studying the problem of North American agriculture, one important generalization can be made at once; namely, that it was founded on maize-growing. All the more advanced tribes, excepting, of course, the Plains Indians, grew maize, and there is no reason to believe in a prior stage of agriculture when this cereal was not yet cultivated.[1] That is to say, the whole of the culture of the United States can be regarded as a unit based on maize-growing. The mode of cultivation and the methods of preparation of the grain for food displayed remarkable skill ; and the same varieties of corn, the same methods of planting, fertilizing, and cooking prevailed everywhere.

The Indians handed on their methods to the Europeans who followed them. In the words of Mr. Wissler : " Our farmers formerly planted, and often yet plant, maize in hills ; this was the universal Indian mode, four to five grains being dropped at one place at regular intervals of about three feet, quite like a cornfield of to-day. In cultivation, the Indian hoed the earth up around the growing stalk, which is still the principle of the mechanical cultivator. For husking, our farmers use a husking pin, which, while now of iron, was not so very long ago of bone and wood, precisely like those still in use among our surviving eastern Indians. Ears of corn to be dried or preserved for seed often have their pendant husks braided together ; this is typically Indian. The corn crib was used by the Indians and elevated on posts to keep the contents dry and to protect it from rodents. The type of crib which is larger at the top than at the bottom was also used by the southern Indians.

" The Indian planted beans and squashes among the corn.

[1] Wissler i. 17.

This has always been a favourite custom of our farmers. He also understood the art of testing his seed and of preparatory germination in warm water. Where fish were available they were used for fertilization, the rule being one fish to a hill.

" The methods of cooking corn are not only still about the same among us, but we also retain many of the Indian names for such dishes, as hominy and succotash. The famous roasting ear in all its forms was known to the Indians. Then we must not forget the favourite mush, which is still stirred with a wooden ladle strikingly like those of the Algonkin tribes. Some years ago our country people still made ' lye hominy ' with wood ashes, just as described by some early observers of the Indian." [1] The Indians of the States who practised agriculture were therefore not ignorant savages, roaming the woods with tomahawks ready to trap unwary settlers. People who had the idea of germinating maize in warm water, who knew of many methods of preparing it as food which the Europeans were content to imitate, must have elaborated a high form of civilization themselves, or have derived it from some people of advanced culture.

Fortunately it is not necessary to speculate on this problem of the origin of the maize-culture of the Indians, with all that it involves. For authorities are agreed on this point. Wissler tells us that, culturally speaking, there is no gap between the eastern area of the States and Mexico : " Although its contact with the great agricultural area of Mexico and the South is slightly broken in Texas, we have no reason to doubt a historical connexion between the two areas, and consequently we may consider them as parts of the same whole." That being so, a further step forward is easy. For maize belongs to the South, to Mexico and Guatemala, and not to the United States ; therefore its cultivation must have spread northwards. In the words of Mr. Spinden, " the concept and the complex of agriculture undoubtedly migrated from Mexico." [2] This statement is supported by other students, among them Mr. Gilmore, who, on the basis of his study of the food-plants of Indian tribes, says : " The several cultivated crops grown by the tribes of Nebraska are all of south-western origin, probably all indigenous to Mexico. . . . After diligent inquiry, the only cultivated crop plants of which I am able to get evidence are corn, beans, squashes and pumpkins, tobacco, and sunflowers. These are all of native origin in the south-west, having come from Mexico by way of Texas. But a large number of plants growing wild, either indigenous or introduced by human agency, designedly or undesignedly, were utilized for many purposes. No evidence appears that any attempt was ever made looking to the domestication of any of these plants. The reason for this is that the necessary incentive was lacking, in that the natural product of

[1] Wissler iv. 656 e.s. Cf. also Waugh. [2] Spinden ii. 269.

each useful native plant was always available. In their semi-annual hunting trips to the outlying parts of their domains, the Indians could gather the products belonging to each phytogeographic province. The crop plants which they cultivated, however, were exotics, and hence supplemented their natural resources, thereby forming a distinct adjunct to the supply of provisions for their needs." [1]

The notion that agriculture, in the shape of maize-growing, came north from Mexico, is not new ; for Schoolcraft, many years ago, enunciated the same thesis as Messrs. Spinden, Wissler and Gilmore.[2] He couples pottery-making with agriculture as derived from the South. In this he is, once again, in agreement with modern authorities. Spinden, for instance, says that " the boundaries of pottery distribution closely parallel the boundaries of agriculture distribution, extending in some regions slightly beyond them," [3] as the result, it must be noted, of the movement into the Plains. The fundamental crafts of agriculture and pottery-making being derived from Mexico and the South, the culture of the Indian tribes can be regarded as derived thence, directly or indirectly, and thus the abrupt boundary between the food-gatherers and the food-producers receives its explanation.

Schoolcraft clearly realized the fundamental importance of the great civilizations of America as foci of cultural influences. For he says : " Notwithstanding the great diversity we have found, there are, on every hand, the unmistakable signs of unity. The higher cultures of Mexico and Peru are, after all, merely the great centres where the fundamental elements of the New World culture were full-blown. Thus, we found that agriculture, metal work, ceramics, architecture, and sculpture all centred there. In addition, there were a number of specific instances of miscellaneous traits that radiated from these centres. Confronted as we are by the undeniable evidence for the local diffusion of culture traits in all parts of both continents, it would be difficult to conceive of the existence of these virile centres in entire isolation." [4] With the aid of the working hypothesis, that the culture of the food-producers of the United States was ultimately founded on Mexico, it is possible to study with profit the various culture-sequences that can be observed in the northern half of America.

It is not generally remembered by writers on the customs and beliefs of Indian tribes of North America that the Cherokee, Iroquois and others are living in a region full of remains of a past civilization which obviously differed from theirs ; so much, indeed, that violent discussions have taken place as to the identity of the earlier folk and their relationship to the post-Columbian Indians. Sketch Map No. 3 is intended to convey to the reader some idea of the extent of the mounds and other remains of this

[1] Gilmore 136, 137. [2] Schoolcraft I. 61-2.
[3] Spinden ii. 269. [4] Schoolcraft I. 202.

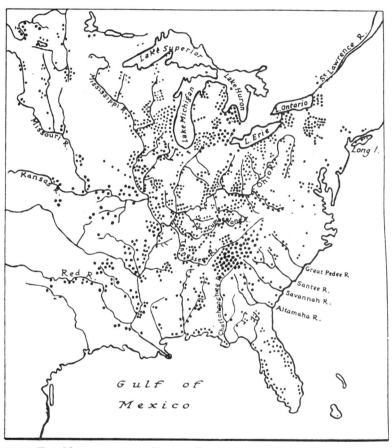

THE MOUNDS OF THE UNITED STATES (AFTER CYRUS THOMAS)

past stage of civilization. The mounds are numbered by hundreds, mainly grouped in the basins of the Mississippi, Ohio, Tennessee, Cumberland, and other rivers, on both sides of Lake Michigan, in West Virginia, North Carolina, South Carolina, and Florida. Large tracts of country are free from them. West of the Mississippi they exist in small numbers in Texas, between the Arkansas and Red Rivers, along the Arkansas, Kansas and Missouri Rivers, and in certain other places.[1]

Much discussion has taken place with regard to these mounds, the result of which has been to establish two conclusions with fair certainty : That the mound-builders were in some way connected with the Indian tribes ; and that the practice of building mounds came from Mexico. The argument that the culture of the mound-builders is similar to that of the Indians rests on a broad basis ; it is said that they had similar burial customs ; everyday implements of the Indians, such as scrapers, hoes, celts, axes, hammers, chisels, gouges, drills, awls, net-sinkers, and so on are similar down to specific forms and finish, leaving absolutely no possible line of demarcation between them and the similar articles attributed to the mound-builders ; maize was the chief food of both ; and there are marked resemblances in the use of shells and tobacco-pipes ; evidence also exists of the construction of mounds by post-Columbian Indians.[2] The fact that the sedentary Indians of post-Columbian times should have occupied practically the same area as the mound-builders is further important evidence connecting the two groups.[3]

At the same time the theory of Mexican origin of the culture of the mound-builders has everything to be said for it. Schoolcraft was strongly of the opinion that the custom of mound-building spread from Mexico. He says that, as it spread, " it evinced a decadence which is the probable result of inter-mixture and encounters with barbarous tribes. Its temples and teocalli [4] dwindle away in almost the exact ratio of the distance which they had proceeded from their central seat. Yet there was a strong clinging to original ideas and forms. On reaching Florida and the Mississippi valley their teocalli assumed the shape of large, truncated mounds, still noted as the sites of their sacerdotal and magisterial residence—for these functions were here, as there, firmly united ; while the adoration of the sun, as the symbol of Divine Intelligence, was found to be spread among all the tribes of North America, to the borders of Lake Superior, and even through New England. Viewed in the present area of the United States, to which the disturbing influence of the twelfth century manifestly reached, there were originally, and still remain, great

[1] For a general account of the mounds and their contents, see C. Thomas i. and iii.

[2] C. Thomas ii. 680, 683, 684, 687, 688.

[3] I shall, in future chapters, refer to this region (see Sketch Map No. 2) as the Mound Area. [4] Truncated pyramids = " god's houses."

resemblance of customs and arts, and of traits mentally and physically." [1] Clark Wissler states that the use of pyramidal mounds for burial and ceremonial purposes extends from Mexico to the Great Lakes, which is yet another sign of the unity of culture throughout this region. [2]

Although the culture of the mound-builders shows manifest signs of continuity with that of the Indians, yet it is superior in the arts and crafts. For instance, some of the mounds contain dolmen-like burial chambers made of large slabs. [3] Some mounds in Georgia, Kentucky and Tennessee contain, moreover, carved stone images. None of the Indian tribes use stone for any purpose except implements, and they certainly do not make carved stone images. The mound-builders also made pottery heads and death masks, both of which are unknown among the Indians. [4] In the making of mounds they are also to be sharply distinguished from the great majority of the Indians. In culture the mound-builders thus stand midway between the civilizations of the South and the Indian tribes. They possess some of the arts and crafts that the Indians lack, while their own accomplishments do not rival those of the Mexicans. For instance, the sculptor's art was at home in the south, so that " no stone-carving worthy of the name occurs north of the Rio Grande." [5] The civilization of the Mexicans and other peoples of the South can be compared with those of the mound-builders and the Indians in yet another way. It is said that " In Mexico . . . gold and silver were skilfully worked by casting, soldering, hammering and inlaying," [6] and that " The North American Indian does not, during prehistoric times, appear to have worked or used gold or silver for either ornament or utility." [7] While it is not quite exact to say that none of the Indian tribes used metals, it certainly is true that a great gulf exists between them and the Mexicans in this respect, and that the mound-builders are intermediate between them.

Mexican agriculture was founded on irrigation, which is unknown in the mound area. Indian tribes invariably grew their crops on small mounds. But the mound-builders seem, partly, to have had a more intensive system of cultivation. " It is pretty well established that since the time of the mound-builders and prior to the advent of the Indians, a race known as the ' villagers ' occupied certain districts in this country and made the ' garden beds ' found in northern Indiana, Lower Missouri, and in the valleys of the Grande River and St. Joseph's, Michigan. The beds exist in the richest soil in that part of the country. Some of the lines of the plots are rectangular and parallel, others are semicircular and variously curved, forming avenues, differently grouped and disposed. They cover from ten to one hundred acres, and sometimes embrace even three hundred acres. The

[1] Schoolcraft V. 30. [2] Wissler iv. 103. [3] Yarrow 115.
[4] T. Wilson i. 468 e.s., 475 e.s.
[5] Wissler ii. 134. [6] Wissler ii. 126. [7] T. Wilson i. 508.

beds are laid out with great order and symmetry, and have certain peculiar features that belong to no recognized system of horticulture. These beds are entirely different from the system of field culture as practised by the Indians, and no similar remains are connected with the enclosures of Ohio." [1]

When the three groups of peoples are compared, Indians, mound-builders and Mexicans, it is evident that their cultures are graded in progression. On the basis of maize-growing it is possible to claim a fundamental unity. The culture of the south came first, and gave rise to that of the mound-builders, which in its turn produced that of the Indians. In every case the arts and crafts, instead of developing as the result of this transmission, degenerate ; often they disappear.

The various groups of Pueblo Indians, although differing in speech, are similar in culture, and are all related to each other, as is evident from a study of their origin stories. These peoples have not always lived in this region in the same stage of culture, but are described as remnants of a dwindling race or as powerful sedentary tribes reduced to distress and decadence. The dwellings of their ancestors are scattered, as may be seen from Sketch Maps Nos. 10 and 11, over an area wider than that occupied by the present tribes (see Sketch Map No. 2). These ruins are found in Utah, Colorado, New Mexico and Arizona and the north of Mexico. They are situated more especially on the banks of the Colorado and its tributaries, the Rio Grande and its tributaries, and the Sierra Madre of Mexico. They are of three main types : cave-dwellings ; cliff-dwellings made by enlarging and altering natural caves or rock shelters, or by cutting caves in the cliffs on the banks of the rivers ; and ruins in the valleys, plains or rocky plateaux. [2] Many of these are on an enormous scale, witnessing to the extent of the past civilization of the Pueblo Indians.

This region is full of existing and disused irrigation systems, the early ones being the more elaborate. The Moqui Indians formerly made reservoirs lined with masonry. " The face of the cliff had been ingeniously converted into terraces. These were faced with neat masonry, and contained gardens, each surrounded with a raised edge so as to retain water upon the surface. Pipes for the reservoirs permitted them at any time to be irrigated. . . . A long flight of stone steps, with sharp turns that could easily be defended, was built into the face of the precipice, and led from the upper reservoir to the foot of the town." [3] Again it is said, " the walls of the terraces and reservoirs were of partially dressed stone, well and strongly built, and the irrigating pipes conveniently arranged." [4] Fewkes says in one place, " Students of south-western archæology are familiar with rows of stones marking off the surface of the land in rectangles of great regularity. Some of these lines of stones extend for several hundred feet." Similar sites are

[1] Maclean 131. [2] Beuchat 187. [3] Bancroft IV. 668. [4] Ibid., 670.

found in the San Simon valley. "They may be regarded as the walls of terraced gardens, so placed as to divide different patches of cultivated soil, and to prevent this soil from being washed down to the plain below." Very extensive irrigated terraced gardens are to be seen not far from San Jose. "It would seem from their distribution that not only irrigation ditches watered the Valley of Pueblo Viejo, but also that the water was in some way carried up the hill-sides, so that land now barren was in ancient times cultivated by the people of this region." [1] The earlier stage of Pueblo culture was therefore, it seems, more elaborate than that of the present-day tribes, such as the Zuni, Hopi, Sia, and others. [2] But many of these tribes still practise irrigation and live in houses of mud brick, thus surpassing the Indians of the Mound region. But they have, in some instances, fallen still lower in the scale of culture. In his commentary on the creation legend of the Zunis, an important group of Pueblo Indians, Mr. Cushing explains how the present tribe originated. It is compounded of two groups, one of which, akin to the Pueblo peoples of Utah and Colorado, settled in the region and practised irrigation. Of the early people Mr. Cushing says : "There is abundant reason for supposing that the ' elder nations '—those peoples whom they ' overtook,' the ' People of the Dew,' the ' Black People,' and the ' Corn People ' of the towns builded round—were direct and comparatively unchanged descendants of the famous cliff dwellers of the Mancos, San Juan, and other canyons of Utah and northern New Mexico." [3] These settled irrigating people were dominated by an incoming group from the west, that made themselves into the ruling class. The later comers were much less advanced in the peaceful arts : they did not cultivate the soil, or, at least, they did not cultivate it to any considerable extent, before they met the first of these peoples ; for, to use their own words, they were " ever seeking seeds of the grasses like birds on the mesas " (mountains). [4] The introduction of the horse had the effect of detaching some of the Pueblo Indians, and caused them to take to the nomadic life ; this was so with the Navaho, Apache, and others, who formerly lived sedentary lives and made stone houses. [5] Pueblo culture has thus gone steadily downhill.

Many reasons can be adduced for believing that the civilization of the Pueblo region was derived from the direction of Mexico ; for in material culture and in ritual and belief many ties connect the two. But apart from this, the fact that the Pueblo Indians grow maize is sufficient evidence of the southern origin of their civilization.

Mexico and the south is thus the home of culture of the tribes

[1] Fewkes viii. 176–8.
[2] See Duff 304 e.s., for continuity between early and late in the Pueblo area.
[3] Cushing ii. 69. [4] Id., 68, 69. [5] Beuchat 225.

of the United States. When the Spaniards arrived at Mexico City they found the Aztecs in power. But these people were the descendants of conquerors who had come a short while before from the north. They were not the founders of Mexican civilization : that was the work of a far earlier people. Behind the Aztecs in Mexico were the Toltecs, whose existence has been so often asserted and denied. The Toltec civilization, although the earliest known in Mexico, is not so old as that of the Maya, farther south ; its beginnings coincide with the time when the Maya had colonized Yucatan, in the second period of their development, for ample evidence exists of cultural relationships between the two groups.[1] The great Toltec cities were Tula, Teotihuacan and Cholula, the first two of which were founded, it is said, in the seventh or eighth century A.D., at about the end of the Maya epoch of greatest brilliancy : and probably these cities were in their greatest splendour several centuries later. They appear to have declined in the twelfth and thirteenth centuries, and other cities rose in their stead ; for instance, Tezcuco, Tlascala, and Tenochtitlan.[2] This civilization was not a local product of Mexico. As Mr. Spinden says : " Similarities in material arts, social organization and religious institutions bind the various peoples of southern and central Mexico in a firm ethnographic union with the Maya." [3] Since the Maya civilization came first, to it are to be ascribed the beginnings of the later civilizations of the area ; and therefore, ultimately, of the rest of North America.[4] Of that there seems no reasonable doubt. For instance, it is certain that the calendar was invented by the Maya, who brought it to its highest degree of perfection. In Mexico it is supposed to have been introduced by Quetzalcoatl (the great culture-hero of the Nahua-speaking peoples). Five of the animals representing day-signs in the Aztec calendar do not occur in the highlands of Mexico, but are indigenous to the Maya country, which is good evidence of origin in that place.[5]

The Maya country extended between 87° and 94° West Longitude, and 14° and 22° North Latitude. It comprised the states of Tabasco and Chiapas in southern Mexico ; Guatemala north of the Motagua river ; part of Honduras, including the head-waters of the Copan river, the lower course of the Ulca and probably the whole valley of the Comayagua ; and the peninsula of Yucatan and British Honduras.[6] The earliest cities probably were Tikal, Copan, Quirigua, Naranjo, Yaxachilan, Piedras Negras and Palenque, which contained great stone pyramids and irrigation systems. This civilization reached its zenith in the first period of development, just after the beginning of our era ; the level of culture was the highest ever reached by a native American civilization. It is said that although inferior to the Peruvians in the

[1] Spinden i. 219.
[2] Spinden i. 220. Sketch Map No. 12.
[3] Id. i. 219.
[4] Spinden i. 1.
[5] Spinden i. 220.
[6] Spinden i. 1. Sketch Map No. 13.

textile arts, to the Chiriqui people in metal-work, and to the Aztec in military organization, they far excelled any other civilization of America in their material culture.[1] In none of the later Maya settlements was there any improvement in the technique of arts and crafts, but rather a deterioration. Mr. Spinden says, " Maya art is on a much higher scale than any art in America except possibly the textile art of Peru." [2] But this level is not maintained. For, speaking of the stelæ found in the early Maya cities, he says : " Instead of an increase of accuracy in the representation of the natural proportions of the human form, there is a marked falling off." [3] He goes on to say : " The mechanics of architecture seem hardly to have suffered a setback. Only æsthetic art in its most spiritual and imaginative phases was blotted out by some potent social change." [4] What that social change was will be discussed in a later chapter.

In the course of time the civilization of Mexico gradually deteriorated in material culture, and the final blow was given by the Spaniards ; so that, at the present day, the Lancadones live in the valley of the Usumacinta, the first home of the Maya race, in a region strewn with ancient cities. " Scattered thinly in family groups, these people have indeed reverted to the wild. Although their religion is now of the primitive guardian animal type, the ritual still preserves features that point upward to the past, as also does the making of pottery or cloth." [5] Direct descendants of the Maya still live in Yucatan with a culture so low that, were it not known that they were of Maya stock, it could be claimed that they represented an early stage in the development of civilization.[6]

The result of the study of the historical sequences of cultures in the northern half of America can be summed up in a few words. First appeared the Maya civilization of Guatemala and its neighbourhood, possessed of all the arts and crafts of the later civilizations, and equalling, if not excelling them all in practically every respect. This Maya civilization gave rise to others in Yucatan and Mexico, of a lower level in culture. These, in their turn, sent out shoots. The United States was influenced, and communities appeared there depending for their sustenance on maize, brought from the south. In time these new civilizations, in their turn, degenerated in the arts and crafts, and the final upshot was to produce communities of a low level of culture, not only in the United States, but also in the home of the Maya civilization. The tale is one of uninterrupted culture degradation, a surprising result : and, so far as I am aware, there is not a single fact to contradict this generalization.

How did the Maya obtain their civilization ? I do not intend at this stage to say anything to bias the reader one way or the

[1] Spinden i. 14. Cf. also Joyce ii.
[2] Spinden i. 14. [3] Id., 158. [4] Id., 198.
[5] Spinden i. 12. [6] Gann.

other, but will simply quote the words of two competent author-
ities in American archæology. According to Mr. Morley, the
origin of the Maya civilization is " lost in the remote past, not
even the shadowy half-lights of tradition illumining its beginnings.
The very earliest inscriptions literally burst upon us fully formed,
the flower of long-continued astronomical observations expressed
in a graphic system of exceeding intricacy. It seems probable,
indeed, judging from the complexity of the earliest texts, which
are in stone, that the hieroglyphic writing must have been developed
on some perishable medium such as wood or fibre-paper or parch-
ment, the destruction of which by natural processes would satis-
factorily explain the entire absence of its earlier stages." [1] Again,
Mr. Spinden : " It would be accepted as self-evident that the
Maya calendar could not have sprung suddenly into being, based
as it is upon exact astronomical facts and intricate mathe-
matical calculations. There was no earlier civilization in the
American field sufficient to furnish even the fundamental concepts
of the calendar. No one can tell how long a period of observing,
recording or correcting was necessary before the Maya year count
was made nearly as accurate as our own, and far superior to the
best that the classical culture of Greece and Rome could offer.
Furthermore, other features of Maya culture must have passed
through a long period of selection and evolution before the
beginning of the period of recorded history. The simple picto-
graphs of the American Indians, the only prototype that research
has offered, could not in a moment have developed into a compli-
cated hieroglyphic system. Government and religion must have
had time slowly to master its control over the mass of the people
before the great pyramids, some of which probably antedated
even the most archaic monuments, could have been attempted." [2]

I leave the reader to ponder over these words, and to solve for
himself the problem with which he is thus faced : How did a
great civilization suddenly arise in one place, spread thence, and
ever after steadily go downhill. Of more immediate concern is
the utilization of the results already achieved, so that they may
be applied to other parts of the region.

It is possible, on the basis of certain cultural elements, to draw
a line of distinction between the civilization of Mexico and the
South, and that, say, of the post-Columbian Indians. It is
necessary not to take too many elements to begin with, for that
would only complicate the argument. But if it is noted that the
civilization of the Maya, and the South generally, differed from
that of the Indian tribes of the United States in that it possessed—

(1) The use of stone for purposes of construction ;
(2) Irrigation ;
(3) Sculpture, especially the carving of stone images ;
(4) Metal-working, especially for the precious metals ;

[1] Morley i. 141. [2] Spinden i. 171.

it will be agreed that the two groups are well differentiated. I do not mean that this division is water-tight, but that it enables us to draw a broad line of division. As the survey works westwards it will be found that a similar distinction between early and late is widespread. This makes it convenient to give the earlier, more advanced stage a name, and I shall therefore call it the *Archaic Civilization*, and shall consider it provisionally as characterized by the four cultural elements above enumerated. I shall make no attempt to distinguish between different sorts of stonework, or metal-working, but shall accept the crafts themselves as the important facts. The justification for this attitude must come later.

CHAPTER IV

CULTURE-SEQUENCE, OCEANIA

THE vast region of Oceania contains two distinct peoples. In Melanesia, which comprises the western part, the Solomons, the New Hebrides and Fiji, the population is dark-skinned and negroid in type. In Polynesia, which comprises the rest of the Pacific with the exception of Micronesia, the population consists of light-skinned people somewhat akin to the inhabitants of countries west of the Pacific. The population of Polynesia is relatively uniform, though the effects of an infusion of Melanesian blood can be detected in certain places. Because of this diversity of race it is customary to divide Oceania into two broad divisions, Polynesia and Melanesia.[1]

Scattered through Polynesia are stone monuments and stone statues, of varying shape and size, which in many cases are not used by the present population for any purpose. Some of these remains, such as those of Easter Island, have, for various reasons, attracted much attention. One principal cause of the interest aroused by them is that, in the words of Rivers, the manufacture of these monuments " seems quite beyond the present powers and implements of the people, and in most cases the inhabitants do not know when or by whom these objects were made." [2]

Easter Island has a fascination of its own. Its remote isolation in the Eastern Pacific strikes the imagination when one thinks of the people who erected the massive stone terraces and carved the gigantic stone statues that it contains. The monuments of this island, according to one authority, consist of " stone houses, massively built, and placed in rows or streets : platforms from 200 to 300 ft. in length, and 15 ft. to 20 ft. high on the outer or seaward side, constructed of hewn stones dovetailed together ; stone statues 3 ft. to 30 ft. high, representing the upper portion of a human figure, sometimes standing on the platform and sometimes on the ground ; and sculptured rocks, the subject being generally the human face. On the heads of the larger figures crowns made from a red volcanic stone were fitted." In the quarries whence the stone was obtained some figures were found. " One of these figures measured 20 ft. from the nape of the neck to the top of the head, which was flattened for the

[1] Rutland iii. 44. [2] Rivers vi. II. 437.

reception of a crown. From the appearance of the eye-sockets, it has been conjectured that black obsidian eyeballs were originally inserted. Another peculiarity of the figures is the disproportionate size of the ears." [1] The platforms on which these statues were placed were pyramidal in shape.[2] The builders of these monuments were evidently skilled agriculturists, for remains of irrigation systems have been found on the island.[3]

Hawaii possesses stone ruins. For instance : " In the remarkable temple of Umi on the desert plain of Hawaii, 7,000 ft. above the sea, the huge pyramids of stone remain to this day as monuments of the devotion and industry of chiefs, priests and the men of the districts of the island." [4] Stone tombs were formerly made for the kings ; one is mentioned as built some time before 1700 A.D. The Hawaiians practise irrigation for taro-growing.[5]

Stone idols and stone walls testify to the presence in the past of a population on uninhabited Necker Island, 450 miles west-north-west from Honolulu. Stone remains also exist in Fanning's Island, near Christmas Island.[6] The Marquesas possess stone remains in the form of statues and buildings.[7] About these Rivers has collected some interesting information. " Several statues with points of resemblance to the remains of Easter Island have been found in the Marquesas. In Nuku-hiva Porter saw a statue of stone, about the height of a man, but ' larger proportioned in every way,' round which the dead were exposed in canoes. This figure differed from those of Easter Island in being in the squatting position, but a greater similarity is present in a statue found by Christian in the island of Riva-oa. This was about 8 ft. high, and in the position of the arms and general character of the features definitely resembled the statues of Easter Island. . . . The ma'ae or sacred places had two or more platforms, but there is no evidence of a pyramidal form." [8] Platforms are also mentioned 100 yds. long, many of the blocks of stone of which they were made being as much as 8 ft. long, shaped and closely fitted. The platforms were surrounded by upright stones, and on top had pyramidal altars. [9] The people of these islands formerly practised irrigation. " In all the valleys one can see a series of terraces, platforms of various sizes, according to the slope of the ground. These terraces have stone supporting walls and irrigation canals for the water supply." [10] Irrigation works are found also in the Paumotus.

[1] Rutland iii. 38–9.		[2] Rivers xiv. 83.		[3] Ratzel I. 254.
[4] Brigham 97–8.
[5] Written communication from Mr. A. M. Hocart.
[6] Ellis I. 124 : J.P.S. 3, 1894, 153.
[7] Christian i. 194.		[8] Rivers xiv. 295–6.		[9] Rivers x. 440.
[10] Tautain ii. 543. Handy mentions ma'ae in these islands "sometimes consisting of several terraces running up a hill-side " (228). In a letter to Rivers he denies the existence of irrigation terraces in the Marquesas. Perhaps he has mistaken the function of those described by him.

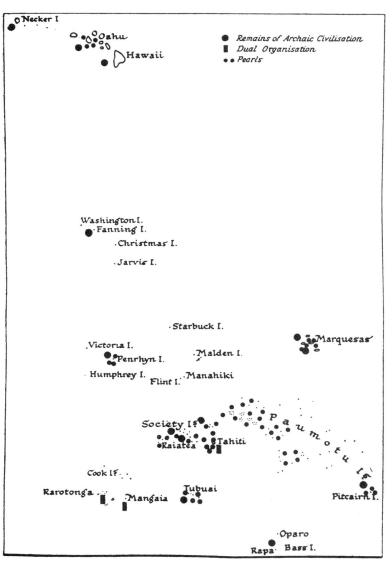

Necker I

Oahu

Hawaii

● Remains of Archaic Civilisation
▮ Dual Organisation
•• Pearls

Washington I.
Fanning I.
Christmas I.
Jarvis I.

Starbuck I.

Victoria I.
Penrhyn I.
Humphrey I.
Flint I.
Malden I.
Manahiki

Marquesas

Society Is.
Raiatea
Tahiti

Paumotu Is.

Cook Is.

Rarotonga
Mangaia

Tubuai

Pitcairn I.

Oparo
Rapa Bass I.

EASTERN POLYNESIA

Stone temple foundations are reported from Pitcairn Island.[1] Stone statues have been found at Raivaivai of the Austral Islands, " and yet in the other islands of this group there is now no trace of megalithism ; the existence of great stone statues and maraes in this islet is still a puzzle."[2] Mangaia of the Cook Islands does not seem to possess any stone remains, but Gill mentions a stone " idol " that the natives broke on conversion to Christianity.[3]

The Society Islands possess many megalithic monuments, and in this respect seem to be the most important of the eastern Pacific. Tahiti possesses a great number of ruins of pyramidal structures that played an important part in the religious rites of the people. Raiatea also possesses some important marae, among them being that of Opoa, of which more will be heard in later chapters.[4] Captain Cook described one of these monuments, called a marae. " It is a long square stonework built pyramidically ; its base is 267 ft. by 67 ft. ; at the top it is 250 ft. by 8 ft. It is built in the same manner as we do steps leading up to a sundial or fountain erected in the middle of a square, where there is a flight of steps on each side. In this building there are eleven of such steps ; each step is about 4 ft. in height, and the breadth 4 ft. 7 in., but they decreased both in height and breadth from the bottom to the top. On the middle of the top stood the image of a bird carved in wood ; near it lay the broken one of a fish carved in stone. There was no hollow or cavity in the inside, the whole being filled up with stones. The outside was faced partly with hewn stones and partly with others, and these were placed in such a manner as to look very agreeable to the eye. Some of the hewn stones were 4 ft. 7 in. by 2 ft. 4 in., and 15 in. thick, and had been squared and polished with some sort of an edge tool. On the east side was enclosed with a stone wall a piece of ground, in form of a square, 360 ft. by 354 ft. ; in this were growing several cypress-trees and plantains. Round about this marae were several smaller ones all going to decay, and on the beach between them and the sea lay scattered up and down a great quantity of human bones. Not far from the great marae were two or three pretty large altars, where lay the skull-bones of some hogs and dogs."[5]

There is a megalithic stone circle on Penrhyn Island.[6] Samoa has its monuments, among them the Fale-o-le-Fe'e, which forms " another link in the chain of mysteries of the past, regarding which we seek in vain for some help to unravel."[7] The earlier generations of Samoa are said to have had idols, but they are not used by the later population of the group.[8]

Tonga has its megalithic remains. Near Kolonga in East

[1] Ellis I. 124. [2] J.P.S. 27, 1898. [3] Gill ii. 15.
[4] Baessler 256. [5] Rutland iii. 38–9. [6] Westropp 56.
[7] Stair i. 42 ; v. 42, 45 ; J.P.S. i. 62. [8] Stair i. 33.

Tongatabu is an immense trilithon, comparable with those of Stonehenge, the purpose of which is not known. It must therefore have been erected in an age of which only traditions persist. It is said that the stones were brought from elsewhere, but this may not be so. At the same time the transportation of large stones is well known in Tongan folklore. In this group is an artificial hill about which nothing is known, a noteworthy fact in an island where the memory of sacred spots dies hard. This mound, built of lumps of coral, is 15 ft. high with a causeway leading to the flat summit.[1]

Fiji has its megalithic monuments. In the island of Rotumah are " stone tombs, composed of masses so large that it was difficult to conceive the means by which the natives had been able to move and arrange them." Many of them were of dolmen form.[2] The Fijians also had enclosures called nanga in which were pyramidal stone structures.[3] According to information supplied me by Mr. A. M. Hocart, " irrigated terraces in Fiji are almost, if not quite, confined to the islands as opposed to Viti Levu. It must be noted that in Viti Levu they can plant taro in dry land on the slopes owing to the damp and possibly the soil. They cannot in the islands, except Vanua Lava. . . . Terraces do not occur in Tonga unless it may be in Kao and Tofua, for the simple reason that the islands are flat and have no streams. I have seen none in Rotuma : they plant in dry land."

Stone causeways and walls show that the Chatham Islands were formerly inhabited by stone-using people.[4] New Zealand presents some fascinating problems. In the first place it must be remembered that the Maoris on their arrival found in the island people called Maruiwi (Moriori), probably so named after one of their chiefs. The first Maori settlers came twenty-eight or thirty generations ago. Their predecessors are said to have been " tall and slim-built, dark-skinned, hairy, having big or protuberant bones, flat-faced and flat-nosed, with upturned nostrils. Their eyes were curiously restless, and they had a habit of glancing sideways without turning the head. Their hair in some cases stood upright, in others it was bushy." According to Elsdon Best these people are similar in physical type to those of Malekula in the New Hebrides.[5] The Maori probably derived much of their culture from these Maruiwi.[6] The Maruiwi are said to have made hill forts, and many terraces in this country cannot be ascribed to the Maoris. " The terraced hills, the fosses and ramparts (presenting scarps in some cases of 20 ft.), the double and treble systems of circumvallation, the ingeniously contrived earthwork defences for weak places and entrance passages—all these are of interest, and well worthy of study. Where or how did they originate ? We know that the Maoris who settled in New Zealand came from the eastern Pacific area ;

[1] B. Thomson ii. 81. [2] Brabrook 5–6 : Allen. [3] Rivers ix. : Joske.
[4] Weule 309. [5] Best xiii. 435, 437. [6] Cf. Rutland 229, 230.

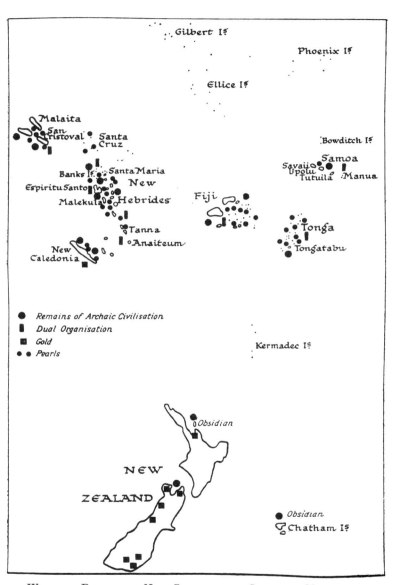

WESTERN POLYNESIA, NEW ZEALAND AND SOUTHERN MELANESIA

we know that no such remains of fortified places are found in that area. A few stone-walled refuges exist on the lone isle of Rapa. The Tongan fortified places were based on those of Fiji, but the Polynesian was not a fort-builder. Apparently the only place outside the North Island of New Zealand where hill-forts, the defensive works of which were fosses, ramparts, stockades, and fighting-stages, were numerous is the island of Viti Levu. . . . The origin of the pa maori is a field for inquiry." Apparently the Maori learned cannibalism and forms of human sacrifice from the people whom they found in the island. They adopted some of their weapons. Wooden coffins of unknown origin have been found in the island.[1]

The Maori learned their mode of carving from their predecessors. " It seems beyond a doubt that the Maori did not bring this knowledge with them from the Pacific Islands. . . . Many splendid specimens of ancient carving have been dug up out of swamps, where they have lain presumably for hundreds of years ; but in these, we see no sign of the beginner's hand, they are of the same type as those of the present day, but better finished, and of a pattern to be found only in New Zealand." " From the ancient inhabitants the Maori obtained a knowledge of the greenstone, and how to work it, besides other useful arts tn which they were further advanced than their conquerors." [2]

It has already been said that traces have been found in New Zealand of a pre-Maori population. In the first place the recent discovery of megalithic monuments must be mentioned.[3] Then in the region of Pelorus Sound are traces of a former agricultural population living in regions where, at the time of arrival of Captain Cook, existed only virgin forest. Since 1855 the clearing of the ground about this sound has " brought to light traces of human occupation wholly unexpected. Scattered over the steep hill-sides and on the small flats, pits, terraces, shell heaps, and other relics have been discovered in numbers that testify . . . to a large population." The pits and terraces are closely associated. The pits are rectangular in shape, and are made in the terraces. They are carefully lined with stone, the terraces being always much longer and about 3 ft. wider than the pit, allowing between it and the bank at the rear a foot or so of level ground. The bank or wall, generally about 3 ft. high, was always levelled at the top so as to form a narrow horizontal ledge, behind which the hill rose naturally. There is a series near Kenepuru so that " the profile of the spur has the appearance of a gigantic staircase." These were the work of a vanished people. " Every part of the ground furnishes the same unmistakable evidence that the forest has taken possession of land once occupied by man." The natives say that the pits were houses, but it is thought

[1] Best xiii. 439, 440, 445–7. [2] Gudgeon i. 210.
[3] Rutland 229, 231 : Campbell 70.

that they may have been sweat-baths, which is not improbable.[1] Some of these pit dwellings were cut out of the rock ; more than 700 cu. ft. of rock had been removed in one case, and this was used in raising walls and levelling the outer margins of the pit. " Throughout, the walls of the chamber are perfectly perpendicular, the angles squarely cut, and the floor even, especially the raised portion or dais." [2] " They made implements of twelve different sorts of stone, some of them, such as greenstone, obsidian, pumice, and diorite, being imported for the purpose." [3] But these people had disappeared long before the arrival of Captain Cook. Their ancient taro gardens have been found near Endeavour Islet, covered with gravel brought up from the seashore. " Between the revival of agriculture when the overgrown Maori gardens were cleared and the days of the pit-dwellers, there was an interval of centuries, during which the Sound could only have been inhabited by people subsisting on the natural products of the district." [4]

Yet other signs point to the presence in the past of strangers in New Zealand. In certain places (Weka Pass, near Waikari Flat ; Takiroa, near the Waitiki ; the Opini ; the levels Tengawai and Pareora) strange inscriptions occur on the rocks. Haast says of them : " I have no doubt that these rock-paintings when closely examined by archæologists and linguists will throw some light upon the questions at issue, and at least prove that at one time there has been some immigration to New Zealand, from the north-west and from countries which then possessed a far higher civilization than the Maori ever reached." [5] Not only have inscriptions been found, but apparently other discoveries are reported. According to Crawfurd, writing in 1867 : " In 1837 there was found among the Maories of the North Island a bronze bell, bearing an inscription. . . . I am satisfied that the relic is a Hindu sacrificial bell such as the Brahmins are wont to use in the performance of the ritual of their religion—that it was cast in Java, and found its way to distant New Zealand, along with portions of the Malayan languages in the course of time." [6] Apparently, according to Haast, other objects, of silver and glass, were found about the same time, but the finders were afraid to bring them to the public notice for fear of ridicule.[7]

Traces are present of ancient occupation on the Great Barrier Island near Auckland in the North Island, where in many places are old terraces with stone retaining walls, and enclosures with stone walls, as well as large heaps of stones that had been collected prior to the cultivation of the soil in places now covered with forests. No signs of Maori occupation could be found.[8]

Clearly the Maori were not the first-comers to New Zealand.

[1] Rutland i. 221 e.s. [2] Rutland v. 78.
[3] Rutland i. 225 ; ii. 111 ; iv. [4] Rutland i. 231.
[5] Haast ii. 50. [6] Crawfurd II. e.s.
[7] Haast ii. 61. [8] Westman 83.

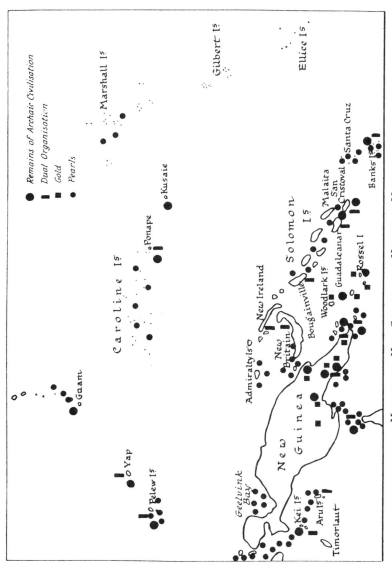

Remains of Archaic Civilisation
Dual Organisation
Gold
Pearls

Micronesia, New Guinea, and Northern Melanesia

Marshall Is.

Gilbert Is.

Elice Is.

oKusaie

Ponape

Caroline Is.

Santa Cruz

Malaita
San
Cristoval

Banks Is.

Solomon
Is.

New Ireland

Bougainville

Woodlark Is.

Guadalcanar

Rossel I

New
Britain

Admiralty Is.

oGuam

New
Guinea

oYap

Pelew Is.

Geelvink
Bay

Kei Is.

Aru Is.

Timorlaut

They were anticipated by people who made great terraces on the hill-sides, who did not hesitate to cut dwellings out of the rock, who taught them the use of several kinds of weapons. These mysterious strangers presumably left cannibalism behind them as a legacy, and certain forms of human sacrifice. They used several kinds of stone for their implements, and were most skilful in stone-carving, their work being better finished than that of later centuries. Here, then, is another mystery, one more vanished people of relatively high civilization, who are succeeded by their inferiors in the arts and crafts. Apparently these old people possessed a civilization somewhat analogous to that of the megalith builders of Polynesia, in that they erected megalithic monuments, used stone for purposes of construction, and made terraces, but whether for agriculture or not, is not certain. As to their relationship to the Maruiwi whom the Maori found in the island, it is not possible to make any definite statement.

Melanesia is of great interest, for stone monuments are there still in use. Terraced irrigation is practised in New Caledonia. Glaumont speaks of huge works for taro cultivation, consisting of terraces with stone and clay walls : " The valley of Tene was at the bottom of a basin, and the mountains which surrounded it were the sides ; the spectator at the centre enjoying the same *coup d'œil* as if he were in the middle of a Roman circus." [1] Macmillan Brown has noted the existence of megalithic monuments in this island : " There are ramparts of stone that might have been fortifications. There are a few dolmens or trilithons. And there is an extraordinary development of carving on rocks and on blocks of stone." [2] Archambault comments upon these early remains : " These monuments must not be attributed to the kanaka population which actually occupies the island. Besides the fact that the Papuan races, to which belong our Caledonian natives, have never, it seems to me, shown any inclination to carve symbols on the rocks, the little attention which they attract suffices to show that they count for nothing in their existence. These monuments are meaningless to them, for the most intelligent of them do not know of the greater part of these inscriptions at all, and are incapable of giving any meaning to the mysterious figures inscribed on the rocks. One tradition only ascribes them to a former chief. It has already been noted that rock inscriptions occur in New Zealand.

"North of New Caledonia, in the New Hebrides, is a certain amount of stone-work, some of it in present use. In some islands, Santo, Malo and Malekula, an important feature of the ritual of the secret societies is the erection of a dolmen-like stone structure consisting of a table-stone resting on stone supports, on which a new member stands when he is killing a pig." [3] An

[1] Glaumont ii. [2] Macmillan Brown ii.
[3] Archambault 266. The best houses in New Caledonia are pyramidal in shape (Ella i. 6 5).

important use of stone is found in the island of Santa Maria in
the Banks Islands, where are stone buildings, a miniature trilithon,
and stone images connected with club-houses. Recently it has
been found that the island is covered with stone walls to such
an extent that they must be " several hundred kilometres in
length " ; they are as big as a man, partly built of great blocks
of basalt, and must have cost an immense amount of labour to
construct. In many of the basalt blocks are hollows, " sometimes
as large as a wash-basin, evidently artifacts which can only
have been made by a gigantic amount of labour, or perhaps
more probably by a very prolonged use of some kind." In
this island are also earthen mounds as high as a man's shoulder.
Worked stone has been found in Mota and Loh of the Torres
Islands. In Malo, south of Santo, are walls and platforms of
stone, sometimes very finely worked, closely resembling those of
Santa Maria. In Aurora certain stone rings are said to have
marked the graves of chiefs, together with monoliths as high as
a man. Rivers states that " there can be no doubt that the
greater part of the stonework of this part of Melanesia is very
ancient. This is certainly so in the case of the stone-walls and
earth-mounds of Santa Maria which are ascribed to the labours
of a people called Mala-vui or Mala-tuniun, who are said to have
had no houses, to have slept in the bush like animals, and to
have had little or no sense." They are said to have built the
walls, heaped up the mounds and made the hollows in the stones
at the bidding of the few " normal human beings " who then
existed. The phrase " normal human beings " is certainly inter-
esting and remarkable.[1]

Farther north, in the Solomons, the recent writings of the
Rev. C. E. Fox have made it clear that stone is used for various
purposes. In the Arosi district of San Cristoval each shore
village has a stone structure called ariari, a platform carefully
and well built of large even stones, its sides even and its top
broad and flat, usually 12 to 15 ft. broad and 4 to 5 ft. high.
Sometimes the ariari is circular. These people also make large
pyramidal or square stone mounds, on the flat tops of which the
dead are buried. They construct dolmens on top of these mounds.
In Guadalcanar and Malaita of the Solomons stone structures
are also used for ceremonial and other purposes.[2]

New Guinea is one of the last places in the world where remains
of an early civilization of a fairly advanced type would be expected ;
for in the minds of most it stands for savagery, primeval and
untouched. Yet little doubt exists that it has had a far different
history from that which would be expected. In 1907 Messrs.
Seligman and Joyce wrote as follows : " Within the past few
years discoveries have been made in British New Guinea of
pottery fragments and implements of obsidian and stone, which

[1] Rivers ix. II. 427-8.		[2] Fox 99 100, 176, 177.

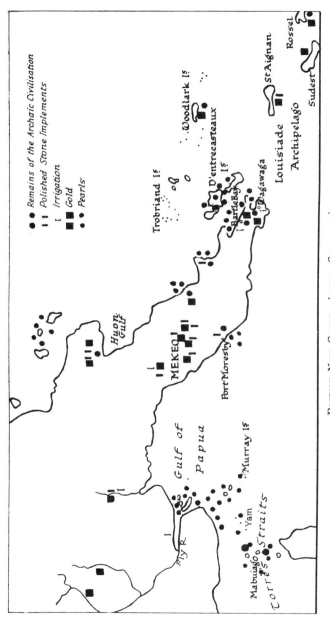

Remains of the Archaic Civilisation
Polished Stone Implements
Irrigation
Gold
Pearls

Trobriand I⁵

Woodlark I⁵

D'entrecasteaux I⁵

Bartle Bay

Wagawaga

St Aignan

Rossel

Sudest

Louisiade
Archipelago

Huon
Gulf

MEKEO

Port Moresby

Gulf of
Papua

Murray I⁵

Fly R.

Yam

Mabuiago

Torres Straits

BRITISH NEW GUINEA (AFTER CHINNERY)

differ entirely in type from the pottery and implements used at the present time by the inhabitants of the localities in which the finds were made." [1] Recently Mr. Chinnery has published a paper enumerating all the known discoveries of antiquities in British New Guinea and the neighbouring parts of German New Guinea. His catalogue is as follows : " The objects are ' sacred ' stones, standing stones, stone circles ; shells with incised ornamentation consisting of concentric circles, spiral scrolls, and human face representations ; fragments of ornamented pottery ; stone carvings of birds (with snake-like head), human and animal figures ; pestles and mortars of granite, lava, and other stone, in various shapes, some of them carved ; perforated quartz implements in various forms, some of which have been converted into stoneheaded clubs, and implements of obsidian and other stone not used by existing races." [2]

In New Britain use is made of stone images, but no mention is made of any other use of stone. [3]

According to Miss Semple, " the islands of Melanesia show generally fenced fields, terrace farming on mountain-sides, irrigation canals, fertilized soils, well-trimmed shade trees, and beautiful flower gardens." Irrigated terraces are reported in New Britain, New Guinea, the Solomons and the New Hebrides.[4] In New Guinea irrigation is confined to the Massim district, but drainage canals are made in the Fly River district and perhaps farther west. The irrigation in the Massim district is for taro, and elaborate works made long ago are still kept up. Near Wamira, Bartle Bay, is an aqueduct about 60 ft. long over a gully 30 ft. deep, " a very fine piece of work." [5] Terraced cultivation is found in the d'Entrecasteaux Archipelago and in Aurora.[6] Mr. Hocart tells me that " terraced irrigation (for taro always) occurs on a large scale in Nduke (on the maps Kulambangara), near New Georgia. The terraces are banked up with stones. Dr. Rivers tells me that terraced irrigation is found in the northern part of Santo in the New Hebrides. The distribution of irrigation thus corresponds with that of stone-work. Both are the remains of an almost forgotten stage of civilization, which only persists in a few places.

The part of Oceania with the most evident signs of a vanished civilization is Micronesia, and especially the Caroline group. Here, in certain spots, are works which would excite the imagination and pride of any civilized man if they were the product of his own countrymen. But when they are regarded as the relics of people living in such an out-of-the-way part of the world as the Carolines, they must cause amazement. Mr. Christian's descriptions will serve to give an idea of the magnitude of the

[1] Seligman and Joyce 325.
[2] Chinnery 279. Sketch Map No. 7 shows the distribution of these remains.
[3] Rivers ix. II. 516. [4] Semple 455, 456 ; Ratzel I. 255.
[5] Perry iv. 16. [6] Ratzel I. 256.

ruins.[1] " All over the Mariannes, in the seats of the native
population, before their discovery by the white men, there exist
certain pyramids and truncated cones, on the top of which are
placed semi-estufas, i.e. half-spherical bodies. These cones or
pyramids on the island of Guahan do not exceed 3 ft. in height,
the diameter of the curious pieces on the tops being about 2 ft.
. . . Amongst the natives these go by the name of *Houses of
the Ancients*. They face each other in parallel lines like a regular
street. According to tradition the old inhabitants used to inter
their dead in these houses or cairns." [2] Irrigation for rice-growing
is practised in the Mariannes.[3]

 With regard to Yap in the Carolines : " The island is full of
relics of a vanished civilization—embankments and terraces, sites
of ancient cultivation, and solid roads neatly paved with regular
stone blocks, ancient stone platforms and graves, and enormous
council lodges of quaint design, with high gables and lofty carved
pillars. The ruins of ancient fish-weirs fill the lagoon between
the reef and the shore making navigation a most difficult matter,
and calling forth many most unkind remarks from trading
skippers." [4]

 The most important remains are those of the harbour of Meta-
lanim, the eastern part of Ponape. Here is Nan-Matal, a regular
Venice built out into the sea, covering an area of several square
miles. One of the ruins, the Nan-Tauach (the Place of Lofty
Walls), is thus described : " The water-front is faced with a terrace
built of massive basalt blocks about 7 ft. wide, standing out
more than 6 ft. above the shallow waterway. Above us we see
a striking example of immensely solid cyclopean stone-work
frowning down upon the waterway, a mighty wall formed of
basaltic prisms laid alternately lengthwise and crosswise after
the fashion of a *check and log* fence, or, as masons would style it,
Headers and Stretchers." [5]

 " The left side of the great gateway yawning overhead is
about 25 ft. in height and the right some 30 ft., overshadowed
and all but hidden from view by the dense leafage of a huge ikoi
tree, which we had not the heart to demolish for its extreme
beauty—a wonder of emerald-green heart-shaped leaves, thickly
studded with tassels of scarlet trumpet-shaped flowers, bright
as the bloom of coral or flame tree.

 " Here in olden times the outer wall must have been uniformly
of considerable height, but has now in several places fallen into
lamentable ruin, whether from earthquake, typhoon, or the wear
and tear of long, long ages. Somewhat similar in character
would be the semi-Indian ruins of Java, and the cyclopean

[1] Those of Yap, Ponape, Nauru and Kusaie of Micronesia are described
and figured in the various reports of the Hamburg Expedition. See A.
Krämer ii., Müller (Wismar).
 [2] Christian iv. 53. [3] Safford 720.
 [4] Christian iv. 19. [5] *Ib.* 79.

structures of Ake and Chichen-Itza in Yucatan. A series of rude steps brings us into a spacious courtyard, strewn with fragments of fallen pillars, encircling a second terraced enclosure with a projecting frieze or cornice of somewhat Japanese type. The measurement of the outer enclosure, as we afterwards roughly ascertained, was some 185 ft. by 115 ft., the average thickness of the outer wall 15 ft., height varying from 20 to nearly 40 ft. The space within can only be entered by the great gateway in the middle of the western face, and by a small ruinous portal in the north-west corner. The inner terraced enclosure forms a second conforming parallelogram of some 85 ft. by 75 ft. ; average thickness of wall, 8 ft. ; height of walls, 15 to 18 ft. In the centre of a rudely paved court lies the great central vault or treasure-chamber, identified with the name of an ancient monarch known as Chau-te-reu, or Chau-te-Leur, probably a dynastic title like that of Pharaoh or Ptolemy in ancient Egypt." [1] As an old chronicler says, the origin of these ruins " is involved in the greatest obscurity. The oldest inhabitants can tell nothing about them, and has no tradition as to their history. Doubtless there existed here a fortified town inhabited by a folk of superior civilization."

The Carolines show other signs of an advanced civilization. Dr. Macmillan Brown has noted the existence in Oleai, or Uleai, of a script. This, and that of Easter Island, are the only known examples in the Pacific. The stone money of Yap, chiefly stone wheels sometimes weighing several tons, has been brought 300 miles across the sea from the Pelews.[2] Dr. Brown mentions also the enormous buildings which are still erected in the Pelews and in Yap as men's clubs as indicative of a former high state of civilization.[3] Traces of ancient cultivation also exist in Yap, in the shape of causeways, roads, terraces, and embankments. [4]

Lele of Kusaie in the Carolines also possesses great stone ruins, of which Christian says : " In careful and minute adjustment they are inferior to the structures of Java, but doubtless the work of a kindred race of builders labouring under less favourable conditions. Looking at their solid outlines, seamed and furrowed with the rains and sun of untold generations, one cannot help marvelling at the ingenuity and skill of these primitive engineers in moving, lifting and poising such huge and unwieldy masses of rock into their present position, where these mighty structures shadowed by great forest trees, stand defying time's changing seasons and the fury of tropic elements." [5]

This survey establishes the fact that in the past the population of Oceania erected stone buildings, carved stone images, and practised irrigation or terraced cultivation, or both. This megalith-building population is not reported in every group of Oceania : I have not found mention of stone remains in Caroline Island,

[1] Christian iv. 79–80, 81, 115. [2] Furness 53.
[3] Brown i. 43. [4] Christian ii. 124. [5] Christian iv.

the Gambier Islands, Bass Islands, Oparo, Tokelau Islands, the Phœnix, Marshall, Gilbert and Ellice groups and Kermadec Islands, and others.[1] The building of stone pyramids seems to have been confined to Easter Island, the Society Islands (especially Tahiti and Raiatea), the Marquesas, Fiji, San Cristoval, the Carolines and the Mariannes. Tonga and Samoa possess mega-lithic monuments of typical form, and it would seem that dolmens have been discovered in Fiji and New Zealand. In Melanesia dolmens are still used on certain islands. In other places, Hawaii, Fanning Island, Necker Island, Paumotos, Pitcairn Island, Austral Islands and elsewhere, the remains do not seem to be so extensive. In the account certain places stand out as of great importance from the extent of their remains ; Easter Island, the Marquesas, Society Islands, and above all, the Carolines. It will be necessary to explain why these places have been chosen for occupation on so large a scale.

On the whole the civilization of Oceania, judging from the crafts of stone-working and irrigation, has suffered a considerable decline, so that the present-day communities live alongside remains beyond their capacity to construct.

Pottery-making is a useful index of alteration in cultural level in the Pacific. In America it occurs along with agriculture, and is one of the last crafts to be lost. The distribution of pottery-making in the Solomons appears to be the same as that of agricul-ture. " The inhabitants of the island of Bougainville Straits display far more interest in the cultivation of the soil than do those of San Cristoval and its adjacent islands." There are " extensive cultivated tracts with consequent abundance of food in the one region, and meagre patches of cultivation with the resulting dearth of food in the other." Pottery is made in Bougainville.[2] It is also made in the Admiralty Islands, Santo of the New Hebrides, New Caledonia, and Fiji.[3] It is not made in Epi or Leper's Isle (Omba) of the New Hebrides, but fragments are found there, as in the parts of British New Guinea where remains are found of a vanished population. The former popula-tion of Easter Island made pottery.[4] Thus the craft evidently belonged to the early people, and has persisted in certain spots that show strong traces of the former civilization.

Australia has been left on one side. In this book a question will have to be faced, the importance of which for the erection of a stable theory of human society can hardly be exaggerated. An immense structure of theory has been raised on the assumption that the culture of Australian tribes is primitive in the real sense of the term, that it was elaborated by men in the first stage of development of civilization. It is evident, from the summary

[1] See Sketch Maps Nos. 4, 5, 6. [2] Guppy i. 62, 81, 86.
[3] Joyce i. 125–6. It is not made in New Britain (B. Danks 617).
[4] Joyce i. 147 ; Rutland iii. 6 ; Suas iii. 202. See also Suas ii. 247, on culture-degradation.

discussion of the remains of the archaic civilization of Oceania, that Australia is ringed with remains of this old civilization, and that these remains approach as close as Torres Straits, through which also passes the boundary of food-producers and food-gatherers. Can we then assume that Australia was never visited by bearers of this civilization ? It is claimed that stone circles existed in Australia.[1] If this be so, then the structure on which these theories rest collapses. It seems certain that no irrigating, stone-working, metal-working, pottery-making people have inhabited Australia for any length of time, but that does not mean that they have not influenced the culture of the natives. The study of the archaic civilization is still too incomplete to permit of a closer analysis being made ; and the matter must be left over until it is possible to apply more delicate tests. At the same time the reported presence of stone circles is significant and important.

It can readily be shown that the cultural elements used in Chapter III to distinguish the archaic civilization in North America from its successors—irrigation, stone-working, the making of stone images, pottery-making and metal-working—have, with the exception of metal-working, similar distributions in Oceania, and can therefore be grouped together as constituting the elements of its archaic civilization. Metal-working plays no part in Polynesia, for the simple reason that no metals occur there. On the basis of these cultural elements it is possible to compare the archaic civilizations of North America and Oceania, and to claim that, for some reason or other, the earliest civilizations of both regions were compounded of the ingredients just mentioned.

Oceania and North America present another point of resemblance. It was possible to claim that the civilization of North America was a unit based on Mexico, whence came the cultivation of maize, the fundamental food-plant. It is probable that the problem of the Pacific can be solved in a similar manner. In the Pacific the distribution of man presents problems similar to those of animal and plant life. In the words of Mr. Guppy, " Man and his distribution in the islands of the Pacific reproduces in a minor degree all the difficulties presented there by plants, birds and other forms of animal life. Like the plant he entered the ocean from the west ; and as with the plants, so with the aborigines, there was an era of general dispersion over this ocean, followed by an age in which Polynesian man, ceasing to migrate, tended to settle down in the several groups, there undergoing differentiation in various respects, as in physical characters, in language and in manners. Just as we can now recognize the type of a plant, of a bird, or of an insect, that belongs to a particular group of islands, so we can distinguish between the Hawaiian, the Tahitian, and the Maori, whether in physical characters, in his speech, or in his customs. Fiji possesses in the Papuan

[1] Chinnery.

3

element of its population the earliest type of man in the Pacific, just as it also possessed in the Coniferae the most ancient types of trees in this region. Divesting his mind of all previous conceptions, the ethnologist might profitably study *de novo* the dispersion of man in the Pacific from the standpoint of plant dispersal. . . ."[1] "Man in the Pacific is almost as enigmatical as the plant. As a denizen of this region he is by no means a recent introduction ; and though his food-plants are mainly Asiatic, they belong to distinct ages in the history of man's occupation of these islands.

" I venture to think that a great deal lies behind the Indo-Malayan mask of the Polynesian, and that there is a story concerned with his origin that had yet to be told. We have by no means solved the riddle when by following the evidence we assign him a home in Asia. It is only then that the real difficulties begin. It required many centuries of European civilization for the discovery of America ; but the voyage of Columbus sinks into insignificance when we reflect on what had been dared and accomplished by uncivilized man when he first landed on the shores of Hawaii and Tahiti." [2]

Polynesian food-plants fall into two indefinite groups : the ordinary food-plants commonly used, such as the yam, taro, banana, etc. ; [and certain plants growing wild that] are [only used when the others fail. Among these are the wild yams, mountain bananas, *Tacca pinnatifica*, and *Pandanus odoratissimus*.[3] With regard to the latter, the older, group Guppy says : " Some of them are now occasionally cultivated ; but most of them only occur in the wild condition, either as weeds or as larger plants growing spontaneously in uncultivated localities. Even the knowledge of them as food-plants has sometimes been altogether lost, the present inhabitants of the Fijis, for example, knowing nothing of *Labla vulgaris* and *Sagus vitiensis*, as sources of food." [3] With regard to the distribution of the early food-plants, we learn that the oldest of them are apparently confined to Fiji. " Here we seem to possess indications of the development of new species since that group was first occupied by man. Others, like *Pachyrrhizus trilobus* and *Cycas circinalis*, that are restricted to the groups of the western Pacific, may come next in relative antiquity."

The wild bananas of the Pacific that are found in New Caledonia, Fiji, Samoa, Rarotonga, and Tahiti grow wild in the interior and are occasionally cultivated. " Birds have no doubt often assisted in the dispersal of the wild seeded plants ; but it is likely that man is responsible for the occurrence of the mountain forms in the Pacific, and probably their fruits when cooked formed one of the principal articles of diet of the earliest immigrants." [4]

It is thus possible that the food-plants of the Pacific indicate

[1] Guppy iii. II. 411. [2] Guppy iii. II. 412.
[3] *Id.*, 412–3. [4] Guppy iii. II. 413–4.

two distinct movements of population into that region. Whether they were all imported by man cannot be decided at present, but there is no doubt in the case of the later group of plants—the breadfruit, banana, yam, taro, ape, Malay apple, winter cherry and others. The taro presents a difficulty. Its home is probably in India or Indonesia ; but it readily escapes cultivation and often runs wild.[1] The breadfruit is an important food-plant in Polynesia. " In popular works the breadfruit has been so intimately identified with the Polynesian people that we are apt to regard it not only as an indigenous production, but as one confined to the islands. Its original habitat was, however, the Malay Archipelago, Java, Amboina, and the neighbouring islands,[2] where it was brought into cultivation at so remote a period that the cultivated varieties, of which there are so many, ceased to bear seed, and are propagated by suckers. As eastwards of the Fiji only the cultivated or seedless varieties are found, it was evidently introduced into and spread through Polynesia by man. . . . For the dissemination of the breadfruit some skill in the art of agriculture was clearly necessary. Were, then, all other evidence wanting, the presence of these seedless varieties would be sufficient to prove the regular colonization of the islands." [3]

The banana and plantain (*Musa sapientum, Musa paradisiaca*) afford evidence of the colonization of the islands of the Pacific. Roxburgh says that both plants are varieties of one species found wild in the hilly districts of East Bengal. The Kew Bulletin quotes from Tuckey's " Congo " (App. 471) that : " There is no circumstance in the structure of any of the states of the banana or plantain cultivated in India or the islands of equinoctial Asia to prevent their being all considered as merely varieties of one and the same species, namely *Musa sapientum* : that their reduction to a single species is even confirmed by the multitude of varieties that exist ; by nearly the whole of these varieties being destitute of seeds ; and by the existence of a plant indigenous to the continent of India producing perfect seeds ; from which, therefore, all of them may be supposed to have sprung." [4] De Candolle also states that the cultivation of the banana spread to the Pacific.[5] According to Rutland, " The banana, like the breadfruit, having become barren by long cultivation, can only be multiplied by offsets and suckers ; its wide dissemination through Polynesia is therefore another proof of the colonization of these islands." The Peruvians had two cultivated varieties of the banana, which plant was unknown in the West Indies. Rutland suggests that the Polynesians introduced the banana to America : " To transplant the banana from Polynesia to the shores of America across more than 2,000 miles of ocean would

[1] Rutland iii. 5. [2] de Candolle 299.
[3] Rutland iii. Cf. Hocart v. for a discussion of the bearing of tradition on the question of the transportation of food-plants.
[4] Botanic Gardens 24. [5] de Candolle 304.

overtax the skill and knowledge of any ordinary European gardener; but for a people who have dispersed this species and the breadfruit through the countless islands that form their home it would be a simple undertaking." [1]

In the case of the coco-nut, botanical and historical facts are in apparent contradiction. For, while innumerable varieties are grown in the East Indian Archipelago, a single wild species exists on the islands off the west coast of America. It is unknown in the West Indies. The botanical evidence seems to be in favour of the New World as its original habitat, all the other species of the genus cocos being confined to America. [2]

But, putting that on one side, the coco-nut tree is of vast importance in the study of the colonization of the Pacific. For many Polynesian islands would have been uninhabitable were it not for its presence. It would seem that the coco-nut must be planted in order to grow. " Pickering, who visited a great many of the small uninhabited Polynesian islands, states that he did not meet with a single instance of the spontaneous extension of the species," in spite of the fact that coco-nuts are designed to float and to resist the influence of salt water. The Singalese have a saying that " the coco-nut palm will not grow out of the sound of the sea or of human voices." Moresby informs us that, although the coco-nut is extremely plentiful along the whole of the south coast of New Guinea, and on some of the islands of Torres Straits, it does not occur anywhere along the coast of north-east tropical Australia. This cannot be due to anything either in the soil or the climate, for trees planted by Europeans at Caldwell were doing well when Moresby made his observation ; we must, therefore, conclude that the spontaneous extension of the coco-nut is not so common as is generally supposed, and that its wide dispersion throughout the whole of the equatorial islands is mainly artificial. This view is further strengthened by the fact that the extension of the species in these seas coincides with the extension of the art of agriculture. [3]

Other food-plants, such as the Malay apple, tell the same tale. The Malay apple belongs to the East Indian Archipelago, and not to the mainland, and it was cultivated in Polynesia before the arrival of Europeans. [4]

In North America the cultural history of an immense region depended on one limited area. If the origin of the Maya civilization could be explained, then the rest of the development of North American civilization would be understood without much difficulty. The cultural history of North America was that of steady degeneration in the material arts and crafts. In the

[1] Rutland iii. 10.
[2] Rutland iii. 10–12 : Guppy iii. II. 413 : de Candolle, however, says (p. 435), " I incline to the idea of an origin in the Indian Archipelago."
[3] Rutland iii. 12–14.
[4] Rutland iii. 15 : de Candolle 241.

Pacific the tale is similar, except that the difference in culture
between the first and last phases is not so patent. Many parts
of this vast area contain signs of a people skilled in agriculture,
who installed irrigation systems, bringing in certain varieties of
cultivated plants such as the breadfruit, the banana, the coco-nut,
and others ; who erected megalithic monuments here and there,
carved stone images and made pottery. The present-day civiliza-
tion of the Pacific displays none of these capabilities. Since
Europeans came to know them in the sixteenth century, the
Polynesians have not made any megalithic monuments on a
great scale, they have not spread the craft of irrigation, and they
have not introduced new food-plants to any appreciable extent.
From the botanical evidence it seems that the founders of Poly-
nesian civilization came into the Pacific by way of Indonesia
(the East Indian Archipelago), for the breadfruit, the banana
and perhaps the taro, must have come thence. The problem of
the Pacific is therefore to be solved either in Indonesia or in some
region farther west. The groundwork of the civilization came
thence, just as maize-growing in North America came from the
south. Botanical and archæological evidence agree in postulating
an early period when a stream of civilization moved out into the
Pacific, carrying with it the fundamentals of a relatively advanced
civilization. Then came a period during which the communica-
tion was cut, and the Pacific lay isolated from the west until
the coming of Europeans. Evidence for this is seen in the fact
that the later variety of the breadfruit, the jackfruit (*Autocarpus
integrifolia*), which is found on the south-east mainland of Asia
and in the East Indian Archipelago, did not find its way into
the Pacific.[1]

The evidence thus converges on one conclusion. The early
civilization of Oceania, as of North America, begins with the
appearance of people with the fundamental arts and crafts of
civilized life. Then comes the gradual degeneration of this
civilization and the obscuring of the old landmarks. In the
Pacific, as in North America, the origin of civilization is to be
found in one locality, no evidence existing of an independent
cultural uplift of any community. The food-plants of the Pacific
came by way of Indonesia, and consequently it is there that the
origins of the civilization of the Pacific must be sought.

[1] Rutland iii. 10, 28, 46.

CHAPTER V

CULTURE-SEQUENCE, INDONESIA

THE evidence derived from the study of food-plants in Oceania suggests that the first colonists of the Pacific came from India by way of the East Indian Archipelago, or Indonesia, as it may be called. But when search is made there for signs of the beginnings of civilization, the results are more difficult to interpret than those presented by Oceania. For many centuries Indonesia has been overrun by strangers bent on domination or exploitation, whose activities have so obscured the past that it is only by devious methods that any idea can be formed as to the course of history. Nevertheless, it is possible to estimate with some certainty what sort of culture first existed in this region. In studying, in my book,[1] the distribution of megalithic monuments and of the sun-cult in Indonesia, I soon found that the complexity of the task would be still further increased if account were taken of those places where signs of Indian and other foreign influence could be detected. I therefore decided to eliminate, for the purposes of that book, South Celebes (Bugi, Macassar), Java, Bali and the surrounding islands, the Sulu group, the whole of Sumatra, the Malay Peninsula and other places that revealed obtrusive evidence of later Indian culture. But that did not eliminate the difficulty. For Horst, in his work on Hinduism in Indonesia, had claimed that Hindu influence could be detected in places like the Moluccas, and in Geelvink Bay of New Guinea.[2] It is true that his views had been controverted by Wilken and others, but their objections did not seem to dispose of his claims. This was a perplexing discovery, for it threatened to make the interpretation of Indonesian cultural history extremely difficult. However, a choice was made of those parts of the region which seemed to be free from alien influence.

The result of inquiry into the cultural history of the peoples chosen for the purpose was to show that, wherever they were raised above the food-gathering stage, they invariably claimed, or showed in their culture, that they owed their progress to outside influence, or else that they were migrants from a place where such influence was obvious. The evidence of this alien culture

[1] Perry vii. [2] Horst.

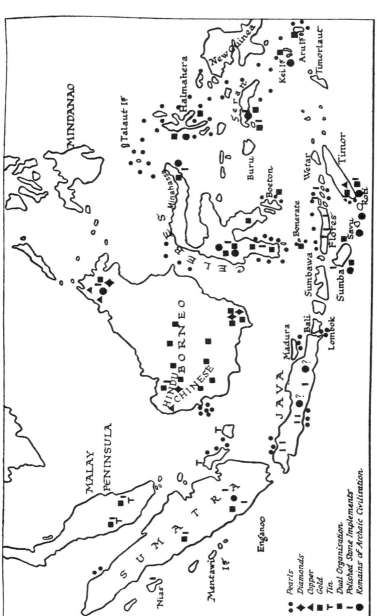

MINDANAO

Talaut Is.

Halmahera

New Guinea

Serang

Kei Is.
Aru Is.
Tinorlaut

Buru

Boeton

Minahassa

C E L E B E S

Wetar
Timor
Roti

Bonerate

Sumbawa
Flores
Savu
Sumba

MALAY PENINSULA

BORNEO

HINDU
CHINESE

JAVA
Madura
Bali
Lombok

SUMATRA

Enganoo

Mentawi Is.

Nias

Pearls
Diamonds
Copper
Gold
Tin.
Dual Organisation
Polished Stone Implements
Remains of Archaic Civilisation

INDONESIA

could be defined as the work of a stone-using, irrigating, metal-working people, who established irrigation systems wherever they settled, left behind them stone remains, and often were working gold as well as the baser metals.[1]

The highly civilized strangers were concentrated more especially in the region east of Java as far as Timor ; in Celebes ; in the Moluccas ; and in the Philippines and Formosa. In the islands of Sumba, Roti, Savu, Timor, and elsewhere in this region, they have left behind them many traces of their presence. Sumba is remarkable for the number and nature of its dolmens ; and it is to be hoped that a more detailed description of them than we possess at present will some day be forthcoming.[2] The whole of the region of the Sunda Islands needs a survey ; for practically nothing is known of some of the lands such as Flores, and existing accounts date back many decades. The region west of Timor is of great importance in the general study of the history of civilization, for many of the people are of Polynesian type, so that it must have been colonized by Polynesians on their way to the Pacific.[3] In the islands east of Timor traditions tell of the coming from the west of the founders of villages, bringing with them sacred stones around which the village cults are centred. The unity of the culture of these islands can hardly be questioned and all signs point to the west as the place of origin.

In Celebes the two regions of Central Celebes and Minahassa were selected for study. Much of the island is still unknown, and other parts have long been under Hindu and Mohammedan influence.[4] In " The Megalithic Culture of Indonesia " evidence was produced to show that the megalithic remains of Central Celebes were the work of strangers, who also taught the people where they settled to grow their food by means of irrigation. Since this book was written, Heer A. C. Kruyt, well-known to ethnologists as a worker in the field in Indonesia, has found further traces of these strangers, and is now engaged in writing an account of his new discoveries. He accepts the conclusions that I had arrived at : and in a preliminary account of his discoveries he states : " On the way by which these strangers moved through Central Celebes, they have left unmistakable traces of their presence, partly in the form of stone images, dolmens, monoliths and phallic emblems, and partly in the shape of a number of pottery urns buried in the ground in which they put the ashes of their cremated dead."[5] The civilization of Minahassa is likewise ascribed by native tradition to strangers ; people who sometimes placed their dead in rock-cut tombs, sometimes in large monoliths hollowed

[1] Perry vii. 170 e.s. See Sketch Map No. 8.
[2] Cf. Kruyt vi., viii., ix., for additional evidence on this topic.
[3] ten Kate for photographs of Savu women of pure Polynesian type.
[4] Nevertheless, as will be seen later, the States of South Celebes retain many survivals of the past.
[5] Kruyt, A. C., and J., 5.

out at the top, who made stone images, and in many respects showed signs of a high form of civilization.

In the Moluccas there is evidence of the coming of a stone-using population into certain islands. These people left behind them stone images, and other traces of a civilization similar to that of the archaic civilization of Oceania. In Luzon of the Philippines, the culture of the Bontoc, Igorot and Ifugao tribes is ascribed to wonderful strangers, who came from the sky and taught them all they know, including the use of stone, the working of metals, and terraced irrigation. The island of Nias also has a high form of civilization, including the use of stone, irrigation and metal-working. The evidence discussed in "The Megalithic Culture of Indonesia" supports the conclusion that these people owe their civilization to a cultural influence similar to that responsible for progress elsewhere in the region.

This is a mere summary of the evidence for the former existence of a highly civilized people in the more backward parts of the archipelago. For further information the reader is referred to "The Megalithic Culture of Indonesia," where the matter is studied in detail.

It is now necessary to consider those places revealing traces of Indian and other definitely alien influences, such as South Celebes, Java and Sumatra. What evidence do they afford of the presence of the archaic civilization ? To answer this question it would be necessary to know what were the relationships between the civilization of the Hindus of Java and the archaic civilization of other places. It is certain that the two have certain elements in common, such as irrigation, the working of metals and stone-carving. But in one respect it is possible to distinguish between the Hindu civilization of Java and that responsible for cultural progress in Oceania ; the Hindus of Java never made megalithic monuments of the dolmen or stone circle type. In India also, as will be seen in the next chapter, the erection of dolmens and stone circles antedated the so-called Hindu civilization by an unknown period of time. If, therefore, dolmens or stone circles exist in regions that were later dominated by the Hindus, it is probable that the first civilization of such places was similar to that which produced the advance in culture of other parts of the archipelago, and that the Hindu civilization was a later arrival.

It has long been known that dolmens exist in Sumba, an island east of Java, and that in other islands near by, such as Roti, Savu and Timor, monuments of large stones have been found, together with other signs of the former existence of a highly developed civilization. Of late years dolmens have been discovered in Java,[1] as well as images of Polynesian type :[2] so in this island, which, from the first centuries of our era, was the headquarters of Hinduisim in Indonesia, relics of the civilization of megalith-

[1] I owe this information to Heer Kruyt. [2] Juynboll 63 e.s.

builders have been found. In various parts of Sumatra remains testify to the influence of people far higher in civilization than the present inhabitants. Some of these remains are undoubtedly Hindu, but in the Passumah lands, inland from Benkulen, Mr. H. O. Forbes saw some sculptured stones of unknown origin. " Some of the most interesting objects in the Passumah Lands are the sculptured figures found in so many parts of it." It has been thought that these images were of Hindu origin, but Mr. Forbes states that this is not so. They are carved in the form of human figures in a posture between sitting and kneeling. " Each figure has a groove down its back and they had apparently stood on a flat pedestal, with their backs towards one centre, with their faces more or less accurately towards the cardinal points of the compass. The features of all four are of the same type of countenance ; but the race now living in this region did not form that model, and it is equally beyond question that the Hindu features are not represented. . . . If these stones are not the work of the Hindus, they must have been carved by either the people in the district or by foreign sculptors. If by Pas-sumahers, did they depict their own features or those of another race ? But who these foreign inhabitants of the Passumah were, whence these foreign artificers came and for what these sculptures were used, is shrouded in deep mystery. It is quite certain also that the present inhabitants could not conceive, much less execute, such work of art. . . ." "The only conclusion is that a superior race, possessing considerable knowledge and refined taste, and with technical skill not possessed by the natives of any part of the island at present, occupied this region ; but who they were and when they dwelt here is absolutely shrouded in oblivion." [1] Unfortunately I have not been able to collect any more evidence of the presence of past civilizations in Sumatra ; but the words of Mr. Forbes make it clear that stone-working strangers were wandering about the island at some unknown time in the past.

Another region of which little is known is that of Southern Celebes. Although highly civilized, not much has been written of the country that is accessible to me. Seemingly, however, the people of the archaic civilization must have been there ; for, in their work on Celebes, the Cousins Sarasin report a stone circle, or, rather, a circle of stone, surrounding two rocks on the sacred Baenteng Peak.[2] So far as I am aware, no megalithic remains have been detected in the Malay Peninsula, except those described by Mr. Ivor Evans in Negri Sembilan. Unfortunately it is not easy to come to a decision about them ; for what are possibly ancient remains are now part of a Mohammedan tomb.[3]

Sketch Map No. 8 shows that the building of megalithic monu-ments, the practice of irrigation, the making of stone statues and

[1] Forbes 201–4. [2] Sarasin, Reisen in Celebes, II. 327.
[3] I. Evans ii. 155.

the working of metals are, in Indonesia, closely associated, which suggests that its earliest civilization was akin to the archaic civilization of Oceania.[1] In Indonesia this archaic civilization has been overlain in places by Hindu and other cultures, which, although similar in some respects, differ in others, chiefly in the absence of megalithic monuments, such as dolmens, stone circles and rock-cut tombs.

The overlap of the Hindu civilization is obvious in Java, Sumatra, and South Celebes. But it is even to be observed in the region just west of Timor. For in the island of Savu as well as in other localities, traditions tell of the coming of Javanese, that is Hindu princesses. Hindu influence can even be detected in the foundation of the civilization of some of the tribes of Borneo. In this island the people of the interior have been raised from the food-gathering stage by the influence of one group, the Kayan and their kinsmen, who have travelled across the island from south to north. It will be necessary later to inquire as to the provenance of the Kayan ; for the present it is to be noted that they were preceded in the centre of the island by people who left behind them, on the banks of some of the rivers, carved stone remains of Hindu workmanship.[2]

It is evident that the overlapping of the Hindu and the archaic civilization in Indonesia has caused complications that will need unravelling, but they may be ignored when supporting the thesis that the study of culture-sequences in any area shows that the first food-producing communities were usually more highly civilized than those that immediately followed. This is certainly the case in those places studied in " The Megalithic Culture of Indonesia." It is also obviously so in Sumatra. In Java the Hindu civilization was immensely superior to that of the natives occupying the same regions after their departure. Wallace describes ruins at Modjo-pahit, the ancient capital of east Java. The ruins he saw consisted of two lofty brick masses, apparently the sides of a gateway. " The extreme perfection and beauty of the brickwork astonished me. The bricks are exceedingly fine and hard, with sharp angles and true surfaces. They are laid with great exactness, without visible mortar or cement, yet somehow fastened together so that the joints are hardly perceptible, and sometimes the two surfaces coalesce in a most incomprehensible manner. Such admirable brickwork I have never seen before or since. . . . Traces of buildings exist for many miles in every direction, and almost every road and path shows a foundation of brickwork beneath it—the paved roads of the old city." He mentions another ruin that he saw. " The size of this structure is about 30 ft. square by 20 ft. high, and as the traveller comes suddenly upon it on a small elevation by the road-side, overshadowed by

[1] The meaning of this map will become clearer after the discussions of the next two chapters. [2] Rouaffer ii. : Perry vii. 61.

gigantic trees, overrun with plants and creepers, and closely backed by the gloomy forest, he is struck by the solemnity and picturesque beauty of the scene and is led to ponder on the strange law of progress, which looks so like retrogression, and which in so many distant parts of the world has exterminated or driven out a highly artistic and constructive race, to make room for one which, as far as we can judge, is very far its inferior." . . . " Sculptured figures abound ; and the ruins of forts, palaces, baths, aqueducts, and temples can be everywhere traced. . . . One is overwhelmed by the contemplation of these innumerable sculptures, worked with delicacy and artistic feeling in a hard, intractable, trachytic rock, and all found in one tropical island. What could have been the state of society, what the amount of population, what the means of subsistence which rendered such gigantic works possible, will, perhaps, ever remain a mystery ; and it is a wonderful example of the power of religious ideas in social life, that in the very country where, 500 years ago, these grand works were being yearly executed, the inhabitants now only build rude houses of bamboo and thatch, and look upon these relics of their forefathers with ignorant amazement, as the undoubted production of giants or demons." [1]

Peoples such as the Tinguian of the Philippines have traditions reaching back to times when they were in contact with a higher civilization. The folk-tales relate to a people that lived in the sky, but connected with their own ancestors, whose material culture, although similar in many respects to that of the present-day tribe, was more elaborate. " The use of gold and jewels seems to have been common in the old times ; the latter are seldom seen in the district to-day, but the use of bits of gold in the various ceremonies is still common, while earrings of gold or copper are among the most prized possessions of the women." Evidently these people of the old times are regarded as human beings by the present-day Tinguian : " They appear rather as generalized heroes whose life and deeds represent that of an earlier period, magnified and extolled by succeeding generations." [2] Apparently these old times are connected in some way with out-side influences that brought in glass, porcelain and agate beads [3] as well as old Chinese jars, which are not of native make. [4] The traditions of the people seem to go back to times before they possessed terraced irrigation for rice, and when domesticated animals were unknown. Mr. Cole states that the tales of the early period are located at Kadalayapan and Kaodanan, which are stated at one time to be in the sky, and at another at Abra, just north of the tattooed Igorot. It is important to note that in the tales of the early period centred round these villages " the terraced fields and the rice culture accompanying them, which

[1] Wallace 77–81. [2] Cole 21, 26.
[3] Cf. Rouaffer for information about the cultural significance of beads.
[4] Cole 31.

to-day occupy a predominant place in the economic life of the people, are nowhere mentioned. On the other hand, the *Langpaddan,* or mountain rice, assumes a place of great importance. References to the cultivation of the land all seem to indicate that the " hoe culture," which is still practised to a limited extent, took the place of agriculture." [1] This is an important statement, for it seems to contradict the evidence already adduced.

A country that really belongs to the Indonesian culture-cycle is Cambodia. It reveals the remains of a civilization, founded by immigrants from India, which excites the wonder of every one who sees its majestic ruins. Its authors, called the Khmer, were overwhelmed by advancing bodies of people from Yun-nan, members of the great Tai-Shan group, which has given so many ruling families to this part of Asia. There are many remains of this mighty civilization in Cambodia : for example the temple of Angkor Wat. This immense building is constructed of sandstone brought from quarries distant some twenty-five miles. Some of the blocks are of great size, weighing more than eight tons, and, though no cement was used, they are fitted together with so nice an accuracy that a line traced on a piece of paper laid over the junction between two stones is as straight as though it had been ruled. What the mechanical contrivances could have been by means of which these huge blocks of stone were cut, transported to the site selected for the temple, and hoisted into their destined places in the temple, is a riddle to which it would by no means be easy to supply an answer. The amount of human labour at the disposal of the architects must have been enormous, and the civilization which inspired such designs and could carry them into successful execution must have attained to a very high standard.

" Even more astonishing than the titanic character of the ruins is the wealth of beautiful detail which they display. Almost every individual stone is curiously carved. Statues of immense proportions, figures of Buddha, of giants and kings, of lions, dragons, and fabulous monsters abound. The bas-reliefs show processions of warriors mounted on birds, on horses, tigers, elephants, and on legendary animals, combats between the king of the apes and the king of the angels, boats filled with long-bearded rowers some of them dressed in the Chinese fashion, cock-fights, women at play with their little ones, soldiers armed with bows, with javelins, sabres, and halberds, and innumerable other scenes. The men who wrought these carvings must have been possessed with a veritable passion for artistic presentiment, by a love of art for its own sake such as would seem to argue a degree of intellectual refinement which has no counterpart among the peoples of the Hindo-Chinese peninsula in our own day." [2] Angkor Thom, great Angkor, the capital of this forgotten empire, was on a

[1] Cole 7, 20, 31. [2] Clifford 147, 148.

similar scale to the great temple. " Judged by the gigantic remains which they have bequeathed to us—the expression at once of a tremendous energy and of a passionate love of art— the Khmers must have been a wonderful people, and such a people cannot fail to have a marvellous and inspiring history. What that story was we know not, and perhaps shall never know." [1] The civilization is gone : " The mountains are inhabited for the most part by aboriginal tribes of a very low standard of civilization who from time immemorial have been pillaged and enslaved by their more advanced neighbours." [2]

The cultural history of Indonesia has, therefore, been of the same nature as that of other parts of the region : the first food-producing people were more highly civilized than the tribes of the present day. When the old civilizations passed away nothing replaced them ; only where their influence extended has cultural progress taken place ; in the rest of the region there is stagnation.

Indonesia presents a novel problem in that the early influence was due to at least two distinct cultural movements. These cultures, in their broad outlines, both come under the heading of the Archaic Civilization, and, as such, stand in direct contrast with the cultures of the other peoples of the archipelago. It is possible, therefore, to state with confidence that the first development of culture in Indonesia was the work of people who irrigated, used stone for making monuments, and worked metals, and that only in the places visited by such people have the natives advanced in culture. These early civilizers can be divided into two groups on the basis of the types of structures that they executed—the earlier group erected megalithic monuments such as dolmens and stone circles ; the second group constructed temples of well-known Indian types.

In another way these two waves can be distinguished. For the earlier group, corresponding to the colonizers of the Pacific, seems to have introduced the practice of irrigation for taro cultivation.[3] Rice-growing, the staple form of culture by irrigation, probably came in with the Hindus about the beginning of our era ; and the growing of taro has been mostly superseded, this plant being only used in times of scarcity.

The conclusion, therefore, seems to emerge, that the early civilization, based on taro-growing, spread out into the Pacific, but that the civilization based on rice-growing did not penetrate so far. This is in agreement with the conclusion arrived at with regard to the history of the Pacific, namely, that after a period when communication with the west was free, there came a time when intercourse was severed. Apparently the spread of Hindu civilization took place after this severance.

[1] *Id.*, 150, 162, 165. [2] Clifford 162, 164.
[3] Rivers xiia, 514. Kruyt vi. 535 for Sumba. In Central Celebes taro was formerly the chief food-plant (communicated by Heer Kruyt).

CHAPTER VI

CULTURE-SEQUENCE, INDIA

AS the survey has proceeded, the problems to be solved have become more complicated. The unity of the civilization of North America was evident on the basis of maize-growing; that of Oceania was also easy to understand on the basis of the food-plants that the Polynesians brought with them. In Indonesia it was hard to discover any such simple formula in explanation of the foundations of civilization. For it was clear that at least two important waves of migration had swept over the region at different times, both of which had played a part in civilizing the native food-gathering tribes. Such difficulties increase in India. This country, as is well known, has been subjected from time immemorial to diverse cultural influences. When historical records begin, about 800 B.C., active trade had existed between India and the West for several centuries.[1] The effects of such constant intercourse must have been profound. Civilization in India, once implanted, was not allowed to remain isolated, as in North America : fresh stimuli repeatedly led to new developments. This makes it impracticable at this stage in the argument to study the history of Indian culture on the same lines as that of North America, for the establishment of culture-sequences would involve an examination of the contemporaneous civilizations of the west. Consequently I shall confine myself to the attempt to show that its first food-producing civilization was fundamentally similar to the archaic civilizations of Indonesia, Oceania and North America ; that it was based on irrigation, stone-working, pottery-making, and metal-working. At the same time attention will be called to the fact that, in several parts of India, peoples of low culture live in regions full of remains of vanished civilizations.

It is now known that India had a well-developed paleolithic age,[2] which was followed by a phase with cultural characteristics analogous to those of the Neolithic Age of Europe. This pre-historic civilization was characterized by the practice of agri-culture by means of terraced irrigation. Unfortunately I have not been able to find sufficiently precise data for the construction of a map to indicate the distribution of irrigation in India,

[1] Rawlinson. See also Schoff. [2] Foote ii. 7 e.s.

46

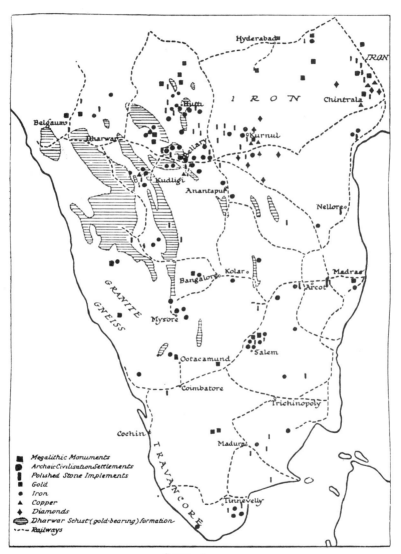

Megalithic Monuments
Archaic Civilisation Settlements
Polished Stone Implements
Gold
Iron
Copper
Diamonds
Dharwar Schist (gold-bearing) formation
Railways

SOUTH INDIA

hence I cannot say anything with regard to its general cultural associations. It is certain, nevertheless, that these early people were irrigators, who left behind them " Terraces revetted with rough stone walls ; near which were great accumulations of pottery, bones of bovine animals, tanks made by damming streams, and shallow troughs hollowed out in the rocks, which were apparently used for crushing corn." [1] One of the chief centres of these people was at Bellary,[2] where many settlements have been discovered. It was the richest district studied by the late Bruce Foote, to whom is due so much of the knowledge of Indian prehistory. Sketch Map No. 9, which is based on those of Bruce Foote and Munn, shows that the settlements of these early people were mainly concentrated in the basis of the Kistna River, and especially in the Bellary district. They were on the tops of hills, together with terraces and workshops for the stone implements then in use.[3] On Kupgal Hill, in the Bellary district, $4\frac{1}{2}$ miles north-east of the North Hill at Bellary, is the most important neolithic site in the country, which contained a large implement factory. " The summit of the peak consists of great masses of rock forming a kind of keep in which are several good rock-shelters. The actual summit is inaccessible without a ladder some 20 to 30 ft. high, and with the upper part of the hill forms a very defensible citadel. The citadel includes three linchets, the lowest of which is kept up by a rough stone revetment. In the rock shelters there are several polished places on the rock floor formed probably by grinding grain with flat mealing stones. Alongside the small stream flowing down the sloping valley between two small tanks and about half-way down between the two tanks, I observed no less than seven large granite blocks which had evidently been used for domestic purposes but were partly broken. On the second big linchet lay an oval trough polished by use and into which a hole had been worked at a later time, such as one sees nowadays in stone rice-mortars." . . . Although the lower parts of the Kupgal are not murally scarped, they are so steep on all sides except the north-east that they could have been very easily defended against any assailants from below. The inhabited parts of the old settlement would seem to have been the citadel and its linchets and the little shallow valley which slopes down eastward from the very rocky summit. The soil of this little valley mostly consists of made-ground held up in several places by low retaining walls carried across as if to form tiny tanks by pointing back the little rill which during the rains flowed down from the top. The little walls are built of smallish stones without any mortar. Below them are little sloping surfaces, some covered with grasses, others bare or rough from the trampling of cattle when wet. Near to the point at which the great dyke cuts across the axis of the little valley, the

[1] Thurston ii. 139. [2] Foote 77 e.s. [3] Foote ii. 28.

ground falls suddenly at a steep angle and becomes quite rugged and unfit for habitation, and all traces of such come to an end." [1] This settlement seems to have been left undisturbed from the day it was abandoned. " From the great number of implements I procured during my first visit to this part of the hill, I came to the conclusion that this old celt factory had never before been visited by anyone taking any interest in the neolithic artifacts and that the place remained in much the same condition as it had been left in by the old people who abandoned the manufacture of stone implements very probably in consequence of the advancing state of the iron industry." [2]

This description of the site at Kupgal is reminiscent of those in New Zealand,[3] where the ancients built terraces, and also had the habit of living on hills. The Kupgal people were irrigators who made terraces, for the remarks of Bruce Foote make it clear that only the makers of the polished stone implements could have been responsible for this installation of terraced irrigation. These old neolithic folk were metallurgists, according to Bruce Foote. He says that the North or " Face " Hill at Bellary had on it " considerable traces of an old settlement of the neolithic people, together with indications of the commencement of an iron smelting industry in the shape of iron slag and of fragments of hæmatite of both rich and poor quality. This hæmatite must have been brought there by human agency, for there are no signs of any geological formation on the hill from which the ore could have been washed down, and the nearest natural source from which it could have been obtained lies in the great hæmatite quartzite beds of the copper mountain located eight miles to the south-westward. The assumption of the existence of an iron-making industry in this neolithic settlement is supported by the occurrence in it of a small pottery tuyère suitable in shape for the protection against direct flame-action of the nozzle of a small bellows." [4]

Bruce Foote's account of the Bellary " Face " Hill settlement shows that the " Iron Age " of India followed hard on the " Neolithic Age," if any distinction at all can be made between them, for remains of the two phases of culture occur in the same sites. " In spite of the great ease with which iron objects of all kinds are utterly destroyed and lost by oxidation when exposed to damp, yet from the very durable character of the pottery the iron age people produced and the vast quantity of it they left, it is evident that in a very large number of cases they must have occupied the old neolithic sites ; and the celts and other stone implements are now mixed up with the highly polished and brightly coloured sherds of the later-aged earthenware. Except in very few cases the dull-coloured and rough-surfaced truly neolithic sherds occur but very sparingly." [5]

[1] Foote ii. 83, 87. [2] Foote ii. 84, 85. [3] Cf. p. 25.
[4] Foote ii. 81, 90. [5] Foote ii. 24.

The close connexion between the so-called neolithic and iron ages of prehistoric India is shown in quotations such as the following: "About twelve miles south-east of Anantapur town, close to the village of Mushturu, on the high road to Cuddapah, in an old site at the southern end of the granite hill there occurring, is a neolithic settlement to which an iron-age settlement apparently succeeded, traces of the latter being numerous in the shape of black iron slag scattered about the surface on which remain also large quantities of trap fragments, probably the rubbish of a celt factory. . . . Much comminuted pottery accompanied the neolithic remains, chiefly of the red and black and salmon-coloured varieties and of excellent quantity." [1] Another region where the neolithic and iron phases of civilization are closely associated is that of the Sheravoy Hills in the Salem district. "The Sheravoys proved themselves even richer in traces of the iron age than of the neolithic age, but all the remains found were derived from graves, 'kistvaens,' which are very numerous on the western and northern sides of the plateau." [2]

The following quotation gives some idea of the cultural stage of these early people: "Of very great interest are two earthenware figures of women found on Scotforth estate by my son-in-law, Mr. Herbert W. Leeming, when digging a trench for the foundation of a wall. The special interest attaching to these figures is due to the unique style of head-dress they show—namely, having their hair dressed in short ringlets all round the head, and wearing high combs on the top. . . . The finding of these little female figures with such an elaborate style of hairdressing throws light upon the use of a neck-rest unearthed in an old iron-age site on the north bank of the Cauvery River opposite the town of Tiruma Kodlu Narsipur in Mysore and just below the Sangram, or junction with the Kabani, or Kapilla River. The use of a neck-rest was essential if the women desired to preserve their curls intact when sleeping, which they doubtless did, a practice in which they are followed by some of the present-day Brahmin ladies on certain special occasions." [3]

It is usual to distinguish between the "neolithic" and "iron" phases of this early civilization. The matter hangs on the pottery, but apparently no real means exists of distinguishing the various types. In the words of Bruce Foote, the early civilization can be divided into four stages: "Four such ages seem recognizable: the neolithic, the overlap of the stone and iron ages, the iron age proper, and the protohistoric age. This assignment to determined position of antique pottery is of necessity only a tentative proceeding, for there is under present circumstances no absolute certainty for judging the age of the pottery by mere collocation with neolithic implements which does not in many cases prove the actual neolithic origin of the vessels or sherds remaining. The facies of the typical neolithic pottery will, I believe, turn out to

[1] *Id.*, 102. [2] *Id.*, 57 e.s., 61. [3] Foote ii. 62–3.

4

be dull-coloured and rough-surfaced with but little decoration, whereas the true iron-age vessel is distinguished by showing rich colours and highly polished surfaces with, in some cases, elaborate and artistic mouldings. There had been a development in the potter's art which then attained a stage of very real beauty. This was probably before the great Aryan invasion, under which the potter's craft came to be despised and neglected, as it is nowaday to a very great extent, as evidenced by the great plainness and often absolute ugliness of the present-day pottery."[1]

Mr. Bruce Foote himself is of the opinion that no real gap separated the two phases. " In the third stage of prehistoric civilization the art of smelting and working iron was introduced, and gave it the name of the Early Iron Age. This was the greatest advance made in arts and crafts since man's first appearance on the earth. The much greater ease and rapidity with which weapons and tools of greatly improved quality could be produced by the working of iron, caused the manufacture of stone imple-ments of the larger and more expensive kind to be given up in very great measure. From this evidence afforded by several old sites in the Deccan and Mysore, it is a very reasonable inference that the iron workers were the direct successors and probably lineal descendants of the neolithic people. . . . In fact, the ages overlapped." [2]

In view of the intimate relationship between these two phases of culture, I shall group them together as the Archaic Civiliza-tion of India. This civilization was characterized by irrigation, pottery-making, metal-working, and also, as will now be shown, by the use of stone for construction.

The people of the archaic civilization in India constructed megalithic monuments—dolmens and stone circles being especially numerous, ranging from the valley of the Nerbudda to Cape Comorin.[3] They are found in the Palni Hills in the Madura district, in the Sheravoy Hills of the Salem district, in Coimbatore, Malabar, Coorg, Hyderabad, and elsewhere, as is evident from Sketch Map No. 9.[4] These megaliths are often large, the following being a description, by Mr. Walhouse, of one in a cemetery at Peramdoory, between Salem and Coimbatore : " In the centre of the cemetery was placed, as if it were the chief, the highest of all the tombs. A vast obelisk-like stone, 13 ft. by 6½, towering above all the others, stood at its head ; great shapeless masses formed the circle ; the heap of stones within had disappeared, and the chamber beneath was laid bare, on one side to the bottom. . . . The chamber, 10 ft. deep, as many wide, and somewhat more in length, was formed of four enormous slabs, placed two at the ends and one at each side ; and was divided length-wise by a

[1] Foote ii. 34. The degradation of pottery is a good instance of the usual culture-sequence.
[2] Foote ii. 3. [3] Lane-Fox.
[4] Walhouse 17 : Cole 299, 302, 303.

partition-slab, somewhat less in depth, into two main compartments, which were again longitudinally subdivided by still lower slabs, thus dividing the whole chamber into four compartments at the bottom, which was paved with great slabs. A colossal capstone had been laid over the chamber."[1] No detailed study of these remains has yet been produced. The writer who as yet has given most information is Colonel Meadows Taylor, who describes the megaliths of Southern India, and says that they lie south of a line running from Bellary to Nagpur.[2] In some parts of the country, as near Bellary and Nirmal, they abound, some of them of great size, " being composed of blocks of stone, very difficult, nay, impossible, to remove them without mechanical assistance, both as to the size of the stones which compose the outer rings of the tumuli, and also the large slabs which form the inner cell or tomb, wherein the body or bones are placed. The diameter of some of these larger tumuli is from 30 to 40 ft. ; others again are much smaller, and on these a much less amount of labour has been bestowed. The depth of some of the large ones is very considerable. You first dig through a mound of from 3 to 5 ft. deep, outcropping and bounded by these immense circle stones, which brings you to the level of the ground about. When you dig down again some 8 or 10 ft. you reach the regular tomb, which is composed of eight immense slabs of gneiss or granite, forming an enclosure of 8 or 9 ft. long, and 4 or 5 broad, giving a total depth from the top of the mound to the bottom of from 16 to 20 ft."[3]

The great concentration of dolmens round Bellary, the place most densely occupied in the archaic civilization, is significant, 2,127 dolmens having been reported in this district,[4] which gives an idea of the extent of the settlement. It can be seen from the sketch map that the distribution of megalithic monuments agrees with those of neolithic and iron-age sites. For this reason, and because of the identity of the remains found in these tombs with those of the archaic civilization of India, it is legitimate to consider these graves as those of the early people.

Megalithic monuments are still erected by certain tribes of India and Burma, the Kurumba, Gond, Bhil, Munda, Oraon, Khasi, and Southern China being prominent among them ; but in no case of the size characteristic of the prehistoric phase of civilization. The culture-sequence of early and late in megalithic monuments thus shows that the earliest known examples are the largest. The loss of culture in the case of tribes that build megaliths is also well shown in the fact that the present-day peoples do not make statues of women as did their predecessors. The present-day makers of megaliths in some cases practise irrigation—for instance, the Munda and Khasi ; but the culture

[1] Walhouse 189. [2] M. Taylor i.
[3] M. Taylor i. 180. [4] Munn 1.

of the people of the archaic civilization has only survived in diminished measure.

Although it is not intended to establish any culture-sequences for the whole of India, yet it is useful to realize that, in many parts of the country, they give the same results as elsewhere.

The present-day tribes of Southern India do not usually display any tendency to construct stone monuments. On the summits of the Nilgiri Hills, near which live the Todas, are cairns, circles and barrows containing pottery, adorned with figures of animals, such as the buffalo, horse, sheep, camel, elephant, leopard (?), pig (?), low-country bullock with hump, none of which animals are mentioned in the Toda legends.[1] The relationship between the makers of these monuments and the Todas themselves is speculative. Rivers says : " If we could accept the view that the cairns, barrows, and cromlechs of the Nilgiri Hills were the work of the ancestors of the Todas, we should have at once further evidence that the Todas have degenerated from a higher culture. We should have an example of a people who once used, if they did not make, pottery, showing artistic aptitudes which they have now entirely lost. The Toda now procures his pottery from another race, and, so long as this is of the kind prescribed by custom, he is wholly indifferent to its artistic aspect. I doubt if there exists anywhere in the world a people so devoid of æsthetic arts, and if the Nilgiri monuments are the work of their ancestors, the movement backwards in this department of life must have been very great." [2] Thus, a people of a low level of material culture live in a district filled with remains of a fairly high civilization. This is another example of a common feature of the whole of the region covered by megalithic monuments.

An interesting case is that of Chota Nagpur, where live the Mundas, who are closely connected with megalithic monuments, of which vast cemeteries are reported in some places.[3] The Mundas claim to have migrated into Chota Nagpur, and say that people called the Asuras, who were there before them, are responsible for certain remains. It is said that " Evidence in the shape of remains of smelting places and slags of iron, ornaments, implements and vessels made of copper, foundations of extraordinarily large but comparatively thin bricks, remains of pottery and burial urns, is gradually accumulating, and would seem to bear out the Munda tradition of the previous occupation of a large portion, if not the whole, of the Ranchi district by an ancient people who used copper and subsequently iron, and who had evolved a comparatively much higher culture than the Mundas who claim to have ousted them." [4] In Ranchi, Roy has found " here and there villages containing remains of very ancient brick buildings, stone temples and sculptures, cinerary urns and huge slabs and columns of sculptured stones, large tanks mostly silted

[1] Rivers i. 712. [2] Rivers i. 715.
[3] Dalton. See Sketch Map No. 14. [4] Roy iv. 434.

up, which are all locally attributed to an ancient people called the 'Asuras.' '. . . Indeed an inspection of the architectural and other remains attributed to them convinces one that these pre-Munda inhabitants of what is now the Munda country had attained a degree of civilization which must necessarily remain a standing wonder to the ruder Mundas of our days." Some of these remains consisted of graves, stone slabs on the ground with funerary urns beneath them.[1] Again Roy comments upon this strange old civilization : " These reputed Asura sites appear to have almost invariably been elevated tracts conveniently situated on the banks of a river or stream commanding a wide view of the country around so as to be eminently suitable for defence against an invading force. Foundations of brick buildings, large tanks, cinerary urns, copper ornaments and stone beads, copper celts and traces of smelting works for iron, are the principal features of these Asura sites on the Chota Nagpur plateau. Ruins of stone temples, carved stone pedestals and stone sculptures of deities and bulls, and certain stone implements, etc., found in some of the reputed Asura sites, are also to-day attributed to the Asuras of old. With respect to the stone bulls and other stone sculptures, however, such high antiquity may perhaps be doubted." [2] This constitutes, therefore, another case in which the earliest civilization that can be detected in a region is more advanced in the arts and crafts than its successors.

This can be seen in yet another region. For in Upper Assam, in the Dibrughar district, are " ruins of magnificent buildings and raised roadways found all over the country." [3] . . . " Mr. T. T. Cooper also writing in 1873 of Eastern Assam again testifies to the energy and civilization formerly characteristic of this people and forming a striking contrast to the lethargic existence of the present-day scanty population. He says : ' The contemplation of these ruins surrounded by almost impenetrable jungle which has overgrown the once fertile and well-cultivated fields of a people that has almost passed away, is calculated to strike one with an intense desire to learn more of the history of those terrible events which robbed a fertile land of a vast and industrious population, converting it into a wilderness of swamps and forests.' The region of the Nambhor Forest between Lumding Junction and Golaghat and bordered by the Mikir and Naga Hills covers ground once occupied by the Kachari clans who were then in a high state of civilization. The railway engineers are constantly coming across ' causeways, canals and sites of buildings,' especially near Rangapahar and Dimapur." [4] This country is now occupied by the remnants of the Kachari, and by other peoples of a low stage of civilization.

Even in the country occupied by the Abor and Mishmi tribes, ruins testify to a former high stage of civilization ; for instance,

[1] Roy vi. 229, 235, 245. [2] Roy vi. 253.
[3] Shakespear ii. 3. [4] Id., 3.

on the hills along the banks of the Dikrang River, a tributary of the Brahmaputra, are forts made of huge blocks of stones. " And when and wherefrom did the wild Abors and Mishmis come who now hold these hills." [1]

A similar fate has overtaken the ancient civilization of Northern India, which extended along the feet of the Himalayas from the headwater of the Ganges to Nepal and still farther east. Such examples could be multiplied in India, but, in view of the chequered cultural history of the country, they would not serve to support any generalization such as can be founded on the evidence in Oceania and North America. These instances illustrate the frequent loss of the material side of culture, and show that regions now inhabited by peoples low in the cultural scale were once the scenes of thriving civilizations. The complications in India are due to the fact that each cultural wave has left a backwash behind it, so that every generalization must be founded on the historical study of each group of tribes. We still await that study. In the case of the tribes who still erect megalithic monuments, a loss of culture can be detected, in that they do not manipulate such large stones as their predecessors. It is also possible to show that they have lost certain elements of the original culture.

The generalization to be obtained from the study of Indian prehistory, as at present known, is that the earliest food-producing civilization was that of people who practised irrigation, worked metals, made pottery, and constructed megalithic monuments. With the exception of the pottery images of the Sheravoy Hills in the Salem district, they do not seem to have made human statues, and no carved stone statues are reported.

The survey has now covered North America, Oceania, Indonesia and India, including Burma. The final result has been to show that the earliest known civilization of food-producers, in any part of the region, is that of people who practised irrigation, built megalithic monuments, worked metals, made pottery and carved stone images. [2] On the basis of these cultural elements it is possible to claim uniformity of the archaic civilization throughout the region, for all these cultural elements tend to disappear in the later civilizations. This generalization takes no account whatever of the relationships between the archaic civilization and its successors ; nor does it concern itself with the varieties of stone or of pottery that are made. In this last I shall probably meet with opposition from archæologists, who usually base so much of their reasoning on differences of technique in certain arts and crafts. It may be objected, on that score, that I am postulating uniformity where it does not exist ; that, for instance, in India megaliths of the archaic civilization are mainly dolmens and stone circles ; in Indonesia there are dolmens, rock-cut tombs,

[1] Shakespear ii. 83. See Sketch Map No. 15.
[2] The exceptions to this generalization have been noted.

stone circles and pyramids ; in Oceania there are dolmens, stone circles and pyramids ; and in America there are pyramids and dolmens. These monuments, it may be asserted, should be considered separately. Similarly with regard to pottery and metal-working. Such objections as these entirely miss my point, which is that the craft itself, whether the use of stone, of pottery-making or of metal-working, can be studied from the point of view of presence or absence, and that the archaic civilization is distinguished from those that followed by the possession of these and other crafts, not on account of any varieties of form in the productions of those crafts. The main point is, Why do some people work stone while others do not ? That question being answered, we may then inquire into the various forms of stonework. Similarly, the distribution and cultural affinities of the pottery industry being determined, we may proceed to consider variations on the theme, those of shape and decoration. If pottery-making owes its introduction in a large area to a cultural influence, the variations in style are not so important as the industry itself. In like manner the important fact about irrigation and terraced cultivation is not the particular food plant grown, but the procedure itself. As has been seen, irrigation is concerned, in America with maize, in the Pacific with taro, in Indonesia and India with rice ; yet the inception of the practice is apparently connected with the archaic civilization. If that be so, the kind of food grown by irrigation in the different countries is merely the variation on the theme. The people of the archaic civilization, in Oceania at least, were skilful enough to transport shoots of food-plants across thousands of miles of ocean and bring them to maturity in their new homes, a noteworthy feat. Therefore, it must constantly be remembered that men in possession of a highly skilled craft such as that of irrigation, are capable of bringing, in different countries, the proper food-plants under cultivation.

CHAPTER VII

THE SEARCH FOR GOLD AND PEARLS

(i) NORTH AMERICA

THE discussion of the relations between food-producers and food-gatherers suggested that throughout the region the food-producers were constantly advancing into the lands of the food-gatherers and dispossessing them of their hunting-grounds. Given this gradual outward movement of civilization, how is it to be explained ? What impelled the food-producers to occupy new lands, and what selective agency caused them to choose certain spots for settlement, and to neglect others ?

· Fortunately it is possible to study, in two places on the boundary between food-producers and food-gatherers, the phenomenon of the advance of civilization into new regions. It is well known that the great colonization of California and Australia by Europeans only began in the latter half of the last century, prior to which both countries were but sparsely inhabited by stock-breeders. Although the analogy between the archaic civilization and that of western Europe in the nineteenth century is not exact, yet it is close enough to serve as a rough guide.

It is perhaps not properly realized by all what an important part has been played in the near past by discoveries of gold. California came into prominence only when it was discovered to be a rich gold region. The Spaniards, ignorant of its gold, tried to colonize it, but with no success.[1] Prior to 1848, when gold was discovered, the country was given over to Spanish priests, mission Indians, and a few American settlers, traders and trappers. But once the presence of gold was known, multitudes flocked there, and the population increased in the year 1850 by one hundred thousand. The gold boom, of course, in time died down, and the country was then forced to develop its agricultural resources.[2]

The same story can be told of Australia. The native population is in the hunting stage, although signs exist of the presence there in the past of people of superior civilization. " Before 1850, men

[1] Coman I. 9, 13–15, 20 ; II. 80.
[2] Coman I. 142, 145 e.s., 155, 187, 189, 207, 228, 239 ; II. 287, 294, 296, 297, 302.

56

went thither for the sake of breeding sheep upon its wide monotonous plains ; and, had no other attraction been discovered, the island-continent of the South would have remained until now a slow-moving cityless country of pastoral settlers—possibly (from lack of the brisk sea-trade now established) still shearing their flocks and boiling down their sheep and cattle, as the only means of utilizing their surplus produce, in exchange for the more or less indispensable commodities of other countries. But the discovery of Gold at once changed the scene. Settlers and ships came thick and fast ; new lines of Commerce tracked the deep ; already the European race is making a new home at the Antipodes ; and a brilliant future has opened upon that Southern continent, of whose greatness we only see the beginning." [1] So wrote an author in 1882. He goes on to say that " The bulk of this vast Emigration came from Europe, the Heart of modern civilization, most fully possessed of the means and appliances for Migration." [2]

As a remarkable example of the way in which the discovery of gold will attract people from their homeland, it is noteworthy that the Chinese are to be found in numbers, when the immigration laws permit, on every gold-field in the world, whether in Australia, the Malay Peninsula, Borneo or California : in non-auriferous parts of the world they are not so prominent.[3]

If a geographer of five thousand years hence should discover ruins on the upper reaches of the Yukon, he would probably wonder what could have induced men to live in such an inhospitable spot. He may speculate about changes of climate, or he may try to give some other reason, but the remarkable nature of the place will probably force him to conclude that some definite cause led men to live there. If he turns to the study of the customs of the people of that remote age, he will find that they desired gold above all things, not because it had any surpassing intrinsic merit in itself, but because it was a medium of exchange, and could enable a man to minister to his selfish desires, and obtain a fuller measure of " life " than his fellows. He would then turn back to the Yukon valley, and conclude that the presence there of gold in the past constituted a sufficient cause for the presence of civilized peoples. And, although he did not see splendid stone buildings and all the appurtenances of civilization in such a spot, he would nevertheless be prepared to conclude that the gold-miners came from more civilized regions, but that, being there to exploit the gold, and not intending to remain longer than they could help, they made shift with what sufficed for the needs of the moment. So, even if there be no direct signs of a high form of civilization connected with ancient mining works in any given place, that in itself is no evidence that the miners were of

[1] Petterson I. 56. [2] *Id.*, I. 57, 457.
[3] Cf. Sketch Map No. 8 for Borneo (Posewitz 345 e.s.).

low culture. They would not have the time, nor the available labour, nor the incentive to construct great works.

It is a commonplace that the presence of minerals of various forms has largely determined the distribution of population in more developed countries. In England the greatest concentrations are on the coal and iron fields, with the exception of London, and the same is the case elsewhere. In the United States there is an interesting example of the way in which new regions can be occupied with dense populations in a short time. The part of Pennsylvania containing the main supply of oil was barren, rocky soil, practically uninhabited, until the discovery of oil in the middle years of the last century. Immediately after the discovery it was transformed into a thriving region, full of large towns, all drawing their prosperity and wealth from the stores of oil in the earth. The discovery of the use of this oil as an illuminant thus brought a new centre of civilization into being.

I now propose to put forward evidence that the same motive must have led to the foundation of civilizations in the places that have already come under review. To begin with America and work westwards.

In North America it is necessary to account for the first Maya cities in Guatemala, Honduras and Southern Mexico, for the Pueblo settlements, and for the distribution of the mounds in the Eastern States. I shall begin with the Pueblo region. The culture of the Pueblo Indians is so closely related to that of Mexico as to suggest that one of them must have been derived from the other.[1] Since the Pueblo folk cultivate maize, which originated south of the Rio Grande, it seems certain that they derived their civilization from Mexico. Another good reason exists for this belief. Turquoise was a favourite precious stone among the Mexicans, the Maya and the Pueblo Indians. " In all three provinces the turquoise found both a religious and an ornamental use, and there are striking analogies between its application among widely separated tribes." [2] Since no turquoise is known in Mexico itself, or in the country to the south, the Mexicans must either have gone themselves to the Pueblo region to get it, or they must have got it by trade. Turquoise occurs in a natural state in New Mexico, Arizona, Colorado and California,[3] the principal sources being near Cerillos in Cochise County, New Mexico, twenty-five miles south of Santa Fé; Little Burro Mountains and Little Hachita Mountains, Grant County, New

[1] " We find peoples in New Mexico and Arizona still practising rites which can at least be compared with those of the Nahuas. . . . Undoubtedly there is a vein of similarity running through the ritual and symbolism of all tribes of the American race ; indeed, we might likewise say, between those of all primitive people in Europe, Asia, Africa, or America " (Fewkes i. 42, 43). [2] Poque 437.

[3] Kunz i. 54, 56, 60, 63 : Mineral Resources II. 1911, p. 1065 ; 1909, pp. 779, 781, 788 ; 1908, pp. 846, 847, 849 : Blake 227 e.s.

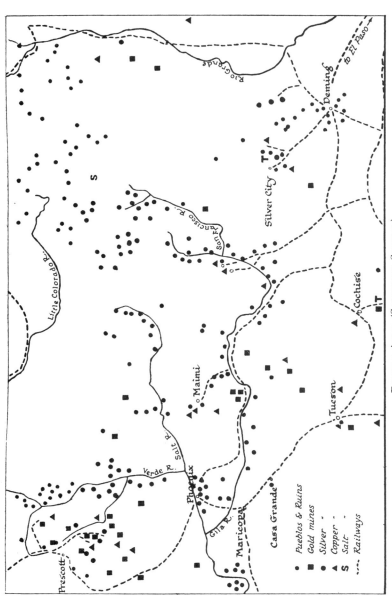

PUEBLO AREA (SOUTHERN SECTION)

Pueblos & Ruins •
Gold mines ■
Silver " ●
Copper " ▲
Salt " S
Railways ---

Mexico; Las Cruces, Dona Ana County, New Mexico; Mineral Park, Arizona; Aztec Mountains, Arizona; La Jara, Comejos County, Colorado; Holy Cross Mountains, Colorado; Taylor's Ranch, Fresno County, California; and Cottonwood, San Bernardino County, California.

"At a number of these deposits were remains of ancient workings, pits, shafts, tunnels, and stopes, with dumps of waste rock, made by Indians or other early inhabitants of the south-west." [1] The places with old workings are—Los Cerillos; Little Burro and Little Hachita Mountains; Las Cruces; Aztec Mountains; San Bernardino County, California. [2]

Presumptive evidence that the ancient Mexicans worked the turquoise mines of the Pueblo region is given by the following quotation : " That the ancient Mexicans held the turquoise in high esteem is well known, and that the Los Cerillos mines were extensively worked prior to the discovery of America, is proved by fragments of Aztec pottery—vases; drinking, eating, and cooking utensils ; stone hammers, wedges, nails, and idols—discovered in the debris found everywhere." [3] The following quotation gives an idea of the extent of the operations : " On reaching the locality I was struck with astonishment at the extent of the excavation. It is an immense pit with precipitous sides of angular rock, projecting in crags, which sustain a growth of pines and shrubs in the fissures. On one side the rocks tower into a precipice and overhang so as to form a cave ; at another place the side is low and formed of the broken rocks which were removed. From the top of the cliff, the excavation appears to be 200 ft. in depth and 300 or more in width. The bottom is funnel-shaped and formed by the sloping banks of the debris or fragments of the sides. On this debris, at the bottom of the pit, pine trees over a hundred years old are now growing, and the bank of refuse rock is similarly covered with trees. This great excavation is made in the solid rock, and tens of thousands of tons of rock have been broken out. This is not the only opening ; there are several pits in the vicinity, more limited in extent, some of them being apparently much more recent. . . .

. . . " The evident antiquity of this excavation, and its extent, renders it peculiarly interesting. Little or nothing appears to be known of it in that region, and I am not aware that it has ever been visited except by the Indians and New Mexicans. It seems hardly possible that such an amount of rock could have been removed by men without the aid of powder and machinery. The evidences were, however, conclusive that it was the work of the aborigines long before the conquest and settlement of the country by the Spaniards." [4]

Recently several caves in this mountain have been unearthed,

[1] Mineral Resources II. 1911, 1065.
[2] *Id.*, 1909, 779, 788 ; 1908, 849. See Sketch Map Nos. 10 and 11.
[3] Kunz i. 60. [4] Blake 227, 229.

extending from the level of the long-abandoned mine. " The
Wonder Caves are about 25 ft. from the surface and run 100 ft.
from the apex of the mountain, being about 30 by 25 ft. in width,
and from 6 to 8 ft. in height above the debris. This group
resembles in shape the five fingers of the hand. Here were found
numerous veins of turquoise from ⅛ in. to 2 in. in thickness, and
strips of gold-bearing quartz cover the walls of the central cave.
. . . It is presumed that further explorations would bring to
light openings through these walls, showing that the entire
mountain was honeycombed by the ancients, and the pillars left
by them to support the roof." [1] Quartz veins were worked for
gold in the same district : " In the mountains known as Los
Cerillos, about eight miles from New Placer, there is a deserted
mine, known among the old Mexicans as La Mina del Oro, the
true character of which could not be well determined. It cer-
tainly is very ancient, and there is no record or tradition concerning
it, except that the work was done before the Insurrection, which
took place in 1680. The principal shaft is over 200 ft. deep and
is cut vertically, with great precision, through solid rock. The
sides are very smooth, and it is evidently the work of experienced
miners. A stone, allowed to drop vertically, does not reach the
bottom for several seconds, and then gives a dull sound as if
striking earth, showing that there is no water in the mine even
at that depth. There are two other shafts, and they all com-
municate by galleries in miners' style." [2]

The hills of Los Cerillos, San Miguel, Jemez and elsewhere,
contain many old mines worked either by the Spaniards or the
Indians.[3] Old mines exist at Abiquin on the Chama River. " The
work exhibits considerable skill in the use of tools, and a familiarity
with the business of mining. The roof is carefully braced where
weak, and old galleries are closed by well-laid walls of masonry.
From the style in which the excavation is done, and from the
perfect preservation of the woodwork, I attribute this and other
similar mines in this region to the earlier Spanish explorers." [4]
In the neighbourhood is a considerable ancient settlement.
" Descending by a steep and tortuous path, we left our mules
at the bottom and climbed a detached mesilla which stands at
the junction of the two branches of the valley (of the Chama),
and on which is situated an ancient and ruined pueblo, once a
stone-built town of considerable size. Even its name is now lost,
and of the inhabitants whose busy hands constructed its walls,
and whose feet in successive generations wore so deeply the
threshold of its entrance, no tradition now remains. The mesa
on which it stands is some 500 ft. in height, is composed of a
cellular trachyte, and the top is only to be reached by a narrow
and difficult path. The houses are now in ruins, but were once
numerous, and all built of dressed stone. Within the town we

[1] Kunz i. 55–6. [2] Lock 179.
[3] J. S. Newberry 40, 67 : J. S. Lindgren ii. 17. [4] Newberry 67.

noticed a dozen or more estuffas excavated from the solid rock. They are circular in form, 18–20 ft. in diameter by 10 or 12 in depth. They all exhibited evidence of once having been covered with wooden superstructures. In most of them, four excavations on opposite sides would seem to have been used as the sockets for the insertion of wooden posts, and in one is a niche cut in the side, with a chimney leading from it ; probably the place where the sacred fire was kept perpetually burning. The style of architecture in which this town was built, as well as the estuffas, show that its inhabitants belonged to the race of Pueblo Indians ; a race now nearly extinct, but once occupying every habitable part of New Mexico." [1]

In Arizona remains of old operations have been discovered : " Various evidence of crude, prehistoric mining have been found at various times and places in what is now called Arizona. However, it is not certain whether this work was done for gold, silver or copper. Discoveries made along the Salt River by Lieutenant Cushing, of ancient oven furnaces in which considerable copper was found, would seem to indicate that the ores treated were copper carbonates." [2]

Beyond doubt, further investigation will reveal the existence of many more ancient mining sites, as is evident from the following quotation from Lindgren and Gratton : " The Great Plains and the Plateau Provinces of eastern and north-western New Mexico do not contain metalliferous deposits, except local iron and copper ores distributed in sedimentary rocks. On the other hand, the metallic ores are present in every mountain range in the Territory. They occur in the continuation of the Rocky Mountain system in northern New Mexico, in the Zuni uplift, in the Sandia, Magdalena, San Pedro, Manzano, San Andreas, Oscura, Organ, Mimbres, and almost all of the small desert ranges of south-western New Mexico. They also occur in the broken-down edge of the Plateau Province about Silver City and in several of the large rhyolite fields in the south-western part, extending from the Mogollon Mountains into Socorro County." [3]

The matter can be approached from another angle, and treated as a problem in human geography. It is unnecessary to emphasize the fact that the opening-up of New Mexico, Arizona and the neighbouring states was due to the discovery, in the latter part of last century, of the vast stores of mineral wealth that they contain. [4] In consequence of this it was not long before railways began to spread their tentacles over the mining districts. Railways are the modern trade-routes, and show unmistakably what are the industrial districts of any new country. A study of the maps published by Hill in his Bulletin on " The Mining Districts of the Western United States " shows how the existence of mining settlements has decided the direction of railway lines.

[1] Id., 69–70. [2] Crane 27, 29, 94.
[3] Lindgren i. 80. [4] Id., ii. 17 e.s.

States with but little mineral wealth, that are given over to cattle-breeding, are sparsely served by railways; those with many mining settlements soon possess a network of railway lines.

Sketch Map Numbers 10 and 11 are built up from the maps of Hill, and those provided in several volumes of the Reports and Bulletins of the Bureau of Ethnology.[1] They are called sketch maps, because it is impossible, at the present moment, to obtain exact details as to distributions. They show the mining centres as given by Hill, the railways, and the sites of past and present ruins of pueblos. These ruins are of different ages and of various kinds, but for the present purpose they are grouped together.

It is evident that modern mining centres have been served by branch lines. This is the case with the mines of the Verde Valley, Arizona; the centres round Globe and Maimi in Gila County, Arizona; Morenci and Metcalf in Greenlee County, Arizona; and Silver City, Santa Rita and Hanover, Grant County, New Mexico. The important mining district round Santa Fé on the Rio Grande is well served by railways, as also is the mining district of Colfax County, New Mexico, which includes Elizabethtown. Another railway branch serves Elvado on the Chama, Rio Arriba County. A railway branch also extends to Farmington on the San Juan River, San Juan County, New Mexico. In Utah a noteworthy relationship exists between railways and mining regions, as may be seen by reference to Hill's monograph.

In practically all these cases the railways are running into regions full of remains of native villages or ruins of some sort. This is particularly noteworthy in the case of the line running from Prescott, through Phœnix, to El Paso on the Rio Grande. With the exception of the upper reaches of the Salt River, it might almost be thought that the distribution of ruins was really that of settlements served by the railway. It stands beyond doubt that identity of aim must have caused such an agreement of distribution. The branch lines in the various mining regions cannot be claimed as natural routes from one place to another: they are obviously made for the transportation of raw material from the terminus, and the choice of route is based on industrial requirements. It can hardly, therefore, be claimed that the ancient settlements in these places were determined by climatic and other geographical circumstances. The founders of these settlements were presumably actuated by the same motives as Europeans, namely, the presence of raw materials of various sorts. The same reasoning applies to the thickly populated region round Santa Fé. The agreement between the ruins and railway lines is too close to be due to chance; it argues for identity of purpose in the minds of their authors, the desire for raw materials. The old mining activities in this region bear out the contention.

[1] Fewkes v., viii., xiii., xiv.: Harrington: Hewett: Hough: E. H. Morris: Mindeleff i., ii., iii.

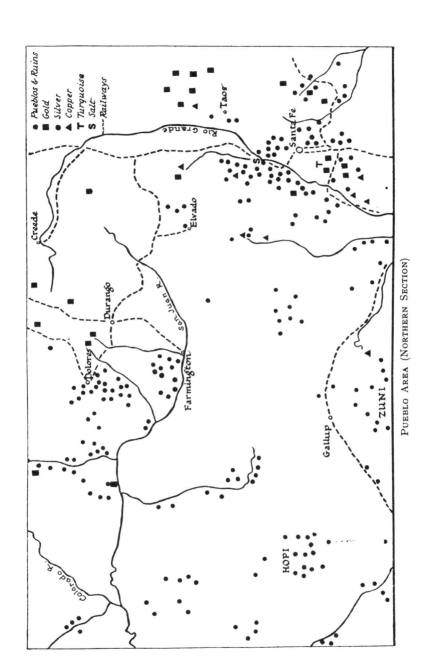

PUEBLO AREA (NORTHERN SECTION)

Legend:
● Pueblos & Ruins
■ Gold
● Silver
▲ Copper
T Turquoise
S Salt
--- Railways

Creede

Rio Grande

Taos

Santa Fé

S

T

Elvado

Durango

San Juan R.

Dolores

Farmington

Colorado R.

Gallup

HOPI

ZUNI

Certain difficulties appear in the way of the full acceptance of the conclusion suggested by these maps. To the north and south of the railway through Gallup (Sketch Map No. 10), in the basin of the Little Colorado, are a number of ruins which do not seem to be directly connected with any mining activities. The existence of such a large group certainly seems to stand in contradiction to the general rule. This discrepancy will have to be removed before any confidence can be placed in the theory now being elaborated. In order to discuss the matter, it is necessary to refer to results obtained in other countries. In a paper published by the Manchester Literary and Philosophical Society, I have shown that the builders of the megaliths of England and Wales, as well as the people responsible for the long barrows, lived in certain well-defined areas of the country. The areas were those in which materials used by them in their daily life or in their industries exist in a state of nature.[1] For example, the greatest concentrations of long barrows are in those places where flint could be obtained, that is, on the Upper Chalk. Similarly the builders of the megaliths were concentrated partly on the places where they could get gold, tin, copper and other metals ; on the chalk where they could get flint for their daily implements ; and also in places where they found materials for ornament, such as jet, hæmatite and ochre.[2] This granted, one can predict, in the case of certain forms of social organization, from a study of the objects used, where the people would probably be settled. Conversely, the materials afforded by the places where they were settled would be those used and desired by them.

The Pueblo Indians do not work metals to any extent. It is said that those on the Gila and Salt Rivers occasionally fashioned rich copper, but they never smelted it or worked it by fire.[3] The Pueblo Indians are also said to have used gold for ornaments.[4] Again, in the Zuni Mountains : " According to oral accounts, the Indians from time immemorial have been collecting copper ore from this field to adorn their persons and barter as gems or curios, and in Smelter Gulch, on the barite vein, described as occurring in the Copper Hill district, stands a couple of adobe smokestacks whose construction antedates the memory of the oldest settlers now living in the region. It is reported that they stood there eighty-five years ago just as they are to-day. They were evidently built for the purpose of treating ore, possibly silver found in the barite vein, or in the copper deposits, of which some are present near-by. They bear no evidence of having been used." [5]

Such activities are evidently of the past, so far as the present-day tribes are concerned, especially in the case of those which have wandered, either, like the Zuni and Hopi, in the Pueblo area itself, or, like the Kiowa, into the Plains. Since they are not actively

[1] Perry xii. [2] Perry xii. [3] Hough 13.
[4] Lindgren ii. 17. [5] Lindgren ii. 140.

engaged in mining, it would not be expected that their migration would be determined by the presence of such things as gold and copper, for which they have little use. But it is going too far to claim that such migrating tribes did not exercise a deliberate choice of settlement. They may have had just as decided notions as to what was a suitable place for settlement as the old turquoise and gold miners, but their preference may have lain in different directions.

It is not wise to call in the action of impersonal natural forces as the causative agents in distributions of human settlement before it is quite certain that the people themselves had no direct choice in the matter. This is particularly so in the case under consideration. For it is well known that the region between the headwaters of the Little Colorado and the headwaters of the Gila River contains many salt lakes and marshes, which were visited by Indian tribes from vast distances. One of the things that struck Coronado when he arrived among the Zuni Indians, was their possession of quantities of excellent white salt.[1] The getting of salt was a religious ceremony among the Indians. It was given to them by the Salt Old Woman,[2] which, as will be evident later on, is direct evidence of the influence of the people of the archaic civilization. Cushing states emphatically that the settlement of the Zuni and other Pueblo Indians near the salt lakes of south central New Mexico, was due to their desire for salt : " The Tanoans so far prized their comparatively inferior source of salt supply in the salinas of the Manzano as to have been induced to settle there and surround them with a veritable cordon of their pueblos." [3] Among the Zuni at the present time the south is the " direction of the salt-containing water or lake." [4] Thus it is possible to claim that the desire for salt determined the distribution of these peoples.

Other cases will have to be decided. The Tusayan district, inhabited by the Hopi Indians, does not seem to afford any material substance that would attract settlers. Again, the great distribution of ruins in the San Juan drainage may be due to the existence of gold gravels, for gold exists in the watershed of the rivers on which many of these settlements were made. These cases must, however, be left on one side. It must be remembered, nevertheless, that the need for various sorts of stone for the manufacture of domestic implements and utensils of various kinds of basic rocks, probably influenced native settlement to some extent. For instance, the Pueblo peoples used obsidian for knives.[5] " Obsidian was worked somewhat extensively in the mountains of northern New Mexico, in Nevada, and Arizona, and the Pacific States are exceedingly rich in this material, and, although no important quarries have been located, there can be

[1] Winship 389, " The best and whitest I have seen in all my life."
[2] J. P. Harrington 535–7.
[3] Cushing ii. 353 e.s. [4] *Id.*, 355. [5] Holmes iv. 114.

but little question that such exist." [1] The problem will have to be attacked in detail before it can be said to have been solved in a satisfactory manner. The run of the evidence, however, is in the direction of supporting the theory that the first food-producing occupants of the country must have come from a place where mining was actively prosecuted.

Although difficulties meet the attempt to account for all the settlements in the Pueblo region, yet if it be conceded that modern railways, even branch lines, run into regions full of ruins of pueblos, it is difficult to contest the truth of the general principle just enunciated. It may well happen that further extensions of railways in this region will make the correspondence still closer. The explanation put forward fits the facts without any difficulty. How else can we explain why men built great dwellings crazily perched on the precipitous sides of deep cañons, that had to be approached by long ladders reaching hundreds of feet up the sides, in an arid and inhospitable country, when the whole of the United States was open to them ? Their actions betray the existence of a strong incentive, and the desire for gold, turquoise and other substances supplies it.

California possesses traces of ancient mining. Turquoise was worked in San Bernardino County. Professor Whitney, in a work on " The Auriferous Gravels of the Sierra Nevada," to which I have not had access, discusses remains found in gold-bearing gravels of this region. I quote from an article by Dr. Southall which quotes Professor Whitney. " He gives a list of the objects which have been found in the gravel, comprising (1) a mortar found in pay gravel under volcanic matter, at the depth of 150 ft. (at San Andreas) ; (2) A stone hatchet, triangular in shape, size 4 in. round, 6 in. long, with a hole through it for a handle, found 75 ft. from the surface in gravel, and under basalt, 300 ft. from the mouth of the tunnel, locality Table Mountain, Tuolumne County ; (3) a large number of mortars, pestles, stone dishes, with bones of elephant and mastodon at ' Murphy's,' Tuolumne Co. ; (4) bones of a human skeleton found in clay at a depth of 38 ft., by Dr. H. H. Boyce, at Placerville ; (5) numerous stone relics, mortars, groved disks, etc., at various depths." [2] The men who made these relics were not at the cultural level of the present-day Californian Indians : they were far above it. They made out of granite mortars and dishes of perfect form, weighing from 20 to 40 pounds, and 12 in. in diameter. They also used a vessel made of lava " hard as iron," circular in form with three legs and a spout ; and polished stone axes perforated with a hole. " And the interesting thing about these remains is that, as Bancroft says, they seem in almost every instance to have been found by miners in their search for gold." [3] The explanation given by Dr. Southall in his paper seems to me to be the only possible one. He points out that these remains " always seem to be

[1] *Id.*, 214. [2] Southall 195–6. [3] *Id.*, 197.

5

found in the auriferous gravels," and he goes on to say that :
" A thousand years, perhaps, before Cortez landed in Mexico, the
Toltec civilization flourished in Central America, in Anahuac,
and on the Pacific Coast, and centuries before the palaces of
Montezuma glittered with the precious metals, the precursors
of the Aztecs had mined into the auriferous gravels of the Sierra
Nevada and the Sacramento Valley. The relics . . . were evi-
dently left where they have been found by the gold-hunters." [1]

It is possible, on the basis of this discussion, to turn to Mexico
and the Maya country. If, as seems certain, the Pueblo region
was colonized from Mexico, what were the Maya and Mexicans
doing in their own country, and how did they choose their original
sites for settlement ? In order to answer this question I shall
have to use indirect evidence. Sketch Map No. 12 shows the
relationship between the important groups of ruins of Mexico,
as given by Lumholtz, Joyce and Bancroft, and the railway lines.
It is significant that, judging the region from New Mexico to
South Mexico as a whole, the railways are plentiful in the basin
of the Gila River, in New Mexico and Arizona, and then sparse
for a great distance, when they begin to proliferate ; and that
ruins should be plentiful in both cases where the railway lines
begin to throw out several branches. As in the Pueblo region,
branch lines run into places with ruins ; as that to Oaxaca,
that to Mexcala less definitely ; and that to Pazcuaro ; while
the proliferation of branches near Mexico city agrees well with
that of ruins. Even the apparent exceptions can be explained.
The name of Placeres del Oro tells its own tale, in view of the
fact that, as Sahagun states, the Mexicans washed river gravels
for gold.[2] The ruins in Vera Cruz are in a State which is notable
for the presence of pearl-bearing freshwater mussels on a greater
scale than elsewhere in Mexico.[3] The Mexicans used much pearl-
shell and many pearls ; only recently Mrs. Zelia Nuttall has
discovered, on top of a pyramid in Mexico, a great depth of
pearl-shell, in the midst of which were burials. So it is possible
that the pearls of Vera Cruz attracted the people of old, but
that they have not been so successful in attracting modern men
as to cause them to build railways.

There may be other explanations for the Mexican railways
than that adduced. But railways are made to make money,
which is not done in Mexico by passenger traffic. The branches
to Oaxaca and elsewhere were certainly made on account of the
mineral traffic, and similar motives presumably caused the men
of the archaic civilization to settle in the same districts.

[1] Southall 197. Holmes (iv. 116) notes " the occurrence of articles of
stone—mortars, pestles, and other objects of kindred culture grade, as well
as fossil human remains—in the gold-bearing gravels of the mountain valleys."
. . . Remains have also been found in the Santa Barbara district—bowl-
shaped mortars, long, graceful sandstone pestles, steatite tobacco pipes,
serpentine cups and bowls, made from materials of local origin (*id.*, 115).
[2] Sahagun 776. [3] Simpson.

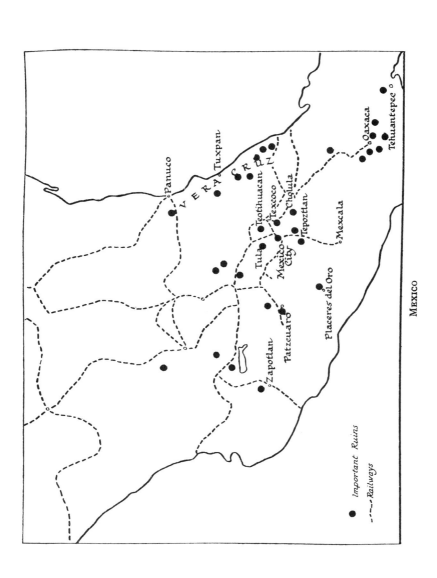

Panuco

VERACRUZ

Tuxpan

Tula

Teotihuacan

Texcoco

Cholula

Mexico City

Tepoztlan

Mexcala

Patzcuaro

Placeres del Oro

Zapotlan

Oaxaca

Tehuantepec

● Important Ruins

------ Railways

MEXICO

The question of the more homely raw materials must not be forgotten when considering the problem of the early colonization of a country. In the case of Mexico, obsidian, so widely used for the manufacture of knives, may have determined certain settlements, as is shown by Mrs. Zelia Nuttall. "Hardly an occupied site in all Mexico and Central America can be found that does not furnish examples of obsidian implements or fragments. The flake-knife is the simplest and most universal of the flaked forms, and occurs in great numbers in and about the valley of Mexico. The immense refuse deposits of the ancient city of Tenochtitlan, now the city of Mexico, are in places literally black with the broken knives, and San Juan Teotihuanan furnishes an apparently inexhaustible supply of these and other forms of implements." Since the stone is found in the San Juan River, the settlement was probably due to its presence ; [1] indeed, it is probable that the existence of obsidian determined many of the old settlements in this part of America. Mrs. Zelia Nuttall has a suggestive article concerning the stone called Chalchihuitl by the Mexicans, a kind of jade. This formed one of the forms of tribute paid by the coast tribes to the Mexicans, the others being gold and turquoise. Mrs. Nuttall gives a long list of such places. " The actual existence of towns in regions which anciently paid tribute of chalchihuitl beads to Montezuma, and of districts whose names incorporate the word chalchihuitl, undoubtedly constitute a most valuable indication which deserves serious consideration by those interested in the possibility of finding jadeite in place." It is noteworthy too, that, as Mrs. Nuttall mentions, in Chiapas, the region where the Maya civilization had its origin, there is a place called " The land of chalchihuitl." [2]

The argument from railways cannot be applied to the Maya country, for none have yet been made there. Sketch Map No. 13 shows the distribution of the early Maya cities. Some are in the basin of the Usumacinta River ; Copan and Quirigua are in the basin of the Motagua River ; and the rest are in Honduras and Yucatan, which last country was the scene of later Maya history, when they had been driven from their earlier home. The settlements of Copan and Quirigua may possibly be explained because the Motagua River is said to be the most important gold river in that part of America.[3] The earliest settlements in the Usumacinta River basin are close to the banks of rivers, which suggests design. The Usumacinta is by far the most noteworthy pearl-bearing river in Mexico and Central America, for it contains several varieties of the pearl-bearing freshwater mussel.[4] It is said, further, by Simpson, that pearl-bearing mussels exist in Honduras, but the information is not precise. The Maya used pearls, both at Copan and in the Honduras and Yucatan settlements, but none have been found in the Guate-

[1] Holmes i. 406. [2] Nuttall i. 228, 238.
[3] Maclaren 608. [4] Simpson.

malan sites.[1] It may be, therefore, that pearls played some part in the settlement of Honduras.

Attention has already been called to the enormous number of mounds that exist in the Mound area of the United States, particularly in the basins of the Mississippi, Ohio, Tennessee and Cumberland rivers, in South Michigan, South Minnesota, Florida and Western New York. The mounds are sparse along the Atlantic seaboard districts, and they soon disappear once the Mississippi is crossed in the westward direction. They do not persist far north of the Great Lakes. It is probable that they exist in some numbers in Texas, which archæologically is but little explored.[2] If that be so, a continuous distribution exists from Mexico to the eastern States.

Sketch Map No. 3 does not show all the mounds, but it is sufficiently detailed to make the reader realize the great extent of the mound-building civilization. If a careful examination be made of the original map, it will be found that no mound is situated far from a river-bank. It can be seen, from the sketch map reproduced here, that this is true in the general sense : it is also true in detail. What cause can have led men, all over this wide area, practically universally to settle in close proximity to water ? I suggest that the cause was the search for pearls and pearl-shell.

It needs a detailed examination of the monograph of Simpson [3] to realize the number of varieties of pearl-bearing freshwater mussels that exist in the Mound area. The details are so numerous that it is impossible to plot them on a map. Nevertheless, certain general principles can be derived from the mass of details. The great bulk of the mussels are found in the basins of the Mississippi, Ohio, Tennessee, Cumberland, Tombigbee, Chattahoochee, Flint, Savannah, and Altamaha Rivers ; also in the St. Lawrence and Atlantic drainages, and in South Michigan and North Florida. The distribution of pearl-mussels therefore agrees closely with that of mounds.

When the Mississippi is crossed, the number, both of pearls and of mounds, rapidly lessens ; so that, although mounds are fairly plentiful in Arkansas, Missouri, Iowa and Minnesota, especially within reach of the Mississippi, they soon vanish in Indian Territory, Kansas, Nebraska and the Dakotas. While the pearl-bearing mussels disappear in like manner, they are fairly plentiful in Arkansas, along the Little Red, White, and Current Rivers, but, beyond a few references to Kansas, they practically are not noted in the more westerly States of the Plains.

The distribution of mounds and of pearl-bearing freshwater mussels supports the contention that the mound-builders appreciated pearls and pearl-shell, and were largely determined in their movements by the presence of these things.

Mr. Jackson has shown that, in various parts of the Mound region, many pearls have been found with burials of the mound-

[1] Jackson 117–18. [2] Pearce 227–8. [3] Simpson.

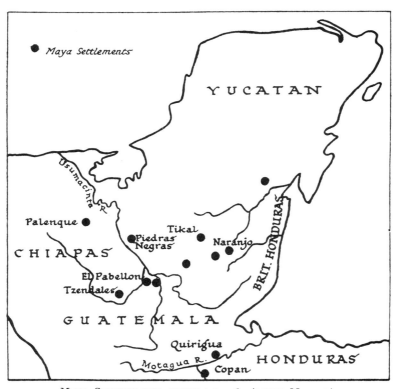

MAYA SETTLEMENTS ABOUT A.D. 460 (AFTER MORLEY)

builders.[1] The valuable paper by Willoughby, on the Indians of Virginia, shows what great value they placed on pearls and other things. He describes the process of mummification of the kings. " They were first disembowelled, then the skin was laid back and the flesh cut from the bones. Strachey says that this was dried over the fire into ashes and preserved in little pots. Hariot tells us it was dried in the sun and preserved in mats which were placed at the feet. The skeleton, still fastened together by ligaments, was enclosed again in its skin and stuffed with white sand or with ' pearls, copper, beads and such trash sewed in a skynne.' Upon it were placed bracelets, copper ornaments and strings of pearls and beads. Thus prepared, the remains were wrapped in a white dressed skin and lastly rolled in mats and laid ' orderly one by one as they dye in their turnes.' The riches accumulated during life, such as beads, pearls and copper, together with his tobacco pipe, and any object especially valued during life, were placed in baskets and deposited at the feet." More than once mention is made, in this account, of the great value placed on pearls as well as copper, by these people.[2]

Jackson quotes from Streeter with regard to the Florida Indians. " As in Cleopatra's time in Egypt, so in Florida, the graves of the kings were decorated with pearls. Soto's soldiers found in one of their temples great wooden coffins, in which the dead lay embalmed, and beside them were small baskets full of pearls. The temple of Tolomecco, however, was the richest in pearls ; its high walls and roof were of mother-of-pearl, while strings of pearl and plumes of feathers hung round the walls ; over the coffins of their kings hung their shields, crowned with pearls, and in the centre of the temple stood vases full of costly pearls."

The use of pearls, therefore, by the mound-builders, and by the tribes of Columbian times, stands beyond doubt ; and its ceremonial nature shows, likewise, that the people attached great importance to them.[3] So, if the peoples responsible for the mounds came to the United States for pearls and other valuables, it follows that their most important settlements would be in the areas richest in what they most desired. I shall now adduce evidence to show that the most important Mound region was that characterized by the richest profusion of substances appreciated by the people of Mexico and elsewhere in pre-Columbian times. Cyrus Thomas quotes the words of Dr. Joseph Jones : " After a somewhat lengthy review of the various kinds of burial practised by the aborigines of America, he arrives at the following conclusions : ' We have carefully examined all the modes of burial practised by the American aborigines, in extenso, and it is evident that the ancient race of Tennessee is distinguished

[1] Jackson 167 e.s. [2] Willoughby 62, 71, 72.
[3] Jackson 167 e.s. See Chapter XXV for an explanation of this fact, which is of so great importance for the understanding of the archaic civilization.

from all others by their peculiar method of interment in rude stone coffins. Whilst the custom of burying the dead in the sitting posture was almost universal with the various tribes and nations of North and South America,[1] the ancient inhabitants of Tennessee and Kentucky buried most commonly in long stone graves,[2] with the body resting at length, as among civilized nations of the present day in Europe and America.' " Cyrus Thomas goes on to comment: " Since the publication of Dr. F. Jones' paper much additional information in regard to these graves has been obtained, and the area in which they occur has been greatly extended, but the result has been, as will be seen in the sequel, rather to confirm than to disprove the opinion here expressed. Graves of the same character have been observed in northern Georgia, in the lower portions of eastern Tennessee, in the valley of the Delaware River, at various points in Ohio and in southern Illinois. Yet, strange as it may seem, all these places were at one time or another occupied by the same people who formerly dwelt in the Cumberland Valley, or by closely allied tribes." Later he states that the Cumberland Valley and middle Tennessee constituted " the chief home of the people who buried in stone graves of the peculiar form mentioned," with whom he connects the Shawnee and Delaware tribes. He sums up a long discussion of this matter in the following terms: " Taking all these corroborating facts together, there are reasonable grounds for concluding that graves of the type now under consideration, although found in widely separated localities, are attributable to the Shawnee Indians and their congeners, the Delawares and Illinois, and that those south of the Ohio are due entirely to the first-named tribe."[3] Thus he claims that the mound-builders are definitely linked to the Indians of post-Columbian times, and any careful reader of his arguments is, it seems to me, bound to agree with him.

Another important fact emerges from the study of mounds containing stone graves. In a group of mounds at Cartersville, Georgia, called the Etowah Mounds, certain remarkable figured copper plates and engraved shells have been found. " It is apparent to every one who will inspect the figures that in all the leading characters the designs are suggestive of Mexican or Central American origin. In fact, there can be no doubt that they were derived in some way from these more civilized countries either directly or, as is more probable, indirectly." It is perhaps doubtful, as Cyrus Thomas points out, whether the copper plates may not perhaps be of European origin. But he notes, at the same time, that copper plates have only been found in mounds with stone graves.[4]

[1] The crouched position in burial extends throughout the region, from Egypt of pre-Dynastic times, to the eastern States.
[2] Cf. C. Thomas i. 353.
[3] C. Thomas ii. 691 e.s. [4] *Id.*, 701.

Cyrus Thomas comments on the use of shell for ornament, and says that the ornamented shells are found " in all parts of Tennessee, except the extreme western portion, in western North Carolina, in northern Georgia, the extreme northern part of Alabama, south-eastern Missouri, southern Illinois, and in Virginia, especially the extreme south-western part ; but western North Carolina, eastern and middle Tennessee, especially the Cumberland Valley, are the places where they have been found in the greatest numbers." [1] He continues thus : " The chief difficulty which arises in connexion with these shells is the fact that a few of them bear undoubted Mexican designs which pertain to pre-Columbian times . . . for example, those found in the ' Big Toco ' mound. . . . The Mexican origin of the designs is admitted by every one who sees them, yet the proof that this mound was built and used by the Cherokees is so strong as scarcely to admit of a doubt. How these two facts are to be reconciled is a problem not easily solved." [2]

Other strong reasons can be given for the presence of people with undoubted Mexican culture in this region. It is well known that the Appalachians contain much gold, especially in the States of Tennessee, West Virginia, North and South Carolina, and Georgia, and in the days of Columbus they were inhabited by the Cherokee, Creek, Chickasaw, and Shawnee, tribes which are all claimed to have strong culture links with the mound-builders. [3] It is certain that gold-mines were worked here in the past. But the problem is obscured by two facts. First of all, it is well known that the Spaniards worked gold-mines in this region. Also it is probable that the first seekers got their gold from the gravels of the river-beds, and thus all traces of their work may well have disappeared. At the time of the Spaniards it seems certain that the natives of this region knew of the gold, and the early writers describe the manner in which it was got by them from the river gravels. [4] The Indian tribes were living in country watered by rivers full of gold. The Cherokee call the Chatta-hoochee River by that name because in its bed there are many rubies. It and the Chestatee River, as well as many others running through their territory, are well stocked with gold in the gravels. [5]

The following quotation from Lock's " Gold " makes it clear that the native tribes had certain knowledge of the wealth of their homeland : " Old chroniclers give an account of a province called Cofachiqui, which was visited by the Spaniard de Soto's gold-hunting expedition in 1538–40, and which was embraced in what afterwards became the States of Florida, Georgia, Alabama and Mississippi, and, according to Logan, had its centre on the western limits of South Carolina. Its capital and chief town stood upon

[1] C. Thomas ii. 702. [2] C. Thomas ii. 703.
[3] C. Thomas ii. 718 e.s. [4] Becker 253 e.s.
[5] Crane 26. The Chattahoochee is also an important pearl river (Simpson).

the tongue of land between the Broad River of Georgia and the Savannah, just opposite the modern district of Abbeville. The Spaniards entered this capital after a two-months' march, and there found hatchets formed from an alloy of gold and copper. At this their cupidity was greatly excited, and they concluded that they had found a country abounding in the long-coveted precious deposits of gold. And so indeed they had : less than six miles south-east of the town, on the opposite or Carolina side of the river, lay one of the most extraordinary gold deposits in the world. The Cherokees were well acquainted with the Dorn mine. This is shown by the numerous relics of their handiwork scattered around it, and there can be little doubt that the massive nuggets of its outcropping gold supplied them abundantly with the finer metal of the alloy that so attracted the Spaniards. It is no less known that the gold and copper, found in the possession of the Indians, in the form of solid masses or curious trinkets, by the first white men who visited the country, were obtained from these sources." He goes on to say : " These chronicles and traditions go to confirm what Lawson says, that the Indians, from time immemorial, were acquainted with valuable mines of gold and silver in Upper Carolina." [1]

These emphatic words of Lock show that the Indians of the goldfield were engaged in working the stores of metal that existed there, and that their capital was, as he says, situated near " one of the most extraordinary gold deposits in the world." Now since the Indians, who had such close cultural associations with the mound-builders, knew of the gold in their midst and worked it, it seems beyond doubt, for this reason alone, that the mound-builders also exploited the mines.

The mound-builders worked other sources of wealth. There are traces of mining over a wide area from Lake Superior to Mexico. " The skill which is shown, and the knowledge of the situation of veins, as well as the patience and perseverance necessary to do so much work, all prove that it was the performance of a people more civilized than our aborigines." Near Lake Superior are numerous traces of copper workings. " It is along the edges or outcrops of these veins that the ancients dug copper in great quantities, leaving, as external evidences of their industry, large trenches, now partly filled with rubbish, but well defined, with a breadth of 10 to 15 ft., and a variable depth of 5 to 20 ft. In one place, the inclined roof, or upper wall work, is supported by a natural pillar which is left standing, being wrought around, but no marks of tools are visible. In another case, east of the recent works, is a case where they have wrought along the vein a few feet without taking away the top or the outside vein stone. The rubbish has been cleared away in one spot to the depth of 20 feet, to the bottom of the trench. . . . The agent found in one pit at about 18 ft. in depth, measuring along the inclined

[1] Lock 122–3.

face or flow of the vein, a mass of native copper supported on a cobweb of timber, principally the black oak of these mountains, but which the ancient miners had not been able to raise out of the pit.

" The sticks on which it rested were not rotten, but very soft and brittle, having been covered for centuries by standing water, of which the pit was full at all times. They were from 5 to 6 in. in diameter, and had the marks of a narrow axe or hatchet about 1¾ in. in width.

" They had raised it 2 or 3 ft. by means of wedges, and then abandoned it on account of its great weight, which was 11,658 pounds, or near 6 tons."

They used stone hammers and mauls ; they also used fire in their work. " With these apparently inadequate means they have cut away a very tough compact rock, that almost defies the skill of modern miners, and the strength of powder, for many miles in a continuous line, and in many places two, three and four adjacent lines." [1]

It is well known that copper mines exist in Tennessee. " The many relics of mining operations in the shape of tools and workings on copper, lead and zinc veins in the State would seem to indicate that the Spaniards had once been engaged in mining operations, not for these base metals but with the expectation of finding gold and silver." [2] The Spaniards very likely went to places already worked by the natives. So the copper found in the Etowah Mounds may well have been mined by the mound-builders. In maintaining that the mound-builders were attracted to the Appalachians not only by the pearls, but also by the stores of mineral wealth that existed there, I am making a claim that is hard to substantiate in one particular. For, so far as I am aware, no gold has been found in the mounds. But the Cherokee and other native races evidently knew of the presence of gold in their streams, and gave information which attracted the Spaniards. Since a continuity exists between the natives and the mound-builders, it is permissible to look upon this as presumptive evidence of the appreciation of gold on the part of the mound-builders. The task of accounting for its absence, presents no insuperable difficulty. For it is safe to argue that anyone who would search the remains of any goldfield would find no gold there, except that which the gold-seekers had overlooked. Goldfields are usually worked in order to remove the metal, not to use it on the spot. The Mexican connexions of the Etowah Mounds suggest strongly that the Mexicans were the instigators of the industry, and they naturally would remove all the gold. The presence of such highly civilized strangers could not fail to raise the natives in cultural level. This would account for the appearance of carved articles apparently beyond the powers of the Indians. The facts, when assembled, suggest, therefore, that the mounds

[1] Schoolcraft I. 96 : cf. also Orr. [2] Crane 104.

of the Appalachian goldfield present cultural features that connect them more closely with Mexico than any other mounds of the States. Further, these mounds are themselves connected with the most advanced Indian peoples, the Delawares, Cherokee and Shawnee. This region, as will be shown later by additional evidence, was one of the hiving-off places, whence swarms of Indians went out to seek fresh homes, who, as they went, dropped still more of the old culture that they had derived from the early gold-seekers of the Appalachians.

A reason can therefore be assigned for the distribution of the mounds that accounts for it in a way that no other explanation has accomplished. It suggests that the search for gold, pearls and copper led the mound-builders to the localities where they found these things, and that they ignored other places probably equally well suited for habitation. In fact, their motives were similar to those of modern men. If a study be made of the behaviour of the Spaniards after their conquest of America, it will be found that their movements were obviously controlled by the reports of supplies of gold. " If we go back in imagination three centuries, and picture to ourselves the most striking characteristic which the aspect of Europe then presented, we shall behold a universal excitement caused by the discovery of a new continent, which had been brought to light by a Genoese navigator, whose genius and persistent daring had been stimulated by a lucky miscalculation of the geographical position of China. In this new world, to which Columbus had traced the path—not merely for Castille and Leon, as is alleged in the inscription placed on the tomb by the tardy gratitude of posterity, but for the whole civilized world—mines of gold, and afterwards of silver (especially the latter), of unheard-of richness, presented themselves to the cupidity of the conquerors. The most enterprising spirits of the Iberian peninsula hastened across the ocean to possess themselves of treasures, the splendour of which had been exaggerated in their excited imaginations ; and they were followed by a multitude of daring adventurers from all parts of Europe, who precipitated themselves on the coast of America, all in quest of mines of gold and silver." [1] Small wonder that they arrived in the Pueblo region and in the Appalachians in their quest for gold, there to find in both places a highly developed civilization. If the motive was the search for gold in the one case, it is hard to see what other motive can be adduced in the other. The Spaniards found out the places where gold and pearls

[1] Chevalier 1–2. I owe the following quotation from a work entitled "Recherches philosophiques sur les Americains" (Berlin, MDCCLXXVII) to Dr. Elliot Smith. Discussing how the Jesuits came to choose a particular region of California for their mission, the writer makes this comment: " Voici les véritables causes de leur prédilection pour cette partie des Indes occidentales. La pêche des Perles, qui est, comme l'on fait, sur les parages de cette Péninsule et des Isles voisines, plus fertile et plus riche que sur ceux de Panama, d'Ormus, de Bassara et du Malabar ensemble " (p. 134).

existed; so did the mound-builders; it is therefore legitimate to claim that the early settlements in the North American gold-fields were made by men deliberately seeking for wealth.

Reliance must not be placed solely on the presence of gold and pearls, and copper, to account for the whole distribution of the mounds. These people used other materials, flint, chert, mica and so on, the need of which would determine in some measure the distribution of their settlements. For instance: " Mica was in very general use among the Indian tribes east of the Great Plains and was mined by them at many points in the Appalachian highlands from Georgia to the St. Lawrence River. From these mines it passed by trade or otherwise to remote parts of the country and is found more especially in burial mounds, stone graves and ordinary burials in the Gulf States and throughout the Mississippi Valley. Mica is also found in workable forms in Dakota and south-western Arkansas, but is not known to have been mined by the aborigines in these sections." [1]

Many mounds contained burials associated with mica. " Atwater describes the discovery of a burial at Circleville, Ohio, of a sheet of mica 36 in. in length by 18 in. in width and 1½ in. in thickness. Other similar finds were made by Atwater in the same region. With a skeleton in the Grave Creek Mound near Wheeling, W. Va., 150 disks of sheet mica measuring 1½ to 2 in. in diameter and having one or two perforations were found. These were probably suspended as tinkling pendants on some part of the costume." [2]

The mica-mines covered a wide area. " No definite idea of the number of ancient diggings can be formed, but that they were numerous and widely distributed over the south Appalachian region cannot be questioned, western North Carolina claiming the largest number." [3] When it is remembered that the natives were, at the time of Columbus, actively engaged in mining for flint, chert, steatite, mica, catlinite, hæmatite, copper, silver and gold, fire-clay, pigment materials, salt and so forth,[4] it is evident that much work will have to be done before it is possible to state that climatic or other geographical conditions have influenced the peoples in their choice of settlement. The great workshops of Flint Ridge, Licking and Muskingum Counties, Ohio, give an idea of the industry of the peoples. " The extent of the ancient operations is almost beyond belief and can be realized only imperfectly by those who have not visited the locality. To say that hundreds of acres of the undulating surface of the plateau have been dug over and countless trenches and pits opened to the depth of from 5 to 25 ft., often so closely placed as to coalesce within the various groups, does not leave an adequate impression upon the mind.[5] . . . The great marvel is that the aborigines

[1] Holmes iv. 241. [2] Holmes iv. 241.
[3] Holmes iv. 244. [4] Id., iv. 158 : T. Wilson ii. 961 e.s.
[5] Holmes iv. 173.

even accomplished the work of which such abundant traces remain, and only those who have ventured to remove a small mass of the flint from its place can realize the appalling difficulty of the work, even to men with tools of steel, unaided by powerful explosives." [1]

These quotations show that the native tribes of the United States were organized on a complicated industrial basis, and that their industrial needs, beyond any doubt, played an important part in the determination of their distribution. I am convinced that a careful survey of the whole country will reveal correlations between settlements and sources of raw materials as exact as those already discovered in the case of the early settlements of England and Wales.[2]

(ii) OCEANIA

It has already been pointed out that megalithic monuments and irrigation systems are not found in every island of the Pacific. The original colonizers of Oceania brought with them their food-plants and made habitable the islands where they lived. They therefore must have had some reason for settling in one place rather than another ; but, from the standpoint of natural conditions, it is hard to see what influenced them. What is the cause of the great activity round Tahiti, with the building of numerous pyramids, when the fertile soil of New Zealand lay ready for occupation, and was known in early days to the Polynesians ? Why were the Paumotu more highly favoured than the Gilberts or the Ellice Islands ? Why was Penrhyn Island chosen as a site for megaliths rather than the others in the vicinity ? What is the difference between New Caledonia and New Zealand that their cultural history should be so different ?

Sketch Maps Nos. 4, 5 and 6 show that the distribution of pearl-shell agrees well with that of the archaic civilization. The Islanders have always been famous for their love of pearls and of pearl-shell. According to Jackson, " In the Pacific Islands pearls and pearl-shell seem to have been appreciated for centuries. Among the native ornaments noted by Captain Cook at Tahiti were feathers, shells and pearls ; but the latter were worn," so he says, " chiefly by the women. In the Marquesas Islands, plates of mother-of-pearl decorated the principal head-dress of the natives, while ornaments consisting chiefly of pearl-shell were seen in Toobouai ; Friendly Islands ; Mangea Islands ; New Caledonia ; New Zealand, etc. The pearl-shell was also found to be employed in the construction of fish-hooks in many of the islands visited by early navigators." The shell from which the pearl fish-hooks

[1] *Id.*, iv. 176.
[2] Cf. Perry xii. : " I have now examined mines and quarries of the aborigines in twelve distinct materials, and each new example has added to my former high estimate of the enterprise and perseverance of the native peoples when engaged in the pursuit of their mineral industries " (Holmes ii. 507).

are made (*Avicula cumingii*) is rare in the Ellice Islands. It is universally used in the Pacific, and the principal source of supply is the lagoon of Nukulailai.[1] On the map are marked the places where the pearls are, or have been, fished. The list of places where pearl-fisheries are reported agrees with those of megalithic remains, irrigation and other signs of the presence in the past of the archaic civilization : Hawaii (Oahu), Marquesas, Paumotus, Tubuai (Austral Islands), Cook Islands, Society Islands (especially Tahiti and the neighbouring islands), Raiatea, Penrhyn Island, Samoa, Tonga (especially Tongatabu), Fiji, New Zealand,[2] New Caledonia, New Hebrides (Espiritu Santo and Vanikolo being especially mentioned), Santa Cruz, Ticopia, Solomons, British New Guinea, New Britain, Torres Straits, Carolines, Pelew, Mariannes, Marshalls, the Lord Mulgrave and Gilbert Islands.[3] The maps show the nature of the agreement between the two distributions.

Some features of this distribution need notice. In the first place, I suggest that, since the two distributions agree so closely, the first colonizers of the Pacific were led by their desire for pearls, and settled where they found banks of the shells that yielded them what they sought. The presence of the early folk is indicated by that of megalithic monuments, stone images and irrigation systems. These are absent in those places where no pearls are reported. Since these latter groups are now inhabited, the inference is that the first colonizers of the Pacific avoided them because they contained no pearls, and not because climatic reasons prevented settlement.

If the people of the archaic civilization in the Pacific were pearl-fishers, their most important settlements would be in places where pearls were most abundant. Writers on the pearl-fishing industry are unanimous on two points. First, that pearl-fishing is the chief industry of the Pacific ; and secondly, that the Society Islands constitute the most important centre. In the words of Kunz and Stevenson : " Gathering pearl-shells and pearls is the principal industry of the semi-amphibious natives of the hundreds of palm-crowned and foam-girdled islands of the southern Pacific, commonly known as the South Sea Islands. Among these the most prominent for pearl-fishing are the Tuamotu Islands or Low Archipelago, the Society Islands, the Marquesas, the Fiji Islands, Penrhyn or Tongareva, and New Caledonia." [4] The most important centre of pearl-fishing is that of the Society Islands and the Paumotus. In the words of the same authors : " Tahiti, the largest of the eleven Society Islands, is the centre of the pearling industry of French Oceania. It is situated in about lat. 17° S. and long. 150° W., and has an area of approximately 410 square miles and a population of 11,000, nearly one-

[1] Jackson 109–10.
[2] v. Hessling 75 e.s. : Huguenin 43 : Taylor 634–6.
[3] Kunz and Stevenson 189 e.s. [4] Kunz and Stevenson 189.

half of whom live in Papeiti, the principal town. This is one of
the most agreeable of the ' Summer Isles of Eden,' Nature
furnishing food in abundance, and climate and social customs
requiring little in the way of dress and habitation. Notwith-
standing its importance as the head-quarters of the pearling
industry, few pearl-oysters are caught at Tahiti, most of them
coming from the Archipelagoes of Tuamotu, Gambier and occa-
sionally Tubai." [1]

Tahiti, therefore, is, for the eastern Pacific, the centre to which
pearls are brought. It is therefore significant that so many stone
pyramids are to be found in the Society Islands, especially in
the neighbourhood of Tahiti. In this respect this group far
excels the rest of Oceania, and in the past it is evident that
Tahiti must have played a part of great importance in the history
of the eastern Pacific. That the region richest in megalithic
remains should be also richest in pearls is presumptive evidence
that the people who first settled in Polynesia were pearl-fishers.
Certain other facts support this. Penrhyn Island is mentioned
as a place with notable megaliths ; it is also an important pearl-
fishing centre. Again, the island of Tongatabu of the Tonga
group is famous for the great trilithon ; it is also specially men-
tioned as a pearl-fishing centre. In Hawaii, the island of Oahu,
where now is Honolulu, contains pearls ; this island has played
an important part in the history of the group (see p. 311).

The Samoa group needs mention. When the migrations of
the Polynesians are mentioned, it will be found that Samoa was
a great hiving-off centre, whence the Society Islands, the Mar-
quesas, Rarotonga and other groups were colonized, an expedition
even setting out thence at an early date for New Zealand. Samoa
is mentioned by Von Hessling as a pearl-fishing centre,[2] but it
certainly is not important in that way to-day. The pearl-beds,
therefore, must soon have been exhausted. It is thus important
to note that the megalithic remains of this group cannot in any
way compare with those of Tahiti. The different degrees of
richness in the pearl-fisheries of the two groups serve to explain
the difference. In the one case there was every incentive to
settle, and this incentive was lacking in the other. It must be
noted, too, that the signs of the archaic civilization are practically
confined to the small island of Tau in Manu'a, at the extreme end
of the group.

Directly the boundary between areas with pearls and those
without them is crossed, the distinction in culture is noticeable,
for in the latter case megaliths are practically [entirely lacking.
In one or two instances further evidence may serve to fill in the
gaps in the evidence ; as, for example, at Fanning's Island, and
the Chatham Islands.

The unimportance of the pearls of New Zealand suggests the
reason why the first expedition from Samoa did not lead to

[1] *Id.*, 189–90. [2] Von Hessling.

settlements of the same nature as those of Tahiti. Nevertheless, people were undoubtedly living in the island before the arrival of the Maoris, and it may be that the pearl-bearing oysters induced them to make a settlement, although the relative unimportance of the pearling industry seems to have prevented a development such as that in Tahiti. In one case it is possible to suggest another motive.

One important region for old remains is the Pelorus Sound. The Pelorus River itself is a gold river, the gravels of which have been worked for gold. Also gold is reported in Mahakipaca Bay, where a statuette of red material like pottery was found.[1] Stone implements have actually been found in gold claims. At Bruce Bay in a claim in the forest belt near the shore " on argillaceous gravel, a party of miners, consisting of S. Fiddean, J. Sawyer and T. Harrison, found a stone chisel and a sharpening-stone lying close to each other ; the former was broken, having been accidentally struck by the pick when the miners were loosening the wash-dirt. The stone chisel is made of a dark greenish chert, and is partly polished ; the sharpening-stone is made of a coarse greyish sandstone, which I found in situ about ten miles south of this locality, near the mouth of the river Piringa."[2] Haast goes on to say that " The beds through which the miners had been working were quite undisturbed, and some very large trees had been growing just above that portion of their claim, near the centre of which these stone implements had been found." Similar finds had been made in Wellington Province in the drainage of swamps and construction of roads, often several feet below the surface. Others occasionally are found in Canterbury Plains, but all these implements are more or less polished, and resemble in many respects those of the present native population. " I wish to point out, however," says J. Haast, " that although these tools are much more perfect than those found in the Moa-ovens, I am not able to say which are of the greater antiquity."[3] It is therefore possible that the early comers in New Zealand, being of a higher civilization than those who followed, had some definite errand. Nothing can be argued definitely from the presence of one stone celt in a gold gravel. But the finding of an implement in such a position does at last raise the possibility that the gold-fields of New Zealand were discovered, if not worked to any great extent, a long time ago.

Another attraction can be suggested. The terraces and other pre-Maori remains of the Great Barrier Island show that some reason must have existed for settling in this particular spot, although the whole of New Zealand was open. The presence there of much obsidian suggests the cause.[4] It has already been claimed that domestic industries have had an influence upon the distribution of population in North America, as well as the more

[1] Rutland i. 226, 230.
[3] Id., 118–19.
[2] Haast i. 118.
[4] Westman.

obtrusive occupations of pearl-fishing and gold-mining. So, in the Pacific and elsewhere, the demand for a homely material such as obsidian may have played an important part in determining the distribution of population, although some more powerful motive must be assigned for the first colonization of the region.[1] It is not suggested that the search for obsidian led men into the Pacific. But, once there, they would seek obsidian for their knives, because they were accustomed to work it. It must be confessed, however, that the question of New Zealand cannot be decided on the present evidence. Nevertheless, the comparative lack of pearls in the sea around the island and in the rivers, together with the small degree of influence of the archaic civilization, support the general contention of this chapter, namely, that the search for pearls and gold led the people of the archaic civilization to colonize the Pacific.

The region of Melanesia from New Caledonia to New Britain is a noteworthy centre of pearl-fisheries, as is shown by Sketch Maps Nos. 5 and 6. But, besides pearls, other substances could have attracted the men of the archaic civilization. In New Caledonia gold exists in several localities both in river gravels and in the rock.[2] Moreover, this island contains jade and sandalwood, both of them much desired by the civilized peoples of eastern Asia. Signs of the presence of metals exist in the Solomons ; tin has been found in San Cristoval and Bougainville.[3] But doubtless the pearls of this region would prove the greatest attraction to people from more highly civilized countries.

The most important centres of the archaic civilization in Polynesia were those characterized by rich pearl-fisheries. Evidence of the same nature exists in the New Hebrides. For those islands mentioned by Rivers as being noteworthy for their megalithic remains—Santo, Malo, Malekula, Aurora, Santa Maria—are situated in the midst of a pearl-fishing region that is especially mentioned by Von Hessling.

It seems certain that the earliest food-producing civilization in British New Guinea was that of gold-workers. Mr. Chinnery has shown that all the remains of antiquity of British and German New Guinea, which belong to a time far beyond the recollection of the present populations, including stone pestles and mortars, stone-carving, pottery fragments, shell ornaments, implements of ophicalcite, obsidian, quartz, stone circles,˙ and incised stones, have a distribution that indicates " a wide movement that had had a most profound and far-reaching influence on the early developments of New Guinea peoples."[4] . . . "What led the immigrants into the formidable regions of the interior in so many places ? Nothing short of extreme pressure or the highest inducement could account for the

[1] Cf., for instance, J.P.S., 1902, for jade axes in Niue, which must have come from some other island.

[2] Maclaren 302–3. [3] Guppy ii. 11, 20. [4] Chinnery 271.

presence of people in the very interior of this, one of the most inhospitable countries in the world. The existing races are there simply because they cannot help themselves, while the white race is attracted there by gold. We can reasonably assume from the evidence that the immigrants penetrated the interior at various points entirely of their own free will. Had they been searching for land they would surely have remained in the fertile coastal region. What, then, did they seek." He goes on to say "that the objects have been discovered either in gold-bearing areas or in neighbouring coastal regions," and also that pearls certainly occur on the coast of New Guinea in every locality which has yielded traces of the immigrants.[1] Also "some of the goldfields into which these objects have found their way lie among the mountains of the interior in the midst of almost impenetrable jungles, rough broken mountains, precipitous gorges, and dangerous rivers. These regions are inhabited by fierce mountain tribes of short peoples, all of which until recent years were at war with one another as well as with their taller neighbours of the lowlands. Yet it is in such inhospitable regions that some of our objects have been discovered, many of them below the surface. The existing races are not able to account for them, so we are forced to conclude that they were part of a culture which has failed to survive." . . . "What induced the immigrants to penetrate the interior is, I think, strongly suggested by the pestles and the mortars and their discovery in goldfields (and on pearl-beds). Many of them are eminently adapted for the purpose of crushing stone, and I feel strongly inclined to support the view expressed by the practical miners of the Yodda goldfield. The peculiar distribution of objects and the cultures I have associated with them, and also the general characteristics of the peoples of the interior, could have resulted from a series of prospecting expeditions into the interior by the immigrants and woolly-haired peoples of the lowlands ; a similar process of culture-distribution and fusion is in fact in operation to-day, as a result of the movements into the interior of white miners and their coastal labourers in search for gold." [2]

Mr. Chinnery has thus provided facts that are of extreme importance for the thesis that I am sustaining.[3] He makes it clear that the first food-producers in British New Guinea were gold-miners and pearl-fishers, who have left behind them traces of their presence in places where these things existed. His analysis of the culture of the peoples living in these regions shows what sort of cultural influence these old miners had. He is of the opinion that when these gold-seekers arrived they found only the nomadic hunters of negrito stock, and that they raised them in

[1] *Id.*, 280, 284.
[2] *Id.*, 280, 287. B. Thomson mentions gold on Sudest and St. Aignan in the Louisiades (i. 525, 530, 540).
[3] Sketch Map No. 7.

6

cultural level so that they now practise irrigation.[1] So, in yet another place, evidence has come to light to show the onward march of civilization in early times in exactly similar circumstances to those in which it is now once again moving up into the interior, namely, the search for gold. For long years the Japanese have worked the pearl-fisheries of Torres Straits, thus showing that the eastern nations of thousands of years ago could have been quite capable of coming there on a similar errand. In the region of the Carolines much pearl-fishery must have gone on in the past, and the Pelews and Yap are still important in that respect.

The history of the Pacific therefore seems to have been one of colonization by a highly civilized people who used stone and practised irrigation, desired pearls and pearl-shell above all things that the islands produced, and made their permanent settlement in places where the supplies of pearls and pearl-shell were most abundant. The Eastern Pacific, judging from the study of food-plants, must have been uninhabited by man until the pearl-fishers came in their boats, seeking here and there, testing every lagoon until they found what they desired. It is thus not remarkable that the Polynesians tell how their great hero, Maui, fished up the islands one after another with his pearl-fish hook. In all parts of the Pacific this tale is told ; and, if the real reason of their search was the pearl, if they actually made the islands inhabitable, its wide distribution is explained—it has an historical basis.

(iii) INDONESIA

In " The Megalithic Culture of Indonesia " I argued that the search for valuable substances led the people of the archaic civilization to the East Indian Archipelago.[2] The discussion in that book was confined to certain places. Now that the basis is widened, it is necessary to make a broad survey of the Archipelago, and to determine what was the most striking object that could have attracted the men of the archaic civilization.

The study of ancient Chinese records throws much light on the early civilization of the regions surrounding that country. The Dutch scholar, Groenenveldt, published in 1877 extracts from Chinese sources which throw a flood of light on the commercial relationships of the East Indian Archipelago just after the beginning of our era, and show that the natural products of that region were then being actively exploited. Indian merchants must have visited the archipelago long before that time, and the

[1] An illustration that can be added to those discussed in Chapter II. This conclusion is in entire harmony with my own as to the cultural conditions of the outlying parts of the region before the coming of the archaic civilization.

[2] On the authority of ten Kate, I noted that Sumba, so famous for its megaliths, was an "Island of Gold." I understand from Heer Kruyt that the island probably never contained any gold. The question of the settlement of Sumba must therefore remain open. The island has always been famous for its sandalwood, so beloved of the peoples of India. I have no record of any pearl-fisheries round its shores.

lure would be the gold, tin, pearls, sandalwood, spices and other treasures for which it was renowned. Since two great peoples were exploiting this region, it is reasonable to conclude that others were on the same errand before them, for active trade has existed in the Indian Ocean from the beginning of the fourth millennium B.C. Sketch Map No. 8 shows that pearls form by far the most obtrusive possible cause of the settlements of the people of the archaic civilization. The settlement of Java certainly seems to have been due to their presence. The island contains little, if any, gold,[1] but its shores are rich in pearls, and, near Batavia, purple shells exist. It is therefore quite in keeping with what has been learned of America and the Pacific, to find that the settlements of the archaic civilization in Indonesia agree so closely with the pearl-beds.

Other factors have helped to determine the choice of settlement. In Central Celebes a considerable amount of gold is washed from the gravels of the rivers, and Heer Kruyt tells me that the distribution of the remains of the archaic civilization agrees with that of the gold.[2] In Timor ancient copper mines have recently been discovered in places with ruins.[3] In Sumatra the earliest settlements, those of the people responsible for the stone images of the south-west, may have been the result of the search for gold; for there are some ancient mines in the Redjang-Lebong goldfield, the only one " certainly known to merit the application of modern methods." [4] It is noteworthy that a Phœnician script is in use in the Redjang district.

Not only were people from India and westward exploiting the wealth of Indonesia at an early date, but the Chinese also took a hand in the game.[5] " In the south-west of Borneo there are traces of very extensive washings of alluvial gravels for gold and diamonds. These operations were being conducted by Chinese when Europeans first came to the country; and the extent of the old workings implies that they had been continued through many centuries." [6] The Chinese also had a colony in North Borneo. It has already been seen that the Kayan have raised the nomadic food-gatherers of the centre of Borneo to a higher cultural level. But, as is known, they were preceded in the centre of the island by Hindus, who left behind them carved stone bulls. These people were evidently on the same errand as the Chinese, for the images lie on the banks of rivers in whose gravels there is gold.

The Malay Peninsula contains numerous remains of antiquity,

[1] See discussions in the Natuurkundig Tijdschrift voor Nederlandsch Indie on the reported presence of gold-bearing sand between Tjilatjap and Noessa-Kambangan (1855, p. 188; 1859, 380): also in dessa Melihan of Kota-Kedirie (1861, 489, 515). But, in any case, the country contains but little gold.

[2] He promises, in his forthcoming work, to publish distribution maps.

[3] Kruyt ix. 784. van Es suggests that the old copper mine at Tanini was the work of Europeans.

[4] Maclaren 298. [5] Cole 21. [6] Hose and McDougall I. 17.

not in the form of temples, but of ancient mines, the technique of which testifies to a high civilization.[1] Many stone implements have been discovered in this region, for example in Perak ; none of them, so far as I am aware, are paleolithic ; they are all of polished stone. We are told that " the multiplicity of the types of stone implements found in Perak shows that the users of them must have been comparatively in a high state of civilization " ; further, that " the people, whoever they were, who employed them, were settlers from some other locality who on arrival had reached the second stage of the stone age." [2] A stone implement was found by a native 3 ft. deep in the alluvial soil of a tin-washing.[3] In Pahang there are remains of unknown strangers. One writer states that he found some stone implements in this State. " The rudest implement was found by myself at the bottom of an alluvial gold-mine in the Tui Valley in Pahang, and it had not been disturbed in its position when I found it. It lay in a deposit of gravel or crystalline limestone rock, and over it had been a deposit of gravel and clay 43 ft. thick . . . the implement must be of very great antiquity." In this same region of the Tui Valley have been found some stone rings, whose use and makers are entirely unknown. " Neither Malays nor Chinese in Pahang have any reasonable theory of the origin or possible use of these things, and it seems very improbable that the rings could have been made by either of these peoples." [4] There are other signs of an alien people in this State. As Sir Hugh Clifford says, " The recent discovery in the Malayan State of Pahang—the home of apes and ivory and peafowl—of immense gold-mines of very ancient date and of a workmanship that has no counterpart in South-eastern Asia, supplies an ample reason for the designation of ' golden ' so long applied to the Chersonese. Here, hidden away under the shade of the primeval forest, are excavations which must have yielded in their time tons of the precious metal . . . of the race that worked them, of the slaves who toiled and suffered and died therein, we to-day possess no clue, for this, the story of the earliest exploration of a portion of South-eastern Asia, is lost to us for ever." [5]

Colonel Gerini, in his studies on Ptolemaic geography, has a fascinating note on the gold-mines of the Malay Peninsula that I cannot resist quoting in full. " Gold," he says, " is found in considerable quantities, either disseminated in quartz reefs or in alluvial deposits, especially about Gunong Ledang or Mount Ophir, to the east of Malacca, where it was worked till 1817 by Malays ; on the upper waters of the Muar River and its tributary the Gemencheh (Chendras and other mines N.N.E. of Malacca town) ; in Upper Perak at Ayer Tawar, Busong, and Belum of Balom mines, of which last McCarthy says (' Surveying and Exploring in Siam,' p. 16), ' *We saw traces of ancient gold-*

[1] Sketch Map No. 8. [2] Wray 44. [3] Hale.
[4] Man, 1904, 34. [5] H. Clifford 13.

mines, gigantic workings, abandoned no man knows how long ago.'
On the east coast of the Malay Peninsula we need not mention its
frequent occurrence in Pahang (on Lui, Lipis, and Jelei Rivers);
in Kelantan (Galas and Pergau Rivers); and in Legeh or Rangeh
(upper waters of the Tanjung Mas and Telubin, and Tomoh dis-
trict). But it is of paramount importance for ethnological
science to call attention to the fact that most of the gold-mines
now being developed in Pahang through European enterprise
were originally opened at apparently a very remote age by men
of an unknown race, whose workings, of which evident and in-
numerable traces still remain, have rightly been styled ' wonder-
ful ' by the Europeans who first visited them (see Denny's
' Descr. Dict. of Brit. Malaya,' pp. 265-6). The chief of these
formerly exploited mines are Raub, Punjum, Selensing, Tui, and
Kechau, the Selensing being one of the most marvellous. It is
situated in a small valley surrounded by low hills, which in some
forgotten period must have been the scene of very extensive
mining operations. The surfaces of these hills are honey-combed
with perpendicular shafts, circular in shape, which in some
instances penetrate to the water-level below the surface of the
valley, a depth of considerably over 100 ft. (Denny, *op. cit.* p.
266, speaks of pits over 160 ft. deep extending for miles.) Many
of these pits are placed so close together that a wall of rock not
more than 2 ft. thick separates them one from another. The
antiquity of these workings is attested by the apparently virgin
forest which clothes the hills in which they are situated, large
slow-growing trees being in some instances found with their
roots centred in the sides of the shafts. . . . No clue has yet
been obtained which might serve to indicate the race to which
these miners belonged. The mode of mining employed by them
differs radically from that in use among the Chinese, and the
Malays possess no tradition on the subject. . . . Whatever the
race may have been, it is evident that it must have attained to
a considerable degree of mechanical skill, and presumably to a
fairly high degree of civilization; and yet, from an examination
of the excavations, one is led to believe that the race which mined
them must have been of a somewhat more diminutive stature
than either the modern Malay or Siamese. From the appearance
of many of these workings, it would seem that probably the work
of mining was suspended suddenly and never resumed, possibly on
account of war, an epidemic, or some other public calamity
(H. C. Belfield's ' Handbook of the Federated Malay States,'
London, 1902, pp. 127-8). As for myself (Gerini), I can add that
traces of similar old workings have been noticed, not only in
connexion with gold, but also tin mines in various parts of the
Peninsula; neolithic implements, such as celts, axe-heads, etc.,
being found in the ancient timbered drives or tunnels. This has
been the case, for instance, in Perak. Since A.D. 1516 Barbosa
speaks of a gold-mine lying abandoned in Pahang (Ramusio,

vol. i., fol. 318 verso). What, therefore, was the race that opened
these mines ? Evidently the same that built those wonderful
monuments in Kamboja—the race of Fu-nan, now still represented
in the Malay Peninsula by the Sakai and allied tribes. However,
this race, as in Kamboja, no doubt did only the manual labour.
But the intelligent mind that planned, directed and superintended
must have been, as there, Hindu, or shall we have to assume that,
in the case of the most ancient of these mines, where neolithic
implements occur associated with the workings, the directive
mind was Phœnician ? This is by no means improbable . . .
(for) . . . Phœnician influence once undoubtedly (as we have seen)
extended as far as Sumatra and the Malay Peninsula. . . ." [1] It
is difficult to write about such happenings as these without
spreading exclamation marks all over the page. To find immense
workings, dating from the unknown past, in places which till
recently have been the happy hunting-grounds of nomadic hunters
of the type of the Semang and Sakai, is to experience a shock,
and it is to be hoped that the effects of this mental shock will be
permanent. Apart from these nomadic peoples, aboriginal in
nature, there are only in this region tribes of Malay origin, who
cannot have been there for many centuries, certainly not by
thousands of years as long as the old workings. So, once again,
the first civilized peoples to arrive in an outlying region were
evidently gold-miners, who found themselves in a place tenanted
only by nomadic hunters and food-gatherers. [2] These people
were, as far as their mining activities are concerned, fully our
equals, when their difficulties are realized. With regard to the
rest of their material culture, it is hard to speak, for they evidently
made no permanent settlements, but, like the Phœnicians in the
districts of Sumatra, have left haphazard traces of their presence.
These people evidently were not colonists ; they were exploiters,
simply bent on getting all the gold and tin that they could, and
then departing. They were different from the Hindus who
followed them and inspired civilizations in Cambodia, Java and
elsewhere. They were the pioneers, who spied out the land, and
it was left for later comers to carry on the work if they could.

Turning now to the coast of this district, it is noteworthy that
the Mergui Archipelago is important on account of its pearls,
which are fished for by the Selung, a people who will play a
part in the next chapter, for they speak a language of a family
that has branches from India to Australia. [3]

(iv) INDIA

An important contribution to the present discussion has been
made by Major Munn, Inspector of Mines to the Nizam of Hydera-

[1] Gerini ii. 477.
[2] Yet another instance of the sort discussed in Chapter II.
[3] H. W. Smyth 522. He also gives an account of the tin-mining industry.
Pearl shell is also found in the Andamans.

bad, who in 1918 presented a paper to the Manchester Literary and Philosophical Society that will serve to lay the foundations of the study of the prehistoric archæology of Southern India. He claims, in that paper, that the dolmen-builders of the Deccan were mining for gold, copper, iron, and diamonds. He says that the two districts where the dolmens are thickest, Bellary and Dharwar, " are riddled with old workings for gold, copper and iron." In the Bellary district 2,127 dolmens have been reported.[1] He asserts that " The area covered by the Dharwar Schists,[2] not only in Hyderabad State, but from Shorapur in the north, to the Wainad in the extreme south of India, is everywhere pitted with the remains of ancient gold-mining, and, as far as I personally have seen in Hyderabad, around or in the vicinity of these workings, dolmens and circle cairns are to be found, and in Dharwar and Bellary even greater quantities are reported." [3] In Hyderabad the memory of these ancient mines is entirely lost, even in the folk-lore. " It was, in fact, not until 1888 that these old gold-mines were rediscovered, and the early efforts of the explorer were watched with intense ridicule by the local Brahmin —who never had had clear proof of the Sahib's madness. The difficulty which attended this prospecting was accentuated by the fact that all the workings had been completely filled up, and practically obliterated by the so-called black cotton soil, an alluvial resulting from the decomposition of the Deccan Trap. So that the surface indications were most deluding, and consisted of typical auriferous blue quartz, and the remains of old metallurgical appliances on the adjacent hard trappoid rock. Everywhere cup-like hollows, undoubtedly nothing but small mortars found in the rock where the gold quartz was pounded with stone pestles, and occasionally small crucibles have been found which, on crushing, gave an assay for gold. Whether the miners possessed the knowledge of amalgamation is a moot point.

" In the Hutti gold mines, discovered by Mr. F. W. Grey, we have the most extraordinary evidence of the skill of these ancient workers. There was little surface evidence at Hutti—a slight series of depressions—and here and there a few splinters of quartz which gave an assay—and the usual marks of crushing on the hard trappoid rocks near the Hutti nullah. Cross-cutting exposed a long series of workings which were not bottomed by means of a small exploratory shaft. The Company was formed and deeper mining on a larger scale was undertaken, but the first attempt failed to bottom the old workings. Finally it was proved that the ancients had excavated all payable quartz to an unparalleled depth of 640 ft. . . . Sufficient evidence was found to state that the quartz reef was extracted by fire-setting—and after it was loosened was gouged out by iron-shod wooden levers. A great amount of timber had been employed ; one piece might have been a windlass and marks on the ' hanging-wall ' suggested the ore

[1] Munn 1. [2] See Sketch Map No. 9. [3] Munn 5.

was raised by means of ropes. It was probably water that finally stopped the old workers from going deeper, for at 640 ft. a large quantity of broken 'chatties' were found, which suggested heavy bailing. No such instance of perseverance and skill has so far as I know ever been discovered in the other ancient mining centres at Kolar, Wainad, Dharwar and Anantagiri. The development of the mine must have taken a considerable period and employed a great number of people, not only in the actual mining, but in the crushing of the resulting ore." [1]

As regards copper : " The copper-mining in Hyderabad State in and around Chintrala is certainly very early, and, as I have already mentioned, so intimately associated with dolmen remains that, even in 1908, I had connected the two things together and never found them apart." [2]

Major Munn makes some important remarks about the iron workings of the Deccan. Unless anyone has visited Hyderabad State, or in fact Southern India, he cannot get even a slight idea of the abundance, the extent, or the pureness of its iron ores. No section of the geological sequence exists in which iron does not occur. In the Archæan, magnetite most frequently occurs in almost unparalleled magnitude, whole hills and ranges being formed of the purest varieties ; specular iron and red hæmatite are also found. The schistose area contains interbedded layers of magnetite and hæmatite schists. The Purana Group contain veins of limonite and bedded magnetite. Nearly every group of rocks in the Gondwana system, save the bottom glacial beds, contain one or more of the ores of iron, in greater or less quantities. The disintegration of the Deccan Trap supplies rich pockets of magnetic iron sand that glisten in the beds of every stream that traverses that area. Lastly the laterite is noted for its richness in this metal. " Each and all of these ores have been used for smelting iron by the natives. In this area iron has been known from earliest times, and the unintentional manufacture of steel practised." [3]

Major Munn contends that the use of iron was discovered in India by the builders of the megaliths. These people worked iron, so his contention is doubtless sound. From the days of the archaic civilization the working of iron has doubtless surpassed in importance that of the other metals. The working of gold died out at a very early date in the Deccan, the old mines being abandoned ; but the working of iron has persisted until this day among the natives.

The examination of the Pueblo Region of North America showed that modern people have constructed their railways through regions full of ruins, even in the case of branch lines. In India the railways of Hyderabad and the country to the south seem to have been built to serve regions full of valuable raw materials, such as gold, iron and copper. This is made clear by Sketch Map

[1] Munn 6–7. [2] *Id.*, 9. [3] Munn 9.

No. 9. Doubtless economic motives induced Europeans to construct railways in some places rather than in others. For instance, they would have made railways in Travancore to a greater extent if they had been needed for transportation of raw material. But that region is singularly deficient in minerals of all sorts, as is evident from a perusal of the work of La Touche. In more than one instance branch lines run up into districts that possess signs of occupation in the days of the archaic civilization. Sketch Map No. 9 shows the railway system, the deposits of iron, gold, copper, and so forth, and the distribution of settlements of the archaic civilization. If the reader will follow the course of the railways, he will notice the extent of the correspondence, which extends even to the cases of branches to Ootacamund, southwards from Bellary, to Kudligi, and from Bangalore to Mysore.[1] These correspondences entirely support the contention of Major Munn, that the builders of megaliths, and thus the people of the archaic civilization generally, settled in places where they found raw materials for their industries. In the beginning it probably was the presence of pearls on the coast and gold in the interior that attracted them. Once the use of iron was discovered, the course of events took another turn, and the native population took it up with avidity. The people of the archaic civilization made implements of polished stone, especially of trap rocks, diabase, diorite, and so forth. This industry has evidently been responsible for one series of their settlements, that of Kathiawar, which are situated near a series of trap rocks that they particularly prized. These sites presumably were those of implement factories.[2] This relationship can hardly be doubted. Bruce Foote was aware of it, for he says : "The extreme rarity of trap dykes in the south of the peninsula may have been a *vera causa* of the rarity of neolithic remains in the regions south of the Cauvery, while it is certain that in the northern parts of the Deccan Plateau, where neolithic remains most abound, dykes of basaltic, dioritic, and diabasic traps are very plentifully distributed. This has reference to their war (*sic*) implements, as their axes are, as a rule, almost without a single exception, made of the trappoid rocks and especially of the finer grained varieties of these."[3] A complete survey, therefore, of

[1] This map is based on those of Bruce Foote and Munn. The distributions of gold, copper, iron and diamonds are derived from La Touche. The Dharwar Schist (gold-mining) area has been copied from Maclaren and Munn. Evidence with regard to remains has been derived from Cole 299 e.s. ; Fergusson 467, 472, 476 ; Lane Fox 60 ; "Imperial Gazetteer of India," XVII. 58, XVIII. 187 ; Rea i. 48, 49, 53, 57, 61, 63, 68, 70 ; Meadows Taylor i. 160 e.s. ; Walhouse 17 e.s. ; Westropp 55 e.s. It will be noted that for many years practically no work of this sort has been done in India. It is to be hoped that the active archæological societies now springing up in various parts of India, in Hyderabad, Chota Nagpur, Madras, Calcutta, will soon collect the necessary data.
[2] Foote ii. 146 e.s., 151–52. See Sketch Map No. 15.
[3] Foote ii. 36.

India will have to take account of the sources of the materials of which the polished stone implements were made.

Bruce Foote gives evidence of the working of copper mines by the people of the archaic civilization. He speaks of pottery from an old copper mine on the left bank of the Kistna River near the centre of the south to north reach of the river south of Muktiala in the Kistna district. The vessel was of polished earthenware, dark red in colour; with it were bowls and dishes of iron-age type.[1] This is proof that the builders of megaliths were working copper mines.

Sketch Map No. 14 suggests that communities interested in the getting of gold and the working of iron will be determined in their choice of situation by the presence of these. For the people of the archaic civilization have left their remains in regions where gold, copper and iron abound. The distribution of megalithic monuments in this region, whether the work of the people of the archaic civilization, or of existing peoples, also supports the same thesis. For the great centres of dolmens are on the banks of the Subanrika River, " the streak of gold," as its name states.[2]

In Assam, again, settlements of civilized peoples have been determined by the presence of desired substances, for the ruins of vanished civilizations mentioned by Colonel Shakespear are close to railways and in districts producing gold and iron.[3] This betrays the existence, in the minds of the former people, of needs similar to those of modern civilized men.

The late Mr. Vincent Ball, in an article on the distribution of gold in India, says : " Gold-washing, as practised in India, affords an example, I believe, of human degradation. The colonies of washers who are found plying their trade in most of the areas where, geologically speaking, the occurrence of gold is possible, must be regarded as the remnants of a people possessing special knowledge : [4] for although the former may have some acquaintance with the appearance of the rocks in the neighbourhood of which gold occurs, so far as I could ascertain from a close examination of the operations of two gold-washers who were in my

[1] B. Foote ii. 129.
[2] " Imperial Gazetteer of India," XXIII. 114. The material for the Map is derived from La Touche, Maclaren, Lock and Ball (ii. 241–2 ; v. 170 e.s.), for gold, copper and iron. For remains, information has been collected from Anderson (347) : Ball (i. 128 ; iii. 143 ; iv. 177 ; vi. 208 ; vii. 268 ; viii. 123 ; ix.) : C. Brown (i. 127 ; ii.) : Dalton (112–15, 119) : Olden : Roy (v. 229, 231 ; vi. ; vii. 485) : J.B.O.R.S. II. 386.
[3] Shakespear ii. 3, 9. See Sketch Map No. 15.
[4] He adds a significant footnote, which is well worth quotation. " I have often been struck with the traditional knowledge of such subjects as Materia medica possessed by individuals of semi-savage tribes who never seem to discover a new idea for themselves, nor to modify in the slightest degree, when uninfluenced by superior races, their methods of performing any one single act in their domestic economy." This is an excellent support for one of the main theses that I am sustaining, namely, the entire dependence of present-day communities on the archaic civilization for their culture.

INDIA AND BURMA

service for about three months, such acquaintance, if possessed, is rarely availed of. Indeed, I doubt if they ever look upon the rocks as being really the source from whence the gold has been derived. They know of its occurrence in the sands and alluvial soils, but whence it ultimately came from they do not trouble to consider.

" But it cannot always have been so, for their earliest progenitors must have ascertained the existence of the gold by the application of experimental research in localities where, from theoretical considerations, they believed it to exist.

" It is scarcely possible that the non-gold-producing areas in which the Deccan Trap or basalt and the rocks of the Vindhyan formation prevail, and which aggregate a total area of about one-fourth of the peninsula, were ever systematically prospected, and for this reason, if for no other, that the washers, if they were comparable to those of the present day, could not have devoted months and years to the exploration of, for them, barren tracts, simply from the fact that they could not subsist under such circumstances.

" By what means, soever, they were led to select and settle in these gold-producing tracts, it is certain that within such limits a process of segregation has been going on towards the richest points.

" In a part of Western Bengal I found that generations of washers had demarcated limits within which washing was remunerative, and these limits corresponded in a striking degree to the well-defined boundaries between two formations—the metamorphic and the sub-metamorphic. In the area occupied by the former, gold was not absent ; but its abundance, as contrasted with that in the latter, I ascertained, by two independent methods of calculation . . . was in the proportion of 1 to 3. Hence, as the washers only managed to eke out a bare subsistence in the sub-metamorphic area, they confined their operations to it." [1]

These remarks of Mr. Vincent Ball show that the practice of gold-washing inevitably tends to restrict the gold-washers to certain geological formations. Sketch Map No. 15 shows the present-day distribution of the Gonds, themselves assiduous gold-washers, and suggests that their movements have been influenced in the way stated by Mr. Ball. The presence of certain desires in the mind of men results in a distinct geographical distribution which corresponds with certain geological formations. [2] The distribution is the expression of the desire ; it has not given rise to it. For, as Mr. Ball insists, the practice of gold-washing must have come down from days when men deliberately sought the gold in situ, and consequently tended to segregate in places with stores of gold.

[1] V. Ball x. 259–60.
[2] An exact confirmation of the thesis of my paper on the distribution of megaliths in England and Wales.

These remarks gain in significance when it is remembered that the Gonds still erect miniature dolmens, and thus show strong signs of continuity with the people of the archaic civilization. If the Gonds, as gold-washers, have segregated themselves on sources of gold, and perhaps iron, why should not the people of the archaic civilization also have done so ? The case of the Gonds also shows that gold-washing is carried on by people whose culture shows signs of direct influence of that of the archaic civilization. This is also the case with the Kurumbas, who, with the Moplas, are the chief native gold-workers of the Madras Presidency. Their gold-washing activities are supposed to date from 500 B.C. " During the inquiry carried out in 1831, Nicolson had discovered the remains of numerous old gold workings, made by a mining people known as Karumbara, along the outcrop of quartz reefs in the S.E. Wynaad." [1] The Kurumbas still erect dolmens, and to them are attributed those of southern India. The Khasi of Assam, also, who are noted iron-workers, erect many megalithic monuments. [2] But this relationship does not hold throughout, for I know of nothing to connect the Moplas with the archaic civilization, nor the Jalgars, the gold-washers of Bombay. [3]

The evidence in India bears out the contentions of Major Munn and myself, that the people of the archaic civilization were engaged in exploiting the wealth of India, and that their settlements were distributed so as to be near the sources of supplies of gold and other precious substances, and of humbler materials for everyday requirements. Certain native tribes, whose culture shows strong traces of the influence of the archaic civilization, have carried on the getting of gold, and have tended to segregate themselves on gold-bearing geological formations.

It is not necessary to insist on the fact that the great civilizations of Egypt and Elam, the earliest known in the region under discussion, were engaged in exploiting various sources of wealth. The Egyptians were, at an early date, seeking copper and turquoise in Sinai, [4] gold in Nubia, and sending out expeditions to the land of Punt for all manner of products. [5] The significance of this fact will be pointed out in the chapter on Egypt.

On the basis of this survey I suggest that the process of settlement of the communities of the archaic civilization was purposive, that these people had desires that they sought to satisfy, even when it caused them much inconvenience. Such a conclusion, I am aware, runs counter to the doctrines of the modern school of geographers, which lay such stress on climatic and other geographical conditions. My theory amounts to asserting that what is in the minds of men counts more than anything else, and that if the desire be but strong enough it will be satisfied, if that be humanly possible. This is in accordance, as I insisted

[1] La Touche II. 208. [2] La Touche II. 236. [3] Ball x. 266.
[4] Peet 21 e.s. [5] Dunn 207 e.s.

in the beginning of the chapter, with what we know of ourselves and our fellows. Therefore, if anyone wishes to advance theories of " Climatic Control " and so forth, he will have to construct a better explanation of the distributions of the settlements than that which is now in possession of the reader.

Right to the boundary of the archaic civilization, and occasionally beyond it, traces exist of former mining activities. Beyond the boundaries are great stores of precious substances. Why did not the ancients exploit these stores that lay so close to hand ? To answer this question it is necessary to discover also why they did not finish their work in places such as California, Sumatra, Borneo, New Guinea, the Malay Peninsula, Hyderabad, and Chota Nagpur. The ancient miners abandoned works which were left for many centuries, until the coming of the European. Evidently something happened that stopped the mining activities of the ancients, and prevented them from extending their operations. The story of this great catastrophe will be told in part in this book, but as yet the full extent of the tragedy is not known. When the world is surveyed at the present time, in the places where, in former days, much activity must have existed, there are now only peoples of a low stage of culture entirely ignorant of the wealth that lies at their feet, or, if not ignorant, at least indifferent. As the story develops, it will be seen that the ancients did penetrate Australia, but apparently had to leave the country in a hurry before they had had time to exploit its wealth. Something happened, perhaps an incursion of war-like people into British New Guinea, or some convulsion farther west, and they disappeared, so that all we know of them is derived from the Australians themselves. The traditions of the Australians tell of these strangers, and of their influence upon the natives whom they found wandering about the country in a state of extreme cultural degradation. When the archaic civilization broke up, as it will be seen later it did, not only were irrigation, stone-working and image-carving given up, but metal-working and mining were abandoned, and the land often given over to people who cared for none of these things. Whence came these barbarians ? That story will have to be told. But it will be well to try to get another view of the archaic civilization before plunging into the description of its relationship to those that followed.

CHAPTER VIII

POLISHED STONE IMPLEMENTS

THE discussion of the last chapter has introduced a complication. Traces of ancient gold-mines have been found in places devoid of obvious remains of the archaic civilization, such as stonework, carved stone images, irrigation systems. In the Malay Peninsula are ancient gold-mines whose workers have long since disappeared ; in the Redjang district of Sumatra some unknown people have been at work on the goldfields, and these people may be responsible for the stone images that are found in the south-west districts ; in California miners have been at work in places devoid of ruins.

If the people of the archaic civilization were decided in their movements by the search for gold, pearls, etc., then we must try to account for such old workings as these. They may have been the work of some European people of the Middle Ages, say the Portuguese or the Dutch ; on the other hand, they may have been the work of the first civilized people that came that way, and thus date back thousands of years to the days of the archaic civilization. If they are the work of people of the archaic civilization, then the possibility will have to be borne in mind, that these people may have influenced native communities among whom they have left none of the cultural elements chosen out as indicative of their presence. If the study of some less obtrusive cultural element than those already chosen can show that the old gold-miners of the Malay Peninsula, and elsewhere, can be included among the people of the archaic civilization, then it may be possible to link up other peoples, such as the Australians, with those already considered ; the study of gold-mines may show that the cultural elements chosen for discussion are not enough to afford more than a limited view of the activities of the people of the archaic civilization : it may be necessary to use some cultural elements of wider sweep than those already considered.

Fortunately, such an element is to hand. To determine it, the account of the old gold and tin workings of the Malay Peninsula is of crucial importance. For, in these mines, as well as in the tin washings, polished stone implements have been dis-

94

covered :[1] the same discovery has been made in British New Guinea and in North America.

In India hardly any doubt can be expressed regarding polished stone implements : they are invariably related to the archaic civilization, and their manufacture has long been abandoned. Their geographical distribution in India, Assam and Burma, as is shown by Sketch Map No. 15, is such as to associate them with bygone mining activities.[2] In Assam they are found in the districts that produce gold, iron and other desired substances. In Burma their distribution also suggests that their makers were intent on the search for gold and tin. In the Irrawaddy basin they seem to be in direct relationship with gold-washing ; for in this stream gold is said to be rare below Prome ; so are polished stone implements. Such implements are also found in the tin-producing regions of Burma.[2]

In Indonesia, as is shown by Sketch Map No. 8, the distribution of polished stone implements agrees so closely with that of pearls and gold, that little doubt can exist as to the intentions of their makers. It has already been seen that the gold and pearl localities were visited by the people of the archaic civilization. Since the makers of polished stone implements have visited the same localities, and have long since vanished, they presumably must be equated to the people of the archaic civilization.

Farther east an interesting contrast exists between New Guinea and Australia. The polished stone implements of New Guinea are the work of the vanished gold-miners and pearl-fishers ; and the existing natives know nothing of the use of such implements. The Australians make them to-day ; so, although far below the natives of British New Guinea in culture, they display an apparent close connexion with the civilization of the old gold-miners.

This discussion brings us face to face with one of the most important problems of modern ethnology. The work of linguists during the past twenty years or so has revealed a family of languages spoken by peoples ranging from the Himalayas, through Further India and Indonesia, right out into the Pacific, and including Australia. This Austronesian group of languages, as it is called, is spoken by people of the Panjab, the Santal Parganas, Chota Nagpur, Orissa, Chattigarh, and north-east Madras in India, the languages of these peoples being termed Munda ; it is spoken in Assam in the Khasi and Jaintia Hills ; in Burma by the Palaung, Wa and Mon or Tailing ; in the Mergui Archipelago by the Selung, and in the Nicobars ; in Indo-China it is spoken along the Mekhong River, and in Cambodia the national

[1] See p. 84 : Pahang (Man, 1904, 34).
[2] Based on Sketch Maps Nos. 9 and 14. Additional information is derived from Ball iii. : Theobald (ii. 155, 169, 170, 171 ; i.) : and from P.A.S.B. (*1865*, 122 ; *1869*, 181 ; *1870*, 220–21, 267–68 ; *1871*, 83 ; *1872*, 41, 46–7, 136 ; *1875*, 102, 158). Information with regard to gold and tin is derived from La Touche, Lock and Maclaren.

language, Khmer, belongs to it; the Semang and Sakai of the Malay Peninsula belong to this linguistic group; and, finally, there are the Malayo-Polynesian languages and some of those of Australia.[1]

The cultures of people with Austronesian languages often possess palpable traces of contact with the archaic civilization: the Khasi of Assam still make megalithic monuments;[2] they erect standing stones in memory of their men, and dolmens for the women: the Mundas of Chota Nagpur are associated with megalithic monuments.[3] On the other hand, it must be remembered that not all the peoples of India who erect megaliths speak languages of this family. The Kurumbas of North Arcot in Madras, who still make dolmens for their dead, speak a Dravidian language.[4] The Polynesians, however, formerly erected megaliths, and their language is of this family. But many peoples speaking these languages show in their culture little or no obvious traces of contact with the archaic civilization; such are the Sakai and Semang of the Malay Peninsula, the Nicobarese and others.

Much discussion has taken place as to how peoples with diverse cultural associations, and of different physical types, came to possess languages of a common family. The close association of the Mundas, Khasi and other with the archaic civilization suggests the cause of the linguistic unity; but from the point of view of megaliths, irrigation, pottery-making and the carving of stone images, this hypothesis breaks down in the case of the peoples of the Malay Peninsula and the Australians, who have none of these things. It is at this point that polished stone implements come to the rescue.

Sketch Map No. 15 shows that polished stone implements exist in places where Austronesian languages are spoken.[5] If the makers of these implements were gold-miners, pearl-divers and so on, who made settlements in certain places, these settlements being permanent or temporary, according to the circumstances; if, further, they spoke Austronesian languages, or a language that gave rise to this group, then an explanation is forthcoming of the spread of this group of languages. This view has already been expressed: " Archæologists are of the opinion that the various stone implements which are found from Chota Nagpur on the west to the Malayan Peninsula on the east are often so similar in kind that they appear to be the work of one and the same race. Attention has also been drawn to analogous customs found all over the area, and to other coincidences. . . . Philological reasons can also be adduced to support the supposition of a common substratum in the population of parts of Nearer India, Farther India, and elsewhere."[6] The explanation of the

[1] Cf. P. W. Schmidt: Grierson: Kern iii.: India Census i. 250 e.s.: Roy i., iv. e.s., 18 e.s. [2] Gurdon. [3] Roy i. [4] Thurston ii. 141 e.s.
[5] Distribution of Austronesian Languages is derived from the Census Report i. [6] Grierson ii. 1.

phenomena would be that the original makers of the celts spoke the language, and that, wherever they went, they imposed it on the natives. Who the celt-makers were in any particular instance does not matter at present. The essential point is that the establishment of the Austronesian languages and their association with polished stone implements enables the student to form a mental picture of the original civilization of the vast region stretching from India to the farthest confines of the Pacific. Whether this civilization was carried by one race, or whether it was handed on from one people to another, need not concern us.

In India, Farther India, the Malay Peninsula and Indonesia, the making of polished stone implements is, generally speaking, a thing of the past. It is necessary to account for the disappearance of this craft after the break-up of the archaic civilization. If the contentions of Major Munn be sound, the people of the archaic civilization discovered the working of iron in India, and transmitted this craft to the natives ; which suggests that the natives have kept on that element of the culture of the archaic civilization, and ignored the manufacture of the stone implements, which is but natural, since iron-working would be far easier. Similarly, in Indonesia, peoples such as the Kayan of Borneo and the Toradja of Celebes have continued to work iron, but do not make stone implements.

Although the continuity between past and present is broken in the case of the manufacture of the implements, some valuable evidence is to be gathered from their present occurrence. In Borneo the natives possess polished stone implements which they hang up in the galleries of their long houses. These axes were not made by them, and are regarded with superstitious awe.[1] Mr. Ivor Evans found polished stone implements in the Tempassuk district of British North Borneo, all of which were got from the Bajaw or Illanun.[2] In this part of Borneo stone circles are found.

Recent work by Heer Kruyt has thrown more light on this subject; for he has found, in Celebes and Sumba, that the rulers preserve as their greatest treasures polished stone implements, or implements of bronze and copper of similar type that are no longer made, which have been handed down through the generations of their ancestors.[3] From Timor eastward a value is placed on old stone implements that the ancestors of the inhabitants brought with them from their homes in the west. In the Kolaka region of Celebes the chiefs, like those of Sumba, have implements that were given to their ancestors. Thus, although the manufacture of polished stone implements is no more in Indonesia, the implements themselves play an important part in the life of the present peoples.

[1] Hose and McDougall II. 11 e.s. [2] I. Evans i.
[3] Cf. Chapter XXIV.

The distribution of polished stone implements in Java and the islands to the east helps to clear up a difficulty encountered in the chapter on culture-sequences, that of the priority of the Hindu or the archaic civilization in Indonesia. Many polished stone implements have been found in Java, especially in the central and western parts.[1] Since the whole island was formerly ruled by Hindus, who did not use the implements, it follows that the makers must have preceded them. Polished stone implements are found also in the islands east of Java as far as Timor, that is to say, in the area which contains so many remains of the archaic civilization in the form of megaliths, irrigation systems and metal-working. This region is full of pearl-fisheries. Thus in a region of Indonesia where Hindu influence was very strong, evidence exists of the priority of the makers of polished stone implements.

The distinction between the people of New Guinea and those of Australia has already been noted. The implement-makers of New Guinea, the gold-hunters of the mountains, are gone, and the existing natives neither make nor use such implements. Over the boundary between food-producers and food-gatherers, that runs through Torres Straits, is a region where the implement-making industry is in full swing among people who do not practise agriculture, but some of whom speak Austronesian languages. Other evidence points to a connexion between the old gold-miners of New Guinea and the natives of Australia; for grinding-stones are found in Australia. " In Northern Australia and Riverina, where stones are indeed a luxury, hundreds of square miles being devoid of stone, some fine specimens of grinding-stones have been found, often one or more feet in length, usually of a close and hard-grained sandstone, and hollowed out by ages of use on one or both sides. These were undoubtedly carried hundreds of miles, and were possessions of considerable value. The pounding-stones, pestle-shaped, perfectly rounded or with one flat surface, are usually of hard, smooth stone, such as quartz, diorite, dense basalt, or limestone. Some of these artifacts were found beneath the surface—near Geelong, in the drift of an ancient water-course on the Barraboo Hills, flints and water-worn gabbro axes were found. In the gravel of an old river-drift near Barnon River there were discovered a gabbro axe, weathered basalt wedges, and a grinding-stone, the latter from an excavation made several feet near Barren River. Also a few years ago, a flint axe of old workmanship was obtained many feet from the surface during the construction of a well near Lake Counewarre." [2] What is the explanation of these facts ? If the presence of an Austronesian language, in a country outside India at least, is a sign of the influence of the archaic civilization, then it follows that the people of the archaic civilization must have visited Australia. Australia has much gold, and the implement-makers would surely

[1] Roulin 1285 e.s. : Brouwer 68 e.s. : Juynboll 45 e.s. [2] Daley 502.

have wandered about in search of it, while their mines of British New Guinea were being worked. The working of polished stone implements has died out in so many places that the possession of the craft must argue for a close association with the people of the archaic civilization; or, at least, for a connexion with them not interrupted by subsequent incursions of peoples with different cultures. It is well known that the subsequent history of New Guinea has been troublous; that of Australia must have proceeded uninterruptedly since the natives first made these implements. So, if the Australians began to make implements under the influence of the men of the archaic civilization, their culture may possibly show signs of that influence which would be absent among the peoples of India, Burma and Indonesia, except those speaking Austronesian languages.

The making of polished stone implements has been, at one time, widespread in the Pacific, invariably in those places possessing direct traces of the archaic civilization. They are often dug up in islands where they are no longer made : some mentioned by Guppy in San Cristoval of the Solomons are said by him to be of paleolithic type, and of origin unknown to the natives.[1] This is probably wrong, and they are more likely to be of neolithic type, that is to say, made by people with a culture similar to that possessed by the makers of the polished stone celts. In many places the manufacture of stone implements, especially of jade, obsidian and so forth, was carried on in historic times, as, for example, in New Zealand, New Caledonia, and so on. It is possible, even probable, that the people of the archaic civilization who visited New Zealand, and also the Chatham Islands, were attracted thither, among other things, by the presence of obsidian. A great trade formerly existed in the Pacific, in this stone being brought to islands, where it did not exist, by expeditions that went to places such as New Caledonia to get supplies.[2] It is easy to show that the use of obsidian by the Polynesians was not born of the presence of that stone, but was due rather to the fact that it was a custom derived from their ancestors. This is evident in the case of British New Guinea, where splendid implements of obsidian have been found that are not the handiwork of the present-day peoples, but are the relics of some people of the past, evidently those of the archaic civilization.[3] The obsidian is ready at hand for use, according to Professor Seligman, who says that : " Small fragments are found mixed with the shingle on which are built the coastal villages of Bartle Bay, an indentation in the large hollow of the coast which faces the d'Entrecasteaux group and constitutes Goodenough Bay. These fragments were until recently used for scarification for medical purposes, and the blocks from which they were struck were

[1] Guppy 77 e.s. He mentions implements in various islands.
[2] Brigham : Skinner 309 e.s.
[3] Chinnery : Seligman and Joyce 326 e.s.

stated to have been brought from Goodenough Island for this purpose ; but it was said that no larger fragments were in existence, that implements were never made of obsidian, and that no one had ever heard or thought of applying it to any use of this kind. At Wagawaga, in Milne Bay, fragments of obsidian, formerly used for bleeding and scarification, though less abundant, were not uncommon, and here they were said to have been obtained from a place called Hiliwau, described as near East Cape, where, according to a somewhat doubtful statement, obsidian boulders were found in the jungle. . . . But, again, it was denied that implements of obsidian had ever been made either at Wagawaga or elsewhere, and the same was said at Tubetube in the Engineer group, where the fragments of obsidian used for medical scarification were formerly imported from Duau, the largest island of the d'Entrecasteaux group. . . . Practically, then, fragments of obsidian have been found wherever search has been made in the south-eastern portion of British New Guinea and its archipelagoes, but nowhere, as far as our present knowledge extends, is there any legend or trace of a belief that it was ever worked to form such implements as are shown (in the accompanying plates)." [1] That is to say, people living in places where obsidian exists in a natural state, and where obsidian implements of unknown origin are found, are ignorant of the working of obsidian for implements. This goes to show that the Australians must have been in contact with people who made obsidian knives ; for they make in glass imitations of obsidian knives so exact that some attention is necessary to distinguish them from the originals.

If the argument be based upon the use of polished stone implements and obsidian knives, it would appear that the ancestors of the present-day Polynesians will have to be equated, culturally, to the ancient gold-miners of British New Guinea, and to the hypothetical people who taught the ancestors of the Australian tribes to make these objects. It is not meant by this that these various groups of people in possession of the archaic civilization were necessarily of the same race, but that they possessed cultures which, so far as the elements in question are concerned, were similar.

In North America the use of polished stone implements runs the whole gamut of culture, with the exception of the food-gatherers and some of the Indians who went out into the Plains in post-Columbian times to hunt buffalo. They occur in the earliest known settlements : at Copan, one of the first, if not the first, of Maya cities, a number of small polished stone implements have been found, made of basalt, diorite and flint, slightly wedge-shaped, flattened with a cutting-edge at one end and blunt nose at the other, in addition to rudely chipped implements which would have done for preliminary dressing of stone.[2] The work of Moorhead on Prehistoric Implements shows how widespread

[1] Seligman and Joyce 327. [2] Morley ii. 5, n. 2.

was the manufacture of implements and of polished stone obsidian in North America among the food-producing, pottery-making peoples. These are so similar in form to those of the rest of the world that no distinction can be made between them.

Attention has already been called to the fact that the peoples of Mexico and the surrounding lands, and those of the northern part of the continent, possess more than one cultural element in common, the fundamental element being that of maize-growing ; and use has been made of the common possession of these cultural elements to formulate a theory of development of civilization in that continent. The use of polished stone implements and of obsidian knives serves to bind together still closer the civilizations of the United States and those of Mexico and the Maya country. We may further say that it links together the whole region from America westward.

These results make it possible to predict what cultural resemblances should be expected between the various parts of the region, Egypt, India, Indonesia, New Guinea, Australia, Oceania, and North America. Egypt remained for thousands of years in possession of the fundamental elements of the archaic civilization, and in Nubia polished stone implements were made for many centuries.[1] In India the earliest food-producers, who irrigated, constructed megaliths and worked metals, also made polished stone implements, and thus will necessarily be nearer in culture to Egypt than their successors, who did not possess all these elements of culture. The Austronesian-speaking peoples who built megaliths would also be expected to approximate closest in culture, of the existing peoples of India, to Egypt. Farther east, in Indonesia, the conditions suggest a less close approximation to the archaic civilization. It would be expected that the existing peoples of New Guinea would be, in some respects, culturally more remote from the archaic civilization than the natives of Australia. The early Polynesians would be nearer in culture to the Australians and to the Egyptians than to their descendants in New Zealand, Hawaii and elsewhere. The peoples of North America, from their long-continued manufacture of polished stone implements, should also betray closer cultural resemblances to ancient Egypt and the Australians than to the later Polynesians, the present peoples of New Guinea and Indonesia and the later comers to India. That is to say, broadly speaking, the cultures of Egypt, of the megalith-building stage in India, of the Australians, of the megalith-building stage of the Polynesians, of the gold-workers of New Guinea, and of the peoples of North America should be similar ; and should differ from the later comers in all parts of the region.

[1] See p. 457 for a fuller discussion of this matter.

CHAPTER IX

THE SUCCESSION OF CULTURES

GIVEN that the first food-producing communities of the outlying parts of the region, that is, from India eastwards, were those of the archaic civilization, what is to be said of the existing communities, whose culture often differs markedly from theirs ? This question is of fundamental importance for the general theory of development of culture, and it must be faced squarely before further progress can be made.

I shall try to show in this chapter that the cultures of the later food-producing communities were derived, directly or indirectly, from the archaic civilization ; and that no evidence whatever exists for believing in an independent development of culture in any of the countries from India to America.

In the case of North America the conclusion of Chapter IV is identical with the thesis of this chapter. The evidence all favours the view that the cultures of the less developed peoples have been derived from those higher in the cultural scale. The fundamental craft of agriculture, founded on maize-growing, forms the foundation of this position, which apparently nothing can shake. I shall assume, until reason is forthcoming to adopt another attitude, that the civilization of the Maya country, Mexico and the United States is a unit ; and that complete continuity exists, each community having derived its culture from some other, the original source and fount being the Maya civilization of Guatemala and its neighbourhood.

With regard to the Polynesians : " The homogeneity of this race is a remarkable feature, scattered as it is over an extent of the earth's surface that in actual area equals—if it does not exceed—that occupied by any other race of like homogeneity. From Nukuroro and Leuanina Islands in the far north-west to Easter Island (Rapa-nui) in the distant south-east ; from Hawaii in the extreme north-west to New Zealand (Aotearoa) in the south-west, we find one people speaking dialects of one language, having practically the same customs and beliefs, and bearing so great an affinity in physique, colour and general appearance that it is difficult to distinguish the inhabitants of one part from those of any other." [1] Or, in the words of Elsdon Best : " How came

[1] Rutland iii. 14 : P. Smith vi. 9, 12.

the Hawaiian to speak of his old-time voyages to Tahiti, and relate the deeds of the ancestors of the New Zealand Maori ; the Samoan to relate his exploration of the Paumotus ; the Tongarevan to maintain his descent from immigrants from New Zealand ? Why do Moriori and Hawaiian claim the same gods ; the Tahitian describe voyages made to Aotearoa of the Maori ; and the Maori of these isles recount his ocean wanderings from Tahiti, Samoa and Rarotonga ?

" The answer to these queries is that all these widely separated peoples are descendants of common ancestors, of the Polynesian Vikings, of the Maori voyagers, the bold seamen who broke through the hanging sky in times long past away, who fretted the heaving breast of Hine-moana with the wake of their swift canoes, who ranged over every quarter of the vast Pacific, and marked off the sea roads for all time." [1]

The decisive proof of the unity of the Polynesian peoples is provided by their genealogies, carefully preserved, a knowledge of which is an essential part of the education of the upper classes. Anyone who had any pretensions to chieftainship whatever was supposed to know his family table for at least twenty generations. A comparative study of tables from New Zealand, Rarotonga, Tahiti, Hawaii shows that these peoples had many common ancestors, and it has been possible on this basis to construct a chronology of the Polynesian movements. [2] The neglect of, or perhaps, one ought to say, contempt for, native tradition, is a marked feature of modern ethnological study. Perhaps one day some one will study the causes of this attitude towards what many of the less advanced peoples consider to be their most precious knowledge. A tendency exists, in some quarters, to look upon the savage, as he is called, as a silly child, who has made up out of his head all sorts of fancies, among them tales about his origin. This attitude is found among ethnologists, and, consequently, among those who read their writings. Perhaps I may be allowed to quote an example, in which the Greeks, of all people, are put into the same class as children. " Most peoples have wondered, like children, how the world was made. When a little child finds something new and strange, he asks such questions as these : ' What is it ? ' ' What is it made of ? ' ' Who made it ? ' and ' What is it from ? ' Like children, the Greeks of old wished to know what the earth was, what it was made of, and who made it. Before they became wise and learned they made up a simple story about it." And so on. So long as this patronizing attitude is maintained towards those who live in other places, and in different circumstances, there is not much hope for any real advance in the study of early civilization.

The members of the Polynesian Society have now spent many years in collecting and studying traditions and myths, and this is what one of the foremost of these students says : " I would like to

[1] Best xii. 448. [2] P. Smith vi. 25, 28.

say, in my humble opinion the European ethnologist is frequently too apt to discredit tradition. It is an axiom that all tradition is based on fact—whilst the details only be wrong, the main stem is generally right. In this, local colouring is one of the chief things to guard against, and here the European ethnologist is generally at fault for want of local knowledge—at any rate when he deals with Polynesian traditions. No one who has for many years been in the habit of collecting traditions from the natives themselves, in their own language, and as given by word of mouth, or written by themselves, can doubt the general authenticity of the matters communicated. But it is necessary to go to the right source to obtain reliable information, and even then the collector must understand what he is about or he will fail.

" The men who really know the traditions of their race look upon them as treasures which are not to be communicated to everybody. They will not impart their knowledge except to those whom they know and respect, and then very frequently only under the condition that no use is to be made of them until the reciter has passed away." These traditions were holy things and any deviation from the truth brought down the wrath of the gods. " It is obvious from this, that traditions acquire a value they would otherwise not possess. The fear of the consequences arising out of false teaching acted as an ever present check upon the imagination." [1]

Anyone who has seriously studied traditions in conjunction with other social facts will bear out these remarks. Frequently they serve to throw a flood of light on dark places, and, if not forced to support any a priori view, but allowed to tell their own tale in their own time, they reveal the most unexpected results. In this inquiry much reliance will be laid on traditions, in conjunction always with other cultural elements. They will not be looked upon as products of imagination, or necessarily as attempts to explain ritual, but as something ranking as fact, to be studied as such.

It is commonly agreed by authorities that the Polynesian race came from the west, probably from India. This conclusion can be supported on many grounds. In the first place, people of Polynesian type still live in India and Indonesia. Mr. Hornell's monograph on Indian boat designs contains a photograph of a man of the Parava caste of Tuticorin, the fishermen of Southern India, which shows a pure Polynesian type. The Mentawi Islands, Halmahera, and other islands of the archipelago have inhabitants of Polynesian type.

The " Log-books " of the ancestors of the Rarotongans, Maoris, Tahitians, Paumotuans and so on, give some sort of account of the journeys of these wonderful travellers.[2] The earliest land mentioned is believed to have been India, which was left about

[1] P. Smith vi. 20–1. Cf. also Pargiter i., iii. : Tod.
[2] P. Smith vi. 108 e.s.

the year B.C. 450. A king who is said to have built a temple 72 ft. high, enclosed with a stone wall, and called Korotuantinim or " place of many enclosures." [1] It was built as a meeting-place for gods and men ; and here the spirits of the ancients after death forgathered with the gods. It was a ngai tapukaka, " a sacred glorious place," of great space within, and filled with many beautiful and wonderful things. Here were originated the different kinds of takuruas, feasts and games, by Tu-te-rangi-marama (the ruling king), to dignify the land. From Atia came the " trumpets, the drums, of two kinds, and the numerous ovas or dances. Here also originated the kariori or houses of amusement, singing and dancing, besides many other things and customs. Here was first originated the takuruatapu, or sacred feasts to the gods Rongo, Tane, Ruanuku, Tu, Tangaroa, and Tongaiti, and here also were the meeting-places of the great chiefs of that period—of Tu-te-rangi-marama, of Te Nga-taito-ariki, of Atea, of Kau-kura, of To Pupu, of Rua-te-atonga, and others, and of the great priests of old when they assembled to elect the kings, to meet in council to devise wise measures for men, slaves and children. These were the orders of men that lived in that land, and these were the people who spread over all this great ocean." The movement from India was caused by great wars,[2] and nothing is known until about the year B.C. 65, when mention is first made of an actual migration.[3]

In his monograph on Indian boats, Mr. Hornell makes some interesting statements about the Paravas, the " Polynesian " fisher-men of South India. He thinks that they migrated to India from Sumatra or thereabouts : " The Sumatran Polynesians would naturally land first in Ceylon, whence they appear to have passed to the south-eastern coast of India, and eventually up the west coast. As they spread they doubtless planted fishing colonies at favourable points, establishing there their peculiar boat designs. Such centres may well have included Galle, Colombo and Korkai, where the embouchure of large rivers makes fishing remunerative. Palk Bay and the Gulf of Manaar, with their wealth of food fishes and treasures of pearls and conch shells, would early attract the attention of the maritime new-comers, and it is not surprising that there we find the Polynesian boat forms in great variety, and, in common with peculiar Polynesian fishing devices, in continued high esteem by the local fishermen and divers." [4] Hornell quotes an important statement with regard to the Paravas by two Dutch officials who wrote in 1669 : " Under the protection of those Rajas there lived a people who had come to these parts from other countries—they are called Parruas—they lived a sea-faring life, gaining their bread by fishing, and by diving for pearls. . . . The pearl fishery was the principal resource and expedient from which the Parruas obtained a livelihood." These Paravas claimed con-

[1] *Id.*, 123. [2] P. Smith vi. 124–5. [3] *Id.*, 150.
[4] Hornell 230. On the other hand, Elliot Smith derives the Polynesian type from the region of the Persian Gulf.

nexion with the great Lunar race of Ayodhya or Oudh, before the war of the Mahabharata. [1]

The Polynesians moved out from India, and reached Oceania by way of Indonesia. Little is known of them during this period, but continual wars forced them ever onward, and nothing more is heard of them until they arrive in the Pacific. [2]

The information gained about the Polynesians now forms a harmonious whole. Their original settlements in the Pacific, as shown by the megalithic remains, are in the region of pearl-shell and of pearls. Their traditions, and other evidence, point to India, or some land in the west, as their original home. In Indonesia and India there still live people of Polynesian type in localities which contain remains of the archaic civilization, and also pearls. In India, and perhaps also in Indonesia, these people are pearl divers, who, in India, claim relationship with one of the great ruling families of India of the days before the arrival of the Aryans. So it is possible that the Polynesians have spread from Ceylon to the farthest bounds of the Pacific, going from pearl-bed to pearl-bed, seeking ever the same objects, and leaving in all places traces of their presence.

How they got to Southern India, it is not easy to say; but Professor Elliot Smith tells me that in physical type the Polynesians are a mixture of the Mediterranean and Armenoid stocks, and that the mixture probably took place in the Persian Gulf, one of the most important pearl-fishing centres of the world. In that case, a definite physical type is associated with a large movement of the archaic civilization, and is found on every pearl-bed from the Persian Gulf to the uttermost ends of the Pacific. Since, in Oceania, the Polynesians were associated with megalithic monuments, it follows that, in India, they probably were also so associated; and that they were responsible for the polished stone implements that are scattered throughout the region. In the course of time they have, in some parts of the region, given up these two cultural elements.

It is necessary to have some idea of the track of the Polynesians during their wanderings in Oceania, in order to appreciate the culture-sequences that can be established from their history. The Polynesians are first heard of in Samoa and Fiji, which is half Polynesian and half Melanesian, about A.D. 450. Mention is also made of Tonga; but little is known of its early history. [3] The people of this date are said to have been responsible for the mysterious Le Fale-o-le-Fe'e of Upolu in Samoa, of which mention has been made, as well as the ruins of stone foundations of houses, roads, enclosures of the group. [4] About the year A.D. 650, great voyages of discovery began from this region out into the eastern Pacific. Tu-te-rangi-atea, brother of Hui-te-rangiora, first reached Tahiti, and built a great house in the island of Raiatea, probably

[1] Hornell 232–3. [2] P. Smith vi. 135.
[3] P. Smith vi. 151, 156–7. [4] *Id.*, 161, 163.

the great marae of Opoa which was "celebrated all over Eastern Polynesia as the sacred meeting-place of all the tribes of those parts." Many islands were discovered by these men from the west, and a list of them is preserved in the genealogies.[1] Hawaii was settled in A.D. 650, so far as can be told. Probably Easter Island was colonized about then; and the Marquesas in A.D. 675.[2] The date of the first colonization of New Zealand is uncertain; it may have been visited during the first great movement out from Fiji and elsewhere about A.D. 650 in the time of Hui-te-rangiora. Mention is made of the visit to New Zealand of a Polynesian voyager, Maku, about A.D. 850; but Maori nobility trace their descent to men who came from Rarotonga about A.D. 1350.[3]

Polynesian history thus falls into three distinct periods. The first Polynesians settled in Fiji, Samoa and Tonga in the fifth century A.D. After a time some of them went farther east, and founded colonies in the eastern Pacific, Tahiti, Hawaii, Marquesas, Rarotonga and so on. Finally a movement about 1350 landed the great body of the Maoris in New Zealand. It will be necessary later on to examine this process in more detail, but these outlines will suffice to show the general trend of the migrations. By this means it will be possible to establish time- and culture-sequences of great value.[4]

Evidence of continuity between the people of the archaic civilization in the Pacific and the present-day population is not hard to find. It is claimed by the peoples of some islands that their ancestors made megalithic monuments: this claim is put forward by the people of Easter Island with regard to the huge stone statues and other megalithic remains that it contains.[5] In Tahiti the pyramids were doubtless made by the ancestors of the present inhabitants; for example, the Mahai-atea, a stepped pyramid of stone, was built in the seventeenth century by the Te Teva clan, who are said to have moved the blocks of stone from the quarries by handing them from one to another, as is done with buckets of water in case of fire in the country. The same is said of the old Kaha la heiau marae of Hawaii.[6]

As already said, people from Samoa colonized Raiatea of the Society Islands, where is the great marae of Opoa, the home of the later rulers of Tahiti and their god Oro.[7] Thence were taken foundation stones for new maraes in other places. Raiatea was apparently connected with Hawaii, for in Hawaii it is said that "Hawaii" was the old name for Opoa.[8] Thus a close connexion

[1] *Id.*, 166 e.s. [2] P. Smith vi. 173–4. [3] *Id.*, 290.
[4] The reader is referred to Mr. Percy Smith's "Hawaiki" for a lucid account of the history of the Polynesians. Also to the volumes of the "Journal of the Polynesian Society," and to the "Transactions of the New Zealand Institute." He will there see how definite and exact is the foundation of fact upon which these conclusions are based.
[5] Churchill 4.
[6] P. Smith vi. [7] P. Smith vii. [8] Ellis 111, 114.

seems to have existed between the early ruling classes of Tahiti and Hawaii, and those of the archaic civilization.

More light has now been thrown on the early history of the Pacific. When Tahiti was colonized, intercourse was general, and chiefs came for thousands of miles to take part in celebrations and rejoicings; the maraes were in full use. But when the archaic civilization broke up, a veil fell over this great island world, and, until the coming of Europeans, only faint traces of its history can be discerned.

In yet other parts of the Pacific there appears to be a relationship between the Polynesians and stone monuments. The Penryhn Islanders, for instance, are known to have made some of the remains on their island. Others are strange to them.[1]

The doctrine that the present-day Polynesians have lost much of their former culture is put forcibly by an eminent Polynesian scholar, Mr. Tregear, who says : " Who shall say that, being barbarians, they have always been barbarians ? It would, indeed, be impossible to prove, and my own belief is opposed to such a notion. To what does this view of the subject lead us ? To the position that if we rely too much upon modern conditions, customs or modern ignorance among savages to explain the birth of myth among primitive men we may be led entirely astray, since our modern savages may not be primitive at all, if by primitive we understand ' original,' ' untouched,' ' near the fountain head of innocence.' They may be, and probably are, the degenerate descendants and broken remnants of mighty peoples, and their simplicity is not the result of innocence, but of ignorance and decay." [2]

Elsewhere in the Pacific a direct connexion can be established between the existing communities and the use of stone. This is so in the Carolines (see p. 398). In Melanesia megalithic monuments are still used; for instance, in San Cristoval and elsewhere in the Solomons, and Ambrym and elsewhere in the New Hebrides (see pp. 27–8).

A comparison between the Polynesians and the Melanesians reveals an extraordinary difference. The Melanesians have no traditions of migration into their region ; they claim to have been created on the spot.[3] They also now use megalithic monuments of types not now made in Polynesia. Given the uniformity of the archaic civilization throughout the Pacific, it follows that the historical experiences of the Polynesians and the Melanesians must have been profoundly different. The one group has constantly lost its culture while moving about from place to place ; while the other, which has not migrated, has retained more connexion with the past. I do not mean to claim that there has been no loss of culture in Melanesia : far from it ; the stone remains of Santa Maria and elsewhere are sufficient evidence on that point. But nevertheless San Cristoval, the New Hebrides,

[1] P. Smith i. 91–2. [2] Tregear vi. 59. [3] Codrington 20.

and New Caledonia seem to stand nearer in culture to the archaic civilization than any part of Polynesia at the present day. That being so, a closer cultural relationship would be expected between Melanesians, Australians and the ancestors of the Polynesians, than between Melanesians and Polynesians.

In Indonesia it is often possible to show, with much probability, that peoples of the lower culture have once been in intimate contact with peoples of relatively high civilization. The nature of that contact varies from case to case. Often it is claimed that the tribe, or rather, its ruling caste, is descended from some ruling house in a civilized country. For example, it is well known that the Malays have spread all over Indonesia, forming various settlements. They originated in the Menangkabau district of Sumatra, and their earliest migrations date from about A.D. 1160. when they settled in Singapore. They spread after becoming Mohammedans, and they have settlements in South Sumatra (Menangkabau, Palembang, Lampongs), in all the insular groups between Sumatra and Borneo, in the Malay Peninsula as far north as the Isthmus of Kra : round the coast of Borneo ; in Tidore, Ternate and Halmahera ; in the Banda, Sula, and Sulu groups ; in Batavia and Singapore. Their settlements have resulted from conquest, as in the case of Ternate[1] and Central Celebes :[2] the Tagalos of the Philippines were descended from Malay chiefs who went with their followers in canoes, and established themselves in that group. Before the spread of the Malays, the Hindus had formed settlements in all parts of the Archipelago, the first of which, those in Java, date from about the beginning of our era.[3] Hindus from Java probably founded kingdoms in the Palembang, Menangkabau and Djambi [4] districts of Sumatra.

Borneo formerly had many settlements of Hindus from Modjopahit in Java. The most important of these old colonies in the west was Sukadana, and this in its turn gave rise to many others, such as Matan, Landak, Tajan, Sanggouw, Sukadana, Sintang ; the Hindu-Javanese founded Bandjermasin in the south ; the ruling house of Pasir claims Hindu descent ; Kuti was also founded by colonists from Java, and especially from Modjopahit. When Modjopahit fell these kingdoms became independent.

The Hindu-Javanese were followed by the Malays from Menangkabau, the date of whose arrival cannot be settled. Later on Buginese from South Celebes, themselves Mohammedans, founded settlements.[5] This does not exhaust the list. For, as has already been said, the Chinese have formed important settlements in this island for the working of gold and diamonds.

The peoples of the interior of Borneo, the Dyaks as they are called, have, consequently, for many centuries been surrounded by communities of higher civilization, which cannot fail to have influenced them in their culture. In the districts under the rule

[1] Wallace 239. [2] Kruyt and Adriani I. 299. [3] Wilken 352-3.
[4] Id., 362-3. [5] Id., 370-1.

of these strangers, the natives were put under the sway of members
of the ruling house ; [1] so possibly many Dyak tribes have derived
their ruling classes directly from the Hindus, the Malays, or from
a similar source. Messrs. Hose and McDougall show that the
natives of Sarawak and British North Borneo have been pro-
foundly influenced in culture by more civilized peoples. For
example, the Idaans claim to be descended from Chinese who
came to seize the great jewel of the Kina Balu dragon.[2] The
court of Bruni in the north was profoundly influenced by the
Hindu-Javanese. "Hindu-Javanese influence also was not
confined to the court of Bruni, for in many parts of the southern
half of Borneo traces of it survive in the custom of burning the
dead, in low relief carvings of bulls on stone, and in various gold
ornaments of Hindu character" ;[3] moreover, "the people of
Sarawak have only lately ceased to speak of 'the days of the
Hindus.'"[4]

What is the bearing of this on the civilization of the peoples
of Borneo ? It has already been seen that the Kayan and their
kinsmen have caused an uplift in the interior of the island that
has given rise to the culture of the Kenyah, Klementan and
others. The approximate date of arrival of the Kayan is given
by Hose and McDougall, who state that, according to a tradition
of the Kapuas Malays, this tribe arrived in the island about the
beginning of the fourteenth century. The ancestors of the
Kayan are said to have been a gang of criminals, with mutilations
in the ear-lobes and elsewhere for incest, who were in the service
of the king of Modjopahit in Java. They landed near Sikudana
and spread into the country between the Kapuas and Banjer-
massin.[5] The Kayan thus arrived in Central Borneo after king-
doms had been established on the coast for many centuries. They
are also said to have been in contact with higher civilizations.
Therefore the cultures of Borneo natives can but be regarded as
degenerate remnants of more advanced civilizations.

In Central Celebes the To Bada originated in three villages
containing stone remains.[6] Although the past history of South
Celebes and the neighbouring islands is still obscure, yet it seems
certain that the States of this region possess ruling families
belonging to the Bugi or Macassar group. Such interrelation-
ships are evident in the case of the Sadan Toradja, the State of
Luwu, the Mandar States of the west coast of the southern
Peninsula, and various other Bugi States. The Bugi and Macassar
peoples are supposed to have a common origin, and this certainly
seems true of their ruling families (see pp. 284 e.s.). The Bugi ruling
group claim to have started from Watoe in Wadjo, and thence
to have spread all over South Celebes, and the neighbouring
islands. The Buginese have founded colonies in Borneo : in the

[1] Wilken 373.
[2] Hose and McDougall I. 11, 17.
[3] Id., I. 17–18.
[4] Id., I. 12.
[5] Hose and McDougall I. 15 n.
[6] Perry vii. 47.

Riouw-Lingga group; in Endeh of Flores and the islands east of Flores, which constitute the principality of Bima.[1] A proliferation of States extending over a wide area thus owes its origin to a common focus, and these States betray no sign of independent origin. As the general argument proceeds it will be seen that this continuity shows itself in many ways. Although Hinduism and Islam have played their parts in Celebes, yet the old political and social organization has survived in sufficient detail to reveal the relationship between these communities and those of the archaic civilization.

Minor examples of the foundation of daughter settlements are those of the To Rongkong, and the Kolaka people of Southeastern Celebes. The To Rongkong have emigrated from the Sadan region, where are ample traces of the archaic civilization; [2] while the Kolaka folk owe their culture to beings who show strong signs of relationship with the ruling family of Luwu and other Bugi States.[3] In Sumba, again, it is known that certain States have derived their ruling families from others, which in their turn probably came from Bima, and, therefore, ultimately from Celebes.[4] Each additional fact that is brought to light thus serves to establish continuity between one State and some other that preceded it, and usually with a higher civilization.

Evidence already adduced shows that the ancestors of the peoples of the islands running east from Timor came from the neighbourhood of Timor, a place where people of Polynesian type are to be found. This is the more significant when it is remembered that, as already pointed out,[5] the peoples of these islands attach great importance to polished stone implements brought with them by their ancestors from the west. Megalithic remains are plentiful in the islands to the west of Timor, and, as may be seen from Sketch Map No. 6, stone implements have been found in these islands. So, it is possible that the whole of the culture of the region, which steadily degenerates eastward from Timor, is derived from the archaic civilization. The culture of the Moluccas also shows strong signs of the influence of the archaic civilization, a fact which has been emphasized in " The Megalithic Culture of Indonesia," where it was also claimed that the culture of those Philippine tribes of whom anything is known, shows signs of a similar mode of origin.

The Batta of Sumatra, who show signs of Hindu influence, are divided into exogamous groups called margas, one of which, called the Marga Simbiring, has subdivisions that, according to the Dutch philologist, Kern, are of Dravidian origin.[6] In physical type some of the Batta are thought to resemble the Dravidians of India,[7] and it is said that the Indians have had much influence upon their religion.[8] Throughout Sumatra the dominant influ-

[1] Indonesia, " Encyclopædia," I. 324. [2] Kruyt v. 367.
[3] Kruyt viii. 691 e.s. [4] Kruyt m.s.s. [5] Perry vii. 57–8. See p. 97.
[6] Kern ii. 359 e.s. [7] Brenner 191. [8] Hagen 500.

ences have been Hindu and Mohammedan, so that it is impossible to detect any signs of the independent development of culture in any one place. Not only must account be taken of these two known influences, but the Phœnician script, the stone images and the stone implements of the south-west must be constantly borne in mind when speaking of the culture of the native peoples of the island of Sumatra.

To sum up : It is not possible, in any part of Indonesia, to point to a group of communities, or even a single community, as an instance of the independent development of culture.

The population of India can be divided roughly into four, or perhaps rather, five groups. In the first place, some food-gathering tribes still remain, such as the Veddhas of Ceylon and certain jungle tribes of Southern India. Secondly, there are peoples speaking Austronesian languages, who have already been discussed in part. Their distribution is seen in Sketch Map No. 13. They, with their ancient languages, are closely linked, in later times in India, with the third group of peoples, commonly called the Dravidians, who speak cognate languages. Fourth come the Aryan-speaking peoples, the product of an incursion from the north. The fifth group is that of the Mongoloid peoples of Assam, Upper Burma and the Himalayas, who will not enter much into the argument.

In those pages of this book which concern India, much space will be devoted to the comparison of the culture of the Aryans with that of the peoples whom they found in the country on their arrival. This will be a task of great difficulty, for the proper study of the cultural history of India has yet to come.

It can be shown that many food-producing peoples of India have been derived from others possessing a higher degree of culture. For instance, the Kunet of the Kulu district of the Panjab, between the Beas and Kons Rivers, live in a region with many remains of a vanished civilization, which are ascribed to their ancestors, who, again, are identified with the Mundas of Chota Nagpur.[1] The Mundas themselves claim that they came from Azimgarh, a district in which now live scattered tribes of Cheros, Seoris, Kols, Kharwars, who all speak Austronesian languages.[2] A Behar tradition states that in the Satya Yogu, the Golden Age of India, the country was ruled by the Savaras, Munda-speaking people, whose dominion extended to Azimgarh, which district contains many ruins of a former highly civilized population. The local traditions of Azimgarh refer to the Rajbhars and Suiris as the most ancient occupants of the soil. Cunningham identifies these Suiris with the Savara, and thus with the Munda-speaking tribes. " Thus the tradition of the Mundas themselves finds unexpected support from the traditions preserved by the Hindus of the Azimgarh district, and we may therefore safely accept the Mundari tradition of their former

[1] Roy i. 24, 50–1, quoting Cunningham xiv. 127–8. [2] Id., 24.

residence at Azimgarh as correct." If so, they were connected with the highest civilization of pre-Aryan times in India. The Mundas seem to have left Azimgarh when the Aryans became dominant in that part of India.[1] They wandered about over a great part of northern India for many years before finally settling in Chota Nagpur. " They must have spent a rude dreary existence in these fastnesses for a considerable time. And in that wide space of time, they probably unlearnt some of the peaceful arts of civilization that they had acquired in their pre-Aryan days of peace and prosperity. In their constant struggle with the adverse forces of the physical and animal world, it is no wonder that they should have slipt down the few rungs of the ladder of civilization that they had climbed up in happier days."[2] Proof of their former existence in certain places is afforded by their remains. The Mundas erect stone monuments over their graves, and have the custom of sitting during council meetings on stones ranged in a circle.[3] The extracts given by Roy from the archæological reports of Cunningham, suggest that some of these old Munda remains are dolmens.[4] One such site is described. Mr. Carleylle found, at a place ten miles south-west of Fatehpur Sikri, near the south bank of the Banganga River, numerous small standing stones which looked as if they had formed stone circles and also " certain solitary erect slabs of stone of which the width across horizontally was generally equal to and sometimes a little greater than their vertical height above ground, and which latter stones might possibly originally have formed the sidestones of cromlechs."[5]

The Mundas are equated to the Cherus, who have left brickwork ruins in several places, among them being some pyramidal mounds thirty-three miles north of Chapras, and also eighteen miles north-west of Mozufferpur. Numerous remains in Behar, one of the places said to have been visited by them on their wanderings, mounds, brickwork, stone images, are ascribed to Munda-speaking peoples. Thus a megalith-building people who speak a language of the great Austronesian family have a culture rooted far back in the past, and formerly in advance of what they now possess. Driven from their early home by a race of conquerors, the Mundas wandered about and lost much of their original civilization, maintaining, nevertheless, their continuity with the past, and preserving the custom of erecting stone graves.[6]

The Oraon of Chota Nagpur are similar to the Mundas in occupations and manners, but differ in language, in which they are allied to the Canarese of South India, and this harmonizes with their claim that Rawan, the demon king of Ceylon, was once their ruler. They are identified with certain peoples who opposed the advance of the Aryans in India, such as the Karushas and the cannibal Rakshahas. A mythical Oraon king, Karakh, is said to

[1] Id., 52 e.s., 61–2, 64–5. [2] Roy i. 73. [3] Id., 122. [4] Id., 82–3.
[5] Roy i. 83–4. [6] Id., 96 e.s., 103 e.s.

have ruled over the region between the Son and Karamansa Rivers.[1]

The work of Gustav Oppert, on " The Original Inhabitants of India," abounds with examples of the relationship between present-day Dravidian peoples and the great ruling houses of the past. He says : " In pursuing the ramifications of the Bharatan, or Gaudo-Dravidian, population throughout the peninsula, I hope I have been able to point out the connexion existing between several tribes, apparently widely different from each other. I have tried thus to identify the so-called Pariahs of Southern India with the old Dravidian mountaineers and to establish their relationship to the Bhars, Brahuia, Mhars, Mahars, Paharias, Paravari, Paradas and other tribes ; all these tribes forming, as it were, the first layer of the ancient Dravidian deposit. In a similar manner I have identified the Candalas with the first section of the Gaudian race which was reduced to abject slavery by the Aryan invaders, and shown their connexion with the ancient Kandalas and the present Gonds. In addition to this, I trust I have proved that such apparently different tribes as the Mallas, Pallas, Pallavas, Ballas, Bhillas and others are one and all offshoots of the Dravidian branch, and that the Kolis, Kos, Khonds, Kodagas, Koravas, Kurumbas and others belong to the Gaudian division, both branches forming in reality only portions of one and the same people, whom I prefer to call, as I have said, Bharatas."[2] The thesis of Oppert is thus that of this chapter, namely, that a great number of peoples, seemingly independent, are really, culturally speaking, derivatives of one original stock, produced by a continuous process of development, and not independently evolving their culture.[3] He brings forward masses of facts to show that many of the Dravidian peoples are but the shattered remnants of once powerful kingdoms, but the evidence is so abundant that it is hard to know what to select. For example, he discusses the Bhars, and says : " The Bhars must have once ruled over a great area of country stretching from Oudh in the west to Behar in the east and Chota Nagpur, Bundelkund and Sagar in the south. . . . Traces of the former supremacy of the Bhars are found scattered all over the country. Most of the stone erections, fortifications, as well as the embankments and the subterranean caves in Gorakhpur, Azimgarh, Janpur, Benares, Mirzapur and Allahabad are ascribed to them. Such forts generally go now by the name of Bhar-dih. The grand ruins known as those of Pampapura in the neighbourhood of the modern Mirzapur probably owed their origin to the Bhars. Mr. C. A. Elliot states that ' almost every town whose name does not end in pur, or abad, or mow or is not distinctly derivable from a proper name, is claimed by tradition, in the east of Oudh,

[1] Grignard 4–8 ; Roy iii. 3 e.s. [2] Oppert, p. vii.
[3] " The Koragas are now treated like Pariahs, though according to tradition they also were once a governing race."—Oppert (171).

as a Bhar town. The district of Bharaich . . . is their oldest abode, and the name of the town Bharaich is said to be derived from them.' Traces of the Bhars abound, according to Mr. Duthoit, late Superintendent of the Maharaja of Benares, ' on all sides in the form of old tanks and village forts. One cannot go for three miles in the districts without coming upon some of the latter.' Not very long ago the Bhars were the lords of the soil in the districts of Benares and Oudh, and according to the still prevailing tradition in Azimgarh, the Rajbhars occupied the country in the time of Rama. The structures left by the Bhars prove that they were equally proficient in the arts of peace and of war. The remains ascribed to them are especially numerous in the Benares district." [1] Nowadays they have fallen from their high estate : " A considerable number of Bhars fill the post of village policemen, while others are ploughmen, but the vast majority of this race are now in a miserable condition. . . . In spite of the abilities they exhibit when suitably employed and in spite of the reputation of their ancestors, which has survived to this day, the descendants of the ancient rulers of the land have now lost nearly everything and are reduced to the most abject conditions." [2]

The low estate of former great races of India has struck more than one writer. For example, an author, in the " Journal of the Royal Asiatic Society," comments thus on the fallen conditions of the Bhars : " I know not why we should be so ready always to ascribe all the ancient civilization of India to successive troops of the Hindu immigrants. The more I investigate the matter, the stronger do my convictions become, that the Hindu tribes have learnt much from the aboriginal races ; but that, in the course of ages, these races have been so completely subdued, and have been so ground down by oppression, and treated with such extreme rigour and scorn, that, in the present condition of abject debasement in which we find them, we have no adequate means for judging of their original genius and power." He goes on to say that : " It would be interesting to learn the history of the degradation of a race of people, of enterprise and skill, of originality and singular personal ability, which, it is evident, once characterized them in no ordinary degree. Their supplanters, whether Rajpoots, Brahmans or Mahommedans, though more civilized and refined, are not to be compared with the nobler aborigines whom they have ruined, in regard to the great works of public utility which have been executed in the land." [3]

Even the Pariahs, or Paraiyan, as they should properly be called, of whom the very name has come to stand for what is most abject in human nature, claim that they once had a glorious place in the country. " However despised a position the Pariah and the Holiya occupy in the places where they live, they have preserved and still cherish, as the Mhar and Bhar do, the memory

[1] Oppert 40–1. [2] Id., 47. [3] Sherring 385, 395.

of former greatness and regard themselves as the original owners of the soil. Political revolutions, about which we now know nothing, have most probably been the cause of their subversion by other kindred Dravidian tribes." [1] The Pariahs are closely connected with the Paravas, the pearl-fishers of Polynesian type of the south, who also claim high rank in the past. The Pariahs are unable to bring forward serious evidence in support of their contention ; but the existence among them of a complicated caste system, with a division into right- and left-hand castes, points to some ancient social order that has long been superseded. The Pariah possess certain privileges which they could not possibly have gained for themselves from orthodox Hinduism. " These seem to be survivals of a past, in which the Paraiyans held a much higher position than they do now ; or at any rate show that they are as ancient in the land as any other Dravidians (Mudaliars, Pillais) whom the Paraiyan calls Tamils, a name which he does not apply to himself." The Paraiyans are supposed to be more intimate with local gods than the high-caste people, and to have better knowledge of the village boundaries. [2]

The Kurumbar people, who nowadays erect megalithic monuments, are also supposed to have had a great past. " They were masters in the south, which is still full of traditions of them, and in the Carnatic formed a federal community of twenty-four castle-states, all of which have been traced, and reached no mean stage of civilization. In the sixth or seventh century they were scattered and destroyed by the Chola kings of Tanjore after a long and widespread domination ; probably continuing to exist in larger or smaller communities, ever wasting and driven farther and farther into the hills and wildernesses by their conquerors. It is to this perished people that the megalithic monuments may be with most probability ascribed ; they are still associated with them in popular tradition ; the circles and kistvaens being often commonly called ' Kurumbar rings ' and ' Kurumbar Forts,' especially round Conjeveram, once a principal centre of their power. . . . Sometimes they retain their ancient name, as the Kurumbars of the Nilgiri slopes, a dwarfish hairy race, dwelling in the densest, most feverish jungles, and feared even by the other mountain tribes as the most dangerous of enchanters. Elsewhere they are known by many titles—Kaders, or wood-men ; Maleiarasar, or hill-kings ; Koragas, or bushmen ; Holyars, or men of the river ; Irular, or people of darkness ; all names indicative of contempt tinged with fear. In still larger remnants they probably survive in the wide unknown jungle regions of the northern circars as Gonds, Kols and many others.

" That these dwindled miserable tribes are the representatives of the race that once covered the plains with megalithic monuments is proved, as far as proof is ever likely to be obtained, by the curious fact of their maintaining at the present day the same

[1] Oppert 50-1 : cf. Shortt 193. [2] Clayton 60-1.

practice in miniature show. The Malei Arryans of the Travancore mountains, who still number from 15,000 to 20,000, on a death amongst them, make an imitation kistvaen of small slabs of stone and place a flat stone over with ceremonies and offerings ; the spirit of the deceased is supposed to dwell in the pebble. The Kurumbars and Irulars of the Nilgiri Hills do the same, and I have seen small covered slab structures there filled with long smooth pebbles, the meaning of which I was long in ascertaining, the people being reticent on the subject. The Gond tribes of the Godavery and Orissa make miniature cromlechs ' like three-legged stools,' which they place over the bones and ashes of the deceased. The Kols are reported by Major Macpherson to place the ashes in a chatty, bury it in the ground, and lay a large flat stone over it. Here we find wild secluded tribes keeping up the semblance of constructing kistvaens and stone monuments on mountain-fastnesses overlooking the plains where such structures abound ; and the inference is strong that they must be the weakened descendants of the people who, when numerous and powerful, dominated the plains and built the structures." [1]

The mass of evidence put forward by Oppert and others makes it clear that it cannot be taken for granted that any Dravidian people of the lower culture has elaborated its culture independently of others. He shows how many strands bind tribes together, linking one with another, and all seemingly derived from a few original stocks, which have lost their culture in the course of ages. A writer just quoted evidently has the same belief as Oppert : " My own belief is, that many of the aboriginal tribes of India were originally blended together. All investigation into the races of India goes to prove that at various epochs separate tribes have spread over the land, one pushing forward another, the weaker and less civilized retreating to the jungle and hilly fastnesses ; and the stronger, in their turn, giving place to fresh and more vigorous clans. It may be impossible to prove, therefore, what is nevertheless highly probable, that in very ancient times most of these tribes were exceedingly few in number ; for it is a singular circumstance, opposed, indeed, when regarded superficially, to the assumption I am making, that the races of India, whether Aryan or non-Aryan, for a long succession of ages, have largely maintained their distinctive individuality, notwith-standing the fluctuations in their respective histories." [2]

The Bhil are Dravidians that have apparently fallen from a former high estate. " The Bhils are, and deem themselves, a distinct people. There are so many different tribes among them, that it has been conjectured by some, that the general name of Bhil only denotes a confederacy of mixed and degraded races of Hindus, associated by political events and local circumstances : but, though there can be no doubt that their strength has been

[1] Walhouse 27–8. [2] Sherring 399.

increased, and their consequence raised, by recruits sprung from
the prohibited intercourse of the primitive Hindu castes, there
is every reason to believe that the original race of Bhils may claim
a high antiquity, and that they were once masters of many of the
fertile plains of India, instead of being confined, as they now are,
to the rugged mountains and almost impenetrable jungles." [1]
Many other examples could be quoted of Dravidian tribes, now
of lowly culture, who can point to a glorious past. In some cases
it is not possible from the historical evidence to claim that a
people has been derived from one of higher culture. But, on
the other hand, it does not seem that any of the Dravidian com-
munities have developed an independent civilization. This, of
course, is purely negative evidence. But the facts here adduced,
which only constitute a tithe of those available, as may be seen
from a perusal of the work of Oppert, make it possible to claim
with some confidence that, with regard to the Dravidian group,
independent origin of culture is not proved, and that degeneration
of culture has demonstrably played a large part in the production
of communities of all degrees of culture. The positive evidence
is on the one side of degeneration, and on that I shall rely, taking
it as a working hypothesis that Dravidian civilization can be
regarded as a unity.

With regard to the Aryans, Sir Alfred Lyall, in his "Asiatic
Studies," shows what an influence has been exerted by the Rajput
clans on the neighbouring aboriginal tribes. He says that, in
the country round Rajputana, dwell peoples called Bhil,[2] who
form the lowest stratum of the population.[3] Above them in the
social scale come half-blood tribes claiming paternal descent,
more or less regular and direct, from Aryan clans, with a social
organization based, although indistinctly, on that of the Rajputs.
These predatory clans, of very mixed and obscure origin by
descent, rank in the order by which they gradually approximate
more and more to the customs and ritual of the pure clans ; " so
that we might make out roughly, in Central India, a graduated
social scale, starting from the simple aboriginal horde at the
bottom, and culminating with the pure Aryan clan at the top ;
nor would it be difficult to show that all these clans are really
connected, and have something of a common origin." The
intermediate groups " usually assert themselves to be fallen
patrician, but they are probably derived from both sources."
Lyall mentions also the Meenas, robbers and caterans, who claim
Brahmin and Rajput descent.[4] He mentions also the Grassias,
a tribe of South-West Rajputana, ranking above the Bhil. "The
Grassia is probably of mixed Rajput blood, possibly in some cases
he may be a pure Rajput stock detached and isolated in the
backwoods. . . . There is also a widely spread tribe of pro-

[1] Malcolm 68.
[2] We have already seen that the Bhils are a degraded remnant of a former
powerful race [3] Lyall I. 176. [4] Id., 176–8.

fessional thieves which is evidently by origin nothing more than an association for the purpose of habitual robbery ; but even there these people pretend to a remote descent from Rajput and shape their internal society upon the pattern of the clan." [1] The process at work is one in which " a wild tribe seems to grow out of a collection of recruits from the scattered communities, who either from necessity, or a love of adventure, join together under some notable leader." [2] And " so far as the actual course of things can be watched, in early and wild times a tribe or clan regularly throws off another tribe or clan after its own kind, as swarms come out of a wild bees' nest." [3]

It is found that all the Rajput clans themselves claim descent from a common ancestor. As Sir Alfred Lyall says : " The pure Rajput clans are those great kindred groups which have kept immaculate the rules and conditions of exogamic connubium, throughout the genealogy of their tribal tree in all its branches, every family showing its pedigree leading back to some branch, however insignificant, which sprang out of the original stem and root of the tribe. This is the real aristocracy of India, with which every Hindu dynasty and family of influence or new wealth (except Brahmans) tries to find, beg or borrow a connexion from the petty non-Aryan chief of the Central Indian woodlands to the greatest Maratha ruler, the kings of Nepal, and the half-Chinese princes in the far north-eastern portions of India and Burma." [4]

One great feature of modern India is the caste system. The vast mass of the population are ranged in groups, formed mainly upon some professional or occupational basis, the members of which are forced, theoretically, to marry within that group. One definition that has been given of caste is the following. It is " a close corporation, in theory, at any rate, rigorously hereditary ; equipped with a certain traditional and independent organization, including a chief and council ; meeting on occasion in assemblies of more or less plenary authority, and joining in the celebration of certain festivals ; bound together by a common occupation, observing certain common usages which relate more particularly to marriage, to food, and to questions of ceremonial pollution ; and ruling its members by the exercise of a jurisdiction the extent of which varies, but which succeeds, by the sanction of certain penalties and above all the power of final or revocable exclusion from the group, in making the authority of the community effectively felt." [5] It is claimed, in some quarters, that this system of caste grew up as the result of the coming of the Aryans into India. In the course of time it has drawn the greater part of the

[1] *Id.*, 183. [2] *Id.*, 194. [3] *Id.*, I. 198.
[4] *Id.*, I. 257. " The Dogras of the Kangre Bhils and the Khas of Nepal are believed to be the offspring of alliances between conquering Rajputs and women of more or less Mongoloid descent "—(Risley 555).
[5] Ris ley 518.

population into its sphere of influence, so that people of all physical types and races are in the system. Sir Herbert Risley gives an explanation of the origin of the caste system that accords well with that of the manner in which the Rajputs have formed other communities outside themselves. He claims that the Aryans came into India with but few women. Some of the adventurous spirits among them set out with followers and managed to seize some of the Dravidian kingdoms, and took the Dravidian women for their wives. Cut off from their relatives by distance, and by their new alliances, these men and their families would form a new caste lower in rank than that from which they came, but would be the ruling caste in the communities formed by them. " As their number grew their cadets again sallied forth in the same way and became the founders of the Rajput and pseudo-Rajput houses all over India. In each case complete amalgamation with the inferior race was averted by the fact that they only took women and did not give them. They behaved, in fact, towards the Dravidians whom they conquered in exactly the same way as the founders of Virginia behaved to the African slaves, whom they imported, and the founders of the Indian Empire towards the women of the country which they conquered." [1] This means that one original community gives rise to others successively lower in cultural status, the ultimate basis of the process being the superposition of one group on another, usually of alien language and customs. In this way it is claimed that the great complexity of Indian society has been produced.

In the Puranas several tribes are mentioned as being descended from Kshatriya migrants.[2] The process was apparently well known to the writers of those books. Not only is this process mentioned in the sacred books, but it has gone on in historic times. In Assam, for example, successive waves of conquerors have disputed for sovereignty. As a result : " The dynasty would ordinarily be overthrown ; the downfallen survivors of the old aristocracy would become merged in some Hindu caste, such as the Kalika." [3] Often the country would, as a result, be split up into a number of petty states. " From time to time a local chief of unusual enterprise and ambition, or possibly some Kshatriya adventurer, would reduce these petty states and make himself master of the whole country." [4] In this way the ruling families of these small states would be depressed to a lower rank, or would be forced to migrate and seek their fortunes elsewhere, that is, to found another small state with themselves as rulers. Thus many old ruling houses have vanished : " The disappearance of former ruling races is one of the most curious phenomena in Indian history. There is no vestige now of the old Bodo rulers of Sylhet. The Khers, who ruled in the north-west of Assam before the Koches, have also for the most part been absorbed in other castes. In Upper India there is now no visible trace of the Greeks,

[1] Risley 556. [2] Wilson, H. H., 375, 481–3. [3] Gait 9. [4] Id., 8.

Huns, Bhars, and other once dominant races or tribes."[1] The Kachari, now a tribe whose beliefs and practices are quoted as examples of primitive modes of thought, claim that their kings once ruled over most of Assam, with their capital at Dimapur, where are remains of a relatively high state of civilization.[2] The Kachari are allied to the Mech, and were formerly part of the Bodo kingdom; so that "it seems not improbable that at one time the major part of Assam and North-East Bengal formed a great Bodo kingdom, and that some, at least, of the Mlecchha kings mentioned in the old copper-plate inscriptions belonged to the Kachari race or some closely allied tribe." The old Kachari kingdom of Dimapur displayed a higher form of civilization, that is, using the term in the sense of the control over stonework and so on, than the Ahoms, a people of Tai-Shan, that is Mongoloid, stock, who displaced them. Their capital Dimapur was built of brick, but much use was made of sandstone for carved pillars, some as much as 12 ft. long and 5 ft. in circumference, which had been brought at least 10 miles from the quarries.[3]

Convulsions in the valley of Manipur, and elsewhere in Assam, have probably brought into being several tribes of the hills. The Naga, Kuki, Manipuri, Lushai and Gurkha are alike in physique. It is interesting to note that some of the clans of these groups, the Anal and Thado of the Kuki, and the Manipuris, claim to be descended from three men whose father was the son of Pakhangba, the mythical ancestor of the royal family of Manipur.[4] The Naga, Kuki and Manipuri also claim a common ancestry.[5]

Examination into the cultural history of Indian peoples therefore gives the same result as in other parts of the region —a lack of positive evidence of independent development of culture.

A further important point must be noted with regard to the relationship between the archaic civilization and its successors. Not only are the early communities situated near sources of valuable materials, but existing tribes, such as the Munda, Gond, Kurumba, Khasi, and so on who, as was seen in Chapters VI, VII and VIII, had retained the practices of irrigation or the erection of megalithic monuments, have not wandered far from such areas. When movements have gone out from such centres, cultural elements have been dropped. Nevertheless it is possible that such secondary migrations, as they may be termed, are directed by desires similar to those of the people of the archaic civilization. For example, the To Rongkong, a people of Central Celebes, who came from the Sadan region,[6] where are many traces of the archaic civilization, have made their principal settlement in a place with much iron ore.[7]

[1] Id., 9. [2] Eliot 1156. [3] Gait 243.
[4] Shakespear i. 150. [5] Hodson.
[6] Cf. Perry vii. Heer Kruyt will shortly publish a monograph on this important district. [7] Kruyt v. 373.

Messrs. Hose and McDougall have some interesting comments on the iron-working of the Kayan of Borneo. " In any account of the arts and crafts of the Kayans, the working of iron claims the first place by reason of its high importance to them and of the skill and knowledge displayed by them in the difficult operations by which they produce their fine swords. The origin of their knowledge of iron and of the processes of smelting and forging remains hidden in mystery ; but there can be little doubt that the Kayans were familiar with these processes before they entered Borneo, and it is probable that the Kayans were the first iron-workers in Borneo, and that from them the other tribes have learnt the craft with varying measures of success. However this may be, the Kayans remain the most skilful ironworkers of the country, rivalled only in the production of serviceable sword-blades by the Kenyahs.

" At the present day the Kayans, like all the other peoples, obtain their iron in the form of bars of iron and steel imported from Europe and distributed by the Chinese and Malay traders. But thirty years ago nearly all the iron worked by the tribes of the interior was from ore found in the river-beds, and possibly from masses of meteoric iron ; and even at the present day the native ore is still smelted in the far interior, and swords made from it by the Kenyahs are still valued above all others." [1] This quotation shows that in iron-working the principle of continuity holds. The other tribes of the interior have derived their iron-working from the Kayan, and do not equal them in skill. No signs exist of the independent origin of the craft in the country, and it is surmised that the Kayan must have brought it with them. That is to say, the possession, by the Kayan, of the craft of iron-working, is evidence of their former contact with a more advanced form of civilization. It is possible that the movements of the Kayan have been directed by the supplies of iron. Iron-working being their chief industry, it is likely that they would make their new villages where they found supplies of ore. The Kayan are said to move on to find new patches of jungle to burn down for their rice cultivation. The choice in that respect is fairly open, and it is likely that the presence of iron-ore would determine the exact spot. Along these lines, it may ultimately be possible to account for the great majority of the settlements of the later periods.

Thus inquiry into the derivation of the later communities of the region as a whole leads, in all cases where enough historical evidence is to hand, to the communities of the archaic civilization. The later communities are living on the cultural capital that they have derived from that original source. The modes of derivation of culture are various. Sometimes members of one community go out and form a fresh community, which is thus simply an off-

[1] Hose and McDougall I. 193–4.

spring of the first. In another case members of a ruling family
go out from home to seek a kingdom, and either impose them-
selves upon a group of people, or wrest a kingdom from some other
ruling family, and take their place. In Polynesia much of the
dispersal has been of such types. The Polynesians have grown
by the natural increase of population, fresh communities budding
off from the old stock. In the later stages, when the islands had
become populated, we hear of conquest and the superposition of
one class on another. In Indonesia, and in India also, both
processes have been at work.

The consequences will vary according to the mode of trans-
mission of culture. Where budding-off has taken place, continuity
in culture is more likely than in the case of conquest of a foreign
people. Examples of both these processes will be forthcoming
in the course of the argument, and they will be discussed in their
proper places.

A third method whereby culture can be transmitted from one
place to another will now have to be considered. It has already
been noted that the people of Melanesia do not claim to be of
immigrant origin ; they were, they say, created on the spot,
whatever that may mean. At the same time their culture
possesses unmistakable traces of the influence of the archaic
civilization in the form of irrigation, dolmens and so on. How
did this happen, since no part of the population claims to be of
immigrant origin ? It is not hard to suggest an explanation.
The existence, in certain islands, of graves of former chiefs, in
places where none now rule, suggests that a former ruling class
brought with them these cultural elements. It is, however,
unnecessary to resort to speculation, for the various native
populations have something to say about it. Tradition is so
highly prized that it will be well to heed its voice.

In " The Megalithic Culture of Indonesia " it was shown that
certain peoples possess traditions that the archaic civilization
was introduced to them by strangers. The best examples are
the Bontoc, Igorot and Ifugao in the Philippines, and the Toradja
in Central Celebes. Both groups claim that, at some time in the
past, a being from the sky came and civilized them. An examina-
tion of their traditions and culture suggested that these culture-
heroes were representatives of the archaic civilization, and that
their arrival in these places was the result of the search for gold.
In other parts of Indonesia, these strangers founded ruling houses,
but in these two cases they did not. The reasons are definite.
Among the Bontoc the hero married one of the women and had
children by her ; but they were all killed, and the people lost their
rulers. In the case of the Toradja it is said that the descendants
of the hero and the woman whom he married went to other parts
and there became chiefs. Culture-heroes may then be looked
upon as peoples of higher civilization that settle among others in
a low stage of civilization, influence them, and depart without

forming a social class.[1] In the case of the Bontoc and the Toradja the native traditions seem reliable, for the strangers have left behind them material evidence of their presence. In other places tales are told of wonderful men who came to a people and taught them their civilization. Of the Kai tribe in German New Guinea, not far from the Huon Gulf, it is said : " The Nemu were demi-gods who inhabited the world before the present race, stronger and more powerful than men ; they made men what they are, and put a black skin on some, and a white on others. They discovered edible fruits, first planted fields, built houses. At first a whole bunch of bananas ripened at once, the Nemu altered this and made them ripen gradually. Also they stopped houses moving about from place to place as they formerly did.

" At first it was always day ; the Nemu told the sun to go down and give them time for rest and sleep.

" In short, Nemu settled mode of life for man ; natives always answer, ' The Nemu did so, and so do we.'

" The Nemu were turned into animals or into blocks of stone at death, and great floods destroyed them all." [2] This region contains remains of old gold-workings : so the claim of the natives that certain beings originated their civilization is apparently trustworthy. The traditions credit the strangers with the introduction of edible fruits and of a settled life, acts already ascribed to the people of the archaic civilization.

The Roro-speaking tribes of British New Guinea believe in a culture-hero, less definite in nature than the Nemu of the Kai,[3] called Oa Rove Marai. In the course of the development of the argument it will be seen that he is in all probability associated with the archaic civilization.

The culture-heroes of Torres Straits, between New Guinea and Australia, introduced new methods of agriculture, new ceremonies and appropriate dances. " Sida, the great culture-hero for vegetable food, came from New Guinea, where he returned after visiting the Western and Eastern Islands of Torres Straits. Everywhere he is regarded as a benefactor ; he instructed the people in language, he stocked reefs with the valuable cone shell, and notably he introduced plants useful to man. He was a very amatory person, and valuable economic plants sprang up as the result of his amours, an example of the close association in the native mind of the sexual act with agricultural fertility. The superior fertility of Mer is also accounted for by the introduction of garden plants from Badu and Moa by two heroes, and at the same time this accounts for the impoverishment of these two Western Islands. The death dances were introduced into the Western Islands by two beings from New Guinea, one of whom brought over some funeral dances to Ewaier, the smallest of the

[1] The reader will find a detailed discussion of these topics in " The Megalithic Culture of Indonesia," Chapters VIII e.s.

[2] Chinnery 282–3. [3] Seligman i. 304 e.s.

three Murray Islands. Two heroes of Mer are reputed to have been the first to build the large weirs for catching fish which they also introduced in the central islands." [1] More will be said about the heroes of the Torres Straits in later chapters, but it is clear that they are associated in tradition with those cultural elements that were ascribed to the archaic civilization, particularly food-plants.

Faint traces exist in Australia, in the shape of reported stone circles, taro growing wild, stone pestles and mortars and neolithic implements, of the former presence of civilized peoples with a culture similar to that of the archaic civilization. It has long been held that the civilization of the Australians is indigenous in origin, although in the past few years a revolt has sprung up against that point of view. Many reasons exist for concluding that the Australians have derived much of their civilization from outside, but it must not be forgotten that the Australians have something to say on the matter.

In South-East Australia certain groups of tribes have traditions of beings more or less human in form, to whom they owe their civilization. [2] These beings were the predecessors and prototypes of the blacks, who believe in their former, and even their present, existence. Their wanderings over Central Australia, the origin of the present native race, and of the sacred ceremonies, are embodied in the legends and preserved by oral tradition. The Mura-muras, as they are called by some tribes, found the ancestors of the Australians as half-formed beings and made them into human shapes. In a legend belonging to the Urabunna, the Kuyani, and the southern tribes as far as Spencer Gulf, it is said that two Mura-mura youths, coming from the north, travelled through the land, introducing the stone knife for circumcision. " After thus showing themselves in many places as life-givers, they turned back northwards, and at Lake Eyre one went to the west, and the other to the east and then to the north, taking everywhere the Tula and introducing its use. Thus they still wander, showing themselves at times as living and as life-givers." [3] These Mura-muras are now said to inhabit trees, and to be visible to the medicine-men. [4] Howitt comments upon these and other similar tales as follows : " They recognize a primitive time before man existed, and when the earth was inhabited by beings, the prototypes of, but more powerful in magic than, the native tribes. Those beings, if they did not create man, at least perfected him from some unformed and scarcely human creatures." [5]

In addition to the Mura-mura youths, some Australian natives believe in what are termed " All-Fathers," beings who have caused an immense amount of discussion. The natives have accounts of these great beings : " The Narrinyeri call the Supreme Being by the names Nurrundere and Martummere. He is said to have

[1] Haddon i. 183–4. [2] Howitt 475. [3] Id., 475–7.
[4] Id., 482. [5] Id., 487.

made all things on the earth, and to have given to men the weapons of war and hunting, and to have instituted all the rites and ceremonies which are practised by the aborigines, whether connected with life or death. . . . Nurrundere went to Wyirrawarre, taking his children with him " (Wyirrawarre being the sky). Again : " The Wiimbaio spoke of Nurelli with the greatest reverence. He was said to have made the whole country with the rivers, trees and animals. He gave to the blacks their laws, and finally ascended to the sky, where they pointed him out as one of the constellations. He is said to have had two wives, to have carried two spears, and his place of ascension is pointed out at Lake Victoria." Bunjil of the Kulin was a being of the same sort. He taught them the arts of life, and finally went up to the sky-land with all his sons. The Kurnai believe in a being, called Mungan-ngaua, who is the equivalent of Bunjil. He lived long ago on the earth, taught the Kurnai of that time how to make implements, nets, canoes, weapons, " in fact, everything they knew." He also gave them the name they have from their ancestors. His son Tundun, the ancestor of the Kurnai, finally went to the sky.[1]

All these beings are practically identical : " It seems quite clear that Nurrundere, Nurelli, Bunjil, Mungan-ngaua, Daramulum and Baiame all represent the same being under different names. To this may be reasonably added Koin of the Lake Macquarie tribes, Maamba, Birral and Kohin of those on the Herbert River, thus extending the range of this belief certainly over the whole of Victoria and of New South Wales, up to the eastern boundaries of the tribes of the Darling River. If the Queensland coast tribes are included, then the western bounds might be indicated by a line drawn from the mouth of the Murray River to Caldwell, including the Great Dividing Range, with some of the fall inland in New South Wales. This would define the part of Australia in which a belief exists in an anthropomorphic supernatural being, who lives in the sky, and who is supposed to have some kind of influence on the morals of the natives. No such belief seems to obtain in the remainder of Australia, although there are indications of a belief in anthropomorphic beings inhabiting the sky-land. That part of Australia which I have indicated as the habitat of tribes having that belief is also the area where there has been the advance from group marriage to individual marriage, from descent in the female line to that in the male line ; where the primitive organization under the class system has been more or less replaced by an organization based on locality ; in fact, where those advances have been made to which I have more than once drawn attention in this work." [2]

It is necessary to adopt some attitude towards those beliefs. It is often assumed [3] that the belief in them has developed in the minds of the natives themselves, and that they do not represent

[1] Howitt 488–493. [2] *Id.*, 499–500. [3] *Id.*, 506 e.s.

any real tradition of an alien race. It seems to me that such a point of view can only be adopted by those who deliberately ignore the actual circumstances of Australian civilization. In British New Guinea, right through the New Hebrides, in New Caledonia, are ample traces of the former presence of people far above the existing population in civilization, who probably came into the region as miners and pearl-fishers. Australian beliefs in culture-heroes are not common property, but are only told to men who have undergone a process of initiation.[1] Their careful preservation must have some traditional value. These traditions relate that the Australians owe their culture and social organization to strangers belonging to the sky-world, their indebtedness even extending to household objects such as nets. Why disbelieve them ? It is useless to say that the natives invented their material culture, their stone implements, their pestles and mortars and their complicated social organization, and then decided to group themselves in certain ways so that peoples with one form of social organization held one form of belief, while people with another held a different form of belief. There is no sign whatever of such an arrangement. The Australians do not claim to be culture carriers : in this way they differ from the Polynesians, who say that their ancestors came into Polynesia with various elements of culture. Tales told of such beings form part of the most precious knowledge that the community possesses, and for this reason they must be studied seriously. If, as is claimed, these beings are the traditional representatives of the archaic civilization, then the study of fresh groups of facts about them should reveal new relationships between them and the archaic civilization ; they cannot be put on one side as beings created by the native mind to explain customs already in existence. I shall consequently accept the tradition that culture was introduced, until it is disproved by irrefutable evidence.

This marks the end of the first part of the book. The setting for the next phase of the discussion has been formed, and attention must now be paid to the constitution of the archaic civilization itself, and to the means whereby it transformed itself when giving rise to its successors. The story, as already told, is somewhat as follows. Into a large region tenanted by food-gatherers has come a civilization characterized by certain cultural elements, irrigation, the use of stone for construction, pottery-making, the use of metals, the carving of stone images and the manufacture of polished stone implements. The introducers were men seeking for various things, who settled where they found them, and introduced their distinctive culture to varying degrees. In the course of time the communities thus established gave rise to daughter settlements, which usually lacked some of the original elements of culture. These derived communities in time gave rise to others in a yet lower stage of civilization. And so on.

[1] *Id.*, 526.

The final result of this process, continued for centuries, is seen in a number of communities, differing in culture, but all derived from those of the original archaic civilization.

This point of view is obviously opposed to that of students who are apt to use the present culture of a community as a means of gauging its place in the scheme of development of civilization. They tend to ignore tradition, which is a trustworthy witness of the past.

Any close student of ethnology knows that the theoretical side of the study has made but little progress, and this is due, in great measure, to the contempt shown by so many students for native tradition. The claim on the part of a community of low culture to have been descended from a royal family is marked down as nonsense, whereas it may be, and probably is, true. The idea of universal steady, continual upward cultural progress must be given up, once and for all, as contrary to patent facts ; and it must be recognized that civilization is an artificial product which can only thrive in certain soils, and is apt to wither or die in fresh surroundings. Far from low culture meaning primitiveness in time, it would seem invariably, putting on one side the food-gatherers, to mean degeneration. On the basis of the facts recorded in the past chapters, I shall consider the culture of all communities in the region, with the exception of obvious intrusions, such as the Aryans, as derivatives of the archaic civilization, even when their culture is as low as that of Australia, for I believe that, prior to the coming of the archaic civilization, India, Indonesia, Oceania and America were peopled by tribes with as much native culture as is exhibited by the Punan of Borneo, the Déné of the Mackenzie basin in Canada, the Paiute of Utah and others, that is to say, entirely by food-gatherers.

CHAPTER X

THE CHILDREN OF THE SUN

I PROPOSE now to examine several aspects of the archaic civilization and its successors. Political, economic, social and religious institutions will be compared, and culture-sequences will be observed, in order to see how the archaic civilization transformed itself in giving rise to its successors. The survey will begin with Egypt and work eastward to America. This is the direction followed by known cultural movements, for instance, that of the Polynesians, and it is in accordance with the known facts of chronology.

This chapter and the two following will be concerned with ruling classes, and their rôle in the development of civilization. For the first time Egypt becomes prominent in the discussion, but it will be so henceforth till the end. The examination will begin with an account of a remarkable group of people called *The Children of the Sun*, who are closely connected with the archaic civilization.

The study of the records of ancient Egypt and Sumer has shown that the earliest rulers were identified with the gods. In Egypt Osiris, the prototype of the kings, was a great national god. " In the sculptures, as well as in the hieroglyphs, it is always in the guise of a king that Osiris appears, and this aspect, too, is inseparable from his myth and his cult. . . ." It is often said that Osiris was a vegetation god, the personification of fertility, but this aspect is secondary. In the words of Dr. Alan Gardiner : " A few early passages from the Pyramid Texts and elsewhere have been quoted in support of the interpretation of Osiris as the source of all vegetable life ; but apart from the feasts the evidence, so far as the Old Kingdom is concerned, must be admitted to be very scanty and indecisive, and is completely outweighed by the evidence testifying to his kingly character." [1] The identity between the dead king and Osiris is borne out in the Pyramid Texts of the Fifth and Sixth Dynasties : " As he (Osiris) lives, this king Unis lives ; as he dies not, this king Unis dies not ; as he perishes not, this king Unis perishes not. . . . (Oh, Osiris) thy body is the body of this king Unis, thy flesh is the flesh of this king Unis, thy bones are the bones of this king Unis." [2] After

[1] Gardiner iii. For a discussion of the connexion between early kings and fertility, see Elliot Smith xx. 29 e.s. [2] Breasted iv. 143 e.s.

9 129

death the king was identified with Osiris, but during life he was identified with Horus, the son of Osiris : thus a complete identity existed between the early kings of Egypt and the gods.[1]

Sumer is a parallel case : " Among the Sumerians their rulers from the most remote antiquity were regarded always as closely related to deity. . . . They were tangible manifestations of the beautiful Tammuz child, the beloved of the great mother goddess. A . . . liturgy sung in wailings for Tammuz has a passage in which five deified kings of the dynasty of Isin are identified with the dying god." [2] The kings of Sumer were supposed to be the descendants of those who had escaped the Flood that destroyed mankind, and were thought to be sent by the gods to the earth to restore peace and prosperity, the first of these kings being Dungi, the son of the great goddess Ninsun.[3] Tammuz was the god of vegetation, and the identification of the king with him " was based upon an ancient belief that some mysterious con-nexion existed between the king and nature." [4] The king was supposed to control life on earth, rain, sunshine and harvests, and in certain festivals held in honour of Tammuz, the king played the part of the god.

In Egypt and Sumer a transformation took place in which the king, instead of being identified with a god of vegetation and fertility, was looked upon as a manifestation of the sun-god. In Egypt this took place about 2750 B.C. at the beginning of the Fifth Dynasty, when a dynasty connected with Heliopolis gained possession of the throne of Egypt.[5] Re, the sun-god, was the great god of the Heliopolitans. As under the previous régime, the king was identified not with Re, but with his son, also, like the son of Osiris, called Horus.[6] This identification was accomplished at the coronation, when the ka, the double of the hawk, which bird was intimately associated with Horus, descended from the sky and incarnated itself in the king. When the king died, the hawk-double returned to Horus, to be incarnated in the next occupant of the throne.[7] To show his divine nature, the king was given several names.[8] He had a divine birth. The sun-god told the king that he alone had created him ; " Life was an emission of fertilizing light and the creating word " ; thence the epithets of " master of the rays " and of " creator by the voice " or " utterer of words " which are given to all those who have the power of demiurges. Above all, Re, the sun, was the creator *par excellence*, and the agents of his power were his eye, the sun, Eye of Horus, and his voice, " the voice of heaven, the thunder." [9] When the god made or procreated a king, he gave him the gift of life, strength and duration, in the form of a magnetic fluid, so that in his veins ran the " liquid of Re, the gold of the gods and goddesses, the

[1] Gardiner iii. 124. [2] Langdon iv. 31. [3] *Id.*, v. p. ix.
[4] *Id.*, vi. 70. [5] Breasted v. 121 e.s.
[6] Moret i. 8, 13. [7] *Id.*, iii. 196. [8] *Id.*, i. 17 e.s.
[9] *Id.*, i. 39 e.s.

luminous fluid from the sun, source of all life, strength and persistence." [1] This fluid the king transmitted to the crown prince, who was associated with him. The accession to the throne of the crown prince was supposed to be due to divine intervention.[2] After the accession of the solar dynasty it was believed that the king was the actual son of Re, the sun-god, and this period marks the first appearance of the Children of the Sun.

The Egyptians of the Fifth Dynasty thus had thorough-going ideas of the divine nature of their kings, and it is doubtful whether the identity between royalty and divinity was carried so far in any other state. Being a god the king had, theoretically, power over the lives of his subjects and the soil of the kingdom. " With his cortège of animals tamed by his charms, with his uræus round his head, his nape protected by the hawk or vulture, he goes escorted by a lion. The Egyptians dare not look at their king. The king could bring on rain, make sunshine ; he was master of magic, the pupil of Thoth the great magician ; he was master of thunder, the uræus spitting the fire and his voice being the thunder, he brandishes his sceptre like a thunderbolt. As king of the harvest he turns over the earth and presides over the sowing. Sickle in hand he cuts the grain." [3] From him therefore could be expected the same benefits as from the gods themselves.

In Sumer, although the first gods and the first kings were, as in Egypt, connected with vegetation and water and fertility, later on the chief gods are solar gods, and the kings are also Children of the Sun. Tammuz himself was identified with the sun-god,[4] Shamash, but probably this aspect is late. The gods of Babylon, such as Marduk and his equivalents, were solar in nature, and the early kings were looked upon as their incarnations.

Egypt and Sumer, therefore, had an early phase of society in which the kings were identified with gods associated with water, vegetation and fertility. This phase was followed by another with kings identified with the sun-god, who has to some extent usurped the place of the vegetation god, the dead king. The kings are now the divine Children of the Sun, and, in Babylon, are remembered in the guise of Gilgamesh, the hero of the great epic.[5] But the custom of deification of kings did not persist in Babylon and Assyria as in Egypt. The pre-Semitic kings of Sumer were deified ; so was the Semitic dynasty of Hammurabi, under which the sun-god Shamash became so prominent. " This custom, inherited from the Sumerians, seems to have been gradually discontinued in Babylon after the Semites became the predominant race, probably because they regarded their kings, as did also the Assyrians, as containing the spirit of the gods, and therefore their (more or less divine) representatives on earth." [6] Thus the deification of kings belongs to the early phase of development,

[1] Moret i. 48. [2] *Id.*, i. 78–9. [3] *Id.*, iii. 210–19.
[4] Langdon i. 31. [5] Pinches i. 90.
[6] Pinches i. 90 : Barton 168–9.

and the culture sequence in Babylonia is one in which kings become less divine.

No trace can be detected, in India, of a stage corresponding to that of Osiris and Tammuz in Egypt and Sumer, for the earliest known kings are of solar descent. It was formerly thought that the Aryans found in India peoples lower in culture than themselves. The Vedas, and the other early compositions, recount struggles with people called Asuras (Nagas, Danavas, Dasyus, and so on). The school of Max Müller interpreted these struggles as descriptions of the contest between the rising sun and the rain-clouds ; but it is now recognized that the Asuras were actual men higher in culture than the Aryans.[1] They were probably the rulers of the Dravidian kingdoms which existed in India before the arrival of the Aryans.

The chief deity of the Aryans of India was Indra, the war-god. He slew the serpent Ahi : " With his vast destroying thunderbolt, Indra struck the darkling mutilated Vritra ; as the trunks of trees felled by the axe, so lies Ahi prostrate on the earth." [2] Again : " Indra, hero, keep up the strength wherewith thou hast crushed Vritra, the spider-like son of Danu, and let open the light to the Arya. The Dasyu has been set aside on the left hand." [3] The Danavas and Dasyu mentioned here are Asuras, enemies of the Aryans. Who was this Ahi or Vritra ? Probably he was, according to Oldham, a king. For the Bundadish of the Persians mentions Azidahaka, who overthrew Yima the first mortal.[4] The name Azidahaka was borne by a dynasty which ended with Bevarasp, who was overthrown by Feridun and condemned to be bound to Mt. Demavand, and has been equated to Astyges, who was overthrown by Cyrus.[5] " It seems," says Oldham, " that the kings of Media and other neighbouring countries, down to the time of Astyges, were serpent-worshippers, and were known by the dynastic title of Azi-dahaka. They doubtless all belonged to the same race, if not to the same tribe, as that Azidahaka who ' sawed Yima in twain.' " [6] So possibly the Ahi or Vritra who was overthrown by Indra was a king. This suggestion is supported in the Mahabharata, where it says that Vritra was "the prince of the Daityas (another name for the Asuras) who occupied the whole earth and the heavens." [7] Mention is made in the Vishnu Purana of a certain Ahi Naga, who was one of the royal family of Ajudha.[8]

It must be remembered that the Asuras were ruling families : and not the common people. In civilization they were far in advance of the Aryans " It would seem, indeed, as if the Asuras had reached a higher degree of civilization than their Aryan rivals. Some of their castles were . . . places of considerable importance. And, in addition to this, wealth and luxury, the use of magic, superior architectural skill, and ability to restore the dead to life,

[1] Bhandarkar 76 e.s. [2] Oldham 32. [3] Id., 35.
[4] Id., 37 : Carnoy 312 e.s. [5] Id., 37. [6] Id., 40.
[7] Id., 46. [8] H. H. Wilson 386.

were ascribed to the Asuras by Brahmanical writers." The Aryans got from them the knowledge of astronomy. The Asuras are credited with the foundation of many important cities in India, among them Taxila, Champa, Multan (Hiranyapura), Kosambi and others. Their chief centre was the traditional Patala, situated somewhere in the valley of the Indus, whence many colonizing movements set out. "Hiranyapura, the city of the great Asura Hiranyakasipu, and the scene of the man-lion avatar (of Vishnu) was, according to tradition, the present Multan. The great temple of the Sun, at this city, was celebrated throughout India from the earliest period to the time of the Moslem invasion."[1]

The Asura colonies of South India appear to have been Dravidian kingdoms. One of them, the result of a defeat at the hands of the Aryans, was in a land ruled over by a Naga raja, that is an Asura, which was called the "Land of Gems," and was situated under the sea. The people there had ships and fished for pearls.[2] This suggests affinities between the Asuras, Dravidians, and the people of the archaic civilization.

Certain evidence implies relationships between the ruling houses of North and South India, for Ravana, a ruler of Ceylon, an Asura, whose grandfather lived in Patala,[3] was chief of the serpents or Nagas. Ancient legends relate that the Hindus on their arrival in South India fought with chiefs of Naga, that is Asura, descent, who had the serpent banner and the title of Supreme Lord of Bhogavati, thus claiming descent from the Naga rajas of Patala.[4] Evidently the Asuras had founded colonies in South India. "Some of these colonies were in the very positions occupied by the Dravidian kingdoms; and there can be little doubt that Asura colonists were the founders of these kingdoms." Linguistically many peoples of Northern India in pre-Aryan times were allied to the Dravidians of South India. That the Northern Indian Dravidians were the kindred of those of South India is made probable by the fact that "Neither the subjugation of the Dravidians by the Aryans, nor the expulsion from Northern India of the southern Dravidians by the Aryans, is recognized by any Sanskrit authority or any Dravidian tradition."[5] Another bond of union between the Asuras and the Dravidians, lies in their common possession of the cult of the cobra, the Naga, with which the ruling families were often connected. It is usual to find images of Naga deities or kings protected by a hood of Nagas, just as the uræus protects the head of the Pharaoh.

In Northern India, in the valley of the Chenab, are tribes claiming Naga descent, called Takkha, who have serpent gods. "The forms of worship and the architecture of the temples have probably undergone little change since the days of the Mahabharata." The cobra, or Naga, is sacred to them. Their temples are dedicated to old rulers, such as Sesh Nag, Tahkt Nag, Prithu Nag,

[1] Oldham 53–4. [2] Id., 56–7. [3] Id., 61–2.
[4] Id., 61, 62, 63. [5] Id., 148 e.s.

who are therein worshipped in human form with multiple cobra-heads to protect them. The sun is carved on the roof of the temple, and ritual use is made of tridents, incense-burning, lamps, and iron scourges like those portrayed in the hands of Osiris in Egypt.[1] The temple services include sacrifices of sheep and goats, votive offerings, incense-burning, circumambulation of the temple, music and dancing. Attached to each temple is an inspired prophet called the Chela,[2] who is the mouthpiece of the god, and not a magician or sorcerer. Self-torture is customary during the ceremonies for fine weather, and human sacrifice was formerly practised.[3] Attached to the temple is a sacred grove.

The main features of Dravidian ritual are said to correspond to those of the Naga tribes of the Panjab. " Some of the deities, too, are the same. Then, the sacred groves, the temple being vested in the village communities, free from Brahmanic control, the non-Brahmanic priests, the inspired prophets, the religious dances, the circumambulation of the temples, the use of flagellation, and of the ceremonial attending on the erection of the Dhwaja or standard of the deity, are all common to the ancient, but no longer orthodox, Hinduism of Northern India, and to the unorthodox Dravidian religion of the south." Dancing-girls constitute yet another link between the two groups of peoples.[4]

Other evidence of connexion between the Nagas, or Asuras, and the Dravidians, is given by the fact that a grove is found in the south-west corner of each Nair house in South India. One such grove near Travancore is the property of a family whose ancestors are said to have been spared when the Khandava forest of the Panjab was burned by Krishna and Arjuna.[5] Each male member of the family was called Vasuki, the name of the king of Patala, the great city of the Nagas in the Panjab. The men are priests of the temple, and the women of the family carry images of serpents in processions.

For various reasons, therefore, the Asuras can be equated to the Dravidians.[6] Oldham thus sums up his discussion of the matter : " Taking into consideration all the evidence which has been put forward, the only possible conclusion seems to be that the Dravidians, of the south of India, were of the same stock as the Asuras or Nagas of the north." [7]

Some time has been spent over this matter because of its importance. In this and later chapters comparison will be made between the beliefs and practices of the Aryan-speaking peoples of India, and those with whom they came into conflict, the peoples recorded by them as Asuras, Nagas, Danavas, Daityas, and so forth. I shall assume, as a working hypothesis, that these peoples can be equated to the Dravidian peoples of historical times. The

[1] Oldham 86–7. [2] Id., 94. [3] Id., 99–100.
[4] Id., 154–5. [5] " Mahabharata " Adi Parva, Khandava ccxxix.
[6] Cf. Hewitt, 1888, 331. [7] Oldham 165.

value of this hypothesis will be tested in later chapters, where it will be found able to bear any weight laid upon it.

The rulers of the Asuras included Children of the Sun,[1] divine beings, incarnations of the sun-god himself, and thus far different from the kings of the Aryans, who contented themselves with claiming divine descent. Like the kings of Egypt, Dravidian rulers claimed the power of controlling the elements. They were even accepted as divine by the Brahmins, the most sacred beings of the Aryans ; an indication of their prestige.[2]

Those parts of Indonesia where distinct traces of the archaic civilization can be detected are associated with the Children of the Sun. The chiefs of the gold-producing region of Sonabait, who once ruled Timor, are the descendants of the sun-gods. In Central Celebes, the Toradja claim that they owe their civilization to Lasaeo, the Sun-Lord, who came to live among them. He married one of their women, and had children. His sons went to places, such as Napu and Luwu, that possessed gold, and there founded lines of chiefs. This agrees with the Luwu version in which the rulers are descended from Puang Matowa, the chief deity, who came from the sky and married a Luwu woman. This, again, agrees with the general mode of origin of Bugi ruling houses, among which is that of Luwu, which is from a being of the sky world who marries a princess of the underground world, and their descendants form ruling houses in the various Bugi States. Conformably with his mode of origin the Toradja look upon the raja of Luwu as an incarnate deity. He is the personification of the old traditions ; he is supposed to have white blood ; and no one may look at him without serious consequences.[3]

The traditions of the Bontoc of Luzon possess traces of the Children of the Sun. Lumawig, who came and civilized them, married a Bontoc woman, but their children were all killed. If they had lived it is probable that they would have been Children of the Sun, for Lumawig corresponds exactly to Lasaeo of the Toradja. The Bontoc tell a story about the Children of the Sun, which shows that they have had experience of these beings.[4]

The bringers of the use of stone and other features of the archaic civilization to Minahassa in North-East Celebes, claimed solar descent. Their ancestress was Lumimu'ut, who married her son To'ar, the Sun : thus they were Children of the Sun.[5]

The solar race of India formerly ruled over certain islands in Indonesia, and in Bali the sun-cult is still an important feature of the religion.[6] The Children of the Sun who ruled over Java were not, as has been seen (see p. 98), of the same wave of migration as those responsible for the archaic civilization of the region, but represent a later movement, led by members of the same ruling

[1] Oldham 71. [2] *Id.*, 72–3.
[3] Perry vii. 75 : Kruyt and Adriani I. 151.
[4] *Id.*, vii. 66, 72, 96, 115, 135: Jenks ii.
[5] *Id.*, vii. 78, 79, 91. [6] Friederich : Liefrinck.

family. Thus both the great civilizing movements into Indonesia were led by the Children of the Sun.

Farther to the east the Children of the Sun ruled in the past in Ponape of the Carolines, where are so many traces of the archaic civilization. These kings were called Chau-le-leur, chau meaning both king and sun. They lived at Matalanim, formerly called chau-nalan, which means " the Sun." [1] Their successors on the island do not claim such an exalted origin. The Children of the Sun still rule in San Cristoval, where are so many evidences of the archaic civilization, such as pyramids, dolmens, and so forth. They are also present in New Caledonia : when a chief dies it is said " The Sun has set." [2] Thus in those parts of Melanesia and Micronesia where the signs of the archaic civilization are most prominent, the Children of the Sun form the ruling class. They have disappeared elsewhere, if they ever existed.

It is now necessary to find if the Children of the Sun were present among the ancestors of the Polynesians. Ample evidence exists to show that the early chiefs in Polynesia were equated to gods. Fijian chiefs were supposed to control the weather and the crops. " The people of Western Vanua Levu (Fiji) believe that they have less food now than formerly because the government head of the province is not their proper chief ; when the last one who was their proper chief died ' the food was buried with him.' . . . Both chiefs and gods have certain things tabooed for their special use ; both have the miraculous power of mana, the belief in which has been claimed by some as an elementary form of magico-religious superstition ; chiefs and gods have cloaks of red and yellow feathers ; chiefs and idols have crests on their heads. Chiefs in Fiji are formally installed, the ceremony suggesting a rebirth, the probable meaning being that the chief thereby becomes a god." [3] The great chief of Mbau was the Roko Tui mbau ; he was sacred, and " at his death no cry of lamentation might be uttered, but a solemn blast was sounded on the conch-shell, as at the passing of a god." [4] These sacred chiefs seem to have ruled widespread in Polynesia : in Fiji they were called Tui, and this title was also found in Samoa, Tonga, Rotuma, and Tokelau. In some places this title once existed, but has been lost.[5] A Tahitian king was, by virtue of the coronation ceremony, made into an incarnate god.[6] He was declared to be the actual son of Oro, the great god of the people, who had been born at Opoa in Raiatea, the centre of so much Polynesian religion. " It was not only declared that Oro was the father of the king, as was implied by the address of the priest when arraying him with the sacred girdle, and the station occupied by his throne, when placed in the temple by the side of the deities, but it pervaded the terms used in reference to his whole establishment. His houses were called the

[1] Christian iii. 188 ; iv. 80 : Rivers x. 441. [2] Glaumont i. 129.
[3] Hocart iii. 637, 640. [4] B. Thompson iii. 61.
[5] Hocart vi. 44. [6] Ellis III. 108 e.s.

aorai, the clouds of heaven ; anuanua, the rainbow, was the name of the canoe in which he voyaged ; his voice was called thunder ; the glare of the torches in his dwelling was denominated lightning ; and when the people saw them in the evening, as they passed near his abode, instead of saying the torches were burning in the palace, they would observe that lightning was flashing in the clouds of heaven. When he passed from one district to another on the shoulders of his bearers, instead of speaking of his travelling from one place to another, they always used the word mahuta, which signifies to fly ; and hence they described his journey by saying, that the king was flying from one district of the island to another." [1]

Enough has been said to establish the divine nature of some of the Polynesian chiefs. The Polynesians came from some place in the west, and have wandered about the Pacific from certain centres. In the course of these travels they have lost much of their original culture, and have in many cases ceased to make the stone monuments for which their ancestors were so famous. As they now possess divine chiefs it is natural to wish to know if they formerly were ruled over by the Children of the Sun. Since the archaic civilization all over the region shows signs of similarity, it is possible that, if the Children of the Sun ruled in one place, they may have ruled in another, and that, in Polynesia, later events may have effectively masked their former presence.

In order to determine the earliest form of ruling class possessed by the Polynesians, use will have to be made of tradition and myth. I have already defined my attitude towards tradition (see p. 104). But in the case of myths it is not so easy to establish any one position. It seems best to conclude that myths contain both fact and fiction, and that it is our business to disentangle them. For that reason I shall try to confine myself to those myths that come nearest in historical sequence to actual history. That is to say, when faced with a long story of the creation of the earth and of man, and of the peopling of certain lands, I shall consider, for the present, only those statements that refer to the more immediate ancestors of man, and shall leave on one side, as far as possible, the preceding epochs. It is obvious that migrating people will take with them beliefs that will be out of place in their new home, and will also have certain traditions concerning their arrival in their new home. The two sets of belief will be preserved, and perhaps mixed, and the process thus set up will eventually produce complications. For that reason, bearing in mind the movements of the Polynesians, the study of the mythology of the eastern Pacific may be more difficult than that of Samoa, for the Eastern Polynesians have had greater historical experience of migration. It may also happen that, in the homeland, the result of wars and invasions has been to break up much of the old civilization, and obscure the past to a great extent. The most hopeful process is

[1] Ellis III. iii. 113–14 : Hawaiian sacred chiefs claim descent from gods, and rank accordingly. Beckwith 308.

that of linking up communities in a time-sequence, and then trying
to detect culture-sequences. In that way the story of the original
peopling of the last place occupied may, perhaps, give some idea
as to the time and circumstances in which the migration left the
former home. The former home may possess a tradition of
colonization, and thus carry the story one step farther back :
and so on as far back as possible. Thus, for example, the present-
day Maori claim to have come from Tahiti or Rarotonga, and say
that their ancestors were certain famous men who lived in other
parts of the Pacific. I shall therefore try to trace back the ruling
families of the Polynesians to their original homes, proceeding
from one stopping-place to another, and relying on the general
trustworthiness of their traditions as to the course of their migra-
tions. In this way it will be possible to test the value of native
tradition, as well as to obtain knowledge as to their original
cultural conditions.

One of the pivots of Eastern Polynesian civilization was the
great marae of Opoa in the island of Raiatea near Tahiti, which,
in early days, was a meeting-place for the peoples scattered in the
surrounding groups. In later days this marae was sacred to Oro,
the war-god of this part of the Pacific. But apparently this was
not always so. Indirectly, from Hawaii, knowledge can be got
of the circumstances of early days. Hawaii is connected with
Tahiti, for traditions make the Hawaiians originate thence.
Hawaiian traditions contain accounts of the conditions in Tahiti
before the old civilization broke up. They tell of gods (akua) ;
and of demi-gods (kupua), who are descended from the gods,
possess supernatural powers, can change their shapes, bring the
dead to life, fly from one place to another like the Tahitian kings,
and at death return sometimes to their ancestors in the sky.
Although the sun-cult is now absent from these islands, as well as
the Children of the Sun, a great Hawaiian princess, in the tale of
Laieikawi, marries a divine chief called " Eyeball of the Sun,"
who lives in a place called " The Shining Heavens " on the borders
of Tahiti, the ancestral home of the Hawaiians.[1] The sun-god can,
according to the Hawaiian story, come to earth : " The divine
approach marked by thunder and lightning, shaken by earth-
quakes and storm, indicates the kupua bodies in which the Sun
travels in his descent to earth." [2] Apparently the "Eyeball of the
Sun " was a kupua, for his approach is heralded in the same way.
He was divine and human at the same time, for he says : " When
the dry thunder peals again, then ceases, I have left the taboo
house at the borders of Tahiti. I am at Kealchilani, my divine
body is laid aside, only the nature of a taboo chief remains, and
I am become a human being like you." [3] These facts suggest that
the Children of the Sun once lived on the borders of Tahiti in

[1] Beckwith 295, 300, 302, 303, 308, 309, 336, 568, 570.
[2] *Id.*, 629. [3] *Id.*, 568.

" The Shining Heavens," but that they have since disappeared, and have remained on in tradition as the kupua beings, who are so closely connected with the sky. This agrees with Fornander's statement that Hiro, the first king of Raiatea, was great-grandson of the Sun.[1]

In New Zealand some of the former Maori chiefs may have been Children of the Sun. For the human race originated from Tane, a being from the sky-world, and Kurawaka, " the earth-formed Maid," who was formed by Tike the god who fashioned the first men.[2] According to Mr. Elsdon Best, Tane was probably the Sun : " Tane was the great generator, and the Maori fully grasped the power of the sun in causing growth." [3] The Maori also once possessed rites connected with the sun-cult.[4]

In Hawaii and New Zealand, both colonized from Eastern Polynesia, the sun-cult and the Children of the Sun persist only in tradition, and their former existence can only be inferred. In the Eastern Pacific, Tahiti, Rarotonga, Mangaia and elsewhere, are traces of the past existence of the sun-cult, and also of extensive displacements of older gods by newer ones. In Raiatea, where is the great marae, it is said that Ra, the sun-god, married Tu-papa, or Tu-metua, who is identical with the youngest daughter of the great mother of the gods of Mangaia, and lives with her in the underworld. Thus traces of the sun-god persist in the place whence radiated cultural influences all over the Eastern Polynesia.[5] In Mangaia, a new god, Rongo, has displaced an older deity, Tangaroa.[6] The dispossessed god was connected with the sky and, according to folk-tales, with the Sun, while Rongo is an underworld god.[7] Tangaroa retired to Rarotonga, where the earliest ruling family was founded by a certain Kariki, who was connected with the famous marae of Raiatea, where is " the stone seat of Aria " (=Kariki).[8] The family marae of Kariki is called Rangi-Maruka, or " Manu'a (=Marika) in the skies." [9] Thus this family of Rarotonga was connected both with the marae at Opoa in Raiatea, and with the sky. It is also connected with a place called Manu'a, and not with Savai'i, the place where Rongo lives. Manu'a is in Samoa, and to it all Samoan traditions point as the starting-place of their history. Tahiti was probably colonized from Samoa. So, the nature of the first rulers of Mangaia and Rarotonga, as well as of the Tahiti group, will probably be disclosed in Samoa.

The history of Samoa has been warlike for at least seven centuries, and thus its beginnings are obscure. The clue given by the family of Kariki, the first king of Rarotonga, leads back to a part of Samoa called Manu'a, which consists of the islands of Tau,

[1] Fornander 44, n. 2 : Stair iv. 104. [2] Best v. 151 ; xi. 139.
[3] Best xi. 138. [4] P. Smith vii. 24.
[5] Gill i. 6. [6] Pratt ii. 761.
[7] In the chapters on the Underworld and the Dual Organization this displacement will be further discussed.
[8] Gill ii. 634. [9] *Id.*, i. 25.

Ofu and Olosaga, of which the first only is of any importance, so that, when I speak of Manu'a, I shall mean Tau, and vice versa. According to universal Polynesian belief, the islands were lifted up from the bottom of the sea ; and, in Samoa, Manu'a, that is Tau, was the first island to appear. We thus have, in native opinion, only to do with Tau, or Manu'a, when thinking of the origin of the ruling family of Rarotonga : Manu'a is " The first resting-place of the Polynesian race . . . it is the sacred hearth-stone of the race." [1]

The origin myths of Samoa tell of the descent of the first ruling families and of the creation of men. In both cases the sun-gods are the originators.[2] The ruling family of which Kariki was a member was descended from beings called Sa Tagaloa, who lived in the lowest region of the sky, and these beings were Children of the Sun.[2] From them were derived the insignia of royalty, the titles and the magical virtue that belong to sacred chiefs descended from the beings of the sky-world.[3] The Children of the Sun once lived in Tau, at a place called Lefaga, where was built the first fale-ula, or temple, the name of which means " Shining House," and represents the ninth heaven,[4] it thus corresponding to the " Shining House " of the " Eyeball of the Sun " that was on the borders of Tahiti, a place first colonized by men from the west—Fiji, Samoa or Tonga.

The first settlement of human beings was at Fitiuta in Tau of Manu'a. Here was born Tagaloaui, a son of the sun, whose mother was Ui.[5] Ui came to Fitiuta from another country, Atafu, where they offered human sacrifice to the Sun.[6] Thus the ancestor of the ruling house of Fitiuta is descended from the Sun by a woman from a place where the Sun lived. Moreover, the people of Tutuila and Upolu, other islands of Samoa, were created by Tangaloa in a place called Malae-La, the " Village of the Sun," where he gave the command that the people of Samoa should always respect Manu'a.[7]

The claim to be descended from gods is not preposterous, for in Egypt the kings were divine, certainly when they became Children of the Sun. The ancestors of the ruling family of Samoa came from some place where lived the Children of the Sun. That again is not preposterous, for such people are definitely recorded in the Carolines, San Cristoval and New Caledonia, in direct connexion with the archaic civilization, and on the track of Polynesian migration. Samoan traditions evidently thus go back into the archaic civilization. So, from Egypt to the ends of the Pacific, the archaic civilization was apparently ruled over by the Children of the Sun, incarnate gods. These rulers have usually disappeared,

¹ Powell and Pratt 213. ² Pratt iii. 293 : F. Krämer I. 8, 22, 24.
³ F. Krämer I. 382. ⁴ Id., 385, n. 4.
⁵ Id., 370, 419. Some Samoan chiefs claim to belong to the Sa Tagaloa family. (Powell and Pratt 216.)
⁶ Pratt ii. 122 e.s. She brought two stone images with her. (Pratt 121 : Powell and Pratt 20.) ⁷ Id., ii. 274–5.

lingering only in certain secluded spots. The present-day rulers do not make such high claims, but usually content themselves with divine descent.

The case is no different in America. The earliest known kings claimed solar descent. Nothing is known directly of the rulers of the Maya while they were still in Guatemala, but they arrived in Yucatan ruled over by kings who probably claimed solar descent. In Mayapan, for example, the kings acted as the high priests of the national cult, and claimed descent from Kukulcan their culture-hero.[1] This Kukulcan was identical with a certain Zamna, who came from the west to Yucatan, and brought many arts and crafts with him. Zamna was a son of the Sun.[2] Thus the Maya kings were probably Children of the Sun. The history of royal families is confused in Mexico, owing to the many convulsions that have shaken the country. The beings credited with the foundation of the Maya and Mexican civilization are constantly referred to as gods, but there does not seem to be any evidence that the later kings were similarly regarded. At the same time, it is possible that the early rulers of Mexico were divine beings, Children of the Sun. For a certain tribe in Louisiana, called the Natchez, had ruling over them, at the time of the arrival of the Spaniards, the Children of the Sun. These men were descended from immigrants from a country in the direction of Mexico. It is said that, many years ago, there arrived a man and his wife, who came down from the sun. He came to bring to the people the rules of good government. He gave them certain laws, among them being the following : That no one must kill anyone except in self-defence ; no one must know any woman but his own ; people must not lie, get drunk or be avaricious, but must be ready to share with all.[3] This stranger further said that temples must be built in which there should be kept the eternal fire. He also brought down fire from the sun in the presence of all. The kings of the Natchez, called Suns, were intimately associated with their agriculture, and took a chief part in the agricultural ceremony, being the high priests of the sun-cult. They could bring on rain by fasting. This tradition, of the origin of a ruling family of Louisiana from the south-west, strongly suggests that the Mexicans were formerly ruled over by the Children of the Sun.[4]

Wherever it is possible to examine the ruling classes of the archaic civilization, it is found that they were what are termed gods, that they had the attributes of gods, and that they usually called themselves the Children of the Sun. This is the case in Egypt, Sumeria, India, Indonesia, Micronesia, Melanesia, Polynesia, and America—that is, from one end of the region to the other.

It is important to find that, in the earliest known phase of civilization, rulers had this exalted position, for thereby certain

[1] Spence 155. [2] Bancroft III. 462–3, 465.
[3] du Pratz 330–1. [4] Bancroft II. 146.

problems can be solved, one of the most pressing being that of culture-heroes. A people often ascribes its culture to divine beings who visited them and then went away again. It is frequently said that this being was deified by the people, that they exalted him to the rank of deity on account of his great superiority in culture over themselves. It is now obvious that this need not be the case at all, but that he may himself have claimed divine nature. It has already been stated that the characteristics of culture-heroes often constitute strong evidence of their connexion with the archaic civilization. The fact that the rulers of the archaic civilization were so often Children of the Sun can likewise be brought to help to identify these beings. For, in Indonesia, in one place certainly, and probably in others, the culture-heroes were Children of the Sun, and were associated with the cultural elements of the archaic civilization. Lasaeo, the culture-hero of the Toradja of Central Celebes, was a Sun-Lord. Lumawig, the culture-hero of the Bontoc of Luzon, was probably also a son of the Sun, for he belonged to the sky-world. It is also said that the Children of the Sun taught the Bontoc head-hunting. So it is possible to bring the culture heroes of the peoples of Indonesia into line with the former rulers of the archaic civilization, and to claim that the native traditions are not the product of imagination, but records of historical events. Apparently the only difference between the Children of the Sun as culture-heroes, and the Children of the Sun as the founders of ruling houses, lies in the fact that the former did not leave descendants to rule over the people among whom they stayed. So the claim that a people owes its culture to a divine being from the sky can be looked upon as meaning that they were visited in the past by men of the archaic civilization who made no permanent settlement.

The American peoples have many traditions of culture-heroes. In the words of Brinton : " The native tribes of this continent had many myths, and among them there was one which was so prominent and recurred with such strangely similar features in localities widely asunder, that it has for years attracted my attention, and I have been led to present it as it occurs among nations far apart, both geographically and in point of culture. The myth is that of the national hero, their mythical civilizer and teacher of the tribe, who, at the same time, was often identified with the supreme deity and the creator of the world. It is the fundamental myth of a very large number of American tribes, and on its recognition and interpretation depends the correct understanding of most of their mythology and religious life.

" The outlines of the legend are to the effect that in some exceedingly remote time this divinity took an active part in creating the world and in fitting it to be the abode of men, and may himself have formed or called forth the race. At any rate, his interest in its advancement was such that he personally appeared among the ancestors of the nation, and taught them the

useful arts, gave them the maize and other food-plants, initiated them into the mysteries of their religious rites, framed the laws which governed their social relations, and thus, having started them on the road to self-development, he left them, not suffering death, but disappearing in some way from their view. Hence it was nigh universally expected that at some time he would return.

" The circumstances attending the birth of these hero-gods have great similarity. As a rule, each is a twin or one of four brothers born at one birth ; very generally at the cost of their mother's life, who is a virgin, or at least had never been impregnated by mortal man. The hero is apt to come into conflict with his brother, or one of his brothers, and the long and desperate struggle resulting, which often involved the universe in repeated destructions, constitutes one of the leading topics of the myth-makers." [1]

These twins were the Children of the Sun, which is shown in many a legend. The Zuni, one of the tribes of the Pueblo Indians, say that they were formed first in the Womb of the Earth.[2] The great sun-god impregnated a foam cap with his rays, and produced twins, the Children of the Sun, to whom he gave knowledge and domination over men.[3] These twins went into the bowels of the earth, and, after many adventures, brought the Zuni out into this world, where, in conjunction with the priests, they ordained their social organization and institutions.[4] Likewise the Hopi were led out of the underworld by the Twin Children of the Sun.[5] The Huron tale may be taken as another example. They were an agricultural tribe, with a highly developed culture similar to that of the southern peoples. In their cosmogony they say : " In the beginning there was nothing but an endless sea under the pristine sky-world. From among the semi-divine people dwelling in the sky an ill-fated woman fell into the lower water regions. Water-fowl rescued her ; and the human-like quadrupeds built an island for her on the Big Turtle's back out of some mud secured from the bottom of the sea. While the island was being enlarged into a continent, the Small Turtle was sent into the sky to create luminaries. She made the sun, the moon and the stars out of lightning and assigned them their course along the various paths in the solid arched vault of the sky. The sun and the moon had to travel westward across the sky once a day ; but the world being flat and the heavy edges of the sky vault resting on the water around it, these luminaries could not return to their starting-point in the east. The Turtle, therefore, bored a passage under the earth, thus allowing them to proceed across the underworld at night, and, in the daytime, through the sky. Once a quarrel broke out between the divine but human-like sun and moon, the

[1] Brinton 27–8. [2] Cushing ii. 379.
[3] *Id.*, 381–2. [4] *Id.*, 382 e.s.
[5] Fewkes iv. 266. " Every new variant of the story of the birth of the little god reiterates the statement that he and his twin brothers were sons of the Sun " (*id.*, i. 49).

results of which are still felt to this day in their phase and variations. On the island the woman gave birth to mysteriously begotten boy-twins, or—according to another tradition—to a daughter who died at the birth of her own twin children. Of the twins one was good, the other bad. Their mission was to prepare the island for the coming of man. All the good things came into this world through the good twin, and all evil through his wicked brother. The rival creators finally fought a duel to decide who would remain supreme on the island. The bad twin was slain by his more powerful brother, who restored the island and called the Indian man forth. As the good one could not entirely blot out the traces of his brother's work, evil has survived to this day, to the greatest detriment of mankind. Death, so far unheard of, for the first time appeared at the downfall of the evil twin or, according to other versions, when the mother of the twins died. Both the deceased woman and her evil son have since remained in charge of the souls of the dead, in the underground or western world ; and the Milky Way is the road along which the souls slowly proceed into their distant and peaceful abode. As to the good twin, it is believed that after he had taught man various arts and precepts, he established his new home far away in the east, where the sun rises. There he is still, subject to all the necessities of life, regulating the seasons from afar, overseeing the harvest and protecting his people." [1] The good twin gave them their life in the beginning.

The Indians of North America are probably the cultural descendants of the Maya. It is therefore in keeping with such a view that they should ascribe the beginnings of their civilization to the Children of the Sun, since those beings evidently ruled over the Maya.

North American peoples agree with those of Indonesia in claiming that their civilization was brought by the Children of the Sun, but they differ in stating that these culture-bringers were brothers, sometimes twins. The extraordinary nature and mode of origin of these twins will have to be explained. It is possible to suggest an explanation of the statement that their mother belonged to the sky-world, and bare her children on earth, or brought them to the earth. For the son of the Sun in Manu'a of Samoa had as mother Ui, who came from a place ruled over by the Sun (see p. 140) ; the Children of the Sun came to Manu'a from the sky (see p. 140) ; also the Great Eyeball of the Sun in Hawaiian tradition lived in The Shining Heavens on the borders of Tahiti (see p. 138). So the claim that a woman came from the sky may simply mean that she came from a place ruled over by the Children of the Sun. In that case the Children of the Sun can be put down as members of the ruling family of the archaic civilization, but their twin nature will have to be reserved for later discussion (see p. 328).

This leads to the question of the culture-heroes of Australia.

[1] Barbeau ii. 7–8. Cf. also Dixon.

They are divided into two groups. One consists of pairs of youths who wandered about the country civilizing tribes, and then departed to some other part of the earth. The other culture-heroes, the All-Fathers, as they are called, live now in the sky. It may be that the two youths correspond to the twin Children of the Sun of America. But what of the All-Fathers ? They are connected with the sky, and thus presumably can be equated to the people of the archaic civilization. But why should they so differ from the other culture-heroes ? This difficulty cannot be considered until other data have been adduced. It will be found that other remarkable cultural distinctions exist between the groups of tribes that hold these distinct beliefs (see p. 249).

This discussion ends with the suggestion that the Children of the Sun were men who posed as incarnate gods, apparently with mothers more or less human. The accounts of times when gods walked the earth, that many people possess, may contain a historical foundation in the claims of these heroes. Such beings are of the past, and their memory persists to tantalize us with its vagueness.

10

CHAPTER XI

THE COMING OF THE WARRIORS

THE Children of the Sun were closely connected with the archaic civilization. Their disappearance from the scene, which has so often happened, was accompanied by certain cultural transformations which will have to be discussed. In this chapter it will be shown that the sun-cult was a constant feature of the archaic civilization, and that it disappeared, the sun-god being replaced usually by a war-god. It will also be shown that this change in deities was accompanied by a change in the habits of such communities, by the adoption of a more warlike behaviour.

Once established the sun-cult was always prominent in Egyptian religion. But later on, under the rule of Thebes, the sun-god became more definitely warlike than in the earlier stage.

In Babylonia and Assyria a definite transition to a war-god can be observed. Tammuz, the god of the Sumerians, was first connected with vegetation and fertility, and kings were indentified with him. Very soon, however, in Sumerian history, he is associated with the sun-god Shamash, who is an important Babylonian god.[1] Although the religion of the Babylonians shows many signs of continuity with that of Sumeria, the religion of Assyria, a Babylonian colony, reveals traces of profound political changes. Ashur, the great god of the Assyrians, was a war-god.[2] He evidently was the product of a process of development such as produced Ramman or Rimmon, the Assyrian god of thunder, lightning, wind and storm, who was originally identified with Shamash, the Babylonian sun-god.[3] The culture-sequences in the case of the Sumerians, Babylonians and Assyrians show that the chief gods are first vegetation and fertility deities, then sun-gods, and then war-gods.

In India the transformation is from sun-god to war-god, for there are no signs of the Tammuz-Osiris stage. The culture-sequences that can be observed are those between the Aryans and Asuras, and between the early and late stages of the Aryans themselves.[4] The sun was a great god of the Asuras, and has

[1] Langdon i. 31. [2] Barton 221: Jastrow. [3] *Id.*, 224 e.s.
[4] By " Aryans " is meant " peoples speaking Aryan languages." Similarly with " Dravidians " and " Austronesians."

146

continued so in those parts of India under Dravidian influence. Peoples such as the Mundas of Chota Nagpur, who speak an Austronesian language, the Gonds, Khonds and other Dravidian tribes, have the sun-god as their chief deity. The sun is an important god among many of the Hindu sects of Southern India, the region where Dravidian influence is so powerful. The Aryan-speaking peoples, on the other hand, had Indra, a war-god, as their chief deity.[1] So, in the culture-sequence between Aryans and Dravidians, the sun-god is followed by a war-god. But it is possible to go farther, and to establish a culture-sequence among the Aryans themselves. It is known that Indra had, some time before the compilation of the Rig Veda, supplanted a group of sun-gods, headed by Varuna, who were the children of Aditi, the great mother of gods and men.[2] These sun-gods are common to the Aryans of India and those of Persia before the Zoroastrian reform, and among them is Mithra. So, among the Aryans themselves, a war-god had come to the front. Varuna himself lost his solar character, and became a creator god and god of waters. In Vedic India, as in Assyria, the sun-gods are trans-forming themselves, and also being supplanted by war-gods.

A culture-sequence can be established in Indonesia. For in Borneo, the Kayan, who have immigrated later than the Hindus, have no sun-god, and no ruling class of Children of the Sun. Their supreme god is Laki Tenganan, who is not endowed with special functions,[3] but is looked upon as a fatherly being who watches over their interests. He is identical with the supreme being of the Kenyah and Klemantan, tribes whom the Kayan have civilized. He is apparently not the creator, but the Kayan are not clear on this point; at any rate he does not figure in the creation myth.[4] The most important of their ordinary gods is Toh Bulu, the war-god.[5] The Kayan—this obviously means the chiefs—claim descent from gods, especially Oding Lahang, who acts as intermediary between men and Laki Tenganan.[6] Oding Lahang, they say, was a chief who lived long ago. It is interesting to note his ancestry. "In the beginning there was a barren rock. On this the rains fell and gave rise to moss, and the worms, aided by the dung-beetles, made soil by their castings. Then a sword handle (haup malat) came down from the sun and became a large tree.[7] From the moon came down a creeper, which, hanging from the tree, became mated with it through the action of the wind. From this union were born Kaluban Gai and Kalubi Angai, lacking the legs and lower half of their trunks, so that their entrails hung loose and exposed. Leaves falling from the tree became the various species of birds

[1] Barnett 22. [2] *Id.*, 18 : Barth 18.
[3] Hose and McDougall II. 5. [4] *Id.*, II. 6–7.
[5] *Id.*, II. 5. Toh Bulu means "feather-spirit" or "spirit of feathers" (II. 18).
[6] *Id.*, II. 10. [7] *Id.*, II. 137.

and winged insects, and from the fallen fruits sprang the four-footed beasts. Resin, oozing from the trunk of the tree, gave rise to the domestic pig and fowl, two species which are distinguished by their understanding of matters that remain hidden from all others, even from human beings. The first incomplete human beings produced Pengok Ngai and Katira Murei; the latter bore a son, Batang Uta Tatai, who married Ajai Avai and begot Sijau Laho, Oding Lahang, Pabalan, Pliban, and Tokong, who became the progenitors of the various existing peoples. Oding Lahang is claimed by the Kayans as their ancestor, and also by some of the Klemantan tribes." [1]

This story raises an important point in mythology. The history of the Kayan tends to connect them with the Hindus of Java.[2] Their chiefs claim descent from the sky, and, indirectly, from the sun. Their most prominent deity is a war-god. But what is the function of Laki Tenganan, their supreme being? What does he mean in their history? He is identical with the supreme being of the Kenyah and Klemantan tribes, whom the Kayan probably have civilized. This god means something in the past history of the Kayan, and possibly he was connected originally with the sun, from which the ancestors of Kayan chiefs seem originally to claim descent. If Oding Lahang, their great ancestor, were one of the Children of the Sun—he certainly is in the line of descent—and if he usurped the place of Laki Tenganan, then it is possible that the creation story presents history through a refracting medium that has distorted the original nature of Laki Tenganan.

The process may have been similar to that of India, where Varuna, originally a sun-god, has been pushed into the background by a war-god, and has lost his solar character. Were it not that other information exists about Varuna, it would not be possible to know that he was originally a sun-god. The case may be the same with Laki Tenganan. Another important tribe of Borneo, the Iban or Sea Dyak, have war-gods as their chief deities.[3] Borneo tribes thus show signs of contact, in the past with the Hindu caste of the Children of the Sun; their chiefs seem originally to have claimed descent from the sun; their chief deity possibly changed from a sun-god into a vague supreme being with no cult; and war-gods have come into prominence.

The culture-sequence of sun-god and war-god can be established in the Pacific. The Carolines, or at least Ponape, formerly had the Children of the Sun as rulers. Then came invasions, and in Ponape the chief god is Tokata or Taukatau, which name is that of the king of Kusaie-Tokasa—whence came invaders who broke up the former civilization.[4] Another account, that of Christian, says that the Children of the Sun were wiped out by warlike

[1] Hose and McDougall II. 138. [2] Id. I. 15.
[3] Id., II. 85. [4] Hahl 1.

peoples from the south, led by Icho-Kalakai, who became their war-god.[1]

With the exception of San Cristoval, New Britain, New Ireland, the Bismarck Archipelago and New Caledonia, the sun-cult is a thing of the past in Melanesia. It is said formerly to have existed in the southern part of the New Hebrides, representations of the sun having been found on rocks in Anaiteum.[2] In New Zealand, along with traces of the Children of the Sun, go certain indications of the former existence of a sun-cult among the ancestors of the Maori, who mention a sacred mountain in their homeland, which is the abode of the Bird of the Sun, so well-known in connexion with the sun-cult from Egypt to America.[3]

Although Melanesia and Polynesia possess traces of a former sun-cult, yet most of the important Polynesian gods are war-gods, who often have demonstrably displaced solar gods.[4] The original rulers of Tau, that part of Manu'a where originated the first ruling families of Samoa, were Children of the Sun. Tagaloa Ui, the son of the Sun and of Ui, a woman who came from a country that possessed a sun-cult, had a son Taeotagaloa, whose sister was the wife of the Tuafiti, that is, the ruler of Fiji.[5] Taeotagaloa married two girls. Each bare a son on the same day, and the ruling power of the two parts of the island was divided between them. When the sons had been instituted by Taeotagaloa in their offices, he said to his brother Le Fanonga, " You stop here in the east and be the war-god of Fitiuta, but I will go and be the war-god of Le-fale-tolu."[6] Taeotagaloa was a son of the Sun : he changed himself deliberately into a war-god. Henceforth the sun-god disappeared from the active cult, and persists only in tradition and myth. Taeotagaloa was the last god of the sky-world who had intercourse with the Samoans : one authority claims that he was the first man, and his son the first human king. It is significant that, at the moment when human dynasties are inaugurated, the beings who previously had been Children of the Sun become war-gods. It would be worth much to know exactly what happened at this moment ; some important historical event must have occurred to cause this profound change. For Taeotagaloa evidently was a real being, in that he is the traditional representative of the Children of the Sun, who came to Tau of Manu'a in Samoa to live. These Children of the Sun went back to the sky, that is, back home, and left the ruling power in the hands of the Ali'a family, members of which spread to Tahiti, Rarotonga and elsewhere.[7]

[1] Christian iv. 84. [2] Rivers x. ; xii. [3] Best x.
[4] Fornander mentions a former sun-cult in Tupai of the Society Group (44, n. 2). [5] Pratt ii. 25.
[6] Pratt iii. 294–5. Le Fanonga and his brothers went to Upolu and became presiding deities (Stair ii. 49).
[7] From the time of disappearance of the Tagaloa family, Samoan chiefs are called Tui, a title similar to that found in Fiji and Tonga. These Tui chiefs are really war chiefs, for they take no part in the administration of the state.

Oro, the god of the marae of Opoa in Raiatea, was the chief god of Tahiti and the Leeward Islands, and the kings of Tahiti in their coronation ceremony became his sons. The Tahitians claimed that Oro originated at Opoa, whence his worship spread to the neighbouring islands, and throughout the Paumotu group. He was the great god of war in Eastern Polynesia,[1] and is equated to Rongo, the great god of Mangaia in the Hervey Group.[2] Rongo was the twin brother of Tangaroa in Mangaia.[3] Tangaroa was the elder and was connected with the sky. He is identical with Tangaloa of Samoa, and thus is really a sun-god. Rongo, on the other hand, is connected with the underworld, where lives the great mother of gods and men. On account of the favouritism shown for Rongo by his mother, Tangaroa went to Rarotonga and settled there, leaving Rongo in possession in Ma ngaia. So the sky-god has retired, leaving the war-god in possession.

The first king of Mangaia, where Rongo dispossessed Tangaroa, was Rangi, who is said to have come from Savai'i, a name of one of the islands of the Samoan group. Since Savai'i occurs so often in Polynesian tradition, and in connexion with widely separated places, it is well not to rely on this. But Savai'i in Samoa is so closely connected with the underworld that Rongo, the god of war, whose son Rangi was the first king of Mangaia, might well, together with his son Rangi, be connected with it. The picture is completed by finding that, in Rarotonga, the island to which went Tangaroa, when disgusted with the favouritism shown to Rongo, the ruling family was founded by Kariki from Manu'a in Samoa, who was descended from the sky-gods. Thus the place with sky-gods is ruled over by people claiming descent from a sky-god, in fact, from the sun; while a place with a war-god, who rules in the underworld, has a king who comes from a place closely connected with the underworld, which, in the case of the Samoan Savai'i, was ruled by families claiming descent from Manu'a, where the sun-god had changed into a war-god.

Behind all this mythology, therefore, a political revolution is being accomplished. The Children of the Sun have vanished, and their place is taken by other rulers ; and the sun-gods give way to war-gods.[4] Thus it is natural to find that, as in New Zealand, all male children are dedicated to the war-god.[5]

The earliest great god of North America was the sun-god, who, in certain parts, reigned supreme to the end. But in Mexico he became partly superseded, but not so much as in Polynesia. Just before the arrival of Europeans, the Aztecs came from the north and seized power in Mexico. They differed in culture from the sedentary agriculturists whom they conquered, and this

[1] Gill i. 14. [2] *Id.,* ii. 635. [3] *Id.,* iv. 10–11.

[4] In Mangaia a king, Tiaio, became a war-god. The Mautara, a priestly tribe, gave up their ancient divinity, Tane, in favour of this new god. The greatness of Tiaio marks the political supremacy of that warlike clan, which is of recent origin (Gill i. 30).

[5] Best vi. 456 ; xi. 128.

difference is shown in their pantheon. They had a war-god, the protector and leader of the tribe, who had come with them on their wanderings, named Huitzilopochtli. According to one account, Huitzilopochtli was a deified man. It is said that when pushing their way to Mexico, the Aztecs had a leader named Huitziton, who, one night, was translated to the sky and presented to the god Tezauhteotl, the frightful god, who had the form of a horrible dragon. The god welcomed him, and thanked him for governing his people ; and, saying that it was high time he was deified, told him to go to earth and tell the people of his impending departure, and to say that his skull and bones would be left with them for protection and consultation. This new deity was called Huitzilopochtli, for the Aztec thought that he was seated on the left hand of Tezcatlipoca. They took his relics with them to Mexico, whither he is said to have guided them. He directed the manner of sacrifice that he wished ; for, some priests who had offended him having been found one morning with their breasts cut open and their hearts pulled out, this was adopted as the common mode of sacrifice. Thus in yet another culture-sequence does a war-god supersede a sun-god.

The Zuni Indians of the Pueblo region afford a remarkable instance of the transition from a sun-god to a war-god. They are formed of the amalgamation of two peoples : a branch that probably is descended from the old cliff dwellers, the people of the archaic civilization ; and a branch from the west or south-west, less advanced in culture, who did not cultivate the soil to any extent before their arrival in Zuni-land, who became the dominant branch of the tribe.[1]

The Zuni have a long creation myth, which, according to Cushing, is that of the later and less civilized part of the nation. It is to the effect that the All-Father Father created himself as the Sun, "whom we hold to be our father." With his appearance came the water and the sea. With his substance of flesh out-drawn from the surface of his person, the sun-father formed the seed-stuff of twain worlds, impregnating therewith the great waters, and lo ! in the heat of his light those waters of the sea grew green and scums rose upon them, waxing wide and weighty until, behold, they became Awitelin Teita, the " Four-fold containing Mother Earth," and Apoyan Tachu, the " All-covering Father Sky." These produced all life in the four-fold womb of the Earth. The earth-mother pushed apart from the sun-father, and man took form in the lowest cave-womb. Then a being called " the all-sacred master " appeared in the waters and arose to ask the All-Father for deliverance. The sun-father impregnated a foam-cap with his rays and incubated it, so that it finally gave birth to twins, the Beloved Preceder and the Beloved Follower, to whom the sun-father gave knowledge and leadership over men.[2]

[1] Cushing ii. 342–3. [2] *Id.,* 379, 381–2.

With their magic knives the twins cleft asunder the Mountain of Generation, and went beneath into the underworld, to their subjects.[1] When they got on the earth they at once set out to find the " middle," the navel of the earth, where they should make their permanent settlement. It was in those days that war began. " At times they met people who had gone before, thus learning much of ways of war, for in the fierceness that had entered their hearts with fear, they deemed it not well, neither liked they to look upon strangers peacefully." [2] Finally they met the dew-people, who claimed to be their elder brothers, and the two groups joined company.[3] After several stays in different places " they sought more often than ever to war with all strangers (whereby they became still more changed in spirit.) "

The twin Children of the Sun, well aware of the temper of the people, changed also in spirit. They founded the Society of the Knife, " the stout warriors of the Twain."

> " Of blood we have tasted the hunger,
> Henceforth by the power of war,
> And the hazard of omens and dance,
> Shall we open the ways for our people
> And guide them in search of the middle.
> And our names shall be known as the Twain
> Who hold the high places of Earth.
>
> Come forth, ye war-men of the knife,
>
> Our chosen, the priests of the bow.
>
> Ye shall changed be forever,
> The foot-rests of eagles
> And signs of our order." [4]

The twins were " strong now with the full strength of evil . . . Twain children of terror and magic were they." [5] Finally their wanderings ended, and they met the black people of the high buildings, their elder brethren, and amalgamated with them.[6]

This story, to my mind, is one of the most remarkable ever recorded. It is a piece of social psychology beyond price, showing, as it does, the change of behaviour in a people as the result of warfare, and the consequent change in their gods. It is remarkable that the Zuni priests should so accurately have analyzed the causes of this change of temper, and have recorded them so faithfully. It has already been claimed that a continuity exists between the archaic civilization and those that followed. In this case the signs of such a continuity are clear. A people begins with the Children of the Sun as their culture-heroes, the twain beloved, and ends with them in the guise of war-gods.

In the Mound area the sun-cult existed universally, and, as has been seen, the Children of the Sun were ruling over some tribes in post-Columbian times. But those tribes who got horses from the

[1] Cushing, 382–3. [2] *Id.*, ii. 390. [3] *Id.*, 397–8.
[4] *Id.*, 417–19. [5] *Id.*, ii. 422–3. [6] *Id.*, 426.

Spaniards, and went across the Mississippi after the buffalo, suffered many transformations in their material culture. Their religious and social organization also was much altered. The process varied with the tribes, so, in comparing the Plains Indians with those of the Mound area, it will be well to begin with the most extreme example. The great Siouan family of the Plains was split into several divisions. One of them, the Omaha, which possesses traditions of movement across the Mississippi from the eastern States, has lost much of its old culture. The tribe has two divisions, each of which plays an important part in the communal life. One half possesses the rites that appertain to the relationship between the individual and the cosmic powers, while the other has those that are more utilitarian, and those that pertain to war. In the course of the wanderings of the tribe, most of the first set of rites have disappeared, while the practical ones are retained. They now have no sacred chiefs, and the only approach to a god is the thunder being, so closely connected with war, who is in the sky, and is sometimes addressed as Grandfather. Certain ceremonies are performed for each individual, such as the Introduction of the Child to the Cosmos ; Turning the Child ; and the Consecration of the Boy to the Thunder, that is, to the war-god, who was invoked by the warriors.[1] No trace exists of the sun-cult among the Omaha, and no Children of the Sun rule over them.[2]

Evidence that the Siouan family once had the sun-cult is afforded by the fact that the chief deity of the Mandan, " The Lord of Life," is said to live in the sun.[3] It is important to note that the Mandan approximate closest in culture to the people of the eastern States, for they have retained maize cultivation to a considerable degree, and have not neglected it like the Omaha and others. Certain other cultural features also show them to be nearer to the archaic civilization than the Omaha, who have lost so much while wandering across the Mississippi. The old sun-cult has also not entirely died out among the Hidatsa, Tciwere, Winnebago and other Siouan tribes.

In North America, therefore, historical events have caused certain tribes to lose the sun-cult that their ancestors possessed. Thus the culture-sequence of the Indian tribes is similar to that of the rest of the region, namely, from sun-god to war-god.

This survey shows that the peoples who followed the archaic civilization, or were derived from it, in any spot, differ considerably from those of the archaic civilization, not only in material culture, in the absence of stone-working, irrigation and so forth, but in other ways ; for they have often replaced sun-gods by war-gods ; and also lack a ruling class of Children of the Sun.

The widespread existence of remains of the archaic civilization

[1] Fletcher and La Flèsche 195, 199, 200, 382.
[2] J. O. Dorsey ii. 430 e.s. [3] *Id.*, 506, 507.

in places occupied by communities not capable of their construction shows that there must be a profound difference between the two cultural phases. There is every reason to believe that the later comers were intellectually equal to the peoples of the archaic civilization ; they simply lacked the necessary organization. Why was that ?

The answer to this question apparently lies partly in the fact that the later comers were more warlike than the peoples of the archaic civilization. In the days of the archaic civilization wars were not frequent, and time and energy were available for great works. But the later communities became educated in war, and gave up constructive work in favour of domination.

It is an error, as profound as it is universal, to think that men in the food-gathering stage were given to fighting. All the available facts go to show that the food-gathering stage of history must have been one of perfect peace. The study of the artifacts of the Palæolithic age fails to reveal any definite signs of human warfare. A critical analysis of the industry of this age in its various phases shows that the minds of the people were intent on their food supply and on art, which, itself, was probably connected with the food supply ; and that the various inventions made in their flint industry were improvements in implements for preparing food, and in modelling tools and other means of exercising their artistic capacities, which were considerable. Such matters are, however, outside the scope of this book, for the great bulk of these remains are in Europe. Some are in India and Tasmania, and none of them indicate warlike activities.

The best evidence of the peaceful tendencies of early man is provided by existing food-gathering communities in various parts of the region. In another place I have collected the descriptions of the early food-gathering communities in all parts of the world, and the unanimous testimony of the authorities leaves no room to doubt that these peoples are peaceful, and entirely lacking in any cruel mode of behaviour.[1]

The coming of the archaic civilization into the outlying regions of the earth therefore meant the beginning of war. But only in the later phases did war become serious. The people of the archaic civilization were comparatively peaceful, as the following accounts show.

Professor Breasted describes the Egyptians as " usually unwarlike . . . naturally peaceful." [2] They became warlike as a consequence of the invasion, about 1688 B.C., of the Hyksos, who dominated the country for some time, but were ultimately driven out. " It was under the Hyksos that the conservatism of millennia was broken up in the Nile Valley. The Egyptians learned aggressive war for the first time, and introduced a well-organized military system, including the chariotry, which the importation of the horse by the Hyksos now enabled them to do.

[1] Perry vi. [2] Breasted iii. 193, 319.

Egypt was transformed into a military empire. In the struggle with the Hyksos and with each other, the old feudal families perished, or were absorbed among the partisans of the dominant Theban family, from which the imperial line sprang. The great Pharaohs of the Eighteenth Dynasty thus became Emperors, conquering and ruling from Northern Syria and the upper Euphrates, to the fourth cataract of the Nile on the south." In the earliest phases of Egyptian history, the king had no regular army : each nome had its militia, commanded by civilians. There was no caste of officers. In case of serious war the militias were grouped together as well as possible and put under a leader chosen from the officials. "As the local governors commanded the militia of the nomes, they held the sources of the Pharaohs' dubious military strength in their own hands." [1]

In Babylonia the sequence in deities is that of Tammuz-Shamash-Ashur. No signs exist of warfare in connexion with Tammuz ; his attributes are the reverse of pugnacious or cruel. In connexion with the sky-gods signs exist of war. But the Assyrians were extremely warlike, as is shown by the following statement : " The Assyrian was even more than most of the empires of antiquity a well-organized fighting machine, and, as all the statements about Ashur occur in inscriptions written after the era of conquest began, they necessarily represent Ashur as a god of war." [2] They thus differed entirely from the Sumerians and Egyptians. The story of Egypt, Babylonia and Assyria is thus one of education in warfare, and in Mesopotamia, along with this change in behaviour, went a change in the ruling families, and in the gods connected with those families.

In India, as elsewhere, the old civilization succumbed to the onslaughts of conquerors who added but little to the cultural heritage of the country. India owes most of its civilization to people who were more peaceful than their conquerors. The Dravidian peoples were not warlike in the same way as the Aryans : they were agricultural, and lacked that element of mobility so characteristic of the great warrior peoples of history. Beyond doubt the break-up of civilization in India was due to the incursions of warlike peoples. Otherwise there appears to be no reason why this civilization should not have persisted indefinitely.

In Cambodia the downfall of the great Khmer civilization, of Dravidian origin, was due to the irruption of the Tai-Shan peoples from Yunnan, with a much inferior civilization but a more warlike behaviour. [3]

Although the States of Southern Celebes have always possessed a military organization, the heads of which were princes of the royal blood, yet the warfare seems to have been of a half-hearted sort. These States had no real armies, which seems to suggest that only officers existed. " It is evident from this that the war-

[1] Breasted iii. 19, 82. [2] Barton 221. [3] Haddon ii. 30-2.

fare must have been of a very different type from that of Europe." [1]
The military organization is thus directly similar to that of ancient
Egypt, being of the nature of a militia, and not a professional
army, such as exist in later civilizations in Indonesia and elsewhere.

The great civilization in the Carolines owes its downfall to
warlike invasions. It is said, in one set of traditions, that Yap
was invaded by warriors, so that the people fled to Ponape. Then
came a great fleet from Koto (? Kusaie) under a certain Ijokalakal,
which captured Ponape ; after this the old customs began to die
out. Another tradition shows how the break-up of a community
can be due to internal causes. Formerly, it is said, a single king
ruled over Ponape. He lived at Metalanim at a place called
Pankatara. This king sent his nobles to rule the provinces, and
in time they became independent, his power was undermined, and
probably wars between the different governors became frequent. [2]

If culture-heroes, who visit food-gatherers and civilize them,
are representatives of the archaic civilization, and if the food-
gatherers were peaceful before their arrival, it follows that peoples
with culture-hero traditions would probably state that they got
their warlike habits from these strangers. This is expressly so
claimed in British New Guinea. Oa Rove Marai, the culture-hero
of the Mekeo people, having quarrelled with the people of some
other village, sent for the Mekeo people, gave them spears and
black palmwood clubs, and sent battle, theft and adultery among
them, and sorcerers to kill people. Thus death came among
them. [3]

Similar traditions exist in Australia. For example, the great
being of the Kurnai, Mungan-ngaua, is said to have given the
people their weapons : " They are told that long ago he lived
on the earth, and taught the Kurnai of that time to make imple-
ments, nets, canoes, weapons—in fact, everything that they
know." [4]

Evidence exists with regard to the former peaceful nature of
Oceania. With regard to the general question, I venture to quote
the words of Mr. A. N. Hocart. He says : " My belief is that a
highly civilized people with a theory of kingship akin to the
Egyptians and of a peaceable nature occupied the South Sea
Islands (with the possible exception of (?) peaceful aborigines in
the interior of the larger islands). [5] They were gradually pushed
back towards the East by various peoples with whom warfare
was a religious function ; and who consequently were constantly
fighting and killing. I should not like to say that the original
civilized inhabitants never did fight, but they certainly did not
make fighting a regular practice." He refers to the fact that the
Tongans have traditions of the times when wars were not, and

[1] Bakkers iv. 80. [2] Hahl i. [3] Seligman i. 308. [4] Howitt 493.
[5] Cf. F. Krämer I. 394, who says that doubtless in the earliest times peace
reigned over Fiji, Samoa and Tonga and Western Polynesia in general. The
quotation from Mr. Hocart is from a letter.

goes on to say, " wars, or at least frequent wars, were certainly imported into Tonga from Fiji. In Fiji one can almost see the war-gods moving East."

The Tongan tradition is recorded by Mariner. " At the time when Captain Cook was at these islands, the habits of war were little known to the natives; the only quarrels in which they had at that time been engaged were among the inhabitants of the Fiji Islands. . . . The bows and arrows which before that period had been in use among the people of Tonga were of a weaker kind, and fitted rather for sport than war—for the purpose of shooting rats, birds, etc. From the fierce and warlike people of (Fiji) . . . however, they speedily learned to construct bows and arrows of a much more martial and formidable nature ; and soon became acquainted with a better form of the spear, and a superior method of holding and throwing that weapon. They also imitated them by degrees in the practice of painting their faces, and the use of a peculiar head-dress in time of war, giving them a fierce appearance, calculated to strike terror into the minds of their enemies. These martial improvements were in their progress at the time of Captain Cook's arrival, but not in general practice, for having few or no civil dissensions among themselves, the knowledge of these things was confined principally to certain young chiefs and their adherents, who had been to the Fiji Islands." [1]

The Fijians themselves seem originally to have been peaceful. " The ancient legends describe a peaceful immigration of a few half-shipwrecked and forlorn people. . . . And so far from being an entrance at that early period of a victorious host, it is not till long after that any serious war is even hinted at ; not, indeed, till several tribes had broken away from the original stock and become independent." The author quoted is confident that war on a considerable scale is comparatively recent in Fiji, and that the introduction of fire-arms has had much to do with it. [2]

Manu'a, the earliest settlement of Samoa, was a land of peace, and was neutral in intertribal wars. [3]

In Eastern Polynesia former times seem to have been peaceful, and chiefs and their followers from all directions assembled at Raiatea in Tahiti for certain ceremonies. This delightful condition of affairs broke up because of quarrels among the priests in charge of the ceremonies, and wars, murders and strife ensued. [4] This is substantiated by the traditions of the people of Hawaii, which state that the Children of the Sun formerly lived in Tahiti and Hawaii. In those days life was more peaceful, and a race of heroes, probably such as the Eyeball of the Sun, the children of the gods, ruled by subtlety and skill, and went to other islands for courtship and barter. Then came a time when these chiefs, having to protect their property against their fellow-chiefs, gave up these long voyages : " Thus constantly in jeopardy from each

[1] Mariner 67. [2] Deane 229. [3] Ella iii. 155. [4] P. Smith v.

other, sharpening, too, their observation of what lay directly about them and of the rational way to get on in life, they accepted the limits of a man's power and prayed to the gods, who were their great ancestors, for gifts beyond their reach." [1]

In later times warfare was not universal in Polynesia. For example, the people of Bowditch Island, who seem to have preserved much of the archaic civilization, were quiet and rarely fought. [2] Similarly the people of Funafiti in the Gilberts and those of Tikopia are described as peaceful. On the other hand, in Penrhyn Island, where are ruins of the archaic civilization far beyond the capacity of the present population, fighting is incessant. The ancestors of the people came from Rarotonga, like those of the Maori. [3]

Peace reigned in Mangaia in the days of Rangi, the son of Rongo, the war-god. The art of war is said to have been taught the people by denizens of the underworld, [4] that is, by followers of Rongo. It is also said that the Mangaians owe the development of their warfare to Tongans, who brought ironwood with them—so useful for weapons. [5] So the Tongans handed on what they had learned from Fiji.

The Maori found, in New Zealand, peoples with a civilization that seems to have been, in some respects, superior to theirs in material culture. These people were peaceful. [6] The cultural decadence of the Maori themselves is ascribed to their fighting habits. " In the centuries immediately after the first immigration all evidence points to the existence of large States, which occasionally were subject to one common head. There seems also to have been a religious centre. This was the period of the national prosperity of the Maoris, when their workmanship also attained its highest perfection. Tasman alone saw in 1642 large and splendid double canoes in use among them ; such canoes the Maori of the eighteenth century were no longer able to build. The decadence was universal. The ancient kingdoms broke up into small communities of bold incendiaries and robbers, who recognized no political centre, but were engaged in fierce feud one against another. . . . The national character, always inclined to pride and tyranny, ended by becoming more and more bloodthirsty, revengeful and cruel." [7] The Moriori of the Chatham Islands, the descendants of those driven out of New Zealand by the Maori, were peaceful. Their laws forbade killing, and they said that all fighting had been prohibited in the days of their ancestor Nunuku. They formerly used stone axes as weapons, but latterly had only a pole, 8 to 10 ft. long, for fighting. [8]

The evidence from the Pacific thus entirely bears out the contention of Mr. Hocart. Where culture-sequences can be

[1] Beckwith 303. This account recalls the history of Ponape in the Carolines.
[2] Turner 268. [3] P. Smith i. 96. [4] Gill i. 130.
[5] Id., 288. [6] Gudgeon 209. [7] Weule 333.
[8] Shand 76 e.s.

established, it is found that the earlier phase was the more peaceful. The break-up of Polynesian society can now readily be understood. When communities give up their peaceful habits and take to fighting on a large scale, attention is diverted from one occupation to another. In the Pacific, the rise of warfare coincides with the degeneration of culture in the arts and crafts. It is thus legitimate to look upon warfare not, as many do, as a sign of strength, but of decay, from the standpoint of material culture.

The same story is told in America. The earliest known civilization, that of the Maya, shows signs of being comparatively peaceful.[1] The early reliefs of the Maya depict, as the principal subject, a human figure, the divine ruler or priest, splendidly clad with the emblems of civil and religious authority. At Palenque, and elsewhere, religious ceremonies, sacrifices, self-torture, are depicted. Curiously enough, the more northerly Maya cities, which are of later date, contain traces of war. "At some of the northern cities the principal figures stand on the backs of couched human beings who have been identified as captives, and at Piedras Negras captives, bound with ropes and stripped of all clothing and ornaments, appear huddled together before a ruler seated upon a throne with attendants standing on either side ; or, again, an elaborately dressed ruler with spear in hand and an attendant standing behind him faces kneeling captives or warriors, also armed with spears. These two monuments . . . have been interpreted, and probably correctly, as records of specific conquests, the captives representing the alien rulers, cities or tribes with their corresponding nemaglyphs on their shoulders or thighs. But at best these are only sporadic cases, and an overwhelming majority of the Old Empire sculptures portray religious ceremonies, deities, rulers and priests."[2] While the Maya in the centre were living in a profound peace, those on the outskirts evidently fought with the surrounding tribes, which, on the hypothesis based on the study of the distribution of civilization of various stages, have been derived from them. That is to say, if it be granted that the Maya first settled peacefully among unwarlike food-gatherers, they brought with them something in their social and political organization that proved their ruin ; that is to say, they ultimately produced warfare. This hardening process is at work in the later Maya settlements of Yucatan, where a certain ruling family, descended from the sacred priest-kings of the early period, the Cocomes, evidently went the way of other ruling families. They ruled at Mayapan in Yucatan ; and at the time when certain convulsions were taking place, "it would appear that they had begun to exercise a closer control over their vassals. To support the harsher methods which they introduced they commenced to employ the services of mercenaries, 'Mexicans,' recruited in Tabasco and Xilxicalance, and by their

[1] Joyce ii. 364–5. [2] Morley ii. 443–4.

aid levied tribute upon the other members of the league to an extent which the latter were not prepared to suffer." [1] Thus a family, claiming descent from Kukulcan, a Son of the Sun, began to take on the aspect of a typical warrior aristocracy. The ruling class of Chichen-Itza, another Maya settlement in Yucatan, also constituted a warrior caste. [2]

So, in the case of the Maya, the story is one of education in warfare. The earliest cities show no trace of fighting : then, on the outskirts, the later cities were engaged in war. The ruling class of the later cities probably were Children of the Sun. When the Maya left Guatemala and went to Yucatan, their rulers tended to become definitely warlike and to behave cruelly. Presumably, like the ancient Egyptians, they were educated in war. The growing aggression of the rulers of Mayapan seems itself to have caused much turmoil in Yucatan. Thus the phenomenon of the increasing warfare will probably find its explanation in that of the change of behaviour of the ruling classes.

The warlike activities of Mexico in the time of the Aztecs are well known. According to Bandelier, speaking of the Aztecs : " War, at first *defensive*, afterwards *offensive*, became the *life of the tribe*." [3] The later civilizations certainly far surpassed, in this respect, the early civilization of the Maya. So, not only did the Maya become more warlike, but their successors, who surpassed them, went through the same process of education.

The hypothesis adopted with regard to North America was that the civilization of that region can be regarded as a unity, derived ultimately from Mexico and the south. The cultivation of maize, pottery making, the working of metals, the use of pearls and manufacture of polished stone implements, and the tales of culture-heroes, have been adduced as evidence of this unity. If it be true that the practice of warfare has been derived from the archaic civilization, that the people who brought in maize-cultivation to the food-gatherers also turned them into fighters, it will not be surprising to find further evidence of unity of culture. This evidence is forthcoming.

In North America in post-Columbian times the military organizations of the various tribes were similar. According to the Huguenot narratives, the tribes of North Florida and the adjacent region had a military system and marching order almost as exact as that of a modern civilized nation, the various grades of rank being distinguished by specific titles. The Indians who went into the Plains after the buffalo had military organizations so similar as to suggest a common origin. [4] Thus once again signs of unity run through the civilization of North America.

The post-Columbian Indians seem to have been more warlike than their predecessors for : " From what we know of the Indian character, there is every reason to believe that the non-sanguinary

[1] Joyce ii. 205. [2] Spence 155. [3] Bandelier 98.
[4] Hand-Book : Art. Military Organization.

sun-worshipping tribes were conquered and rudely driven off " [1] by the ancestors of the post-Columbian Indians. In their place are warlike tribes such as the Iroquois, with war-gods as their chief deities.[2] This agrees with the Huron and Wyandot tradition that the sky-world, the place associated with the people of the archaic civilization, was peaceful.[3] Several of the Plains tribes were very warlike, especially the Pawnee, for whom war was business and pleasure. By it they amassed wealth, and gained credit and renown. They conquered all the surrounding tribes, and claimed to hold the country from the Missouri to the Rockies, and from the Nebraska southwards to the Arkansas or the Canadian River.[4] They had given up the sun-god; which is shown by the fact that they came out of the south-west, where the sun-cult was universal; and also by the fact that the Skidi, a branch of the tribe, still retain some sort of sun-cult, although, even in this case, the sun is unimportant.[5]

The study of culture-sequences has led to the generalization that, in all parts of the region, the earlier civilization seems to be the more peaceful. The archaic civilization has spread out into countries inhabited by peaceful food-gatherers, and the earliest settlements were probably also peaceful, which accords with their apparent industrial nature. Men engaged in mining for gold would be more interested in that than in fighting. Moreover, such settlements would be sparse; India, for example, with the exception of Bellary, and one or two other places, does not seem to have possessed any great concentration of population in those early days, so that a pretext for warfare would hardly exist.

One fact points to warfare in this period—the building of fortifications. What, it may be asked, would be the aim of such fortifications if no warlike peoples were feared? This difficulty tends to ignore the probable nature of these settlements. They were, according to the hypothesis, those of peoples with a fairly high degree of civilization, of whose provenance it will be necessary later to inquire. If it be assumed that they came from some country where war had already begun, where the building of fortresses was a habit, then, to account for the fortifications, it is only necessary to invoke the innate tendency for settlers to reproduce the culture of their homeland. Perhaps an instance from outside the region will help. The great ruins of Zimbabwe, south of the Zambesi, built by men working the goldfields, are fortresses. Yet, beyond doubt, they were built without reason. The warlike Bantu had not yet swarmed down from the north: the only possible inhabitants of the country were the peaceful Bushmen and Hottentots. This makes these great fortresses simply ridiculous. So, in places such as India, the habit of living on hill-tops may have been brought by the people of the archaic

[1] Schoolcraft v. 203. [2] Tylor II. 308.
[3] Barbeau i. 289. See Chapter 13 for sky-world.
[4] Grinnell 303, 306. [5] *Id.*, 224: Wissler iii. 335, 337.
11

civilization from their homes, and thus would have no reference to the conditions of the countries where they lived. It is further necessary to add that the more warlike peoples of the earth have not usually been given to the making of fortifications, and this makes the peaceful nature of the people of the archaic civilization more probable. At the same time these people must have had some warfare, and the habit of fighting must have developed. It must be remembered that the archaic civilization was based on agriculture, which implies a steady increase of population. A new world was created wherever these people settled; food-gathering gave place to food-producing, and new peoples came into being. In this way the chances of war must have increased in several ways.

The surveys of this chapter have shown that the loss of the sun-cult and of the Children of the Sun, and the appearance in their place of warrior chiefs and war-gods, has been accompanied by an actual change in the behaviour of peoples. This is the first example yet adduced of the relationship between various elements of civilization : a change in the ruling class is accompanied by a change in the deities of the community, and also by a change in the behaviour of the community. Evidently one change caused the others. This raises one of the ultimate problems of social psychology, that of the interrelationship of institution and behaviour in society. As the general argument proceeds, it will repeatedly be seen how close is this interrelationship. Once it is realized, it is obvious that the ultimate problem of all is that of explaining, in psychological terms, the process that is now being described in historical terms. Such a problem must be left on one side until the historical process is itself clear enough to make it possible to attempt its solution.

The aboriginal inhabitants of the region were peaceful food-gatherers with no social organization, wandering about in family groups. Then there came into existence at various points, India, Cambodia, Indonesia, the Carolines, Polynesia, Mexico and elsewhere, an advanced civilization based on irrigation, located near sources of wealth of various sorts, and characterized by stone-working and other arts and crafts. Some of these early settlements were obviously only there for the purpose of mining, and no attempt was made to colonize the country. But, in others, great cities sprang up, that must have numbered their populations by tens of thousands. These early civilizations were ruled over by divine kings, usually claiming descent from the sun. This archaic civilization gave rise to others, less advanced in the arts and crafts, but more warlike, with war-gods, which ultimately destroyed it. The rulers of these later communities were not divine beings.

The next task is that of determining what other circumstances attended this remarkable transformation. The archaic civiliza-

tion contained some element destined to destroy it, in spite of its achievements in all parts of the world : it was rotten somewhere. This archaic civilization has exercised a tremendous influence upon all that followed : even that of Western Europe is deeply rooted in it. Maybe that some of the problems that face us at the present day will find their solution in the determination of the reasons that brought to ruins this civilization that was so rich in material culture.

CHAPTER XII

RULERS AND COMMONERS :

(i) THE DOCTRINE OF THEOGAMY

FROM one end of the region to the other the Children of the Sun were looked upon as gods, that is, as beings far removed from the rest of mankind. They had great powers : they could control the weather, they could fly through the air, they could visit the world in the sky, and do all manner of things impossible to mortal men. In looking back to the days when the Children of the Sun ruled in Polynesia and elsewhere, a time is being considered when " gods " walked the earth, divine beings incarnate as men, the like of which have not since been seen. The importance of this fact in the history of civilization, and especially in the study of mythology and tradition, cannot be exaggerated. For, when it is known that the rulers of the archaic civilization were really regarded as gods, tales that speak of olden times, when gods lived on earth, assume an historical significance. Such tales show that various communities, who now have no incarnate gods living with them, must in the past have known of such beings, for imagination can be put on one side as a factor in the production of tradition and myth until details otherwise inexplicable are encountered.

The supreme importance of this theme makes it imperative to try to find what was the essential difference between the Children of the Sun and the rest of mankind. In what did their divinity really consist ? If it can be discovered what was the actual relationship between the Children of the Sun and the sun-god, then it may be possible to understand in some way how the war-gods came into existence.

Before starting on this quest, one important point must be noted. It has been stated that the Children of the Sun were rulers over the communities of the archaic civilization. That does not mean that they were the sole rulers. The analogy of our own country shows that more than one category of rulers can govern a country. At the head of the constitution is the royal family : then comes a nobility, with an extensive variety of rank. Likewise, in the archaic civilization, which, as will be

evident in the course of time, was complicated in nature, the ruling group did not consist merely of the Children of the Sun. Other grades of nobility and of royal rank existed, and the parts that they played will be discussed in some detail in succeeding chapters. For the present, however, attention will be paid to the Children of the Sun, so as to define their position as closely as possible.

In the chapter on Egypt, which comes at the end of the discussion of the archaic civilization as a whole, it will be shown of what importance was the coming into being of a ruling group calling themselves the Children of the Sun. It is well known that this happened at the beginning of the Fifth Dynasty. Prior to that the sun-cult was not the state cult of Egypt, and the kings were more closely associated with Osiris, with whom they were identified after death, and Horus, with whom they were identified during life.

What distinguished the Children of the Sun from their predecessors in Egypt, and from the rest of the community, was their claim to be the actual sons of Re, the sun-god. It was said that Re took the place of the king and became the father of his heir.[1]

Unfortunately the Children of the Sun have died out in most parts of the region, or have not sufficiently been studied, so that it is hard to find instances of the belief in theogamy as an everyday occurrence. Nevertheless, I have found two other examples (not including that of the Incas of Peru, who also were Children of the Sun) in which it is believed that the sun-god can become the father of mortals. In both cases the people claim solar descent. The Abarihu ruling class of San Cristoval in the Solomons, who call themselves Children of the Sun, and are so closely connected with the archaic civilization in their use of pyramids, dolmens, portrait statues and so forth, believe that women can mate with the sun.[2] The Yuchi of the Savannah River in the United States call themselves Children of the Sun. Dark-skinned members of the tribe form a kind of empty aristocracy, and it is believed that they are the actual children of the sun himself and one of their maidens.[3]

Although only in Egypt, San Cristoval and among the Yuchi have I been able to collect instances of the belief in theogamy as a factor in everyday life, it has been preserved throughout the region in tradition and folk-lore. In the epic literature of India the Children of the Sun usually were born through a process of theogamy. A noteworthy example is that of Kunti, or Pritha, a maiden of royal birth, who, by the Sun, became the mother of Karna (Vasusena), the brother of Arjuna, the son of Indra. He was born encased in natural armour and with face brightened by

[1] Cf. Moret i. 39 for a vivid account of the ideas connected with the doctrine of theogamy in Egypt. Also Breasted ii. II. 187 e.s.

[2] Information from Dr. Rivers. [3] Speck ii. 106.

ear-rings, the first of all wielders of weapons,[1] endowed by the
beauty of a celestial child.[2] Again it is said of him: "That
far-famed destroyer of hostile hosts, the large-eyed Karna, was
born of Pritha in her maidenhood. He was a portion of the hot-
beamed Sun. . . . Born of the Sun himself . . . he was capable
of slaying a lion."[3] Madri, the wife of Pandu, the ancestor of
the Pandavas, the famous race of kings that fought the Kurus in
the epic of the Mahabharata, had two sons by the Acvins, the
twin gods of the Vedas.[4] This form of maiden birth by the action
of the Sun is a commonplace in the stories of heroes in ancient
India.[5] Indonesian folk-lore tends to connect theogamous
origins of ruling families with the archaic civilization. The
Batta of Sumatra show signs of connexion with the Dravidian
civilization of India, which itself is so closely connected with the
archaic civilization. Their first great king was Singa Mangaradja,
the son of a Batta princess and their great god, Batara Guru.
The royal girl one day ate a fruit of the Anacardicum, in which
Batara Guru had temporarily incarnated himself. Seven years
later she bare a son, Singa Mangaradja, who was the ancestor of a
line of chiefs ruling over Bakara, on the west shore of Lake Toba.
He could make the sun shine or the rain fall at pleasure, and the
welfare of the community depended on him. His descendants
were not born in like manner.[6] Among the Tontemboan of
Minahassa the ancestress of the race was Lumimu'ut, who is said
to have arrived in a ship, and is thus looked upon as human. In
one story she came out of a rock, under the action of the sun's
rays, and then gave birth to To'ar, the Sun, who became her
husband, and presumably was the ancestor of the upper class of
the Tontemboan. Or else it is said that To'ar came out of a hump
of foam, that gave birth to him under the action of the Sun's rays.
Thus, in the beginning, a theogamy takes place, in that To'ar is
produced by the Sun. He then marries Lumimu'ut, but it does
not seem, so far as I can tell, that the Sun has any more children.[7]
Folk-lore and tradition in the Pacific show that the idea of solar
theogamy must formerly have been a living thing. Mr. Hocart
claims that the earlier kings of Fiji were divine beings. He also
says that, according to a folk-tale, the daughter of one of these
kings was confined, when of a marriageable age, in a room, so
that the Sun could not impregnate her with his rays.[8] This
points to belief in the doctrine of theogamy among the early
Fijians, just as it exists to-day in San Cristoval, not as a vague
tradition, but as something that could happen any day. A
similar tale is told in Fiji of the Tongan royal family. The
daughter of a Tongan chief was called the Mother of the Sun-

[1] This remark is significant in view of the conclusion that the Children
of the Sun introduced warfare.
[2] " Mahabharata," Adi Parva, Sambhava cxi.
[3] *Id.*, cxxxviii. [4] *Id.*, cxxiv. [5] H. H. Wilson 147, 149.
[6] Pleyte 4 e.s., 46 : J. G. Fraser i. I. 398.
[7] Schwarz Tales Nos. 109–19. [8] Hocart vi. 48.

child. Her father hid her on account of her great beauty, but without avail ; the Sun looked upon her, and saw her, and loved her ; and in the course of time a child was born to her, whose name she called the Sun-child.[1]

In Samoa the Children of the Sun disappeared, and the later ruling families were more especially connected with the under-world. The doctrine of theogamy is found in tradition associated with the original family of Children of the Sun at Manu'a ; for it is said that the rays of the sun fell on a woman of Leipata, who bare Aloalolela, Sun-beam, who married the daughter of the king of Fiji.[2] Yet the progeny of the Tagaloa family, the original Children of the Sun who came from the sky to Samoa, and of a woman, Ui, who came from a place with the sun-cult, were not Children of the Sun. Tagaloa, it will be remembered, changed himself into a war-god. One of this family became ancestor of Pili, whose sons were the first rulers of Upolu.[3] The doctrine of theogamy disappeared in Samoa, together with the Children of the Sun.

The birth of Oro, the war-god of Tahiti, was as follows : " The shadow of a breadfruit leaf, shaken by the power of the arm of Taaroa, passed over Hina, and she afterwards became the mother of Oro."[4] Taaroa is similar to Tagaloa of Samoa, and therefore originally was a sun-god. Other evidence, already quoted (see pp. 138-9), suggests that the Children of the Sun originally ruled over Tahiti ; this supports the identification of Taaroa as a sun-god. Direct evidence of the doctrine of theogamy is not apparent in Hawaii, so far as I know. It is said that formerly some of the chiefs claimed descent from the great god Kane, evidently a sun-god, in which case their birth must have been by a process of theogamy. These chiefs went to the sky to visit their relatives, just like the Sa-Tagaloa family in Manu'a. Hawaiian tradition also mentions the days when sky beings came to earth and married their women. These gods " shaped the customs of mankind," and thus seem to correspond to the Children of the Sun ; but all this is past, and all that remains is the knowledge that chiefs used to claim divine descent.[5]

The break between early and late times in Oceania is seen clearly in New Zealand. The doctrine of theogamy is not held by the Maori ; but tradition recounts cases of that nature, such as the union between the wife of Tamatea, an historical personage, and a supernatural being, the offspring of which was Uenuku-titi.[6]

Although the Children of the Sun have long since disappeared in Mexico, it is possible, from collateral evidence, to conclude that they must have come of theogamous unions. In the United States, the Natchez of Louisiana were ruled over by Children of

[1] Fison 33.
[3] F. Krämer I. 254–7.
[5] Beckwith 302–8.

[2] Pratt i. 451 : Turner 200.
[4] Ellis I. 123, 231, 326.
[6] Best xi. 157.

the Sun, whose ancestors are supposed to have come from the direction of Mexico. Nothing is known of the doctrine of theogamy among them ; but the Yuchi of the same region, also Children of the Sun, believe in the fatherhood of the sun. Thus the Mexicans and Maya had it. Other evidence points the same way. For the great gods of the Aztecs and other late comers to Mexico, Huitzilopochtli, Camaxtli, Mixcoatl, were said to have gods as fathers and earthly women as mothers. In the case of Huitzilo- pochtli, it is said that one day a devout woman saw, in the temple at Tulla, floating down from the sky, a ball of feathers which she put in her bosom. She found herself pregnant after this. Her many children, seeing her in that state, agreed to kill her. But the child yet unborn cried out, " Fear not, O my mother, for this danger will I turn to our great honour and glory." He was born with shield and spear ; on his left leg and his head he had green plumes, and his face, arms and thigh were barred with lines of blue. He fell on the other children and killed them. He was the protector of the Mexicans and led them on their journey to Mexico. He possessed a shield on which were five balls of feathers in the form of a cross, and a golden flag with four arrows in the upper part. This shield and flag are said to have been sent down to him from heaven to enable him to perform the glorious deeds of their national history.[1]

Among tribes of North America with no Children of the Sun living among them, tales of theogamies are concerned with culture-heroes. The Pueblo Indians claim that the Twin Children of the Sun are the children of an earthly woman, or of a foam cap, or of the ancestress of the race, embraced by the Sun.[2] Some of the Plains Indians have preserved such tales. The Kiowa, for example, say that formerly a girl climbed up to the sky in pursuit of a porcupine. To her amazement the tree got taller as she climbed, so that she finally got to the sky, where she found that the porcupine had turned into the Sun. They married and had a son. Her husband warned her against going near a certain plant, of which the top had been bitten off by a buffalo. With the usual feminine curiosity, she found one that had been cropped by a buffalo and pulled it up. It left a hole through which she could see the world that she had forgotten. She took a rope, and let herself and her son down by means of it ; and her husband, seeing what she did, threw a stone after her and killed her. The child was uninjured, and got to the bottom, where he was taken care of by the Spider Woman. One day in a game he threw up a wheel, which came down and cut him into two, so that there were twin brothers. After many adventures, in the course of which these twins rid the world of many dangerous monsters, one of them walked into a lake and disappeared for ever, while the other transformed himself into a " medicine " which is the great palladium of the tribe, and is kept in a small pouch fringed with

[1] Bancroft III. 288–9. [2] Stevenson ii. 24.

scalps, and used on certain ceremonial occasions.[1] The Kiowa have no ruling class of Children of the Sun, and the tale is told of a being who has been transformed into their national palladium.

The Osage branch of the Sioux of the plains have two divisions : one connected with peace, and the other with war. The warriors claim that they once lived in the sky, and that they were the children of the sun and moon.[2] But among the Omaha, who were formerly connected with them, even this attenuated belief has disappeared, and no connexion with the sky-world is claimed. The Omaha simply have the Thunder Being, about whose origin apparently nothing is known.

Evidence has been accumulating from more than one quarter to identify the culture-heroes of various parts of the region. In some instances they are actually the Children of the Sun, born of theogamies. In others, while they are not said to have been sons of the Sun, their form of birth suggests that they may originally have had that title. For instance, the great hero of Kiriwina in the Trobriands, east of British New Guinea, was born of a virgin fertilized by a drop of water.[3] In Melanesia there are tales of culture-heroes, such as Qat of the Banks Islands, and Tagaro of the New Hebrides. The story of the birth of Qat is similar to that of To'ar in Minahassa. He was born of a woman, who was a stone that burst asunder, and no mention is made of his father. Tagaro, the great hero of Whitsuntide Island, is said to have had a child by an earthly woman. Also it is believed, in Leper's Island, that Tagaro can give women children.[4] A similar belief in theogamy seems to persist in the Ponape belief that a pregnant woman must not allow the sun to shine on her lest she have a difficult labour.[5] In all these cases the original setting of the tale has been largely destroyed, and the belief survives only in fragments.

The occurrences of the doctrine of theogamy serve to throw light on the relationship between the communities of the archaic civilization and those of its successors, particularly in respect of the connexion between sun-gods and war-gods.

The stories of theogamy centre round two groups of beings : the Children of the Sun and war-gods. The Children of the Sun are the actual progeny of the sun-god himself, and thus are semi-divine : the war-gods, themselves born of like unions, are thus of the same nature, that is to say, semi-divine, and not of the rank of the original sun-god himself. Therefore a son of the Sun could become a war-god, for this change would neither exalt nor abase him in rank.

Who were these war-gods ? The Children of the Sun were actual men who once lived in Oceania and elsewhere. Therefore when it is said that the first war-god in Samoa, Taeotagaloa, was a descendant of the Tagaloa family, of the Children of the Sun,

[1] J. Mooney vi. 239. [2] Fletcher and La Flèsche 63.
[3] Malinowski 412. [4] Codrington 154, 169, 230. [5] Hahl 10.

it seems that we must accept the story as historical and grant him a human form. Similarly, it is said that Oro in Tahiti had a son who became a great king.[1] Oro lived at Opoa, which suggests that he was a man. Moreover, no mention is made of theogamy in the case of his son. Huitzilopochtli of the Aztecs is said to have been a great warrior. Similarly, on the hypothesis that the Children of the Sun of American tradition were actual men, the twin war-gods of the Zuni must have a human shape. Therefore it is reasonable to believe that the war-gods throughout the region were actually members of the ruling group of the archaic civilization, who founded dynasties for themselves, and, apparently, failed to preserve in their family the belief in the constant intervention of the sun-god. In this way the title of Son of the Sun disappeared. The relationship between the archaic civilization and its successors must, if this scheme be stable, be founded on some peculiarity of the original ruling group. While possessing Children of the Sun, who perpetuate themselves to the accompaniment of the belief in constant divine intervention, there must be present some other element that makes it possible for the war-gods to emerge and to found families who are born in a normal manner. This problem will be discussed at length in Chapters XX and XXIII, where it will be seen that the ruling group of the archaic civilization really consisted of two independent groups, of which the Children of the Sun formed one, while the war-gods formed another.

The scheme just outlined serves to establish a threefold grading of divine nature. First comes the sun-god, supreme over all others, who can intervene on earth and produce children of mortal mothers. These men are semi-divine, incarnate gods as it were, but not partaking of the nature of their father. Some of these god-born men can found dynasties, and become war-gods. Their descendants are not so divine as they, for no mention is made of the belief in theogamy as a mode of birth among them. Thus, although claiming descent from war-gods, who are really only semi-divine, they are a step farther removed from the divinity of the sun-god himself. It must not be forgotten that this scheme rests on the basis of the restriction of the belief in theogamy as a common occurrence to the Children of the Sun. If it can be shown that war-gods are in the habit of producing children by similar means, then the scheme will have to be abandoned. But this will not affect the main argument of the book.

[1] Ellis, loc. cit.

CHAPTER XIII

RULERS AND COMMONERS:

(ii) THE SKY-WORLD

THE Children of the Sun differed in yet another way from the rest of the community. They were closely connected with the sky-world, and when they disappeared direct communication with this world ceased.

In Egypt the sky-world is closely connected with the Children of the Sun, and it is first mentioned in the Pyramid Texts, in which the king, instead of being identified after death and ruling over the Osirian land of the dead, went to the sky, there to live in the company of Re. " The kings of the early Pyramid Age in the thirtieth century B.C. evidently looked confidently forward to indefinite life hereafter maintained in that way." [1] The Pyramid Texts " deal almost entirely with a blessed life in a distant realm." [2]

> " Men fall,
> Their name is not,
> Seize thou king Teti by the arm,
> Take thou king Teti to the sky,
> That he die not on earth among men." [3]

This sky-world was at first reserved solely for the king; the extension of the privilege to his family and to the nobles was accomplished on the basis of the fiction of identity with the king, which was produced by ritual means. It is not necessary at this point to inquire into the origin of this doctrine. But it is evident that, once formulated and accepted, it split the community into two groups : that comprising the king and his family, who built pyramids, and those of his nobles who ultimately got to the sky; and the rest of the community, who went to the old land of the dead. Speaking generally, the nobles of Egypt continued to be buried in mastaba tombs, the form of tomb made by the royal family before the invention of the pyramid, and these tombs contain no traces of solar ideas.[4] It must therefore be borne in

[1] Breasted iv. 81 : " The prospect of a glorious hereafter in the splendour of the sun-god's presence is the great theme of the Pyramid Texts " (*id.* iv. 103).

[2] *Id.,* iv. 99. [3] *Id.,* iv. 102. [4] Murray v. : Petrie ii. 22.

mind that connexion with the sky-world does not necessarily, in other parts of the region, apply to the whole of the ruling class, for, as in Egypt, certain sections may be connected with other places of after life.

In Sumer the idea of a land of the dead in the sky does not seem to have been prominent : " The idea of a celestial paradise in the far-away skies where only immortals lived, or mortals who had partaken of the bread of life, does not appear to have had a firm hold in popular religion." [1] These words of Mr. Langdon show that the belief in Sumeria was confined to certain favoured beings. The older land of the dead in Sumer was the underworld, and only later, when the sun-cult began to exert an influence, and the Children of the Sun appear, does the tendency appear to transfer deities such as Tammuz to the sky. [2] The underworld was, throughout Babylonian history, the chief place to which went the dead : never had they such elaborate doctrines as those expounded in the Pyramid Texts of Egypt.

In Ancient India the ruling families were partly connected with the sky-world. In the Rig Veda both the Daevas and the Asuras belonged to the sky, [3] where they lived in Swarga, the heaven of Indra. This is natural, in that the Asuras claimed solar descent. Both they and the Daevas were children of Kasyapa, the Sun. [4] The Mahabharata mentions Asuras living in the sky. For example, the Paulomas and Kalakanjas live in Hiranyapura, the golden city, floating in the air. [5] At the same time some of the Asura group were closely connected with the underworld. The great city of the Nagas was Patala, which is usually represented as an underworld. Here live not only the Nagas, but also the birds, the Garudas, another branch of the family of the Asuras. [6] Again, Hiranyakasipu was the king of the universe and god of the dead, who lived at Hiranyapura, which, although represented as floating in the air, at the same time is in Patala, that is, the underworld. This underworld is represented as far more beautiful than the heaven of Indra ; it is " infinite in extent, filled with hundreds of palaces and elegant mansions with turrets and domes and gate-ways, abounding with wonderful places for various games and entertainments." In this underworld the houses are made of silver and gold decorated with lapis-lazuli, corals and gems, one of which is identical with crystal, and with the sun. These houses are high and close to one another. [7]

The connexion that the Asuras have both with the sky and with the underworld needs careful attention, for it is not only important, but it is apt to cause great difficulty. Why should the ruling groups of the Dravidians, or Asuras, be connected with the sky and with the underworld ? What is the cause of this duality ?

[1] Langdon i. 37. [2] *Id.*, i. 30.
[3] "Mahabharata," Adi Parva liii. : Oldham 31. [4] Oldham 30.
[5] H. H. Wilson 148, n. 12. [6] Oldham 81.
[7] "Mahabharata," Udyoga Parva xcix.

When dealing with mythology and with traditions, the historical aspect of facts must never be forgotten. In the epics of India it is clearly understood, in the beginning, that the contest between the Daevas and Asuras was fought out in the sky, and that these two groups of beings became incarnated in mortal women in order to take part in the great struggle between the Kauravas and Panchalas that is the main theme of the Mahabharata.

So when these beings became incarnated on earth, they would bring their associations with them. If, therefore, it should happen that any branch of the Asuras, say the Nagas, were connected with the underworld, it would follow that they would be considered as having lived in the underworld part of the sky-world. For the sky-world is not necessarily thought of as something quite different from the earth : it can be the place on earth where the Children of the Sun had previously lived. It is enough to mention the " Eyeball of the Sun " of Hawaiian tradition, who lived in the " Shining Heavens " on the borders of Tahiti, to see that the idea of the sky-world in tradition need not mean anything more than the former home of the Children of the Sun (see p. 138). What really is important is the fact of the duality in the ruling groups. The Nagas are practically always represented as living in the underworld, at Patala and elsewhere, not in darkness and gloom, but in a kingdom full of life, wealth and pleasure. It can, therefore, be taken that the Nagas of India represent that part of the ruling group of the non-Aryan peoples who were connected with the underworld. The Nagas were looked upon in the epic literature as half-brothers of the Garudas, or birds, and they both are represented as living in the sky or in the underworld. They are both sons of the Sun, but with different mothers.

It was shown in " The Megalithic Culture of Indonesia " that, in cases where the people of the archaic civilization had founded ruling classes, the members of which claimed descent from the sky-world, the members of those classes went at death to the sky-world. The commoners never made such a claim. The spread of Islam over the region has obscured the original beliefs of ruling groups such as the Bugi and Macassar. But their traditions invariably assert that their male ancestor came from the sky.[1] Similarly, the founders of the civilization of the Kolaka of South-East Celebes are said to have been men from the sky-world.[2]

The available evidence suggests that all the ruling groups of Indonesia are derived, with the exception of Mohammedan and other invaders, from the ruling groups of the archaic civilization. In some instances, as has been seen, these rulers called themselves Children of the Sun, and, presumably, this title was formerly held much more widely than at present. But a closer study of the ruling groups of Indonesian peoples, as well as of those of Polynesia and elsewhere, has made it clear, as was pointed out some time ago by Mr. Hocart, that the ruling groups themselves are

[1] Kruyt iii. 467 : Morris 549 : Erkelens 81. [2] Kruyt, viii. 692.

composite. In India, for instance, the Nagas, ancestors of ruling families of the Dravidians, were connected not only with the sky but also with the underworld, and this duality of association forms a bewildering element in the study of Indian literature of the epic period. Similarly, in places such as South Celebes, it is found that the Bugi ruling groups had as ancestors a god from the sky-world and a goddess from the underworld. The ruling family thus had its origin, according to the myth, in a union between members of two entirely different groups. For the present, therefore, it is not only advisable, but necessary, to claim simply that an association with the sky-world is only found in connexion with members of ruling groups ; and that commoners, except perhaps in the case of warriors, never have any connexion with that place. On the other hand, some members of the ruling group can be connected with the underworld.

In Polynesia the sky-world is a thing of the past ; it belongs to the days of the Children of the Sun. In Samoa the traditions of the colonization of Manu'a depict the Tagaloa family coming from the skies on to the earth, and the ancestress Ui, of the ruling family, coming from a place with a sun-god who received human sacrifices. But when the Children of the Sun disappeared, the connexion with the sky-world was evidently broken off for good, and henceforth the gods and the dead lived in the underworld. In other parts of Polynesia a similar sequence is to be observed. In Hawaii the great chiefs of the past were closely connected with the sky.[1] According to Ellis the rulers of Hawaii, who sometimes went to the sky, did not stay there, but were reincarnated in a rejuvenated form on the earth.[2] The commoners go to the gloomy underworld. In Tahiti, with which Hawaii was formerly connected, the classes separate at death.[3] The king of Tahiti was the son of Oro, who was born at Opoa in Raiatea. The rulers and nobility, and the members of the great Areioi society, an institution founded by two brothers of Oro, went after death to an earthly paradise on top of a mountain in Raiatea,[4] while the commoners went underground. It is possible that formerly the land of the dead for kings in that group was the sky ; for the dwelling of the " Eyeball of the Sun," so famous in Hawaiian tradition, was " The Shining Heavens " on the borders of Tahiti.

The evidence regarding the existence of a belief, in New Zealand, in a sky-world for the dead is somewhat doubtful. Some writers state that the great chiefs and priests of the Maori formerly went to the sky. This is disputed by Elsdon Best, an authority whose word is to be trusted ; he claims that the dead always went to the underworld, in the island of Hawaiki, the mythical home of the race of the Polynesians.[5] At the same time he does not seem to be quite consistent. In 1914 he says : " The broad way of Tane is the path or way by which the spirits of the dead pass on their

[1] Beckwith 302, 308, 309.	[2] Ellis IV. 411 : Beckwith 299, n. 2.
[3] *Id.*, IV. 428.	[4] *Id.*, I. 397.	[5] Best v. 230 e.s. : iv. 24.

way back to the fatherland of the race, the place where man originated, whence they pass down to the underworld, or ascend to the heavens, according to whether they sympathize most with the Earth Mother or the Sky Father Parent." [1] This would harmonize with the statement that, in some tribes, the great priests called tohungas, who are said to have died out, went, together with the great chiefs, to the sky. [2] It is, I think, best to conclude that the sky-world is, for the Maoris, a thing of the past ; that the class connected with it has disappeared, leaving only people connected with the underworld. This agrees with the fact that theogamy and the sun-cult only persist in tradition and folk-lore among these people. A careful comparison of the various Maori tribes in this matter would evidently produce interesting results ; for the two groups of authorities may be basing their evidence upon facts derived from different sources.

In Melanesia the underworld is practically universal, especially in these places with no ruling class. The only beings in such places connected with the sky are the culture-heroes, who have already been claimed as representatives of the archaic civilization.

The ruling class in Mexico believed themselves to go to the sky after death, while commoners went underground. [3] The Yuchi of the Savannah River, who call themselves Children of the Sun, all go after death to the sky, whence came their ancestors. [4] The Natchez of Louisiana were ruled over by Suns, whose ancestors came from the sky. [5] I have no evidence with regard to their beliefs as to the destination of the ghosts after death ; but from the principle that ghosts usually go back to the place of origin of their ancestors, [6] it would be expected that these Suns believe themselves, like the Children of the Sun elsewhere, to go after death to the sky. The Pueblo Indians, who have no ruling class of Children of the Sun, universally believe that they go after death to the underworld. [7] The analogy of the Yuchi, just quoted, suggests that the Zuni, who call themselves Children of the Sun, would go to the sky after death. But the Zuni have no belief in theogamy, and they have no people produced by such unions, as among the Yuchi.

The beliefs of the Indian tribes of the Plains are complicated, as would be expected, for their culture has suffered many modifications as the result of their movement from the Eastern Area. Among the Sioux, the Dakota have no land of the dead in the sky, but they believe that certain stars are men transported to the sky. Another indication of a former land of the dead in the sky lies in the belief that the ghost of the dead, on the way to the land

[1] *Id.*, xi. 136.
[2] Goldie 25. "The only item pointing to anything like a system of star worship is in connexion with agriculture." Best viii. 448.
[3] Bancroft III. 533–4. [4] Speck ii. 97.
[5] du Pratz 330. [6] Perry ii.
[7] Stevenson ii. : Cushing ii. 343 : Fewkes iv. 258 : Cf. Chap. 17.

of the dead, is pushed over a cliff or from a cloud, if it is not tattooed.[1] This suggests a former land of the dead in the sky. The Omaha believe that their ghosts go to the land of the dead by the Milky Way.[2] The Mandan claim that the stars are ghosts, and believe that when a child is born a star comes to earth and appears in human form : at death it returns to the sky.[3] The associated Hidatsa, on the other hand, have an underground land of the dead.[4] Such are the beliefs of some of the Indian tribes of North America with regard to the destiny of the ghost after death. Their indefiniteness is an index of separation from their original context.

This survey shows that the Children of the Sun are invariably connected with the sky-world, and claim to go there after death. In the course of time the Children of the Sun have disappeared, and other rulers are usually found in their place. In Polynesia, for instance, these later rulers are connected with the underworld, or with an earthly paradise. This suggests, once again, that the ruling class of the archaic civilization was complex, for the evidence derived from the examination of the doctrine of theogamy leads to the conclusion that the later dynasties were derived from these early ruling groups. In India, it will be remembered, the Asuras, were connected both with the sky and with the under-world, and yet were said to be of solar race, which shows that they were not homogeneous like the Children of the Sun of Heliopolis, but resemble the ruling classes of Polynesia, which, originally, partly at least, connected with the sky, are now wholly connected with the underworld, or with an earthly paradise.

If it be true that the archaic civilization has given rise to com-munities with war-gods connected with the underworld, it follows, as has already been pointed out, that the rulers of the archaic civilization must have formed a complex group. The nature of this group will have to be discussed, and this discussion will take place when the dual organization of society is under review. For the present it can be stated that the sky-world is apparently associated solely with the Children of the Sun, that commoners never enter it, and that when the Children of the Sun disappear, communication with the sky-world is broken off, or is sporadic.

The association between the Children of the Sun and the sky-world serves to bring the culture-heroes into greater contact with the archaic civilization. The two culture-heroes of Indonesia that have played so prominent a part in previous discussions, Lasaeo of the Toradja of Central Celebes, and Lumawig of the Bontoc of Luzon in the Philippines, are both connected with the sky. Both came to their respective peoples, married women, had children, and then went back to the sky, leaving their wives and children behind them. Similarly with the culture-heroes of Australia. The two youths who civilized many of the peoples are

[1] J. O. Dorsey ii. 484–5 ; i. 145. [2] Fletcher and La Flèsche 588.
[3] J. O. Dorsey ii. 508. [4] *Id.*, ii. 518.

thought to be still wandering about the earth, but the All-Fathers, who are associated with other tribes, are believed now to live in the sky.[1] For example, Nurelli of the Wiimbaio made the whole country, rivers, trees, animals : he gave laws to the natives, and finally ascended to the sky. In the tribe of South-West Victoria the chief being is a gigantic man who lives in the sky. He is of a kindly disposition and harms no one, is seldom mentioned but always with respect.[2] All the beings believed in by the tribes conform to the same type : they once dwelt on earth, gave the people their civilization, and then went up to the sky to dwell.[3]

Melanesian culture-heroes belong to the sky-world. Tagaro, the culture-hero of Araga, or Whitsuntide Island, came down from heaven, made men and other things, and finally went back to the sky. He was the father of a boy by an earthly woman. Mother and son went up to the sky to see Tagaro, and persuaded him to return to earth with them. They climbed down. Tagaro came last and on the way cut the line above the woman and child, and thus severed connexion between the earth and sky-world.[4] Several Tagaro beings exist in Melanesian folk-lore, all of which belong to the sky-world (as the Tagaloa of the Samoans, and of the rest of Polynesia). They are all vui, spirits to whom are ascribed the remains of stone structures that exist in various places, so that they evidently belong to the archaic civilization. These culture-heroes did not stay. Qat, one of them, who came to Vanua Lava, left in a canoe, and his return is confidently expected.[5] Atabulu is a village of Pentecost with many remains of the archaic civilization, in the shape of sepulchral stones. In this place are ancient house sites raised perhaps a yard above the ground : near by, at Anwalu, are stones over the graves of former chiefs. In the village place of Atabulu lies a stone of winged shape called Vingaga. This Vingaga, " The Flyer with webbed wings," who came from the sky to the village, was a supernatural being, a vui, who, after a time, returned to the sky-world.[6]

American culture-heroes are connected with the sky-world. Their mother comes thence, or else their father is said explicitly to have been the Sun himself. In the case of the Pueblo Indians, these heroes stand in strong contrast with the rest of the community. The Zuni Indians, for instance, claim to be connected solely with the underworld : there they were made and there they go after death. At the same time Zuni culture came from the twins born of the foam-cap by the action of the rays of the great Sun-Father ; to them were given knowledge, and the leadership and dominion of all men. In the beginning the twins and the priest fathers gathered in council for the naming and selection of " man-groups and creature-kinds," and thus organized the social organization of the whole tribe.[7] The Sia Indians, of the Pueblo

[1] Howitt 477. [2] *Id.*, 480. [3] *Id.*, 500.
[4] Codrington 169. [5] *Id.*, 166. [6] *Id.*, 46.
[7] Cushing ii. 386.

region, say that the Twin Children of the Sun organized, on the earth, the cult societies of the people.[1] Among the Hopi Indians the story is told of Twin Children, who brought them out of the underworld, and civilized them.[2] In the Eastern States is found the claim to have been civilized by beings associated with the sky-world. The founders of the Natchez ruling house came both from the direction of Mexico and from the sky. The Yuchi claim that their culture-hero was either a supernatural being or else a child of the Sun. The story runs that formerly, when nothing existed but an expanse of water and air, certain sky-beings with animal names, made the earth by fishing it up from the waters. A woman of the sky-world became with child, and when the boy was born she took him to the Rainbow, the gathering-place of the sky-beings, to be initiated. After a time the mother and child were driven away, and seem to have fallen to the earth. The son was called the Sun, and he became the ancestor of the Yuchi. He taught them all their ceremonial, and gave them the knowledge of certain remedies.[3] The Creeks attribute their civilization to a being called " The Master of Breath," who is associated with the sky-world.[4] The creation tale of the Huron, already quoted, shows how the culture-hero came from the sky. It is not necessary to give more examples of the sky-origin of American heroes : that has already been done by Brinton, and summarized in the quotation already made from his work.

The survey just completed shows that the sky-world often is a thing of the past. Either the Children of the Sun have once ruled and disappeared, or else culture-heroes have come from the sky and returned there, breaking off connexion with the earth. Only where the Children of the Sun, or their direct descendants, still rule, does direct communication with the sky-world still exist. In all places, the passing of the beings connected with the sky-world means the severance of direct intercourse with that land. When, therefore, mention is made of sky-gods among a people who have no class of the community connected with the sky, it will have to be borne in mind that these sky-gods may be, and probably are, survivals from the time when " sky-born " beings lived on the earth. When mention is made, for example, among the Maori, of Tangaloa, who is in the sky, the explanation cannot be that he is a deity who is the product of native speculation : on the contrary, Tangaloas actually walked the earth at Manu'a, the homeland of the Eastern Polynesians. What has happened is that the Children of Tangaloa have gone, but that Tangaloa has survived in tradition.

The relation between the Children of the Sun and the sky-world makes it possible to link still closer the rulers of the archaic civilization and culture-heroes among various peoples. They belong to a world with which no one else has any connexion.

[1] Stevenson 43–75. [2] Fewkes iv. 266.
[3] Speck ii. 105. [4] Speck iii; 163.

The rest of the community belong to the underworld, or to some land of the dead over the sea.

It is possible to approach the problem of the sky-world from another standpoint. It can be shown that the Children of the Sun acted as high priests of the sun-cult wherever they went. This is only a special example of a general theorem, that cults of gods are only carried on by their descendants. I have already established this thesis in " The Megalithic Culture of Indonesia " for the communities therein studied : [1] but it is necessary to return once again to this matter.

In Egypt, from the time of the Fifth Dynasty onwards, the king was the high priest of the sun-cult, and had to perform daily ceremonies in connexion with the sun-god.[2] The cult which he had to render towards the god was that which a dutiful son renders to his father. The king in relation to the gods, and the eldest son in relation to his father, were on exactly the same plane : the king was himself a god, and the god whose cult he carried on was his father. Therefore the cult of the gods of Egypt was an ancestor-cult in the royal family. In the tomb the ancestors of each man received the funerary cults of their sons ; in the temples the gods received the divine cult at the hands of their sons, the kings.[3] In the cult of the god, the son, that is, the king, was assisted by his wife, usually his sister, and his mother, the wife of the dead king. The temple itself was planned in the same manner as a palace : round it was a sacred wood, and a lake was in the grounds, just as are seen in the pictures of private houses of the upper classes. Nothing distinguished the dwelling of the god from that of his descendants. The gods of Egypt lived in their temples in the manner of mortals : they had luxurious rooms fitted up for the use of the occupant.[4]

The first appropriations of lands in Egypt were apparently those destined for the upkeep of the temples and their staffs. The military chiefs only appeared later, about the time of the Twelfth Dynasty, or perhaps even later. The cause of the expeditions to Asia and to the regions of the Upper Nile, was simply the need of materials for the building and decorating of temples, and for use in the temple ritual : in fact, it is not saying too much, according to Moret, to claim that the upkeep of the table of the gods, the filling of the sacred vases, and the procuring of the necessary clothing and ornaments for the state cult, was one of the chief preoccupations of the king and the royal administration.[5] The king had to provide all the supplies for the temples, and for the tombs whose occupants had been granted the favour of the royal funerary ceremonies. It is thus obvious that the greater part of the organization of Ancient Egypt was focussed on the temples and the royal palaces. The king stood at the centre of a vast complex organization concerned mainly with the cult of the

[1] Perry vii. Chap. 18. [2] Blackman ii. 16 e.s.
[3] Moret i. 117. [4] *Id.,* 118, 126, 130. [5] *Id.,* 186,

royal dead, and the whole economic and social life of the community revolved round this centre. This makes it possible to understand the significance to the Egyptians of their king. In the words of Moret : " The Egyptians worshipped in Pharaoh not the strongest, best born, richest man, but the son of the gods and their priest, who acted as intermediary between men and gods. On this priest descended the cult of the gods and of the dead. This cult having preserved the religious rites of his ancestors, it was necessary that the king in order to be able to celebrate them should be of the same race as the gods and the Osirian dead, whence the theory of the divine birth of the Pharaoh. The king had, moreover, each day to receive a new supply of the fluid of life." [1] One consequence of this interdependence of state cult and ruling family was that when one dynasty, or one branch of the ruling family, overthrew another, the result was a new state god. For example, when, as seems to have been the case, the Heliopolitan ruling family got power, the solar cult became the state religion of Egypt, this cult being that of the god from whom the king of Heliopolis was descended. Similarly, when the ruling houses of Memphis or Thebes got the throne, the state gods were changed. So when, in consequence of invasions of victorious strangers, the king of Egypt no longer was the son of the gods, their cults, left in the hands of ordinary mortals, were neglected. According to the Papyrus Salliari, says Moret, the Hyksos king Apopi abandoned the cult of Re for that of Sutekh, of which cult the Theban Seqenenre, as descendant of the indigenous royal family, took charge. [2]

It is not surprising that, so intimate being the ties between the ruling family and the state cult, the commoners seemingly played no part in the formation of the Egyptian religious system, certainly not of the solar cult. The necessity for the maintenance of this vast system made it imperative to found large priestly corporations, usually hereditary, and, in the higher orders, of noble or royal birth. This priestly class has produced the great developments of religious thought in Egypt, the commoners apparently taking no part in this matter. As is said, " No one was of necessity excluded from the mysteries of the Egyptian religion : these were as accessible to the people as to the nobility, however true it may be that the former troubled themselves but little on the subject, and left it to the priests to take thought for the offerings. The people would naturally have more faith in the power of amulets and magic than had the cultured classes, yet fundamentally the religious belief of all classes was the same." [3] Since the cult of the state deities was primarily an ancestor-cult of the royal family, it is not surprising to meet with this indifference on the part of the ordinary people.

Little is known of the manner in which the religious system of the Sumerians was carried out. At the time of the first dynasty

[1] Moret i. 281. [2] *Id.*, i. 280, n. 4. [3] Wiedemann 206.

of Babylon the priesthood seems to have contained members of the royal family.[1] The Sumerian kings were evidently identified with Tammuz, the god of vegetation, the son of the great mother goddess, and represented him in certain ceremonies.[2] As in Egypt, the ordinary people seem to have taken no part in the production of religious system. In the words of Robertson Smith : " The official system of Babylon and Assyrian religion, as it is known to us from priestly text and public inscriptions, bears clear marks of being something more than popular traditional faith ; it has been artificially moulded by priest-craft and state-craft in much the same way as the official religion of Egypt—that is to say, it is in great measure an artificial combination, for imperial purposes, of elements drawn from a number of local worships. In all probability the actual religion of the masses was always much simpler than the official system." [3]

Indian religion seems to have been primarily an affair of the ruling groups. The compositions of the Aryan immigrants into India were long regarded as typical of the first strivings of the human mind towards the comprehension of the mysteries of the universe ; they were supposed to represent the infancy of human speculation. But of late years the advance of knowledge of the conditions under which the civilization of the Aryans of India was developed, and the more critical study of the writings themselves, has convinced most students that these writings, far from being the spontaneous products of naïve speculation, are, on the contrary, highly artificial, and the product, not of the beginnings of religious thought, but rather of its later and modified forms. This point of view has forcibly been expressed by Barth. " My views on the Veda are not precisely the same as those which are most generally accepted. For in it I recognize a literature that is pre-eminently sacerdotal, and in no sense a popular one ; and from this conclusion I do not, as is ordinarily done, except even the hymns, the most ancient of the documents. Neither in the language nor in the thought of the Rig-Veda have I been able to discover that quality of primitive natural simplicity which so many are fain to see in it. The poetry it contains appears to me, on the contrary, to be of singularly refined character and artificially elaborated, full of allusions and reticences, of pretensions to mysticism and theosophic insight ; and the manner of its expression is such as reminds one more frequently of the phraseology in use among certain small groups of initiates than the poetic language of a large community. And these features I am constrained to remark as characteristic of the whole collection ; not that they assert themselves with equal emphasis in all the hymns—the most abstruse imaginings being not without their moments of simplicity of conception ; but there are very few of these hymns which do not show some trace of them, and it is always difficult to find in the book and to extract clearly defined portions of

[1] King ii. 116. [2] Langdon i. 26. [3] R. Smith ii. 14.

perfectly natural and simple conception. . . . The hymns, as I have already remarked, do not appear to me to show the least trace of popular derivation. I rather imagine that they emanate from a narrow circle of priests, and that they reflect a somewhat singular view of things. . . . I am therefore far from believing that the Veda has taught us everything on the ancient social and religious condition of even Aryan India, or that everything there can be accounted for by reference to it. Outside of it I see room not only for superstitious beliefs, but for real popular religions, more or less distinct from that which we find in it. . . . We shall perhaps find that . . . the past did not differ so much from the present as might at first appear, that India has always had, alongside of its Veda, something equivalent to its great Civaite and Vishnuite religions, which we see in the ascendant at a later date, and that these anyhow existed contemporaneously with it for a very much longer period than has till now been generally supposed." [1] Later on, when the ascendancy of the Brahmins was complete, the relationship between the priesthood and the cult of the gods became even more intimate. The Brahmins claimed to be divine, and the worshipper had to have all his religious rites performed for him by a Brahmin priest. The Brahmins were responsible in India for the institution of caste, with its multitudinous restrictions of all kinds. The official culture of Brahminism, says Barth, was aristocratic, and is competent only for chiefs and men of wealth. Even the domestic ritual which it involved was costly, and far beyond the means of the poor man. The Brahmins formed " the intellectual and religious aristocracy of the nation," and they were at the head of all new religious movements in Hinduism in subsequent ages. [2]

With regard to the Dravidians, it is not possible to estimate accurately the part played by the ruling classes in the religious systems. It would seem, however, that cults of gods were associated with hereditary priesthoods of royal birth. For example, it is probable that certain cults were introduced to the Aryans by the priestly family of Bhrigu, who seems to have been an Asura, that is a Dravidian. It is known, further, that the Brahmins derived the fundamental doctrines of the Upanishads from Kshatriyas, that is Children of the Sun. [3] The priests of the Nagas, another people of the Dravidian, or non-Aryan civilization, probably belonged to the Kshatriya, or royal caste of Children of the Sun. This is so nowadays among the peoples of the Chenab Valley in the Himalayas. Oldham says : " In this we have a survival of ancient customs existing in the far-off days when the Kshatriya chief offered his own sacrifices." [4] These temples are in honour of the old deified chiefs of the Nagas, and the cults carried on in them constitute another example of the temple ritual being simply an ancestor-cult of the ruling family.

[1] Barth xiii.–xv. Cf. also Moulton. [2] Id., 154–5, 158.
[3] Deussen 18–20 : Oldham 70. [4] Oldham 93.

It is beyond doubt that the main developments of religion in India were in the hands of the two upper castes, the Brahmins and the Kshatriyas or rulers. Not only did the Brahmins produce Brahminism, and the multiplication of the Hindu sects; but to the Kshatriyas India owes many dogmas, especially that of reincarnation. Buddhism and Jainism are intimately connected with the ruling families of the serpent-worshipping Naga races of the Dravidian times.[1] The gradual development of a sacred language, only understood by a few priests, still farther shows that the religious thought of India was in the hands of people who claimed special relationships with the gods. It may be claimed that this great priestly development of Indian religion was accompanied by another development of popular religion, and many customs are pointed to in support of this contention. This argument certainly may have some weight. But it is not stably founded. For, as has been seen, the present-day Indian peoples have a long history behind them, and many of them clearly are derived from highly civilized peoples of the past. If it is proposed to select communities possessing the popular religions that stand outside of the great priestly development, where shall they be found? Apparently nowhere in India outside of the food-gatherers like the Veddas and other jungle tribes of South India. A Dravidian tribe, such as the Oraon of Chota Nagpur, possesses a religious system compounded of elements brought with them from their original home, and others that they have derived from the Kols.[2] Their religion is purely utilitarian: " They look upon God as being too good to punish them, and therefore they do not think that they are answerable to him in any way for their conduct. . . . All their anxiety is about this world, and all their religious practices tend only to worldly things, namely, to get good crops and be free from sickness." [3] The Kols, again, are connected with the ancient ruling races of India. In this case, as in others, inquiry invariably leads to the communities of the archaic civilization.

Ignoring these considerations for a moment, and conceding the feasibility of separating peoples into categories according to the nature of the deities whom they are said to worship, can any signs be detected of an independent development among the peoples of lower culture in India of a cult of gods? In the Census Report for 1901, Sir Herbert Risley discusses the less advanced peoples of India whom he calls *Animistic*. He says: " We may . . . sum up the leading feature of Animism in India. It conceives of man as passing through life surrounded by a ghostly company of powers, elements, tendencies mostly impersonal in their character, shapeless phantasms of which no image can be made and no definite idea can be formed." [4] He

[1] Cf. de Visser, where it is shown that the belief in dragons and Nagas was carried about the East by Buddhists.
[2] Dehon 124. [3] *Id.*, 125. [4] India, Census of, 1901, i. 356.

then goes on to compare this Animism with the popular Hinduism of the present day, that form of religion which came into being after the revival of Brahminism and the downfall of Buddhism in India. It is a medley of all kinds of religious systems—Vedic, Dravidian, Brahmanic, Christian, Mohammedan, and so on—but the main thread of development is, as has been seen, held by the Brahmins, who have been responsible for the production of the new sects. Risley defined Hinduism as Animism more or less transformed by philosophy, or as magic tempered by meta-physics. " The fact is," he says, " that within the enormous range of beliefs and practices which are included in the term Hinduism, there are comprised two entirely different sets of ideas, or, one may say, two widely different conceptions of the world and of life. At one end, at the lower end of the series is Animism, an essentially materialistic theory of things which seeks by means of magic to ward off or to forestall physical disasters, which looks no farther than the world of sense, and seeks to make that as tolerable as the conditions will permit. At the other end Pan-theism combined with a system of transcendental metaphysics." [1] He then goes on to say that " The Animistic usages of which we find such abundant traces in Hinduism appear indeed to have passed into the religion from two different sources. Some are derived from the Vedic Aryans themselves, others from the Dravidian races who have been absorbed into Hinduism. As to the first, Bergaigne has shown in his treatise on Vedic religion that the Vedic sacrifice which is still performed by the more orthodox Hindus in various parts of India is nothing more nor less than an imitation of certain celestial phemonena.[2] It is, in other words, merely sympathetic magic directed in the first instance to securing the material benefits of sunshine and rain in their appointed seasons. The Vedas themselves, therefore, are one source of the manifold Animistic practices which may now be traced through popular Hinduism. They have contributed not only the imitative type of sacrifice but also the belief, no less magical in its character, that by the force of penance and ascetic abnegation man may shake the distant seat of the gods and compel them to submit themselves to his will. It would be fruitless to attempt to distinguish the two systems of magical usage—the Vedic and the Animistic. They are of mixed parentage like the people who observe them, partly Indo-European and partly Dravidian." [3] In other words, it is possible that the whole of the Animism of the peoples of India represents what the native mind has selected from more highly developed religious systems, and that it has nothing primitive about it. The quotation at least compels an open mind on the subject. Because the archaic civilization stands behind that of the present peoples of India, it is imperative to seek in it first of all the source of the present-

[1] India, Census of, 1910, 357. [2] Bergaigne. [3] Risley 358.

day Animism. No valid reason exists to deny this conclusion, and much to accept it.

In Indonesia the available evidence goes to show that cults of gods are carried on by those who claim descent from them, that is, by the immigrants who came in with the archaic civilization and imposed themselves as rulers. They claimed to be connected with the sky-world, and carried on cults connected with their divine ancestors : the ordinary people take no active part in these cults, and obviously could have had nothing to do with their development. Not only are they excluded from the state cult, but they do not seem to take any interest in it at all. For, as has been pointed out, the indigenous population cares but little for the gods in the sky, the ancestors of the sky-born rulers. This evidence is so important that I may perhaps be allowed to quote it in full.

Heer Kruyt says : " Where the belief in and the worship of gods is an integral part of the life of primitive man, he has no more than a suspicion of his gods, and that suspicion has but little influence upon his daily life." Again he says that a Toradja man is " quite conscious of the relationship between man and the ghosts of his ancestors. But when anyone asks him about his gods and spirits, then perhaps he may have something to tell which he has learned by chance, but generally he refers the questioner to the priests." In Nias, where the religion is well developed, " the Nias people do not worship their gods, they only expect good from them." Heer Westenberg says of the Karo Batta of Sumatra that " the tales about the gods are preserved by the priests, for the ordinary people know practically nothing about them ; they only know what they have picked up here and there." [1]

It is fortunate that these field workers have noticed this indifference of commoners towards the gods of the community. I am confident that this proposition is of universal application, and that inquiry will bear out the statements of these students. It is possible to support this conclusion from another direction. " Among all the peoples of Borneo a number of myths are handed on from generation to generation by word of mouth. These are related again and again by those who make themselves reputations as story-tellers, especially the old men and women ; and the people are never tired of hearing them repeated, as they sit in groups about their hearths between supper and bed-time, and especially when camping in the jungle.

" The myths vary considerably in the mouths of different story-tellers, especially of those that live in wide-separated districts ; for the myths commonly have a certain amount of local colouring. Few or none of the myths are common to all the people, but those of any one people are generally known in more or less authentic form to their neighbours.

" Although many of the myths deal with such subjects as the

[1] Perry vii. 166–7.

creation of the world, of man, of animals and plants, the discovery of fire and agriculture, subjects of which the mythology has been incorporated in the religious teachings of the Classical and Christian worlds, the mythology of these people has little relation to their religion. The gods figure but little in the myths, and the myths are related with little or no religious feeling, no sense of awe, and very little sense of obligation to hand them on unchanged. They are related in much the same spirit and on the same occasions as the animal stories, of which also the people are fond, and they may be said to be sustained by the purely æsthetic or literary motive rather than the religious or scientific motives." [1]

This quotation shows where lie the real interests of the Borneo peoples. They are concerned with homely matters, and not with the vague figures of the gods, the ancestors of their ruling classes. Knowledge of the gods belongs to the priests, whose business and interest it is to preserve it. The ordinary man is more interested in his own affairs, and in the ghosts of his own folk. The fact that the tales are allowed to be varied shows the absence of any religious feeling. For the usual rule in the case of sacred myths is that the slightest deviation from the exact wording will be visited with the direst penalties.

The corollary to the theorem that cults of sky-gods are in the hands of those who claim relationship with them, is that where no such class exists such cults will be absent. It is possible to put this matter to the test. Certain peoples have been visited by culture-heroes, beings who came from the sky, married some of their women, and then departed without founding a ruling class. Such people include the Toradja of Central Celebes, the Bontoc of Luzon, the Australians, and certain peoples of New Guinea, Melanesia and North America.

The Posso-Todjo group of the Toradja of Central Celebes, who have no chiefly class, say that a culture-hero, Lasaeo, the Sun-Lord, once visited them and civilized them, and that his sons went away elsewhere to found chiefly houses. These peoples have no hereditary priesthood, and men, except in rare instances, do not act as priests. That is reserved for women. Priestesses are not concerned with cults of gods : their functions are practical, for they are needed in ceremonies connected with illness, agriculture, funerals, and house-building. It may be thought that these functions of priestesses are of native origin, but the Toradja deny this, and claim that the sky people began the craft by instructing some woman whom they took to the sky for the purpose. In " The Megalithic Culture of Indonesia " it has been shown that these functions of the initiated priesthood persist because the culture-heroes and other people of the archaic civilization who introduced the use of stone, irrigation and so on, also brought with them ideas with regard to the nature of the life of man which made it imperative for the priesthood to continue if men were to remain in

[1] Hose and McDougall II. 136–7.

health, to get their food-supply, to build houses satisfactorily, and to find their way to the land of the dead.

The Toradja have a few deities, although, as Kruyt says, they take no real interest in them. If these deities are derived from the archaic civilization, and are not the product of native thought, their survival must be explained; and it can be shown that they bear a direct relationship to each Toradja man and woman, as well as to the people of the archaic civilization. In the first instance the Toradja have two chief deities, iLai above and iNdara below. " These are known as otiose deities, who reign above and beneath as rulers, and do not trouble themselves with men." These two deities made the first Toradja man out of stone images, and then retired to the background, being but rarely called upon.[1] Another god, Pue di Songi, " the lord in the room," figures in the Toradja mythology, presumably because he plays an important part when the priestesses are engaged in the cure of illness. The theory of illness is that the " life " of the patient has been taken from him by some agency, such as a sky-being. When she wishes to cure anyone, the priestess goes into a trance, and her " life," accompanied by her familiar sky-spirit, goes to the sky, to Pue di Songi, to claim the life of the patient. Pue di Songi decides whether it shall be restored or not. Thus the persistence of a god is accompanied by some useful function on his part.

Kruyt goes on to say : " We shall find the names of other gods in various prayers that are included in this volume. It is superfluous to mention here that ordinary people know no more of them than the name. In general, the knowledge of these gods and of many spirits is the property of the priestesses. The people know them not ; the people know only of one god and that is Pue mPalaburu." His name means " the kneader " and this refers to his function of " man-maker," Although creation was performed by other gods, it was Pue mPalaburu who ordered it to be done. In prayers he is named as the god who separated the fingers of the hand, the lips and so on. In his function of manmaker he is supposed to live in a house, the floor-laths of which consist of human fingers, the roof-beams of ribs and so on, and he uses these to make men. His betel-pouch consists of a human scalp.[2] This important god performs a function of vital interest to every Toradja, the making of human beings. The Toradja have none of the usual type of deities that are to be found in Egypt and elsewhere, no war-gods or sun-gods, or any of the personifications of nature. The two gods who really do play a part in their theology are intimately associated with them in connexion with the cure of illness, and with the process of birth.

The Toradja tell of the time when close intercourse existed between the sky and the earth. In those days the sky lay near to the earth, and the separation took place on account of the

[1] Kruyt and Adriani I. 268. [2] Id., 269.

nausea caused in the gods by the Toradja pigs. Now that intercourse is broken off, except for the priestesses, the Toradja know practically nothing of the sky-world. This tradition of separation agrees with that of Lasaeo, in that it can be interpreted as meaning that sky-descended people once lived among the Toradja. Now that they have gone the priestesses alone can communicate with the sky.[1]

The Toradja in their religion pay no attention to deities that perform no useful function; iLai and iNdara, having created men have retired, so to speak, and are not the objects of any cult. Pue mPalaburu, the actual maker of each human being, is of importance, and is the object of a cult. In this way he, and similar gods, constitute an exception to the rule that cults of gods are really ancestor-cults. Precisely the same attitude is taken by the Australians with regard to their culture-heroes. They have retained no sky-gods at all, and simply remember their culture-heroes as beings, superior to them in magic and knowledge, from whom they derived their civilization. It is said that the Australian All-Fathers were deities in the making. But no reason exists to believe this to be so. For their culture-heroes, whether the two youths or the All-Father, seem to be traditional. The youths certainly are not the object of any form of cult. As for the All-Father, it is only necessary to quote the words of Howitt. " In this being, although supernatural, there is no trace of a divine nature. All that can be said of him is that he is imagined as the ideal of those qualities which are, according to their standard, virtues worthy of being imitated. Such would be a man who is skilful in the use of weapons of offence and defence, all-powerful in magic, but generous and liberal to his people, who does no injury or violence to anyone, yet treats with severity any breaches of custom or morality." [2] Howitt fails to see any form of religious feeling associated with this being. He discusses the matter and says in conclusion : " But all this does not bring us to the worship of the ancestor, who is supposed to have developed into the All-Father." He goes on to say, " Although it cannot be alleged that the aborigines have consciously any form of religion, it may be said that their beliefs are such that, under favourable conditions, they might have developed into an actual religion, based on the worship of Mungan-ngaua or Baiame." [3]

The culture-heroes of Melanesia are in the same case as those of Australia ; although sky-beings, they do not receive any active cult. Throughout Melanesia ancestor-cults are prominent, and little of a cult of deities can be observed. This goes with the absence throughout the greater part of the region of a ruling class. As among the Toradja and in Australia, certain beings, who are remembered as creators, receive no cult : in San Cristoval there are beings called Figona or Hilona. " The name figona is also known at Florida, and is applied to beings whose power exercises

[1] Kruyt and Adriani III. Cf. Adriani. [2] Howitt 506–7. [3] *Id.*, 507.

itself in storms, rain, drought, calms, and in the growth of food ; but these the natives decline to admit to be simple spirits, thinking they must once have been men ; and doubtless some so called were men not long ago. One being only is asserted there to be superhuman, never alive with a mere human life, and therefore not now a ghost ; one that now receives no worship, but is the subject of stories only, without any religious consideration. This is Kosvasi, a female. How she came into existence no one knows ; she made things of all kinds ; she became herself the mother of a woman from whom the people of the island descended. She was the author of death by resuming her cast-off skin ; she was the originator of the varying dialects of the islands round ; for having started on a voyage she was seized with ague, and shook so much that her utterance was confused." . . . These spirits, such as they are, have no position in the religion of the Solomon Islands ; the ghosts, the disembodied spirits of the dead, are objects of worship ; the tindalo of Florida, tidadho of Ysabel, tindaolo of Guddalcanar, lio'a of Saa, " 'ataro of San Cristoval." [1] So, in the Solomons, as in Indonesia, supernatural beings, whatever their powers, do not receive cults unless they have relatives on earth, or else are useful to the community ; even then they do not get much attention.

In the Banks Islands a form of cult is attached to certain spirits, called Vui, to whom belong culture-heroes such as Qat and Tagaro. This cult is not attached directly to the spirit, but to certain objects, usually stones, identified with the spirit. " Such stones have some of them been sacred to some spirit from ancient times, and the knowledge of the way to approach the spirit who is connected with them has been handed down to the man who now possesses it. . . . Some of these objects of sacrificial worship are well known, but can only be approached by the person to whom the right of access to them has been handed down ; there must be between the worshipper who desires advantage and the medium spirit who bestows it not only the medium of the stone, or whatever material object the spirit is connected with, but also the man who through the stone has got a personal acquaintance with the spirit. . . . In the Northern New Hebrides, spirits are approached very commonly at stones, and offerings are made to them upon the stones, to secure their favour or to reconcile them if offended. Such sacrifices are made for sunshine, rain and abundant crops." [2] So, sacrifices made to spirits are for material benefits, and not by way of worship of the particular spirit. It is important, too, that the cult is associated with stones, and with beings that have already shown strong signs of association with the archaic civilization, with its divine rulers possessed of magical power beyond other men. It would therefore appear, from the statements of Codrington, that the religious systems of the Melanesians are centred round ghosts of ancestors. Spirits,

[1] Codrington 124. [2] *Id.*, 140–3.

whatever their powers, are neglected, unless some link connects them with the earth in the form of stones that are supposed to be their seat.

The Polynesians stand in strong contrast to the Melanesians. Ellis, in his "Polynesian Researches," gives an account of the priesthood of the Polynesians of Tahiti. "The priests of the national temples were a distinct class ; the office of the priesthood was hereditary in all its departments. In the family, according to the patriarchal usage, the father was the priest ; in the village or district, the family of the priest was sacred and his office was held by one who was also a chief. The king was sometimes the priest of the nation, and the highest sacerdotal dignity was often possessed by some member of the reigning family. The intimate connexion between their false religion and political despotism, is, however, most distinctly shown in the fact of the king's personifying the god, and receiving the offerings brought to the temple, and the prayers of the supplicants, which have been frequently presented to Tamatoa, the present king of Raiatea. The only motives by which they were influenced in their religious homage, or service, were, with very few exceptions, superstitious fear, revenge towards their enemies, a desire to avert the dreadful consequences of the anger of the gods, and to secure their sanction and aid in the commission of the grossest crimes." [1]

The Polynesians lived in the midst of religious ceremonies. Ellis mentions a large number of such ceremonies. "An ubu or prayer was offered before they ate their food, when they tilled their ground, planted their gardens, built their houses, launched their canoes, cast their nets and commenced or concluded a journey. The first fish taken periodically on their shores, together with a number of kinds regarded as sacred, were conveyed to the altar. The firstfruits of their orchards and gardens were also taumaha or offered, with a portion of their live-stock, which consisted of pigs, dogs and fowls, as it was supposed death would be inflicted on the owner or the occupant of the island, from whom the gods should not receive [such acknowledgment." [2] Other ceremonies were connected with the purification of the land after the incursion of an enemy, the building of temples, the illness of their rulers, and various other events ; thus forming a strong contrast with the customs of peoples with no ruling class descended from the beings of the sky.[3]

Apparently the real old hereditary priesthood of the Polynesians was formed in their ancestral home, and the necessary knowledge was handed on from generation to generation. "They

[1] Ellis I. 342. In Bowditch Island the king was called Tui Tokelau, the same name as the chief god, whose high-priest he was. This king was chosen from among three families (Turner 268).

[2] Ellis I. 350.

[3] Members of priestly families introduced sacerdotal systems, as in Hawaii (Beckwith 298).

were the astrologers, magicians, poets, historians, often warriors, and, not least important, the navigators, where the great knowledge of the stars they possessed enabled them to guide their vessels from end to end of the Pacific, and even to the Antarctic regions."[1] These old priests were credited with all manner of extraordinary powers, including such feats of illusion as the " Mango Trick."[2] Now that as for example, in New Zealand, these old priests have died out, much of this knowledge has gone with them ; so it is not surprising to find that the culture of the Polynesian shows signs of decadence. Elsewhere in Polynesia, as is natural, considering the uniform nature of their culture, the office of priests is hereditary. In Samoa the father of the family carries on the ancestor-cult. With regard to the gods of the villages, it is said that " The priests in some cases were the chiefs of the place ; but in general some one in a particular family claimed the privilege, and proposed to declare the will of the god. His office was hereditary. He fixed the days for the annual feasts in honour of the deity, received the offerings and thanked the people for them. He decided also whether or no the people might go to war."[3] It is significant that in Samoa the chief classes of priests are the Prophets or Sorcerers, Family Priests, Priests of the War-gods, and Keepers of the War-gods,[4] and that the priests of the war-gods evidently constituted the most important group.[5] No sun-cult is now reported on the island ; so with the disappearance of the Children of the Sun has gone that of any priests who may have had charge of the sun-cult

The evidence from Melanesia, when compared with that from Polynesia, shows that, while the form of cult attached to the personal gods of the Polynesians is not exactly the same as that associated with the vui spirits of Melanesia, the two are probably connected. Cults of gods in Polynesia, such as Oro in Tahiti, Rongo in Mangaia and the various war-gods elsewhere, are carried on by men who claim to be their descendants. When these ruling families die out, with them go the actual cults of these gods. But some indirect cults are connected with the Vui spirits of Melanesia, who, for various reasons, have been equated to the Children of the Sun of the archaic civilization. They have left no descendants, but are remembered as culture-heroes ; therefore no direct cult of them is maintained. At the same time they are connected with certain stones, where are carried on ceremonies directed towards utilitarian ends. Since the archaic civilization is directly concerned with stones, it is reasonable to claim that this fact has caused the peoples of Melanesia to attach importance to certain stones (see p. 393). The cult carried on in this way is purely for utilitarian ends, and does not constitute a cult of the spirits themselves. They are remembered as Vui, and not as ancestors of various groups.

[1] P. Smith v. 255–6. [2] *Id.,* v. 267 : Huguenin 141 e.s.
[3] Turner 20. [4] Stair vi. 70. [5] *Id.,* 220.

The cults of the initiated priesthoods of Indonesia belong to this category. The archaic civilization is credited with their institution, and they are concerned with utilitarian ends, leech-craft, agriculture and so on ; and, although connexion with the sky has been interrupted, the priestesses can get there when necessary.[1]

It must therefore be borne in mind that, although the actual cults of gods of the sky-world are carried on by their descendants, yet ceremonies connected with these beings can be performed in other ways, but in every case the means of intercourse must be some material object or some social institution directly associated with the people of the sky-world, that is with the archaic civiliza-tion. The inference is that, while the natives are not concerned with the family cults of the rulers of the archaic civilization, yet they have learned from them the necessity, imaginary of course, of performing certain ceremonies for the maintenance of health, food supply, and so on, and have taken good care to preserve the means of performing these ceremonies.

In North America the evidence points to exactly the same conclusion. Cults of gods were in the hands of ruling classes. In the Maya settlement of Mayapan, the rulers were priest-kings, claiming descent from the divine founders of the city.[2] Probably Mexico formerly had priest-kings ; for the kings in later times acted on certain occasions as high-priests of the state-cult ; but in the days of the Aztecs this office had become hereditary in families of very high birth.[3] The head priests were called Quetzalcoatl, and probably the most revered priest in Mexico was the priest of Quetzalcoatl, the great culture-hero of the Mexicans, who dwelt at Cholula, and was regarded as the direct descendant of Quetzalcoatl. He lived a life of great austerity.[4] In the origin myth of the Kiche of Guatemala, it is said that their ancestors were led by priests and the early royal family acted as priests.[5]

In reviewing the religious systems of the rest of North America it becomes evident that the forms of their various cults are determined by processes similar to those which acted in the case of the regions already discussed. In Mexico and among the Maya, the highest ranks of the priesthood were recruited from the royal family ; and the peoples had a great and elaborate pantheon, consisting of divers deities. But in regions such as those of the Pueblo Indians, the religious system is utilitarian. The Zuni are looked upon as the most religious people among the Pueblo Indians, on account of the number of their ceremonies. Their religion is thus summed up by Mrs. Stevenson : " They look to their gods for nourishment and for all things pertaining to their welfare in this world, and while the woof of their religion is coloured with poetic conceptions, when the fabric is separated

[1] Perry vii. Chap 18. [2] Bancroft III. 472.
[3] Bancroft II. 200 e.s. [4] Joyce ii. 91–2.
[5] Brasseur de Bourbourg lxxxvi. 311.

thread by thread we find that the web is composed of a few simple practical concepts. Their highest conception of happiness is physical nourishment and enjoyment, and the worship of their pantheon of gods is designed to attain this end." [1] Similarly the religion of the Hopi, another important Pueblo Indian tribe, is concerned with the getting of food and of other material blessings. [2] Some other of the Pueblo Indians have less complex ceremonials. The Pima, a " powerful sedentary tribe, reduced to distress and decadence, [3] . . . are far less given than their Pueblo neighbours to the outward show of religion, . . . they appear to have no other than occasional ' rain-dance,' the naviteo, and other ceremonies for the cure of disease. . . . So far as could be ascertained in a comparatively brief sojourn among them, their religion comprised a belief in the supernatural or magic power of animals, and especially in the omnipotence of the sun." [4] These people have a class of hereditary priests who are concerned with the cure of disease : they also have magicians who bring on rain, and have power over the weather, crops and so forth. They have no hereditary class with cults of deities ; for the doctors and magicians are the rulers of the tribe. So, in this case, as in others, the effect of a drop in the level of culture has been to cause the gods and their cults to disappear, and to leave only those elements of the former religious system that pertain to the practical benefit of the community.

In the Pueblo area, the ritual is mainly concerned with food. It would be thought that this might be due to the natural desire of the people to protect their food supply, and to appeal to their gods to get it for them. This suggestion, which is so often made, assumes the existence among the bulk of the people of a lively sense of their gods, which cannot be conceded, for it assumes that the knowledge of the gods is really a common possession of the peoples, and not simply part of the priestcraft, as it is in so many places. It must be remembered constantly that the civilization of the Pueblo area is founded upon the cultivation of maize, which cereal comes from Mexico. Moreover, Mexican and Mayan ritual centred round agriculture, that is, on maize-growing. This ritual, as Fewkes has asserted, is similar to that of the Pueblo Indians, [5] who, consequently, must have got it, together with their maize, from the Mexicans or Maya. Their traditions assert that their ceremonial was taught them : the Hopi, for example, say that the sun-cult was introduced from the south by one of their clans. With this sun-cult go certain ceremonies, among them that of the " calling back of the sun." " The object of this winter solstice ceremony is not only to draw back the sun, the arrival of whom is dramatized . . . but likewise to impart new life to all nature, to fertilize the earth, that the germ-god may vitalize

[1] Stevenson ii. 15. [2] Fewkes xv. 493.
[3] F. Russell 25, 250. [4] *Id.*, 250.
[5] Fewkes xv. 499–500.

13

not only the crops, the seeds of which are piled below the altar, but also all game, domestic animals, human beings, material resources of all kinds." [1] Other Hopi stories recount the arrival of clans with certain rites, and the whole of their traditions support the view of an alien origin for their ceremonial, agricultural and otherwise. In this they are typical of the Pueblo tribes as a whole.

Among the tribes of the Mound area, and those that migrated thence into the Plains, the relationship is clear between the ruling class and cults of gods. The Chief Sun, the ruler of the Natchez of Louisiana, acted as high-priest in certain agricultural ceremonies : he brought on rain and acted as an incarnate deity. [2] The Yuchi of the Savannah River, who claim to be Children of the Sun, have a number of ceremonies taught them by their culture-hero, probably a Son of the Sun. [3] The Cherokee say that the knowledge of cults died out with their hereditary priesthood. [4] Consequently the following is a description of the Cherokee's attitude towards religion. " All his prayers were for temporal and tangible blessings—for health, for long life, for success in the chase, in fishing, in war and in love, for good crops, for protection and for revenge. He had no Great Spirit, no happy hunting-ground, no heaven, no hell, and consequently death had for him no terrors, and he awaited the inevitable end with no anxiety as to the future. He was careful not to violate the rights of his tribesmen or to do injury to his feelings." [5]

The relationship between hereditary groups and definite rites is evident in the case of the Omaha, the Siouan tribe of the Plains. Their relatives of the east had an absolute monarch. A high-priest was the only person who could make sacrifices to a Supreme Being, who, however, paid little attention to them. [6] The Omaha tribe is divided into two groups of five gentes. When the tribe is camping out, one group occupies the northern half of the camping-circle, while the other five gentes occupy the southern half of the circle. These gentes were the possessors of certain ceremonies that only they could perform ; they constituted, as it were, hereditary priesthoods. The five gentes of the northern half of the circle were the custodians of the rites that pertained to the creation of the stars, and the manifestation of the cosmic forces that pertain to life. [7] Nearly all these rites have become obsolete, except those of the last-named class : these constituted the ritual by which the child was introduced to the Cosmos, the ceremony through which the child was inducted into its place and duty in the tribe, and the ritual required when the two sacred tribal pipes were filled for use on solemn tribal occasions. Miss Fletcher, who with Francis la Flèsche, himself an Omaha, has studied this tribe so thoroughly, says : " In view of what has been discerned of the

[1] Voth ii. 142. [2] du Pratz 329, 339–40. [3] Spech ii. 149.
[4] J. Mooney vii. 392–3. [5] Id., i. 318.
[6] Id., v. 22, 31 e.s. [7] Fletcher and La Flèsche 194–5.

practical character of the Omaha, it is interesting to note that only those rites directly concerned with the maintenance of the tribal organization and government were kept alive and vital, while those other rites, kindred but not so closely connected with the tribal organization, were suffered to fall into neglect." [1] The rites that have survived are, in addition to those already mentioned, those pertaining to the Sacred Tent of War, and the first thunder of the spring, and those connected with the food supply, which were connected with the two Sacred Tents. One of these tents contained the sacred white buffalo hide, the keeper of which conducted the rites connected with the planting of maize and the hunting of the buffalo. In the other sacred tent was kept the sacred pole, the keepers of which were associated with the maintenance of the authority of the chiefs in the tribe. In short, protection from without and the obtaining of food and clothing were the objects of these rites that have survived. The Omaha, it is said, had no gods, or goddesses, [2] and no tribal priesthood, also many rites pertaining to the sky have been lost. What is the cause of this loss ? It is significant that they formerly had a class of hereditary chiefs, for nowadays they only have elective chiefs. [3] Possibly, therefore, the loss of the ruling class involved that of rites pertaining to the gods, as well as of the gods themselves. This would account for the vague and obscure nature of the Omaha ideas. The Sioux in their ancestral home had rulers, and high-priests and deities ; so evidently the culture of the Omaha is but a wreck of its former self, and only comparison with the religious systems of the other Siouan tribes will make possible its reconstruction. The Omaha are in two groups, of which that concerned with the rites pertaining to the sky is itself connected with the sky. According to the tribal myths, human beings were the result of the union between the sky-people and the earth-people. [4] Since the sky-people were concerned with the rites pertaining to the sky, it seems probable that the tribe once had cults of gods along with their hereditary chiefs. The Dakota branch of the Sioux have cults associated with the sun-god which are carried out by the "high-priest." [5]

The evidence in North America, as in Oceania, shows that cults of gods are the affair of their descendants ; when the people connected with the sky disappear, so do the gods and their cults. This appears clearly in the case of the Omaha, where the loss of rites is ascribed by the people themselves to the dying out of those family groups in which they were hereditary possessions. But when the groups with their ancestor-cult have gone something is usually left that harks back to the archaic civilization, some rites are retained that deal with practical ends. This is evident in the Pueblo region, where the people ascribe all their civilization to the Twin Children of the Sun, who led them out of the underworld.

[1] *Id.*, 195. [2] *Id.*, 601. [3] *Id.*, 202.
[4] *Id.*, 135. [5] J. O. Dorsey ii. 449.

These beings have not founded a ruling class claiming descent from them : so a direct cult of the sun, as is found in Egypt, does not exist. The cults of these peoples are centred mainly round their agriculture, which is the chief preoccupation of their lives. Certain fraternities among them deal with healing, but the most important deal with the food supply. In this they are acting similarly to the peoples of Indonesia and Melanesia. It is probable, therefore, that the archaic civilization was, in all parts of the region, in possession of a theory of agriculture and of disease that required ceremonies to procure good health and an abundant food supply. Since these people probably brought agriculture with them to all parts of the region, it would be expected that they would teach their subjects, not only the practical methods of cultivation, but also the theoretical considerations underlying the process of getting food, which necessitated the institution of a priesthood. This would make the performance of ceremonial a matter of practical necessity ; and the natives, even when the people of the archaic civilization had departed, would tend for that reason to maintain such ceremonial. It stands to reason that this ceremonial was based upon false analogy, and was obviously absurd ; but the prestige of the people of the archaic civilization, and the claim of their rulers to divinity, would serve to endow their statements with a glamour that would not fail to impress itself upon the natives, and once such ideas had become part of the social heritage they would not readily be lost.

On the other hand, the loss of cults of sky deities shows that the Children of the Sun and the commoners were possessed of entirely different social traditions. Both were living in the same communities, but their antecedents were utterly dissimilar. The original Children of the Sun carried about with them beliefs concerned with the sky-world, they maintained a cult connected with their relatives in the sky, and this cult disappeared with them. After they had gone the connexion with the sky was only maintained for practical ends. Moreover, these sky-born folk differed from the rest of the community, in that they went after death to the sky, while the others went underground or elsewhere. It therefore would seem that communities ruled over by the Children of the Sun consisted of two entirely distinct parts that had no real connexion with one another, either during life or after death. The explanation of this deeply rooted distinction will, it is evident, go far to solve the problem of the origin of the archaic civilization. It must be borne in mind, at the same time, that the Children of the Sun, although they bulk large in the story of the archaic civilization, do not necessarily constitute the whole of the ruling class. It has been found, in India, that some of the Asura ruling families were closely connected with the underworld, the place so often frequented by the commoners in various places from Egypt to America. Moreover, in Polynesia,

the later ruling class was closely connected with the underworld, and it has been claimed that this ruling class has been derived from the archaic civilization. So it must be realized that the archaic civilization may have possessed a complex ruling group, formed of two or more distinct elements, of which the Children of the Sun constituted only one. It is with this group of Children of the Sun that the sky-world is associated.

The ruling group of the archaic civilization can at the same time be distinguished as a whole from the commoners. Throughout the region it is associated with the custom of mummification, which is practically never practised in the case of commoners.

Elliot Smith, in his " Migrations of Early Culture," has shown that mummification is practised throughout the region. And, although he does not stress the point, it is evident, from his exposition of facts, that this custom is reserved for members of the ruling class. For the commoners interment is the usual fate.[1] Anyone who wishes to study the matter in detail is referred to Elliot Smith's monograph. I shall content myself here with filling up one or two small gaps in the evidence, and with stressing the relationship of the custom to rulers. It is unnecessary to insist on the practice of mummification by the ancient Egyptians. On the other hand, it was sporadic in Babylonia, which is another token of the cultural difference between the two civilizations. It has already been said that Dravidian India shows traces, more or less definite, of Babylonian influence, but the nature and extent of this influence cannot as yet be estimated. At the same time certain peoples of Dravidian India show strong traces of relationship with the archaic civilization, in that they still erect dolmens. The problem of the origins of Indian civilization is therefore complex.

Although cremation is now so widespread, it is noteworthy that Indian tradition speaks of mummification. Dr. Crooke mentions " the belief in the possibility of securing the body from decay in the Deccan tales of Chandan Raja and Sodewa Bai." [2] In the Vishnu Purana it is said that the body of Nimi, the son of Ikshwaku, the son of Vaivaswata, the Son of the Sun, and therefore of the solar line, was preserved from decay " by being embalmed with fragrant oils and resins, and it remained as entire as if it were immortal." [3] Thus the practice was certainly known among the Children of the Sun. Dr. Crooke says that in the Mahabharata [4] the body of King Pandu, the father of the Pandava princess, was smeared with sandalwood paste. The Brahmins also knew of it : for Wilson, in his translation of the Vishnu Purana, comments upon the case of Nimi, by saying that a

[1] And the body is usually in a crouched position. When the burial customs of the region are discussed in detail, it will be seen how strong a confirmation is forthcoming for the support of the main thesis of this book. The practice of crouched burial will play an important part in such an inquiry.

[2] Crooke 272. [3] H. H. Wilson 388. [4] Crooke 272.

certain Brahmin mummified his mother's body. " For this purpose he first washes it with the five excretions of a cow, and the five pure fluids, or milk, curds, ghee, honey and sugar. He then embalms it with (I leave out the native terms) Agallochum, camphor, musk, saffron, sandal and a resin called Kakkola ; and envelops it separately with flowered muslin, silk, coarse cotton, cloth dyed with madder, and Nepal blanketing. He then covers it with pure clay, and puts the whole in a coffin of copper. These practices are not only unknown, but would be thought impure in the present day." [1] Aryans also seem to have disembowelled the dead and filled the cavity with clarified butter, but it is not said whether this holds of the rulers only or not.[2] Not only is mummification mentioned in India in the Epics, but it was practised lately in certain places. The Todas of the Nilgiris now cremate their dead, but their burial practices were formerly different. An old manuscript, written in 1603, says that they " burn the dead body, but it must be wrapped in a veil of pure silk, which they call a toda-pata, worth five or six fanams ; and if this is lacking they must wait for it, though it be for a year. In the meantime, in order to preserve the body they open it at the loins, take out the entrails, and cut off the occiput ; then they place it in an arbour and dry it in the smoke." [3]

A certain amount of mummification is still practised in Assam and Upper Burma. The Khasi, who speak an Austronesian language, and erect megalithic monuments, preserve the bodies of their chiefs in honey and after a time cremate them,[4] which suggests that the practice of cremation has been superposed on that of mummification. It is probable that this has been very generally the case in India.

The Naga tribes perform some process of desiccation. It is not said whether this applies to any section of the community. The Mao are mentioned as placing their dead in a bamboo coffin shaped like a house, and just large enough to admit the body. This coffin is put up in the outer compartment of the house and the body is smoked, the process lasting for from ten days to two months, after which the coffin is taken and placed on a platform outside the village.[5] The Tamlu Naga also smoke the bodies of their dead, and then place them in wooden coffins in the forks of big trees. They exhibit signs of a class distinction : for " in the case of men of distinction the body is thoroughly cured, the head is wrenched off and placed in an earthen pot. This pot is then neatly thatched with Tokapat and deposited at the feet of the tree in which the coffin containing the body is placed." [6]

Mummification is practised also by the Chin tribe of Upper Burma, the Siyin and Sokte branches being mentioned.[7]

The topic of the disposal of the dead in Indonesia is one that

[1] H. H. Wilson 387, n. 2. [2] Elliot Smith xii. 68 e.s.
[3] Rivers i. 727. [4] Gurdon. [5] Assam Census Report (1891), 245.
[6] *Id.*, 246. [7] Carey and Tuck I. 196–7.

requires special treatment, and I do not intend here to discuss the modifications of mummification that can there be detected. It must be mentioned that mummification of rulers occurs in close connexion with the archaic civilization. In Timor the Children of the Sun were mummified. They were placed, after death, in open coffins in the branches of trees, "and only when the flesh is decayed and the remains are reduced to a mummified condition are they buried facing the Sun, the chief's 'Father.'"[1] Heer Kruyt has lately told me that mummification of chiefs is practised by the Toradja of the Sadan district of Central Celebes, a region closely connected with the archaic civilization.

The Igorot of the Philippines, who ascribe their culture to beings from the sky, practise mummification.[2] The custom is also reported, in the Philippines, among the Bicol, Visaya, Tinguinan and Gaddanes.[3] Farther south the practice occurs in Dutch New Guinea at Mairassi and in Geelvink Bay,[4] a region that shows strong signs of the influence of the archaic civilization, but my information does not state whether the practice is confined to the chiefly class, if one exist in such places.

Working eastwards along the New Guinea coast brings us out into the Pacific, where the relationship between the preservation of the dead and the chiefly class has been fully established by Rivers. He surveys both Melanesia and Polynesia, and comes to the conclusion that "the balance of evidence is . . . in favour of the ascription of the practice of preservation to chiefs."[5] Mummification is also practised in Torres Straits, as well as in certain parts of British New Guinea which, according to Mr. Chinnery, show strong signs of the influence of the archaic civilization. Chinnery speaks of the mountain tribes, whom, he maintains, have been strongly influenced by the gold-seekers, and says that many of these mountain tribes have also elaborate practices in connexion with the dead, of which he gives several examples. Elliot Smith has discussed at length the mummies of the Torres Straits and Northern Australia, and has given as his considered opinion that they show signs of Egyptian technique of the XXIst Dynasty.[6] That this practice of mummification was introduced to Torres Straits Islanders by the culture-heroes of the archaic civilization is made probable by the following remarks of Dr. Haddon. "A hero-cult, with masked performers and elaborate dances, spread from the mainland of New Guinea to the adjacent islands : part of the movement seems to have been associated with a funeral ritual that emphasized a life after death. . . . Most of the funeral ceremonies and many sacred songs admittedly came from the west."[7] This evidence tends to ascribe

[1] Cabaton 356. [2] Sawyer, Inhabitants of the Philippines, 259.
[3] Kern i. 232 : Sawyer 259, 279 : Blumentritt i. (?), 204 ; ii. 54.
[4] S. Müller I. 105, 106 : Bastian II. 35 : Nova Guinea III. 274 : Goudswaard 73 : TNAG, 1902, 168. [5] Rivers ix. II. 277, 281–2, 291.
[6] Elliot Smith xii. 21. [7] Id., xii. 28.

mummification to the people of the archaic civilization. Evidence of the same nature is forthcoming from Samoa, where, in Upolu, embalming, formerly practised, is said to be due to people who came from the sky, and told people to bury them in a standing position with their heads uncovered.[1]

The Australian tribes of Queensland practise preservation of the dead. It is said that : " Desiccation is a form of disposal of the dead practised only in the case of very distinguished men. After being disembowelled and dried by fire the corpse is tied up and carried about for months."[2] So, if mummification be a practice connected with the archaic civilization, its existence in Australia is further evidence of the influence of this civilization in that continent.

The distribution of mummification in the region from Egypt to America suggests its connexion with the archaic civilization, and the evidence brought forward by Elliot Smith in his monograph is enough to convince most. But the new evidence in Indonesia, that serves to fill up certain gaps, makes his case still stronger, for it removes the possibility of objections founded on these former gaps.

In America mummification was evidently connected with the archaic civilization, and with ruling families.[3] For, in Mexico, and among the Indians of the Mound area, only rulers and nobles were mummified. The old cliff-dwellers of the Pueblo region practised mummification, but I do not know whether they reserved it for any social class.

Throughout the region mummification has tended to die out. The Plains Indians, for example, who once must have lived in a region where the chiefs were mummified have moved out thence, and have lost the custom. Similarly with the Pueblo Indians. In Oceania, again, mummification tends to be a thing of the past. Only recently has its former practice in New Zealand been proved. It is obsolete in India.

[1] Turner 235. [2] W. Roth 393. [3] Elliot Smith xi. 114–15.

CHAPTER XIV

SKY-GODS AS LIFE-GIVERS

QUOTATIONS in the last chapter from certain Dutch ethnologists show that, in speaking of the "religious system" of any community, it is necessary to be clear what that term means. A given tribe is said to possess a pantheon of gods. What is meant is that these gods are known to the priesthood, or certain members of it ; but the laity is usually ignorant about such matters, often not even knowing the names of the gods. When the Children of the Sun have disappeared from any community, they have generally left the native population in possession of certain ideas about the nature of the soul, the causation of disease and so forth ; but the solar pantheon has usually vanished. Rites connected with gods that are preserved by such peoples as the Toradja of Celebes or the Melanesians, and practised by members of a profession, tend to centre round material objects. Even among the priesthood initiated by the people of the archaic civilization, a selective process has been at work, weeding out deities and cults, so that the priestcraft becomes directed towards practical ends.

This generalization has an apparent exception. For sometimes deities are retained who are not obviously connected with any practical ends—such as Varuna in India, Laki Tengagan of the Kayan of Borneo, Bunjil of the Wurunjerri in Australia, Tangaloa of the Maori. Such beings do not as a rule receive any cult, and could on that account be ignored. But they still persist for some good reason. It is because the life of man is supposed by these peoples to be derived from the sky, and to return there after death. In spite of the fact that the sun-cult disappears in all parts of the region, sky-gods are sometimes remembered on account of their possession of the life of man. This makes them an object of interest to all men, and for this reason they have not wholly been forgotten.

The association between the sky and life is well seen in Egypt. Whatever the beliefs associated with the life of man, prior to the elaboration of the theology connected with the sky-world, it is certain that the Heliopolitan priests made it clear that henceforth life was essentially the possession of the sky-gods. Re, the sun-god of Heliopolis, was looked upon as the actual father of the

king.[1] The Pyramid Texts of the Fifth and succeeding dynasties were written by men whose ideas of the future life differed from those previously held. Instead of the otherworld, whether underground or not, they conceived the sky as the home of the dead king. The dominant note of these writings was that "life was in the sky. . . . The prospect of a glorious hereafter in the splendour of the god's presence is the great theme of the Pyramid Texts."[2] According to Heliopolitan theory, life was an emission of vitalizing light and of the creating word; thence the terms of "master of the rays," and "creator by the voice," or "utterer of words" which are given to all those deities that play the part of demiurge. Above all, Re, the sun-god, was the creator *par excellence*, and the agents of his creative power were his eye, the sun, "Eye of Horus," and his voice, "the voice of heaven, the lightning."[3] Re was said by the priests of Heliopolis to have created from his body Shu and Tefnut, from whom were born the great gods of the Egyptians, Osiris, Herkhent-an-ma, Set, Isis, Nephthys.[4] Thus not only was life in the sky, but the sky-gods were held to be creators. The Pyramid Texts are full of such ideas : in them "the chief and dominant note throughout is insistent, even passionate, protest against death. They may be said to be the record of humanity's earliest supreme revolt against the great darkness and silence from which none returns." The dead king is not now supposed to rule over the dead in the Osirian otherworld : on the contrary he goes to the sky, and lives among the gods : "King Teti is this eye of Re, that passes the night, is conceived and born every day. . . . His mother the sky bears him living every day."[5] As each dead king was identified with Osiris, it follows, naturally, that Osiris was ultimately raised to the sky-world, there to be the judge and ruler of the dead, and to be confused inextricably with Re and the dead king.

When the dead king died, his ba, or soul, which was his breath, went to the sky, in the form of a bird, there to join the ka, or afterbirth, that had gone there when he was born. His earthly body was thus bereft of the soul, which had to be restored. This could only be done by certain magical processes. Horus was supposed to have helped the dead Osiris to live again by giving him his eye that had been wrenched out in a fight with his enemy Set. Consequently all offerings to Osiris are called "Eye of Horus," and the dead body is thus made once again into a "soul," ba. Thus the king is given back his breath, his life, he now "existed as a person, possessing all the powers that would enable him to subsist and survive in the life hereafter."[6]

The bodies of Egyptian kings were mummified, and an important accompaniment of the practice of mummification was that of

[1] Moret i. 39. [2] Breasted iv. 102–3. [3] Moret i. 41.
[4] Wiedemann 33. [5] Breasted iv. 123, 136. [6] *Id.*, iv. 61.

making a portrait statue of the deceased, which was " animated " by magical process. Libations of Nile water were made with the aim of restoring to the statue the bodily fluids of the deceased. Then incense was burned to restore the odours of the living. Finally was performed the most important ceremony of all, that of the ritual " opening of the mouth," in which a priest touched with a copper chisel the mouth, eyes, ears and nose of the statue, which was then supposed to be alive in the fullest sense of the term. Elliot Smith points out that the Egyptian tried to make the portrait statue as life-like as possible, and paid special attention to the eye. The making of portrait statues seems only to have been attempted because of the failure of the first attempts to preserve the body in the full likeness of the living person. All through the ages the Egyptians persistently strived to preserve the dead in the real likeness of their living selves ; and in the Eighteenth Dynasty they seem to have considered that they had succeeded.

The three cultural elements of sun-cult, mummification and the making of stone portrait statues, became closely connected in Egypt with the Children of the Sun. The Egyptians also believed that men were created from images. It was first held that Khnum, the potter, made men on his potter's wheel. And in the later accounts of the birth of the Pharaoh it is said that Khnum makes the young king on his wheel at the commands of Re. Khnum made the egg from which Re emerged on the surface of the primeval ocean. Ptah, the great god of Memphis, was also closely connected with the idea of creation. His name probably comes from the root *pth*, " to open," especially as used in the ritual of the " opening of the mouth " of the stone statue. Like Khnum, he uses the potter's wheel ; and in his work of creation he is helped by the Khnumu, the modellers, who are said to be his children. Later on they became the children of Re. They were dwarfs with big heads, crooked legs and long moustaches ; and earthenware images of them are found in Egyptian tombs, for they were supposed to help in the reconstituting of the bodies of the dead.[1] The evidence thus points to Ptah as a later god, connected with the making of portrait statues, to whom have been transferred the attributes of Khnum. Both of these gods helped in the process of theogamy, acting on the orders of Re (see p. 443). Thus the two creative crafts, pottery-making and the carving of portrait statues, have come to be associated, in Egyptian thought, with the ideas of the creation of men and gods.

The contrast between Egyptian and Sumerian ideas of the life to come serves to emphasize the fact that life, in the fullest sense, was connected with the sky. This is shown by the following quotation from Langdon : " According to the doctrine of Eridu, man, in the beginning, was doomed to die ; he could wish for nothing better than long life. Sumerian and Babylonian

[1] Wiedemann, 133 e.s.

traditions state that the gods created man as mortal. According to the Assyrian version of the creation story, the gods created man ' to enrich the fields of the Anunnaki,' that is to say, to people the underworld : and in an ancient version of the epic of Gilgamesh, Sabitu, the woman who guarded the banks of the river of death, addresses Gilgamesh as follows : ' When the gods made men they made him mortal, and life, they kept that in their possession.' " [1] Tammuz in the underworld is asleep, and has to be revived with the " water of life " that it possesses. The Sumerian underworld thus contrasts strongly with the sky-world of the Egyptians, where all is life. Also, in the early Sumerian texts, no mention is made of breath as a means of animation.[2] This is a later feature of Sumerian, and probably also of Egyptian, thought, and it is bound up with the practice of animating portrait statues.

Before setting out on the survey of the rest of the region it will be well to sum up the various ideas possessed in Egypt concerning creation, the production of children, the nature of the soul, the destiny of a man's life, and the animation of portrait statues. The creation of men and the production of children seem to be the work of the same deities, the potter- and sculptor-gods. It is significant that the act of creation should be ascribed to the gods who personify the creative crafts ; for, later on, it will be found that iron-working plays a part in the story, this being another creative craft. These creator-gods appear to be ancient, but how ancient it is not possible to tell. In the Heliopolitan theology they become associated with Re in the act of theogamy, although Re himself is gifted with powers of creation by various means, and can produce children. In the Heliopolitan theology life is in the sky, and at first is the exclusive property of the king. The ritual of animation of portrait statues shows that the life of a man was closely connected with his breath, and only when the breath of life had been restored was the statue supposed to live in the real sense of the term. Thus several strands ran through the fabric of thought that the Egyptians had woven on the theme of life and death, which strands will be found to run through the whole of the archaic civilization from one end of the region to the other. As would be expected, the ideas will be clearer in some places than in others, according as contact with the archaic civilization has been more or less continuous.

In India ideas on the subject of the creation of man and his spiritual nature are complicated. The Rig-Veda and subsequent writings contain various accounts of the creation and origin of gods and man. The Rig-Veda itself has few references to creation. In the tenth book it says that the four castes were produced from the sacrificial body of Purusha.[3] The Aryans of India claimed descent from Aditi, the mother goddess ; also from Prajapati, and from Manu.[4] The act by which Prajapati produced men is

[1] Langdon v. 91-2. [2] Id., v. 63. [3] Muir I. 9. [4] Id., IV. 59.

described as follows : " Prajapati alone was formerly this universe. He desired, ' May I be propagated and multiplied.' He practised austere fervour. He suppressed his voice. After a year he spoke twelve times. This nivid consists of twelve words. This nivid he uttered. After it all beings were created." [1] This recalls the creative word of Re, and the notion of Brahma creating sons from his own mind is certainly the most prominent of all the creative ideas possessed by the post-Vedic writers of India. The Vedas also possess ideas of creation similar to those connected with Khnum and Ptah in Egypt. [2] " Let us celebrate with exultation the births of the gods, in chanted hymns (every one of us), who may behold them in (this later age). Brahman-aspati shaped all these (beings) like a blacksmith. In the earliest age of the gods, the existent sprang from the non-existent. Thereafter the different regions sprang from Uttanapad. The earth sprang from Uttanapad ; from the earth sprang the regions. Daksha sprang from Aditi, and Aditi came forth from Daksha. For Aditi was produced, she who is the daughter, O Daksha. After her the gods came into being, blessed sharers in immortality. When, O gods, ye moved, strongly agitated, on that water, there a violent dust issued forth from you, as from dancers." [3] This extract shows the confusion of thought in the Vedic age concerning the creation of men and gods. Brahma is the creator. Like Re he came up out of the primeval ocean, or issued from an egg floating on it. Daksha was his mind-born son, and the father, in later times, of Aditi, Diti, Danu, Vinata and other ancestresses of men and gods. The confusion is well exemplified in the fact that Daksha and Aditi in turn produce one another. Another important feature of this account lies in the idea that the creator was a blacksmith. The blacksmith, like the potter and the sculptor, brings new things into being, and thus can well serve as the symbol of the creator. The idea is also present, in Indian thought, of the creation of each human being. Twashtri is the god who develops the germ in the womb and is the shaper of all forms, human and animal. " Twashtri has generated a strong man, a lover of the gods. . . . Twashtri has created the whole world." [4] The intimate relationship between the creation of men, the world and the production of each being is well shown in this extract.

In the Rig-Veda all life is held to come from the sky. Man's soul is his breath, which at death returns to the sun : when the sun wishes he draws out the life of a man so that he dies.[5]

The Aryans came to India to find a flourishing Dravidian civilization. The study of Vedic gods has shown that they probably represent a stage of development in which the war-god has pushed the sun-gods into the background. In the Dravidian religions, on the other hand, the sun-gods are predominant.

[1] *Id.*, I. 181. [2] X. 72. [3] Muir IV. 12.
[4] *Id.*, V. 225. [5] Hopkins 205, 221, 232.

Since, in Egypt, the ideas of the breath as life, and the doctrine of the sky-world, belong to the solar theology, it is natural to look for similar ideas among the Dravidians rather than among the Aryans. The Aryans made no stone images, but such are common among the Dravidians. The Tantras, which, although of late date, contain much of the early Dravidian religion, gave elaborate directions for the animation of statues of gods.[1] It is also possible that Twashtri, the god connected with birth, was originally a Dravidian deity.

In the culture-sequence, therefore, the making of images is present in the civilization nearest to the archaic civilization, and is not found in the later civilization. It is not possible, so far as I am aware, to claim that the writers of the Rig-Veda once made images. Probably they did. But it is noteworthy that people, who have relegated their solar deities to the background, emerge into history with ideas of the life of men as his breath, and of this breath as closely connected with the sky ; with a deity, Brahma, who shows strong signs of similarity with Re, the great sun-god of Egypt ; and with notions of the creation of men and gods from this deity, and also by way of the craft of the blacksmith, that agree well with the Egyptian ideas on the same subject. The ideas of the Rig-Veda can well be explained as scattered fragments from an archaic civilization similar in essentials to that of Egypt.

Indian thought in the post-Vedic period elaborated a theory of the soul similar to that which in Egypt is so bound up with the making of portrait statues. The writers of the Upanishads and the Brahmanas are more concerned with this theme that so interests mankind, than with the doings of the gods, who are allowed to be forgotten. This process culminates in Buddhism, in which the gods finally disappear, as being of no real interest to man, whose attention is now paid to personal considerations, to the ordering of life so that the highest good may accrue. This culture-sequence is obviously one in which the gods and their cults are gradually forgotten, and attention is increasingly paid to those elements of the religious system that directly affect man.

On the other hand, the Dravidian religion is permeated with gods and goddesses, in whose cults images play an important part. The later forms of Indian religion included under the heading of Hinduism, which represent the coming back to power of Dravidian ideas, make use of images, and the ideas expressed in many of these sects hark back to the beginnings of Indian civilization.

When India with its complications is left on one side, and search is made farther east, a relationship can be detected between image-making, life-giving, and the production of children by sky-gods. In such places no great intellectual movement, such as that connected in India with Brahminism and Hinduism, has caused complications that tax the wit of man to unravel. These people have had a much simpler history, and their ideas of beginnings

[1] Avalon 115–16.

are clearer. The Toradja of Central Celebes have a god, said to be universally known, Pue mPalaburu, who like Khnum, Ptah, and Twashtri, makes each child, in this case in a smithy.[1] They say that formerly the earth was uninhabited, so the god of the sky, and the goddess of the underworld, decided to create men. They caused Pue mPalaburu, called " the kneader," " the smith," or " the man-maker," [2] to make two images, man and woman, of stone, or perhaps, as some say, of wood. When he had done this, the god went to the sky to fetch the " breath of life " that was up there, the " eternal breath " ; but, while he was away, the goddess let the wind blow on the images, and they were animated as mortals.[3] Pue mPalaburu enters into the life of every Toradja in a practical manner, for he is the actual maker of them all. He is also the maker of the stone images from which their ancestors were derived. This intimate association with each man and woman is probably the reason why the Toradja have preserved him in their memory ; while the original deities, the god of the sky and the goddess of the underworld, have gone into obscurity, and persist only in priests' tales. Corresponding to the idea that Pue mPalaburu, who is probably a sun-god, makes each of them, is that of the derivation of life from the sky. The Toradja have dual ideas with regard to the spiritual nature of man. They claim that he possesses a " life " which can separate itself from the body and assume various shapes. It is important in the life of the individual, for its absence from the body, if temporary, causes illness, if permanent, death. It is, in fact, life itself. The Toradja are themselves usually doubtful of the nature of this " life," but their creation myth shows that it is the breath, and this explanation is given by some of the people themselves. In illness the " life " has been extracted from the body. This may be done by various agencies, but only when the sky-gods have taken it, and keep it, does the person die. Therefore the home of this breath is in the sky, the place to which the creator gods went to get the " eternal breath " to animate the images. At death the breath apparently goes to the sky. The ghost, which comes into existence for the first time at death, goes to the underworld, a place ruled over by the goddess who took part in creation.

The Toradja make no stone images ; but the people of the archaic civilization have left some in their lands.[4] Since the Egyptians and the Hindus animate their images, it is reasonable to suppose that the image-makers of Central Celebes performed similar ceremonies, and that the creation story of the Toradja is connected with this assumed power of animating stone statues. In any case, the power of animating stone images is ascribed by

[1] Iron-working is an important craft among the Toradja. (Kruyti.)
[2] Kruyt and Adriani I. 269–70. [3] Id., I. 245–6.
[4] Heer Kruyt tells me that the people of the archaic civilization have left behind them stone images in parts of Central Celebes where gold is found.

Toradja tradition to beings who have been equated to the peoples of the archaic civilization.

The creation story and the accounts of the spiritual nature of man of the Toradja contain one important discrepancy. In the creation story the images are animated by the wind, not by the " eternal breath." In the accounts given by Kruyt of the spiritual nature of man, it is evident that the " eternal breath " must be the life. It is possible to account for this discrepancy by recalling to memory the fact that, when Lasaeo went back to the sky, intercourse with the sky-world was cut off, and access could thenceforth only be had by means of a sky-spirit that helped the priestess. The Posso Todjo group of the Toradja possess no sky-descended class, no one who claims to go at death to enjoy eternal life with the sky-gods : all go to the underworld. Therefore, from the point of view of the " life " that is derived from the sky, these people are mortal. Although they may live indefinitely in the underworld, they have become divided from their sky-derived life. Thus it may be that the incident in which the images become mortal is a reflection of the fact that the sky-born folk departed, leaving no one behind to keep up the close inter-course with the sky that must have obtained in their days.[1]

The Toradja beliefs concerning the spiritual nature of man are dual, in that, while the " life," which is derived from the sky, goes to the sky, the ghost goes underground. This duality will have to be explained, for it is hardly natural that men should so imagine their destiny without some good cause. The belief held in Nias, an island to the west of Sumatra, shows that it is not inevitable that man should so divide at death. The south part of this island has a class of sky-descended chiefs, the members of which believe themselves to go at death to the sky. When a commoner dies his breath, his " life," goes to the sky, into the possession of the sun-god Lature, who had given it to him while he was yet unborn. His ghost goes underground. Thus, to the sky-born, life in the sky is certain after death, and presumably, as in the case of the Egyptian kings, eternal life as of the same order as on earth : while the commoner loses his " life " and persists in the underworld as a ghost.[2]

Melanesian culture-heroes, such as Qat and Tagaro, are creators of men :[3] and so are the All-Fathers of the Australians, of whom Bunjil, for example, is said by the Wurunjerri to have made men of clay, and to have imparted life to them.[4]

The ancestors of the Polynesians made stone images which are scattered throughout the Pacific. In Nukahiva of the Marquesas these stone images are called tiki, in Hawaii tii, and in Easter Island tii.[5] In Tahiti the ghosts of chiefs were called tii, and were associated with stone images, in some of which their skulls were

[1] I owe the realization of this point to my pupil, Mr. C. Humphreys.
[2] Kruyt iii. 448, 474, 481, 482. [3] Codrington 26, 28, 154, 171.
[4] Howitt 484. [5] Blyth 533 : Tregear iii. 390.

kept, and received the same cult as the ghosts themselves.[1] The tii spirits formerly lived at Opoa in Raiatea, which has been so important in the history of Eastern Polynesia.[2] The name Tii or Tiki occurs in all Polynesian genealogies.[3]

Thus in certain parts of Polynesia a connexion exists between rulers and stone images, that serves to determine still more clearly the relationship of the later people to those of the archaic civilization. But it is possible to go farther. Polynesian mythology speaks of a being called Tii in Tahiti, Hawaii and Samoa, and Tiki in New Zealand and the Marquesas. In New Zealand he is associated with small greenstone images of grotesque shapes, called heitiki, which are worn as charms. Tiki in New Zealand is looked upon either as the first man or as the creator of men : [4] thus the Tahoe tribe call themselves the children of Tiki.[5] His important function was that of taking part in the procreation of children, for a new-born babe was, according to Taylor, called he potiki, a gift of Tiki from the po or underworld.[6] So far as I can tell, the Maori have no recorded idea of Tiki actually forming the child as Pue mPalaburu in Celebes or Khnum in Egypt. Perhaps this part of the belief is lost.

It is claimed by some that the heitiki images represent the fœtus. For example, Elsdon Best, a competent authority, says : " Now, regarding the singular pendant worn by Maori women, and termed a heitiki, often fashioned from nephrite, and which, although of human form, has the head sideways and the legs doubled up, it is known to every old native that this pendant is, properly, worn by women only, and herein lies the story of its origin. It is highly probable that this curious figure represents a human fœtus or embryo, as indeed some old natives state, and that the wearing of it by women is a survival of, or allied to, certain acts connected with phallic symbolism of long past centuries. The figures were ever most highly prized by the Maori folk." [7] The first heitiki was given by her father to Hine-te-iwaiwa, the goddess of childbirth.[8] But Mr. Skinner differs. He says : " There may, as Mr. Best suggests, be some connexion between women and the ornament. It is certainly much more often worn at the present time by women than by men. But in Cook's time it would seem to have been observed on men only, for Banks says, ' The men often carry the distorted figure of a man made of green talc.' It should be remembered that Cook's plates show a portion of the men wearing the tiki, as do other early writers." [9] He goes on to say that both he and Karl van den Steinen have come independently to the conclusion—" That the disproportionate size of the head, the slant at which it is set, and the curved legs depend not on a realistic representation of

<hr/>

[1] Ellis I. 335. [2] *Id.*, I. 111. [3] Tregear iii. 390.
[4] Goldie 7 : Tregear iii. 389, 391 : Blyth 533, 546–7 : Best iii. 17.
[5] *Id.*, iii. 19. [6] Blyth 533. [7] Best xi. 130.
[8] *Id.*, 131. [9] Skinner 310.

14

the human embryo, but on the proportions of the greenstone adze," which is worn as an ornament. He goes on to say that the figure resembles the human figures of the rock carvings and paintings of New Zealand and elsewhere, which, as has been seen, are possibly associated with the archaic civilization.[1]

The difference between Messrs. Best and Skinner is one upon which it is difficult to pronounce judgment. Perhaps they both will be able to collect more facts on this important point. The claim of Elsdon Best, that the heitiki are connected with birth, is in consonance with the data collected in this chapter ; and the argument of Mr. Skinner, that the heitiki takes its shape from that of the adze charm, hardly seems to be evidence against this claim.

Among the Maori Tiki is concerned in the production of children : throughout the Pacific his name is connected with stone images and with ruling families : the cycle of ideas is thus similar to that of Egypt, India and Indonesia. Moreover, the Maori connect " life " with the sky. Hina, the mother of men and goddess of the underworld, was the daughter and wife of Tane, a sky-being, and probably a Child of the Sun, if not the sun-god.[2] When Hina went down to the underworld to rule over the ghosts of the dead, she was pursued by Tane, who tried to stop her. But she said, " Return thou to the upper world, that you may draw up our descendants to light and life : while I remain here below to drag them down to darkness and death."[3] Again, Rangi, the great father, said to Tane : " The whare a aitua yawns below, the abode of life is above."[4] The Maori priests were all aware of the existence of life in the sky. " Our ancestors desired that man should die as the moon dies : that is, die and return again to this world. But Hine-nui-te-to said, ' Not so let man die and be returned to Mother Earth, that he may be mourned and wept for.' "[5] Ultimately life, the breath of life, and the power of conception came from Io of the Hidden Face, the great mysterious supreme being of the Maori, who is only mentioned in connexion with childbirth. He it was who gave the first breath of life to Hine.[6] Each Maori receives his life from the sky,[7] so presumably it returns there at death. During parturition, in the case of a child of noble birth, the priest thanks the gods (of the sky-world) for their gift.[8] The position of Maori belief is evidently similar to that of the Toradja of Central Celebes : although each man gets his life from the sky, his ghost goes to the underworld.

Maori thought seems ultimately, in some instances, to have made both the life of man and his ghost go to the underworld ; for it is said that Hina, the Great Mother, has the " life-breath " in the underworld. Her son, Maui, a great hero in Polynesia, and probably a Son of the Sun, went down to get it from her,

[1] Skinner 311. [2] Best v. 151. [3] Id., 152.
[4] Goldie 7. [5] Best v. [6] Id., xi. 130, 132.
[7] Tregear iv. 391. [8] Best xi. 137.

but failed, and died in the attempt.[1] The fact that, in Maori mythology, the life of men, which came originally from the sky, is now, according to some accounts, in the underworld, is entirely in consonance with what is conjectured of Maori history. In the background is the vague sky-world, with which closer communication must once have existed. The men of the sky-world have gone, and with them their peculiar beliefs, and the present folk have but faint notions of the real nature of the past. This is characteristic of the whole of Polynesia.

Here and there the idea of life in the sky still persists in tradition in definite association with the rulers. In Hawaiian legend great chiefs went to the sky, conducted thither by two sky-spirits, and were there rejuvenated and brought back to earth.[2] It is significant that one of the conductors is called " Eyeball of the Sun." This fact supports the conclusion that such peoples as the Maori once had a similar class of beings who could get renewed life from the sky.

In Mexico it was said that gods made images and animated them, and thus produced the first human beings.[3] The Natchez of Louisiana, a people ruled over by a group of Children of the Sun, whose ancestors presumably came from Mexico, believed that the sun-god made an image of clay into which he breathed, so that it became a human being.[4] In the same region, the Yuchi, who call themselves Children of the Sun, name the sun " The One who is Breath," or " Makes Indians," thus accrediting him with creative functions.[5] The Cherokee, despite the general break-up of their culture, have retained traces of a former belief in a sky-world. For they say that the seventh upper world is the final abode of the immortals " where his soul thereafter stands erect." [6]

The Zuni of the Pueblo area regard the Sun as their creator: the Earth is called the mother of all, but the Sun is the father— " All peoples are the children of the Sun." The supreme being of the Zuni is A'wonawilo'na, the supreme life-giving, bi-sexual power called He-She, " the symbol and initiation of life, and life itself, pervading all space." Directly associated with this supreme power is the Sun, the great god above all gods except the supreme being, and, through the supreme being, the giver of life.[7] According to Cushing the supreme being made himself in the form of the Sun, " whom we hold to be our father." The Sun-father created the earth, and the actual production of life on the earth was due to Mother-earth and Father-sky, from whose union human beings were produced in the womb of the earth.[8]

[1] Best v. 153–4. This is like the Hawaiian legend, in which the Sun god becomes the first ghost (Beckwith 337), shunned by all and doomed to live in darkness (Grey 7). By him and Maui came death.
[2] Ellis IV. 145.
[3] Bancroft III. 57 : Brasseur de Bourbourg cxxiii. 23 e.s.
[4] du Pratz 330. [5] Speck ii. 102. [6] J. Mooney viii. 3.
[7] Stevenson ii. 20, 22. [8] Cushing ii. 379.

The Zuni have no class claiming to go to the sky at death, although the people say that they are the Children of the Sun. In other places " breath " or " life " is usually associated with the sky. But among the Zuni, as among the Maori, this life-giving breath is connected with the underworld. They say that man possesses a " breath body " which goes to the underworld after death, and not to the sky. Similarly the Hopi ideas of creation centre mainly round the underworld, where, according to one account, the Great Mother created their ancestors ; [1] or, according to another account, the Sun performed this function in the underworld—" and to this house of the Sun return the spirits of the dead." [2]

The Pima Indians, on the other hand, hold that " Elder Brother " made human beings in the form of images. These image people multiplied and began to destroy one another, so he said : " I shall unite earth and sky ; the earth shall be as a female and the sky as a male, and from their union shall be born one who will be a helper to me. Let the Sun be joined with the moon, also even as man is wedded to woman, and their offspring shall be as a helper to me." [3] " Earth Doctor " also had the power of making men out of images. [4] This tribe has lost the sun-cult, and only retains the idea that the male person has the power of making and animating images. The Sia Indians, on the other hand, were created by Spider Woman in the underworld. [5]

No tribe of the Pueblo Indians has a class of sky-descended people. At the same time they have legends of the Children of the Sun born of a virgin mother. The rôle of creator is not always filled by the Sun, but sometimes by the Great Mother herself. Thus the sun-god is the creator among the Zuni, and among the Pima " Elder Brother " is the creator who makes images and animates them : while among the Hopi and the Sia the creator is the Great Mother herself. Throughout the Pueblo Region breath plays an important part as a creative force, and the breath bodies of people leave them at death to go to the underworld. This confusion of ideas is to be expected among the Pueblo Indians, for it has more than once been evident how chequered has been their past history. The Hopi, for example, are but the product of the fusion of several independent clans coming from all direc-tions, and are not the outcome of a direct process of growth, as are the Yuchi or the Huron or many other tribes.

The process of degradation of creation ideas can be seen still farther developed among the Indians of the Plains. The Omaha have no idea whatever of creation, nor have their cognates the Osage, Ponco and others. Some of the Osage claim that the sun is their father and the moon their mother, [6] but that is about the extent of their beliefs. The Dakota have no myth of the creation of men images by the sun, but they pay the sun great

[1] Voth i. 1 e.s. [2] Fewkes vii. 86. [3] F. Russell 208.
[4] Id., 215. [5] Stevenson i. 27. [6] Fletcher and La Flèsche 63.

respect, for it is the favourite residence of the " Master of Life." [1] The Tciwere and Winnebago have no such belief in the creation of man by the sun-god.[2] The Saponi branch of the Sioux believe in a creator.[3] The Mandan of the upper Missouri believe in the " Lord of Life," a being with a tail, living in the sun, who created men and women.[4] The Hidatsa believe in a " Man who never dies," or the " Lord of Life," who made all things.[5] It is important to note that these two tribes have kept on their agriculture to a much greater extent than the other Plains Indians, and consequently approach nearer in culture to the tribes of the south. The Cheyenne believe that they were created by the Great Medicine.[6] The Algonquian wild-rice gatherers known as the Menomini believe in the creative power of sky-beings, for Mesha Manido, their " Great Spirit," made spirits in the form of animals and birds. He also made a bear into an Indian.[7] The Fox Indians also believe that their supreme being could create men and animals,[8] in the form of images into which he breathed life. The Pawnee state that their supreme being, Tirawa, who lives in the sky, sent down the power to put life into all beings.[9]

The most general result of this discussion is to show that life is usually connected with the sky, even in places where no communication with the sky-world now exists. Not only do sky-beings possess " life," they create men ; they are also often expressly said to be associated with the life of each person. This life is brought from the sky at birth, and returns there at death, the ghost going underground or elsewhere. The connexion between life and the sky-gods is almost universal ; the only exceptions are places where the Children of the Sun have failed to establish a ruling family. This suggests that the ideas were part of the archaic civilization, and have been handed on in more or less distorted form to its successors.

The definite association between the making of stone images and the ideas of creation and production of children goes far to support this conclusion. For the idea of creation from stone images seems to be connected geographically with the making of stone images. It is met with in Central Celebes, where the people of the archaic civilization have left stone images behind them ; it is absent in Australia, where no stone images are reported ; it is connected with stone images in Polynesia, as is seen by the associations of Tiki ; in Mexico the making of stone images has an accompanying creation myth ; the Natchez of Louisiana, who, to the best of my knowledge, had no stone images, made their creator use clay ; and the Plains Indians, who have 'no images at all, for the most part have no such creation myth. The idea of creation from stone images, and of the animation of stone images, is natural from the point of view of the people of the archaic civiliza-

[1] J. O. Dorsey ii. 449. [2] *Id.*, 424 e.s. [3] Mooney ix.
[4] J. O. Dorsey ii. 506. [5] *Id.*, 513. [6] *Id.*, iii. 34–5.
[7] Hoffman ii. 243. [8] Owen 36. [9] Fletcher i. 732–3.

tion. In Egyptian ritual the animation of portrait statues was regarded as a definite act of creation. Images could also be animated by the Dravidian peoples of India. So when people among whom the Children of the Sun settled have tales of the creation of men by sky-beings, it is legitimate to equate such acts to the ritual animation of portrait statues by the people of the archaic civilization. The study of culture-sequences therefore shows that people, who presumably have been influenced by the archaic civilization, derive their origins from creative acts so similar to the ritual practices of the people of the archaic civilization, as to make it possible to claim with confidence that such creative acts have a foundation in fact, and not in childish fancy. This power of animation of statues probably constitutes one important reason why sky-gods have not entirely been forgotten when their actual descendants disappeared : they enter into the lives of all men in that they give them their life, and thus self-interest would prompt mortals to remember them.

The acceptance of this interpretation of the evidence involves an assumption that at first sight would appear to be unwarrantable, but which is permissible on the basis of results already arrived at : that the sky-beings of the Toradja and others can be equated to the rulers, say, of ancient Egypt—that they are beings of the same order. It has already been shown that the first kings of whom anything is known in the region were looked upon as incarnate gods, and that subsequent ages produced nothing like them. On the contrary, as was shown in Chapter XII, the later ruling groups were decidedly less divine than the Children of the Sun. So, when mention is made, in tradition, of ages when gods walked the earth, it is within the bounds of probability that these gods were actual men, and that the sky-gods of mythology are their reflections in the sky. The making of stone images by gods may well mean their making by men, and the geographical distribution of stone images supports this contention. It is well to remember that this discussion rests on the basis of the distribution of certain material objects whose existence cannot be gainsaid, such as stone images. It cannot, therefore, be claimed that the ideas put forth above are due to fancy, when material evidence is to hand to substantiate them. The creation of children by a potter, or some other craft-god, recalls the doctrine of theogamy, in which the sun-god becomes the husband of a mortal woman, and raises the question of the connexion between the two sets of ideas. In both cases it certainly is true that men are made by gods, but the creative act is different in nature. In a theogamous union, the god is the actual father of the child, who is one of the Children of the Sun. In the other case the god is not the father of each child, he simply makes embryos. Thus the two cases are different, and no apparent connexion exists between them.

CHAPTER XV

THE GREAT MOTHER AND HUMAN SACRIFICE

THE preceding chapters have shown that relationships can be established between the social, political and economic organizations, and the religious system of a people. For example, cults of gods are in the hands of hereditary priests claiming descent from them, and connected with the sky-world. Another relationship is that existing between the behaviour of a community and its gods : sun-gods have been replaced by war-gods, and the communities have lost their Children of the Sun and become more warlike. These results only touch the fringe of the matter. In this, and following chapters, an attempt will be made to sketch another fundamental relationship between religious systems and the rest of the life of a community. It will be argued that the agriculture of the people of the archaic civilization was accompanied by human sacrifice, and that, associated with this practice of offering victims, was the Great Mother goddess, the earliest deity known to man. In the next three chapters further discussions will be devoted to the Great Mother, and in the chapter on the Dual Organization the whole of the argument dealing with the sky-world, the Children of the Sun, and the Great Mother will be combined in an examination of the social and political organization of the archaic civilization, in which it will be urged that the most complete parallelism exists between religious and other institutions.

In the earlier paleolithic age of Europe no traces have, as yet, been discovered of magical or religious ideas. The later, or Upper Paleolithic Age, of Western Europe, Egypt and elsewhere reveals a culture of a much more developed nature. These people used colouring materials both for their paintings and for self-adornment, and it is probable that they tattooed themselves. They used shells and perforated animals' teeth for ornaments, and put them with their dead in their graves. They made necklaces of amber, jet, crystals, fossils, and minerals. They usually interred their dead in a crouched position. Their art can be divided into two phases : in the earlier they sculptured in the round, and rarely executed those carvings on ivory, bone or wood objects which are so abundant in the second phase.[1] These carvings have

[1] Déchelette I. 203 e.s., 207 e.s., 213, 214, 301, 471.

a great interest, for those of the early phase represent women, usually with extraordinary physical characteristics.

Why should these people make feminine statuettes of such grotesque form ? They were not alone in this. For, in the civilization that followed, that termed " Neolithic " in Europe, characterized in its later stages by the building of megalithic monuments, and the use of stone implements of the types already discussed, constant use is made of similar figures, male figures being practically non-existent. The late M. Déchelette said that, along with the building of megaliths, " there penetrated into Gaul the image of a primitive deity . . . a female idol." He claims that the images, wherever found, are so similar that they conform to one type, and he says that they act as the guardians of the tomb. This form of idol was found also in the Aegean in these times, and certainly was the deity of the neolithic age.[1] This agrees with the contention of Elliot Smith, who claims that the images of the Upper Paleolithic Age are those of the first deity, the Mother Goddess. He postulates the gradual development in prehistoric times of " the conception of a creator, the giver of life, health, and good luck. This Great Mother, at first with only vaguely defined traits, was probably the first deity that the wit of man devised to console him with her watchful care over his welfare in this life, and to give him assurance as to his fate in the future." [2] There seems to be little doubt that, so far as Europe itself is concerned, the Great Mother was the first deity. For, in the region whence the culture of the neolithic age is supposed to have penetrated into Europe, the Aegean, the cults of mother goddesses held sway for thousands of years. This makes it reasonable to surmise in Egypt the cult that was predominant in the far past was that of the Great Mother. Owing to the early development of the kingship in Egypt it is not possible to speak with any documentary knowledge of this matter ; we must rely on inference and on indirect evidence. Fortunately, Sumerian records contain much information on this point.

The Great Mother is the earliest Sumerian deity. " Throughout their history, from the most ancient period to the very end of their existence as a race, the unmarried goddess is a dominating figure, the persistent and unchanging influence in the vast and complex pantheon." [3] The Mother Goddess does not stand alone in Sumer. This civilization was probably founded upon irrigation, for evidence is lacking of a pre-irrigating population, and, as in Egypt, documentation only exists from periods after the introduction of irrigation. This is an important point ; for, although the Great Mother apparently stands alone in the Ancient East and Western Europe, in the earliest texts she is provided later with a son, who, in the case of the Sumerians, is her lover, Tammuz. Langdon says that " the worship of the Mother Goddess and her son evidently forms the earliest element in human religion," and

[1] Déchelette, 217, 428–9, 584, 594.　[2] Elliot Smith xx. 151.　[3] Langdon i. 4–5.

this worship was vitally connected with irrigation.[1] The Great Mother and her son-lover were inseparably connected in the minds of the early Sumerian priests ; for the feminine titles of the ancient Mother Goddess were applied to the youthful god of vegetation.[2] Great confusion also existed between Tammuz and the Mother Goddess in the Liturgies.[3] Whence came Tammuz ? According to Mr. Langdon, he was a real king of Erech in prehistoric times, and identified with the god Abu.[4] This suggests that the Tammuz idea was associated with the first kings of Sumer, who actually looked upon themselves as born of the virgin Great Mother ; Lilazag, king of Isin, was " first-born son of the holy goddess, the woman, mother Bau." These early kings were also associated with irrigation.[5]

Tammuz is compared with Osiris of Egypt, for they have identical functions : both are regarded as real kings ; both are connected with vegetation, water and fertility. But one difference distinguishes them : Tammuz is the child of the Great Mother, who is unmarried ; on the other hand, Osiris married his sister Isis, who is a form of the Great Mother. It must be remembered, however, that the king of Egypt was identified, not with Osiris, but Horus his son, and that with Horus is associated Hathor, " the house of Horus." Osiris is a dead king, and the Osiris type of king of Egypt seems to correspond to the later development in Sumer. Beginning with Dungi, of Ur, the king married the Mother Goddess, and no longer looked upon himself as her son. This transition, whereby the king married the Mother Goddess, is well known in Sumerian literature. It resulted from Tammuz becoming the local tutelary deity ; as, for example, at Larak, the gods of which were Tammuz and the Mother Goddess, his spouse. In the same way Enki gained his wife Dangalnunna, who was a development of Nintud, a virgin mother goddess.[6]

Each city of Sumer had its own cults. It is commonly assumed that these cults sprang up locally, probably spontaneously. But the views of Langdon put the matter in quite another light : " It is probable that the gods of the numerous cities of Babylonia and Assyria, whatever may have been their special attributes acquired in later times, are, at the beginning, each and all, shadows of the young god. They and their consorts are derived from this one great and primitive cult, and set aside for the performance of the more human and joyous side of this cult. I am not sure but that this formula applies to every other local bel and belit in the history of religion."[7] He adds that the great gods of the cities, such as Ningirsu of Lagash, Nergal of Kutha, Marduk of Babylon, are but solar manifestations of Tammuz.[8] In similar manner he postulates continuity in the Mother Goddesses of Sumer, Babylonia and Assyr, which can all be

[1] Langdon i. 6. [2] *Id.*, ii. 175. [3] *Id.*, i. 24.
[4] *Id.*, ii. 208, n. 1. [5] *Id.*, ii. 176, 191.
[6] *Id.*, 176, 190. [7] *Id.*, i. 28. [8] *Id.*, 30.

equated to one another. According to Mr. Langdon, the earliest form of the Great Mother Goddess in Sumer was connected with the vine, for she was called Lady Vine-Stalk. As Gestin-anna, " heavenly mother goddess of the vine," she was identified with Nina, queen of waters ; and the two of them were goddesses of canals, irrigation, sheep, cattle, sacred song, incantation, and they were also identified with Isharru, the scorpion-goddess. The vine-goddess is also the Western Mother Goddess and the Grain Goddess. Ninanna is identified with Innini, both being the mother-earth. Innini, " heavenly lady," was first a snake goddess ; she is ruler of the sky and of the underworld, and she is identified with Antu, the goddess of war.[1] Thus could be recounted a bewildering list of goddesses, all derived ultimately from the original Great Mother. As Mr. Langdon says : " A considerable portion of the pantheon was derived by erecting a new name into a separate deity."[2] For instance, Ishtar, a great Mother Goddess of the early unmarried type, was superseded in many of her functions by the personifications of these functions.[3] Similarly Innini, " having cast off many concrete qualities which were personified into female consorts of local gods, she retains for herself the commanding position of a detached deity mother of humanity, defender of her people."[4]

The Great Mother was, in later times certainly, the incarnation of the principle of fertility, and, as such, she collected round herself all sorts of qualities associated with the welfare of mankind. In the course of her history she became associated with a multitude of qualities and objects, plants and animals, the enumeration of which would take some time, and would involve much discussion. Some of these associations will be discussed in this book, but the complete examination into the history of the Great Mother has yet to be undertaken. At the beginning of her documentary history she is intimately bound up with her son, so intimately that it is said that " we cannot always be sure whether we have to do with a goddess or her son."[5] Later in her history she turns into a married goddess, the wife of the dominant god, or even becomes his daughter ; but, even to late times, she retains her position as the mother of mankind. This is shown in the case of Ashurbanipal, king of Assyria :

" A little one art thou, O Ashurbanipal, whom I confided to the goddess, queen of Nineveh.

"Weak wast thou, Ashurbanipal, when I satiated thee on the lap of the queen of Nineveh.

" Of the four teats which were put to thy mouth, two thou didst suck, and with two thou didst cover thy face."[6]

Subsequent to the early period, when the king was identified with the son of the Great Mother, came another, in which the goddess took a less important place in the pantheon. She even

[1] Langdon i. 7, 45 e.s., 49, 87, 92, 95 ; ii. 132. [2] *Id.*, i. 50.
[3] *Id.*, 59. [4] *Id.*, i. 110. [5] *Id.*, 120. [6] *Id.*, 56.

came to be changed into a god, a fact that has been emphasized by Barton. He says that the old mother goddess of South Arabia, the home of so many Mother Goddesses, became changed, why, we know not, into a god. He says: " We are safe . . . in assuming that the ba'al (= Lord) Athtar is later than the 'umm Athtar and was developed out of her." This god was localized in various places and developed certain variant qualities like local Virgin Marys. " It frequently happens in such cases that some favourite epithet of the deity is used so constantly to designate him that it finally displaces his original name : thus Tammuz (or whatever the primitive name was) became Adon, as did Yahwe in Israel. . . . It is possible to show how several divine names in Arabia originated in this way. At 'Amram the epithet Ilmaqqahu, ' the divine protector,' very nearly displaced the older name of Athtar. In thirty inscriptions Ilmaqqahu has displaced the name Athtar except in two instances, and in the former of these the meaning of the inscription equated Ilmaqqahu with Athtar. Ilmaqqahu is, moreover, throughout this group of inscriptions, a protector of children and a giver of fertility— functions not only performed by Athtar elsewhere . . . but also performed by Athtar in this very town." At times this personi- fication of an epithet went so far that Athtar and Ilmaqqahu were put side by side as separate deities. " From this phenomenon it is safe to infer that if other South Arabian, or indeed Semitic, gods appear, whose names are epithets, and whose characteristics and functions are clearly those of Athtar, that they are offshoots from him and may have arisen in a similar manner." [1] Barton is of the opinion that both Tammuz and Shamash were originally Mother Goddesses : for Shams was a sun-goddess in Arabia and Shamash a god elsewhere.[2]

I do not propose to push this argument too far. It does, however, appear certain, from the arguments of Barton, that many of the old Semitic gods of Arabia and Babylon were origin- ally goddesses. He shows also that the goddesses themselves, as well as the gods derived from them, showed much power of expansion and of splitting off into other forms, as the result of the personification of epithets of the original deity.

The bearing of this discussion upon the problem of the origins of Babylon is important. That country was conquered by Semites. In the early stages of Sumerian history the mother goddess was prominent. Then came people with gods who, according to Barton, had developed out of goddesses. By the time the Babylonian hegemony was established the original unmarried mother goddesses had become the married type, and thus lost much of their prestige.

The next chapter will show why this transformation took place in the sex of deities ; it was but part of a radical transformation in all departments of social life which occurred throughout the

[1] Barton 12. [2] *Id.*, 13.

whole region, and was not confined to Sumer and Babylonia.

Before discussing any further problems of early Sumerian and Semitic deities, it will be well to turn to Egypt to see what is the relationship between goddesses and gods.

The great mother goddess in Egypt was directly concerned with the nursing and upbringing of the young members of the royal family, and was supposed to suckle the royal children. As an example, the inscriptions relating to the birth of Queen Hatshepsut of the Eighteenth Dynasty contain a scene representing the nursing of the infant. " On a couch at the left sits Queen Ahmose, supported by a goddess, and before her the child and its ka are nursed by two cow-headed Hathors. Below the couch are two Hathor cows suckling the child and its ka. On the right are the ka's twelve in number, which have already been suckled and are being passed on to the Nile-god and an obscure divinity deity named Heku, who present them to three enthroned divinities." [1] Not only was the royal child suckled by goddesses, but the queen herself says " I am thy mother Hathor (or Isis, or Anoukit). I give thee the panegyrics of accession together with my good milk, so that they may enter thy limbs with life and strength." [2]

The gods of Egypt being equated to their kings, it is natural to find that they too were born of goddesses. When the dead king reaches the sky, in the Pyramid Age, he is supposed to have a mystic relationship with the mother goddess. " King Teti is the Eye of Re, that passes the night, is conceived and born every day. . . . His mother the sky bears him living every day like Re. " [3] The king is also said, in the Pyramid Texts, to be the " son of Re, born of the sky-goddess," and suckled by the sky-goddesses. [4]

The great goddesses of Egypt were, according to the priestesses of Hathor, in her great temple at Denderah, but " forms and attributes of Hathor worshipped under different names, so that . . . all prayers to them were in reality addressed to Hathor." [5] The claim that all the goddesses were but forms of Hathor can be substantiated by an examination of the equations that take place, as in Sumer. For example, Hathor is equated to Mut, both of them being the Eye of Re, and represented by the vulture. [6] Mut, or Hathor, again, is identical with Sekhet the Lioness, Tefnut, and Bast, all of whom are solar goddesses. At Philæ, Isis-Hathor personified all the goddesses in one : " Kindly is she as Bast, terrible is she as Sekhet." [7] Neith, the goddess of Sais, is associated there with Osiris and Horus, and thus is identified with Isis, and therefore with Hathor ; she is the goddess of war and the mother of the gods. [8] Mut, the celestial mother, is identified with Hathor, and gave water to the souls of the dead out of a

[1] Breasted ii. II. 210. [2] Moret i. 64. [3] Breasted iv. 123.
[4] Id., 130. [5] Wiedemann 143. [6] Id., 123.
[7] Id., 138. [8] Id., 140.

sycamore tree.[1] Many other examples could be quoted to show that all the mother goddesses of Egypt can be derived from one original form. For the purpose of simplicity it is possible to take Hathor as the type, for she was associated so closely with Horus, the prototype of Egyptian kings. Her name means "House of Horus." Horus, according to Elliot Smith, adopted many of the attributes of Hathor, so that it is not easy to distinguish his original qualities.[2]

It is possible to adduce evidence to show that the mother goddess was originally a prominent deity in Egypt. The difficulty in the way of this task lies in the fact that the texts from which so much knowledge of Egyptian origins is derived, the Pyramid Texts, are relatively late, and are devoted to ideas mainly centred round a male god, the sun-god Re, of Heliopolis. But one line of evidence points to the mother goddess as a very important deity. The earliest form of royal tomb in Egypt was the mastaba. This was a development of the pre-dynastic grave, originally scooped out of the sand, that, in time, became an underground house, with sets of rooms for the use of the deceased, and with a superstructure of bricks with sloping sides. This ultimately gave rise to the pyramid, which, in its initial form, was made of brick like the mastaba, the use of stone not appearing till the Third Dynasty. The ruling family had, at first, the monopoly of the Pyramids, and the texts found in these structures were purely solar in their theology. But the nobles continued to make mastaba tombs, and the deity usually found on the walls of these mastabas is Hathor.[3] Although so prominent in the mastabas, Hathor does not appear in the Pyramids, except as a secondary manifestation of the sun-god. The process of thought therefore, in ancient Egypt, had gone through the same phases as that in Sumer; the original mother goddess had been pushed into the background. In the Fourth Dynasty the wives of local magnates regularly acted as priestesses of Hathor. It is therefore possible, if not probable, that the later developments of Egyptian religion have masked an earlier stage when Hathor was predominant.

This discussion suggests that the religious systems of Egypt, Arabia and Babylonia have passed through the same phases. The great mother seems to be all alone in the days before the discovery of irrigation. Later she is accompanied by a son, who is also her lover. This son is personified on the earth by the kings of these States; and the king, the god and the mother goddess are primarily associated with irrigation, fertility, vegetation and similar things. The next phase of development is that in which the male element begins to assert itself, and the mother goddess is gradually pushed into the background, and relegated to the position of wife of the chief god, who was formerly her son. This process of substitution has been accompanied by a progressive expansion in which epithets of the deities become

[1] *Id.*, 64, 143. [2] Elliot Smith xx. 79. [3] Petrie ii. 22.

separate deities. With the foundation of new cities the god and goddess are transplanted into new soil, and at once begin their own course of development. This process of expansion is, of course, paralleled by that of the actual dynasties that claim relationship to the gods, and, as far back as it is possible to go, evidence exists of the strict relationship of kings to gods. Since new deities are continually being given off in historical times, it is probable that this process must be projected into the past, so that all the dynasties of Egypt and Babylonia may have sprung from one original group.

Having thus defined the general trend of development in the Ancient East, it is now possible to pass on to the problem of this chapter, the practice of human sacrifice. It seems probable that in ancient Egypt, as in Sumer, the king was himself originally killed as a sacrifice for the vegetation. Osiris, according to some accounts, met his death in the Nile flood-water.[1] This agrees with what is known of Sumer, where the Tammuz rites are but the memory of the times when the king was actually drowned : " Not the divine son perished in the waves, but a human being who was slain represented at first this tragedy of birth and death." [2] This ritual was connected with agriculture above everything else ; it was part of a ceremony to ensure the proper supply of food, and the king evidently, in Egypt and Sumer, was the victim. This phase, in which the king was killed, did not last ; few traces of it exist in Egypt. The Egyptians, however, had the remarkable story of the Destruction of Mankind, in which Hathor, as Sekhet the Lioness, destroys human beings in order to procure for Re, the sun-god, blood that would serve as an elixir of life. This story is, to my mind at least, extremely obscure ; and at present it seems hardly possible to guess at its meaning. It is evident that, in the story, the king is not killed, but one of his subjects is sacrificed instead. A late tradition existed in Egypt to the effect that formerly a virgin was sacrificed in order that the irrigation might be prosperous.[3]

It is noteworthy that the change in the mode of human sacrifice may be connected with the solar theology of Heliopolis, for the tale of Destruction of Mankind, which contains the first sign of the substitution sacrifice, is connected with Re.[4] In this connexion the mother goddess is cruel and destructive. This is in harmony with the Sumerian evidence ; for only, in that country, when the sky-world came into question, did the mother goddess develop martial and bloodthirsty qualities : " As soon as the queen of heaven becomes associated with the light that streams from the heavenly bodies, the sun, moon, stars, she develops warlike qualities." [5] Indeed there was " a close connexion between the astral and martial types " :[6] the warlike Ishtar was represented

[1] Murray ii. 128–134 ; iii. [2] Langdon i. 26.
[3] J. G. Frazer i. II. 38. [4] Wiedemann 59 e.s. : Budge 1.
[5] Langdon i. 98. [6] *Id.*, 105.

by the star Sirius and the lion, "and she becomes, in fact, especially in Assyria, the principal genius of battle." [1]

The evidence therefore suggests that human sacrifice was especially associated with the great mother goddess, and with the sun-god, and that the earlier phase was that in which the king himself was the victim. The form of human sacrifice which is most widespread over the earth is that in which a captive, or some other victim, is offered in connexion with the state-cult, and not the king himself; and it is this form of human sacrifice that seems first in the Ancient East to have been connected with the sun-cult.

The mother goddess is important in India. Both the Vedic and the Dravidian religious systems recognize male and female deities; but with this difference, that in the Vedas the goddesses are negligible, while throughout Dravidian religion, and in the Hindu period, they are of great importance. [2] The worship of mother goddesses has always flourished where Dravidian civilization held its ground, [3] and this prominence exists as far back as literary sources go. The Hindu sects that resulted from the post-Buddhist revival of Brahminism are permeated with the worship of mother goddesses : almost every village in South India has its shrine for the goddess, the guardian spirit of the village, situated outside the village in a sacred grove. Many of those goddesses bear names that show them obviously to be of the nature of the derivative mother goddess of Egypt and Sumer, such as "the mother who wears the circular crescent," "the pearl-like mother," "the golden mother," "the beautiful queen mother." [4] Modern Hinduism includes a series of cults associated with certain aspects of the mother goddesses. Each god has associated with him a goddess called his Shakti, or creative force. "The cultus of the Caktis, as it is formulated in certain Upanishads, in several Puranas, and especially in the Tantras, must not be confounded with the customary homage rendered by all sects to the wives of the gods. It forms a religion by itself, that of the Caktas, which again is subdivided into several branches, having their special system of doctrine and forms of initiation, and in the heart of which there arose a quite distinctive mythology. At the summit and source of all beings is Mahadevi, in whose character the idea of the Maya and that of the Prakriti are blended. Below her in rank are arrayed her emanations, the Caktis of Vishnu, of Brahma, of Skandha, etc., etc. (an order which is naturally altered in favour of Lakshmi or of Rahha in the small number of writings belonging to the Tantras which Vishnuism has produced), and a whole complex hierarchy, highly complex, and as variable as complex, of female powers, such as the Mahamatria, ' the Great Mother,' personifications of the productive and nourishing powers of nature ; the Yoginis, the sorceresses, whose interference is always violent and capricious ; the Nayikas, the Dakinis, the

[1] *Id.*, 59. [2] Hewitt (1890) 400. [3] Barnett 5. [4] Sastri 223–4.

Cakinis, and many other classes besides, without consistently defined powers, but almost all malignant, and whose favour is secured only at the expense of the most revolting observances. All this in combination with the male divinities goes to form the most outrageous group of divinities which man has ever conceived." [1]

The non-Vedic literature of India shows that the fundamental unity of the mother goddesses was well recognized in that country. For instance, in the Vishnu Purana, the various forms which Vishnu assumes when he comes to the earth are accompanied by changes in his consort Lakshmi : " her first birth was as the daughter of Bhrigu by Khyati : it wâs at a subsequent period that she was produced from the sea, at the churning of the ocean by the demons and the gods, to obtain ambrosia. For in like manner as the lord of the world, the god of gods, Janarddana (Vishnu), descends among mankind (in various shapes), so does his coadjutrix Sri (Lakshmi). Thus when Hari was born as a dwarf, the son of Aditi, Lakshmi appeared from a lotus ; when he was born as Rama, of the race of Bhrigu, she was Dharani ; when he was Raghava, she was Sita ; and when he was Krishna, she became Rukmini. In the other descents of Vishnu, she is his associate." [2] In the Tantras the great mother is recognized as having all sorts of forms. In one Tantra Siva speaks thus to his consort : " Thou art the only Prakriti of the Supreme Soul Brahman, and hast sprung from the whole universe—O Shiva—its Mother. O gracious One, whatever there is in this world, of things which have and are without motion, from Mahat to an atom, owes its origin to, and is dependent on, Thee. Thou art the Original of all the manifestations ; Thou art the birthplace of even Us ; Thou knowest the whole world, yet none know Thee.

" Thou art Kali, Tarini, Durga, Shodashi, Bhuvaneshvari, Dhumavati. Thou art Bagala, Bhairvai, and Chhinnamastaka. Thou art Anna-purna, Vagdevi, Kamalalaya. Thou art the image or Embodiment of all the Shaktis and of all the Devas. Thou are both Subtle and Gross, Manifested and Veiled, Formless yet with form. Who can understand Thee ? " [3]

The Dravidians put their mother goddesses in the forefront of their religious systems, and even in village shrines the goddesses are all-important. This makes it evident that these mother goddesses play a part in the life of these people that is lacking among the Aryans. In the Vedas the solar deities, the Adityas, are the sons of Aditi, a goddess of indefinite attributes, of whom little is said. The Adityas and their mother Aditi recall the Egyptians and Sumerian gods with their mother goddesses. Their supersession by Indra suggests that the Aryans have passed from a stage similar to that of the Dravidians, a conclusion that has already been drawn from other evidence. During the process the practice of human sacrifice was also abandoned.

[1] Barth 202. [2] H. H. Wilson 80. [3] Avalon 46-7.

The Vedic and Dravidian religions are sharply contrasted : " Both the Vedic and the Dravidian religions acknowledged deities of both sexes ; but in the former the masculine members of the pantheon chiefly engrossed the worshipper's regard, while in the latter the position is reversed. Vedic religion, though it has its darker side—occasional human sacrifice, frequent cruel slaughter of animals, outbursts of filthy obscenity, and a mass of vulgar superstitions and crude magic rites enwrapping almost every function of life—was nevertheless in its official aspect a fairly bright and respectable system ; Dravidian religion was dark and repulsive, obscene and bloody. The worship of the mother goddess with human sacrifice, of the emblems of generation with wholesale prostitution, has always flourished where Dravidian religion held its ground." [1]

This contrast reveals two characteristics of Dravidian religion ; the connexion of the mother goddess with fertility and with human sacrifice.[2] It is strange that the great mother of all things, the source of all life, should also be destructive, yet such is the case. The wife of Shiva is Uma, " the gracious," who, as a mother goddess, has many forms, Devi, "the goddess " ; Parvati, " the daughter of the mountains " ; Durga, " the inaccessible " ; Gauri, " the bright one " ; Sati, " the devoted wife " ; Bhairavi, " the terror-inspiring " ; Kali, " the black one " ; Karala, " the horrible one." [3] She is thus beneficent and terrible. Her cults are dual ; they are divided into black and white, benevolent and cruel ; " and they constitute in this way two series of manifestations of the infinite energy, as it were two series of supreme goddesses, one series presiding more specially over the creative energies of life, the other representing rather those of destruction. To both a twofold cultus is addressed : the confessed public cultus . . . or ' cultus of the right hand,' which, except in one particular, namely insistence upon animal sacrifice in honour of Durga, Kali and other terrible forms of the great goddess, observes essentially the general usages of Hinduism ; and the ' cultus of the left hand,' the observances of which have always been kept more or less secret. Incantations, imprecations, magic and common sorcery play a prominent part in this last, and many of these strange ceremonies have no other object than the acquisition of the different siddhis or supernatural powers. These are practices of very ancient date in India, since they are deeply rooted in the Veda, and a special system of philosophy, the Yoga, is devoted to the explanation of them ; but nowhere have they found a soil so congenial as in Civaism and the cultus of the Caktis. Neither is there room to doubt that the blood of human victims not unfrequently flowed on the altars of these gloomy goddesses, before the horrible images of Durga, Kali, Candika and Camunda." [4]

[1] Barnett 5. [2] According to Hewitt (1890, 933), man was the first sacrificial animal in India. [3] Barth 165.
[4] Barth 203. Durga was fond of wine and blood (Mazumdar 357).

15

The human sacrifices held in connexion with the mother goddesses of India are usually agricultural.[1] The Mundas and Oraons of ancient times practised human sacrifice, and even to this day still do so in secret.[2] This seems to be a degenerate form of the original practice, for the ceremony is on account of some evil spirit that has to be appeased. The Mundas have a varied history behind them, and this form of sacrifice may well be a survival of the earlier mode. The Gonds practised human sacrifice, especially to Kali Danteshwari, the tutelary deity of the rajas of Bastar.[3] The human sacrifice of the Oraon is connected with the goddess Anna Kauri, or Mahadhani.[4] " She can give good crops and make a man rich." Sir E. B. Tylor well expresses the nature of the human sacrifice of the Khonds, one of the Dravidian tribes. He says : " Of all the religions of the world, perhaps that of the Khonds of Osissa gives the earth-goddess her most remarkable place and function. Boora Pennu or Bella Pennu, the light-god or sun-god, created Tari Pennu the earth-goddess for his consort, and from them are born the other great gods. But strife arose between the mighty parents, and it became the wife's work to thwart the good creation of her husband, and to cause all physical and moral ill. Thus to the sun-worshipping sect she stands abhorred on the bad eminence of the Evil deity. But her own sect, the earth-worshipping sect, seem to hold ideas of her nature which are more primitive and genuine. The functions which they ascribe to her, and the rites with which they propitiate her, display her as the earth-mother, raised by an intensely agricultural race at an extreme height of divinity. It was she who with drops of her blood made the soft muddy ground harden into firm earth ; thus men learnt to offer human victims and the whole earth became firm ; the pastures and ploughed fields came into use, and there were cattle and sheep and poultry for man's service ; hunting began and there were iron and plough-shares and harrows and axes, and the juice of the palm tree ; and love arose between the sons and daughters of the people, making new households, and society with its relations of father and mother, and wife and child, and the bonds between ruler and subject. It was the Khond earth-goddess who was propitiated with those hideous sacrifices, the suppression of which is matter of recent Indian history." [5] The Gonds, Khonds, Mundas, Oraons, who are especially prominent in India as practising human sacrifice, are tribes whose culture shows clear signs of contact with the archaic civilization. Thus it is probable that, in India, human sacrifice goes back to the archaic civilization. The Tantrik cults originated in Assam, and several tribes practise human sacrifice, among them the Tipperas, Kacharis and Jaintais.[6] It is important to note that some tribes of Assam, such as the Nagas, practise

[1] Hewitt (1890) 374. [2] Roy ii. 32–6 : Dehon 141.
[3] R. V. Russell 112. [4] Dehon 141.
[5] Tylor II. 270–1. Cf. Macpherson. [6] Gait 15, 40 : Elliot 1157.

head-hunting. Since these people live in places formerly occupied by a higher civilization, and since their culture shows signs of being derived from that of the archaic civilization, it follows that their head-hunting practices are probably derived from human sacrifice, the heads being used for similar purposes.

Human sacrifices used to be made to the cobra, the Naga snake, so closely connected with the great Dravidian ruling group of the Nagas. This indicates a line of inquiry which cannot be followed up here on account of considerations of time and space. But it may be mentioned that the mother goddesses of Egypt and Sumer were especially connected with snakes. The tutelary goddess of Buto in Lower Egypt was Buto, who was connected with the deadly uræus, the asp, which adorned the diadem of the king, and served as his protector. The tutelary goddess of the other half of Egypt, Nekhbet, was the vulture-goddess, who also helped to protect the king. In Sumer the serpent aspect of the mother goddess was extremely important.[1] One of the original names of the mother goddess must have been " mother-great serpent." Not only was the mother goddess intimately associated with the serpent, but so also was her son. As is said by Langdon, it is sometimes impossible to know whether mention is made of the mother goddess or her son when serpents are spoken of in the texts.[2]

Human sacrifice was not practised by the Aryans of Vedic times, but traces of it exist. One instance is that of Purusha, from whose sacrificial body the four castes were made.[3] Thus, in the culture-sequence of Aryan and Dravidian, human sacrifice belongs to the first period but not to the second. In India the cults of mother goddess, the practice of human sacrifice and the craft of agriculture have disappeared among the writers of the Rig-Veda. They obviously were pastoral, for the whole ritual centres round cattle, and agriculture is barely mentioned. The disappearance of these cultural elements, so intimately bound together among the Dravidian tribes, raises the important problem of causation. Which was given up first—the earth-goddess, the human sacrifice or the agriculture ? This question will arise again in the next chapter, where it will be seen that the disappearance of the mother goddess was part of the tremendous social transformation which took place on the break-up of the archaic civilization.

The archaic civilization of Indonesia being mainly extinct, traces would hardly be expected of a relationship between the great mother goddess, agriculture and human sacrifice, even if they ever existed. The region has received at least two great civilizing influences coming from India, the archaic civilization and the Hindu movement, and both of these phases included the three cultural elements. This complicates the matter.

Indonesia possesses but few instances of a mother goddess

[1] Langdon i. 115 e.s. [2] *Id.*, 120. [3] Muir I. 9.

holding a place similar to that of Sumer or India. But mother goddesses are reported among the Tontemboan of Minahassa, and in the Sadan district of Central Celebes, two places strongly influenced by the archaic civilization as is shown by the custom of making rock-cut tombs.[1] Lumimu'ut is the great deity of the Tontemboan of Minahassa, the mother and wife of To'ar, the Sun, who came over the sea in a ship bringing food-plants with her.[2] The people of the Sadan region of Central Celebes tell of a Goddess of the Sea, to whom they owe most of their culture.

It has been seen that the people of the archaic civilization took with them into Polynesia the food-plants with which they made habitable several of the islands. In their home in India they probably knew of rice, but they did not take it into the Pacific. I do not know whether they brought rice into Indonesia ; but certain evidence, especially that collected by Heer Kruyt, leads to the conclusion that they were concerned in Indonesia with taro cultivation. Rice, therefore, would have been brought by the Hindus. In an important monograph on the " Rice-Mother," Kruyt has collected information from all over the archipelago with respect to rice-cultivation. The idea is widespread throughout the archipelago that rice has a soul of similar nature to that possessed by man, and ceremonies have to be performed in order that the crop may be abundant. The peoples who grow rice usually term certain heads of the newly cut rice by the name of the " rice-mother " ; sometimes they are called the ·' rice-uncle " or " chief." [3] In this " rice-mother " is supposed to be concentrated the soul of the rice ; her function is that of the maintenance of its health.[4] The origin of these ideas and practices associated with the rice-mother must apparently be sought in India ; for, in Sumatra, Java, Bali and South Celebes, places strongly permeated with Hindu influences, the " soul " of the rice is called after names derived from that of the great Indian goddess, Sri, another form of Lakshmi, the consort of Vishnu, from whose body the rice is supposed to have come.[5]

Both sets of mother goddesses of Indonesia are therefore connected with agriculture. In this region human sacrifice is also connected with the past. It is, or was, found among the Batta of Sumatra, at Kupang in Timor, in West Sumba, and among the Toradja of Central Celebes and certain Borneo tribes. The Batta, in addition, were cannibals, and their culture shows signs of Dravidian affinities, which makes it interesting to note that in the Mahabharata mention is made of the Rakshanas, a cannibal people, who were included in the Dravidian group.[6] The human

[1] Perry vii. 10, 13. [2] Schwarz 407–8.
[3] Kruyt ii. 384. [4] Id., 393.
[5] Id., 410–11. Miss Blackman has recently shown that the ancient Egyptians had identical ideas and practices. See Journ. Manchester Egypt. and Orien. Soc., No. X., 1922.
[6] "Mahabharata," Adi Parva, Vakabadha clxii.

sacrifice of west Sumba is closely allied to that of India, for it is connected with the snake race. In this part of the island the python is sometimes held to be a great ancestor, and human sacrifices are made to it. Offerings are made to such snakes in order that the springs shall be full for the irrigation and that the agriculture shall prosper. Since, in these instances, agriculture is practically universally carried on by means of irrigation, the evidence suggests a close connexion between the snakes and the archaic civilization. In a story told in west Sumba a man was given some irrigated fields by a snake, on the understanding that he offered human sacrifices to it every year.[1] The snakes involved in such stories are not looked upon simply as animals, but as men who can assume a snake form ; so they correspond to the Nagas of India.

In Central Celebes traditions tell of human sacrifices on sacred stones.[2] The Olo Ngadju of South-east Borneo formerly practised human sacrifice in connexion with their warfare. Before going on an expedition they broke eggs on certain sacred stones, called pangantoho, that were put in position to the accompaniment of a human sacrifice. On their return the blood and heads of slain enemies were brought to the stone, and the heads were placed in a hut near by.[3]

Formerly the practice was much more widespread in Indonesia. In Borneo, where it is almost unknown, " there is a number of rites of which it is admitted by the people that the slaughter of human beings was formerly a central feature ; of these, the most important and the most widely spread are the funeral rites of a great chief, the rites at the building of a new house, and those on returning from a successful war expedition. In all these fowls or pigs are substituted now as a rule, but we know of instances in which in recent years human beings were the victims." [4]

The associations of these sacrifices suggest the influence of the archaic civilization ; for it has already been stated that the chiefly class of the Borneo tribes claims kinship with the sky-world ; and the rites for which human sacrifices are needed are exactly those for which the members of the initiated priesthood are necessary, those rites having been derived from the sky-world.[5] As for war, it has already been claimed that the people of the archaic civilization introduced the practice.

The modification of human sacrifice in Borneo brings into prominence the question of the meaning and origin of the custom of head-hunting, so widespread in Indonesia. The evidence indicates that this custom is derived from that of human sacrifice. For instance, Borneo tribes that formerly practised human sacrifice now seek heads at certain periods. A Sebop legend shows that this practice is connected with agriculture. The Sebop claim descent from Tokong, a brother of the supposed

[1] Kruyt m.s.s. [2] Kruyt and Adriani I. 60. [3] Kruyt iii. 219.
[4] Hose and McDougall II. 104. [5] Perry vii. 145 e.s.

ancestor of the Kayan, Kenyah and other chiefly groups, which suggests connexion with the archaic civilization. Tokong introduced head-hunting to the Sebop on the advice of a frog, which assured him that head-hunting would bring them prosperity of every kind. They took its advice. " As the party returned home and passed through their fields the padi (rice) grew very rapidly. As they entered the fields the padi was only up to their knees, but before they had passed through it was full-grown with full ears. . . . The words of the frog thus came true, and Tokong and his descendants and people continued to follow the new practice, and from them it was learned by others." [1] Thus the people of Borneo directly ascribe the custom to a foreign source.

Kayan beliefs provide striking evidence with regard to the relationship between head-hunting and people of another civilization. They hang up heads taken in war in the verandas of their houses. These heads are supposed to be the abodes, not of the ghosts of their owners in life, but of certain spirits called toh, who show every sign of being the traditional representatives of the forerunners of the Kayan in Central Borneo, the people who left behind them carved stone bulls on the banks of certain rivers. Further, the Kayan war-god is Toh Bulu. [2] The toh are not wholly malevolent. It is held that in some way their presence in the house brings prosperity to it, especially in the form of good crops ; and so essential to the welfare of the house are the heads held to be that, if a house has lost its heads through fire, and has no occasion for war, the people will beg a head, or even a fragment of one, from some friendly house, and will instal it in their own with the usual ceremonies. [3] The head-hunting of the Kayan is apparently associated with rice-growing, and thus with the Hindu or the archaic civilization. In this case the great mother, if she ever existed, has left no traces, except perhaps in the connexion supposed to exist between the fertility of women and of rice. Among the Toradja tribes of Central Celebes headhunting is intimately connected with agriculture, the possession of a head being essential for the procuring of a proper crop of rice. The Bontoc of Luzon in the Philippines say that the Children of the Sun took the first head, and thus ascribe the custom of head-hunting to their influence.

The evidence from Indonesia, while not conclusive, agrees in associating human sacrifice and mother goddesses with the archaic civilization, and also with the Dravidian civilization of India. Human sacrifice has been modified in the region into head-hunting, and a direct association with agriculture is not always apparent. The mother goddesses also have associations with agriculture. But, so far as can be told, no such direct connexion between the mother goddess, agriculture and human sacrifice can be detected in Indonesia as in India and elsewhere. This is what would be expected from what is known of the

[1] Hose and McDougall II. 139. [2] *Id.*, 18. [3] *Id.*, 23.

history of culture in Indonesia. The archaic civilization has been so broken up by subsequent incursions that it only survives in fragments, that have to be pieced together with reference to other groups of data in order that their former nature may be recognizable.

Human sacrifice occurs in New Guinea, in the form of cannibalism, where it is apparently closely connected with the influence of the archaic civilization ; for it is found in Bartle Bay, Southern Massim and Wagawaga. In the rest of the region studied by Prof. Seligman, the custom is not recorded. Some of the stone circles of British New Guinea are used as squatting-places, a custom similar to that of the Khasi and elsewhere ; but others were used for cannibal feasts, each clan using its own circle.[1] Bartle Bay is further remarkable in that a ceremony is performed there in connexion with the mango.[2]

Throughout Melanesia cannibalism and human sacrifice still persisted during late years. In San Cristoval Mr. Fox couples human sacrifice for agriculture with the earliest stratum of food-producing culture of Melanesia. Dr. Codrington mentions human sacrifice as occasionally practised in the Solomons, often for the dedication of a new canoe, or a chief's dwelling-house. He states that cannibalism has extended itself in the Solomons during the past century,[3] as in the case of Ulawa. " The natives of San Cristoval not only eat the bodies of those who are slain in battle, but sell the flesh. To kill for the purpose of eating human flesh, though not unknown, is rare, and is a thing which marks the man who has done it." Cannibalism is absent from the Banks Islands and Santa Cruz, but present in the northern New Hebrides. Dr. Codrington was told by eye-witnesses that it was practised in Pentecost : " In Leper's Island they still eat men (1891)." He reports head-hunting in the Solomons.[4] Of this practice Rivers says : " The primary motive which seems to have underlain the practice of head-hunting in Melanesia was that they might act as an offering on such occasions as the building of a new house or the launching of a new canoe. . . . It is probable that the offering of the head of an enemy on these occasions has arisen directly out of the practice of human sacrifice, the head being used as the representative of the human victim." He goes on to state that the practice of head-hunting certainly belongs to a late stage of Melanesian history.[5] This agrees with the evidence in India and Indonesia, where head-hunting is evidently a modification of human sacrifice.

Further south in Melanesia cannibalism and human sacrifice flourish in New Caledonia, a place ruled over by the Children of the Sun, with mummification, terraced irrigation and other signs of close relationship to the archaic civilization.[6]

[1] Seligman i. 556 e.s. [2] Id., 589, 650.
[3] C. E. Fox 158, 134, 297, 343. [4] Codrington 344–5.
[5] Rivers ix. II. 259. [6] Lambert 178.

Human sacrifice and cannibalism are mainly things of the past in Polynesia, although in later times these customs have been introduced once again from the west to Fiji and elsewhere. In the story of the peopling of Samoa it is said that the ancestress of the ruling family of Manu'a, Ui, came from a land where human sacrifices were offered to the sun. Ui managed to procure the use of substitutes for human beings, and then departed.[1] Cannibalism is said to have been practised by the first settlers at Manu'a in Samoa.[2] It was unknown in later times in the group, and human sacrifice had largely been abandoned. In places settled by the Samoans, such as the Gilberts, human sacrifice is unknown. Human sacrifices in Polynesia were mainly associated with the great gods of Fiji, Tonga, the Hervey Group, the Marquesas,[3] the Paumotos and Hawaii. Cannibalism was also practised : " Their mythology led them to suppose that the spiritual part of their sacrifices is eaten by the spirit of the idol before whom it is presented. . . . In some of the islands, ' man-eater ' was an epithet of the principal deities ; and it was probably in connexion with this that the king, who often personated the god, appeared to eat the human eye." [4]

Cannibalism and human sacrifice occur in New Zealand.[5] Elsdon Best comments thus upon these practices : " Though cannibalism was practised in some isles, yet it was no universal Polynesian custom. In the Society Group, whence the Maori of New Zealand came, it was rare, and it horrified several Tahitians who sailed in Cook's vessels in the Pacific. How is it that our Maori has become such a pronounced cannibal in these islands ? No such condition of general cannibalism—of its becoming such a common practice—is known among Polynesians of the south-eastern area. In order to find the eastern limit of this custom as a common habit we must turn to Fiji, in the Melanesian area. It is fairly clear that the Maori did not bring this shocking custom in any excessive form with him to New Zealand. Did he borrow if from the Maruiwi ? Tradition shows that the aborigines were of a lower plane of culture than that on which the Maori stood (but cf. p. 27). The Maori immigrants took large numbers of Maruiwi women, first as gifts, afterwards by force ; such a whole-sale system of inter-marriage must have had some effect on the culture and customs of the intruding people. . . . Was cannibalism as a common custom acquired by the Maori ? The dreadful Maori custom—or, at least, occasional habit—of kai pirau was also a Fijian custom—the exhuming and eating of buried human bodies." [6]

Since Elsdon Best derives the Maruiwi from the New Hebrides, it is probable that they were cannibals and handed on the practice to the Maori. In the case of human sacrifice Elsdon Best says : " We are aware that the practice of human sacrifice was followed

[1] Pratt ii. 121–2. [2] Tautain i. [3] F. Krämer I. 10.
[4] Ellis I. 357–8. [5] Haszard. [6] Best vi. 429.

in Eastern Polynesia, and probably the Maori brought it with him to New Zealand. There is, however, some evidence to show that in former times two singular examples of this custom obtained here that we cannot trace to the former home of the Maori ; these were the burial of human beings at the bases of the main forts of the stockade of a pa, or fortified village, and also at the bases of posts supporting a house. There are several allusions to the latter custom in Maori tradition ; and, curiously enough, there is proof that in many cases some other object—such as a bird, a lizard, or a stone—was so buried, the human sacrifice being omitted. It would be interesting to know whether or not the depositing of a stone, etc., was the more modern custom, such objects serving as substitutes for a human sacrifice ? Or were both forms of the ceremony practised during the same period ? There is a certain amount of evidence to show that such sacrifices at the completion of a new fort or superior house, and perhaps also of a new cánoe (as in the Solomons) of the larger type, were practised at one time, but that in later times they became much less frequent, if indeed, they did not entirely cease in some districts. . . . The allusions in tradition to the burial of a human being at the base of a house-post are but few, and there is no record, so far as the writer is aware, of such an occurrence in late generations. . . . In regard to the burial of human beings at the bases of stockade-posts, we know of no tradition concerning this custom, and no old natives questioned on the subject knew anything about it. We have, however, some very direct evidence in the fact that the remains of such sacrifices have been found in one locality." [1] This evidence from New Zealand suggests that the tendency is for animal sacrifice to be substituted for human sacrifice. The Maori claim to have come from India, where the cult of the Great Mother and the practice of human sacrifice for agriculture were prevalent. On their travels they lost some of these practices, but in New Zealand they once more seem to have come into contact with the archaic civilization, and to have adopted cannibalism and the wider forms of human sacrifice which later they again abandoned.

Definite traces exist throughout Polynesia of the Great Mother, usually called Hina or Ina, or Sina.[2] Among the Maori she is the cause of illness and death,[3] and she tries to obtain the blood of Maui, her son and brother, for magical purposes.[4]

In Polynesia, therefore, human sacrifice tends to die out, especially in its more intensive form of cannibalism. As for the relationship between the cult of mother goddesses, human sacrifice and agriculture, the evidence at my disposal is not enough to warrant any conclusion. It is possible to make some generalizations on the matter : that human sacrifice and cannibalism have tended to die out ; that agriculture was formerly at a much higher level ; and that goddesses were formerly much more important.

[1] Best vi. 440 ; iv. : P. Smith v. 268. [2] Tregear v. 20 e.s.
[3] Goldie 5–6 : Best vi. 464. [4] Best v. 153–4.

These statements are generally true. But as to the real relationship between the cult of mother goddesses, human sacrifice and agriculture in early days it is not possible for me to speak with confidence. Human sacrifice is connected with agriculture in San Cristoval and thus this relationship may originally have been universal. If continuity in Polynesian culture be admitted, then it certainly would have held in the past.

The Australians practise some ceremonial cannibalism in connexion with fighting and funerals.[1] If cannibalism be associated with the archaic civilization, this will constitute yet another sign of the influence of this civilization in Australia. Since no other of the food-gathering tribes of the region practise human sacrifice or cannibalism, it is probable that the Australians learned the habits from some food-producers, and no good reason exists for refusing to credit one more cultural element to the account of the people of the archaic civilization.

In North America the cult of the great mother goddess, human sacrifice, cannibalism and agriculture are elements of the archaic civilization that tend to die out, especially among those tribes that have moved out into the plains. That is to say, the highest form of civilization of North America is characterized by customs of the most horrible cruelty, while those far below them in material culture stand above them in this respect.

In Mexico the mother goddess was important, and, as in Egypt, Sumer and India, adopted many forms : she was especially associated with the sedentary agriculturists of Mexico, and not with the pastoral peoples such as the Aztec who came in later and conquered the country.[2] Prominent among the goddesses was Centeotl, the goddess of maize and the earth, the Great Mother, identified with the other important goddesses such as " the mother of the gods," " the snake-woman," " our grandmother," " the universal mother," " the Earth." She was the patroness of medicine, doctors and the sweat-bath. As in Egypt and Sumer, the mother goddess was closely associated with intoxicating drinks. " They feign that Mayaguil was a woman with four hundred breasts, and that the gods, on account of her fruitfulness, changed her into the Maguey, which is the vine of that country, from which they make wine." [3]

Human sacrifice was prominent in the ritual of the mother goddesses. Teteoinnan, or Toci, the Mexican mother of the gods, was the goddess of ripe maize, healing herbs, the patroness of doctors, bath attendants and diviners. In a sacrifice in her honour the human victim was flayed. In other sacrifices to the great mother the victim was decapitated.[4] Certain gods, especially the sun-gods, had human sacrifices in their honour.

[1] Howitt 750 e.s. [2] Joyce ii. 36.
[3] Bancroft III. 349 e.s., 351, n. 4.
[4] Joyce ii. 38. The victim, in Mexican human sacrifice, represented the god (Toy 175).

The peoples of North America possessed a conception similar to that found in Indonesia, namely that of the corn mother, round which centred their sacrifices. In Mexico the religious festivals were arranged in an annual cycle connected with the growing of maize. The feast of the first-fruits of the maize consisted of the decapitation of the goddess of the young maize, Xilonen, represented by a maiden. This feast inaugurated the harvest and the eating of the new maize. When the shoots begin to appear above the ground they go to seek the god of maize, that is, a young plant which is carried to the house and treated as a god. In the evening this is taken to the temple of Chicome-coatl, the goddess of food, where the young girls go each with a bundle of seven head of maize from the last harvest. The name of this bundle also stood for that of the goddess of maize ; it was the maize mother. After the sacrifice of the goddess of young maize, Xilonen, came another, that of Toci, the goddess of harvested maize.[1]

The ritual associated with the maize mother and the accompanying human sacrifice has been dealt with in full by Sir James Frazer. The study of this ritual, important as it is, cannot be undertaken here, for my aim is to establish relationships between certain cultural elements and the archaic civilization. An account of the human sacrifice of the Mexicans is found in "Prescott's Conquest of Mexico." This author describes their cannibalistic practices. " The most loathsome part of the story, the manner in which the body of the sacrificed captive was disposed of, remains to be told. It was delivered to the warrior who had taken him in battle, and by him, after being dressed, was served up in an entertainment to his friends. This was not the coarse repast of famished cannibals, but a banquet teeming with delicious beverages and delicate viands, prepared with art, and attended by both sexes, who, as we shall see after, conducted themselves with all the decorum of civilized life. Surely never were refinement and the extreme of barbarism brought so closely in contact with each other."[2]

Cannibalism in North America was confined as a practice to Mexico and some tribes of the Mexican Gulf :[3] its occurrence to the north was sporadic. The distribution of human sacrifice in the United States is significant. It is reported among the Natchez of Louisiana, the Skidi Pawnee, the Iroquois, and the Pueblo Indians. The Natchez were ruled over by Children of the Sun whose ancestors had come from the south-west. Their traditions state that certain members of their ruling family went away because they disapproved of this custom of human sacrifice.[4] So once again does human sacrifice disappear in places remote from the archaic civilization. The Skidi Pawnee differ from the rest of the Pawnee tribe in possessing a " centre of specialization

[1] Loisy 237.
[2] Prescott I. Chap. 3, p. 53.
[3] Handbook, Art. Cannibalism.
[4] du Pratz 314.

of rituals relating to the gods above." [1] Sacred ears of corn, " reminding one of those seen upon some Pueblo altars," are very prominent in their ritual, and the Corn Mother is of fundamental importance.[2] Each spring the Skidi offered a human sacrifice to their supreme being, and not to Mother Corn. " This sacrifice seemed acceptable to Tirawa, and when the Skidi made it they always seemed to have good fortune in war, and good crops, and they were always well." [3] The Pawnee have moved out from the Pueblo region, have suffered much dislocation of culture, and become definitely warlike : so it is not surprising that the god has usurped the function fulfilled in Mexico by the Great Mother.

The human sacrifice of the Skidi assures good luck in war as well as good crops. Although the mother goddess has been pushed into the background, women play an important part in the ritual, for they prepare for the corn dance and afterwards are treated as chiefs.[4] The Skidi human sacrifice is similar to that of the Mexicans : " The scaffold upon which the human captive was tied is quite like the one shown in ' Le Manuscrit du Cacique,' Plate X, Fig. 8 (Henry de Saussure, Geneva, 1892). There we have the shooting of an arrow into the victim, the catching and offering of his blood, and particularly the idea that the captive must be induced to do everything willingly. These very striking parallels to the Aztec sacrificial ceremony leave us little doubt as to their interpretation." [5]

Human sacrifice among the Iroquois is allied to much agricultural skill : " One of the outstanding features of Iroquois material culture was their aptitude for agriculture. This was at first concerned largely with the cultivation of corn, beans and squashes. The importance attached to these may be noted from the fact that they were called the Three Sisters." [6] The Iroquois were also in other respects more similar in culture to the southern tribes than the rest of the northern tribes of the States and Canada.

The Pueblo Indians came out of the underworld where they were ruled over by the Great Mother. According to the Zuni, Earth is the mother to whom all are indebted for food.[7] The Zuni symbol of life is an ear of corn clothed in beautiful plumage, which embraces " all life-mysterious, life-securing properties, including mystery medicine." [8] This symbol is closely connected with the Corn Maidens.[9] The Zuni creation story says that " corn shall be the giver of milk to the youthful and of flesh to the aged, as our women folk are the givers of life to our youth and the sustainers of life in our age ; for of the mother-milk of the Beloved Maidens is it filled, and of their flesh the substance." [10] These people are said to have practised human sacrifice. A study of their traditions makes it evident that they are far from their original condition, and the story of their movements makes it obvious that their

[1] Wissler iii. 335. [2] Id., 337. [3] Id., 367. [4] Id., 373.
[5] Id., 338. [6] Waugh 3. [7] Stevenson ii. 20. [8] Id., 24.
[9] Id., 53-7. [10] Cushing ii. 397.

original culture must have undergone modifications on account of their experiences.

In other Pueblo tribes these cultural elements are less closely associated. The Pima evidently have forgotten about the Great Mother, for the chief actors in their creation story are males. But in one important incident in this story the aid of a woman is necessary. The ancestors of the Pima tried to make an irrigation system, but failed because the soil was poor and the rock too hard ; so the sister of Elder Brother, the being who brought them out of the underworld, White-eater-old-woman, made irrigation canals for them.[1] The Sia claim that the Spider was alone in the lower world, and made both the mother of the Sia and all Indians and the mother of the rest of men. She divided the people into clans and gave them corn. The mother of all Indians, Utset, whom the Spider created, chose the first priest and directed that the priesthood should always belong to the Corn clan. She also instructed the first priest how to make the Sacred Ear of Corn, the supreme " idol " of the Sia. The people were brought out of the underworld by the Twin Children of the Sun, and Utset stayed in the lower regions.[2]

Apparently, in the Pueblo area, as among the Skidi Pawnee, the original mother goddess has split up into the Earth Mother, the being who lives in the underworld, and into the Corn Mother, usually represented by an ear of maize. In Indonesia the grain goddess only appears in those places near in culture to the archaic civilization : in other places the Rice Mother took her place. Similarly in North America the form of the great mother as a grain goddess is only really prominent in Mexico : farther north she is replaced by the Maize Mother, usually in the form of an ear of corn. This process of degeneration has gone still farther among the Omaha, who practise but little agriculture : they simply have a tale that maize was discovered by a woman, just as the Pima say that the sister of Elder Brother had to be called in to dig the irrigation canals.

Human sacrifice is apparently unknown in the United States, excepting the tribes already mentioned (the north-west coast always being left on one side). This custom in Mexico is bound up with agriculture and the cult of the great mother. In the north, where the cultural influence of Mexico becomes weaker, the practice dies out, the Great Mother, as associated with agriculture, tends to disappear, and her place is taken by an ear of corn called the Maize Mother. Since the Plains Indians have mostly dropped agriculture, it is not surprising that they have no maize mother, except where agriculture has survived, as among the Mandan and Hidatsa of the Upper Missouri. So, both the food-gatherers of North America and those peoples who have tended to abandon agriculture, lack in their culture human sacrifice,

[1] F. Russell 215. [2] Stevenson i. 16, 39, 40.

ceremonial cannibalism, and the Great Mother as associated with agriculture.

This survey is not intended to exhaust either the study of human sacrifice, or of the Great Mother goddess. The aim is to show that, in the archaic civilization, the mother goddess was associated with agriculture, in connexion with which human sacrifices were offered to procure blood for the fertilization of the fields. Human sacrifice was performed for other ends, for instance to provide servants for rulers in the next life, and these wider associations of human sacrifice have tended to survive the agricultural, and in certain instances signs of the substitution of other victims for man have been apparent. Head-hunting is a mitigation of human sacrifice, for it does not involve the cold-blooded slaughter of the victim.

It is significant that human sacrifice tends to die out among peoples of lower culture. This fact opens up a field of research in social psychology, and tends to give a new idea of the meaning of civilization and its relationship to human behaviour. In North America and Mexico the contrast is striking between the highly civilized Mexicans and the Indians of the plains, greatly their inferiors in culture, but lacking their hideous customs. These Indian tribes have rejected human sacrifice and cannibalism as foreign to their ideas and desires. The practice of human sacrifice is certainly a great blot on the archaic civilization. Due as it was to mistaken ideas, it was fraught with fearful consequences to mankind, and the people of the archaic civilization have left behind them a legacy that has caused untold misery and suffering to mankind.

Human sacrifice has an important bearing on the development of the archaic civilization into those that succeeded it. For it would seem that the warfare of this early period was centred mainly round human sacrifice, it being waged primarily for the purpose of getting victims to offer to the deities. It is well known that the Aztecs tried not to kill the Spaniards, but to capture them, and the Spaniards were forced to witness the slaughter of some of their comrades on the pyramid of the sun-god. In Indonesia it is not an exaggeration to say that warfare is confined to head-hunting raids and the consequent reprisals, and it is hard to see that any fighting would happen if such a custom did not exist. Warfare and personal combat, being unknown among the food-gatherers, must have originated for some definite cause, and cannot be the outcome of some innate tendency to fight. The widespread existence of human sacrifice throughout the region, and its direct association with the head-hunting of Indonesia and elsewhere, suggests that the earliest form of warfare was bound up with the killing of victims for human sacrifice. This custom could have provided men with the education in cruelty necessary to cause them to injure their fellows. The possible sequence of

events is as follows. In the first instance the earliest kings were peaceful : Osiris and Tammuz certainly bear this character. These kings, it is said, were themselves sacrificed for the good of the community, probably by drowning. So long as this persisted, it is hard to see what warlike developments could take place. But a great transformation took place with the coming of solar ideas. Both in Egypt and Sumer the mother goddess, when connected with the sun-god, is destructive and martial. In Egypt she gets the human blood necessary to rejuvenate the king. That is to say, instead of the king being killed, human victims are now got, and thus the situation is entirely altered. The king, no longer doomed to die, has the power of life and death over his subjects. The education of ruling groups in warlike behaviour begins from that time.

This conclusion will doubtless appear surprising to some readers. They must remember, however, that the available evidence is dead against the ascription of regular pugnacious behaviour to early man, and that the causes of this behaviour must be sought in food-producing communities. It seems certain, to me at least, that the whole study of social psychology will have to be ordered on different lines in the future if any progress is to be made. The facile habit of inventing pictures of early times will have to be abandoned in favour of the method of relying solely on facts, however unpalatable they may be. It will have to be realized that civilized men, in their actions, afford but little evidence of those of their forerunners, that in the course of development of civilization entire transformations may have taken place in human behaviour. These contentions are immensely fortified by the work of the modern school of neurologists in this country, such as Head, Rivers, Stopford and others, together with that of Elliot Smith on the evolution of the cerebral cortex. I hope at some time in the near future to show how many and powerful are the reasons for believing in the immense influence of social institutions on human behaviour.

CHAPTER XVI

MOTHER-RIGHT

THE existence of parallels between the religious and the social, political and economic life of a community suggests that the great mother goddess as mother of gods and men may have some social significance. It seems as if, in the Ancient East, a time was when only the Great Mother existed. Then she was accompanied by her son, who became her husband, and finally pushed her into the background. On the hypothesis of the parallelism between the religious and other aspects of the life of a community, this gradual supersession of the mother goddess has some historical significance. Just as the sun-god disappeared with the Children of the Sun, so may the mother goddess have been relegated to the background on account of some transformation, political or social, in the life of the community. In this chapter, therefore, further inquiry will be made as to the part played by the Great Mother in the life of the communities of the archaic civilization and of those that followed.

One of the best-known features of ancient society is that of mother-right. Much has been written about this stage of social development, and many theories have been advanced to account for its meaning, and the part it has played in the development of human society. In our own civilization the rule is that we take our names, inherit our property, and succeed to the rank of our fathers, and not of our mothers. If Mr. Smith marries Miss Jones, the children are called Smith ; the eldest son of the Duke of Norfolk succeeds to the title, and inherits the property : the mother has no part in these things, except in so far as she is able to will her property, if she has any, to her son, if she please. But, leaving on one side the inheritance of property, descent, meaning by that the membership of a social group, and succession to rank, go through the father. We live in what is called a patrilineal form of society ! But it is found that in certain communities descent is in the social group of the mother. For example, in the case of the marriage of Mr. Smith and Miss Jones, the children would be called Jones, and the succession to rank and inheritance of the property of the family would go through the daughters and not through the sons. In all parts of the region there are com-

munities which possess these matrilineal customs. What is the cultural significance of this form of social organization ?

Before starting it will be necessary to know what to seek. The three matters concerned are descent in a social group, succession to rank, and inheritance of property. For the purposes of this chapter inheritance can be left on one side, and the survey confined to descent and succession. In treating of descent two distinct matters will have to be observed. Many peoples with matrilineal descent have tales of a race ancestress, who often clearly belongs to the category of mother goddesses : that is to say, it is possible that descent from a great mother and descent through women ultimately mean the same thing. The survey must therefore take account, not merely of the actual social mechanism of matrilineal descent, but also of the claim to descent from a race ancestress.

Further, treating of succession to rank, it will be found that, although succession is through women, the actual rulers are usually men. In such cases a man's son does not succeed to the throne, but his brothers, and failing them, the eldest son of his sister. So it will not be necessary to explain how it came about that women were ousted from the rule by men ; but simply to explain why succession to the throne was transferred from a man's brother and nephew to his son.[1]

The survey will therefore be concerned with :—
(1) Descent from a race ancestress, a great mother.
(2) Descent in the female line.
(3) Succession of kings in the female line.

This survey will show that these three cultural elements existed together in the archaic civilization, and that they were followed in all parts of the area by patrilineal institutions ; further, that the distribution of these matrilineal institutions is similar to that of the great mother goddess connected with fertility, agriculture, war and human sacrifice.

The beginning of the exposition of the material is difficult. For, in the earliest times in Egypt, the situation seems to be one in which matrilineal institutions are giving way to patrilineal institutions. Under matrilineal institutions the daughter of the king is the lawful heir to the throne, so that anyone who wishes to rule will have to marry her and reign as her surrogate. From the earliest-known times in Egypt, the king was sometimes the brother of the queen : Osiris married Isis his sister. Why did he do that ? Miss Murray has some remarks upon this matter that seem to be essentially just. She says that " where in ancient history we find consanguineous marriages in the closest possible degrees of relationship, we are not always dealing with records of licentiousness and vice, as the historians ancient and modern would have us believe, but with a system of matrilineal descent

[1] At the same time, it must be realized that women often do rule under mother-right.

16

and female inheritance preserved in a royal family. . . . I am convinced that wherever marriages are found to be closely consanguineous, there one must look for inheritance (i.e. succession) in the female line." [1] She analyses several dynastic tables of the Egyptian kings to support her contentions. In another place Miss Murray quotes evidence to show that the queen was the theoretical occupant of the throne. This is derived from an article by Erman, in which he shows that the name of Isis means " the throne-woman," while Osiris means " the occupier of the throne." [2]

In Sumer the relationship between Tammuz and his mother is commented on as follows by Langdon : " That the son should be also the lover of the goddess is explained by Frazer, on the assumption that in ancient society the imperial power descended through the female line. In that case the heir to a throne is the daughter of a king. To retain a throne a son of a king must marry his sister, or failing a sister, his own mother. In the Sumerian myths we have both circumstances represented." [3] In early Sumer the king actually ruled as the son of the great mother, and only later was he emancipated so as to rule in his own right.

A strong feminine element is characteristic of the early constitution of the kingship in Egypt and Sumer, a feature of society very unlike that of later times. Corresponding to the union in mythology of the mother goddess and the king, is a form of marriage in which the king is the brother or son of the queen, who appears to be the lawful heir to the throne. So, in these cases, if the interpretation here adduced be correct, female descent and descent from the mother goddess are synonymous. The king, although he must have been the son of a mortal woman, claimed sonship of the great mother. Therefore the descent through the mother has some relationship to descent from the great mother, though that relationship may not be clearly expressed.

In Arabia a remarkable transformation occurred when Arabs began to move out from Yemen on account, either of some political upheaval, or of the bursting of the great dam of Mahreb. It has been shown by Barton that the goddesses of the Arabians of Yemen were changed into gods, so that, for example, Semitic invaders of Babylon arrived there with Shamash, the male form of Shams. [4] It appears also that the tribes that migrated from Yemen changed, within a few generations, their descent from the matrilineal to the patrilineal mode. [5] This was accompanied by an abandonment of the irrigation for which the people of Yemen were famous, and the adoption of the pastoral mode of life. Thus in Arabia irrigating, cattle-breeding people with the great mother

[1] Murray iv. 308–9 ; iii.
[2] *Id.*, iii. : Cf. ZAS 1909, p. 92. Miss Murray gives an interesting account of the importance of women in Egyptian religion (i. 220 e.s.).
[3] Langdon i. 25. [4] Barton 124 e.s. [5] Robertson Smith i.

cult, and matrilineal institutions, swarmed out of their homeland and appeared subsequently as pastoral, patrilineal peoples who had changed their goddesses into gods ; certainly one of the most dramatic social, economic and religious transformations that the world had witnessed.

The culture-sequence, therefore, seems to be from mother-right to father-right, with mother-right as a feature of the archaic civilization. When irrigation is dropped the goddesses become gods, and the social transition takes place. Which is cause and which is effect ?

In India the contrast between matrilineal and patrilineal institutions is patent. The people of the Vedas paid little attention to their goddesses : on the contrary, Dravidian religion was much occupied with them. It is possible to show, from the Puranas and the Mahabharata, that probably the Aryan and Dravidian ruling families were originally descended from the same stock. For the chief god of the Vedic period was Indra, a war-god, who had pushed the Adityas, sun-gods, into the background. The chief Aditya was Varuna, who has been identified by Darmsteter with Ahura-Mazda, the great god of the Iranians. Ahura, as Darmsteter has shown, is the same word as Asura, and Varuna was called the great Asura.[1] So the Aryans possessed a great god that bears the name of the Asuras, their enemies. Varuna became supplanted by Indra in accordance with the adoption of warlike habits on the part of the Aryans. But the matter does not end here ; for the Adityas, of whom Varuna was one, were named after Aditi, a goddess, which fact suggests matrilineal institutions. Can it be that the older Aryan ruling family had matrilineal institutions ? There is every reason to believe so. For, in the Puranic tables, Aditi is directly related to the great beings of the Dravidian ruling families. The Puranas were written under Brahminic influence, so Brahma plays an important part in the creation of man. But if attention be paid to the posterity of Brahma, it will be found that the relationship between the Aryans and the Dravidians was clear, and that the Dravidians were certainly matrilineal in their institutions. Daksha, a " mind-born son " of Brahma, one of the Rishis as they are called, had a number of daughters, Aditi, Diti, Danu, Arish'ta, Surasa, Surabhi, Vinata, Tamra, Krodhava, Ida, Khasa, Kadru, Muni.[2] Aditi is the mother of the gods of the Aryans, and Diti is the ancestress of the Daityas who fought the Aryans, Danu of the Danavas who also resisted them, and Vinata of the Twin Children of the Sun. Thus Aryan and Dravidian gods are supposed to be descended from sisters, and are named after their ancestresses, and not after ancestors. This is shown in the case of Hiranyakasipu, son of Diti and Kasyapa, the sun. Hiranyakasipu, the son of Diti, had formerly brought the three worlds under his sway. He had usurped the authority of Indra, and

[1] Darmsteter 45, 47, 62–3, 67, 68. [2] H. H. Wilson 122.

exercised the functions of the sun, of air, of the lord of waters, of fire, and of the moon. He was the god of riches, and judge of the dead ; and he appropriated to himself, without reserve, all that was offered in sacrifice to the gods.[1] The descendants of Hiranyakasipu were not called after him or any other male ancestor, but after Diti.[2] His brother Hiranyaksha had many sons, but none of them were called after him. It is said, on the contrary, that they were all Daityas of great powers, that is, they were named after their grandmother, a matronymic form of naming. Then Kasyapa, the sun, married Danu, and the descendants in the words of the Vishnu Purana "were the renowned Danavas," or sons of Danu.[3] Thus certain of the Children of the Sun called themselves after their ancestresses, and not after their ancestors, however famous they may have been. On the contrary, among the Aryans, the patrilineal mode of reckoning descent is patently in vogue. The descent of Manu, himself one of the Children of the Sun, is patrilineal : Manu Vaivaswata was a Child of the Sun ; one of his sons was Karusha :[4] "From Karusha descended the mighty warriors termed Karushas (the sovereigns of the north)." [5] The whole of the descent of Manu is of this type, and the feminine element never enters. Yet both those lines are equally Children of the Sun, and, as has been seen, related to one another, in that Aditi, the mother of the sun-gods of the Aryans, was the sister of Diti, the race ancestress of the Dravidians who opposed the Aryans. Evidently the rise to prominence of Indra had pushed the solar deities into the background, and during the process the mode of descent had changed.

A further contrast between the Dravidians and the Aryans must be noted. The Dravidians were keen irrigators : the Aryans, on the contrary, were cattle-breeders, the whole of their ritual is bound up with this craft, their agriculture being carried on by the Vaisya caste. This is in strong contrast with the communities of the archaic civilization, in which the royal family were intimately concerned with the irrigation of the country. As in the case of the Arabs, matrilineal and patrilineal peoples exhibit striking differences, not only in their religious institutions, but also in their economic and social life. And in India, as among the Semites, the transition from matrilineal to patrilineal institutions has taken place among related peoples.

The institutions of the Dravidians were thoroughly matrilineal, and were accompanied by a claim to descent from a race ancestress. Women played an important part in the court of Magadha, an important Dravidian city ; they were more trusted than men, formed the personal bodyguard of the king, went hunting with him, and served as soldiers. Magadha was the great mother goddess of the city.[6]

Existing Dravidian tribes of North India display strong matri-

[1] H. H. Wilson 126. [2] Id., 147. [3] Id., 147.
[4] Id., 348. [5] Id., 351. [6] Hewitt.

lineal tendencies. The Bahikas or Takhas of the Panjab, the Newar, who appear to be kinsfolk of the Nairs of the Malabar Coast, and the Arattas, all have mother-right.[1] Mother-right is important in the Dravidian country in the south. In the words of Mr. Richards, "there is abundant evidence that inheritance through females was at one time general throughout South India. It would seem that a matrilineal system of inheritance was a general feature of the sub-culture of the south, on which the Brahmanic super-culture was imposed." [2] The succession in the royal families of Travancore, Cochin, Calicut and Colastri on the Malabar Coast is matrilineal, the heirs to the throne being younger brothers or sisters' sons. These ruling groups seem certainly to be of Dravidian origin,[3] and to belong to the Nair caste.

The Khasi of Assam, who erect megalithic monuments, have preserved matrilineal institutions. Sir Alfred Lyall, in his introduction to Major Gurdon's work on the Khasis, says that " their social organization presents one of the most perfect examples still surviving of matriarchal institutions, carried out with a logic and thoroughness which, to those accustomed to regard the status and authority of the father as the foundation of society, are exceedingly remarkable. Not only is the mother the head and source, and only bond of union, of the family ; in the most primitive part of the hills, the Synteng country, she is the only owner of real property, and through her alone is inheritance transmitted. The father has no kinship with his children, who belong to their mother's clan ; what he earns goes in his own matriarchal stock, and at his death his bones are deposited in the cromlech of his mother's kin. In Jowal he neither lives nor eats in his wife's house, but visits it only after dark. In the veneration of ancestors which is the foundation of the tribal piety, the primal ancestress (Ka Iawbei) and her brother are the only persons regarded. The flat memorial stones set up to perpetuate the memory of the dead are called after the woman who represents the clan (Maw Kynthei), and the standing stones ranged behind them are dedicated to the male kinsmen on the mother's side. In harmony with this scheme of ancestor worship, the other spirits to whom propitiation is offered are mainly female, though here and there male personages also figure. The powers of sickness and death are all female, and these are most frequently worshipped. The two protectors of the house are goddesses, though with them is also revered the first father of the clan, U Thawlang. Priestesses assist at all sacrifices, and the male officiants are only their deputies ; in one important State, Khyrim, the High Priestess and the actual head of the State is a woman, who combines in her person sacerdotal and regal functions." [4] Of course Khasi rulers are usually men, not women. The king

[1] Oldham 158 : "Mahabharata," Karna Parva xlv.
[2] Richards i, [3] Mateer 119, 387, [4] Gurdon, pp. xxiii. e.s.

inherits the right to rule from his mother, but he is not her deputy.[1] It is significant to find that a tribe that has such strong cultural affinities with the archaic civilization of India, should have such definitely matriarchal institutions.

The disappearance of much of the archaic civilization in Indonesia, as is shown by the distribution of implements of polished stone, copper and bronze, makes it probable that many cultural elements of the archaic civilization and of the Dravidian peoples of India will be absent from that region. It is thus not surprising to find that mother-right is only recorded among the Malays of Menangkabau, in the Sangir, Talaut and Siaw Islands north of Minahassa,[2] in Timor and in Sumba. The genealogies of the Minahassa people reveal an important culture-sequence ; for some quoted by Prof. Hickson trace descent from Lumimu'ut, the race-ancestress : the descent from the first few generations is through women, and then it changes and is recorded henceforth through men. Matrilineal institutions have lately been discovered by Heer Kruyt in other parts of Indonesia, and this gives rise to the hope that more will yet be forthcoming from this area. He states that in the Kodi district of West Sumba, so closely connected with the archaic civilization, descent is matrilineal, and the husband goes to live with his wife's family. In Timor the people of Annas still preserve matrilineal institutions.[3]

The political convulsions which have devastated Micronesia have destroyed much of the old civilization, but in the Pelews and elsewhere there persists what may be a survival of the old social organization. The people of the Pelews are divided into matrilineal exogamous clans, each of which claims descent from a woman, or perhaps, it might be said, a goddess. Women are called " Mothers of the Land " and " Mothers of the Clan," and enjoy complete equality with the men in every respect. Indeed Kubary states that they are in every way superior to the men. The women cultivate the taro fields.[4] In Ponape of the Carolines, which possesses immense stone ruins of the archaic civilization, the people are divided into clans with matrilineal descent and inheritance.[5] In Guam of the Mariannes, the succession to the chieftainship is matrilineal, the brother or nephew of the ruler succeeding him.[6] Descent is matrilineal in the Marshalls. Thus in Micronesia the religious, social, and economic elements in the life of the community are closely related. Moreover, the goddesses have priority over the gods, and the race or clan ancestress approximates to the Great Mother.

In British New Guinea matrilineal institutions exist in a developed form in Bartle Bay only, in which spot are the stone circles, irrigation systems with aqueducts, cannibalism, the mango ceremony, and other elements of the archaic civilization.[7]

[1] Gurdon 66–71. [2] Hickson 197. [3] Kruyt ix. 799.
[4] J. G. Fraser ii. II. 204 e.s. [5] Christian iv. 74 : Hahl 39.
[6] Safford 716. [7] Seligman i. 16, 81, 199, 447.

The institutions of Torres Straits are patrilineal : yet the culture-heroes of the Eastern Islands, Bomai and Malu, are related so as to suggest that they belonged to matrilineal communities.[1]

The earliest food-producers of Melanesia were matrilineal, and the later comers were patrilineal in their institutions. The association between descent from women and mother-right is well shown in Aurora, Maewo of the New Hebrides, where a story is told of the first woman. She was a cowry shell that turned into a woman, and called the men to her and divided them into her husbands and brothers, fathers and maternal uncles, as in the dual organization, which will shortly be studied.[2]

At the end of a discussion, Rivers says that the evidence leads to the conclusion " that matrilineal descent is a feature of Melanesian society which now possesses far less social significance than in the past. In some places it is perhaps only the last relic of a condition of mother-right which once governed the whole social life of the people ; which regulated marriage, directed the transmission of property, and, where chieftainship existed at all, determined its mode of succession, while many other aspects of social life were altogether governed by the ideas of relationship between arising out of this condition."[3] He goes on to say that this old form of social organization has, under the influence of immigrants, given rise to a condition of father-right : " It is beyond all doubt that the direction of change in Melanesia has been from the matrilineal to the patrilineal mode."[4] Much of the second volume of his work on the History of Melanesian Society is devoted to establishing the truth of this statement. The Fiji Islands possess signs of the transition from mother-right to father-right, and it is important to note that the matriarchal communities have no tradition of immigration, while the patrilineal peoples have vivid traditions of their wanderings : this itself is evidence of the antiquity of mother-right in Fiji.[5] According to Hocart, " The evidence collected showed clearly that chieftainship was originally matrilineal : it is now common for a man to succeed his father, but let there come a bad year and the people will remember that this is not the right thing."[6]

The social organization of Tonga is now patrilineal. This island has sent a colony to Tikopia at some time in the past, and the culture of Tikopia seems to represent the early stage of Tongan civilization : " both Tikopia and Tonga . . . possess the institution of father-right in a definite form." But certain cultural indications suggest a transition from mother-right to father-right : for maternal relatives play an important part in the lives of children ; so that, in the words of Rivers, we have to suppose that " the people of both Tonga and Tikopia once followed matrilineal descent."[7]

[1] Torres Straits Report VI. 282. See p. 253.
[2] Codrington 26. [3] Rivers ix. II. 102. [4] Id., 101.
[5] Deane 3. [6] Hocart iv. [7] Mariner 95 : Rivers ix. II. 240–1.

As regards succession to the throne in Polynesia, Rivers is of the opinion that it " seems to have passed in the female line," although chieftainship is now strongly patrilineal.[1] In Mangaia, of the Cook's Islands, kinship was, in the time of the Rev. W. Gill, in a condition of transition from the matrilineal to the patrilineal mode, as far as descent in the clan was concerned.[2] The former existence of matrilineal institutions in this island is shown by the fact that " the three tribes of the Ngariki, literally the royal house, the kingly tribe, represented as being the three original tribes of Mangaia, deduced their descent from a common mother, Tavake, and her three illegitimate sons, Rangi, Mokioro, Akatauria ; while all the tribes throughout the Hervey group trace back their origin each to one of a series of gods, who were the offspring of Vatea and Papa, and ultimately of a woman of flesh and blood, Varu-mate-takere, or ' The very beginning.' "[3] In Hawaiian legends the hero claims the help of the gods by proving his relationship to them on the mother's side. This suggests the existence of matrilineal institutions in the days before the break-up of the old Polynesian society.[4]

Throughout Polynesia mention is made of an ancestress called Sina, Hina, or a similar name. She is usually the wife of some god, either of the sky or of the underworld, who does not occur alone, as in the case of the Sumerian mother goddess. This is significant, in view of the fact that, in Polynesia, the transition has taken place from mother-right to father-right, the effect of which would be to cause gods to assume greater prominence than goddesses.

An account by Elsdon Best of the cult of Io, the supreme being of the Maori, shows that the people traced their descent to a woman : " All life originally emanated from Io. Man is not a descendant of Io, but from Io was obtained the spirit, the soul, the breath of life, that were implanted in Hine-ahu-one, the earth-formed maid, from whom man is truly descended." He suggests also that the high respect in which the maternal line of descent is held is a probable sign of the past existence of the matriarchate.[5] In the Chatham Islands Hine-tehu-wai-wanga, who is the same lady as Hine of the Maori, was the " goddess or deified ancestress." She was associated with the making of stone implements, and thus was connected with the archaic civilization, if it be true that these early people were responsible for these implements.[6]

In the Pacific, therefore, mother-right has given place to father-right, and gods are in the ascendant, with a great mother in the

[1] Rivers ix. II. 322. [2] Gill i. 36. [3] *Id.*, 3, 5, 6, 10.
[4] Beckwith 628. It is significant that Palinli, spoken of in Hawaiian legend as the first home of the race, and as " the hidden land of Pane," " the great land of the gods," should also be called " the land of good women " (*ib.*, 305, n. 2, 334).
[5] *Id.*, iii. 24, [6] P. Smith iii. 82.

background. The old form of society was evidently similar to that of the Carolines or of the Khasi of Assam.

In Australia the associations of matrilineal institutions are remarkable. The peoples with mother-right claim that they owed their culture to two youths who came among them and then departed. The patrilineal tribes, on the other hand, claim that their culture hero was an " All-Father," who went to the sky. Twin culture-heroes are closely connected with the archaic civilization, which is evident in North America, where so many tribes claim to have received their culture from these beings. On the other hand, single culture-heroes are found in Indonesia, also from the sky, but in communities that have no matrilineal institutions. It will shortly be seen that the tribes of North America with dual culture-heroes are matrilineal, or have lately passed from that stage, so the evidence suggests that dual culture-heroes go with mother-right, and single culture-heroes with father-right, as happens in Australia.

The transition from matrilineal to patrilineal institutions is an interesting feature of the history of North America. An important part was played in Mexico and among the Maya by the Great Mother in all her manifestations. Although the later history of the nations of these regions has obscured the beginnings, yet it would seem that the queen of the country was an important personage, and had to be of royal blood.[1] This is also characteristic of the Natchez of Louisiana, ruled over by the Children of the Sun, where only men descended from a royal princess could reign.[2] So far as I am aware, there is no further evidence of matrilineal institutions in Mexico and the Maya country.

The Pueblo Indians are partly matrilineal, and partly patrilineal. All the surrounding tribes, with the exception of the Navaho, and Apache, who claim relationship with them, as well as the Yokut of California, are patrilineal, in their institutions.[3]

The case of the Seri Indians must be noted as an apparent contradiction to the generalization that matrilineal institutions belong to the archaic civilization. The Seri live on the Tiburon Islands and the opposite coast of the Gulf of California. Their material culture is extremely primitive. They live chiefly on turtles, fish, molluscs, land game, cactus fruits, mesquite beans, and a few other vegetables. " They neither plant nor cultivate, and are without domestic animals, save dogs, which are largely of coyote blood." They have no houses, but make flimsy shelters of boughs.[4] They are loosely organized in matrilineal clans, and there are indications that the clan organization was formerly much more developed before the tribe was reduced by warfare. They make very crude pottery.[5] The dead are clothed in their finest

[1] Brasseur de Bourbourg cxix. 205–7. [2] du Pratz 347.
[3] Rivers xii. : Cushing ii. 368 : Stevenson i. 19 : F. Russell 197 : Matthews iv. 33.
[4] McGee 9. [5] Id., 185.

garments, folded and wrapped in the smallest compass like Peruvian mummies, and placed in a grave and covered with turtle-shells. The grave is then filled with stones or thorny branches to keep off the wild animals, and some possessions are placed with the dead. Their only implement is " the original natural cobble used for crushing bones and severing tendons, for grinding seeds and rubbing face paint, for bruising woody tissue to aid in breaking okatilla poles for house frames or mesquite roots for harpoons (both afterwards finished by firing), and on occasion for weapons ; and this many-functioned tool is initially but a wave-worn pebble, is artificially shaped only by the wear of use, and is incontinently discarded when sharp edges are produced by use or fortuitous fracture." [1]

These people appear to be of the stage of culture of the food-gatherers, but they make pottery, which has been assigned to the archaic civilization and its derivatives. It is thus necessary to be cautious in claiming that the matrilineal institutions of the Seri are of native origin. This caution must be increased on learning that " Seriland is surrounded with prehistoric works, telling of a numerous population who successfully controlled the scant waters for irrigation, built villages and temples and fortresses, cultivated crops, kept domestic animals, and manufactured superior fictile and textile wares ; but (save possibly in one spot) these records of aboriginal culture cease at the borders of Seriland. In their stead a few slightly worn pebbles and bits of pottery are found here and there, deeply embedded in the soil and weathered as by the suns of ages. There are also a few cairns of cobbles marking the burial places, and at least one cobble mound of striking dimensions but of unknown meaning ; and there are a few shell mounds, one so broad and high as to form a cape in the slowly transgressing shoreline (Punta Antigualla), and in which the protolithic implements and other relics are alike from the house-dotted surface to the tide-level 90 ft. below." [2] This makes it impossible to claim that the Seri are primitive, or their culture indigenous ; rather must they be viewed as an example of cultural influence on the part of the archaic civilization, with which further investigation will probably show other traces of contact.

The Zuni Indians have matrilineal descent in the clan, but the infant is said to be the " child " of its father's clan, a sign of a transition to patrilineal modes.[3] The creation myth contains evidence of the former presence of matrilineal institutions. It is said of the first Sun Priest that " He and his sisters became also the seed of all priests who pertain to the midmost clan-line of the priest-fathers of the people themselves, ' masters of the houses of houses.' " Again, " as the Earth-mother herself had increased and kept within herself all things, cherishing them apart from

[1] McGee 12, 154. [2] *Id.*, 12. [3] Stevenson ii. 291 : Cushing ii. 367.

their father even after they came forth, so were our mothers and sisters the keepers of the kin-names and of the sacred seed thereof, nor may the children of each be cherished by any others of kin." Also in the creation poem :

> " As a woman with children
> Is loved for her power
> Of keeping unbroken
> The life-line of kinsfolk."

When the group of the Zuni who tell the creation myth, the later comers, arrived at the country of the Black-Corn people, the sedentary irrigating Zuni with whom they amalgamated, they were opposed by the " elder nations " who were led by the " Ancient Woman" who carried her heart in her rattle, and was deathless of wounds in the body." [1] The evidence thus goes to show that the Zuni formerly had well-developed matrilineal institutions.

The Tewa of Arizona have matrilineal institutions, while those of New Mexico are patrilineal. [2] The Sia Indians of the Pueblo region are apparently in a process of transition from one mode of descent to another, for their clans are exogamous for either parent. [3] This accords with their degenerate culture. The Sia compare usefully with the Pima, who are patrilineal and have suffered still greater transformations in culture, for the Great Mother still survives among them as the sister of Elder Brother, their culture-hero who brought them out of the underworld, [4] while the Pima have lost all memory of such a being.

The Navaho, in spite of their abandonment of the sedentary life and of agriculture, have matrilineal institutions. The child belongs to the group of its mother, whence it takes its name ; but the group of both father and the mother are forbidden for the purpose of marriage, which shows that the system is beginning to turn to the patrilineal side. [5] Correspondingly, in the creation myths, although the twin gods, the culture-heroes, are born of a mother, the people themselves seem to have been created in the form of images. At the same time, other memories of their origin seem to have been retained, in that the clans are said to have been named according to the words uttered by the women when they drank of the magic fountains. The memory of a race ancestress is thus apparently preserved by those people who retain mother-right, while among those who are undergoing the transformation to father-right, this memory is becoming faint.

The Pawnee, who came into prominence in the discussion of human sacrifice, have matrilineal institutions. [6] All the tribes of the south-eastern States, the Creek, Choctaw, Chickasaw,

[1] Cushing ii. 386, 387, 411, 426. [2] Freire-Marreco 269, 270.
[3] Stevenson i. 19.
[4] F. Russell 197, 215. [5] Matthews iv. 33.
[6] Grinnell 203 : Wissler iii. 335 : cf. Fletcher ii.

Seminole, Yuchi, Timuquanan, Biloxi are matrilineal. The Yuchi claim that they are descended ultimately from a woman of the sky-world.[1] The Iroquois, whose culture shows such strong affinities with that of the south, have a matriarchate that is famous in ethnology.[2] The Huron are also matrilineal, and, like the Yuchi, claim to be descended from a woman from the sky.[3] The Delaware and Mohican among the Algonquians are matrilineal, but the Abnaki, Ojibway and Potawattomty are patrilineal. The Ojibway and the Menomini tribes were formerly matrilineal, but have changed to the patrilineal mode. Of the Siouan tribes of the plains, the Omaha, Ponca, Osage, Iowa, Kansas, Dakota, Assinibion, Tciwere, Winnebago, are patrilineal; while the Mandan, Hidatsa, Crow, Missouri, and Ote are matrilineal. The Winnebago have traces of former matrilineal institutions.[4] The Sioux of the eastern States, the Nayhassan, were matrilineal, being divided into four clans claiming descent from women.[5] After migration into the plains some of the Siouan tribes had patrilineal institutions, and others matrilineal. These facts suggest that some Siouan tribes have changed from mother-right to father-right since setting out from their homeland in the eastern States. This is the view of Sir James Frazer : " Taken together with the case of the Mandans, another Siouan or Dacotan tribe who retain maternal descent, the custom of the Otoes and Missouris raises a presumption that all the Siouan or Dacotan tribes had formerly mother-kin instead of father-kin, and that the change from the one line to the other, wherever it has taken place, has been comparatively recent." [6]

The survey reveals the past existence of mother-right throughout the region. Where contact with the archaic civilization is closest matrilineal institutions are retained, and where the old order has gone father-right has appeared. In Arabia, India and North America this social transformation has been accompanied by the abandonment of agriculture, and the adoption of the pastoral or purely hunting mode of life. The close connexion between the mother goddess and agriculture, revealed in the past chapter, suggests that the dropping of this craft may have caused loss of prestige by the mother goddess and the transition to father-right. But the transition was accompanied by other cultural changes, such as the adoption of warfare, the disappearance of the Children of the Sun, and so forth, and it is not advisable to attempt here an explanation of its cause.

The survey has shown that the descent through women and the claim to descent from a race ancestress or a Great Mother are closely connected. If the history of any matrilineal people be considered, it would seem that the descent of the people is reckoned

[1] Speck ii. 105.
[2] Rivers xv.
[3] Rivers xv.
[4] J. G. Frazer ii. 122.
[5] J. Mooney ii. 33.
[6] J. G. Frazer ii. II. 123.

through a long line of ancestresses. The first of these is sometimes a goddess, and then is evidently the ancestress of the ruling family. This is natural, for only the ruling families preserve genealogies. This race ancestress cannot in some cases be distinguished from a mother goddess, so it is possible to think of communities of the archaic civilization budding off from the parent stock, and carrying with them the tradition of descent from women, who in the first instance were of the royal family. It is not yet possible to understand the real relationship between the great ancestress and the bulk of the people : that matter must be reserved for discussion at the end of the next chapter, where it will be seen that she does play an important part in the lives of all members of the community, rulers and commoners alike.

A noteworthy feature of mother-right is the close association between the twin culture heroes and their mother. Dual culture heroes generally seem to live in an atmosphere of mother-right. For instance, the two culture heroes of the eastern islands of Torres Straits, Bomai and Malu, stand in the relationship of mother's brother and sister's son, relationships which are important under mother-right, the mother's brother being the counterpart of the father under father-right.

CHAPTER XVII

THE UNDERWORLD

DURING the discussion of the creation of man by sky-gods an important matter was left on one side. It was found, in Nias, and among the Toradja of Central Celebes, that the spiritual nature of a commoner was bisected, as it were, at death : his life—his breath—went to the sky, back to the god who gave it, while his ghost, something that only came into existence at death, went to the underworld. The ruling class in Nias, on the other hand, went entirely to the sky. So, at death, the community divides into two parts, each going its appointed way. Why should not sky-chiefs rule over their subjects in the life to come ? Why should they go elsewhere ? It is easy to understand that the breath of the commoner goes back to the sky to the sky-gods. Why should his ghost go underground ?

Before proceeding to study this distinction of classes it will be well to lay down a general principle. Many peoples hold ideas with regard to the origin of men and their destiny after death. Some years ago I published a preliminary account of a survey of the peoples of Indonesia with a view to establishing the thesis that a relationship existed between these two sets of beliefs and the form of burial that accompanied them.[1] The result of the investigation of as complete a collection of the evidence as possible suggested that the land of the dead is the place where the people believe themselves to have originated ; and further, that the mode of disposal of the dead is intended to help the dead back to their home. A few examples will illustrate the principle. Various ideas are held as to the origin of the race. When the ancestors came from over the sea, the dead are usually placed in canoes which shall serve to take them back home. It is probable in some cases that the dead were formerly taken back in canoes to the old home whence their ancestors came. Often the dead are buried to face towards the land of origin, which is also the land of the dead. In Savu, an island to the west of Timor, the dead are interred in a sitting position facing the west, the direction whence the inhabitants are said to have come.[2] Some people declare that their ancestors came from a certain mountain : in the Belu district of Timor, it is said that the ancestress of the

[1] Perry ii. [2] *Id.*, ii. 140–1.

254

race came out of a mountain, and the dead are supposed to go back there, and are interred, presumably to reach the underworld. The Dusun of British North Borneo believe that their ancestor, when he saw them comfortably settled, went to Mt. Kinibalu to live, and it is there that their ghosts are supposed to go at death.[1] In one case, that of the Karen of Burma, not only is it believed that the dead return to the mountain of their origin, but care is taken to ensure this. An annual festival is held, during which the bones of all the clan or family who have died during the year are collected and taken to the common burial-place, situated on some remote and inaccessible mountain called the Hill of Bones.[2]

A singular belief is that of origin from trees. This is found in Borneo among other places. The Bahau of Kutei on the east coast hold that " men came from trees and to trees they shall return. . . . When a Bahau woman bears a child before the appointed time, it is placed in a tree ; it is, as it were, returned to the place which it has lately left." [3]

Interment is the means of returning the dead to the place of origin, the underworld. A tribe in upper Burma, called Bunjogee or Pankho, who inter their dead, claim that their ancestors came out of the underworld by means of a cave, and say that " The cave whence man first appeared is in the Lhoosai country close to Vanhuilen : it can be seen to this day, but no one can enter. If one listens outside the deep notes of the gong and the sounds of men's voices can still be heard. About their future home they are most explicit. After death they believe that the deceased go into the large hill whence man first emerged ; this they say is the land of the dead.[4] Certain tribes believe that their ancestors came out of stones, among them being some Naga tribes of Assam. They inter their dead and place a stone on the grave, or else put the body in a cave in the side of a mountain, the mouth of which is filled with stones.

These examples illustrate the general correspondence between beliefs and practices connected with death and origins. In this chapter this correspondence will be studied with regard to the elements of the society of the archaic civilization that were not connected with the sky. It has already been found that the Children of the Sun had close ties with the sky, and went there at death to join their ancestors. It was found, moreover, that the rest of the community went elsewhere, usually underground. The peoples of the archaic civilization tend to claim descent from a race ancestress, one of the forms of the Great Mother. If it be true universally that the dead return whence they came, it should follow that the Great Mother, the ancestress of the race, should be found in the land of the dead to which go the ghosts of those elements of the community that do not claim descent from sky-beings.

[1] *Id.*, 144. [2] *Id.*, 145. [3] *Id.*, 146. [4] *Id.*, 150.

The study of the disposal of the dead is one of great complexity, owing to the large number of forms that have developed from a few original methods. For that reason it is not possible to generalize so freely about burial customs as about some other cultural elements. But, in certain parts of the region, particularly Egypt and Polynesia, there are indications of the probable condition of things in the archaic civilization. The pre-dynastic people of Egypt and those of early Sumer were interred in the sand, often without any covering, in a contracted position. According to the evidence from Indonesia, this practice should be accompanied by a belief in an underground land of the dead. This belief was present in Sumer in the earliest known times : the dead went underground and there were sunk in deep sleep. This underworld at first seems to have had no ruler ; but later on it had a queen, Erishkagal, one of the forms of the Great Mother,[1] who ruled alone : " truly queen of all decrees am I ; a god with me rivals not." [2] Later on she was given a spouse, Nergal, god of fire and of war, one of the forms of the sun-god. In the story of Tammuz and Ishtar, Tammuz goes to the underworld, lies there in a deep sleep, and has to be rescued by Ishtar from the queen of the underworld. Tammuz does not seem to rule over the underworld. Yet in Egypt, Osiris, who holds a similar position in Egypt to Tammuz in Sumer, was lord of the dead : " It was a subterranean kingdom of the dead over which Osiris reigned, and it was as champion of the dead that he gained his great position in Egyptian theology." [3] Osiris was associated with water, and was supposed to encircle the underworld like a snake. He is also said in the Pyramid Texts to be " with outstretched arms, sleeping upon his side upon the sand, lord of the soil." The cult of Osiris moved from the Delta to Abydos, where it was preceded by that of Khenti-Amenti, the First of the Westerners. This title originates from the land of the dead situated in the west, or below the horizon, where it merged into the underworld, out of which the Nile flowed. Thence Osiris was called Lord of Dewat. Osiris became associated with Anubis of Siut, who was sometimes called " First or Lord of the Westerners," the title of the old god of the dead at Abydos.[4]

In Egypt and Sumer, therefore, the land of the dead, usually underground, is presided over by the Great Mother and by a god identified with the king. In Egypt a contrast exists between the kings of the solar period and Osiris. The solar kings went after death to the sky and lived in the company of Re ; but the rest of the people went to the land of the dead ruled over by Osiris, the first king who became mortal. It is true that later on Osiris was raised to the sky ; but in the beginning the Osirian cycle of deities were clearly distinguished from the solar cycle.[5] Therefore the

[1] Langdon ii. 131, 132. [2] i. 18.
[3] Breasted iv. 37. It is not certain that this land was originally subterranean, although it was so in later times. [4] *Id.*, 100, 144. [5] *Id.*, 143.

bisection of the community at death characteristic of communities ruled over by the Children of the Sun is not a necessary feature of society : for the earliest kings continued in the other world to rule over their subjects, and, in the days in Egypt when the solar kings ruled on earth, the old kings still ruled in the underworld over the dead. The sky element of the population thus shows every sign of superposition, and of being a more or less artificial element of society.

In India the Aryans and the Asuras held different ideas regarding the underworld. The Aryan nobility looked upon a land of the dead in the sky as their home after death, and practised cremation in order to get there. But some of the Dravidians were associated with an underworld. Hiranyakasipu, the son of Diti, the king of the universe, was the judge of the dead. Mention is made of " the crystal palace, where the Asura with pleasure quaffed the inebriating cup." [1] This underworld of the early Dravidian peoples was not a dreary place as in Babylonia. For, according to the Vishnu Purana, the regions below the earth number seven, Atala, Vitala, Nitala, Gabhastimat, Mahatala, Sutala, and Patala. Their soil is severally white, black, purple, yellow, sandy, stony, and of gold. They are embellished with magnificent palaces, in which dwell numerous Danavas, Daityas, Yakshas, and great snake-gods. The Muni Narada, after his return from those regions to the skies, declared amongst the celestials that Patala was much more delightful than Indra's heaven. " What," exclaimed the sage, " can be compared to Patala, where the Nagas are decorated with brilliant and beautiful and pleasure-shedding jewels ? Who will not delight in Patala, where the lovely daughters of the Daityas and Danavas wander about, fascinating even the most austere ; where the rays of the sun diffuse light, and no heat, by day ; and where the moon shines by night for illumination, not for cold ; where the sons of Danu, happy in the enjoyment of delicious viands and strong wines, know not how the time passes ? There are beautiful groves and streams and lakes where the lotus blows ; and the skies are resonant with the Koil's song. Splendid ornaments, fragrant perfumes, rich unguents, the blended music of the lute and pipe and tabor ; these and many other enjoyments are the common portion of the Danavas, Daityas, and snake-gods, who inhabit the regions of Patala." [2]

Below Patala was Naraka, or hell, presided over by Yama, which had several divisions for those guilty of various crimes. Yama in the Vedas presided over the underworld, and he still occupies that position in later Indian religion. Yama was a child of the sun, " son of Vivasvat, the assembler of men, who departed to the mighty streams, and spied out the road for many." [3] Again, " Reverence ye with an oblation Yama, the son of Vivasvat, the assembler of men, who was the first of men that died, and the

[1] H. H. Wilson 126. [2] Id., 204. [3] Muir V. 292 : Rig Veda X. 14.

first that departed to this (celestial world)." [1] Like Osiris he married his sister Yima, or rather, had intercourse with her.

The Atharva Veda contains traces of a conflict between the land of the dead of Yama and that of the sky. In Hymn 30 it says: "Let breath come, let mind come, let sight come, then strength; let his body assemble; let that stand firm on its two feet. With breath, O Agni, with sight unite him; associate him with body, with strength; thou understandest immortality : let him not now go; let him not now become one housing in the earth." In Muir it has for this last phrase : "Let him not depart, or become a dweller on a house of clay." From this it has been suggested that the Aryans of India first of all practised interment, and that cremation, associated with Agni, the god of fire, and the sky-world, was a later development, when Yama was removed to the sky, like Osiris in Egypt. [2]

The Atharva Veda contains ideas reminiscent of the Pyramid Texts of Egypt. " When thou, O Brihaspati, didst release us from Yama's otherworld existence, from Malediction, the Acvins bore back death from us, O Agni, physicians of the gods, mightily. Walk ye (two) together; leave not the body; let thy breath and expiration be here alike; live thou increasing a hundred autumns; (be) Agni thy best overruling shepherd. Thy lifetime that is set over at a distance—(thy) expiration, breath, let them come again—Agni hath taken that from the lap of perdition; that I cause to enter again in thy self. Let not breath leave this man; let not expiration, leaving him low, go away; I commit him to the seven sages; let them carry him happily unto old age. Enter ye in, O breath and expiration, as (two) draft-oxen a stall; let this treasure of old age increase here unharmed. We impel hither thy breath; I impel away thy yaksma; let Agni here, desirable one, assign us life-time from all sides. Up out of darkness have we, ascending the lightest firmament, gone to the sun, among the gods, highest light." [3] Again (in 8, I) we read, " Do not regard the departed, who lead (one) to the distance; ascend out of darkness, come to light; we take hold on thy hands. Let not the dark and brindled one, sent forth (seize) thee, that are Yama's dogs, road-defenders; come thou hitherward; do not hesitate; stand not there with mind averted. Do not follow that road; that is a frightful one—the one thou hast not gone before, that I speak of; to that darkness, O man, do not go forth; (there is) fear in the distance, safety for thee hitherward. . . . Up hath heaven, up hath earth, up hath Prajapati, caught them; up out of death have the herbs, with Soma for their king, made thee pass." [4]

Numerous other passages could be quoted to show that, in the minds of the early Aryans of India, life was in the sky, and death and darkness in the underworld of Yama. This Yama was the first mortal, the first king of men, who found his way to the

[1] Atharva Veda XVIII. 3, 13. [2] *Id.*, V. 30.
[3] *Id.*, VII. 53. [4] VIII. 1.

land of the dead, which was not the land of the dead of later times. Men, therefore, tended to go back to the land where they should be ruled over by their first king, and had to be saved from that fate by the gods of the sky-world. In the Aryan version, the mother goddess has been driven into the background, but she seems to survive in the person of Nirriti, the goddess of destruction, whose sons are Fear, Terror and Death.[1] Yama is akin to Osiris, the Egyptian ruler of the dead in the underworld, in that he seems to have married, or had connexion with, his sister. Presumably the Aryans of India passed through a stage in which the land of the dead was underground and ruled over by the first king ; or else they adopted ideas of that type from some other civilization. It is significant that the earlier people of India, the Dravidians, claimed a relationship with an underworld, not a dark and gloomy place, but superior to Indra's paradise, a place full of wealth, light, and happiness.

It is now possible to understand the Indonesian instance in which the ghost of a man goes underground, while his life goes to the sky. In the case of the Posso-Todjo Toradja, among whom the Sun-Lord came to stay, the life of a man goes to the sky and his ghost goes to the underworld, ruled over by I nDari, the goddess who took part in the creation of men out of stone images. These people have no chiefly class, because the children of Lasaeo went to the district of the mountain Toradja, so none go to the sky, the place whence came Lasaeo ; all go underground.[2] The mountain Toradja, on the other hand, place their land of the dead on the earth in the direction whence they believe themselves to have come. The act of migration has therefore caused a change in belief with regard to the land of the dead, and thus complications are introduced into the problem of determining the relationship between the mode of disposal and the home of the dead.

If the reasoning from the Toradja be correct, it should be found, on a general survey of Indonesia, that only in certain places do the commoners go to an underground land of the dead. This should happen where a distinct division of classes takes place at death, such as in Nias and south-west Timor, or where culture-heroes came from the sky, as among the Posso-Todjo Toradja ; provided no other circumstance, such as subsequent migration, has tended to complicate the belief.

It is impossible here to give details for the whole of Indonesia— the data are too numerous. I hope at some future time to publish the material. A preliminary analysis, set out in tabular form, shows that the belief in an underground land of the dead is closely associated with the archaic civilization. In addition to the Posso-Todjo group of the Toradja, the belief is found among the Batta of Simelungun in Sumatra, the Kayan of the Kapuas region and of Sarawak, the Baju of Banjermassin, the people of the Sangir

[1] "Mahabharata," Adi Parva. [2] Kruyt and Adriani I. 268.

Islands, certain tribes of Mindanao in the Philippines, and the Galela people of Halmahera ; in the Geelvink Bay region of Dutch New Guinea, in South-West Timor, and in South Nias. The cases of Nias and Timor have already been discussed, and it has been found that the ghosts of rulers, in the case of Timor those of the Children of the Sun, go to the sky, while those of commoners go underground. It is significant that in those places of Indonesia, Central Celebes and South-West Timor, where mention is most definite of the Children of the Sun, and in Nias, where the sun-god is important, the underground land of the dead should be the place of destination for the ghosts of the commoners, whilst, when the archaic civilization begins to break down, it tends to disappear. This is well shown in the case of the tribes of the interior of Borneo. The Kayan have the belief, while those tribes presumably influenced by them lack it.

It is interesting to note what happens when the archaic civilization begins to dissolve. This process can be watched in the region west and east of Timor, ranging from Sumba to Luang-Sermata, where the only example, so far as I am aware, of an underground land of the dead, is in that place formerly ruled over by the Children of the Sun. In the other cases this belief is not recorded, in my knowledge. Yet from Sumba to the Luang-Sermata group, interment is the invariable mode of disposal, except, again, in the case of the Children of the Sun, who are mummified. In these islands, therefore, the land of the dead should be underground. Sumba contains many dolmens, Roti and Savu have megalithic monuments, and thus have been profoundly influenced by the archaic civilization. In the islands east of Timor, which have, according to tradition, been peopled from Timor, the use of stone gradually dwindles away to practically nothing. When inquiry is made with regard to the land of the dead in these places, it is found that it is in the direction of migration : it is never underground, so far as I am aware. In one case it is possible to watch the apparent transition from an underground land of the dead to one in the direction of migration. In the Fialarang district of Belu in Timor, the people believe that they are descended from an ancestress who came out of Mt. Lekaan. Their ghosts go to Mt. Lekaan after death, but as to whether they go underground or not is not clear.[1] Evidently they went underground at first ; but migration has caused them to remember only their place of origin, and to forget the fact that their ghosts went underground. This is natural, if it be remembered that ghosts return to the ancestral home.

Throughout this region, in Sumba, Roti, Belu, Keisar, Leti-Moa-Lakor, Babar, Timorlaut, the people believe in an underground world. These peoples are immigrants, so this underworld is probably the ancestral home of the dead that has become detached from its setting, and lingers on in popular memory as

[1] Gryzen 46.

an underworld. The Naga tribes of Assam exemplify the case. They usually practise interment,[1] and most of them claim to have come from elsewhere. The Mao and Kabui Naga believe that the dead go underground in certain cases, and both these tribes are closely associated with the archaic civilization. The Mao Naga say that the " good " go to the sky and the " bad " go to the underworld,[2] and thus have a duality of belief somewhat akin to that of Nias and of the Posso-Todjo Toradja.

This discussion therefore leads to the expectation that the underground land of the dead will only be found among those people whose culture shows most signs of the influence of the archaic civilization ; and that, as the break-up sets in, it will tend to be displaced by some other home of the dead.

The connexion between the archaic civilization and the underworld is shown in yet another way. The creation myth of the Posso-Todjo Toradja of Central Celebes recounts that the first images were made by a god of the sky and a goddess of the underworld, so evidently both places were equally connected with the archaic civilization. In the origin stories of the Bugi and Macassar people, farther south, it is also said that the ancestors of the ruling houses were derived from both worlds, for a male being from the sky married a princess of the underworld. The story told in Luwu states that the male being from the sky was Batara Guru. He married several princesses from the underworld, among them being We Opoe Sangang, by whom he had twin children—a boy Sawerigading, and a girl We Tanrijabeng.[3] This Sawerigading was the great hero of the Bugi folk ; and he went all over Celebes and the neighbouring islands waging war and contracting matrimonial alliances. He married We Tjoedai, a princess of the underworld, and finally retired to the underworld to live. His sister, on the other hand, married Ramang ri langi, " the clouds of the sky," and finally went with him to the sky and dispossessed the rulers of that place.[4] Sawerigading thus acts as other early kings, and goes to rule over the underworld, although his ancestry is derived on one side from the sky-world. (See p. 373).

In Oceania the evidence bears out the conclusions already reached. In Guam of the Mariannes, with matrilineal' institutions, the ghosts of the dead go underground.[5] In Melanesia various beliefs are held with regard to the land of the dead. " Dr. Codrington has put on record the striking difference between Northern and Southern Melanesia in regard to the beliefs concerning the abode of the soul after death. In the Banks and Torres Islands, and in the New Hebrides, it is the almost universal belief that the dead live underground, the way to the home beneath the earth being in some cases through the volcanic vents

[1] The exceptions being the Ao and Tamlu Naga.
[2] Hodson 161. [3] B. Morris 550. [4] *Id.*, 551. [5] Safford.

which occur in these islands. In the Solomons, on the other hand, the prevailing belief is that the dead find their way after death to islands, either in other parts of the Solomons, or more remotely situated. Here and there in the Solomons, however, as in Savo, we find, either alone or in conjunction with the more widely diffused belief, the idea that the dead go into volcanic craters or caverns, while in at least one place in Southern Melanesia, in Anaiteum, it is believed that the dead reach their future home by sea." [1]

The underground land of the dead is associated in Southern Melanesia with a woman, who is, according to some ideas, the mother of Qat, the great culture-hero : in one story she is Iro Puget, the wife of Mate, Death. In a Mota tale it is said that the dead are met by her at the entrance to the underworld. [2] Codrington gives an account of the way in which Iro Puget came to live in Panoi, the land of the dead : " In one (island) the cause of the introduction of Death was the inconvenience of the permanence of property in the same hands while men changed their skins and lived for ever. Qat therefore sent for Mate, who dwelt in Panoi, or by the side of a volcanic vent in Santa Maria, and assured him that he would only have to go to Vanua Lava and not be hurt. Death therefore came forth ; they laid him on a board, killed a pig, and covered him over ; then they proceeded to divide his property and eat the funeral feast. On the fifth day, when the conch was blown to drive away the ghost, Qat opened the covering over Mate and found him gone ; nothing but bones remained. In the meanwhile Tangaro the Fool had been set to watch the way to Panoi, where the paths to the lower and upper worlds divided, lest Mate should go below ; the fool sat in front of the way to the world above, and let Mate go down to Panoi ; all men have since followed Death along that path. Another story makes the same fool—under his name of Tagilingelinge—the cause of death, because when Iro Puget set him to guard the way to Panoi in prospect of her own death, he pointed out that way to her descending ghost instead of the way back to the world, and so she, and all men after her, died and never came back to life." [3] This quotation suggests that, in the region of the dual organization of Melanesia,[4] the choice existed between two different destinies after death : one land of the dead was associated with the upper world and with life, and the other with the underworld and with death ; and the people with their interment and contracted position of burial came to go underground. The idea of the first mortal being the ruler of the dead is implicit in the story of Mate, and the Great Mother apparently is also there in the form of Iro Puget. In the case of Leper's Isle, the land of the dead is underground, and is ruled over by Nggalevu, a vui,[5] and consequently connected with the archaic civilization.

[1] Rivers ix. II. 261–2. See Macdonald 728, for Efate. [2] Codrington 265.
[3] Id., 266–7. [4] See pp. 294 e.s. [5] Id., 285.

The beliefs in Melanesia would be expected on the basis of the evidence gained in Indonesia. The people of Southern Melanesia have no traditions of migration, and their land of the dead is underground ; which is exactly what would happen if the ruling class of former times had disappeared, leaving the commoners with their ideas of the underworld. In Southern Melanesia the vui, so similar to the sacred chiefs of Fiji, the culture-heroes who have been associated with the archaic civilization, the carved stone images, and the numerous other signs of the archaic civilization, go to show that life was far different in the past. The disappearance of the ruling class associated with the sky has caused the community to be associated completely with the underworld. The other parts of Melanesia, where migrations have taken place, lack such ideas. For instance, the people of Santa Cruz, who have migrated, have no underground land of the dead.

In Polynesia the sky-world is mainly a thing of the past, and all classes of the community as a rule go to the underworld, which is often reached over the sea, this journey by sea being presumably consequent upon migration. The evidence from Polynesia suggests that the bisection of the community into rulers and commoners, one group connected with the sky, and the other with the underworld, is not comprehensive. On the contrary, one element of the ruling group from the beginning has evidently been connected with the underworld. In Samoa, the children of the sun were associated with a family connected with the underworld, with whom they intermarried.[1] This family, the Salefe'e, ruled the underworld, and La Fe'e its head, played an important part in the early history of Samoa. On the disappearance of the Children of the Sun, the only land of the dead was underground, where dwelt Nafanua, the goddess of war ; and the great gods of Samoa were henceforth underworld gods. After the disappearance of the Children of the Sun the ruling chiefs were called Tui in Fiji, Tonga, Samoa, and elsewhere in Western Polynesia. These chiefs are connected with the underworld, the land of the dead of the whole community.

The race ancestress of Mangaia, Vari-ma-te-takere, lives in Avaiki, the underworld. She made Vatea, who rules over the underworld. Vatea married Papa and they had twin sons, Tangaroa and Rongo.[2] Rongo, as is known, ultimately superseded Tangaroa, and became the god of Mangaia, raising it up from the underworld. Tangaroa and Rongo are children of the same mother ; one is connected with the sky, and the other with the underworld. Thus, as the result of the departure of Tangaroa, there results an underground land of the dead ruled over by the first king and the mother goddess. In Tahiti the land of the dead for all the community, except members of the Areoi society, is underground.[3] In Hawaii the bulk of the people,

[1] This matter will be discussed at length in Chapter XXIII.
[2] Gill i. 10. [3] Ellis I. 396.

chiefs included, go underground, the land of the dead being ruled over by Wakea, the counterpart of Vatea of Mangaia, for the upper part, and Milu for the lower part.[1] In the Marquesas Tiki and Hina Mataone, said to have been the ancestors of part of the population, are king and queen of the underworld, to which go the bulk of the people.[2] The land of the dead for the Maori is in the underworld, reached over the sea, the land whence the people originally came :[3] this underworld is presided over by Hina-nui-te-po, the ancestress of the race, and by Whiro. No connexion is now held with the sky-world ; only certain traditional heroes, such as Tawhaki, Kariki, Rongomaui and Hauki-waho are supposed ever to have visited this place.[4]

The Polynesian evidence shows that the ruling class was formerly composed of two divisions, connected with the sky and with the underworld, and that the disappearance of the Children of the Sun leaves the underworld people in possession. The bisection of the community in the archaic civilization in Polynesia is thus not complete, for part of the ruling element goes underground, as in Egypt. It seems certain that this " underground " ruling element was intimately connected with the sky element, for the two groups intermarried, as in Celebes and Samoa. Usually a sky man marries an underground woman ; but instances of the opposite form of marriage are sometimes recorded.

The rulers of the underworld are the Great Mother and her son, sometimes together, sometimes singly. The evidence so far adduced is hardly enough to make for certainty ; but it is possible to suggest explanations of the variations. The culture-heroes of the Posso-Todjo Toradja left no children to form a ruling class. The only deity mentioned in their underworld is I nDari, who took part in the creation of man from stone images. In Southern Melanesia, again, a ruling class, whose past existence seems certain, is absent, and the underworld is ruled over by a race ancestress, in one case accompanied by a vui, presumably one of the former ruling class. On the contrary, among the Egyptians, Sumerians, the Dravidians, and the Polynesians, the underworld is ruled over by a god in addition to a goddess, the goddess sometimes being relegated to the background, as in Egypt, India and Samoa. In all these cases the community has a ruling class. Thus the constitution of the underworld appears to reflect that of the earth. For, when no ruling class exists, no god presides over the underworld ; but kings on the earth have their counterparts in the life to come. The Great Mother forms the constant element, presumably as the ancestress of gods, rulers and commoners.

It is now necessary to see what light can be gained by the study of American peoples.

In Mexico the land of the dead for commoners was the under-

[1] Beckwith 299, n. 2. [2] Christian i. 190.
[3] Best xi. 137 ; v. 155, 229. [4] *Id.*, i. 184.

world, Mictlan, where the dead were sunk in deep sleep, as in Sumer. It was ruled over by one of the forms of the great mother goddess, and also by Mictlantecutli, the first man and the first mortal, like Osiris and Yama, who was connected with the moon, as were the rulers of the dead in other places. He was the king of Xibalba, the underworld city destroyed by the culture-heroes of the Kiche of Guatemala.[1]

In the Pueblo region the dead go to the underworld, where lives the Great Mother. The Hopi underworld, the place whence their ancestors emerged, is peopled by sentient beings who perform ceremonies similar to those of the people on the earth. The ruler of this underworld is the goddess of germs, who is said to resemble Mictlantecutli of the Mexican underworld.[2] According to the Hopi a man has a " breath body," which after death becomes a Katcina, a spirit that plays an important part in the ritual of Pueblo peoples. The Sun is the father of the Katcinas, and the " breath body " follows him westward on its way to the opening of the underworld.[3] The Katcinas are also said to have been the offspring of the earth-goddess.[4]

The " breath body " of the Hopi, therefore, instead of, as among the Toradja, going to the sky, goes underground. At the same time the Katcina, the ultimate form of the breath body, is the offspring of the sun and the earth mother, and follows the sun to the West before entering the underworld. Thus the breath body and Katcina show signs of relationship to the sky, as in other places, but ultimately both are related to the underworld. It is said, further, that the Katcinas, like men, came out of the underworld ;[5] so, in returning there, they are acting like the spiritual part of men in other places. The problem is thus that of explaining why the Katcinas did not come from the sky, being the offspring of the sun. That problem, however, is part of the wider problem of accounting for the entire absence among the Pueblo peoples of any sky-world, which will shortly be considered.

According to a Zuni priest, " It seems—so the words of the grand-fathers say—that in the underworld were many strange things and beings, even villages of men, long ago. But the people of those villages were unborn-made, more like the ghosts of the dead than ourselves, yet more like ourselves than are the ghosts of the dead, for as the dead are more finished of being than we are, they were less so, as smoke, being hazy, is less fine than mist, which is filmy ; or as green corn, though raw, is soft like cooked corn which is done (like the dead), and as both are softer than ripe corn which, though raw, is hardened by age."[6] Dead Zuni go to the underground Dance Village, and there join the council of the gods. As their ancestors came out of the earth, their mother, so they return there. Members of the Bow Priesthood, founded

[1] Bancroft III. 396, 534. [2] Fewkes iv. 259.
[3] Fewkes xv. 513, 524. [4] *Id.*, iv. 266.
[5] *Ibid.*, vii. 86. [6] Cushing iii. 400.

by the Twins when they had become war-gods, go to become lightning-makers, and thus differ from the rest of the community.[1] Among the Sia Indians, who were created by the Great Mother, the dead are believed to go to the underground whence men emerged. When the Sia came out of the underworld they were accompanied to the earth by Utset, their great mother, who then left them to return to her world beneath, where she awaits them after their death.[2]

The Pueblo Indians are wholly connected with the underworld. Their creation myths tell of wanderings, and it might be expected that the land of the dead would be thought to be in the direction whence they came ; but these people have not forgotten their real origin, and the ghost finds its way back into the underworld through the hole whence its ancestors emerged. The correspondence between place of origin and home of dead is thus complete.

The Pueblo Indians, though telling of the Children of the Sun in their creation stories, have no beliefs at all in a sky-world, nor have they any ruling class connected with the sky. The nearest to such a class that they possess is the Bow Priesthood of the Zuni, instituted by the twins, whose members become lightning-makers after death. The absence of a sky-descended class accounts for the lack of a sky-world, and for the concentration of the beliefs of the people on the underworld. The absence of a ruling class is also reflected in the fact that the Great Mother is apparently the only ruler of the underworld. But although the lack of beliefs in a sky-world may be accounted for by stating that none of the Pueblo Indians came thence, yet one serious difficulty still remains. How is it that, among the Toradja, the " life " goes to the sky, while, among the Pueblo tribes, it goes underground ? It is possible to suggest an explanation. The Toradja were created from stone images animated by breath, and made by the god of the sky-world and the goddess of the underworld. Stone images are also found in the lands of the mountain Toradja, which helps to supply an historical background for the story. But the creation of the Pueblo peoples takes place in the underworld, only the Twin Children of the Sun being produced by the intervention of sky-beings. In the case of the Toradja, the dual nature of creation is reflected in the dual destiny of the breath and ghost. But in the Pueblo instances the creation takes place in the underworld, and it is not connected with the animation of images. It therefore seems as if the absence of the idea of animation of stone images, so closely associated with the sky-world, accounts for the difference between the Pueblo and Toradja.

The creation story of the Pima tribe tells of Elder Brother creating from clay human beings, whom he destroyed for fighting

[1] Stevenson ii. 20–1. [2] *Id.*, i. 26 e.s., 39 e.s., 68.

among themselves, and mention is also made of the creation of men by Earth Doctor. The Pima are patrilineal, and they have a tradition of a former line of chiefs. This tradition of a ruling class, together with the creation story from images, suggests that possibly all the Pueblo tribes were formerly in like condition, and that the disappearance of the ruling class caused the ideas of creation to be centred round the Great Mother.

The Navaho, who are derived from the same source as the Pueblo peoples, began in the underworld, and ghost and breath go there after death to be ruled over by the Woman Chieftainess, the goddess of witches.[1] The solitary presence of the mother goddess in the underworld is in keeping with the democratic nature of the Navaho. But one feature of their origin story merits careful attention. On their way out on to the earth the Navaho had to pass through several successive worlds. When they got to the fourth world, the earth and sky joined together for a moment, and out of the union came Coyote and Badger : " We think that Coyote and Badger are children of the sky," a statement which suggests the former existence among them of a sky-descended ruling class. This is supported by the Navaho statement that the chief of all the people in the fourth world, except the Pueblo people.[2] This first man led them out of this underworld. It therefore seems as if the Navaho once had a ruling class which they have lost. This may be so, for their tribal organization is evidently in a state of disintegration. When this ruling family disappeared, the people went to their ancestress in the lowest world.

In the Mound area the underworld is not so prominent as in the Pueblo region. The Yuchi, who call themselves Children of the Sun, and claim descent from a woman from the sky, believe that both ghost and life return to the sky ; no mention is made of an origin from the underworld, and that place, so far as I know, does not exist in their beliefs. They thus form a direct antithesis to the Pueblo peoples. Their beliefs form, nevertheless, a perfectly consistent whole, for the place of origin and the land of the dead are identical. Unfortunately but little is known of the beliefs for the rest of the eastern States.[3]

The Huron, who claim descent from a woman, who came from the sky, and gave birth to twins who were their culture-heroes, believe that ghosts go to the underworld, there to be ruled over by this race-mother and one of her sons. This case differs from that of the Yuchi, in that the Huron do not claim to be Children of the Sun, but simply look upon the twins as their culture-heroes. That one of the twins should be their ruler in the underworld suggests that they were once ruled over by a class of sky-descended people which has disappeared. This suggestion is

[1] W. Matthews iii. 164. [2] *Ibid.*, 71.

[3] The Choctaw were created, in the underworld, out of clay, by the good spirit above, Aba, near the headwaters of the Pearl River (Bushnell 527, 530).

borne out by the fact that the Huron themselves speak of the
council-meeting when they constituted their tribes, and selected
their clans and phratries; which seems to show that they had
become disorganized for some reason or other, and had to recon-
stitute the tribe as well as possible. The Huron retain traces of a
contact with the sky-world, for ghosts go to the land of the dead,
which is underground in the west, by way of the Milky Way.
The good twin, who animated them and gave them their culture,
lives in the eastern sky.[1]

 The Plains Indians nearest in culture to the archaic civiliza-
tion have the most coherent ideas about creation and the destiny
of the ghost. For example, the Mandan tribe of the Sioux, who
have retained agriculture and other cultural elements that the
Plains Indians have tended to lose, believe in a " Lord of Life "
in the sun, and in an " Old Woman who never dies," the Mother
of the Sun, who lives in the south.[2] The race originated from the
underground, where the old woman lives, and ghosts go there at
death.[3] Corresponding to the belief that the sun-god is the Lord
of Life, is the belief, already quoted, that when a child is born a
star descends on earth and appears in human form. When a
man dies, it goes back to the sky and reappears as a star.[4] The
Hidatsa, who resemble the Mandan in their nearness to the archaic
civilization, have ideas which are not so definite. They believe
that their ancestors were created by the " First in Existence."
They also believe in a grandmother, who is connected with their
agriculture, as is the "Old Woman who never dies " among the
Mandan. At death the dead go underground, but it is not said
whether they go to the grandmother. It is also said that a man
has four souls, but not much is reported about them. Apparently,
among the Mandan, the organization of beliefs is becoming dis-
located, so that they have no logical interrelationship.

 This process has advanced much farther among other tribes of
the Plains. The Omaha, who have lost so much of their culture,
inter their dead in a sitting position under a mound. They believe
that they have only one soul, and that the ghost goes at death to
the land of the dead by means of the Milky Way.[5] The Dakota
do not have a land of the dead in the sky, but some of the stars
are believed to be men transported to the sky.[6] Although they
are said not to have a land of the dead in the sky, yet it is said
than an old woman sits on the road leading to the land of the
dead and examines the ghosts as they pass for tattoo marks.
Those without them are pushed from a cloud or a cliff and
fall into this world,[7] which suggests the former existence among
them of ideas connected with the sky-world as a home of the
dead.

[1] Barbeau ii. 8. [2] J. O. Dorsey ii. 507.
[3] Id., 512 : Matthews v. 739. [4] Id., 508.
[5] Id., 583–92. [6] Id., 493.
[7] J. O. Dorsey i. 145.

This ends a long discussion centred round the Great Mother. She was apparently the first deity that man knew, and in the course of time she came to acquire many characteristics that finally in all parts of the world developed into independent goddesses. Some of her characteristics were those of a goddess of fertility, of agriculture and of grains, and throughout the archaic civilization she was closely associated with human sacrifice. This great mother was in time supplanted in many of her functions by a god, who, at first, was her son. He became associated with human sacrifice, and so did his earthly representatives, the divine kings of the archaic civilization. But when he changed into a war-god, human sacrifice tended to die out, and was reserved mainly for funerals of chiefs.

The next stage in the argument was to show that the archaic civilization was matrilineal in its institutions, and that mother-right was intimately bound up with the idea of a race-ancestress, who was seemingly identical with the Great Mother. Corresponding to the idea of a great mother of the race is the idea that the dead return to her. In this chapter it has been found that, while the sky-descended part of the community goes to the sky after death, the rest of the community goes underground, or else to a land of the dead situated in some other place on the earth, according as to whether a migration has taken place or not. These beliefs are clearly shown in the case of the Pueblo Indians, where the ideas of creation and death are centred round the underworld and the great mother. These conceptions regarding the Great Mother are accompanied, in the archaic civilization, by the notion of the " life " of each person belonging to the sky-world, which causes a duality in the ideas concerning the spiritual nature of men, one part being connected with the sky, and the other with the underworld. In the case of the " life," it would seem that the Great Mother has little or nothing to do with the matter ; the breath usually goes to a god in the sky, not to a goddess. The ghost goes back to the mother of all, and the life goes back to its giver.

In Egypt of the Fifth Dynasty and onwards the kings went to the sky, while the rest of the community went to the underworld. All over the region, sky-descended rulers go to the sky after death, while commoners and other members of the ruling group usually go to the underworld. The association with the underworld exists among people who apparently once had sacred rulers. In no case does a sky-descended portion of the community go underground at death ; and in no case do people that originated in the underworld go to the sky. The evidence suggests that the beliefs connected with the Great Mother and the underworld are earlier than those associated with the sky. This is so in Sumer. In Egypt, where it is not so definite, it is best to assume that the solar ideas developed out of those associated with gods such as Osiris and the Great Mother. Otherwise it is hard to see how a god such as Re, who could produce life of himself, should be born

anew each day of the mother goddess; also why the mother goddess should help Khnum by giving to the embryo the life that it needed. Although it is possible that, in Egypt and Sumer, the underworld preceded the sky-world, and the rulers of the underworld those of the sky-world, no signs are present in other parts of the region of such a sequence. The evidence from Polynesia suggests strongly that, in the archaic civilization, both groups of rulers existed together in the same communities, and that these connected with the underworld survived the Children of the Sun. This makes it possible that, in India and Mexico, a process of stripping had taken place in the past, the Children of the Sun having disappeared and left the underworld rulers.

The bisection of the community that takes place at death is important. It happens in communities where the ruling class consists of the Children of the Sun, or of peoples descended from sky-beings. In such communities the sky-born go back to the sky, and the others, rulers and commoners alike, go elsewhere, usually underground. The sky-world is bound up with the sky-born class, and disappears with it. The underworld was probably an earlier land of the dead than the sky for the peoples of the Ancient East; and since the commoners never go to the sky, it follows that the condition of things when both rulers and commoners go underground together is the more natural. The bisection of a community, such as takes place where the Children of the Sun rule, is artificial. The two groups live together on earth, but after death the rulers go elsewhere, and some one else rules over their dead subjects. This suggests that these rulers of the dead were originally ruling groups on earth who were supplanted by the sky-born group, and that when the sky-born people disappeared the others entered again into their own.

It is possible to go one step farther. In some cases the mother goddess is alone in the underworld. In such instances, as among the Toradja and the Peublo peoples, no ruling class exists on earth. Are these conditions therefore representative of the stage before the arrival of rulers? It certainly is plausible to argue that the Great Mother, having survived the shocks of fortune, was therefore the first deity, and that she represents the condition of affairs before the rise of kings.

CHAPTER XVIII

THE DUAL ORGANIZATION—EGYPT AND INDIA

THE study of various peoples of the great region under examination has shown with increasing clearness that the religious, economic, political and social sides of the life of a community are closely interrelated. This interrelation becomes closer the farther it is possible to penetrate into the maze of facts ; and it is difficult to surmise where it would ultimately break down. In this chapter, and those that follow, an attempt will be made to penetrate farther into the jungle, and to elucidate more definitely the nature of the archaic civilization that looms so largely behind the civilization of later times. The problem began to shape itself when the study of the Children of the Sun was undertaken. It was seen that the archaic civilization possessed a ruling class of Children of the Sun, divine beings connected with the sky-world, and born of theogamies. It was noted, too, that these Children of the Sun were often represented as twins, hostile to one another ; and that sometimes one twin was connected with the sky and the other with the underworld, even when the mother came from the sky. The Children of the Sun disappeared, and in their place ruled chiefs associated with the underworld, and often of a warlike nature. Also the sun-god gave place to a war-god born of a theogamy, who thus had some relationship to the archaic civilization. The chiefs of this later stage of civilization are not born of theogamies. Nevertheless, it was evident that the two branches of the ruling class, the Children of the Sun, who belonged to the sky, and the war chiefs, who belonged to the underworld, were in some way related, for they intermarried. Thus the ruling class of the archaic civilization was dual in nature, one part belonging to the sky and the other to the underworld. A parallel, therefore, exists between the ruling class and the Twin Children of the Sun. A further duality has been observed in that men in the archaic civilization who do not belong to the sky-born class usually go at death to the underworld, while their life goes to the sky.

It is obvious that such dualism of culture will have to be explained, for the facts are remarkable and unexpected. Why should the thought of the archaic civilization be permeated, through and through, with the ideas of duality, such as have been revealed in the past chapters ? It is difficult, if not impossible,

to frame any a priori reason for the division of the ruling class, such as is patent in Polynesia and elsewhere. Before any explanation of these facts is sought, it is necessary to inquire whether any other dualisms are noticeable in the archaic civilization, so as to determine still further the relationships between the various aspects of its life.

The constitution of Egypt in dynastic times was thoroughly dual. The country was originally divided into two distinct parts, Upper Egypt in the south, and Lower Egypt in the north, that is, the Delta of the Nile. At the beginning of the First Dynasty the country was united under one throne, and ever since it remained united ; but it was never forgotten that the king was the ruler of a dual country.[1] He was always called the king of Upper and Lower Egypt ; his crown was double, his coronation ceremony was double ; even his palace was double. In an inscription on the Palermo Stone, which has revealed such important evidence for the early chronology of Egypt, it is said " Exalted is the White-Crown-of-Snefru-upon-the-Southern-Gate." " Exalted-is-the-Red-Crown-of-Snefru-upon-the-Northern - Gate." Prof. Breasted comments : " These are the names of the two gates or parts of the palace of Snefru : one for the south and one for the north. We have thus the double name of a double palace which, like the organs of government, was double, to correspond with the old kingdoms of south and north. . . . The state temples also were double ; each had a double façade, and the hypostyle was divided into north and south by the central aisle." [2] Kings are usually called " The King of Upper and Lower Egypt. . . . Favourite of the Two Goddesses." Then again there are inscriptions on the Palermo Stone of the type :

KING NEFERIRKERE.

Horus . . . King of Upper and Lower Egypt ; Favourite of the Two
Goddesses (Upper and Lower Egypt respectively).
Year I.
Second month, seventh day.
Birth of the Gods
Union of the Two Lands
Circuit of the Wall,[3]

which reveal the persistence of the idea of duality of the kingship. As king of Upper and Lower Egypt the king personated Set, the god of Upper Egypt, and Horus, the god of Lower Egypt.[4] He sometimes had a double name. For example, Khasekhmoui of the Third Dynasty was called Horus-Set, as is shown by numerous

[1] Blackman ii. 244, n. 2. It is thought by some scholars that the country had formerly been united under one king, because in the late pre-Dynastic times the kings of Upper and Lower Egypt bore the same name of Horus. But this is doubtful. Even were it true, it would not affect the present argument.

[2] Breasted ii. I. 66. [3] *Id.*, 70. [4] Blackman ii. 244.

cylinders found at Abydos and Hieraconpolis.[1] He is called " Khasekhmoui, the Wielder of the Two Sceptres," " Khasekhmoui in whom are united the two Divinities." [2] Archaic inscriptions, dating from the times prior to the Fifth Dynasty, refer to " daily purifications of the king of south and north, Double Lord Noutirni." [3] The king even sometimes had two tombs, one in either land.[4] His treasury was double. Apparently the office of high-priest was sometimes dual : for the high-priesthoods of Memphis and Heliopolis, the incumbents of which were called " Great Chief of Artificers," and " Great of Seeing," respectively, were usually two in number, and were, of course, held by men of high rank.[5]

A marked feature of the mythology of Egypt was the enmity between Set and Horus, which, apparently, had not always existed, for in some passages of the Pyramid Texts Set helped Horus in the offices for the dead. Certain events in the dim past, presumably connected with the dispossession of Set, caused a hostility to grow up between them, and this hostility continued throughout the whole of Egyptian history. A hostility also existed between the communities of Upper and Lower Egypt.[6] The two parts of the realm were distinguished from one another by different colours ; white being the colour of Upper Egypt and red the colour of Lower Egypt.[7]

Another remarkable feature of the constitution of Egypt in the Fifth and succeeding Dynasties must be mentioned. In the days before the accession to power of the Children of the Sun, the heir to the throne acted as vizier, and carried on, for his father, the administration of the State. When the Heliopolitans came into power, at the beginning of the Fifth Dynasty, the king was high-priest of the sun-cult, but his son did not act as vizier. This office was now held by a family presumably belonging to Memphis.[8] The ruling power was thus split into two parts, sacred and secular, and this distinction held through the Pyramid Age. More will be said on this matter in the chapter on Egypt. The constitution of Egypt was thus a *Dual Organization* of Society in the widest sense of the term, the social, political, economic and religious organizations all manifesting a like condition.[9]

Egypt is the only country of the region where conditions remained approximately unchanged until the end. So, if other communities possessed the dual organization, it will probably have fallen into ruin as the result of the coming of the more war-like communities. The existence of the dual organization through-

[1] Weill 97.
[2] *Id.*, 98.
[3] *Id.*, 150. Cf. also 152, 155.
[4] Meyer iii. I. 2, § 247.
[5] Breasted v. 64.
[6] See p. 430.
[7] See p. 272.
[8] Breasted v. 126. In the Sixth Dynasty the family of the vizier belonged to Abydos (see Chapter XXVI).
[9] In Chapter XXVI certain aspects of the dual organization of Egypt are studied in detail.

18

out the region in the archaic civilization has first of all to be established, and this will have to be done by means of fragments. In this and the next two chapters will be collected all the scraps of information on this topic that I have been able to find ; and in Chapter XX the material will be examined, and ample reason will be forthcoming for believing that the archaic civilization was based on a dual organization similar to that of ancient Egypt.

The study of early forms of human society is peculiarly difficult in India. The great spread of Brahmanism during the past centuries has obscured many features of the old civilization and produced great cultural transformations. The general adoption of the caste-system, for example, under Brahmanic auspices, has caused the obliteration of many old landmarks ; whole communities of the Dravidian area have been thereby absorbed, so that their social organizations has often been transformed. Consequently the task of finding traces of the dual organization of society in India will not be easy. This is to be expected, for other discussions have shown that it is further east, in Australia, Polynesia and America, that the clearest traces of the archaic civilization exist, and not in India and Indonesia. So, if in India the inquiry only serves to bring to light evidence that may possibly be interpreted as vestigial remains of a former dual organization of society, judgment must be deferred until the whole survey is completed. For it will then be evident that these scattered facts are really the remains of a former coherently organized system of society.

If the dual organization belonged to the archaic civilization, it must be sought in India among the Dravidian and Munda groups, and not in the more northerly peoples of the Panjab and elsewhere, who have become thoroughly Hinduized. The sacred writings contain possible traces of a dual grouping among the matrilineal ruling groups that are included under the term Dravidian. In the Mahabharata it says : " There were, in former days, celebrated throughout the three worlds, two brothers named Sunda and Upusunda living together and incapable of being slain by anybody unless each slew the other. They ruled the same kingdom, lived in the same house, slept on the same bed, sat on the same seat, and ate off the same dish. . . . Both of them were mighty Asuras endowed with great energy and terrible powers. The brothers were both fierce and possessed wicked hearts. . . . Of exactly the same dispositions and habits, they seemed to be one individual divided into two parts." [1] They could go everywhere at will. They went to the sky to the region of the celestials, and, after conquering various divine beings, they set out to conquer the earth. Sunda and Upusunda were descendants of Hiranyakasipu, the son of Diti, the great mother of the Daityas and sister of Aditi. They thus belonged to the ruling group of the Asuras, the enemies of the Aryans. Other twins

[1] "Mahabharata," Rajyalabha Parva ccx. i.

occur in this family of daughters of Daksha. In the first place Hiranyakasipu has a brother Hiranyaksha, who seems to be his twin.[1] In another case, Vinata, a sister of Diti, has by Kasyapa, the sun, twins called Garuda and Arjuna. Kasyapa said to Vinata concerning them :—"Two heroic sons shall be born to thee, who shall be lords of the three worlds. . . . These two shall be lords of all winged creatures. These heroic rangers of the skies will be respected of all worlds, and capable of assuming any form at will." [2] Garuda, the ruler of the birds, was the son of Vinata, whose sister Karma, was the mother of the Nagas or serpents, the father of both sons being the sun. Although of the same parentage, and although allied to one another, a hostility existed between Garuda and the Nagas. Garuda was associated with the sky and the Nagas with the underworld, where they lived in splendid palaces.[3] This brings to light further evidence that the rulers of the Dravidians were divided into two groups, one connected with the sky and the other with the underworld, both related but yet hostile. This corresponds to the division of Egyptian society into sections connected with the sky and the underworld, combined with the hostility between the two gods Horus and Set, connected respectively with birds and snakes and water animals.

In the Jataka Tales, the stories of the Buddha's former births, mention is made of pairs of brothers similar to Sunda and Upusunda. The Ghata-Jataka mentions Kamsa and Upakamsa, sons of Mahakamsa, who reigned in Uttarapatha in the Kamsa district, in the city of Asitanjana. When Mahakamsa died, Kamsa became king, with Upakamsa for his viceroy. Mention is made also of a king Mahasagara, who ruled at the same time in Upper Madhura. He had two sons, Sagara and Upasagara, of whom Sagara succeeded to the throne, with Upasagara as his viceroy.[4] The Mahabharata contains many examples of pairs of brothers. For instance, in the list of the sons of Dhritarashtra, the king of the elder brother of Pandu, occur Dussaha and Dusçhala, Vinda and Anuvinda, Durmarshana and Durmukha, Dushkarna and Karna, Chitra and Upachitra, Durmada and Dushpradharsha, Urnanabha and Padmanabha, Nanda and Upanandaka, Senapati and Sushena, Kundodara and Hahodara, Chitravahu and Chitravarman, Dridhahasta and Suhasta, Vatavega and Suvarchasa.[5] These pairs are mentioned together in a long list of brothers. In view of the cases of Sunda and Upasunda, Kamsa and Upakamsa, Sagara and Upasagara, the definite association between two brothers of like name, which constitute the great majority of the linked pairs in the list, suggests some peculiarity

[1] "Mahabharata," Adi Parva lxv. : Wilkins ii. 124, 130.
[2] Id., Adi Parva XXXI., XVI.
[3] Id., Adi Parva XXII., lxv., lxvi.
[4] Jataka IV. 50, No. 454.
[5] "Mahabharata," Adi Parva, Sambhava Parva lxvii.

in the political constitution of the past in India in which two
" brothers," whether of the same mother or not it is not possible
at present to tell, share the rule. The possibility of different
mothers must be borne in mind, for the instance of Garuda and
the Nagas is one in which two sisters have children by the same
father, and these " brothers " are associated in that they are
mentioned together and are said to be hostile. Before long
further instances of a similar nature will be forthcoming, and it
will be seen that such instances of linked brothers as have been
adduced are not the product of imagination. In the case of the
Garuda-Naga relationship, it will be remembered that, in Poly-
nesia, it was found that the ruling groups were really dual in
nature in the earliest settlements. They consisted of the Children
of the Sun connected with the sky, and another group connected
with the underworld, where usually lived the great mother of
the community. These two groups intermarried, the sky-men
marrying underworld women. When the Children of the Sun
disappeared in Polynesia, only the underworld people were left.
The evidence from India suggests that both groups were originally
Children of the Sun, and that the Naga branch was associated
with the underworld. It would therefore seem that the ruling
group consisted of two branches, one connected with birds, and
the other with snakes, or their equivalents, such as dragons,
crocodiles and so forth.

It has already been seen that the ancestors of several ruling
houses of Dravidian tribes were Nagas. The evidence just
adduced suggests that the Nagas and Garudas formed part of a
dual organization of society, an hostility existing between them,
as between the different parts of Egypt. Moreover, it can be
shown that the women of the Naga race gave birth to twins, the
sun usually being their father. The foundation of the kingdom
of Pegu in Burma is due to immigrants from Dravidian India who
were of Naga race.[1] Tha-htun was the first colony, forty-four
miles north-west of Martaban, in a country called Suvarnabhumi
—" golden land," and old gold-workings have been found 120
miles from Tha-htun on the Paunglaung or Sit-taung River,
where gold still exists : " The name Tha-htun is derived from
vernacular words having the same signification." [2] Evidently
the gold attracted the colonists, who are said to have come from
Thubinga, in the country of Karanaka or Karanatta. The story
goes that a king Titha, who ruled over Thubinna or Thubinga in
Karanaka, had two sons, Titha Kumma and Dzaya Kumma,
who became hermits and settled near Tha-htun. One day they
found on the shore two dragon's eggs, from which emerged two
boys. One of these boys died when ten years old, and was reborn
in Mittila to be a disciple of Buddha ; the other boy grew up,
built Tha-htun with the help of Thakya (Sakra, the chief of the
second heavenly region, and corresponding to Indra), and reigned

[1] Phayre 32.　　　　　　　　　　[2] Id., 24–6.

there as Thiha Radza. A certain Adinna Radza, one of his descendants, ruled over Tha-htun, having dispossessed two half-brothers, Thamala and Wimala, born of a different mother, a woman of Naga race, who laid two eggs, out of which they came. The dispossessed twins went away with one hundred and seventy families, and founded Pegu in A.D. 573, the elder brother, Thamala, being chosen king.[1]

This tradition shows that women of the Naga race were supposed to give birth to twins, bearing similar names, as in the case of Sunda and Upusunda. It is important to note that, in this tale, the two brothers set out with their followers, and thus evidently the whole structure of the old society was transplanted to the new home.

The Gonds claim that their ruling class was descended from a Naga king of Ceylon, and they certainly originated in South India. They have two aristocratic subdivisions, Raj-Gonds and Khatolas, but it is not possible to say anything as to the significance of these divisions.[2] The Gonds of Bastar have two divisions, Maria and Muria, and in one part of Bastar the Maria group is divided into two exogamous groups. Therefore the Gonds appear to have the dual organization in some of its elements. It is said also that there is a " probability that the Gonds and Khonds were originally one tribe in the south of India, and that they obtained separate names and languages since they left their original home for the north." [3] Possibly these two tribes originated, so far at least as their ruling classes are concerned, from people of the Naga group, and then split up into distinct divisions. The Khonds are divided into Kutia Khond, hill Khond, and plains Khond, but whether this division has any significance and is anything but territorial, I am unable to say.[4]

Similar evidence, suggestive of the break-up of a former dual grouping of society, is found in the case of the Mundas, who are ruled over by a Naga race of chiefs, whence Nagpur gets its name. The Mundas and the Khangars are descended from two brothers, but are now separate tribes.[5] This may correspond to the Gond-Khond split. The Bhars, who formerly ruled in Bihar, were divided into Rajbhars, a superior caste, and Bhars. Similarly the Bhil were divided into White Bhil and Black Bhil.[6]

All this is not of much value in itself, but, in conjunction with the examples previously adduced, it suggests that the Dravidian peoples formerly possessed a dual organization that is now in ruins. Farther south the Nairs of Malabar afford more precise evidence. They live in the heart of the Dravidian country, and

[1] Phayre 25–32. [2] Russell III. 63. [3] *Id.*, 44.
[4] *Id.*, III. 465. [5] Roy i. 400–1.
[6] Sherring 367. The Korwa and Korku show signs of a former dual organization (Russell 554–574). The Yeravas, an important tribe of Coorg, are divided into two divisions, Panjiris and Paniyas (" Imperial Gazetteer," XI. : Coorg 28).

possibly belong to the Naga race. They are organized in clans of two groups, localized in North and South Malabar respectively.[1] The clans of North Malabar are the superior, and the highest clan of South Malabar is supposed to correspond to the North Malabar clans. " The Nayars of North Malabar are held to be superior all along the line, clan for clan, to those of South Malabar, which is divided from the north by the River Korapuzha, seven miles north of Calicut ; so that a woman of North Malabar would not unite herself to a man of her own clan name of South Malabar." Some clans are divided into two groups ; the Vattakad clan of South Malabar, for example, is composed of the Veluttatu or White division, which is the superior ; and the Karuttatu or Black division. In another place this clan has two divisions with different names ; in North Malabar the Akattu Charna clan is in two divisions. In addition, each lord in North Malabar formerly had two groups of adherents, Purattu Charna, outside adherents or fighters, and Akattu Charna, inside adherents or clerks and so forth, the first group being the superior.[2] The dual organization of the Nair was evidently of a thorough-going nature. The country itself had two broad territorial divisions, as in Egypt. Each local group was dual, with definite marriage regulations, one group being the superior.

Signs of a dual grouping of society exist elsewhere in South India. Among the Todas, for example, " the fundamental feature of the social organization is the division of the community into two perfectly distinct groups, the Tartharol and the Teivaliol."[3] Each of these groups is composed of clans, local exogamous groups. Normally each clan is in two groups called Kudr, which are of ceremonial importance, but the real significance of this form of grouping is now lost. So the dual grouping runs through the whole of their society, and is similar to that of the Nair and other peoples. It is important to note that the Todas ascribe their dual organization to Teikirzi, their great mother goddess.[4]

Traces are recorded among other South Indian peoples, such as the Urali, Sholaga and Irula,[5] of what may originally have been a dual organization of society, but the evidence, so far as I know, is scanty.

Some tribes of Assam show traces of it. According to Lt.-Col. Shakespear, the Ao and Sema Nagas are divided into two large clans, Chungli and Mongsin for the Ao, Yepatomi and Zijhumoni for the Sema. According to another authority the Sema Naga have a culture that is evidently in an advanced stage of degradation. They have father-right and signs of a former totemic system. They probably were once organized on the dual system, for some villages have two divisions with distinct chiefs, and in one case mention is made of " an ancient and abiding feud " between

[1] Mateer 388 : Fawcett ii. 187–8.
[2] Fawcett ii. 188, 189, 203, 218. [3] Rivers 34.
[4] Rivers 186. [5] MGMB IV. 1901.

them.[1] The dual grouping of clans may possibly be connected with two brothers with similar names—Chesha and Chishi ; [2] but the old social organizations has been so broken up that its original nature can only be surmised.

The Mao Naga, who show special associations with the archaic civilization in that they are connected with a stone circle and other megalithic monuments, are divided into two groups : in the Mao village of Liyai (Yemi) live four clans divided into two exogamous groups ; the Mao village of Maram has two hereditary priests Khullakpa, instead of the customary one, which corresponds to the two exogamous groups.[3] Other Naga tribes have a dual grouping. The Marring are divided into Saibu, the older group, consisting of seven clans ; and Marring or younger, also consisting of seven clans. Likewise the Kabui Naga are divided into Songboo and Poeran.[4] The Chirus have a similar organization. The Tangkhul Naga possess two divisions, Luhupas in the north and Tangkhuls in the south.[5] It might be thought that the north and south groupings were accidental and due to local circumstances, but the evidence forthcoming from all parts of the region will show that such an explanation is untenable. The Angami, Ao and Konyak Naga also have dual groupings.[6]

The Naga are not the only Assamese peoples with traces of the dual organization. The Ahom, of Tai-Shan origin, say that their kingdom was founded by Khunlung, Prince-elder, and Khunlai, Prince-younger, who came from the sky.[7] The Minyong branch of the Abor of Upper Assam are divided into two groups, claiming descent from two brothers who were Children of the Sun : the Dobang branch also have the dual organization.[8]

It is noteworthy that the Khasi, who speak an Austronesian tongue, possess no apparent signs of the dual organization. It is possible that they have lost it, or else the traces that remain have not yet been recorded.

The evidence suggests a former dual organization of society throughout the non-Aryan population of India. The claim that the peoples of India were grouped in two divisions was made by Oppert in his work on "The Original Inhabitants of India." He asserts that the Gaudo-Dravidians, as he prefers to call them, were formerly divided into two hostile groups, and that the great war of the Mahabharata was the outcome of this hereditary division into hostile camps. His theory is that some of the Dravidian tribes became intimately associated with the Aryans : "I contend that the Bharatas mentioned in the Rigveda, principally as the followers of Visvamitra, were warriors of non-Aryan origin, who, disconnecting themselves early from their aboriginal kindred and gaining access into the Aryan pale, became by their

[1] Hutton i. 121, 125. [2] *Id.*, i. 126. [3] Hodson 73 e.s., **83.**
[4] *Id.*, 75. [5] *Id.*, 84.
[6] Hutton ii. 110, 111, 113, 372, 385.
[7] Gait 71. [8] Dunbar 9, 84, 85.

superior prowess and influence the representative tribe of the Aryan race, as their relatives beyond the pale were the representatives of the aboriginal inhabitants. They were divided into two great branches, the Kurus and Pancala-Pandavas, round which were grouped the other clans. In a similar manner two great tribes, the Gaudians and Dravidians, formed the chief component parts of the non-Aryanized Bharatas, who, split up in numberless subdivisions, were spread over the whole length and breadth of India, and even beyond it, if we include the Uttarakurus and Bahlikas with their immediate kindred who lived in the Himalayan mountain range." [1]

Another suggestive piece of general evidence is supplied in the case of the division of the population in South India into right-hand and left-hand castes. The agricultural castes are on the one side, while the mechanical and commercial interests of the country are on the other. [2] " This movement seems to have been originally confined to Southern India, its centre being at Kancipuram, [3] the seat of so many religious and political dissensions, where there are to this day special halls for both parties, called Valankai-mantapams and Itankai-mantapams. . . . At the time of the Bhagavat Ramanujacarya this division into right-hand and left-hand castes was already an acknowledged institution, as different hours were assigned to right- and left-hand people for entering the Gelvapillai temple at Melkota, which place is also called Patita-pavanaksetra, i.e. the field where even outcastes can be purified." [4] This mode of grouping of castes is described in Mysore. " The agricultural, artizan, and trading communities form a species of guilds called phana (apparently a very ancient institution), and these are divided into two factions, termed Balagai (right hand) and Yedagai (left hand). The former contains eighteen phana, headed by the Bana jiga and Wokkaligo, with the Holeya at the bottom ; while the latter contains nine phana, with the Panchala and Nagarta (traders) at the head, and the Madiga at the bottom. Brahmins, Kshattriyas, and most of the Sudras are considered to be neutral. Each party insists on the exclusive right to certain privileges on all public festivals and ceremonies, which are jealously guarded. A breach on either side leads to faction fights, which formerly were of a furious and sometimes sanguinary character." [5]

The right- and left-hand caste system suggests the grouping of the followers of North Malabar chiefs. The correspondence is exact, for in both cases the distinction lies between the agricultural, land-owning and military elements on the one hand, and the industrial and commercial elements on the other. Thus the right- and left-hand castes may simply be the relics of former kingdoms, whose ruling classes have disappeared.

[1] Oppert 621–2.
[2] Id., 57 e.s., 61 e.s.
[3] The old Pallava capital (Rea 1).
[4] Oppert 61–2.
[5] " Imperial Gazetteer," XVIII. : Mysore 199.

More light is thrown on the early organization of South Indian Society by Rivers in his paper on Cross-cousin Marriages. Cross-cousin marriages are those in which the children of brother and sister are allowed to marry, but not those of two brothers or two sisters. This form of marriage probably is derived from the dual organization of society as defined in its sociological aspect. Rivers defines the dual organization as follows : " In the dual organization the whole population consists of two exogamous groups which I call moieties, a man of one moiety having to marry a woman of the other. Further, in every case where this form of social organization is known to exist, descent is in the female line, so that a man belongs to the moiety of his mother." [1] A remarkable result accrues from this form of social organization. Given that the community is so divided with the rule of exogamy, the children of two brothers or two sisters will belong to the same moiety, and therefore will not be able to marry. But the children of a brother and sister will be of opposite moieties, and thus will be eligible for marriage. This is what is called the " Cross-cousin " marriage. It seems to be found only in cases where the dual organization exists or has existed in the past ; but on this point there cannot be entire certainty.[2] Rivers, however, has found that " The kinship system of Southern India . . . provided abundant confirmation of the general prevalence of the cousin-marriage, and leaves no doubt that this form of marriage must at one time have been universal in that part of India." He goes on to say, " I have been able to find but little similar evidence for Central or Northern India," from which he concludes that the cousin-marriage is a Dravidian institution.[3] Further, in the dual organization it is obvious that the father of a child under the matrilineal form of descent is of the opposite moiety, and that his mother's brother will be of his own moiety. Thus it is found in such cases that the mother's brother is nearer to the child than his father. Rivers says : " A careful examination of the evidence would seem to show that the relation between uncle and nephew at marriage is especially a feature of Dravidian society." In this way he links up the Dravidian society of India with that of Australia. " It is a familiar view that the Dravidian population of India is related to that of Australia, and recent research is tending to link together not only those two peoples but also the ruder tribes of the interposed region of Malaysia, such as the Sakais. The evidence that I have brought forward in this paper adds another similarity to those which are already known to exist between these different peoples." [4]

The existence of an underlying cultural basis for the peoples of

[1] Rivers ix. I. 17. [2] Rivers ii. 319–20.
[3] Rivers iii. 621 : Saldanha (3–4) records the cross-cousin marriage in Bijapur, Dharwar and Kanara ; and marriage between a girl and her maternal uncle's son in Konkan, Deccan and Gujarat : in Kanara marriage is practised between a man and his sister's daughter. [4] *Id.*, 618–20.

India, Burma, the Malay Peninsula, Indonesia, and Australia has already been discussed, and it has been claimed that the people of the archaic civilization supplied it. The statements of Rivers add further support for this conclusion, and tend to show that the earliest communities of this vast region based their social organization on the dual system. That this probably was so, will become clearer as the general argument proceeds.

The definition of the Dual Organization as given by Rivers differs from that adopted in this book. The definition of Rivers is perfectly satisfactory when dealing with the dual organization of Melanesia ; but, as will be seen in the course of the discussion, it is somewhat limited. While convinced of the justice of the point of view of Rivers, I regard the duality of which he treats as the social aspect of a much wider organization which runs through the social, political and economic organizations of a people. In the political sphere there is the duality of the kingship, and also the division of the administrative power between two families, allied, yet distinct. In the economic sphere, the country is dual. The population in many places is divided into two distinct parts, living in different divisions of the territory, and maintaining that hostility characteristic of the two lands of Egypt. The sphere of mythology comprises the dualism of the Twin Children of the Sun, with their distinctive characters and hostility. As fresh facts are brought to light, this dualism will be seen to run through every department of life, and not merely to be a marriage regulation. I shall therefore use the term in that wider sense, without in any way wishing to violate its original meaning.

If the evidence for the former existence of the dual organization in India be summed up, it is possible to reconstruct an organization similar to that of Egypt. The kingship, as shown by the extracts from the Mahabharata and the Puranas, was dual in its early stages : the country was in two parts, one of which was superior to the other, each local group of the larger unit was divided into moieties, and the followers of any ruler were in two groups. The idea of twin kings is also present in literature, these kings being hostile to one another. It is true that these details are not typical of any one community, but the cultural similarities already found to exist between the various tribes of the Dravidian group make it possible to claim that they probably describe roughly the original state of Dravidian society.

The case can be put still more clearly. As has been stated, many of the ruling families of Dravidian India were connected with the cult of the Naga : they were the Naga people, and, in dealing with Dravidian India, it is impossible to ignore the importance of this great race. Naga families have ruled in many parts of the country, notably Chota Nagpur, South India, Assam, and Burma, and from them several peoples claim descent, among them the Nagas of Assam, the rulers of Pegu in Burma, the Gonds, Khonds, the rulers of Nagpur and several ruling houses in South

India such as the Nayars or Nairs. When therefore it is remembered that a group of peoples with traces of a dual organization in their culture, all claim an ultimate relationship with a single group of rulers, it is probable that their dual characteristics are but the remains of the original form of society. From beginning to end the Nagas are connected with the dual grouping; the Naga dragon women give birth to twins, hostile to one another; peoples claiming descent from them are divided into two parts; one superior to the other; and the whole society shows a thoroughgoing duality. It is therefore possible to claim that one element at least of the ruling family of ancient India possessed the dual organization, and that this mode of grouping has in places survived the great spread of Brahminic influence.

The analysis of ancient India society can go still farther, and deal with the quarrel between the Aryans and Asuras, the origins of the Vishnu and Shiva sects, the relationship between Indra and Agni, Kshatriyas and Brahmins, and other apparently dual elements of culture. But the time is not ripe for that task. The cultural skeletons of India will best be reconstituted when the living organisms of other peoples have been studied in detail.

The study of the dual organization of the Polynesian race can begin with India, and thence to America on practically every pearl-bed will be found traces of this form of society. The pearl-fishing Parava caste of Southern India comprises people of Polynesian types, who are probably remnants in India of that great race (see p. 105). They are allied to the Pariahs, the Pulayars and the Pallas, and form part of the great right- and left-hand caste grouping that has already been mentioned. Before launching out into the Pacific the case of the Pariahs deserves notice. They have two great divisions, east and west; the eastern Pariahs claim that they were the slaves of Suyodhana and his brother Kuruvas, while the western division were the slaves of the Pandavas in the war of the Mahabharata. The defeat of the Kuruvas caused the western division to be the superior.[1] Their traditions thus couple them with the great ruling houses of the past.

This claim has an important bearing on the problem of continuity. For in Chapter VIII it was seen that several peoples, low in the cultural stage, claimed to be the remains of former highly civilized communities. It is evident from the Pariah traditions that this claim is capable of rational interpretation. It may sometimes merely imply that they were the lower orders of dual communities. It is possible to interpret the whole of the right- and left-hand caste system in this way, and thus to avoid the difficulty of accounting for the apparent great drop in culture. For it can be assumed that the Pariahs and other tribes, who belong to the right- and left-hand caste system, were never more than labourers, craftsmen, and so forth, who have maintained through the ages about the same level of culture. Thus, although

[1] Mateer 38–9. Cf. 35 for other signs of duality.

the Paravas are people of Polynesian type, it does not follow that they ever possessed the culture of the archaic civilization in its highest degree. They are pearl-divers, and presumably always have followed that occupation. Of stone-work, irrigation and metal-working they may never have known much.

The Paravas are mentioned in old chronicles in connexion with dual settlements : " Vidanarayanam Cheddi and the Parava men who fished for pearls by paying tribute to Alliyarasani, daughter of Pandya, king of Madura, who went on a voyage, experienced bad weather in the sea, and were driven to the shores of Lanka, where they founded Karainerkai and Kutiraimalai. Vidanarayanam Cheddi had the treasures of his ship stored there by the Paravas, established pearl fisheries at Kadalihilapam and Kallachihilapam, and introduced the trees which change iron into gold." [1] The similarity in the names of the two pearl fisheries suggests a dual grouping of society.

[1] Thurston i. 123.

CHAPTER XIX

THE DUAL ORGANIZATION: INDONESIA AND OCEANIA

PREVIOUS chapters have revealed but few traces of the archaic civilization among the existing tribes of Indonesia. The making of polished stone implements, the building of megalithic monuments, are mostly things of the past. Such cultural elements as mother-right, human sacrifice and the sun-cult only survive in fragments, so also traces of the dual organization are not plentiful.

The Sakai of Sumatra are said to be divided into two groups distinct from one another for purposes of marriage.[1] They speak an Austronesian language, and thus presumably have been influenced by the archaic civilization.

Although the introduction of Hinduism and Islam into South Celebes has obscured the old form of religion, yet the social and political organization retains enough of its former shape to show that it was once dual in nature. This is the case with the Bugi and Macassar states.[2] The best instance known to me is that of Gowa, the chief Macassar state. Gowa and Tallo formed, in bygone days, a dual state, "one folk under two rulers,"[3] which is said to have resulted from an alliance.[4] In this dual realm the ruler of Tallo acted as vizier for him of Gowa,[5] a form of government utterly unlike those of the Hindu or Mohammedan states of Indonesia, as is evident from the following quotation from Prof. van den Berg: "In the Malay states the heir to the throne is usually, after attaining his majority, the vizier (Rijksbestuurder), and bears the title attached to the office. . . . In the Macassar and Bugi states the functions of heir to the throne and vizier are usually distinct, the first plays but little part in the government, but sometimes acts as substitute for the ruler." The state of Macassar, that is, of Gowa and Tallo, therefore possessed a

[1] Moszkowski 708. Cf. p. 281, where Rivers states that the Sakai of the Malay Peninsula practise the cross-cousin marriage.

[2] I speak without knowledge of the Adatsrechtsbundel, which, like so much Dutch literature, is inaccessible to me at present. See Sketch Map No. 8 for this region.

[3] Eerdmans 66. [4] Erkelens 82.

[5] Eerdmans 41 : Tidemans 353 : Indonesia I. 324. [6] Berg 35–6.

remarkable constitution, utterly unfamiliar to us, and strangely like that of Egypt in the later Pyramid Age, a form of constitution that did not persist in Indonesia, for it is not found among the Malay States or those founded by the Hindus.

The duality in the constitution was apparent in the case of the principal offices. Below the vizier were two officials, Toemailalang matowa, the elder Toemailalang, and Toemailalang malolo, the younger Toemailalang,[1] who were in a position of intimate relationship to the ruler, and acted as intermediaries between him and his council, of which more will be said in Chapter XXI. The state also possessed two heads of the army, who were princes of the blood.[2] It also had two harbour-masters, Sabanna-matowa and Sabanna-malolo, who looked after shipping, who also were royal princes.[3] Corresponding to the dual institutions of Gowa and Tallo is the story that the first mortal king of Gowa had two sons, Batara Gowa and Karaeng lowe ri Tallo, who became the rulers of Gowa and Tallo, and founded the ruling houses of these realms.[4] Another form of duality exists in connexion with these rulers, in that they were descended from marriages between denizens of the sky and the underworld, a matter that will receive attention in Chapter XXIII.

The constitutions of all Bugi states are so similar that the old form of government can be reconstructed from different sources.[5] Formerly Bugi states had an important official, corresponding to the vizier (Pabitjaraboetta) of Gowa (Macassar), called Mandarang in Boni, and Makadangana-tanae in Luwu.[6] This post no longer exists. In Boni the founder of the ruling house came from the sky and married a woman from the sky. His son reigned after him, but, since he married no wife of royal blood, it became necessary for his sister's son to succeed him. But he had two sons by a woman of low rank, and these sons acted as Makadangang and Tomarilalang for his nephew when he became king; that is, they filled the two most important offices in the state.[7] This tale shows that the title of Makadangang formerly existed. The chief official in Bugi states is now the Tomarilalang, the office usually being single, if it is not extinct.[8] The office of harbour-master in Bugi states is now single,[9] and sometimes is extinct. The office of war chief usually has only one incumbent.[10] The universal tendency, therefore, is for the old dual offices to become merged into one, or else to disappear, which is natural under Mohammedan and other alien influence.

An intensive study of the old political and social constitution of the Bugi and Macassar states would doubtless reveal many traces of a former dual organization. In Boni, for instance, it is

[1] Eerdmans 46, 67. [2] Id., 46.
[3] Id., 46. [4] Erkelens 81.
[5] Bakkers i. 251. [6] Eerdmans 65.
[7] Bakkers iv. 174. [8] Id., 69, 70 : Matthes 146.
[9] Bakkers iv. 97. [10] Matthes 147.

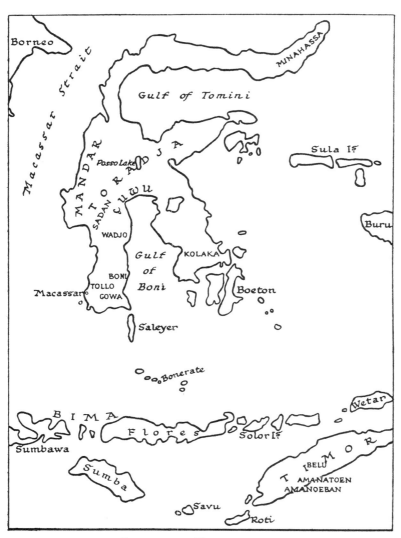

CELEBES AND NEIGHBOURHOOD

said that the first ruler had a flag, a universal custom in those states. When he had organized the constitution he caused two red flags to be made, called " the red flag on the right-hand side," and " the red flag on the left-hand side," which suggests a dual grouping of his followers.[1] In those days the office of vizier (Makadangang) existed ; but signs are lacking, so far as I know, of a former dual grouping of states in Boni, which would correspond to that of Gowa and Tallo, although this story of the two flags and of the office of vizier suggests that formerly Boni, and subsequently other Bugi states, were organized like that of Macassar. The constitution of the Mandar states of the west coast of South Celebes indicates a dual organization of society. Their rulers are of Bugi stock. The lesser chiefs of Madjene, one of these states, who form the council, are divided into two distinct groups, each with a head, and over the whole state rules a single chief.[2]

Kolaka, a state in Southern Celebes, founded by two brothers from the sky-world, who are, according to Kruyt, identical with Sawerigading, the great hero of the Bugi peoples, is divided into two parts ; the elder brother settled in Kandari, and the younger at Mekonga, on the Gulf of Boni.[3] The distinction of " elder " and " younger " as applied to rulers and founders of states is familiar wherever dual institutions exist. The To Seko in Central Celebes are divided into two groups, the To Seko and the To Seko Pada, the latter being the younger. Each division of the tribe consists of two villages ; those of the To Seko claim once to have lived together, and the To Seko Pada say that they migrated from the To Seko. The process suggests the successive fissions of one original community.[4] Farther south, the rulers of Bonerate came from Boeton, and, originally, it is presumed, were of Bugi or Macassar stock, for they claim the great Sawerigading as ancestor. The first settlements were made by two women, Opoe Rongga and Opoe Djongga, who founded Lagoendi and Bonerate.[5] The Bugi rulers say that they originated at Wadjo in South Celebes. I much regret not being able to see the work of Matthes on this district ; for he says that each state of the Wadjo confederacy has two chiefs, one for peace and the other for war.[6]

Further investigation will probably reveal links between the ruling groups of the great region comprising Celebes, the islands west and east of Timor, and the Moluccas. It seems certain that the Sultanate of Bima, which comprises parts of Flores and the neighbouring islands, was formerly in close association with South Celebes ; and it is further possible that it was responsible for an invasion of Sumba, which gave that island some of its present ruling groups. Be that as it may, the states of the east

[1] Bakkers iv. 176.
[2] Mandhar 661, 690.
[3] Kruyt viii. 692.
[4] Id., vi. 398.
[5] Kriebel 208.
[6] Berg 68.

and central parts of Sumba are sometimes founded on a dual basis. " In the states of Central and East Sumba there are generally two power-holding groups, one of which is the possessor of the relics of the ancestor, the Marapoe, while the other chiefly house controls the administration. Wielenga gives an example of this in the royal house of Malolo. There the radja of Watoe Pelitoe (a division of the Walolo district) is the ' lesser ' or ' younger,' and the radja of Palai Malamba (another division) is the ' greater ' or ' elder.' The sacred chief, the guardian of the relics, is the superior, or ' elder ' chief of the state." This suggests that formerly, in Celebes, the chieftainship was divided between the sacred and civil functions, the sacred chief being the superior, and his vizier belonging to the other ruling group. This arrangement persists in Wadjo, as has been seen. No more information is given with regard to the constitution of the state in Central and Eastern Sumba, much as it is needed ; but some is forthcoming from West Sumba. This part of the island is more closely connected with the archaic civilization than the others, for it possesses more megalithic monuments, more irrigation and so on. " It is a peculiarity of the districts of the west, that they are all divided into two parts, of which one is looked upon as the elder, and the other as the younger. So we have in Louli : Louli data and Louli wawa, which is nothing more than ' Louli above ' and ' Louli beneath.' The district of Lamboja consists of Lamboja and Patijala ; Wajewa of Baliomba or Lewata and Bali loko ; the first-named part must be the older, and consequently it is said to own the land. In Loura they speak of Maradana the plain and Latana the mountains. Kodi has the divisions of Kodi bokoel and Kodi bengedo. This division of the community is, so far as is known, only territorial and has no social significance." [1] The last comment of Kruyt shows that the old form of society has almost disappeared, which is understandable when it is realized that at least one invasion must have swept over the country in the past, that which gave rise to the ruling houses of the centre and eastern parts. Evidently the old order has passed and left behind it simply a small amount of wreckage. Doubtless further investigation will reveal more facts.

The accounts, now being published so rapidly by Heer Kruyt, of the various places in Indonesia lately visited by him, are bringing to light many new facts. Not only has he found the dual organization in Sumba, but in Timor his published account shows that the signs of the dual organization are still more plentiful. This is only to be expected ; for in the past there ruled Children of the Sun, who were mummified after death, and otherwise differed culturally from their subjects. At the present day two districts on the south coast show signs of being dual : they are called Amanoeban and Amanatoen, names strikingly similar. The people are of the same origin and speak the same language,

[1] Kruyt vii. 538.

and it is said that they must have come from Mollo, a neighbouring district. The ruling houses are nearly related and were founded by strangers. The accounts of their origin differ somewhat ; one says that two brothers came from a place called Banam, and brought with them some soil which they placed under a stone. The younger became chief, and ruled Amanoeban under the name of Noebatonis, while the elder is said to have been an ordinary noble, and to have ruled the " sister-district " of Amanatoen. This suggests that Amanoeban was the superior district, and that its chief took precedence over the chief of Amanatoen.[1] The other account states that a stranger landed on the coast of Amanatoen and married the two daughters of the ruler, who only had the rank of noble. A second stranger, who was found sitting between two stones under a lontar-palm, married the daughter of the first arrival, and ruled over Amanoeban. The two families are closely related, so that members of each attend funerals of the other.[2] Not only are the ruling houses of these two districts nearly connected, but in Amanoeban the ruling power is evidently divided between two related families. A sister of a former ruler of this district, who went to dwell at a place called Pene, had descendants called " Lords (descended) from the sister." The descendants of the ruler who lived at Niki-niki were called " Lords (descended) from the man, or brother." The ruler of Niki-niki must have as his chief wife a woman from the ruling family of Pene.

The extinct kingdom of Sonabait, in Timor, ruled over by Children of the Sun, seems to have been divided into " greater " and " smaller " parts. The founder of the ruling house was the brother of the founder of the ruling house of Belu, according to one account. Also it is said that the rulers of the two chief districts of Sonabait were two brothers.[3] Several accounts have been given of the dual organization of the Moluccas, but none of them supply many details. It has long been known that, in Halmahera, Seran, the Kei and Aru groups, and probably elsewhere in this region, society is divided into two parts. These divisions, which are hostile to one another, have names, such as Ursiwa and Urlima ; Ulisiwa and Ulilima ; Patasiwa and Patalima ; in Halmahera the distinction is between Galela and Tobelo peoples. These groups are under the suzerainty of the Sultans of Ternate and Tidore.

The Ursiwa-Ulisiwa-Patasiwa group is connected with the seaward part of the islands, and the other group with the inland part. Their founders brought with them the use of stone to the islands ; in one instance they have actually transported across the sea a large stone that is used for ceremonial purposes ; in Seran these groups are connected with the sun-cult, and one is higher in rank than the other, forming a kind of aristocracy ; the

[1] Kruyt ix. 792, 793, 796. [2] *Id.*, 796-7.
[3] *Id.*, 777, 779, 780, 790.

19

members of this group, who possess a sun-cult, go to the sky after death, while the others go elsewhere.[1]

Traces of a dual grouping exist among the Tobelo and Galela people of Halmahera. They are supposed originally to have formed one group;[2] for in the account of their arrival on the island of Halmahera, it is said that they were under one chief.[3] Hostility broke out between the Galela and Tobelo people on account of two gongs that the Tobelo people brought with them, so they thus possess another constant feature of the dual organization. The Galela people are divided into two groups.[4] The Tobelo are divided into four clans, the two most important being the Lina and the Gura, between which hostility has existed from time immemorial.[5] The two other clans are but of small importance. The Tobelo and the Tobaru are also hereditary enemies,[6] but I have no further evidence concerning them.

The evidence from Halmahera therefore suggests that the dual organization of society, characterized by the Patasiwa and Pata-lima, is widespread and fundamental. It is unfortunate that no detailed study has been made of this duality of society in Indonesia, or elsewhere for that matter; for it is immensely important for the proper understanding of the early history of the Polynesians. The district of the Moluccas contains peoples of Polynesian type, and stone circles are reported in Halmahera. It is therefore probable that the Moluccas, in addition to South Celebes, and the islands near by, were inhabited by the Polynesians on their way to the Pacific; so the study of these regions will help to elucidate the history of that race. The regions of South Celebes and the Moluccas are notable for their pearl-fisheries, and thus are emin- ently suitable as stepping-stones for the ancestors of the Poly-nesians. In addition, the gold and copper regions of Timor are characterized by the dual organization. The only place that causes difficulty is Sumba, which does not seem to possess materials to attract strangers, and judgment must be deferred about that island. It will be found, however, as the survey works across the Pacific, that the places characterized by the dual organization are usually those noteworthy for their stores of pearls.

The close relationship between the culture of Micronesia and the archaic civilization raises the expectation that, if the dual organization formed part of the old order, it would there have left its mark. Although the Children of the Sun have disappeared and but little has been recorded about this most important region, yet enough is known to make it certain that the dual organization was once paramount. In tradition Ponape exhibits signs of duality, for two brothers, Olo-sipa and Olo-sopa, are mentioned as the builders of the great ruins of Nanmatal.[7] The ruling power of Ponape is shared by two families. The king is a sacred

[1] Perry vii. 46, 114, 115, 143. [2] Hueting 225. [3] Id., 224.
[4] Id., 225. [5] Id., 220–1.
[6] Id., 231. [7] Rivers x. 441.

priest-king, who alone knows certain secrets associated with sacred stones, upon which he sits during ceremonies. On the other hand, the nobility is associated with the civil function ; its head, although he can never be king, holds much power in his hands, while the king has practically none. The family of the king and the nobility form two intermarrying groups.[1]

The villages of Yap are divided into two parts, north and south, and sometimes these parts have separate names.[2] The villages each have a village chief, who does not go out to fight, but is concerned with the civil administration, and a war chief, who has complete charge of the fighters.[3] Moreover, the people are divided into two groups, hostile to each other, between which fighting takes place. Sometimes a village consists of members of one group only, but in other cases both are present in the same place.[4] Other signs exist of a dual organization. " In Yap are two great wizards, the head of all the magicians (Uleg-uleg, or Machmach) in the island, both well on in years, who support their dignity under very strict conditions indeed. With them truly it is a case of *Sagesse* if not *noblesse oblige*. They are only allowed to eat fruits from plants or trees specially grown for them. They may not smoke tobacco, but, subject to the condition above-mentioned, may enjoy a quid of betel-nut, the chewed-up remains being reverently collected after them, borne away, and burnt in a special manner, for fear of any ill-disposed person getting possession of the rubbish and doing mischief by uttering a curse over it, a superstition like that of the Nahak in the Melanesian area. When one of them goes abroad the other stops at home, for were the two to meet one another on the road the natives hold that some dreadful calamity would surely follow. There are plenty of lesser degree Machmach men, who go about always with divers errands in hand, such as recovering missing property, divination, and the like, but all grave and important questions come up before the Mighty Two." [5]

Much more is known of the social and political organization of the Pelews. The work of Kubary has already revealed the importance of the matriarchate in that group. This author has also described other aspects of the sociology in much detail. He says that the foundation of Pelew society is the matrilineal clan. It was possible for a clan to bifurcate, for it is said that the descendants of two sisters might constitute themselves two distinct groups and thereafter look upon one another with hostility.[6] Villages comprise groups of clans, and form independent political units.[7] The constituent clans of the village differ in rank and are grouped round the two principal clans. To this political grouping corresponds a territorial grouping ; for the land is divided into two halves, just as happens in the case of the clans themselves.

[1] Hahl 5 e.s. [2] Müller 169. [3] *Id.*, 242–3.
[4] *Id.*, 234. [5] Christian iv. 289–90. [6] Kubary 46.
[7] *Id.*, 33 e.s.

Formerly it was customary for two clans to unite in a relationship of reciprocal helpfulness, but this custom has died out.[1] Each village possesses other dual features. Two landing-places are provided, one for each half of the village, and between them is a stone dam. The people strive to maintain the equality as far as possible between the two sides of the village, in clan-houses, and so forth. This division of villages is even observed in small places, where there is only one landing-place and often no dam. Hostility exists between the two sides, which on certain ceremonial occasions comport themselves as two strange houses.[2] The head chief of the village, who comes of the first clan, lives on one side of the village, and his successor on the other.[3] The society of the Pelews thus has a basis of thorough-going duality.

In British New Guinea the dual organization exists in places possessing traces of the archaic civilization. " In some parts of the Massim district, e.g. Milne Bay and Bartle Bay, there is a dual or multiple grouping of the clans. Where this occurs, not only should no one marry into his or her own clan, but no one might take a mate from his or her own clan-group. . . . But with the extinction of warfare and cannibal feasts within the last few years the dual grouping has so fallen into decay as to be largely ignored."[4] Bartle Bay possesses stone circles, matrilineal institutions, and other signs of the influence of the archaic civilization. In Gelaria of Bartle Bay the community is divided into two exogamous parts, Garuboi and Elewa, the Elewa division being subdivided into Giriwoa and Elewa. The people ascribe this division into clans to the great garuboi snake that lived on one of the twin peaks, Viara and Gaova, of a mountain near by.[5] In Wagawaga a like grouping of clans exists, Garuboi and Modewa : in this case the Modewa group has subdivided into Modewa and Hurana.

It is unfortunate that the study of the dual organization was not pushed farther by Prof. Seligman, but he had not time to finish the investigation. In his work on "The Melanesians of British New Guinea," he gives an excellent account of the history of certain groups of peoples, which affords the clearest idea, outside Egypt, Samoa, the Pelews, and, perhaps, South Celebes, of the real meaning of the dual organization. The tribes of the Central District, the Motu, Koita, Sinaugolo, and so forth have their clans divided into right and left halves. Of these peoples presumably the Sinaugolo were the most important, the Koita, for example, having derived certain cultural elements from them.[7] Little is said of the Sinaugolo, but enough to excite curiosity. Their clans are divided into two exogamous divisions which occupy either side of the village street, these divisions being right and left hand. Each division has two big corner posts

[1] Kubary 69–70. [2] *Id.*, 86–8, 99 : A. Krämer ii. 4.
[3] Kubary 86–8. [4] Seligman i. 10. [5] *Id.*, 438.
[6] *Id.*, 435. [7] *Id.*, i. 17 e.s.

and the big carved horizontal beam on one side of the council-house. The Elema Papuan tribes of the Papuan Gulf have club-houses divided into right- and left-hand sides. Men eat and sleep on their side of the house, and exogamy is practised between the sides. The chief of the right is especially the chief of the men's house, and takes precedence over the chief of the left.[1]

The Koita, who seem to have derived some of their institutions from the Sinaugolo, have a tale of origin from two brothers, Kirimaikulu and Kirimaikape, and a female dog.[2] As a whole the tribe seems to be divided into two hostile sections, for Prof. Seligman has tabulated a list of villages that live in a state of chronic hostility. He says : " It is obvious that a line joining the island Lolorua to Pyramid Hill divided the Koita settlements into eastern and western moieties, which correspond geographi-cally as closely as possible with the distribution of the sections at enmity. Although nothing was said by my informants to show that they recognized such a local grouping, the enmity between eastern and western sections was so constant that I have found it convenient to regard the Koita as consisting of eastern and western moieties." The Koita are divided into clans, each with its club-house, over which was a hereditary clan chief. One particular chief of each section of the Koita was looked upon as the head of that section, and this office was usually hereditary in one clan. The clan chief owns the right-hand front post of the club-house, while a sub-chief owns the left-hand post.[3] The Roro-speaking group does not seem to be divided into two divisions : nevertheless, one section of them, the Kevori tribe, has two groups of settlements, coastal and inland, but nothing is said about the significance of this grouping. Roro villages consist of two parallel rows of houses,[4] and appear to be in two divisions, right and left hand, each with its own side in the club-house. Each side is ruled over by a chief, the chief of the right and chief of the left, so called from their positions in the club-house on ceremonial occasions. The chief of the right was the more important. He had the power to stop fights, and thus was a peace chief.[5] Sometimes the chief of the left was a war chief.

In the tribes just mentioned, therefore, a division runs through the community. The tribe consists of two groups, and each village or clan is divided into two distinct parts, one of which is superior to the other. The chief of the superior part is concerned with peace, and the chief of the other part with war. The institutions of these peoples are in a condition of degradation, for many of the club-houses have fallen into disuse.

Prof. Seligman studied one group of tribes, the Mekeo group, with such thoroughness that it is possible, from their history, provisionally to reconstruct that of the others. The Mekeo group

[1] *Id.*, 28, n. 1. [2] *Id.*, 43. [3] *Id.*, 42, 52, 54, 56.
[4] *Id.*, 198, 199. [5] *Id.*, 216–17.

consists of two tribes, Biofa and Vee, " who speak a common language and who, in spite of chronic warfare, have long inter-married and have even formed colonies in each other's villages." [1] They thus form one community, with two divisions. The original settlements of these tribes respectively were Ioiovina and Ioio-faopo, names strangely alike, as are the names of other dual settlements. These original settlements were divided into two exogamous groups. Each clan group is also divided, if large enough, into two divisions, each with a chief, the more important performing the functions of sacred chief, and the other that of war-chief.[2] From top to bottom, therefore, the social and political constitution of this group is dual.

In Torres Straits dual institutions exist in both island groups : they are more important in the western group, but were dis-appearing on the arrival of the Cambridge Expedition in 1898. The island communities are divided into two sections, and in one case at least these moieties are hostile.[3] Some of the culture-heroes of the western group were dual ; for instance, garden plants and death dances were introduced by two men. Even single culture-heroes have dual characteristics, as is shown in the case of Kwoiam, the culture-hero of Mabuiag, who bore two crescentic ornaments of turtle-shell that blazed with light when he wore them at night-time. These became the insignia of the two groups of the island. Associated with his cult were two heaps of shells, called " navels of the augud," which word means the totem of a clan, which lay in the place where the moieties were supposed to have originated.[4]

In the eastern islands the dual grouping is apparently only of a ceremonial nature.[5] In Murray Island tales are told of Bomai and Malu, Bomai being the mother's brother of Malu, and thus bearing to him a relationship which is important in the dual organization with matrilineal descent.[6] These men brought the dual grouping from Tuger on the mainland of New Guinea. The people of Mer, with the exception of some later immigrants, are grouped into two divisions, which have ceremonial significance, and are connected with the cult of Bomai and Malu, but it is doubtful whether these groups have any social significance.[7]

The advanced cultural degradation of Torres Straits peoples makes it difficult to understand the past form of society ; neverthe-less, the islands presumably in the past possessed dual institutions. Dr. Haddon and Dr. Rivers think that the culture-heroes arrived after the dual grouping had been set up.[8] Be that as it may, they certainly are connected now with the dual organization.

In Melanesia the dual organization is associated with the com-munities that stand in closest relationship to the archaic civili-

[1] Seligman i. 311.
[2] Id., 336 e.s.
[3] Torres Straits Report V. 172 e.s.
[4] Id., V. 183–4.
[5] Id., VI. 169 e.s.
[6] Id., VI. 282.
[7] Id., VI. 169, 172, 173, 178, 281.
[8] Id., VI. 172, 179.

zation. Codrington states that, in this region, " nothing seems more fundamental than the division of the people into two or more classes, which are exogamous, and in which descent is counted through the mother." [1] In the Banks Islands, and the Northern New Hebrides, he says, the community consists of two divisions, in the Solomons of more than two. Rivers tells of the former existence of the dual organization from the Solomons to the Northern New Hebrides and thence to Fiji.[2] He believes, with Codrington, that the dual organization " is the earliest of the forms of social structure found in Melanesia," and that probably it was once universal in Melanesia.[3] I do not propose to go into its exact distribution, but to say that all the available evidence goes to show that it was the earliest form of social organization in Melanesia. The later immigrations have been organized otherwise ; for Codrington states with regard to the dual organization : " There is, however, one very remarkable exception to this general rule in the Solomon Islands ; it is not to be found in Ulawa, Ugi, and parts of San Cristoval, Malaita, and Guadalcanar, a district in which the languages also form a group by themselves, and in which a difference in the decorative art of the people, and in the appearance of the people themselves, thoroughly Melanesian as they are, can hardly escape notice. In this region, the boundaries of which are at present unknown, there is no division of the people into kindreds as elsewhere, and descent follows the father. This is so strange that to myself it seemed for a time incredible, and nothing but the repeated declarations of a native who is well acquainted with the division which prevails in other groups of islands was sufficient to fix it with me as an ascertained fact." [4] The work of Rivers has shown that the people with this social structure, that caused such astonishment to Dr. Codrington, were later comers.

The dual organization throughout Melanesia displays certain notable similarities. In the Gazelle Peninsula the moieties are named after To Kambinana and To Kovuvuru.[5] To Kambinana is said to be clever and full of guile, while To Kovuvuru is said to be stupid and ignorant. Corresponding personages are spoken of in New Ireland and Duke of York Island.[6] The moieties in the Gazelle Peninsula are said to be descended from two women, one light and the other dark, and to be associated with the dark and the light coco-nut.[7] In the Solomons the Rev. C. Fox has lately described the social organization of San Cristoval, and has made discoveries that promise to throw much light upon the history of Melanesia. He states that the earliest form of social organization, after that of the legendary food-gatherers, was the

[1] Codrington 21. [2] Rivers II. 73. [3] *Id.*, II. 16, 83.
[4] Codrington 22. [5] Rivers ix. II. 501.
[6] Rivers ix. II. 503–4. To Kambinana made everything good and useful, including plants and animals, and was the founder of every art and trade (S. Danks 452). [7] Rivers ix. II. 560.

dual grouping. In Bauro, for example, the social organization is that of moieties. " The real division of society in Bauro is into Atawa and Amwea. . . . In the bush villages . . . especially in the centre of the island, I have so far never found any clan except Atawa and Amwea, which are always present, while on the coast the other clans are frequently called divisions of these two. . . . In all cases Atawa and Amwea are present, and in the central main mass of the island in the interior, usually, at least, only these two are present. . . . I would say emphatically that the social atmosphere of Nauro is that of a dual community. Atawa and Amwea are the only divisions of importance in native estimation ; they are the real basis of society." These two moieties are hostile and formerly had regular fights. The Atawa are looked upon as being the superior, and are " bitter," gentle, cleverer, talkative and fair in appearance : the Amwea are silent, morose, fierce fighters, and dark in complexion. Villages were once divided between them, as now on Santa Anna, where the moieties live on either side of the centre path. Mr. Fox states that no clans have such a body of tradition of hostility, and of opposition in character and physical appearance, or in status in society as the moieties. " Their distribution all over the island, and their identification with different clans at different places, seem to point them out as the original and older people." Tradition connects them with the light and dark coco-nut.[1]

In the Banks Islands the moieties bear different characters. On Mota they are called Tatalai and Takwong : the Tatalai are well versed in social lore and are peaceful ; the Takwong are ignorant, unimportant and quarrelsome.[2] The dual grouping exists in Tanna of the New Hebrides : the community has two great divisions, largely geographical ; the Numrikuenimim live in the south and east ; while the Kauyameramin live in the north and west. The latter group use red paint for their faces, but the others do not.[3] When these two divisions go to war there is cannibalism, but not otherwise.[4] Apparently the real hostility in the island is between these two groups.

The work of Mr. Hocart is gradually revealing the former condition of society in Fiji. He shows that the older stratum of the population had the dual organization in most of its typical forms. For instance, the Fijians formerly had the dual chieftainship : " Our reasons for believing this are that the dual chieftainship exists in Tonga and Rotuma ; it is common among the coastal High Fijians, in the Rewa delta it is the rule ; but as we ascend that river it disappears suddenly and completely. It cannot have been introduced by the hill tribes, since they have not got it ; they can only have caused its disappearance among the coastal tribes that have not got it now. For instance, in legendary times we hear of a Tui Lakemba ; in historical times the chief of

[1] Fox 122, 123, 124, 125, 160. [2] Rivers ix. I. 22.
[3] Gray 648. [4] Id., 649.

Lakemba bears the title of Sau. The suggestion is that originally there were both a Tui and a Sau ; the Tui went over to Tonga, as we know, and only the Sau remained. The dual tradition, however, is still strong, and I have heard it laid down in Lakemba that every Fijian chief has his second." [1]

" Society was certainly organized on the dual plan with two exogamous moieties and matrilineal descent. One division was nobler than the other, so that a lady of rank always married an inferior." Mr. Hocart goes on to say that the dual organization is found in that part of Vanua Levu least affected by subsequent influences. It is somewhat disguised and not easy to identify in Eastern Fiji and on the east coast of Na Viti Levu. " I allude to the common division of villages into ' nobles ' on the one hand and ' the land,' or ' the teeth of the land,' on the other." [2] This dual grouping of the village was associated with the game of reed-throwing, the players being divided into camps according to their social division.[3] Hocart's information is valuable, for it links the ruling class with social organization. He couples on the dual kingship, the division of the ruling power into that of sacred chief and war chief, with that of the division of the village into nobles and commoners.

The traditions of the origin of the Fijian Nanga agree with the evidence of Mr. Hocart. The Nanga are stone enclosures surrounded by a stone wall, and containing four stone pyramids. The story of their origin relates that two men came from across the sea to Viti Levu. " When they landed they conferred together and said : ' Let us go to the chief of Vitongi and ask him to divide his men between us that we may teach them the Nanga for which purpose we have come to Fiji.' So they went and preferred their request, and the Chief said : ' Good, divide my men amongst you.' He also gave them each a piece of flat ground on which to build the Nanga, and the name of the place where the first one was built was called ' Tumba Levu.' Now it was the descendants of men to whom Veisina and Rukuruku taught the Nanga, that practised it ; and their descendants, even unto this day, are divided into the Kai Veisina and the Kai Rukuruku." [4] Thus not only is the dual organization part of the former condition of things in Fiji, but the pyramidal stone structures of the island are also associated with a dual grouping of the people for ceremonial purposes. The account of the Nanga suggests that the presence of the dual grouping is due to deliberate intent. For the man who brought over the Nanga rites asks that the people should be divided into two groups.

[1] The Vunivalu (Root of War) always belonged to Tui Kamba ("Lords of Kamba Sept "), and the Roko Tui Mbau to the Vusaratu (" Chief Sept ") (B. Thomson iii. 61). [2] Hocart vi. 47.

[3] Hocart ii. " In the game of tingga (reed-throwing) the vosa dhauravou will make one side and the vosa turanga the other side " (Hocart iii.). His article shows that the dual organization is breaking down, and is now hardly recognizable. [4] Joske 257-9.

It is possible to go still farther with the aid of Hocart's work; for he claims that the vui spirits of Melanesia correspond to the vu or ancestors of the sacred chiefs of Fiji. In Fiji the dual chieftainship is connected with the dual grouping in the villages. No chiefs are reputed in Southern Melanesia, but it would seem that the culture-heroes of that region correspond to the vu chiefs of Fiji. In the Banks Islands and the New Hebrides the culture-heroes seem to be dual in nature. In Vanua Lava, for example, Qat was the culture-hero; he was a vui, and therefore, according to Hocart, corresponded to the sacred chiefs of the archaic civilization. He had eleven brothers, all named Tangaro, among them being Tangaro the wise man, and Tangaro the fool.[1] In Aurora Tagaro was the hero: his companion was Suqematua, " who in all things was contrary to him," and does all he can to thwart him. In Whitsuntide Island Suqe is the companion of Tagaro, and accompanies him and thwarts him: Tagaro was always right and Suqe always wrong. Elsewhere in Melanesia stories are told of similar hostile personages in places with the dual organization.[2]

In Tonga the ruling function was shared by the sacred chief and war chief, the sacred chief being higher. There were two sacred chiefs, one superior to the other. The highest chief of all in the time of Mariner was the Tuitonga; next to him, and a colleague of his in the sacred office, was the Veachi. Then came the secular chief, the How. The Tuitonga always belonged to a certain family, and was descended from the chief god who visited the island.[3] " Tuitonga and Veachi may easily be conceived sources of nobility, on account of their supposed divine originals, and the How because he holds the reins of government, and is invested with power. The family of Finow, who is the present How, say that they descended neither from Tuitonga nor Veachi, but are altogether a distinct race. . . . The present Finow's father was the first of the family that came to the throne, which he did by usurpation and expulsion of the reigning family." The previous Hows had been the relatives of the Tuitonga.[4]

The Samoan group has always been closely associated with Fiji and Tonga. It is here that it is possible to see farthest into the past, for the work of Krämer, Stair, Fraser, Powell, Pratt, and others has brought together a mass of facts that show how the first settlements of Polynesia took place. The traditions of the eastern Pacific place the homeland of the race in Samoa, and especially in Manu'a, at the eastern end of that group. Moreover, the culture associated with Manu'a is much closer to that of the archaic civilization than that of the rest of Samoa, or even of the

[1] Codrington 156 e.s. In the chapter on Exogamy further evidence will be forthcoming of the connexion of these culture-heroes with the Dual Organization.
[2] *Id.*, 168–170. See also Suas i. 33.
[3] Mariner 75–6. [4] *Id.*, 83, 84.

rest of the eastern Pacific, with the exception perhaps of early Tahiti. It is therefore in Manu'a that search should be made for facts about the archaic civilization of the eastern Pacific.

The story of the peopling of Manu'a begins with the Tagaloa family, Children of the Sun. A Tagaloa fished the island of Tau, in Manu'a, out of the water, and intercourse then began between the sky and the earth. The first settlement in Tau was at Fitiuta. Later on another was made at Tau, on the other side of the island.[1] In Fitiuta lived the Sa-Tagaloa, the Children of the Sun, and there was brought the first beautiful house from the sky which later became the temple of the reigning chief,[2] where lived the gods on earth, the Tagaloa family. Since by " gods " is meant " beings related to a ruling family," this story means that the first settlements of Samoa were made by men claiming connexion with the sky-world, which is in agreement with the fact that the first kings of Samoa were sacred and looked upon as gods.[3] It is said that in the sky-world were many malae, council-places, in possession of the various branches of the Tagaloa family, the most important being the malae o toto'a, " the malae of peace "; the malae o vevesi, " the warlike," and so forth.[4]

The first settlement in Samoa, Fitiuta in Tau of Manu'a, was divided into two, Aga'euta, Aga'e landward, and Aga'etai, Aga'e seaward. In one tale it is said that Aga'euta and Aga'etai were husband and wife, who lived at Saua in Fitiuta. The Tagaloa family came down from the sky to them and brought the dignity of the Galea'i for their son Aga'e, who was the first chief of all Manu'a. Aga'e was one of the Children of the Sun,[5] so his parents must have been of solar birth. Thus the first ruler in Samoa was one of the Children of the Sun, of a race that has long since disappeared.

The peopling of Manu'a can be looked at from another angle, from that of the ancestress of the royal family. A woman named Ui, the daughter of the Tuiatafu, that is, the Tui chief, of a place called Atafu, came to Manu'a, swimming across the sea. In Atafu was a sun-god who demanded human sacrifices. Ui persuaded him to accept substitutes, and then left the country, accompanied, in some accounts, by her brother. She landed in Fitiuta, and bore to the Sun, Tagaloa-la, a son named Tagaloaui.[6] Tagaloaui married Sinasa'umani, the daughter of La Fe'e, later the ruler of the underworld, and their son was Taeotagaloa,[7] with whom real men are supposed to begin.[8] Thus the first rulers of Samoa were born of a woman of royal birth, who came from a place where the sun-cult was practised, where, if the equation of gods and rulers be true, the Children of the Sun reigned. This account, therefore, agrees with that of Aga'euta and Aga'etai,

[1] Krämer I. 362, n. 1, 370, 382. [2] Id., 9.
[3] Pratt i. 657. [4] F. Krämer 393.
[5] Id., 382, n. 1, 382, 384. [6] Id., 241, 419.
[7] Id., 8. [8] Id., 382, 385 n. 7, 393.

husband and wife, the parents of Aga'e, a Child of the Sun. According to another version, Tagaloala married Sina, the daughter of the Tuifiti, the ruler of Fiji, and their son was Taeotagaloa, while their daughter, Muiu'uleapai, married the Tuifiti.[1]

The two first settlements in Tau, Fitiuta and Tau, are connected with the ruling family, for it is said that Taeotagaloa, the son of Tagaloaui and Sina, married two girls, Laulaulefolasa, the daughter of Le Folasa, who lived at Le Faga in Fitiuta and Sina, the daughter of Taotoaiseaualuma, in Aualuma in Tau. The sons of Taeotagaloa by these two wives were Atiilagi and Fa'aeanuu,[2] of whom the one born at Tau was destined to become the temporal ruler of Manu'a, while the one born at Fitiuta became the sacred chief.

The transference of the temporal power to Tau is explained in the following story. Taeotagaloa, the first human king, had three brothers, Lefanonga, Lele, and Leasiasiolagi, and two sisters, Muiu'uleapai and Moatafao.[3] These sons were gods, and could go to the sky to attend the council meetings of the Tagaloa family : "They had all the same power to ascend from earth to heaven, to pass over seas, and to go to the most distant regions."[4] But when Tagaloaui went with his sons uproar always resulted. Taeotagaloa was peaceful, but his brother, Le Fanonga, was quarrelsome. "This was utterly unlike the propriety required in the realms ; for, at all times, perfect peace and order were there, and silence during the holding of councils. Annoyed by these disturbances Tagaloa—the creator and Tagaloa-le-fuli proposed that dignity and authority, and the palace, and sovereign rule, should be given to Tagaloaui to take to earth with him, so that he might appoint one of his sons king of earth, with all the royal rights ; thus there would be no occasion to have the peace and quiet of the heavenly regions any longer broken." So Tagaloaui went to Le Fanonga and said to him : "You are a disobedient boy ; you stop here. Taeotagaloa shall be king ; to him shall be given the royal sway over all lands under heaven ; the proclamation of the ao shall go forth in his name."[5] Thus Taeotagaloa became the first Tui, and Le Fanonga took a subordinate place. Apparently they both lived in Fitiuta. For, when the sons of Taeotagaloa had grown up, Taeotagaloa says to his brother Le Fanonga[6] : "You stop here in the east and be the war-god of Fiti-uta, but I will go and be the war-god of Le-faletolu."[7] . . . Ta'e-o-tangaloa then went to his sons and gave them formally their appointments. To Fa'a-ea-nu'u he said, "Let the imperial dignity abide with thee ; let them stand up and make their council-speeches in thy palace, King of Manu'a and all Samoa." To his brother he said, "Be thou named Ati-i-lagi ; let the royal dignity

[1] F. Krämer 392.
[2] Id., I. 370: Pratt iii. 294.
[3] F. Krämer I. 393 : Pratt ii. 123.
[4] Fraser iii. 67.
[5] Id., iii. 67–8.
[6] Cf. F. Krämer I. 389.
[7] Pratt iii. 294–5.

be associated with the inferior human gods through thee; sit thou in thy palace and speak to the heavens."[1]

This account of the change of a god associated with the sky, claiming descent from the Sun, into a war-god has already been noted. This change of nature on the part of the god formed part and parcel of a revolution on the island, whereby the power was transferred from Fitiuta to Tau, Fitiuta henceforth enjoying but little prestige.[2]

The son of Aga'etai and Aga'euta was Aga'e, who had the Galea'i title, which was brought down from the sky by the Tagaloa family. This title was replaced by that of the Tui. It is curious to note that the Tuimanu'a was really only concerned with war, and that the peace functions were carried on by the council of heads of clans, the faleula, of which more will be said in the chapter on Totemic clans. It may thus be that the Galea'i title was that of the original Children of the Sun, who, by some social revolution, changed their capital to the war side of the island, and themselves became war-gods instead of Children of the Sun. As further evidence of this, the chiefly offices of each part of the island may be considered. Each ruler of a district had two such councillors : these " brother chiefs," as they are called, had formerly as titles, in Fitiuta, Soatoa and Galea'i; in Tau, Soatoa and Lefiti, the Galea'i title being replaced in Tau by that of Lefiti.[3] These two chiefs alone can prevent war, and on this account they are called " Freshwater." [4] I have not been able to find out anything more about these two brother-chiefs. The fact that the Galea'i title has gone, and been replaced by another, is suggestive, as is also the fact that these two chiefs can act as preventers of war. The members of the early ruling family were themselves looked upon, in later times at least, as dual in nature. Chiefs were addressed as " you two." [5] " Fue, the son of Tangaloa, that came down from heaven, had two names, Fue-tangata and Fue-sa ; he peopled the two flat lands." [6]

The earliest settlement of Samoa was dual. The island of Tau was divided into two parts, and the chief settlement of each part was dual, with a seaward and a landward part. The ruling family broke up into two parts, one sacred and the other temporal, and in the councils the chief had two chiefs as intermediaries

[1] *Id.*, 295.

[2] Another account of the splitting-up of the royal power is given by Pratt. Le Faga, who lived at Le Faga in Fitiuta, had a son Folasa, who married Sina. Their son, Le Lologa, had several wives. Le Folasa said that the son born first should have the royal title. Two were born on the same day. " O Ali't'a-tama, ' the younger ' Ali'a ; and 'Ali'a-matua, ' the elder ' Ali'a." The younger had the insignia of royalty. They occupied opposite ends of the house. " Be thou named Ali'a-matua, the presence of Moa ; and be thou named 'Ali'a-tama, the Circle-of-chiefs-of-Moa " (Pratt ii. 134–5).

[3] F. Krämer I. 367, 368.
[4] *Id.*, 377.
[5] Powell and Pratt 118.
[6] Pratt ii. 274.

between him and the councillors, one of these " brother chiefs " formerly holding the ancient Galea'i title. So far as can be seen these arrangements were deliberate. The Tagaloa family gave certain titles to the people on earth ; and the Tagaloa on the earth divided up the island and assigned their parts to the actors.

Another sort of duality is evident. The Tagaloa men marry women connected with the underworld, which suggests that the ruling power was held by two distinct families ; one connected with the sky, the Children of the Sun, the Tagaloa family ; and the other connected with the underworld, and associated especially with La Fe'e, the ruler of that region. This latter branch of the ruling class evidently also had dual characteristics : La Fe'e, the ruler of the underworld, and his brother Sa'umani are said to have separated, La Fe'e going inland and Sa'umani going to the coast.[1] Moreover, the ancestress of the Tuimanu'a of Manu'a, Ui, that is, " darkness," arrived with two stone idols.[2] Her brother Luama'a was called " two stones,"[3] and at Fitiuta their place of landing is marked by two stones called Luama'a.[4] Also the son of Fe'e named Faia,[5] married a woman named Sina, and their son Luanu'a was called " two lands."[6] Further evidence of duality in the ruling family is supplied by the family at Le Fanga in Fitiuta, to which belonged the wife of Taeotagaloa. According to one account Pega and Pega, man and woman, with the same name, had three children, Pilimoelagi, Pilimoevai and Sina. The first son lived in the sky ; the second lived in the water near the home of Sina, and in the form of a fish became the father of Pili, the ancestor of the rulers of Upolu.[7]

In the creation story Savai'i was created after Manu'a. The first settlement in that island was Samata, which was colonized by people from Manu'a.[8]

" Together with the group of small lands ;

" With the home of Alamisi (the two Samatas arose)—Samata inland and Samata by the sea.

" The seat of Tangaloa and his footstool.

" But great Manu'a first grew up

" The resting-place of Tangaloa.

" After that, all the other groups of islands."[9]

Samata, like Fitiuta, was a dual settlement. It's parts, Samata iutau (Samata inland), and Samata itai (Samata to sea), were named after two boys, Mata-i-uta (Eyes Inland) and Mata-i-tai (Eyes to Sea), whose occupations were appointed by their father respectively inland and on the coast.[10] The ruling power of Samata was derived from Manu'a. The Tuisamata is looked upon

[1] Powell and Pratt 70. [2] Id., 125.
[3] Id., 127. [4] F. Krämer 370.
[5] Powell and Pratt 203. [6] Powell and Pratt 201–2.
[7] F. Krämer I. 439. [8] Id., 75.
[9] Powell and Pratt 208. [10] Fraser iii. 113–14.

as the brother of the Fua-au in Pagopago of Tutuila,[1] being descendants of sons of Tele and Malae, two immigrants from Manu'a. They had held the office of preparing food for the Tuimanu'a, but were banished and went to Lefutu in Tutuila, a dual settlement, where the first Tuisamata married the daughter of the Mata (Matalula); hence the name Samata.[2]

In this way have arisen new settlements from Manu'a. It is to be noted that the dual grouping of the village is connected with two brothers, but that one man only is held accountable for the foundation of the office of the Tuisamata. This man was a brother of the founder elsewhere of a chiefly house. Thus the dual grouping of ruling families has broken down.

Another example of the same process is provided by Leapai and Fa'a-toafe, descendants of Fai-malia and Fai-tama'a, who came from Manu'a. Fa'a-toafe became ruler of Sangoni in Savai'i, and Le-apai chief of Sangona in Upolu—so that settlements with similar names were founded, by brothers, on different islands.[3]

The founders of the Tuisamata and Fua-au houses were not Children of the Sun, but merely the sons of officials in the service of the Tuimanu'a. Their new homes were in villages split up as before, but with the ruling power in the hands of one family only, with no apparent division of sacred and war chief. It has already been said that the Tuimanu'a was really only a war-chief, and that the council ruled in peace time : also that, in Tau of Manu'a, the brother chiefs could exercise a veto on the warlike proclivities of the Tuimanu'a, the ruling chief. In Manu'a the Galea'i title, the first title to be given to the descendants of the Tagaloa family, disappeared, and it is only said that one of the brother chiefs was a Galea'i. This, coupled with the fact that Taeotagaloa became a war-god, and got the Tuimanu'a title from the sky, suggests, as has already been pointed out, that the original sky-born chiefs disappeared at an early date in Samoa, and left simply the war-chiefs, that is, the part of the ruling class connected with the underworld. If, as appears probable, the ruling families of other islands were founded by nobles from Manu'a who served the Tuimanu'a, then it is to be expected that the original sacred sky-born chiefs would not appear, but that simply the warrior chief family would be represented. This is what appears to have happened. On the other hand, the dual grouping of the village is maintained, with a corresponding tale of foundation by two brothers.

The earliest ruling family of Upolu in Samoa came from Manu'a. The political organization of this island has been much broken up by conquest, but enough is known to make the early conditions

[1] Tutuila is dual. " Tutu and Ila, that is a pair. Tele and Upolu were placed to people the land of Upolu-tele ; but Tutu and Ila, they two were to people the land now called Tutuila " (Pratt ii. 274).
[2] F. Krämer I. 75. [3] Fraser iii. 116–17.

fairly certain. Apparently in the beginning only two districts existed on the island, Aana and Tua.[1] In the story of the political foundation of the island Aana and Tua appear as twin sons of Pili from Manu'a.[2] Aana is divided into Itu alofi and Itu tuafanua.[3] Also, signs exist of a former duality ; for a story is told of a former chief of Aana, who, on the point of death, divided his sceptre between his two sons, Fasito'otai taking the seaward part, and Fasito'outa taking the part nearer the centre.[4] Corresponding to this story is the fact that the chiefs of these two places play a most important part in the council of Aana, and that the two places correspond to one another.[5] The capital of A'ana is Leulumoenga, but this settlement is not absolutely paramount. " In all the principal divisions of the islands there were some settlements, in addition to the leading district, which possessed greater influence than others. In A'ana, the division with which I was most familiar, there were two important settlements that had to be consulted in addition to Leulumoenga, viz. Fasito'otai and Fasito'outa. These had the privilege of following the opening speech, and their decision was often final, the other places adopting pretty much the tenor of their addresses ; but this was not always the case. So great was the influence of these places, that it required the presence of the representatives of one or the other of them to render valid the proceedings of that assembly, so that in case both absented themselves from the meeting, the fono dispersed without entering upon business." [6]

I do not like to push speculation too far ; but it would seem, in this case, as if the capital Leulumoenga had been imposed upon a former dual grouping of the community, so that the chiefs of the old dual settlements, who are connected in tradition with a former chief who so divided his kingdom, still play a paramount part in the councils of the district.

In the later history of Samoa the dual grouping of society has disappeared, and one searches in vain through the detailed pages of Krämer, with their descriptions of each settlement and village, for any signs of it. Only rarely has the dual organization persisted, and even in such cases decay has long since set in. In Manu'a, the Tagaloa family ruled in the early times, when there was connexion with the sky. But in the other islands, Savai'i, Upolu and elsewhere, search is vain for the Children of the Sun, their sky-world and their other characteristics. They have gone, and in their place rule gods of war connected with the underworld, beings such as Le Fanoga, Fe'e, Pili, and others, who came over from Manu'a to Savai'i and Upolu, and became war-gods and maintained a connexion with the underworld, not with the sky, and thus represent the family with which the men of the Tagaloa family married.

[1] Ella i. 629.
[2] Pratt ii. 257 : F. Krämer I. 9, 27.
[3] F. Krämer I. 148.
[4] Pratt iii. 301.
[5] F. Krämer I. 153–4.
[6] Stair vi. 88–9.

The early disappearance of the dual organization in Samoa does not raise any great hopes of the discovery of its counterpart elsewhere in Polynesia. But signs persist of its former existence in Tahiti, where traces are to be seen of the sun-cult. In the Tahitian legend of Honoura, mention is made, in the domain of Aua-to-i-tahiti, a former king of Tahiti, of districts called Teraitopi and Teraitopa,[1] names suggesting that districts went in pairs. Honoura himself says in one place in the poem " Here are my names : Maui-tua and Maui-aro " ;[2] that is, " Maui-behind " and " Maui-in-front,"[3] which suggests that the rulers of that day were dual. It is said that the progenitors of men were Tii Maaraauta and Tii Maaratai, " Tii extending towards the land " and " Tii extending towards the sea," who lived at Opoa and produced the human race.[4] This is reminiscent of the dual organization in Samoa and elsewhere.[5] Twin war-gods are also mentioned : " The two pupils for whom the life of the stone battle-axe was created. . . Before the face of the armies of Rai and Roo."[6] Thus a duality exists in the districts under the rule of former kings, in the beings who first lived at Opoa in Raiatea, and in the war-gods of Tahiti.

More evidence of duality is forthcoming from Mr. Percy Smith. He mentions that formerly the people of the eastern Pacific met at Raiatea for ceremonies, prominent among which were those connected with the Whare-kariori, the great Areoi Society of Polynesia, which, according to Polynesian tradition, was brought from India (see p. 105). The founders were Urutetefa and Orote-tefa, the brothers of Oro, the great war-god of Tahiti and else-where in eastern Polynesia, whose similar names suggest the dual organization. In the concluding part of the ritual of the cere-monies, temporary pyramidal structures are erected for the brothers, who are represented by two stones from the marae of Oro at Opoa in Raiatea, into which the gods were supposed to enter after the priest had uttered a prayer.[7] Other evidence pointing to the dual nature of the Areoi societies is furnished by Mr. Percy Smith. " Tradition seems to infer that these gatherings broke up after a time, owing to the hostility of two factions, the Ao-tea, or eastern people, and the Ao-uri, or western people, resulting in murders, war and all kinds of evil. . . . The meaning of these two distinctive terms, ' Ao-tea ' and ' Ao-uri ' is the light and the dark world, derived from the sun-rise and sun-set."[8]

The coming to power of the descendants of Oro has evidently destroyed in Tahiti many traces of the dual organization, just as in Samoa only the earliest settlements are dual. Enough remains,

[1] Honoura 265, 279 : P. Smith vi. 236–8.
[2] *Id.*, 267. [3] Gill vi. 126. [4] Ellis I. 111.
[5] As is natural where the old order has changed, other tales are told. One says that Tii was a man made by the gods, who married a woman named Tii or Hina. Their ghosts, called Tii, are connected with stone images (Ellis I. 111).
[6] Ellis I. 201. [7] *Id.*, I. 231–4. [8] P. Smith v. 258.

20

however, to show that it must have been a prominent feature of the life of the past. It is, however, in Mangaia and elsewhere that the best evidence can be found of the past existence of the dual organization.

Mangaia was brought up out of the sea by Rangi, the grandson of Rongo, the great war-god, who lives below in Aviki, the place of origin of the race and the land of the dead. Rongo is identifical with Oro, the great warrior-god of Tahiti. He and his twin brother Tangaroa were sons of Vatea and Papa. Vatea was the son of Vari-ma-te-takere, the great mother of gods and man, who lives in Aviki, the land of the dead. Tangaroa, like the Tagaloa of the Samoan group, was connected with the sky,[1] and doubtless was originally one of the Children of the Sun.

> "The fair-haired children of Tangaroa
> Doubtless sprang from dazzling light"[1]

Tangaroa and Rongo separated. " Now, Tangaroa was altogether the cleverest son of Vatea ; he instructed his brother Rongo in the arts of agriculture. Their father wished to make Tangaroa the lord of all they possessed ; but the mother Papa objected, because as parents they dared not taste the food or touch the property of Tangaroa, the eldest *by right*. The mother had her own way. Hence, when a human sacrifice was offered to Rongo, the refuse, i.e. the body, when thoroughly decayed, was thrown to his mother, who dwelt with Rongo in the shades, in order to please her."

" Government, arrangement of feasts, the drum of peace, i.e. all the fountains of honour and power, were secured to Rongo, through the selfish craft of Papa." Tangaroa left Mangaia disgusted with the continual preference shown to his brother. " He made a long journey, and touched at many islands, scattering everywhere the blessings of food piled up for the purpose in his canoe. Finally, he settled down on his beloved islands, Rarotonga and Aitutaki, leaving Auau, or as it was afterwards designated, Mangaia, in the quiet possession of Rongo—*The Resounder*."[2]

This sounds like an imaginary tale. But the remarkable feature has yet to come. Rongo in Mangaia represented the underworld ; so when Tangaroa left, the people were without any communication with the sky-world. Rangi, Mokoiro and Akatauira, the three sons of Rongo, were the first kings on Mangaia after it had been pulled up out of the ocean, for their father had remained below.[3] To make good the lack of a sky-god, Rangi had recourse to a remarkable expedient. " Rangi, Mokoiro and Akatauira were probably veritable persons, chiefs of the first settlers on Mangaia.[4] Their wives were respectively named Tepotatango (Bottom of Hades), Angarua and Ruange.

Then came Papaunuku, son of Tane-papakai, or Tane-giver-of-

[1] Gill i. 4, 13, 14, 16, 17, 18. [2] *Id.*, i. 11, 13, 14. [3] *Id.*, 16.
[4] This agrees with the conclusions of Chapter XII.

food. When Tane died he was worshipped by his son, who was sent for by Rangi as a priest. But Rangi was not pleased with Tane, as he spoke only as a man, without frenzy, through his son Papaunuku. His grandfather Rongo lived only in the shades; Rangi wished for a god who would live with him in the upper world. He therefore sent to Rarotonga to ask Tangiia, a renowned warrior-king of that island, to send him over one of his sons ' who had grown up under the sacred shade of the Tamanu leaves ' to be his god. Rangi's wish was gratified, and Motoro was fixed upon by his father for the purpose." [1] Accordingly, Motoro combined with Rongo as chief deities of the island. " The three original tribes, and the kings, invariably worshipped Rongo and Motoro; but many are said to have disapproved of this new worship, correctly regarding Rongo as the great original heathen divinity of Mangaia. Until 1824 both were conjointly worshipped as the supreme deities of this island, Rongo taking the first place." [2] Motoro was connected with the interior of the island, and he was the god of the living; while Rongo had his marae on the seashore, and was the god of the dead. [3]

This is evidently an account of a deliberate arrangement made by a king of Mangaia. It was necessary to have two deities, one for the dead and the other for the living; so when Tangaroa went away, he had to be replaced, and this was done by arrangement with the rulers of Rarotonga. Corresponding to this arrangement of deities, the principal king lived inland in the sacred district of Keia, and kept away the evil spirits from the east; while the second king lived on the seashore, and kept away the evil spirits from the west. [4] Sometimes the shore-king was an illegitimate son of the sacred king. [5]

The departure of Tangaroa means that some political change had taken place, the nature of which can only be inferred. An account given of a change of deity, accompanied by that of the ruler in Mangaia, helps to the understanding of this point. A certain warrior chief, named Tiaio, routed some invaders, and thus gained mighty fame. For some act of impiety he was killed by a priest of Tane-the-man-eater, and his spirit entered first an eel, and then a shark. " The Mautara, or priestly tribe, gave up their ancient divinity, Tane, in favour of this new god. The greatness of Tiaio marks the political supremacy of that warlike clan, which is of recent origin." [6] Since Tane was superseded by the son of a warrior king from Rarotonga, and also, in another account, by the ghost of a warrior king or chief of Mangaia, it seems possible that the supersession of Tangaro was, in like manner, due to some conflict in the ruling power which led to the exile of the Tangaroa family. In Samoa the sacred chief undoubtedly has more than once been exiled by the council; in Timor, also, the Children of the Sun were exterminated; the

[1] Gill i. 19. [2] Id., 27. [3] Id., 19.
[4] Id., iii. 635; i. 293. [5] Id., iii. 636. [6] Id., i. 29–30.

account of Percy Smith of the break-up of society in the eastern Pacific likewise shows that the disappearance of the Tangaroa family, the Children of the Sun, may have been due to political dissensions and warfare, in which the Children of the Sun would stand but little chance. Evidently the departure of Tangaroa from Mangaia was not pleasing to Rangi, who was left behind. Something had to be done, so help was sent for from Rarotonga, where Tangaroa had gone. But the god who came was not the son of Tangaroa, but of Tangaia, and dwelt, not in the sky, but on earth. Thus the link with the sky-world was partly broken with the departure of the Tangaroa family, and the best that could be done was to secure the services of a god who could rule over the living on earth. As in Samoa, the ruling power was not entirely vested in the hands of the occupant of the throne. " Upon gaining a decisive victory the leading warrior was proclaimed ' Temporal lord of Mangaia.' The kingly authority was hereditary and distinct from that of the warrior chief ; the former representing the spiritual, the other the temporal power. . . . It sometimes happened that the temporal chief was at enmity with the king of his day. In this case the king would refuse to complete the ceremonies for his formal investiture ; life would remain unsafe ; the soil could not be cultivated, and famine soon followed. This state of misery might endure for years, until the obnoxious chief had in his turn been dispatched, and a more agreeable successor fixed upon." [1] Such conflicts would soon break up the original dual grouping.

The choice of a successful chief to be the temporal king of Mangaia, while the descendant of Rongo, the great war-god, became the spiritual chief, shows that the original dual grouping has altered in nature ; for the sacred chief is now the son of the war-god, not of the Sun, and he, in his turn, has someone else to take over the charge of temporal affairs. The system thus is again in a state of degeneration, but it still retains some semblance of its original condition.

Rarotongan history begins in Tahiti and Samoa. Five hundred years ago two chiefs ruled in Tahiti, Tutapu and Tangiia, Tutapu being the elder. [2] They possessed opposite ends of Tahiti-iti. [3] Tutapu had killed Pou-te-anua-nua and Pou-rakaraka-ia, the sons of Tangiia, who were chiefs in Tahiti. [4] Tangiia fled by way of Huahine, the Leeward Islands, and Aitu, to Rarotonga, followed by Tutapu. At Rarotonga the Tangiia party amalgamated with Kariki and his followers, and together they beat and ate Tutapu. [5] The Karika family of Rarotonga say that they came from Manu'a in Samoa ; " the family marae of the Kakea tribe is therefore named Rangi-Manuka or ' Manu'a in

[1] Gill i. 293. [2] Id., 23. [3] P. Smith vi. 238.
[4] Id., ii. 26. The presence of rulers with such similar names is additional evidence for the former presence in Tahiti of the dual organization.
[5] Gill ii. 24.

the skies.' " [1] . . . The Karika family is identical with the Ali'i family of Manu'a, and therefore with the earliest settlers, the descendants of the Tagaloa family, the Children of the Sun. Thus both the Karika family and the Tangiia family of Rarotonga had come from places with the dual organization, and consequently set up once more this form of society. Tangiia said to Kariki: " Let us select from the people some to be Ariki (chiefs), some to be Taungas (priests), some to be Mataipos and Komonos (minor chiefs)." They did so. Tangiia set up his adopted son Te-ariki-upoko-tini to be ariki of the Ngati-Tangiia, and Kariki chose another to be chief over Te-au-o-tonga.[2] They chose the priests and eighty each of the sorts of minor chiefs. They then said, "To-morrow we will divide the lands "; and they did so, "completing the circuit of the land " : Kariki went inland while Tangiia went seaward.[3]

Rarotongan history goes still farther back. It was first settled, probably about 875 A.D., by two brothers, Apopo-te-akatinatina and Apopo-te-ivi-roa, who came from a place called Atu-Apai. This may be the Haapai group, but Mr. Percy Smith thinks that they really came from Samoa.[4] Other signs exist of a dualism in Rarotongan society. Mention is made of two priests named Paoa-uri and Paoa-tea, who went from Rarotonga to Raiatea with a sacred drum for the marae of Oro at Opoa.[5]

The account of Mangaia and Rarotonga is interesting because it shows that the Polynesians of early days took care to set up a form of dual organization of society wherever they went, even though this dualism did not always contain all the original elements. It is interesting to note that the establishment of the dual grouping in Rarotonga and Mangaia is not the work of men with similar names, but that the families are quite distinct. On the other hand, in both cases, the chiefs who set up the dual grouping come from places where the early ruling groups have, in tradition, similar names. This important feature of the dual organization will have to be explained.

New Zealand was peopled from eastern Polynesia. Traditions point to the migrations of the ancestors of the Maoris as being due to wars. As an example, Elsdon Best quotes the quarrel between two chiefs of eastern Polynesia, one of whom, Manaia, decided to go away, and he sailed to New Zealand with his family.[6] Probably the great break-up of society in Eastern Polynesia had much to do with the migrations of the Maoris ; for they claim to belong to one of the divisions of the former eastern Polynesian society—the Aio-tea or eastern people, the people of the light. This corresponds to a tradition which seems to divide the ancestors of the race into two groups. That led by Tane, the ancestor of the race, apparently a sun-god, is said to have been of a kindly

[1] Gill i. 25. [2] P. Smith ii. 27.
[3] Id., 26–7. [4] P. Smith vi. 203, 204, 211, 231.
[5] Id., vi. 287. [6] Best xii. 450–1.

peaceful disposition, and to have come out of the underworld into this world. Then came another group, led by Whiro : " Whiro especially appeared in a very peevish condition, irritated at Tane for leading them out of the Earth Mother to be assailed by cold. From this time on, Whiro and Tane were enemies, and, in after times, when Whiro had been defeated by Tane, the former retired to the underworld, that is he returned within the Earth Mother, with whom his sympathies lay."[1] It is difficult to reconcile this account with the claim that the Maori do not go at all to the sky after death. Evidently the society of the Maori must formerly have been different in nature, and they must have had sky-born rulers.

A similar difficulty exists in Maori mythology. Hina, the great ancestress of the Maori, and ruler of the underworld, seems to be connected with twin deities : for, in one of her forms, she married Irawaru, who was killed by Maui, her brother or son. She went to find Irawaru, and when she arrived at the Sacred Isle, obviously an island connected with a previous home of the race, she married two brothers, Ihuatamai and Ihuawareware,[2] with names so similar as to suggest the dual organization. The Sun has two wives, Hine-raumati, or Summer Maid ; and Hine-takurua, or Winter Maid, with each of whom he dwells in turn.[3] Maui, the great god of the Polynesians, who is so often concerned with the raising of islands from the bottom of the sea, is, in New Zealand, the brother and son of Hina, the mother goddess, the ancestress of the race, who rules in the underworld. Maui is a twin, being born together with an egg ;[4] and he also seems to be a dual personage, Maui-mua and Maui the Great,[5] which is in keeping with his dual nature in Tahiti.

Taylor has an interesting statement which suggests the former presence among the ancestors of the Maori of the dual organization. He speaks of a whare-kura. " The whare-kura is spoken of as having been a very large edifice, in which all the tribes were accustomed to meet together for worship, and the rehearsal of their sacred pedigrees, as well as the heroic deeds of their ancestors, for holding their solemn councils, and administrating justice. The word literally means a red house from the colour it was painted, and is said to have been in existence at a place called Reporoa, before they left Hawaiki ; its extreme antiquity is seen from the circumstance of all those who are recorded as having met there, being regarded as ancient gods ; the temple had a porch or veranda, such as they still make to their houses, this was placed at the gable end, by which they entered, and at the other extremity was a small building in which the high priest resided. The Whare-kura and the Tuahuas were enclosed by a fence, beyond it were the abodes of seventy other priests who had their

[1] Best xi. 137-8. [2] Tregear i. 488.
[3] Best xiv. 5. He gives other interesting examples of duality (pp. 7, 9).
[4] Tregear ii. 30, 54. [5] Id., i. 495-6.

houses ranged around. These were called the Tauira, and their abodes were also enclosed by a fence, being considered a sacred court, each building bearing the name of one of the heavens ; the posts which supported the building were carved to represent their chief ancestors.

" The different tribes which met there were ranged in two grand divisions, one Kahui or party being on one side of the building, and the other on the other ; one company possessed a staff, called To Toko-toko o Turoa, whose owner was Rangit-awaki, the other side also had a staff, named Tongi-tongi, which belonged to Mai-i-rangi, perhaps these individuals were the chiefs who marshalled their respective companies." [1] The break-up of this former stage of society is said to have been due to the quarrels of the two priestess sisters, Rito-wara and Rito-maopo. " At first this temple was a grand place of union for all the tribes, but afterwards it became the source of discord. The tribes which assembled in it quarrelled." [2] Thus they developed warlike modes of behaviour, as so often occurred among the communities of the archaic civilization.

Ancient Hawaiian society probably was organized on a dual basis. Fornander speaks of two classes of chiefs, Iku-pau and Iku-nuu. The Iku-pau were direct descendants of " Kane " the god, or Kumuhenua the first man, and they had the spiritual and temporal power. The Iku-nuu had temporal power. Kane being a sun-god, the Iku-pau would therefore be Children of the Sun, and thus ancient Hawaiian society falls into line with that of the archaic civilization in general.[3] Oahu was the sacred place ; thither went the women of the royal family to give birth to children.[4] This place is the site of a pearl-fishery. There also two girls were born, Laieilauai and Laieloheloche, to the accompaniment of claps of thunder, the prerogative of sacred beings.[5] Thus in New Zealand and Hawaii, the last homes of the Polynesians, as later on in Fiji, Samoa and elsewhere, the dual organization has disappeared.[6] On the other hand, wherever approach can be made to the original home of the Polynesians, and also to the days before the general break-up of Polynesian society, traces of the dual organization can be detected. Apparently, for many centuries, society was founded upon this basis, and, about 1200 A.D. or so, the hostility of the two factions became acute and disintegration set in.

Easter Island society is divided into two parts, the western part, which includes the clan of Raa, the Sun, claiming to be the superior.[7] Hostility exists between the two groups. The story of the peopling of the island suggests a dual society, for the ancestors are said to have come from two adjacent islands, Marae Renga and Marae Tohio. Mention is made of their arrival at

[1] Taylor 174–5. [2] Id., 176–8. [3] Fornander 41–4.
[4] Owen 53. [5] Beckwith 334.
[6] Newell 604 e.s. [7] Routledge i. 221.

Easter Island in groups of "Long-ears" and "Short-ears."[1] The facts are not enough to enable us to understand the real history of the people.

It is unnecessary to insist at length on the widespread distribution of the dual organization, and its modifications, the four- and eight-class systems, in Australia. This topic has been dealt with by numberless writers, and forms one of the commonplaces of ethnological literature. As Howitt says, " It may be laid down as a general rule that all Australian tribes are divided into two moieties, which intermarry, but each of which is forbidden to marry within itself. . . . The division of the tribe into two classes is the foundation from which the whole social organization of the native tribes of Australia has been developed."[2] He states in another place that throughout wide areas of Australia a strong similarity exists between the names of the classes, and, further, that the whole system shows signs of growth from small origins.[3] This is significant, and well worth remembering when speculating on the origins of native tribes. The Rev. John Mathew has also remarked upon the similarity of names. He shows, too, that they are connected with different colours, just as were Upper and Lower Egypt. He thinks that the colour differences betray the mode of origin of the dual organization, namely, the fusion of two different races, one Papuasian, very dark, with curly hair ; and the other stronger, more advanced, lighter in colour, akin to the Dravidians and Veddahs of India.[4]

A curious custom exists in Australia—that of the ball game : " A game of ball-playing was a favourite pastime of the Victorian tribes, of which the Wotjobaluk, Wurunjerri, and the Kurnai will serve as examples. The ball used by the former was made of strips of opossum pelt rolled tightly round a piece folded up and covered with another bit sewn tightly with sinews. The ball used by the Kurnai was the scrotum of an ' old-man ' kangaroo, stuffed tightly with grass. This was called Turtajiraua.

" The Wurunjerri called their ball, which was like that of the Wotjobaluk, Manguri. In playing this game the two sides were the two classes, two totems, or two localities. For instance, in a case which I remember in the Mukjarawaini tribe, the Garchukas (white cockatoos) and the Batyangal (pelicans) played against each other. But this was in fact the class Krokitch against Gamutch. The Kurnai played locality against locality or clan against clan, their totems being merely survivals.

" Each side had a leader, and the object was to keep the ball from the other side as long as possible, by throwing it from one to the other. Such a game might last for hours."[5]

Hewitt remarks that the ball game is a useful index as to the class of a particular totem group. He says that "in games

[1] Routledge 223, 280–1. [2] Howitt 88–9. [3] Id., 137 e.s.
[4] Mathew 166. It will be seen, in the next chapter, that this view is untenable, [5] Howitt 770.

played with a ball, the two segments of one class will play together against those of the other ; or when the whole tribe is gathered together on some ceremonial occasion, the two pairs of sub-classes will camp on opposite sides of a creek. In ceremonial or expiatory encounters, one pair of fellow sub-classes will always side together against the other two."[1] The ball game is mentioned here because it will turn up again in other places as part of the dual organization. This remarkable custom will help much to understand the cultural nature of the dual organization, and to counteract the tendency to imagine that it sprang up independently in various parts of the region.

Coupled with the dual grouping of Australian tribes must go the myths of two culture-heroes who are found connected with the matrilineal tribes, that is, those nearest in culture to the archaic civilization.

The evidence adduced for Indonesia and Oceania is enough to establish the connexion between the dual organization and the society of the archaic civilization. Unfortunately it has not been possible in any one place to discover the original form of the dual organization : that appears to be reserved practically for Egypt. In all parts of Oceania and Indonesia the dual grouping has long since begun to break up, so that mere remnants are left behind to indicate what was the original condition. The complicated nature of the group of customs and beliefs centring round the dual organization will need extended examination, so it will be well to see what evidence can be gained from America before launching out into any discussion.

[1] *Id.*, 14–15.

CHAPTER XX

THE DUAL ORGANIZATION: AMERICA AND CONCLUSION

THE general break-up of society in Oceania has obscured the old form of social organization so thoroughly that it is only possible to piece it together with much labour. It is therefore not to be hoped that the study of the civilization of Mexico will afford many returns. The data are but few, and reliance has to be placed on inference for the understanding of the past. But in the outlying districts, such as the Mound area, the story is much plainer, and the dual organization will be found to exist in its typical form.

The wide prevalence of stories of twin culture-heroes in America gives reason to hope that the dual organization will exist on earth to provide such a reflection in mythology. It has been found that the Twin Children of the Sun correspond to the dual grouping of society: it is thus to be expected that, where such stories are told in North America, the dual organization will be present in some of its elements.

The greatest figure of American mythology is Quetzalcoatl, the Divine Twin, whose brother is Tezcatlipoca. Hostility exists between them, for Tezcatlipoca drove out Quetzalcoatl from their former home at Tulan. They play a ball game in a court running north and south.[1] The sacred book of the Kiche of Guatemala abounds in twin heroes. Two of them, Hunbatz and Hunchouen, play the ball game in a court, just as Quetzalcoatl and his brother Tezcatlipoca.[2] Twin Kiche heroes, Hun-hun-ahpu and Vucub-hun-ahpu, go to Xibalba, the underworld capital ruled over by their enemies, Hun-came and Vucub-came, who are dual kings.[3] This evidence suggests that the old civilizations of Guatemala were on the dual basis, and that the rulers of the Kiche and of Xibalba formed a dual group, of which Xibalba was connected with the underworld. Further evidence is supplied by Landa, who says that the Maya armies were always commanded by two generals: two human faces on a mound temple probably represent these two Maya generals.[4] In later Mexican ritual signs appear

[1] Seler 19: Hagar ii. 89. [2] Brasseur de Bourbourg 71 e.s.
[3] Hartman 148. [4] Hagar i. 27.

314

of a duality. During an annual feast a paste statue of Huitzilopochtli, the great war-god of the Aztecs, was eaten. This was the act of a fraternity, the leaders of which, who wore the insignia of gods, were two in number, corresponding to Tezcatlipoca and Huitzilopochtli,[1] Tezcatlipoca was looked upon as being the twin of Huitzilopochtli, as well as of Quetzalocoatl.

I have not been able to collect more evidence of the former existence of the dual organization in Mexico and the Maya country ; but ample traces of it exist in the United States.

The archæological evidence suggests that the region of the Appalachian gold-field is that which has been most strongly influenced by the Mexican civilization ; for in its mounds have been found obvious Mexican designs, as well as stone graves with extended interments. This is the homeland of the Siouan and Iroquois groups ; it is thus a focus of cultural intensity in the Mound area.

In the Mound area the dual organization appears formerly to have been universal, it being mentioned among the Creek, Chickasaw and Natchez. The Yuchi have a dual grouping of societies, which corresponds to the dual organization of the other tribes. The tribes farther north, such as the Iroquois and the Algonkins, have the dual organization, as have also some of the Plains Indians. But some tribes of the Plains, who are derivations from other regions, for example the Pawnee and Kiowa, show no sign of it. The Cheyenne show traces of what may formerly have been a dual organization, but it is not possible to be certain on the matter.[2]

Mr. Barbeau makes some general remarks upon the dual organization of North American tribes : " The occurrence of the phratries and moieties, although sporadic, is fairly common in the North American Indian tribes, and among people whom the Indian tribes are likely to have come into direct or indirect contact with, such as the Yuchi, the Siouan Indian tribes, the Muskhogean tribes, and the Pueblo and Mexican Indians." [3] He goes on to say that " the phratries and moieties are distinctly at home in the south-east, centre, south-west and Mexico, wherefrom the Indian ones must have been derived. It is, moreover, remarkable that wherever the phratric system is wanting as a whole the clans show no tendency towards growing into phratries." [4] Clark Wissler makes the following interesting statement : " There appears a tendency for certain tribes to divide into two halves, usually described as summer and winter groups, whose chiefs lead alternately according to the season. This is quite conspicuous in the Mississippi Valley, whence it extends into Mexico, and has its counterparts in Peru." [5]

[1] Loisy 405.
[2] Dorsey iii. 49.
[3] Barbeau iii. 397.
[4] Id., 399.
[5] C. Wissler v. 202. Another instance of a widespread unity in American civilization.

Mr. Barbeau claims that the phratric division has been a deliberate matter of politics. "The lack of uniformity in the arrangement of clans in the phratries reveals arbitrary purpose rather than unconscious growth or transmission."[1] The remarks of Mr. Barbeau entirely agree with the conclusions derived from the study of the dual organization in the Pacific. It was found, in Mangaia and Rarotonga, that deliberate efforts were made to set up the dual organization ; and that, in the case of Mangaia, help was actually appealed for from Rarotonga, where lived people who could take on that part of the constitution which dealt with the living. The distribution of the dual organization in North America is what would be expected if it belonged to the archaic civilization, for it is present among those tribes nearest in culture to the archaic civilization. Among tribes who show signs of considerable cultural degeneration it is lacking and, as Mr. Barbeau says, such tribes show no signs of adopting it.

One constant feature of the dual organization in North America is the ball game, which is universal among the tribes from Maine to California, and Mexico to Hudson's Bay.[2] The moieties of the tribes play on different sides in these games. This agrees with the story of the twins in Mexico and among the Maya playing the ball game in a court running north and south. Not only are the twins hostile, but also a hostile feeling exists between the two sides of the community.[3] The tribes are usually divided into two parts, chiefs and warriors, connected with peace and war ; so, in general, the dual grouping has the same characteristics as elsewhere.

The Creek Indians lived in " towns," each with its badge, and belonging to one or other of the two " fires." Those belonging to the same fire were friends ; while those who belonged to different fires were opponents. One fire was that of the " peace " side, while the other was that of the " war " side. Their colours were respectively red and white. Of all the Creek towns, four had precedence, two among the red towns and two among the white towns, while one of the red or peace towns was the head of the whole tribe. I do not know whether this selection of two towns has any reference to a duality of ruling power ; this will have to be a matter for further inquiry. But the following quotation from Mr. Swanton is significant. Speaking of these four principal towns of the Creek confederation, he says : " As a matter of fact these were the leading towns among the Upper and Lower Creeks respectively."[4] In addition to a dual grouping of towns, the Creeks had a dual grouping of clans into " Whites," and " People of a different Speech." Speaking of this dual clan grouping, Mr. Swanton says that it is natural to ask if the white clans belong to the white towns, and the other clans to the other towns. " This is probably a fact, but it is not so consistently shown as would be

[1] Barbeau iii. 398, 400. [2] J. Mooney iii. 105.
[3] Speck ii. 77. [4] Swanton ii. 594.

expected." The clan grouping is evidently fundamental, for the two clan groups play on different sides in the practice ball games.[1]

Mr. Swanton comments on the dual organization of the Creeks. " Creek society," he says, " has resulted from a combination of a number of tribes speaking Muskogee with others employing different languages, mainly those of the same stock. The dual division of towns seems not to be due in this case to a union of distinct tribes, because the non-Muskhogean tribes are found on both sides, and there is a strong tradition that Kowi'ta and Kasi'ta,[2] now in opposite fires, separated from one original Muskogee tribe. An attempt to correlate the dual division of clans with the dual division of towns is not altogether satisfactory. Still the white clans are certainly associated by some Creeks with the white towns and the Tciloga'lgi (' people of a different speech ') with the red towns." [3] Since the Creek people are a confederation, it can hardly be claimed that the dual organization is a matter of chance ; it must have been due to some deliberate organization on the part of men who knew what they wanted. In the Pacific it has already been seen that men from communities where the dual organization certainly existed, took care, if possible, on landing in a new place, to set up the constitution to which they were accustomed at home. This is but natural, as is evident from the consideration of our own political life.

The Chickasaw, the most westerly of the Muskhogeans, possess a dual organization : they have matrilineal clans, each with its own officials, its place in the tribal encampment, and its rank among the other clans. The clans are in two groups, each with its own religious ceremonial, named " Their hickory chopping " and " Worn-out places." The first, the superior, who are the warriors, live in substantial lodges, while the others usually live under the trees in the woods. The groups occupied opposite sides of the council-fire of the tribe.[4] The dual grouping of warriors and inferiors suggests that the " chiefs " have gone, leaving only the warlike part of the tribe, as in Polynesia, and that the people have set up a dual grouping of a modified form.[5]

The Yuchi of the Savannah River have a dual grouping of societies, and each male child belongs to one or other of them. The superior society is that of the chiefs ; that of the warriors is inferior. These societies were originated by the culture-hero. In one place he is spoken of as the Son of the Sun ; but some ambiguity exists about this.[6] Commenting upon these divisions, Speck says : " In a general way there appears to be some points of resemblances between these divisions and the ceremonial and

[1] Id., 597.
[2] This is a significant fact in view of the similarity of names. It is strangely reminiscent of the dual organization of Oceania.
[3] Swanton ii. 598. [4] Speck i. 51, 54.
[5] According to Speck (ii. 75, n. 1), the Chickasaw had the grouping of " chiefs " and " warriors," with the chiefs as the superior division.
[6] Gatschet 280–1.

military societies of the plains. . . . To a certain extent, bearing in mind the feeling of superiority on the part of the Chiefs, and their position in the towns, the two Yuchi groups remind one of the social castes of the Natchez, if we rightly interpret the nature of the latter from historical records." [1] It will be remembered that the ruling class of the Natchez came to the country from a place which was probably Mexico. The Great Sun was the ruler and high-priest of the nation. The head of the army was, in the time of du Pratz, his brother, called Stung Serpent. So this community had religious and military sides, with the religious element predominant.

The Shawnee had five divisions which occupied the two sides of the council-house. "They claimed that they could tell to which division anyone belonged by his general appearance." [2] In a manuscript of 1666 the Iroquois are said to be divided into two bands, one of four families and the other of five families. [3] Corresponding to this they have stories of twins, one light and the other dark. [4] The Seneca likewise had a story of twins, one light and the other dark, born of a woman from the sky-world. [5]

The Huron or Wyandot have the dual grouping of clans. Their account of its origin is as follows : " This is what happened. The Wyandot, the Potawatomi, and the Delaware, speaking three different languages, met together and had a council, wherein they settled their marriage customs. They laid down the law about how they were to get married. First (the Wyandots) were divided into seven (nine in fact) groups (or clans). Then they studied the nature and habits of the game which they used. The first animal that was found was the Deer. Now, no fault could be found with this fellow, for he had a perfectly good nature. That is why they made him their first choice and gave him a clan. Their next choice was the Bear, to whom they also gave a clan. The next was the Porcupine, and here was his clan. Another was the Beaver, and there was his clan. They had thu made one side of the (council) Fire.

" Then they began to form the other side of the fire. It consisted of the Big Turtle, the Prairie Turtle, the Small (striped) Turtle, and, coming the last, the Hawk.

" Another was the Wolf. And the people (belonging to the two sides of the fires) were his cousins.

" Now then (the four clans on one side of the fire formed ' one house,' while the four opposite clans made up another. As to the wolf, he remained all by himself. The four clans in each house were brothers to each other). Were all (mutual) ' cousins ' (those who belonged to opposite houses, so that whoever stood on one side of the fire called ' cousin ' anybody standing on the other side).

[1] Speck ii. 78. [2] J. Spencer 320. [3] Barbeau iii. 394.
[4] Parker iii. 495. Cf. L. H. Morgan 97, 129 : Parker i. 474–6.
[5] Parker ii. 610.

" It was then agreed that this was the law which the Wyandots were to observe. And it had to be proclaimed in such a way that, on all possible occasions, the opposite groups may be known as cousins.

" This is the very first thing done (when they were assembled in council, framing the rules by which henceforth they were to be governed). It was so arranged that those who belonged to the same clan should not be allowed to intermarry. That is why a woman, having a clan, may not get married within it, but only in that of her cousins. This was the established marriage rule which the whole household of the Wyandots was bound to observe.

" Moreover, the same custom was accepted by the Potawatomies, the Delawares, and all the people with different languages who, in time, became friends or allies of the Wyandots, and at the head of all these nations stands the Wyandot for ever. That is why the customs of the Wyandot are also the law for them all." [1] The Delaware of Caney River had three phratries, each with a chief and his assistant, and a war chief and his assistant. There was also a head chief, to whom the phratry chiefs acted as advisers.[2]

The account of the Wyandot is that of the deliberate setting-up of the political constitution of a tribe on a basis of the dual grouping. The probable reason for this is that the Huron had lost their ruling group : for, in the tale of the origin of their tribe, the Good Twin goes back to the sky, while the Bad Twin goes to the underworld, there to rule over the dead in the company of his mother, the ancestress of the tribe. The dual organization had thus broken up, and it was necessary, as in other places, to set matters right.

In the case of the Sauk-Fox Indians, the relationship between the twin culture-heroes and the dual grouping of the tribe is plain. Once upon a time the Manitos lived on the earth. The Great Manito had four sons, two of whom were called Elder and Younger, who were grandsons of the Sun. The Great Manito called all the chiefs together and divided the people into two groups, elder and younger. The younger brother was killed, and became the lord of the land of the dead, " the land beyond the place where Sun goes down." The Elder Brother says to him, " I will create a people after the race of our mother, and they shall follow you, and live with you there for ever." Accordingly, after a flood, he created a new race of men out of red clay, and said to them that he was going away, but would come back : " Then I shall take you with me to the west, to the place where rules . . . my younger brother, your uncle. There we shall meet our kindred that have gone before us, and we shall dwell with them for ever." [3]

In this case the dual division of society is linked up with the Twin Children of the Sun ; each section of the community belongs to one of the twins, and both sections are to be joined together in the next world.

[1] Barbeau ii. 82–9. [2] M. R. Harrington 211. [3] Jones 225–38.

Among the Menomini Indians, who also have the dual grouping, the gods are divided into two sets, which have their own localization. The sky-gods and the underworld-gods are said to meet. " We are two sides—the good gods in heaven, and the gods under the earth. How shall we be partitioned off from each other ? What sides shall we choose ? " The underneath-gods spoke first : " We shall take our own side on the north." The good gods said : " We will choose the side where the sun goes south." So they made a lodge and chose their places.[1]

The Winnebago had a dual grouping of the tribe. The Upper or heavenly group had bird ancestors ; while the lower or earthly group had land animals for ancestors. No significance attached to the twofold division of the tribe.[2]

These somewhat disjointed accounts show that the Indian tribes correlated their social organization and their mythology. The twins are associated, one with the sky, and the other with the underworld, the twin of the underworld being the ruler of the dead in company with his mother. Correspondingly, one division of the tribe was connected with the sky, and the other with the underworld. The political nature of the dual organization is well shown in the case of the Omaha branch of the Sioux of the Plains.[3] They camped in circular fashion, each clan in its appointed place. The circle was divided into two halves, north and south, and each division of the tribe had its appointed half. On the northern side were the clans associated with the sky and peace, and on the southern those associated with the temporal affairs of the tribe and war. According to the Omaha, the sky was masculine and the earth feminine, the union of these two being considered necessary for the perpetuation of all living forms. This order or method for the continuation of life was supposed to have been arranged by Wakonda, and thus it was symbolized in religious rites and social usages and organization.[4] These divisions were based on mystic ideas as to how creation came about and how life must be continued on the earth. The myths relate that human beings were born of a union between the sky-people and the earth-people ; and, in accordance with this belief, the union of the sky-people and the earth-people was conceived to be necessary to the existence of the tribe. There was a teaching preserved among the old men that the division of the tribe was for marital purposes, a teaching which bears out the mythic symbolism of these two divisions. Corresponding to this dual organization, the tribe possesses two principal chiefs, two tribal pipes and so forth, just as the Egyptians had their dual regalia.[5]

The dual organization is in a state of decay among the Plains Indians.[6] The Osage, Dakota, Yankton, Teton, Ponca, Quapaw, Iowa, Omaha, Kansas and Missouri had it, but it is evidently

[1] Michelson 77–8. [2] Radin 211 e.s.
[3] Fletcher iii. 259 e.s. [4] Fletcher and La Flèsche 134.
[5] Id., 135. [6] Id., 62 : J. O. Dorsey ii.

lacking among the outlying tribes, such as the Blackfeet, Crow, Cheyenne, Pawnee and Kiowa. This may be seen by comparing Sketch Maps Nos. 2 and 3. It can therefore be stated that the dual organization is confined to the region of the mounds. Several remarks made with regard to the Siouan group of tribes suggest that more could be learned with regard to their dual organization. For instance : " Among the Eastern Dakota the phratry was never a permanent organization ; but was resorted to on special occasions and for various purposes, such as war or the buffalo hunt." [1] But the Teton division into Upper and Lower, like the Creek and Egyptians ; and certain facts pointing to the splitting of tribes into two distinct parts, hostile to one another and with different functions, suggest that these tribes once had a thorough-going dual organization of society, that is now in process of disappearance.[2]

To turn now to the Pueblo region. The creation myth of the Zuni recounts the origin of the dominant part of the tribe that afterwards joined the sedentary agriculturists to form the present tribe. Although the Zuni community thereby is dual in a way, yet the dominant portion, the new-comers, already possessed the dual organization of society. They were brought out of the underworld by the Twin Children of the Sun. Among the ancestors of the Zuni was Yanauluha, who brought water from the inner ocean of the underworld, the seeds of life-production and growing things, and things containing the " of-doing powers." He had a plumed staff, decorated with feathers, shells and other potent contents of the underworld. With this staff Yanauluha struck a hard place and then blew on the staff. Four round seeds of moving beings appeared among the plumes, two blue like the sky or turquoise, and two dun-red like the earth-mother. Achi, the elder of the Twin Children of the Sun, said that two of these seeds should become birds of brilliant plumage which would fly to the region of summer and plenty, while the other would be pie-bald and would fly to the region of winter and scarcity. Yanau-luha and others followed the macaw into the south, while yet others followed the raven to the north : thus arose the dual organization of the Zuni people. The twins and the priest-fathers consulted together as to the proper constitution of this dual grouping.[3] So evidently the Twin Children of the Sun played an important part in the constitution of the Zuni tribe, and to them must be ascribed the dual organization.

The Children of the Sun among the Zuni changed into the twin war-gods, and preserved their dual characteristics. For their shrines are divided into two sets : those to the north for the elder war-god, and those to the south for the younger. The following quotation shows how much information is still to be gathered with regard to dual institutions. " Cushing refers to six new

[1] J. O. Dorsey iii. 221 : Riggs 195.
[2] Riggs 156 e.s. : J. O. Dorsey iii. 213 e.s. [3] Cushing ii. 384-6.

21

shrines of the war-gods, three to the north belonging to matsailema, he being associated with the left hand (facing the east, the north is on the left), and three shrines to the south belonging to ahaiiuta, he being associated with the right hand. In addition there are two peace shrines, one on towa yallane belonging to matsailema, and one on the ' Mountain of Lovers ' (?) belonging to ahaiiuta." [1]

The Hopi Indians of the Pueblo group, formed by the amalgamation of clans coming from all directions, have not constituted themselves into moieties, such as are possessed by other tribes. The Pima Indians of the Pueblo group, whose culture has degenerated much from its former condition, are divided into two groups of clans, one called the Vulture or Red people, and the other the Coyote or White people. These groups are also named Red Ants and White Ants. The red people are said to have been first in possession of the land ; while the white people, who were brought out from the underworld by the culture-hero, the Elder Brother, conquered them.[2] The Sia, another degenerate Pueblo tribe, have no dual grouping. Other tribes associated with the Pueblo Indians who have adopted the nomadic mode of life, such as the Navaho, have no dual grouping.

Little mention has been made in this book of the food-gathering Indians of California. Situated, as they are, in a country possessing traces of ancient mining activity, and living near to the Pueblo region, it is improbable that they would have escaped the influence of their neighbours. Some of these tribes have a dual organization : the moieties are connected with land and water ; sometimes they perform reciprocal ceremonial functions ; they oppose one another in games ; sometimes a dual chieftainship exists ; and the moieties are usually exogamous.[3] This case is reminiscent of that of the Australian tribes, who, although they do not seem to have acquired much material culture from the archaic civilization, have been profoundly influenced in their social organization. The Sakai of Sumatra are also similar in this respect. These three examples show that different elements of culture move with varying ease into new territories.

In the Pueblo region, which has witnessed so much migration and so much disturbance during the centuries, the signs of the dual grouping of society are not plentiful, but when they occur it is in conjunction with the Children of the Sun. At the same time these people have no class descended from the Children of the Sun living among them. Consequently, all their interests are centred on the underworld, where live the great mother, the ghosts of the dead and the " breath bodies " that, in other places, go to the sky after death. This suggests that the first settlers of the Pueblo region were led by Children of the Sun, that is, by members of the ruling group of Mexico, and came there to work the turquoise, gold and other deposits. For some reason the rulers disappeared,

[1] Parsons, AA, 1918, 391. [2] F. Russell 197. [3] Gifford 291 e.s.

and left only their subjects, who, like the right- and left-hand castes of Southern India, maintained their original form of social organization. But this dual grouping, as is shown in the case of the Hopi, disappeared when the original communities were broken up.

It now remains to try to understand the significance of the dual organization of society. The evidence shows that, in later times, it has almost, if not entirely, disappeared. In India it survives in fragments; in Indonesia it has almost disappeared; it is not found in those parts of Melanesia tenanted by the last-comers, the betel people of Rivers; it is not in New Zealand, and in various groups of the Pacific, such as Hawaii, the Gilberts and the Ellice group, that have been colonized last of all; in North America it is lacking among the Indians of the Western Plains, such as the Arapaho and Cheyenne. That is to say, the youngest peoples, so to speak, lack it entirely, or possess it only in fragments. The places where it has been possible to gain the clearest impression of this form of society are Egypt, Southern India, South Celebes, Sumba, Timor, the Moluccas, New Guinea, Australia, Southern Melanesia, the earliest settlements of Samoa, and in the Mound area of the United States, just in those places where clear signs of the archaic civilization have been detected, as may be seen from Sketch Maps Nos. 2, 3, 4, 5 and 6. It is thus possible to watch, as it were, the spread of this form of civilization from pearl-bed to pearl-bed, and goldfield to goldfield; for traces of the dual grouping exist in the region of the pearl-beds of Ceylon and South Celebes, in the gold and copper regions of Timor, in the region of the pearl-fisheries of the Moluccas,[1] in the pearl-fisheries of Micronesia, British New Guinea and Melanesia, and in those parts of Polynesia specially noted for their pearls, Fiji and neighbourhood, and Tahiti and the surrounding groups.[2] The only place where the relationship does not hold so closely is that of Samoa, where the pearl-fisheries are not so important. Nevertheless pearls are reported, and there may formerly have been more. In any case the dual grouping did not last long in Samoa; it did not survive the first settlements in Manu'a and Savai'i. Thus right across the pearl-fishing region, from Egypt to America, is a chain of dual settlements. Off the track of pearls and gold they are rare. They thus provide a geographical test for determining the route of the Polynesians on their journey out into the Pacific, and search should reveal further dual settlements left behind by these people.[3] It would also be of great interest if, farther west, say in the region of the Persian Gulf and the Red Sea, other dual settlements such as those recorded in Ceylon should be found; for, in that case, every pearl-field from Egypt to America

[1] Sketch Map No. 8.　　　　[2] Sketch Maps Nos. 4–6.
[3] The papers now being published by Heer Kruyt constitute an example.

would have been occupied by people making dual settlements.[1]

The evidence collected regarding the dual organization is not of uniform weight. In some instances it is mythological or traditional, in others it concerns the structure of the village, in others the whole society from the ruling family to the clan is dual.

The most widespread form of dual grouping is undoubtedly that of the dual village, whether occupied by one clan, or by a group of clans. This form of dual grouping is found among the Naga tribes of Assam, the Parava caste of South India (traditional); in Sumba of the East Indian Archipelago; in Yap, the Pelews and Ponape of Micronesia, where it even extends to two landing-places for canoes; in British New Guinea; in Fiji and in the early settlements of Samoa. A corresponding grouping is that of the tribe, which is especially characteristic of Australia and North America, but is found also in Assam and elsewhere. The tribe consists of a group of clans occupying a given territory and speaking a common language. The tribes in the places mentioned are divided into two groups like the villages, and really correspond, except that they are not necessarily sedentary in habit. In some cases the clan itself can divide into two parts, as among the Nair of Malabar, the Todas; in Micronesia and in British New Guinea; and among the Creek Indians of North America. The wide distribution of villages or tribes with the dual grouping does not necessarily mean that this form of grouping is fundamental, and that the dual nature of the kingship is secondary, for it can quite well be that the dual organization of the Australians and of the villages of British New Guinea represents what is left after the break-up of a centralized authority, as is evidently the case with the right- and left-hand castes of South India.

A further dual grouping is that of the whole territory of a tribe into two parts. In some cases this is accompanied by a ruling class, but this need not be so. Such a localized grouping is found in Egypt, in Assam among the Nagas, on the Malabar Coast; in Timor as well as in Macassar of Indonesia; in British New Guinea; in the New Hebrides (Tanna being noteworthy); in Samoa, in early Tahiti, according to the legend of Honoura; and among the Creeks of North America.

The two sides have feelings of hostility to one another. This hostility can be experienced between the two sides of a clan group, as in the Pelews; between two sides of a village, as in the Pelews and British New Guinea; between two parts of an island, as in Southern Melanesia; or between two sides of a tribe, as in North America and British New Guinea. This hostility often extends to continual warfare, as in British New Guinea among the Mekeo tribes. Associated with it is the ball game or its

[1] It is significant that the Phœnicians, who probably came from the Bahrein Islands in the Persian Gulf, possessed so many cultural elements of the archaic civilization, and show signs of dual institutions. See p. 501.

variants. In Australia, Fiji, and throughout North America, it is customary for the moieties to take opposite sides in a game played with a ball, or with some object such as reeds. The wide distribution of this custom makes it certain that further search will reveal its existence in other places.[1]

Another persistent feature of the dual divisions is the superiority of one group. This is the case in India among the Bhar, Bhil, Nairs and Pariahs; in Micronesia in the Pelews and Ponape; throughout the dual region of Melanesia, in Fiji villages; and throughout North America. In certain cases the divisions are connected with distinctive colours; the colour of Upper Egypt was white, while that of Lower Egypt was red; in India the Bhil divisions are white and black; some Nair clans are divided into white and black divisions; in Melanesia the dual divisions are connected with light and dark colours; the dual divisions of Tanna of the New Hebrides are connected with different colours; and so are the two groups in Australia; in Samoa, the primordial ancestors of the people, Po and Ao, are connected with two pearl-shells, one bright and the other dark; in America the Creeks are divided into red and white divisions; the Pima groups are also red and white. A wide association with colours is thus characteristic of the moieties of the dual organization, and the superior side of the community is invariably connected with the lighter colour. The dual grouping also possesses a ceremonial significance. In India at Kancipuram the right- and left-hand castes have separate halls; the Kaldebekel, the clubs of the Pelews, are grouped in two divisions corresponding to the two sides of the villages; in British New Guinea the club-houses are sometimes in pairs for each village, or else each side of the village or of the clan has its own side of the club-house; in the Nanga society of Fiji the members are divided into two parts; the Areoi society of Eastern Poly-nesia was dual in nature; the Yuchi of North America have a dual grouping for ceremonial purposes; so have the Omaha, the whole tribe being divided into two parts, one connected with the sky and the other with the earth, each side possessing the proper ceremonies; and the Californian moieties have reciprocal cere-monial obligations. Sometimes the dual divisions are distin-guished as elder and younger. The clans of the Pelews split up into elder and younger branches; the clans of the Mekeo of British New Guinea likewise split into elder and younger. Another grouping is that of right- and left-hand sides. This is especially prominent in India, the castes of South India being divided in that manner. This division of right- and left-hand castes was connected with the duality of ceremonial buildings, as in British New Guinea, where the divisions are right and left hand, and occupy the corresponding parts of the club-houses and of the

[1] W. Müller notes the ceremonial nature of the ball game in Yap. It is evidently a survival (222).

village itself, which often consists of a street with the houses on either side.

Dual settlements also have similar names : this is so in the legend of the Parava caste in India; in Sumba the village names mean a seaward and an inland part ; in the Moluccas the dual societies have similar names, and the groups are connected with the sea and the land respectively ; in British New Guinea the Mekeo tribes originated in two settlements with names extremely alike ; the clans of the people of British New Guinea that split up have very similar names for their divisions ; the early settlements of Samoa in Manu'a are of a similar nature to those of Sumba and elsewhere, consisting of a seaward and a landward part with similar names ; in Tahiti the territorial divisions are similar in name : one of the clans of the Creek split up into two divisions with similar names.

It has been suggested that the dual organization owes its origin to the amalgamation of two distinct peoples. But the bizarre nature of its characteristics make it imperative to reject this solution. How could it come about that people in North America, Fiji and Australia play games, the different sides of the community playing on either side ; why should the moieties be distinguished by colours ? Certain characteristics, such as the feeling of hostility and the superiority of one side over the other, could be explained in this way, and possibly in some cases the colour distinction ; but what is the explanation of the sea and land side of the villages, the elder and younger distinction, and the great similarity of names ? In certain countries, in Egypt for instance, and in North America, amalgamation seems to be out of the question. The fact that, in Rarotonga and Mangaia, and among the Huron and Omaha of North America, steps were taken to set up the dual organization that had broken down, shows that it was part of the political organization, and that it was considered essential for the well-being of the community. In this way alone can the multiplicity of characteristics be explained, and not by some fortuitous process at work all over the world.[1]

The hostility between the moieties is a remarkable feature of the dual organization. It is not necessary to inquire at the moment into its origin. Its effects on the archaic civilization are evident. For in more than one instance, in eastern Polynesia and among the ancestors of the Maori, it is directly said that this hostility finally broke up the old order and gave rise to migrations of peoples. Such an instability is bound finally to lead to such consequences in certain circumstances. The case of the Mekeo tribes of British New Guinea, added to those just mentioned, suggests that this hereditary hostility, together with the custom of human sacrifice, serves to account for much of the warfare of the region.

This analysis has as yet taken no account of political groupings.

[1] Cf. B. Spencer 6, who rejects the idea of admixture.

The important part played by ruling groups in the story already told makes it certain that they must figure prominently in the dual organization. In some places the dual grouping of clans, the dual divisions of villages, and the dual divisions of the larger community, evidently depend upon a duality in the ruling group. The Nair chiefs had adherents divided into two groups, which correspond to the right- and left-hand castes of southern India ; but it is not said whether this duality corresponds to any duality of the rulers. This may indeed formerly have been the case ; for the right- and left-hand grouping of villages in British New Guinea is accompanied by a duality of chiefs, each side of the village, among the Koita, Roro, and other tribes, having its own hereditary chief. The work of Kruyt and others has revealed the existence of dual States and ruling families in Sumba and in Timor, while some of the Macassar and Bugi States of Southern Celebes have dual ruling groups. The co-existence of dual ruling families and dual divisions of a village or tribe is recorded in the Pelews and Ponape in Micronesia, where the clans are grouped round two principal families, who supply the head chiefs of the village ; Fijian villages are divided into " nobles " and " teeth of the land " ; the story of the setting-up of the dual organization in Rarotonga suggests also that a duality of ruling families was a necessary part of society ; Kariki took one side of the island, Tangiia took the other side ; and each had associated with him eighty subordinate chiefs as well as priests ; the ruling family of the Natchez of Louisiana was dual, and this duality is compared with that of the Creek and other tribes of the Gulf region. The lack of more facts illustrating the relationship between ruling groups and the dual organization is due partly to insufficient data. It is evident, however, that further information should not be sought where ruling classes are lacking, in Australia, Southern Melanesia and elsewhere ; in such places discussion can only be concerned with mythology.

A further duality characterizes the ruling element of society. Chiefs are divided into sacred or peace chiefs, on one side of the community, and war chiefs, on the other side. This form of duality is found in Egypt in the Fifth and Sixth Dynasties, when to all appearances, the ruling power was divided between the royal family of Heliopolis, and other families, associated with Memphis in the Fifth Dynasty, and Abydos in the Sixth Dynasty, these latter families supplying viziers. Evidence is lacking, so far as I am aware, of a similar condition in India, except that the grouping of adherents of the Nair chiefs suggests a duality of the ruling power. Sacred and war chiefs are widespread from one end of the Pacific to the other. In Ponape, Yap, and probably the Pelews, the two ruling families around which the villages are grouped supply the hereditary peace and war chiefs. Evidence is also forthcoming from British New Guinea, where the sacred chief is the superior ; he occupies the right-hand side of the village

house, and is connected with the right-hand side of the village street. In Tonga and Manu'a of Samoa the ruling chiefs were divided into peace and war chiefs, the sacred chief being the superior : this evidently was also the case in Mangaia before the departure of Tangaroa. In North America the grouping of tribes into peace and war sides is common ; one side of the tribe supplies the peace or sacred chief, and the other supplies the war chief.

If the dual organization formed part of the archaic civilization, the Children of the Sun should play some part in it ; and in the distinction of sacred and war chiefs it would be expected that they would supply the sacred chiefs. This certainly seems to have been the case in the Manu'a settlements of Samoa, and among the Natchez, as well as in Egypt. Direct information on this point must necessarily be scanty on account of the early disappearance of the Children of the Sun in most parts of the region. Nevertheless, it is possible to approach the matter otherwise, and to observe that, in addition to Samoa, the early organization of Mangaia, Rarotonga and that of the ancestors of the Maori certainly consisted of two parts, one connected with the sky and the other with the underworld. This form of dual grouping persists still among the Omaha of North America, in spite of the fact that they have lost their class of hereditary chiefs. Other Indian tribes of North America display a like duality of sky and underworld. It is thus legitimate to claim that, in the archaic civilization, the dual grouping of the community was centred round a ruling group that, being dual in itself, was connected with the sky and the underworld.

It is now time to turn to the culture-heroes, founders of villages, ancestors of ruling groups that have figured throughout the discussion. It can be shown that these beings have characteristics similar to those possessed by the two sides of the dual grouping ; they have similar names, they are hostile, they are connected with different colours, they are elder and younger, superior and inferior. They have similar names in some instances. They occur as Sunda and Upusunda and the numerous pairs of brothers with linked names in Indian Epic ; as the founders of Tha-htun and Pegu in Burma, Titha Kumma and Dzaya Kumma, Thamala and Wimala ; as Khunlun and Khunlai, prince-elder and prince-younger, who came from the sky to found the Ahom kingdom of Assam ; the great ruins of Nanmatal in Ponape of the Carolines are connected with Olo-sipa and Olo-sopa, who in all probability are Children of the Sun. The Koita of British New Guinea claim descent from two brothers, Kirimaikulu and Kirimaikapa ; in Manu'a of Samoa, " Fue, the son of Tangaloa, that came down from heaven, had two names, Fue-tan-gata and Fue-sa ; he peopled the two flat lands " ; one account of the early rulers of Tau in Manu'a makes the rulers of the two sides of the island Ali-'i-a-tama, and Ali'i-a-matua, the younger Ali'a and the elder Alia ; in the story of the foundation of Samata in Savai'i the two

boys are named Mata-i-uta and Mata-i-tai, " Eyes to inland " and " Eyes to sea " ; in Tahiti, Honoura calls himself " Maui behind " and " Maui in front," a dual name for a single person ; the ancestors of the race were Tii Maaraauta and Tii Maaratai ; in America dual names of twins occur ; the Kitche twins were Hun-came and Vucub-came, Hunbatz and Hunchouen. Throughout the region, therefore, culture-heroes and other traditional beings have dual names. They are also hostile and different in disposition ; the story of Sunda and Upusunda centres round their ultimate quarrel over a girl ; in Melanesia To Kumbinana and To Kovuvuru of the Gazelle Peninsula have different qualities, being clever and full of guile on the one hand, stupid and ignorant on the other ; one is light and the other dark. In the Banks Islands and the New Hebrides, the two culture-heroes have similar qualities. In North America the culture-heroes are hostile and possess different qualities : they play in the ball game ; one is light and the other dark among the Iroquois ; the Huron twins are distinct, one being good and the other bad. The twins are connected, by the Zuni, with the right and left hands.

Culture-heroes and other traditional beings differ in their characteristics from place to place, but correspond in their associations to the ruling groups of the particular community with which they are connected. Where the community as a whole is connected with the underworld, no apparent distinction exists between the culture-heroes. This is so among the Koita people of British New Guinea, who claim descent from two brothers, Kirimaikulu and Kirimaikape, and a female dog. The culture of these people is of secondary derivation from the archaic civilization, and the dual grouping has no reference to sky and underworld. This is also in the foundation of Samata in Savai'i of Samoa. The settlement was dual, and so were its founders. They did not belong to the original ruling family of Manu'a, the Children of the Sun of the Tagaloa family, but were nobles ; consequently, in Savai'i, the underworld is the sole place with which men are concerned. The duality of the founders of the settlement, and their exclusive connexion with the underworld, is a reflection of the form of duality of the original settlement. This is again shown in the case of the dual settlement of Fasito'otai and Fasito'-outa, in Aana, which are connected with the sons of a former king of Aana. No mention is made of their connexion with the sky-world and the underworld, and their ancestry is not solar. In Aana the home of the dead is underground and the gods are war-gods. The founders of those settlements which have a ruling class associated with the underworld evidently do not show a variety such as characterizes the ruling groups that include the Children of the Sun. This contrast is well shown in the early traditions of Manu'a in Samoa. In Manu'a it is evident that the ruling power was dual in the beginning, and this is reflected somewhat in the character of the first rulers, Taeotagaloa and Le

Fanonga. They divided the rule of Fitituta between them. Taeotagaloa originally was the sacred ruler and Le Fanonga the war chief, and it would be expected that Taeotagaloa would be connected with the sky-world and Le Fanonga with the underworld. This is so, for Le Fanonga was a war-god of Upolu, having come there from Manu'a. Thus connected with the fact that the Children of the Sun were in Manu'a, the two rulers of their settlement were connected respectively with the sky and the underworld. Then came the remarkable change in which Taeotagaloa changed himself into a war-god, and went to the other side of the island. This means, if the conclusions arrived at be correct, that a political change had taken place, and that the Children of the Sun had disappeared,[1] so that henceforth the whole of the mythology of the island was centred round the underworld. This is seen in the settlements of Upolu and Savai'i, already mentioned, in which the founders are both apparently connected with the underworld. In Manu'a the duality of founders of settlements accompanies that of the ruling family. This consisted of two branches, the Children of the Sun, represented by the Tagaloa family, and a group connected with the underworld, represented by La Fe'e and others. The duality of the settlements is thus faithfully reflected in their founders. When the Children of the Sun disappear, so does the duality of sky and underworld; the other side of the ruling group sets up a like organization, but associated solely with the underworld.

What is the real meaning of the twin nature ascribed to culture-heroes ? It is patent that the real founders of dual settlements were not twins, and that they did not have names such as " Eyes to sea " and " Eyes to land." The twins are not real. They correspond in characteristics to such dual settlements, and thus must be their mythological reflections. This is not the end of the matter ; for the dual settlements are themselves presumably but the reflections of the ruling group. It follows, therefore, that the culture-heroes reflect the nature of the ruling class of the community.

This conclusion is in harmony with those already reached concerning the relationship between mythology and history, between gods and men. It has repeatedly been evident that the social, political, economic and religious sides of the life of a community are inextricably interlinked. This latest conclusion only carried one step farther the realization of the mutual interdependence of the various aspects of society. In the present instance it is evident that the dual settlements have an objective existence ; the twins must therefore be their mythological reflections, for they have similar characteristics to those of the settlements.

The conclusion, that the founders of settlements derive their characteristics ultimately from the ruling group that founded the

[1] Perhaps exterminated as in Timor.

settlement, makes it possible to suggest, from the characteristics of the founders, the form of the original ruling group. It has been seen that settlements derived from the secondary movements show no signs of a distinction of sky-world and underworld; this characterizes only the communities of the archaic civilization, as Egypt, Manu'a, Mangaia and elsewhere. The certain existence of this distinction in such places makes it possible to claim that, wherever the founders of settlements are connected with the sky and the underworld, this duality was derived from the original ruling group itself, and from no other source.

An examination of those cases where such a distinction exists between the founders of communities show that they are usually Children of the Sun by a process of theogamy. Sometimes it is only said that they were born of women from the sky-world. In either case they are connected with the ruling class of the archaic civilization. In India the sun-gods, especially Kasyapa, are the fathers of twins, or of brothers with the characteristics of the dual organization. The Garudas and Nagas in India are the children of sisters, their father being Kasyapa the Sun ; the sons of women from the sky in North America are connected with the sky and the underworld. In both these countries, therefore, reason exists for believing that the ruling groups originally consisted of two parts connected respectively with the sky and the underworld. In this scheme can be incorporated the Kiche-Xibalba group of ruling families, connected respectively with the sky and the underworld, hostile, and reputed to be twins. Doubtless the twin names of founders of settlements are derived from the settlements themselves. This feature of the Children of the Sun and other founders of settlements can thus be put on one side as secondary. When that is done these traditional beings still possess characteristics that need explanation. In certain places, such as Manu'a in Samoa, Mangaia, Rarotonga and elsewhere, the founders of ruling houses have entirely different names and are connected with the sky and the underworld respectively. Taeotagaloa and Le Fanonga in Manu'a ; Kariki and Tangiia ; perhaps Rongo and Tagaloa in Mangaia ; Garuda and the Nagas in India. This corresponds evidently to the duality of the ruling group which consists of two families. One important fact remains, however, even when the twin characteristics have been cleared out of the way. The two beings are brothers, usually half-brothers, and usually the father is a being of the sky-world. Taeotagaloa and Le Fanonga were both the sons of Tagaloaui, and they could go to the sky to attend council meetings. That is to say, in the case of Le Fanonga, a being of the underworld belonged to the sky-world, or rather was descended from a father of the sky-world. How comes this unity of father and duality of association ? This question will have to be answered in Chapter XXIII.

CHAPTER XXI

THE TOTEMIC CLAN SYSTEM

THE discussion of the dual organization of society in the archaic civilization struck one practical note. Although in many instances the dual grouping has been allowed to fall into decay, yet, in the cases of Tahiti, Mangaia, Rarotonga, as well as among North American tribes, it was deliberately reconstructed after its disruption. This points to its utility in the lives of the people. A study of one example where the dual organization was set up again, shows that the dual grouping in itself was not necessarily the cultural element that was most prized ; the real aim was to reconstruct the tribal council that could carry on the affairs of the community. In the Huron story already recounted, the people were divided into clans, each connected with an animal. These clans were, moreover, grouped into two sets, that were said to sit on opposite sides of the fire. The meaning of that phrase lies in the fact that the heads of the clans sat in the tribal council, and that, during the meetings, the two sides of the dual grouping sat on opposite sides of a fire.

Since these people took the trouble to reconstitute the tribal council, it evidently must have formed an important part of the life of the tribe. In the case of the Huron, or Wyandot, it has been suggested that the reconstruction of the tribe took place after this disappearance of the ruling group. If that be so, the people evidently laid more store by the council of elders of clans, than they did by the rulers of the tribe. Similarly, the Omaha, having lost their hereditary chiefs, retained their council, and preserved certain symbols of unity of the tribe, such as the pipes. Since such peoples are supposed to have derived their social and political organization from the archaic civilization, it follows that the clan grouping and the council must also have belonged to the archaic civilization. It would also be expected that, reasoning from the cases of the Huron and Omaha, the council of the archaic civilization would show more power of persistence than the kingship, and that the disappearance of the ruling class would not involve that of the council.

Another feature of the clan system of the Huron and Omaha must be remembered—the association of each clan with an

animal.[1] Is this a constant feature of the archaic civilization, or do the local circumstances in North America account for it ? From general reasoning it would be expected that it belonged to the archaic civilization, and inquiry will show this to be the case. It may, therefore, be asked : Do the communities of the archaic civilization consist of related groups claiming descent from a common ancestor, the heads of each group forming a council to adjust the affairs of the community ? And are these groups invariably connected with some emblem ?

Egypt was divided into a number of provinces, called by the Greeks " nomes." They existed in pre-Dynastic times, and were probably twenty in number, ten in each part of Egypt.[2] As to their constitution, Maspero says that : " The country was divided among communities, whose members were supposed to be descended from the same seed (pait) and to belong to the same family (paitu) ; the chiefs of them were called ropaitu, the guardians, or pastors of the family, and in later times their name became a title applicable to the nobility in general." [3] The nomes were designated by signs of sorts, animals, plants or material objects. Thus the hawk gave its name to the " Followers of the Hawk." The dog, ibis, scorpion, lion, ram, owl, elephant, bull, palm, bee, viper, reed, sycamore, bow, arrows, harpoon, axe, boomerang, mountains, and the sun also appear as ensigns.[4] The relationship between the animal of the nome and the people of the nome, especially the ruling group, was close ; it was supposed to be the actual incarnation of the deity of the nome ; it guarded the community during peace ; in war it marched at the head of the army. Periodically a woman slept in the temple of the nome-god, and was supposed to have connexion with the animal.[5] This relationship played an important part in later times in connexion with the kingship, the foundation of the sovereignty being the result of struggles between the ruling families of the nomes. But that side of the development of the relationship between men and animals cannot be discussed here ; the inquiry must be kept strictly to the connexion between the territorial divisions and the animals, and to the part played by these territorial divisions and the later history of the country.

An inquiry into the political functions of the nomes of Egypt enters into obscure places. Breasted gives, as usual, a lucid account of what is known. He shows that in the early dynastic times, known as the Old Kingdom, and comprising the first six

[1] The association is sometimes with plants or material objects. This point will be dealt with in the next chapter.
[2] Breasted iv. 30, 31.
[3] Maspero ii. 70–1. It must be remarked that his statements with regard to kinship are disputed.
[4] Moret iii. 188–9.
[5] *Id.*, 193. What of the plants and material objects that are associated with some nomes ? It would be interesting to know their relationship to the people of the nomes.

dynasties, the whole of the administration of the country was bound up with the ruling family. " The entire complex of palace and adjoining offices was known as the ' Great House,' which was thus the centre of administration as well as the dwelling of the royal household. Here was focussed the entire system of government, which ramified throughout the country.

" For purposes of local government, Upper Egypt was divided into some twenty administrative districts, and later we find as many more in the Delta. These ' nomes ' were presumably the early principalities, from which the local princes who ruled them in prehistoric days had long disappeared. At the head of such a district or nome there was in the Fourth and Fifth Dynasties an official appointed by the Crown, and known as ' First under the King.' Besides his administrative function as ' local governor ' of the nome, he also served in a judicial capacity, and therefore bore also the title of ' judge.' In Upper Egypt these ' local governors ' were also sometimes styled ' Magnates of the Southern Ten,' as if there were a group among them enjoying higher rank and forming a college or council of ten. While we are not so well informed regarding the government of the North, the system there was evidently very similar, although there were perhaps fewer ' local governors.' Within the nome he administered the ' local governor ' had under his control a miniature State, an administrative unit with all the organs of government : a treasury, a court of justice, a land-office, a service for the conservation of the dykes and canals, a body of militia, a magazine for their equipment ; and in these offices a host of scribes and recorders, with an ever-growing mass of archives and local records." [1] These local governors in their judicial capacity were said to be " attached to Nekhen " (Hieraconpolis), " an ancient title descended from the days when Nekhen was the royal residence of the Southern Kingdom." [2] In the New Kingdom the Vizier's " Hall " was also called the " Great Council," the vizier being in charge of the administration of the State. In the Fifth Dynasty, when the Children of the Sun appear on the scene, the ruling power was dislocated, and the rulers of the nomes took the opportunity of making their office hereditary, instead of elective, as hitherto. In those days, therefore, Egypt probably was governed as follows : At the head of the State was a king, the sacred ruler. Then came the vizier, who, from the Fifth Dynasty onwards, belonged to a different family. He presided over a Council composed of the hereditary rulers of the territorial divisions, each of which was distinguished by some ensign. Each nome was ruled by its Governor.[3]

In India the inquiry falls under two heads : firstly, the relationship between clans and animals ; secondly, the mode of government

[1] Breasted v. 79–80.　　　　　　　　[2] Id., 81.
[3] Cf. Newberry i. 23, for a description of the Vizier's Hall, where he was assisted by the Elders of the Southern Tens. See also Strabo xvii. I. 37.

of the clans and of the people as a whole. Egypt provides little evidence to show whether the people of each nome believed themselves to be related to the animal or plant, or thought that their ancestor was associated with the material object from which it took its name. But in India, and the countries to the east, a definite relationship binds together clans and ensigns, which is well known under the heading of Totemism. This relationship may be defined provisionally, with Rivers, as : " (1) The connexion of a species of animal or plant, or of an inanimate object or class of inanimate objects, with a definite social group of the community, and typically with an exogamous group or clan ; (2) a belief in a relationship between the members of the social group and the animal, plant or object, a belief in descent from the animal, plant or object being a frequent form which this relationship takes ; (3) respect shown to the animal, plant or object, the typical way of showing the respect being that the animal or plant may not be eaten, while an inanimate object may not be used at all or only with certain restrictions." [1]

The subject of totemism is very large, and, as may be seen from the definition, complicated ; for not only is descent from the totem claimed, but also the system is coupled with various restrictions. For the present attention will be paid chiefly to the totemic clan in itself ; its relations to other clans, in the form of marriage regulations, will be discussed in a later chapter.

Fortunately it is not necessary to go into the distribution of totemism in detail ; that task has been performed by Sir James Frazer. He shows that totemic institutions are possessed by the Dravidian- and Austronesian-speaking peoples, and to a certain extent by the tribes of Assam, but are lacking among the Aryan-speaking peoples. [2] The Aryans are therefore distinguished in yet another way from the other peoples of India. It is possible, however, to go farther. The Aryans of India formerly had sun-gods, which have been pushed into the background by Indra, a war-god. These sun-gods were the children of Aditi, the mother goddess ; so, bearing in mind the relationship between ruling groups and deities, it is possible that the Aryans formerly had totemic institutions, and that they are related, by their ruling groups, to Dravidian and other royal families.

The Epics and Puranas give accounts of the beginnings of the earth and of human society, that agree in fundamentals, even if they differ in detail. The creation of the universe is ascribed to Brahma, who produced certain male beings, called mind-born sons, who were the ancestors of mankind ; he is also said to have produced all animals and plants. [3] One of his mind-born sons, named Daksha, became the father of sons through his wife Asikini, whom he had wedded when he decided to begin sexual intercourse. [4] The story of these sons is suggestive. They numbered five thousand,

[1] Rivers ix. II. 75.
[3] H. H. Wilson 37 e.s.
[2] J. G. Frazer ii. IV. 329 e.s.
[4] *Id.*, 117.

and Daksha determined that the universe should be peopled by them. But, owing to the intervention of Narada, another mind-born son of Brahma, they decided first of all to explore the universe : " Having heard the word of Narada, the sons of Daksha dispersed themselves through the regions, and to the present day have not returned ; as rivers that lose themselves in the ocean come back no more." Daksha then propagated some more sons, with like result : [1] then he created sixty daughters of the daughter of Virana (Asika), his wife, and gave some of them in marriage to Kasyapa, one of the forms of the sun-god. These daughters were Aditi, Diti, Danu, Arishta, Surasa, Surabhi, Vinata, Tamra, Krodhavasa, Ida, Khasa, Kadru, Muni ; [2] so Aditi, the great mother of the gods of the Aryans, is grouped with Danu, Diti and others, who are the race-mothers of the Dravidians. The posterity of all these sisters are, moreover, the Children of the Sun. These gods bore their mother's name ; and just as the Adityas were the children of Aditi, so also were the Danavas and the Daityas the children of Danu and Diti. But it is possible to go still farther ; for " Tamra " (a wife of Kasyapa) had six illustrious daughters, Suki, Syeni, Bhasi, Sugrivi, Suchi and Gridhrika. Suki gave birth to parrots, owls and crows ; Syeni to hawks ; Bhasi to kites ; Gridhrika to vultures ; Suchi to water-fowl ; Sugrivi to horses, camels and asses. Such were the progeny of Tamra : Vinata bore to Kasyapa two celebrated sons, Garuda and Arjuna ; the former, also called Suparna, was the king of the feathered tribes, and the remorseless enemy of the serpent race : the Children of Surasa were a thousand mighty many-headed serpents, traversing the sky.

" The progeny of Kadru were a thousand powerful many-headed serpents, of immeasurable might, subject to Garuda ; the chief amongst whom were Sesha, Vasuki, Takshaka, Sankha, Sweta, Mahapadma, Kambala, Aswatara, Elapatra, Naga, Karkota, Dhananjaya, and many other fierce and venomous serpents.

" The family of Krodhavasa were all sharp-toothed monsters, whether on the earth, amongst the birds, or in the waters, that were devourers of flesh.

" Surabhi was the mother of cows and buffaloes ; Ira of trees and creeping plants and shrubs and every kind of grass ; Khasa, of the Rakshasas and Yakshas ; Muni of the Apsarasas ; and Arishta of the illustrious Gandharbas.

" These were the children of Kasyapa, whether movable or stationary, whose descendants multiplied infinitely through successive generations." [3] Thus the enemies of the Aryans were divided into families of animals, and, as Sir James Frazer has shown, this is characteristic of the Dravidian- and Munda-speaking peoples of India. The Aryans, being related in this manner to the Asura, Naga and other peoples, who evidently were totemic, would therefore seem to have passed through the totemic stage,

[1] H. H. Wilson 117.　　　[2] *Id.*, 122.　　　[3] *Id.*, 150-1.

and to have abandoned it when they changed to patrilineal institutions.

The political organization of this early society is little known. Rhys Davids gives an account of the life in the days of Buddha which probably holds true generally for the Dravidian communities. Buddha was a member of the Sakhya clan, one of a number scattered throughout the valley of the Ganges, and probably belonging to the Naga race.[1] The administration of the clans was as follows : "The administrative and judicial business of the clan was carried out in public assembly, at which young and old were alike present, in their common Mote Hall (santhagan) at Kapilavastu. A chief was chosen to preside over the sessions, and over the State when the sessions were not sitting, this chief being called the raja."[2] In other towns were also Mote Halls. The affairs of the villages were carried out in the open assemblies of the householders, " held in the groves which, then as now, formed so distinctive a feature of each village in the long and level alluvial plain." [3] Thus people, closely connected with the Naga race that presumably was grouped in totemic clans, had councils for the transaction of public business. These clans were not ruled over by a class, but formed autonomous units. The council plan was typical, not merely of the life of the State, but also of that of the village : in the case of the capital, the council met in the Mote Hall, and in the case of the village, it met in the grove ; this provides an explanation for the grove that characterizes Dravidian villages.

It is possible, however, to bring this matter closer into touch w`ch the archaic civilization. The Khasi of Assam are divided into totemic clans. Each State is ruled over by a chief, who usually holds in his hands both the spiritual and the temporal powers ; but he does not rule despotically, for he has to consult his durbar or executive council, on which sit the chief men of the State.[4] This durbar is supposed to be of divine origin, which probably means that it was founded by people of the archaic civilization. When in session, the members of the durbar sit on stones arranged in a circle ; [5] that is to say, the State council is related to the custom of erecting stone circles, which has been claimed as a feature of the archaic civilization.

Among the Naga tribes of Assam the institution of the council is not so well defined. Naga tribes are divided into clans, now patrilineal, that formerly were matrilineal, and possibly totemic. The Sema Naga chief conducts the village business in the following way : " He has to direct the village in war, nominally at any rate, and to decide either by himself or in consultation with the elders (Chochomi), all questions of the relations between his own and neighbouring villages. The extent to which he would consult

[1] Oldham 172, 180, 181 : Indian Arch. Rep. 1898 : de Visser 3 : Rhys Davids 3. [2] Rhys Davids 19. [3] Id., 20.
[4] Gurdon 67. [5] Id., 92.

22

his elders would depend almost entirely on the personal character of the chief himself." [1] This system of village councils is thus much less definite than that existing among the Khasi, and, as will be seen, among other peoples more directly associated with the archaic civilization. The culture-sequence thus tends to connect the council system with the archaic civilization. It is curious that the Asi clan of the Sema Naga, as well as the Kacha Naga, erect, in memory of rich men, shallow circles of stones set in the ground so as to slope away from the centre of the circle. Stone circles, usually dilapidated, are found in Marring Naga villages, [2] and thus may formerly have played a part in the social life. It must not be forgotten, also, that a large stone circle, of unknown origin, exists at Uilong in Manipur. It is thus possible that the Khasi custom of sitting during council meetings on stone seats ranged in a circle may formerly have been possessed by the Naga, together with the dual organization, but that it has been given up as a result of the break-up of the old order.

The Mundas of Chota Nagpur, who make great use of stone, and irrigate their lands, also have councils, the members of which sit on stones arranged in a circle. The Mundas are grouped in clans, similar to the Sakhyas, Lichavis and other clans of the time of Buddha, and their political organization is exactly similar. When they arrived in Chota Nagpur, they consisted of a small number of totemic groups, and were united to the Santhals, Bhumijes and other peoples. In the course of time the clans increased greatly, and members went out to found new settlements, but these new clans still retained their political organization, that of the council, even when living in distinct settlements. [3] The council meetings are held in the village place. " Here public meetings are held, the Panchayat hold their sittings, offenders against social rules as well as suspected witches and sorcerers are brought to justice, and the young folk of the village assemble in moonlit nights and on festive occasions to dance and sing. A number of large stone slabs placed underneath the tree serve as seats for actors and spectators." [4] This is not definite evidence of the use of stones for seats on assemblies, but it certainly is suggestive, in connexion with the evidence concerning Khasi councils.

The Todas, who are divided into clans, but without any trace, so Rivers states, of their ever having been totemic, have councils to regulate their affairs. " The most important feature of Toda government is the naim, or noim, a council having a definite constitution. The naim proper has to do with the affairs of the Todas in general, and, in addition, more informal councils, consisting of the chief members of a clan, may be held to settle matters arising within the clan. It seems, however, that the supreme naim may sometimes be called upon to settle the internal affairs

[1] Hutton i. 150. [2] Hodson 188. [3] Roy i. 413. [4] Id., i. 387.

of a clan." [1] The members of this council number five, and they are drawn from certain clans. As for their meeting-place : " On the slopes below the hill called Mirson, near Paikara, there are the remains of ruined walls marking a place where the naim used to meet. This place is called Idrgudipem, and seems to have been at one time the chief meeting-place." At present the naim may meet anywhere, and its members sit in a semicircular row. [2]

The hills that surround the Todas are sometimes crowned with stone circles, probably not the work of Todas themselves, but associated with their gods or ancestors. Toda gods live like themselves. " In the legends he lives much the same kind of life as the mortal Toda, having his dairies and his buffaloes. The sacred dairies and the sacred buffaloes of the Todas are still regarded as being in some measure the property of the gods, and the dairymen are looked upon as their priests. The gods hold councils and consult one another just as do the Todas, and they are believed to be swayed by the same motives and to think in the same way as the Todas themselves.

" At the present time most of the gods are believed to inhabit the summits of the hills, but they are not seen by mortals. Before the Todas were created, the gods lived on the Nilgiri Hills alone, and then it was believed that there followed a period during which gods and men inhabited the hills together. The gods ruled the men, ordained how they should live and originated the various customs of the people. The Todas can now give no definite account of their beliefs about the transition from this state of things to that which now exists.

" Each clan of the Todas has a deity especially connected with it. This deity is called the nodrochi of the clan, and is believed to have been the ruler of the clan when gods and men lived together." [3]

The Todas thus ascribe their social institutions to the gods, who formerly lived in the Nilgiri Hills. These gods, according to the interpretation put on them in former chapters, would be rulers of the archaic civilization : so the Todas, according to their accounts, owe their political and social organization to these people. The Todas say that the gods hold council meetings on some special hill-top, each god coming from the hill where he lives. " There is one important feature which is said to be common to all the hills inhabited by deities. They all have on their summits the stone circles which the Todas call pun. My informants were very definite about this and fully understood that these stone circles corresponded to the cairns and barrows opened by Breeks and others." [4] Since the Todas' gods live on hills with stone circles, and hold their councils on such hills, it is reasonable to suppose that these stone circles were their council-places, as among the Khasi. The Todas' culture is an evident degradation

[1] Rivers i. 540, 550. [2] *Id.*, i. 550–1.
[3] *Id.*, i. 185. [4] *Id.*, 444.

product of something more advanced, and the facts suggest that the former society would possess divine rulers, a dual organization, clans, perhaps totemic, and a system of council meetings held in stone circles. Of this the Todas have retained what appertained to the council, evidently the feature they most prized. As Rivers says, they are " the slaves of their traditions and of the laws and regulations which have been handed down to them by their ancestors." [1] They have in recent times abandoned a stone building for the council meetings, and now meet anywhere ; so it is possible that they formerly used stone circles.

Totemism in Indonesia is confined to but few peoples, the most important being the Batta of Sumatra, whose culture has already been noticed as showing strong signs of Dravidian influence. Elsewhere on the west coast of Sumatra, as in Mandailing, among the Gajos, and perhaps in other parts of that island, persist traces of totemism.[2] There are traces of totemism in Seran, Ambon, Buru, in the Babar Islands, and elsewhere in the group east of Timor, but little is known of the institution in these places. Nowhere in Indonesia, so far as I am aware, is there any totemism with matrilineal descent, apparently its original form.

It is possible to ascribe to the people of the archaic civilization a belief in relationship with animals that is not found among the indigenous peoples of Indonesia whom they civilized. I have already summed up the evidence on this point as follows: " Several facts go to show that the whole group of notions concerning the relationship between men and animals were introduced by the stone-using immigrants (the people of the archaic civilization). For they appear to be more closely connected with animals than the indigenous peoples. The chiefs of Kupang in Timor are said to be descended from crocodiles ; and the carved crocodiles on the backs of the stone seats of chiefs in Nias suggest a close relationship between these creatures and the chiefs. Food restrictions among the Naga and Khasi in Assam fall more especially upon chiefs, priests, those who have erected memorials, and warriors, all of them persons who are more closely associated with the influence of the stone-using immigrants than the rest of the people.

" The available evidence thus points to the stone-using immigrants as the introducers of certain notions concerning the relations between men and some animals. These notions are based, it seems, upon the assumption that men and these animals differ from other organic beings in possessing a ' soul-substance ' (equal to the ' life ' spoken of in Chapter XIV), which is derived from the sky-world. In such circumstances it is to be expected that the attitude of the immigrants towards animals which are connected to them by such close ties of kinship will differ profoundly from that of the indigenous peoples, who, so far as can be told, before their coming possessed no ideas concerning the

[1] Rivers i. 445. [2] J. G. Frazer ii. II. 192 e.s.

nature of soul-substance and the relations between men and animals. Strong evidence of the existence of such a difference of attitude has already been discovered. For in the punishment tales which were discussed in Chapter XVI it was found that the sky-people were enraged when certain animals were laughed at. The animals mentioned in the tales were cats, dogs, frogs, apes, fowls and pigs. This list is very like the other two already compiled, and it would probably be more like if a greater number of tales had been collected by workers in the field. The anger of the sky-people is thus aroused when animals, which, according to the evidence, are related to them by the closest ties of kinship, are laughed at by people who have no suspicion of the existence of such a relationship." [1] The evidence in Indonesia thus points definitely to the people of the archaic civilization as the introducers of ideas concerning the relationship between man and certain animals.

It has already been stated that the political organization of the States in South Celebes was allied to that of the archaic civilization, in that it showed strong traces of the dual organization. As might be expected, successive incursions of Hindus and Arabs have obscured much of the past social organization, so that, so far as I know, no indisputable signs exist of a former grouping in totemic clans. Nevertheless, government in the South Celebes States differs profoundly from that of the Hindus and Mohammedans elsewhere in Indonesia. Their councils are organized on a definite basis, and play an important part in the government of the country. These States are in divisions, each ruled over by a noble, who sits on the council of the State. The constituent States thus resemble the totemic clans, in that their heads sit on the council of the whole community. The resemblance is even closer : for the members of the councils each had an ensign; which corresponds to the usage in Egypt, where the nomes were so distinguished.[2]

The Patasiwa of Seran, one of the moieties of the dual organization of that island, have three divisions, which are related to those of the Kakian society. Each division of the Kakian society is presided over by a council called Saniri, the head of which, called the Kapala saniri, is aided by an assistant. Each council also has two officials called respectively, saer ue, "the bottom of the flagstaff," and saer hahue, "the top of the flagstaff," who formerly were war chiefs.[3] The members of the Kakian society sit, in their club-houses, on stone seats, and therefore in this respect come into line with the councils of the Khasi, Mundas and others. Thus, in Indonesia, the communities nearest the archaic civilization in culture are ruled over by means of councils, this form of government being less prominent in the rest of the region. The evidence, therefore, so far as it goes, tends to associate, in

[1] Perry vii. 159–60. [2] Berg 43.
[3] Wilken 348–9.

Indonesia, the totemic clan grouping, with its system of councils, with the archaic civilization.

Ponape of the Carolines, noted for immense remains of the archaic civilization, possesses pure totemism in so far as it connotes descent from animals or plants. Families believe in their descent from totems, called " mother," which are holy in the clan and must not be hurt.[1] The account of Christian in his work on the Carolines suggests that what he terms " tribes " are really clans, which consist of a chiefly family, and presumably freemen, commoners and slaves. Christian mentions several of these tribes as possessing " totems," which evidently are really looked upon as the ancestors of the rulers of the tribe. The tribe or clan formed a unit : " The chiefs mingle amongst their tribesmen with great familiarity and affability, which, no doubt, forms a fresh bond of sympathy and union. They all hold together loyally ; offend one, and all are eager to take up his quarrel. If the chief be a kindly hospitable man, his people will follow his example. If he be a rogue and a churl, his people will act as rogues and churls. And this I have observed is a characteristic of Caroline Islanders in general. They seem to have little independence of judgment, and love to follow the lead of their chiefs in all things crooked or straight, right or wrong." [2] These nobles, together with the priests—Chaumaro, high-priests, and Laiap, lesser priests—formed, with the king, the great council of the kingdom of Ponape, which, while in session, sat on a stone platform in the Council Lodge.[3] I am unable to tell whether each " tribe," or clan, had a council house. Probably this was so, for each clan in Yap has one.[4]

The Pelew Islanders possess pure totemism, or something practically indistinguishable from it. The group forms part of Micronesia, which has abundant traces of the archaic civilization. The people " are divided into a large number of exogamous families or clans (blay) with descent in the maternal line. In an ordinary village there will be members of a score of such clans living together. Each clan has its sacred animal, bird, or fish, in which perhaps, though this is not certain, the souls of dead members of the clan may formerly have been supposed to lodge. Among these sacred creatures or clan totems, as we may call them, are sea-eels, crabs, fish and parrots. Further, each district or village has its god, and all these district or village gods have their sacred animals, which are generally fish. Among the sacred animals of the village gods are the shark, the rayfish, the *Platyurus fasciatus*, the *Dysporus*, the *Birgus latre*, a species of crab, the puffin, and a species of night-heron (*Nycticorax manilensis*). According to Mr. J. Kubary, our principal authority on the Pelew Islands, the sacred animals of the village gods have certainly been developed out of the sacred animals of the families or clans. The

[1] Hahl 10.
[3] *Id.*, iv. 325–6.
[2] Christian iv. 326.
[4] *Id.*, 290.

inference, if it is sound, points to totemism as the origin of all these cases of sacred animals associated with families."ₗ¹ . . .

The evidence certainly points to the existence of pure totemism in the Pelews at some time in the past. Probably incursions of warlike peoples from New Guinea have caused much disturbance in the social organization, so that the original totemism has become masked. On the assumption that village gods are ancestors of ruling classes, it certainly looks as if these ancestors were connected with totemic institutions. The whole problem is, however, obscure, and hardly capable of any useful discussion. The forthcoming account by Dr. Krämer will doubtless help much to elucidate this matter.

In the region of British New Guinea the distribution of totemism is such as to suggest its connexion with the archaic civilization, for it is found in Bartle Bay, Wagawaga and elsewhere in Southern Massim, as well as in the Northern Massim district. The Koita, the Roro-speaking tribes and the Mekeo have a clan organization, with badges, that without much doubt represents a degenerate form of totemism. Throughout this region, whether in the matrilineal totemic communities, or in those with patrilineal institutions and the non-totemic organization, the chief feature of political life is the clan organization. In each village each clan as a rule has its own club-house, where matters are discussed, exactly as among the Munda and other peoples of India. It is important to note that, while the custom of sitting on stones arranged in a circle exists in Bartle Bay, Wagawaga and elsewhere in the totemic area, it is not found farther west among the Mekeo and the other groups, who use their club-houses for council meetings. The great difficulty with British New Guinea is that contact with the archaic civilization has apparently largely been broken. This makes it possible that, in Bartle Bay, the use of stones for squatting-places may be the survival of something more important. " The information that the stone circles and rows of stone were ' old-time fashion,' and were only used as squatting- and debating-places by the men, is doubtless correct for some of them, and there does not seem to be any doubt that some of the Bartle Bay circles are debating-places for the men, and correspond to the non-cannibal *gahana* of Bartle Bay."² This suggests that the stone circles formerly had a regular ceremonial use for council meetings.

In British New Guinea the unit of social organization is the clan, and not the village. It may happen, as it sometimes does, that a single clan occupies a single village ; but often several clans are found in the same village. In that case each clan has its own council house ; and has right- and left-hand divisions to correspond to the opposite sides of the council house. Throughout the region each clan, whether totemic or not, is connected with some badge, which is carved on the principal posts of the club-house. Thus it seems that the essential feature of the totemic organization, in

¹ J. G. Frazer ii. 184. ² Seligman i. 465.

the minds of these people, as among the Mundas, Todas and others, is not the totemic relationship, but the clan organization in the political sense, the council that directs the affairs of the group and preserves intact the customs, for this feature has survived the strictly totemic organization with matrilineal institutions.

In Torres Straits, " while totemism exists among the Western Islanders, it is entirely absent as a cult from the Miriam. We have no information concerning the other Eastern Islanders, but probably they agreed in this respect with the Miriam. . . . We may certainly regard the totemism of the Western Islanders as of unknown origin." The dual organization of the Western Islanders is not found among the eastern group : [1] at the same time a degraded form of totemism appears there, as is shown by the existence of dances connected with animals, derived from the Western Islands, and originally from the mainland of New Guinea.[2] It is noteworthy that the culture-heroes of the Eastern Islands, as well as those of the western group, appeared in the forms of animals.[3] Since the culture-heroes of the Eastern Islands came from the western group, it would seem that, in the course of the transference of culture from one region to another, elements were lost. The villages of the islands of the western group manage their affairs by means of councils of old men.[4] Formerly chiefs existed : " It may be that primarily they were the head-men of a totem clan, but as the clan had a definite geographical distribution, so the head-men would naturally be regarded as chiefs of districts, and a territorial rather than a totemic chieftainship would be recognized. It is possible that the territorial idea is more ancient and therefore more fundamental than the totemic." [5] No evidence is to hand concerning the account of the government of the Eastern Islands.

In Melanesia totemism can be ascribed to the influence of the archaic civilization. In the first place, it is completely absent from the peoples who have, according to the scheme of Rivers, come last into the region ; and in the matrilineal part of the Solomons, that is, the region supposed to be most nearly connected with the archaic civilization, totemism is prominent. Rivers says : " The matrilineal part of the Solomon Islands, comprising the islands of Florida, Guadalcanar Ysabel and Savo, is another region where we find definite exogamous clans associated with objects which are regarded as sacred. When these objects are animals they may not be eaten, and there is a belief in descent from these animals or from human beings more or less closely identified with them." He continues : " The general resemblance with the typical institution in this matrilineal region of the Solomons is so close that there can be little doubt we have to do with totemism, but in a state of modification." Further, " In

[1] Torres Straits Report VI. 254. [2] Id., 255, 282.
[3] Id., 282. [4] Id., V. 263.
[5] Id., V. 265, 266.

one region of the Solomons, that comprising Ruviana, Eddystone and Vella Lavella, totemism is certainly absent, and there is little which can be regarded even as its survival. At the eastern end of the Solomons, and especially in San Cristoval, however, totemism exists in certain districts, though it would seem as if the institution were absent in some parts." [1]

He sums up in these words : "The result of this survey of Melanesia has been to show the existence of genuine totemism in the Santa Cruz groups, in the Buin and Shortlands region of the Solomons, and probably in Sandwich Island in the New Hebrides, the latter place differing from the others in the plant-nature of its totems. Further, the institution is present, though in a modified form, in the matrilineal district of the Solomons, and in a still less typical form in Fiji. The regions from which it seems to be most clearly absent are the New Hebrides (except Sandwich Island), the Banks and Torres Islands, and certain regions of the Solomons, or, at any rate, certain parts of these regions. It seems probable that its absence in these parts of the Solomons is only due to a greater progress of the changes which have given the institution the aberrant character it possesses in the matrilineal region of this group." [2] Rivers is definite in claiming that totemism is not part of the culture of the latest, most warlike, incursion into the Pacific. "About one people I suppose to have come into Melanesia it is possible to speak with some confidence. It is just in those parts of the Solomon Islands where the influence of the betel-people seems to have been especially potent that we have no evidence whatever for the presence of totemism. No trace of this institution has been found in Malaita, Ulawa and Eddystone Island. . . . This distribution makes it extremely unlikely that the betel-people were totemic or that they held beliefs which were the starting-point of totemism." [3]

Rivers also seems inclined in his evidence to believe that totemism did not belong to the dual organization, which has been ascribed to the archaic civilization.[4] In this survey I hope to show that, speaking generally, the association between the two institutions is very close. At any rate, in Southern Melanesia the unit of grouping is the clan, whether totemic or local, and the old men rule the community as what is called a gerontocracy. Unfortunately little is recorded of the matter in this region, but what is known tends to bring the social and political organization into line with those of peoples already discussed.

Australia is a classic home of debates on totemism, which occurs there in a pure form. The institution in that continent is so closely bound up with the life of the tribe that it has long been thought that it was an indigenous product. But, of late years, the work of Rivers, Schmidt, Graebner, and others, has thrown doubt on this. In the present volume, more than one indication

[1] Rivers ix. II. 76–7. [2] *Id.*, ix. II. 79.
[3] *Id.*, II. 372–3. [4] *Id.*, II. 373.

has been found to support the idea that the people of the archaic civilization have given to the Australians most of their culture, including the totemic grouping. Australian tribes usually have the dual organization, but the ultimate basis of the tribe is the clan, both matrilineal and patrilineal. Usually the oldest man of the totem is its head : " But it does not follow that the head of a totem or of a local division has necessarily much, or even any, influence outside his totem or division." [1] The tribe is governed by a council. As Howitt says : " I have constantly observed in those tribes with which I have had personal acquaintance, that the old men met at some place apart from the camp and discussed matters of importance, such as arrangements to be made for hunting game, for festive or ceremonial meetings, or indeed any important matter. Having made up their minds, one of them would announce the matter at another meeting, at which all the men would be present, sitting or standing round, the younger men remaining at the outside. At such a meeting, the younger the man the less he would have to say ; indeed, I never knew a young man who had been only lately admitted to the rights of manhood presume to say anything or to take part in the discussion. All that they have to do as part of the assembly is to listen to what the leaders have to say.

" In the Dieri tribe such meetings as these are composed of the heads of totems or local divisions, fighting-men, medicine-men, and, generally speaking, of old men of standing and importance." The real constitution of the council in this, as in other tribes, is that of men who have been fully initiated.[2] From India to Australia, therefore, the clan organization functions in the political constitution of the tribe, and usually exists independently of a ruling class. Evidently rulers in the archaic civilization were not absolute, and had to reckon with their councils.

Although in but few communities, as yet, has it been possible to observe closely the mode of government of the archaic civilization, in Polynesia we can gain some idea of former political and social conditions. The Polynesians show signs of an early condition of totemism, most traces of which, according to Rivers, are found in Samoa and Tonga.[3] He says : " There are a few indications that the place of animals in Polynesian religion was greater than is generally supposed. When Captain Cook saw the great marae in the western part of the island of Tahiti, there were figures of a bird and fish on the platform of the pyramid which formed one side of the marae. On this platform were placed the images of the gods, and the presence of figures of animals in this situation suggests that they must have occupied a prominent place in the religious cult. The available accounts of Polynesian religion are of a most superficial kind, and the record of these animal figures is more important than any amount of negative evidence." [4]

[1] Howitt 297. [2] Id., 320-1.
[3] Rivers ix. II. 357-8. [4] Id., ix. II. 372.

Sir James Frazer comments thus upon the totemism of Polynesia : " In the wide area occupied by the Polynesian race totemism and exogamy appear to exist, or at all events to be reported, together, only in the Pelew Islands, which are situated to the extreme west and are inhabited by the Micronesian branch of the Polynesian family. It is true that in some of the other islands, particularly in Samoa, there exists or existed a system of animal-worship and plant-worship associated with families or clans which bears a close resemblance to totemism, and has probably been developed out of it. But in these islands the system lacks one of the characteristics of ordinary totemism, in that the families or clans are not reported to be exogamous."[1] . . .

The existence of a modified form of totemism in Polynesia accords well with the other signs of the alteration of the archaic civilization in that region, the disappearance of the sun-gods, the change from matrilineal to patrilineal institutions, the dropping of the use of stone, and other signs of the coming of a new order. Therefore, if totemism, especially in the form of a claim of descent from animals, once existed there, it presumably would have changed its form in the course of the great cultural transformation.

It has more than once been evident that traces of the old order could be detected in Samoa. The political and social rôles played by the various sections of the Samoan people can also be understood with fair certainty. It is not possible, however, to state the exact conditions in the beginning, for wars have obliterated landmarks. For instance, as Sir James Frazer states, it is not known whether the clans associated with animals were exogamous, and, so far as I know, the association between the clans and the various divisions of the community are not recorded. The former political organization of Samoa is thus described by Stair : " Until a comparatively recent period, the government of Samoa appears to have approached more nearly to that of Tahiti and the Sandwich Islands, which is monarchical, than would be supposed from its present condition. Perhaps it may best be described as a combination of the monarchical and patriarchal forms. Although for a long series of years, perhaps for ages, the whole group was nominally governed by one head, in whom the supreme authority was vested, the different districts were governed to a considerable extent by their own local authorities or chiefs, who in many respects were independent of each other. Heads of families also possessed great power over their relatives and dependants, which they used as they pleased, and were irresponsible to any other authority." [2] Stair describes the relationships between the settlements and the districts. The local affairs of the settlement were under their immediate control, and were discussed and decided upon in a public assembly composed of the leading men of each village or district. More weighty matters, such as declaring war or making peace, the appointment and installation of

[1] J. G. Frazer ii. II. 150. [2] Stair vi. 76.

chiefs, or indeed any matter of general importance to the whole district, were deliberated upon in a general fono, or parliament of the whole district, composed of representatives of all the leading settlements and villages of the district. Each district had its leading settlement called its Laumua. It was the province of the Laumua to convene the fono, or general assembly, of its respective district, to announce the object for which it had been summoned, to preside over its deliberations, to arrange disputed or knotty points, as well as to sum up the proceedings and dismiss the assembly ; in fact, to sustain the office of chairman. These meetings were usually conducted with much formality and decorum, the general fono of the district being always held in the open air, in the great marae of the leading settlement, or Laumua. In sitting in the marae each group of representatives had its proper place.

In the district fono the members were the tulafale, the landed aristocracy, as it were ; and sometimes the faleupolu or smaller landholders.[1] The tulafale were a very powerful class, the real power in the settlements being usually vested in them.[2] They could depose the chiefs of the settlement. Thus, for example, in Aana, a district of Upolu, the tulafale could depose the Tuiaana, for in their gift was the ao, the authority by which he ruled. The power belonged to nine families of councillors in the chief settlement of Leulumoega, who could appoint or depose the ruler. Some of the tulafate group were more important than others ; they were the tulafale ali'i, the council chiefs, who were often connected by marriage with the ruler of the district.[3] These chiefs were said to be the heads of clans. Also, in the same district, the dual settlements of Fasito'otai and Fasito'outa, which are so important in the councils, each possessed seven such families, Fasito'otai also having a House of Chiefs, seven chiefs that had to do with war.[4] The heads of local groups, the landed nobility, thus had great power, being able to control the whole affairs of the community by virtue of their power to depose or appoint the ruling chief.

In Aana of Upolu, from which the examples have hitherto been drawn, the chief of the district, when sitting in council, has on either side of him a pair of chiefs called tofa'i and tu'itu'i, who are his supporters (Stutzen). In Samoa certain royal titles can be held by the kings : it is not necessary to go into their history ; but it should be stated that they probably did not exist in the beginning, but have arisen owing to various historical events. These titles are Tuiaana, Tuiatua, Gatoaitele and Tamasoali'i,[5] and if, by any means, a king can obtain them all, he is king of all Samoa. But it is an empty kingship, for he has but little to do with the internal administration of the country,

[1] Stair vi. 84–5. [2] Id., 76.
[3] Stair iii. 597, 616 : F. Krämer I. 10, 482 : Ella ii. 596 e.s.
[4] F. Krämer I. 153. [5] Id., 18.

that being, as is obvious, in the hands of the tulafale. For each of these titles the ruler has a pair of chiefs sitting on either side of him as supporters. These officials are hereditary, like all the others of importance.

The political circumstances of Samoa make it evident that the kingship is by far the least permanent institution; the ruler has no land, and his rule is determined by the good-will of his council. Instances are known of the deposition of obnoxious rulers. Such an act can happen without in any way inconveniencing the life of the community; for each district would depend, as before, on its council for the management of its affairs, and each settlement in the district would manage its own business. For instance, in Aana, the great fono would legislate for Aana, and in the settlement of Fasito'otai, the seven councillors and the seven members of the house of chiefs, who presumably are the heads of clans, would act for the settlement : each head of a family would in the same way rule his descendants and dependants. The political organization is thus compact and stable and capable of standing many shocks. The least stable element is the kingship.

It is now possible to understand what may have been the history of all the peoples that have been considered. Their ruling classes have disappeared, and the state has disintegrated, each part going its own way. This would account for the Mundas, Korkus and other peoples : they may have been clan groups under some ruling family of the archaic civilization, which, when the ruling group was eliminated, became autonomous units.

The Khasi of Assam say that their council is of divine origin ; that is to say, they refer it back to the archaic civilization ; the Todas again say that the gods hold council meetings ; in like manner the Samoan traditions claim that they got their councils from the sky, from the Children of the Sun, and thus from the archaic civilization. A tale states that the father of the first human member of the Tagaloa family, Tagaloaui, used to go to the sky to attend council meetings ; and it is said that this Tagaloaui got from the sky-world the title of the ruler, the chief's house, and the institution of the council.[1] The right to institute the council seems to have been vested, in early times, in the women. The story of the foundation of the districts of Upolu and Savai'i of Samoa recounts that the founders of the ruling houses came from Manu'a. They were Le-apai and Fa'a-toafe, the descendants of Fai-malie and Fai-tama. Le-apai married Amete, the daughter of the Tui-samata. Fa'a-toafe said to him, " If your wife is a favourite with her father, get her to intercede with him for me to give me fono—the authority to hold councils—to take to Upolu." He thus got the power through his wife, and established councils throughout the island.[2] The other daughter of the Tui-samata, Sina, married and had six sons. " When these sons grew up, Sina called a council to establish good order and industry among

[1] F. Krämer I. 409. [2] J. Frazer ii. 115 e.s.

them." [1] She had the right to establish the council. Therefore the right to hold councils was evidently handed on from one settlement to another, the ultimate source being the sky-world, that is, the archaic civilization. The widespread custom of sitting on stone seats constitutes another link between the council and the political organization of the archaic civilization.

North America is a part of the region where the institution of totemism would be expected, if it formed part of the archaic civilization. In the words of Sir James Frazer : " The institution of totemism was first observed and described by Europeans among the Indian tribes of North America, and it is known to have prevailed widely, though by no means universally, among them. Within the great area now covered by the United States and Canada the system was most highly developed by the tribes to the east of the Mississippi, who lived in settled villages and cultivated the soil ; it was practised by some, but not all, of the hunting tribes, who roamed the great western prairies, and it was wholly unknown to the Californian Indians, the rudest representatives of the Redskin race, who had made little progress in the arts of life, and in particular were wholly ignorant of agriculture. Again, totemism flourishes among the Pueblo Indians of the south-west, who live in massively-built and fortified towns of brick or hewn stone and diligently till the soil, raising abundant crops of cereals and fruits, and whose ancestors even constructed canals on a large scale to irrigate and fertilize the thirsty lands under the torrid skies of Arizona and New Mexico. It is certainly remarkable that over this immense region, extending across America from the Atlantic to the Pacific, the institution of, totemism should be found to exist and flourish among the tribes which have made some progress in culture, while it is wholly absent from others which have lagged behind at a lower level of savagery. As it appears unlikely that these rude savages should have lost all traces of totemism if they had once practised it, while the system survives among their more cultured brethren, we seem driven to conclude that among the Indians of North America totemism marks a degree of social and intellectual progress to which the more backward members of the Redskin family have not yet attained." [2]

These remarks of Sir James Frazer show that totemism is an institution of those tribes that are nearest to the archaic civilization. He distinctly states that the food-gatherers have it not, and he also says that some of the Plains Indians show no signs of it. In this connexion he quotes from Mooney with regard to tribes of the western Plains whose social organization shows no signs of the dual organization, and who consequently belong to those whose culture has become highly modified. " There seems to be no possible trace of a clan or gentile system among the Arapaho, and the same remark holds good of the Cheyenne, Kiowa

[1] J. Frazer ii. 115. [2] J. G. Frazer ii. III. 1–3.

and Comanche. It was once assumed that all Indian tribes had the clan system, but later research shows that it is lacking over wide areas in the western territory. It is very doubtful if it exists at all among the prairie tribes generally. Mr. Ben Clark, who has known and studied the Cheyenne for half a lifetime, states positively that they have no clans, as the term is usually understood. This agrees with the result of personal investigation and the testimony of George Bent, a Cheyenne half-breed, and the best living authority on all that relates to his tribe. With the eastern tribes, however, and those who have removed from the east or the timbered country, as the Caddo, the gentile system is so much a part of their daily life that it is one of the first things to attract the attention of the observer." [1]

It is not possible to state, from direct evidence, whether the Maya and other civilizations of Mexico and the south had totemic institutions or not ; but their gods were connected, generally speaking, with animals similar to those from which the totemic clans of the Indians claim descent. Herr Stempell says that the Maya have chosen for their calendar and for use in their inscriptions only a small selection of the fauna of the country. [2] It is significant that these animals should be sacred among the Maya, and that they should occur as totems among the peoples of the United States. [3] Other facts suggest that the ancient civilizations of Mexico and the Maya country possessed totemic institutions.

The culture-hero of the Nahua and the Maya was called " Feathered-Serpent," his name being Quetzalcoatl, Kukulcan, Gucumatz, according to the people whom he visited. Ruling families were themselves associated with animals, from which they claimed descent. This is clearly brought out in the Popol Vuh of the Kiche, for the early kings were represented as animals. [4]

In North America totemism with matrilineal descent exists among the tribes of the eastern States and the Pueblo region. The Plains Indians have it in a modified form, but usually with patrilineal descent ; and those who have wandered farthest lack the institution altogether : the earliest ruling families of Mexico were probably associated with animals : totemism is unknown among the food-gatherers. Therefore totemism must evidently be ascribed to the archaic civilization.

An examination of the culture of the American Indians of the United States shows that the council was the leading feature of tribal government, the organization in totemic clans being closely associated with the political organization of the tribe. This has been known for many years, for Lewis H. Morgan in his work on " Ancient Society," has said what is necessary on this point.

[1] J. G. Frazer ii. III. 1, n. 1. [2] Stempell 705.
[3] This statement may be verified by comparing the list given by Stempell with those recorded in Frazer's volume on America. With these should also be compared the lists given by Moret iii.
[4] Brasseur de Bourbourg cxviii.

" The plan of government of the American aborigines commenced with the gens and ended with the confederacy, the latter being the highest point to which their governmental institutions attained. It gave for the organic series : first the gens (called clan in this book), a body of consanguinei having a common gentile name : second, the phratry, an assemblage of related gentes united in a higher association for certain common objects ; third, the tribe, an assemblage of gentes, usually organized in phratries, all the members of which spoke the same dialect ; and fourth, a confederacy of tribes, the members of which respectively spoke dialects of the selfsame language." [1] Originally in North America the clan, or gens, as Morgan calls it, was matrilineal,[2] a fact which still further serves to bind the institution to the archaic civilization.

Morgan states that the clan or gens is individualized by the following rights, privileges, and obligations :

1. The right of electing its sachem and chiefs.
2. The right of deposing its sachem and chiefs.
3. The obligation not to marry in the gens.
4. Mutual rights of inheritance of the property of deceased members.
5. Reciprocal obligation of help, defence and redress of injuries.
6. The right of bestowing names upon its members.
7. The right of adopting strangers into the gens.
8. Common religious rites (query).
9. A common burial-place.
10. A council of the gens.[3]

The gens or clan is thus a self-contained unit carrying on its life independently of the rest of the tribe.

Each gens had a hereditary head chief called the sachem, who was concerned with peace. Certain men were also chosen out of the gens for bravery and skill in war, for eloquence, or for other outstanding qualities. They ranked below the sachem in authority, for he was the official head of the clan or gens.[4]

In the tribes of North America the dual grouping played no part in government : the moiety had no council. The next higher council from that of the simple clan was the council of the tribe as a whole, which usually consisted of clan chiefs. The sachem, the clan chief, had to be invested in office by the tribal council.[5] " It devolved upon the council to guard and protect the common interests of the tribe. Upon the intelligence and courage of the people, and upon the wisdom and foresight of the council, the prosperity and the existence of the tribe depended. Questions and exigencies were arising through their incessant warfare with other tribes, which required all the exercise of these qualities to meet and manage. It was unavoidable, therefore,

[1] Morgan 66. [2] Id., 67. [3] Id., 71.
[4] Id., 73–4. [5] Id., 114.

that the popular element should be commanding in its influence. As a general rule the council was open to any private individual who desired to address it on a public question. Even the women were allowed to express their wishes and opinions through an orator of their own selection. But the decision was made by the council. Unanimity was a fundamental law of its action among the Iroquois ; but whether this usage was general I am unable to state." [1] The confederacy of tribes was carried out by the Iroquois, in which the Mohawks, Oneidas, Onondagas, Cayugas and Senecas joined together, for mutual help and protection, on a basis of equality.

It is not necessary to discuss in detail the system of rule by councils in North America, for it is evident, from the statements of Morgan, that it was of fundamental importance. This makes it obvious why the Huron, the Omaha and other tribes took the trouble to maintain their organization of clans and phratries.

Since it is possible to group together the more advanced tribes of North America by virtue of their common possession of a council as the mode of government, it is to be presumed that the peoples of Mexico were governed by councils. When the Spaniards arrived they found the country ruled by a confederacy consisting of Aztecs, Tezcucans and Tlacopans. These tribes formed part of seven kindred tribes that had migrated to Mexico from the North, and imposed their rule on the country.[2] The confederacy of the three tribes was ruled by a council : " The government was administered by a council of chiefs, with the co-operation of a general commander of the military bands. It was a government of two powers ; the civil being represented by the council and the military by a principal war-chief. Since the institutions of the confederate tribes were essentially democratic, the government may be called a military democracy, if a designation more special than confederacy is required." [3] So much for the general government of the tribe. " Each tribe was independent in whatever related to local self-government ; but the three were externally one people in whatever related to aggression or defence. While each tribe had its own council of chiefs, and its own head war-chiefs, the war-chief of the Aztecs was the commander-in-chief of the confederate war bands. This may be inferred from the fact that the Tezcucans and Tlacopans had a voice either in the election or in the confirmation of the Aztecs' war-chief. The acquisition of the chief command by the Aztecs tends to show that their influence predominated in establishing the terms upon which the tribe confederated." [4]

Morgan was fully persuaded of the existence of phratries and clans among the Aztecs and other peoples of Mexico. "There is a large amount of indirect and fragmentary evidence in the Spanish writers pointing both to the gens and the phratry.[5] . . .

[1] Morgan 117. [2] Id., 188. [3] Id., 188.
[4] Id., 192. [5] Id., 197.
23

The Pueblo of Mexico was divided geographically into four quarters, each of which was occupied by a lineage, a body of people more nearly related by consanguinity among themselves than they were to the inhabitants of the other quarters. Presumptively, each lineage was a phratry. Each quarter was again subdivided, and each local subdivision was occupied by a community of persons bound together by some common tie. Presumptively, this community of persons was a gens. Turning to the kindred tribe of the Tlascalans, the same facts nearly reappear. Their pueblo was divided into four quarters, each occupied by a lineage. Each had its own standard and blazon.[1] As one people they were under the government of a council of chiefs, which the Spaniards honoured with the name of the Tlascalan senate. Cholula, in like manner, was divided into six quarters, called wards by Herrera, which leads to the same inference. The Aztecs in their social subdivisions having arranged among themselves the parts of the pueblo they were severally to occupy, these geographical districts would result from their mode of government.[2] . . . Assuming that the lowest subdivision was a gens, and that each quarter was occupied by a phratry, composed of related gentes, the primary distribution of the Aztecs in their pueblo is perfectly intelligible. Without this assumption it is incapable of a satisfactory explanation. When a people, organized in gentes, phratries and tribes settled in a town or city, they located by gentes and by tribes, as a necessary consequence of their social organization. The Grecian and Roman tribes settled in their cities in this manner. For example, the three Roman tribes were organized in gentes and curiae, the curia being the analogue of the phratry ; and they settled at Rome by gentes, by curies and by tribes. The Ramnes occupied the Palatine Hill, the Tities were mostly on the Quirinal, and the Luceres mostly on the Esquiline. If the Aztecs were in gentes and phratries, having but one tribe, they would of necessity be found in as many quarters as they had phratries, with each gens of the same phratry in the main locality by itself. As husband and wife were of different gentes, and the children were of the gens of the father or mother as descent was in the male or the female line, the preponderating number in each locality would be of the same gens."[3]

The inheritance of property is also used by Morgan to establish the existence of clans among the Aztecs. He also insists that the possession of a Council of Chiefs involves the same form of social organization : " The existence of such a council among the Aztecs might have been predicted from the necessary constitution of Indian society. Theoretically, it would have been composed of that class of chiefs, distinguished as sachems, who represented bodies of kindred, through an office perpetually maintained.

[1] Which recalls the Egyptian nomes and the states of South Celebes.
[2] Morgan 198. [3] Id., 199.

Here, again, as elsewhere, a necessity is seen for gentes, whose principal chiefs would represent the people in their ultimate social subdivisions as among the northern tribes. Aztec gentes are fairly necessary to explain the existence of Aztec chiefs. Of the presence of an Aztec council there is no doubt whatever; but of the number of its members and of its functions we are left in almost total ignorance." [1]

In North America the culture-heroes are invariably represented as originating the councils of the various tribes. The peoples of the sky hold councils. The Sauk-Fox, for instance, tell of the time when the gods, the manitos, lived on earth, and the Great Manito called a council, at which the people were divided into " elder " and " younger " divisions. [2] The Yuchi say that the people of the sky-world lived just like those on earth, so it is to be presumed that they had councils. Four of the Yuchi clans were looked upon as superior to the rest, and from them were chosen the four chiefs of the tribe. The Yuchi held their ceremonies in the Square Ground, which was said to be similar in every respect to the Rainbow of the sky-world. The officials of this place were called Rainbow or Square-ground Chief, and Rainbow or Square-ground Warrior. According to tradition the ceremonies performed there originated in the sky-world and were taught the people by the Sun. [3] The Cherokee state that the " Animals," the mythical predecessors of the tribe, had chiefs, town houses, councils, and ball games, just like men. These animals once lived on earth on terms of perfect equality with men, and for some unexplained reason they left this world and went to the sky. Trees and plants could formerly talk and had their places in the councils, the leader of which was the frog. [4]

The survey just completed shows that the clan system plays an integral part in the society of those communities nearest to the archaic civilization. So far as the evidence goes, each community consists of a number of totemic clans claiming relationship in some way or another with an animal, plant or material object. The totemic clan plays an important part in the political life of the community, for it has its own council for the regulation of its domestic affairs, and each clan council sends its representatives to the council of the tribe. This part of the life of the community therefore goes on independently of the ruling group. If, for any cause, the community should be split up, the clan groups are quite capable of independent function. These communities therefore possess an elastic and useful form of social organization capable of indefinite extension, so it is not surprising to find that the system of clan groups, each with its council, has survived the totemic relationship.

Other evidence shows that the system of clan councils belonged

[1] Id., 203. [2] Michelson 225–6.
[3] Speck ii. 111–12. [4] Mooney vii. 230, 231, 261.

to the archaic civilization. The council is derived from the sky or from the gods, or it is instituted by the Ancestral Animals: also during council meetings use is made of stone seats. The evidence with regard to the use of stone for seats during councils falls into line with what was collected in "The Megalithic Culture of Indonesia." It makes especially suggestive the account of the meeting on Mt. Tonderukan, when the ancestors of the Tontemboan met to divide up the land; for the chiefs are said to have sat "round about" on stones.

The derivation of the council from the archaic civilization brings up the problem of the constitution of the tribal council. It is evident that the clan council can, and usually does, consist of the elders of the clan, often with a hereditary chief as president. A clan council can act without any hereditary chief, and does so in Melanesia and Australia. The constitution of the tribal council is a different matter. In South Celebes and Samoa the state council was composed of hereditary chiefs, rulers of certain territorial districts, who formed the nobility. In Samoa the king himself, in the particular instance quoted, the Tuiaana, was not a landholder; he was at the mercy of his council, who could depose him if they wished. Therefore, from the point of view of the district of Aana, the nobles were the real rulers. The great council was not democratic: it was aristocratic, in the full sense of the term, as much as the House of Lords of our own country. This form of organization accords well with that presumably existing in ancient Egypt, where the governors of the nomes in the Fifth Dynasty became hereditary. Such local magnates appear once again in Ponape, although but little is known of them. In Virginia the land was formerly divided into petty provinces, each with its local governor subject to a higher authority.[1] In like manner when Tangiia and Kariki set up the organization of Rarotonga, they chose eighty minor chiefs for each moiety of the island. No mention is made of the function of these chiefs in Rarotonga, but, since Kariki came from Samoa, it seems beyond doubt that they were chosen for the purpose of holding council meetings in the proper manner. The constitution of the archaic civilization therefore appears to include landholding chiefs forming a nobility, after the same manner as that of our country, and constituting a national council such as our House of Lords.

If the council of the tribe or district of the archaic civilization consisted of members of the nobility, each of whom was associated with an animal, which was an ancestor, or was simply used as an ensign, a ready explanation is forthcoming for the claim made by several of the North American tribes, the Cherokee for instance, that they got their institutions from the ancestral animals who lived in the sky. The localization of the ancestral animals in the sky suggests that they were people of the archaic civilization, and their membership of a council serves to equate them to the

[1] Willoughby 57.

hereditary chiefs of the clans of earthly tribes. Thus it would seem that the hereditary chiefs of the clans were the descendants of the ancestral animals, that is to say, of the ruling class of the archaic civilization. The conclusion, therefore, is that the totemic clan, as a part of the political constitution of the tribe as a whole, really centres round one family, that family which claims direct descent from the animal ancestor that gave rise to the clan.

CHAPTER XXII

THE TOTEMIC CLAN SYSTEM

THE totemic clan system can be viewed from at least two standpoints. As has been found in the last chapter, the typical grouping is related to the institution of the tribal council, on which sit representatives of each clan. In some cases the clan representatives on the tribal council are hereditary chiefs. The clan itself has a council, formed of its elders, and is thus an autonomous unit. It has another characteristic, now to be studied. A relationship exists between its members and some animal, plant or inanimate object, called the Totem of the clan. The definition of Rivers makes descent from the totem an essential feature of the totemic clan system. Since a belief of this sort is manifestly impossible in the case of inanimate objects, this discrepancy in the definition of Rivers will have to be taken into account when coming to a conclusion as to the real nature of the totemic clan system. It can, however, be left on one side for the moment, while the actual mode of descent in the clan is studied.

It will be well to begin with a specific case. That of the Yuchi of the Mound area of North America will do for the purpose. The stories of the mode of origin of the tribe differ. Two are given by Speck ; in both cases it is said that a sky-woman became pregnant in some mysterious way, and gave birth, either to a son, or to twin sons. In the story in which she gave birth to one boy, the Sun-boy, it is said that she took him to the Rainbow, the gathering-place of the sky-beings, and there had him scarified according to custom. After a time the mother and her offspring were driven away, and came to the earth. The Sun-boy became the ancestor of the Yuchi, who consequently call themselves Children of the Sun. He taught his descendants ceremonies, for protection from evil influence, and in honour of the supernatural beings in the sky.[1] Another version claims that the Sun is an old woman, and that the ceremonies were taught by a supernatural being called Gohantone.[2]

A further complication in belief arises from the statement that the members of each clan believe themselves to be the

[1] Speck ii. 107, 112. [2] *Id.*, ii. 145.

relatives, or, in some vague way, the descendants, of pre-existing animals, whose name and identity they now possess. These totemic animals are held in great reverence, are appealed to privately in certain exigencies, and are publicly worshipped in dances and celebrations. Each boy is initiated, and thenceforth is supposed to have acquired the protection of his ancestral totemic animal. The clans were named by the Sun-boy or by Gohantone.[1]

Speck's account is obviously confused, for some of its elements are mutually contradictory. It is, nevertheless, clear that the Yuchi derive themselves from the archaic civilization : in one version, their ancestress came from the sky-world, from a place where lived the Children of the Sun, for she gave birth either to twins or to the Sun-boy in a manner that suggests theogamy ; while, in another version, the Yuchi are descended from animals who lived in the sky-world.

Nothing is said, so far as I am aware, about the origin of the clans. For information on this topic it is necessary to turn to other peoples, for instance, the Huron or Wyandot, who are matrilineal in organization, and are divided into totemic clans. They claim origin from a woman of the sky-world, who rules over the dead in the underworld with one of her twin sons. Her other twin son is the creator, who now lives in the sky. A tale already quoted in detail recounts that the phratries and clans were decided upon by a council-meeting of men of several tribes, who met to reconstitute communities that probably had been broken up by warfare.

The Huron say that the Hawk and Snake clans each originated from one of their women and a being who could assume human or animal forms at will.[2] This recalls the semi-human, semi-animal beings of the sky-world, from whom the Yuchi sometimes claim descent ; and suggests that the mode of origin of the clans of both peoples may have been identical.

A careful examination of the Huron story reveals an apparent contradiction. The clans are now matrilineal, which means that every man or woman derives his or her totem from his or her mother : the father has nothing to do with the matter ; and it is presumably a matter of indifference to what clan he belongs ; except that, as will be seen in the next chapter, regulations as to marriages exist in such communities. Although the father is of such insignificance, nevertheless the clan, in the beginning, is named after the male ancestor. This means that the first male of the Snake clan, for instance, was a snake, who was the father, by a Huron woman, whose clan is not specified, if she had any, of snake children. That is pure patrilineal descent ; but it did not persist ; for, of the children of this union, only the daughter carried on the clan. The son married a woman of another clan, and his children were bears, or something else ;

[1] *Id.*, ii. 70-2. [2] Barbeau iii. 90.

they were not snakes. The children of his sister were snakes, and so on indefinitely. Thus the clan apparently began with a patrilineal mode, and then changed to the matrilineal mode of descent, which is incredible on the hypothesis that mother-right was the rule in the archaic civilization. In order to solve this riddle, or to approach its solution, we must go deeper into the constitution of the totemic clan, especially under matrilineal descent. This will lead into obscure places, where but few facts at present light the path.

The Yuchi, already mentioned in this connexion, believe that they are the reincarnations of their maternal ancestors, and each child is named after a maternal grandparent's brother or sister. The child is not named for four days, for it is thought that the soul takes that time to go to the land of the dead, and, presumably, that it needs the same time to return to earth. This process of rebirth is controlled in the sky by the Old Woman.[1] The Huron also had a belief in reincarnation, and used to bury little children by the side of paths in order that their souls might enter women to be reborn.[2] The Huron also possessed a set of names for each clan, all derived from characteristics of the totemic animal. These names were chosen by the council women of the clan, which is significant, in view of the fact that the process of rebirth among the Yuchi is controlled by the Old Woman in the Sky.[3]

Further light is to be obtained from the Hidatsa, a tribe of the Upper Missouri, whose culture has not suffered, as a consequence of migration, so much loss as that of the Omaha. The Hidatsa believe in an underground land of the dead. They had also a belief in reincarnation, a curious account of which is quoted by Sir James Frazer, in his work on "Totemism and Exogamy," from the description of Long's Expedition to the Rocky Mountains in 1819. " At the distance of the journey of one day and a half from Knife-creek, which divided the larger and the smaller towns of the Minnetarees from each other, are situated two conical hills, separated by about the distance of a mile. One of these hills was supposed to impart a prolific virtue to such squaws as resorted to it for the purpose of crying and lamenting, for the circumstance of their having no male issue. A person one day walking near the mount, fancied he observed upon the top of it two very small children. Thinking they had strayed from the village, he ran towards them to induce them to return home ; but they immediately fled from him, nor could his utmost speed overtake them, and in a short time they eluded his sight. Returning to the village, the relation of his story excited must interest, and an Indian set out next day, mounted on a fleet horse, to take the little strangers. On the approach of this individual to the mount, he also saw the children, who ran away as before, and although he endeavoured to overtake them by lashing the horse into his

[1] Speck ii. 94, 108. [2] J. G. Frazer i. I. 91. [3] *Id.*, ii. III. 34, 35.

utmost swiftness, the children left him far behind. But these children are no longer to be seen, and the hill once of singular efficacy in rendering the human species prolific, has lost this remarkable property." In an account by Washington Matthews, the infants were said to emerge from a very narrow cavern that ran into the earth.[1]

The evidence gathered in North America suggests that the idea originally underlying the totemic clan was that of the successive reincarnation of a limited number of spirit individuals. The clan itself, according to the Huron story, originated in the union of a Hawk man and a girl ; so it is to the conditions attending this union that attention must be paid, for it gave rise to the spirit individuals. What, however, had the male ancestor to do with the process ?

North America, so far as I know, gives no answer to this question ; and if so, none can be expected in Polynesia ; it is in Australia that search must be made for the original ideas as to the origins of totemic clans. The search must be confined, also, to the matrilineal tribes, which correspond more strictly to the archaic civilization.

Inquiry in Australia produces the following results. The Urabunna, a tribe of Central Australia, state that, in the old days, the Alcheringa times as they are called, the ancestors of the different totemic groups lived as a number of half-human, half-animal or plant people. No one can suggest how they arose.[2] These ancestors left behind them spirit individuals, called mai-aurli, which have continually undergone reincarnation. These spirit individuals are supposed to inhabit certain spots, sometimes only one kind at a spot, sometimes two or three kinds.[2] Each living individual is the reincarnation of a mai-aurli, or spirit that emanated from the body of an Alcheringa ancestor. " Every individual goes back after death in spirit form to the spot at which it was left in the Alcheringa by the ancestor of the totem. If, for example, it were originally a pigeon spirit, then it will go back into the rocks at the spot where the pigeon ancestor performed ceremonies in the Alcheringa and left spirits behind. In the course of ages any single individual can run the whole gamut of the totems, but always returning at death to its original home."

Among these people " the child must belong to the same moiety and totem as its mother, but they have the curious belief that in each successive reincarnation the child changes its sex, moiety and totem." [3]

One feature of interest of the Australian belief is that it does not involve any idea of a race ancestress. The existence of the clan depends entirely upon the continuous reincarnation of spirit individuals produced by the culture-heroes, those mysterious

[1] J. G. Frazer ii. III. 150-1. [2] Spencer and Gillen 145-7.
[3] *Id.*, 148-9.

beings to whom so much is ascribed. The culture-heroes were said to be life-givers, which ascription is evidently well founded, for they have provided a self-working mechanism for the perpetuation of communities with totemic clans.

Before discussing this matter further, mention must be made of the ideas concerning reincarnation held by the people of the Trobriand Islands off the coast of British New Guinea. A ghost in these islands is believed to go to the underworld. In course of time it grows old, the teeth fall out, and the skin gets wrinkled. It then goes to the sea and bathes ; the skin is thrown off and it becomes young again, an embryo indeed. A ghost woman then takes it and places it in an earthly woman, who in due course gives birth to a child, who is the reincarnation of the previous individual. Sometimes spirit children are supposed to float in the scum on the shore, or to be in stones. An important feature of this system of reincarnation lies in the fact that the spirit child is brought to a woman of its own clan by a ghostly woman of the same clan.[1] Thus the clan reproduces itself by a continuous process.

All this bears out the suggestion founded on the American evidence, that the totemic clan is a group of individuals constantly undergoing reincarnation. The evidence from Australia shows that these spirit individuals are supposed to have been derived from culture-heroes, i.e. from the archaic civilization. They are limited in number, and once the clan is started, it reproduces itself unceasingly. It does not seem that the semi-human, semi-animal ancestor of the clan plays any part, or that a notion of a totem is essential for the constitution of the clan. Rather would it seem that the totemic clan is an artificial construction, and not an organic institution with interdependent parts. The perpetuation of the clan evidently depends solely on the idea of the reincarnation, through the women, of the spirit individuals.

If this be compared with the manner of birth of peoples like the Toradja of Central Celebes (see p. 207), it will be noticed that the sky-beings had the necessary power, for they made embryos and placed them in position to be born. The mode of inception of totemic clans thus harmonizes entirely with the notions of the people of the archaic civilization, and lends still further support to the conclusion that they started the totemic clan system in all parts of the region.

India supplies further evidence that the idea of reincarnation belonged to the archaic civilization. For it is a commonplace of Epic and Puranic literature, as well as of the Jataka texts of the Buddhists, that sky-beings could enter women to be reborn. In the Mahabharata it is said that the Daevas and the Asuras both became incarnated on earth in order that they might continue their struggles. Instances of this kind could be multiplied beyond number in Indian literature. In the Vishnu Purana, that store-

[1] Malinowski 403 e.s.

house of facts with regard to ancient society, it says : " There were twelve celebrated deities in a former Manwantra (world-epoch), called Tushitas, who, upon the approach of the present period, or in the reign of the last Manu, Chakshusha, assembled, and said to one another, ' Come, let us quickly enter into the womb of Aditi, that we may be born in the next Manwantra, for thereby we shall again enjoy the rank of gods ' : and accordingly they were born as the sons of Kasyapa, the son of Marichi, by Aditi, the daughter of Dahska." [1] This is exactly the idea of reincarnation which is found in association with totemic clans, the entry of spirit individuals into a woman in order to be reborn. Note, too, that these gods said that they must enter Aditi, their mother. Perhaps this is the reason for matrilineal descent in the real totemic clan ; for what happens is the perpetual rebirth of a man from his mother, who is reborn in her daughter. In the Indian Epics the idea of reincarnation through the mother is definite. " The husband, dividing his body in twain, is born of his wife in the form of his son." Again, " After the dissolution of his body, man, according to his acts re-entereth the womb of his mother and stayeth there in an indistinct form, and soon after assuming a distinct and visible shape reappeareth in the world and walketh on its surface." " The mother is but the sheath of flesh in which the father begets the son. Indeed, the father himself is the son." [2]

It is possible to establish, in India, a culture-sequence in the ideas concerning reincarnation. No mention is made of the doctrine in the Vedas. It was brought forcibly to the notice of the Brahmins by Kshatriya kings, that is, by the Children of the Sun. It is said that a Brahmin was responsible in the first case for its inception, but, nevertheless, the Brahmins had to be instructed by the Children of the Sun in this doctrine, which shows such strong signs of belonging to the culture of the people of the archaic civilization. [3] It is probable, nevertheless, that the Aryans of India once held the notion of reincarnation. For the quotation just made from the Puranas shows that the Adityas, the sun-gods, the sons of Aditi, the great mother, entered her in order to be reborn. The Adityas were pushed into the background on the rise of Indra, and probably during this change the old ideas concerning reincarnation became weakened. Thus the Aryans yet once more seem to have gone through the phase of the archaic civilization. Earlier gods, named after their mother, and reincarnating themselves through her, are pushed into the background by a war-god, who is connected with patrilineal institutions. Yet, at the same time, it must be mentioned that Indra himself has children by earthly women ; so that the Aryans had not entirely broken loose from the old ideas. They preserved the idea in their mythology when they had lost it in actual life.

[1] H. H. Wilson 122. [2] " Mahabharata," Adi Parva xxiv., xc., xcv. Deussen 17, 18, 396 e.s.

The evidence derived from India thus bears out the contention based on the study of beliefs in America, Australia and elsewhere ; namely, that the totemic clan depends for its perpetuation on the successive reincarnations of spirit individuals, and that it has no essential connexion with animals, plants or material objects. The belief is based, evidently, on the notion that the sky-beings could make embryos. The essential independence of the two groups of ideas accounts for several difficulties in the proper understanding of the totemic clan system. In the first place, it shows that the fact that totemic clans may be chosen, as in the case of the Huron, that they may have originated from a woman who gave birth to animals, or that they were the result of the marriage of an earthly woman and a semi-human, semi-animal male being, is not of any great importance from the point of view of the origin of the clan system : these are but accounts of the inception of the clan system in particular cases. The clan depends upon the sky-beings for its inception, and its perpetuation is ensured by the process of reincarnation through the women.

The clan could persist even though it were not named after an animal, plant or material object. It is therefore possible that the doctrine of reincarnation has intermingled with ideas concerning the relationship between certain families and totems of different sorts, and that the belief in descent from the animal, or even in identity with the animal, has not been the basic element of the system.

The notion of actual descent from the totem is understandable when the first ancestor of a clan was a Bear, Lion, and so forth ; it is hard to see how man conceived of birth from trees ; and the notion of birth from material objects can hardly be primitive. Men may identify themselves with animals, or even with plants, but when it is claimed that they identify their life and personality with material objects, it is time to cry a halt, and to seek in some other direction for the real relationship between a clan and its totem.

Signs of ideas of a relationship between men and animals are found as early as the Upper Paleolithic Age in Europe, when the teeth and claws of animals were worn as necklaces. The idea at the back of this practice was evidently that of protection. For, at the present day, the custom is world-wide, and the teeth or claws are certainly worn as protectors. It has been seen in the case of the Yuchi that the totem animal is a protector. And when the totemic clan system broke down in North America the idea of the animal as protector survived, so that some students look upon this aspect of the system as fundamental. So it probably is, but not perhaps in their sense. It is fundamental in that, in North America, it has shown itself most capable of surviving the forces of disintegration, and of persisting when the transition has taken place to patrilineal descent. It is therefore possible to claim, with some plausibility, that the aspect of the

totemic clan system concerned with the relationships between men and the totem, is based originally on the notion of the animal as the protector of the member of the clan. All other ideas of the relationship between a man and his totem may be purely secondary derivatives of the system itself. The only way to discover the truth in such a case is to institute an historical inquiry into the belief. It is evident that such an inquiry will have to concern itself with the vast mass of facts concerned with the initiation ceremonies by which a youth is made a full member of the clan. He has to undergo certain ordeals and is subjected to certain rites, such as scarification, tattooing, and circumcision. He also has to undergo a process of ritual death and rebirth, the significance of which is obscure.

The ritual of the totemic clan initiation ceremony has persisted, after the break-up of the clan system, in the form of secret societies, the members of which are connected with animals, not by birth, but by other ties. They are initiated into the society, and then only do they attain to full communion with the animal or other object round which centres the ritual of the society. Before, therefore, pronouncing judgment upon the meaning of the relationship between the clan and the totem, it would be necessary to subject the ritual of totemic clan initiation ceremonies and secret societies to a close analysis.

In one case it is possible to see that the relationship between the man and an animal is not that of descent. It has already been stated that the king of Egypt was closely identified with the hawk, the bird of Horus. When the king was crowned, the double of the hawk came from the sky, and incarnated itself in him ; on his death it returned to the sky, and became identified once more with Horus. This king was thus half human and half hawk, and the relationship between his two aspects was not that of descent. The king of Egypt belonged to the Hawk Clan, it may be said, for he was closely identified with the hawk. But, after the Fifth Dynasty, at any rate, his actual father was stated to be the sun-god Re, who, according to the later accounts at least, performed this feat by causing a manufactured embryo to be placed in the queen. The life-story of the king of Egypt was thus complicated. He was born of a theogamy in a certain family connected with the hawk ; he really was a spirit individual manufactured by Khnum, and placed in his mother for the purpose of birth ; his real identification with the hawk did not take place until his coronation, when the hawk-double descended on him. It might thus be said that the king of Egypt was the reincarnation of Horus, and that he belonged to the Hawk Clan, his full membership of that clan beginning at his coronation.

This series of facts can be paralleled elsewhere in the region. Hocart states that the ceremony of coronation of important Fijian chiefs resembles a process of rebirth. Moreover, it is an universal feature of the initiation ceremonies of totemic clans

and of secret societies that the initiate does not really belong to the clan or society until he has gone through a process of ritual death and rebirth.

The point common to these three groups of ceremonies is that the king, or the member of the clan, or of the society, is not fully identified with the totem, or the animal of the society, until he has gone through some process of initiation. He is not, just by the fact of birth in the clan, made a full member of that clan. That has to be accomplished by a ceremony. It is therefore imperative to understand the real meaning of the ceremony of ritual death and rebirth common to the coronation ceremony of the Fijian chief, the totemic clans and the secret societies, and to know what relationship this had to the coronation of the Egyptian kings.

The difficulties in the way of this comparison are obvious. The coronation ceremony of the Egyptian kings was, so far as is known, performed in his case alone : it was not performed for all Egyptians, even for all members of the nobility. Again, nothing is known of the ideas of the Egyptians about reincarnation, and it is doubtful whether they had such ideas.[1] Although it is possible to compare the nome system of Egypt with the totemic clan system of other parts of the region, this comparison is not exact. Whereas it is well known that each male member of a community throughout the archaic civilization was probably initiated into his clan, the initiation in Egypt was, so far as I know, confined to the king. This constitutes a difficulty in studying the relationship between the members of a totemic clan and the totem.

To take another point of view. The ritual of initiation is so closely connected with that of death that it may be necessary to consider the death ceremonies of Egypt and elsewhere in conjunction with those of secret societies and totemic clans. A suggestive comparison has already been made between the ritual of the Midewiwin secret society of the Ojibwa of North America and the Egyptian Book of the Dead, and perhaps the prosecution of this line of thought would lead to important consequences.[2]

Evidently the study of the totemic clan system has to be approached from at least three different directions. The clans are grouped together, in the first instance, so that they contribute members to the council of the tribe or state : each clan consists of a number of individuals perpetually undergoing reincarnation : finally each clan is connected with some animal, plant or material object, with which the male members are identified by means of an initiation ceremony. These three elements of the system are apparently independent. The clans can carry on their business

[1] Certain modern Egyptian customs suggest that the ancient Egyptians had such ideas.

[2] Emerson. Cf. C. S. Wake for another instance of similar beliefs in Egypt and North America.

by means of their own councils : reincarnation can take place in other circumstances than those of the totemic clan : and the relationship with animals can persist after the original clan system has broken up. The system, therefore, has been brought into existence through the amalgamation of at least three distinct cultural elements, none of which have any real inter-relationship, and all of which can exist in complete independence of the others ; and it is only in the archaic civilization that these cultural elements appear to be in their proper setting.

CHAPTER XXIII

EXOGAMY

ONE important feature of social organization has hitherto been ignored—the rule of exogamy, under which marriage is prohibited in a given social group. This custom has long interested students, and many attempts have been made to discern its origin in some rudimentary stage of society, but an examination of the practice in various phases of society shows that its origin is to be sought in a highly developed, rather than a lowly, civilization.

I have postponed the study of exogamy until the totemic clan system had been examined, because this custom is, in certain circumstances, associated with totemism, so that a man may not marry a woman of his own clan. This rule of clan exogamy has been taken by some students as typical of the totemic clan system; but one writer at least, Sir James Frazer, has realized that, although totemic clans are often exogamous, the rule originally held only between the moieties of the dual organization. Therefore a knowledge of the relationship between clans and moieties is essential for an appreciation of the meaning of exogamy.

L. H. Morgan describes the social organization of the Iroquois. The Seneca branch of the confederacy was' divided into eight clans, grouped in two moieties : Bear, Wolf, Beaver, Turtle, on one side ; and Deer, Snipe, Heron, Hawk, on the other side. " Each phratry (i.e. moiety) is a brotherhood (De-a-non-da-a-yoh) as this term also imports. The gentes in the same phratry are brother gentes to each other, and cousin gentes to those of the other phratry. They are equal in grade, character and privileges. It is a common practice of the Senecas to call the gentes of their own phratry, brother gentes, and those of the other phratry, cousin gentes, when they mention them in their relation to the phratries. Originally marriage was not allowed between the members of the same phratry ; but the members of either could marry into any gens of the other. This prohibition tends to show that the gentes of each phratry were subdivisions of an original gens, and therefore the prohibition against marrying into a person's own gens had followed to its subdivisions. This restriction, how-

ever, was long since removed, except with respect to the gens of the individual.

" A tradition of the Senecas affirms that the Bear and the Deer were the original gentes, of which the others were the subdivisions." [1]

In its original form, therefore, the exogamy of the Seneca was between the moieties. Each moiety consisted of a number of clans, but they were not exogamous in themselves, and, for the purposes of marriage, need not have existed.

The practice of exogamy has two aspects. When marriages are only allowed between the two sides of a community, it can be said that, for some reason, the members of one side are prevented from marrying women of their own side, and, consequently, must seek their wives on the other side ; or else it can be said that men of one side are forced to seek their wives from the other side. There is either a repulsion in either side, or else an attraction between the sides. For instance, some think that the desire to prevent incest led men to institute exogamy : such students explain the custom by the existence of a repulsion in the moiety. Other explanations have been forthcoming, most of them based on similar reasoning. So far as I am aware, the existence of a political reason for such a form-of marriage has escaped notice.

Morgan shows that the mechanism of exogamy broke down among the Seneca, so that the prohibition became restricted to the individual clans. The principle was maintained, but the area of choice has widened, so that a mate can be chosen from every other clan. The custom of exogamy, fixed in the tribes as a cultural legacy from the culture-hero, and thus buttressed by the sanctions of tradition, survived, as a regulator of marriage, the breakdown of the dual grouping.

Sir James Frazer, in his work on " Totemism and Exogamy," has already reached a similar conclusion. He thinks that exogamy first held between the moieties, and that clan exogamy came later. At the same time his scheme differs from that outlined here, in that he wishes to find the origin of the practice in some communities like those of the Australians, as the result of the desire to prevent incest.[2] Sir James Frazer adds further important support for the scheme, as is to be seen in the following quotation :—

" We have seen that wherever the system of relationship of a totemic people has been ascertained that system is classificatory, not descriptive in its nature. To that rule there appears to be no exception. But, further, we have found that the classificatory system of relationship follows naturally and necessarily as a corollary from the system of group marriage created by the distribution of a community into two exogamous classes. Hence we may infer with some degree of probability that, wherever the

[1] L. H. Morgan 90-1. [2] J. G. Frazer ii. IV. 132-4.

24

classificatory system now exists, a two-class system of exogamy existed before. If that is so, then exogamy would seem everywhere to have originated as in Australia by a deliberate bisection of the community into two exogamous moieties classed for the purpose of preventing the marriage of near kin, especially the marriage of brothers with sisters and of mothers with sons." [1]

This shows that it is possible to reconstruct the past form of society from the relationship systems of existing peoples. [2] The classificatory system of relationship depends upon the dual organization, for it is its natural result ; the classificatory system is found among totemic people the world over, whether they now have the dual organization or not ; therefore, in the past, all peoples with totemic clans must have been organized on the dual basis, that is, into two exogamous moieties, each of which was divided into totemic clans ; and, although the dual organization has broken down, the classificatory system of relationship has persisted to witness its former existence. Sir James Frazer thus provides the scheme in process of construction with a powerful support ; he makes it plain that, in all parts of the region, the dual organization was formerly predominant, a contention already sustained in this book. I have argued that the totemic clan system itself belongs to the archaic civilization. Sir James Frazer, in associating the classificatory system of relationship with totemic clans, is adducing yet another reason for the acceptance of this conclusion.

A quotation given by Swanton with regard to the Creeks of the Mound area suggests that clan exogamy was deliberately instituted : " An old and very intelligent Kealedji Indian positively declared that anciently clans were not exogamous, but that at one time a council was held at which it was determined that they should be made so." [3] The clan system is followed, in North America, by a third stage. Tribes such as the Arapaho, Cheyenne, Kiowa, and Comanche of the Plains have no phratries, no clans and no totemic divisions. [4] In their case the system is in ruins.

If others besides Morgan had made adequate records, it would be possible to witness in all parts the development of new forms of society out of the original dual organization of the archaic civilization, to see the dual organization breaking down and the peoples rearranging themselves on the basis of clan exogamy, itself finally destined to disappear. The case is clear among the Iroquois ; but in that of the Mekeo peoples of British New Guinea it is even clearer. For the diligence of Professor Seligman has

[1] J. G. Frazer ii. IV. 135–6.

[2] This is another confirmation of the soundness of Rivers' contention, that social structure persists longest. This is but natural, when it is remembered that the dual organization of the archaic civilization, due entirely to the ruling groups, survived their disappearance.

[3] Swanton ii. 596. [4] Kroeber 9.

put on record the history of the Mekeo tribes from their origin, and this history is well worth following in detail.

The Mekeo group of tribes consists of the Biofa and Vee, who, since they have a common language, and have always intermarried, in spite of chronic warfare between them, possess characteristics of the two sides of a dual organization. The original settlements of these tribes were, Ioiovina for the Biofa, and Ioiofaopo for the Vee, names that again suggest the dual organization.[1] Each village was divided into two exogamous groups called pangua, connected respectively with the breadfruit tree, and a sort of palm. These two villages in turn gave rise to daughter settlements, the cause of migration being incessant strife between the divisions. Every pangua group consisted of a number of clans, each claiming descent from a common ancestor, and members of these clans went off to found new villages of their own.

The birth of new pangua is easy to understand. Certain clan groups that belong to the same pangua, or exogamous group, come to feel themselves more closely linked together than the other clans of the same large group, and set up a constitution of their own, and thus form another pangua, independent, yet remembering its relationship to the original larger group. When a new pangua comes into existence, and is of sufficient strength, it divides into two groups of clans calling themselves " first born " and " later born," thus corresponding to the widespread dual grouping of " elder " and " younger." It might be expected that these divisions would practise exogamy. But this is not so. The memory of the original system has persisted through all the fissions, so that a " first-born " group of one pangua is associated with the " later-born " group of some other pangua that traces its descent to the other side of the original villages. This relationship is called ufuapie, and it involves certain reciprocal services. The word ufuapie means " club-house of the other side of the village," and this is thought to refer to the original village, in which, as usual in dual settlements, the two divisions live on either side of the street.[2]

Professor Seligman comments thus on the marriage relations between ufuapie groups :—

" The effect, if any, on the regulation of marriage exercised by the ufuapie must now be considered. In discussing this matter with natives of Mekeo the impression left on my mind was that it was considered better to marry within the ufuapie group, though this was not necessary. Dr. Strong independently arrived at the same conclusion, and Father Guis in his account published in 1898 also takes this view, indeed he goes so far as to say that ' the young men of a village may only marry the girls of their allied village . . . (ufuapie, auai at Mekeo) . . . by these words is understood . . . a village that in every contingency and under all circumstances acts with another (en tout

[1] Seligman i. 366. [2] Id., i. 349 n.1.

et pour tout est de moieté avec une autre). For example, the people of Beipaa (Veifa) feed pigs and bring up dogs, but these pigs and dogs are not for them, they are for the village of Amoamo, their ufuapie, and in return the pigs and dogs of Amoamo come to Beipaa. . . . The same condition holds in the matter of marriage ; the girls of a village, according to the accepted rule, should not marry any others than the men of the ufuapie.' " [1] Professor Seligman says further that marriages in the ufuapie are now exceptional. All that can be said, therefore, is that the ufuapie groups are in some ways related, and that a tradition has been handed down of regular intermarriage between them, which is a continuation of that which existed in the original villages. The original dual grouping with intermarriage can thus still be discerned, in that such marriages are still considered desirable, though really not much practised. The only rule now observed is that members of clans must not marry. This case has thus every appearance of one in which clan exogamy has resulted directly from the original intermarriage of the two sides of the dual organization.

Another instance is that of Santa Cruz in Southern Melanesia, where the people are grouped in exogamous totemic clans. The dual organization is lacking, but, since the people have the classificatory system of relationship, it probably once existed.[2] The exogamous totemic clan system is followed in Melanesia by the rule of prohibition of marriage between relatives, which is found among the " betel-people " of Rivers, the latest immigrants, who live principally in the Western Solomons.

The study of culture-sequences in North America and Melanesia reveals three stages of development of marriage rules : (1) marriage forbidden between members of the same moiety ; (2) marriage forbidden between members of the same clan ; (3) marriage forbidden between blood relatives. The bearing of this on the marriage rules of the Aryans of India is instructive. They are divided into exogamous groups, which are not totemic. When these people first emerge on the scene of history their culture shows signs of the former prominence of sun-gods, of mother-right, of human sacrifice, and perhaps totemic clans. Their division into exogamous groups suggests that they had proceeded one step towards the third stage in the regulation of marriage, but that, for some unknown reason, they gave up the idea of relationship with animals, so typical of the totemic clan system, and the original relationship with animals has survived in their mythology.

On the assumption that exogamy was primarily connected with the dual groupings, and was independent of the clan system, it is possible to enter on the discussion of an important question. For, if the dual groupings take their characteristics from the ruling group of the archaic civilization, it should follow that the

<hr>
[1] Seligman 364. [2] Rivers ix. II. 72, 75.

ruling groups themselves practised exogamy : that is to say, in the original settlements ruled over by the Children of the Sun, intermarriages should take place systematically between the sky people and the underworld people.

The practice of intermarriage between the ruling families of two sides of a dual settlement is universal in Ponape and the Pelews of Micronesia ; in Ponape two intermarrying families supply the sacred chief and the war-chief of each district ; [1] in the Pelews, again, the clans of the two sides of each village are grouped round two principal families, who intermarry. This is also presumably true of the two leading families in the dual villages of Fiji. A probable case of the same sort is reported by Kruyt in Timor, in the district of Amanoeban, which with Amanatoen forms a dual grouping. It is said that, formerly, the sister of the ruler of Amanoeban, who lived at Niki-niki, went away and settled at a place called Pene. At the present time the rule is that the chief of Amanoeban, who now lives at Niki-niki, must marry a woman of the ruling family of Pene. [2] Cross-cousin marriage is the favourite union in this part of Timor, [3] and this is evidence of the past existence of the dual organization, and of the practice of intermarriage between the two groups. Further instances have been recorded in Sumba by Wielenga. In Malolo of Eastern Sumba, the government is in the hands of two families, one of which supplies the sacred chief, and the other the civil chief. The civil chief must marry, for his principal wife, a woman of the family of the sacred chief. It is not said whether the sacred chief in his turn takes a wife from the side of the civil chief ; but, in some instances, the members of the sacred chief's family must obtain their principal wives from the rulers of Toboendoeng, who constitute the oldest ruling group of Sumba. This restriction in marriage does not apply universally in Sumba, but only in the case of Malolo, Toboengoen, Rende and Kanatang.

The ruling houses of the Bugi and Macassar states of South Celebes probably once were exogamous. According to Bugi traditions the rulers of the sky-world and of the underworld were brothers, the ruler of the sky-world being the elder. The elder brother said that no one existed on earth to carry on their cult, and that he intended to send down his eldest son, Batara Guru, to the earth, for this purpose, demanding also that the ruler of the underworld should send up his daughter to be the wife of Batara Guru. The sky-god told Batara Guru that he would no longer be a god, but that when he wanted anything he was to ask for it. [4]

This story shows plainly the relationship between the gods, both of the sky and of the underworld, and ruling houses. Men worshipped only their ancestors. The sky-god, having no descen-

[1] Hahl 5 e.s.
[3] *Id.*, 790.
[2] Kruyt ix. 790.
[4] *Id.*, iii. 467–8.

dants on earth, received no worship until he sent down his son to establish his cult and perpetuate it through his descendants. Batara Guru came to earth, made it habitable, and planted vegetables. His father made him a house to the accompaniment of thunder and lightning. Njilitamo came up from the underworld and became his wife, and they were the ancestors of the ruling houses of the Bugi.

Another account, from Luwu, throws more light on the early history of the Bugi. For, in this case, the ruler of the underworld is the brother of the wife of the ruler of the sky, and the wife of the ruler of the underworld is the sister of the ruler of the sky-world. Thus pairs of brothers and sisters have married, a perfect example of intermarriage between the two sides of the ruling group. A son of the sky people married a daughter of the underworld people, and thus practised a cross-cousin marriage. The children of this marriage were Sawerigading, the great Bugi hero, and his twin sister We Tanrijabong. Sawerigading married a princess of the underworld, and ultimately retired there with her. His sister married a being of the sky-world, and they went to the sky. After several intermarriages between the two worlds, the Luwu chiefs were ultimately descended from a sky prince and a princess of the underworld.[1]

The conditions in these stories show that the sky people and the underworld people systematically intermarried. In the Luwu tale the two beings who came to earth to found the royal family were cross-cousins, that is, children of brother and sister. It is therefore striking that the royal family of Boni seem formerly to have practised this kind of marriage.[2] In later times it disappeared, so far as I can tell from the study of the available facts. The cross-cousin marriage being almost certainly the result of the dual organization with exogamy, its practice among the rulers of Boni suggests that this group formerly was divided into two parts, the members of which intermarried; one part of this ruling group would, on the basis of the origin stories, have belonged to the sky-world, and the other to the underworld, but those days are evidently long since past.

The history of the Mandar confederacy likewise suggests a former condition of exogamy between the ruling groups of the Bugi; for it is said that, after the spread of the ruling house of this confederacy, their homeland, Toboelawang, remained the leading mountain settlements, and the chief of Boni was the ruler of the lower settlement, because the sister of the Toboelawang ruler had married him.

These examples, derived from places where the Children of the Sun existed in the past, suggest that the practice of intermarriage

[1] B. Morris 550.
[2] Bakkers iv. 154 e.s. It would be interesting if a complete set of tables for the various Boni states, Palakka, Soppeng and the others cou d be procured.

formerly held between the two branches of the ruling groups of the archaic civilization.

Twin or brother culture-heroes are closely connected with the ruling families of the dual organization, so should also be connected with exogamy. This is inferred from their association with the beginnings of social life in North America, Australia and elsewhere. In one case it is expressly said that they instituted exogamy between the two divisions. In Opa (Omba), or Leper's Island, of the New Hebrides, the culture-heroes are Takaro and Mueragbuto. Takaro created the people, and organized them in two exogamous divisions, which were connected with the right and left hand, because they sucked at the right- and left-hand breasts of their mother.[1]

The evidence, so far as it goes, points to intermarriage between the two branches of the ruling family of the archaic civilization. Since the examples have not been taken from places where the Children of the Sun can be observed, it is necessary to pursue the inquiry. The only places where it is possible to do so are Egypt and Manu'a in Samoa, for only here have we enough data concerning marriages. Egypt will be left over till Chapter XXVI, for the evidence is complicated, and attention will be solely occupied with Manu'a.

The island of Tau in Manu'a of Samoa, which was first settled, was divided into two parts, Fitiuta and Tau. Fitiuta, the first settlement, differs from all other places in the Samoan group, and indeed from most other places in Polynesia, for its first inhabitants were the Children of the Sun, the Sa-Tagaloa.[2] The two parts of Fitiuta are connected, in one account, with Aga'euta and Aga'etai, man and wife, who had a son Aga'e, presumably one of the Sa-Tagaloa; [3] for it is said that the Tagaloa family brought from the sky, that is, from their home, the Galea'i title, which they gave to Aga'e.[4] This was, so far as can be told, the first royal title in Samoa, and, as has been seen, it was later on connected with peace, and not with war, as was the Tui title.

Now comes an important story, the meaning of which must depend entirely upon the interpretation placed upon the facts recounted as to the foundation of Fitiuta. It is said that Taga-loaalagi, the sun-god, was the father, by a girl of Fitiuta, of Aga'e, and, by a Tau girl, of Tau : [5] thus the ruling families of both sides of the island, and therefore of the dual organization, were the children, by different mothers, of a sky-being. Descent evidently was matrilineal in those days, for the two children belonged to the settlements of their mothers. The two settlements had different characteristics : Tau was always associated with the temporal power, as the seat of the Tuimanu'a ; while Fitiuta was always the home of the sacred chief. Tau was never connected with the sky-world, whence it may be presumed that

[1] Suas i. 47. [2] F. Krämer I. 370. [3] Id., 371, 378,
[4] Id., 382. [5] Id., 370.

the Tau girl was connected with the underworld, which in Samoa in later times was the universal abode of the dead and of deities.

On the other hand, the girl of Fitiuta evidently belonged to the sky-born part of the ruling family. This can be surmised from the story of Galea'i, or Aga'e, and of the loss of the Galea'i title, which came from the sky. Aga'e, the Galea'i, married, not a girl of Fitiuta, or of the Tagaloa family, but a daughter of the Tuiosana ; [1] and their child, Taeotagaloa, was the first Tuimanu'a, the first Tui chief of Samoa. Since the wife of the Galea'i belonged to a Tui family, the title evidently descended through her to her son, which is natural under matrilineal institutions. It is said that the Tui title was at this time brought down from the sky, and given to Taeotagaloa ; it did not exist before in Samoa. The title belonging to Aga'e was, of course, the sacred title of Galea'i. The question is, why was not this title given to his son ? The answer comes from the comparison between the marriages of Tagaloaui, the father of Aga'e, with that of Aga'e himself. Tagaloaui married two women, one of Fitiuta, and the other of Tau ; Aga'e was the child of the first marriage, and Tau of the second. Aga'e evidently succeeded to the Galea'i title because his mother belonged to Fitiuta. He could only hand it on to his son by marrying a Fitiuta woman, which he failed to do.

This explains why the Galea'i title was superseded by the Tui title, which became the most important in Manu'a, for it was in closest connexion with the people of the sky-world. Therefore the lapsing of the Galea'i title in Samoa gives exactly the conditions found among the Bugi and Macassar of Celebes, that is, a ruling family descended from a man of the sky-world and a woman of the underworld. The account from Manu'a is more important, however, for it reveals the conditions of the days of the Children of the Sun.

The other accounts of the ancestry of Taeotagaloa, the first Tuimanu'a, show that he is always the son of a woman of the Tui family, or of a woman belonging to the underworld. In one instance the Sun married Ui, the daughter of the Tuiatafu, a ruler in Atafu, where the sun-cult was practised. Their son was Tagaloaui, who married a daughter of La Fe'e, the ruler of the underworld.[2] Their son was Taeotagaloa the first Tuimanu'a. Thus the ancestry of Taeotagaloa, on his mother's side, connected him directly with the Tui chieftainship and the underworld group. Another account makes Taeotagaloa, the first Tuimanu'a, the son of Tagaloa-la, the sun-god, and a daughter of the Tui-fiti.[3]

This collection of stories provides consistent facts. Evidently the various titles were hereditary, and a man had to marry the heiress in order that his son might succeed to them. The coming into prominence of the Tui title coincides with the marriage of

[1] F. Krämer 383. He therefore married into the other group of the dual organization.
[2] *Id.*, I. 393, 45. [3] *Id.*, 393.

a member of the sky family with a woman of the underworld family, a daughter of a Tui chief. This title is said to have been derived from the sky-world. It is thus evident that the ruling class of the archaic civilization had two chief titles, the Galea'i and the Tui, one belonging to the sky family and the other to the underworld family. It was necessary for a Galea'i chief, a sacred chief, to marry a woman of the sky-world if the title was to persist. Once such a union was lacking the title lapsed, and the less lofty title took its place. According to tradition Taeotagaloa, the first Tui chief, went from Fitiuta to become the Tuimanu'a at Tau, while Le Fanonga, his brother, was left at Fitiuta to be the war chief. Taeotagaloa is also said to have married two girls, one from Fitiuta and the other from Tau, and the two sons that resulted, who were born on the same day, were respectively sacred chief and war chief of the island.[1] Thus the distinction of sacred chief and war chief has survived the disappearance of the Tagaloa family and the original sacred title of Galea'i ; that is to say, Fitiuta supplies the sacred chief, and Tau the war chief ; but the original ruling family has disappeared.

If these stories have any semblance of reality, it would seem that, in the times when the Children of the Sun existed in Tau, the ruler was in the habit of marrying women from both sides of the community. The woman from Fitiuta was of royal blood, and, assuming matrilineal descent, the sacred title of Galea'i went with her. On the other hand, the Tui title, that of war chief, went with the girl of Tau. Thus the Children of the Sun practised two sorts of marriage, with their own stock and with the war chief's side of the ruling group.

The marriage of the Children of the Sun with their own stock is a well-known feature of that family. For in several places they married their sisters or some other blood relative, and the eldest son of such unions succeeded to the throne. This was so in Egypt, where the king seems to have married his sister, mother or daughter, so as to obtain the throne and the inheritance that went with her. In Indonesia the evidence collected in " The Megalithic Culture of Indonesia " shows that ruling classes that claimed descent from the sky-world invariably asserted that their first ancestors practised incestuous unions. In Hawaii and elsewhere the early ruling class of Children of the Sun seems to have practised such unions. Since the Children of the Sun practised polygyny, it could easily happen that the ruler also married the eldest daughter of the war chief.

The conclusion to which this discussion points is that the Children of the Sun married relatives, and women of the other side of the ruling group, that side associated with the underworld. The side of the district inhabited first of all by the Sun family was that side which continually provided the sacred chief, and the other side, that of the underworld group, supplied the war

[1] Pratt ii. 135.

chief, the descent being through the mother. Thus the dual associations of the twins is explained, as well as their brotherhood. They were not twins, but half-brothers ; their twin nature was due to the dual settlement, as has been suggested. This would explain why du Pratz found among the Natchez of Louisiana, ruled over by the Children of the Sun, that the brother of the Great Sun, Stung Serpent, was the head of the army.[1] It is known that the Natchez ruler had to be the son of a woman of royal blood, which agrees with what was inferred in India. Presumably Stung Serpent, who, on the analogy of the rest of the Indian tribes, belonged to the other side of the dual grouping from the Great Sun, was the son of a woman from the other side of the ruling group.

In the original settlement of Tau of Manu'a, one side of the island provided sacred chiefs and the other provided war chiefs. The dignity of the war chief, the Tui, was founded later, and was less than that of the sacred chief. In the course of time the family of the Children of the Sun disappeared, apparently, in Manu'a, when the Galea'i failed to marry a woman of Fitiuta. Thereafter the Tui chief was the chief ruler. None the less the distinction of sacred and war chief was still a feature of the political organization of the island. For Taeotagaloa, the first Tuimanu'a, the first war chief of Samoa, married women from Fitiuta and Tau, the opposite sides of the island, whose sons, born on the same day, were respectively sacred and war chiefs. Thus the organization set up by the original Children of the Sun was continued by their successors, so that marriages took place between both sides of the island.

The deliberate institution of the dual organization has already been described in the case of Rarotonga and among certain North American tribes. It appears, consequently, that the dual organization persisted when the originators had vanished, but in a modified form, for the brother-sister marriage, which was typical of the sky-people, if not peculiar to them, disappeared, and the underworld folk seemingly did not practise it in Polynesia. So, when the Children of the Sun vanished, the community would be left with a dual grouping of the ruling class, the two sides providing the sacred and war chiefs. The custom of intermarriage already existed, and presumably it took the form of exogamy as is found in Ponape and the Pelews.

The analysis of the traditions of the Samoans and others leads to a discussion of an important point in mythology. How is it that certain peoples claim that the race began with the union of sky and earth, with a man of the sky-world and a woman of the underworld ? Such stories as these apply to the ruling group, for the commoners, in Samoa, were said to have been created by the sky-folk, the Tagaloa family.

In examining Samoan stories of origin it must be remembered

[1] du Pratz 43.

that these people had no direct knowledge of the days of the Children of the Sun, so that they would know nothing of the incestuous unions that were practised, and stories of theogamy would not refer to an event that might happen any day. Samoan tradition really only goes back to the times when the Tui chief-tainship was already in existence ; for, from the earliest times, marriages take place with that family, either in Samoa or in Fiji. The marriages are usually between a man of the sky-world and a woman of the Tui family, connected with the underworld ; and, since descent is evidently matrilineal, the son is a Tui chief.

The interpretation of this story has already been put forward : it is concluded to be the result of the break-up of the original organization, of the disappearance of the Children of the Sun, and to show that the early ruling groups of Manu'a in Samoa consisted of two intermarrying families. Since the later chiefs were all connected with the underworld, the interpretation fits the facts. But it is necessary to go further in order to reach greater certainty. If the two sides of the dual grouping inter-married, we should hear of marriages between men of the under-world and women of the sky-world whose children would be Children of the Sun, or at least would belong to the sky-world, the land of their mothers. It is significant that the Samoans interpret the manner of birth of the Sun in this way. They say that the Sun was the son of a masculine being called Po, darkness, and a feminine being Ao, light.[1] Thus the two stories give a complete exogamous system, in which the people of the sky and those of the underworld intermarry, and the children follow their mothers in descent. This is, of course, surmise, based on the amalgamation of Samoan tales, and must be treated as such. It is nevertheless remarkable that Samoan tradition should yield results so harmonious.

The history of Samoa thus resembles that of the Bugi and Macassar people of South Celebes, whose ruling families, in the three stories of origin that were quoted, were invariably descended from marriages between beings of the sky-world and those of the underworld. The existence of the cross-cousin marriage in the royal family of Boni, coupled with its popularity in Timor, suggests that this traditional form of union between two distinct families actually was in practice ; and that, when the old order broke up, only the form of marriage and the tradition persisted. As in Samoa, the conditions usually suggest that the mode of descent was matrilineal, so that the setting is the society of the archaic civilization.

The instance of South Celebes may be taken as a second phase in the break-up of the dual organization after the disappearance of the Children of the Sun with their incestuous unions. The Maori of New Zealand provide a possible third stage. They have come from Rarotonga, where the dual organization was deliber-

[1] F. Krämer 393, 413 : Pratt ii. 242–3 : Stair ii. 48.

ately set up, and they retain less trace of the dual organization than the peoples of South Celebes. The Maori claim descent from Taaki or Tawhaki of Rarotonga, the brother of Karii or of Kariki. They claim also to have been formerly part of the dual organization. Since Kariki is associated, in Rarotonga, with the dual organization, it is probable that his brother, Taaki, is also so connected. Kariki came from Manu'a in Samoa, and belonged to the sky-family, the Ali'a, the descendants of the Tagaloa folk of the sky. According to the Maori he was the ancestor of the Rarotongans.[1] Since the Maori came from a place with the dual organization, and are predominantly connected with the underworld,[2] their ancestors should, with matrilineal descent, be a woman of the underworld and a male being of the sky. This is so, for the ancestors of gods and men are Rangi and Papa, Heaven and Earth, male and female.[3] The facts are therefore in agreement. This agrees with the Samoan belief that the " Sun " was descended from a woman of the sky and a man of the underworld. The two cases correspond to one another on the assumption that exogamy took place between the two sides of the ruling family.

Other instances of the origin of the dual grouping from the union of sky-people and underworld-people, or rather, people presumably originally connected with the underworld, exist in North America. The Omaha claim that the sky is male and the earth female, so that the union of these two is necessary for the perpetuation of all living forms. These ideas are not fanciful, but are connected with the dual divisions of the tribe.[4] The Osage tribe of the Sioux were likewise formed of the union of people belonging to the sky-world and the underworld.[5] The case of the Omaha shows that a tribe in which the old rules of society are disappearing, in which matrilineal descent has given place to patrilineal descent, retains, in its mythology, traces of the former organization ; which further supports the conclusion derived from the Maori and the peoples of South Celebes. The disappearance of the teaching of the old men, who state that the dual division formerly had to do with exogamy, would serve to produce an exactly similar condition of affairs.

The story, that the earth and the sky are the first ancestors of a race, founded on the past existence of the dual organization, constitutes another example of the close connexion between all aspects of the life of a community. It may be claimed, on the

[1] P. Smith vi. 191.

[2] It must not be forgotten that an ambiguity exists in respect of this matter (see p. 174).

[3] R. Taylor 116 e.s. : Best xiv. 3.

[4] Fletcher and La Flèsche 135. " Amid the wreckage of the ancient tribal organization at the present time, the practice of exogamy is still observed " (135).

[5] *Id.*, 63–4. The Zuni state that human beings resulted from the union of Father Sky and Mother Earth (Cushing ii. 379). Among the Hopi the Sun and Earth " are the parents of all clans " (Fewkes vii. 85).

other hand, that it is " natural " to ascribe a sexual antithesis to the sky and the earth, and that the sky is naturally male. This would be plausible if such a form of origin myth were universal ; but it breaks down because such an origin is not always claimed. Moreover, the sky is sometimes female, as in Samoa, which destroys the " naturalness " of the sexual antithesis. At the same time it need not be thought that no speculative element enters at all into this antithesis of light and darkness, sky and underworld ; for it may lie at the root in the formulation of the solar theology.[1] But what has gone before suggests that it is necessary, in cases such as that of the Maori, to look first to the history of the people for an interpretation of their origin myths, before inquiring whether such stories are the result of pure speculation.[2]

The topic treated in this chapter is one upon which an immense amount of ingenuity has been expended.[3] It has been approached from many points of view, according to the attitudes of different students. In the present case, the subject was approached by way of the dual organization. Exogamy was a constant feature of that form of society, and, as such, demanded explanation. The search for the explanation revealed the ruling groups of the archaic civilization as consisting of two intermarrying families, or clans, and the exogamy of the rest of the community as derived thence. The culture-sequences established in North America, Oceania and elsewhere, show that the institution of exogamy has a like history in each part of the region : in the beginning it is connected solely with the dual organization itself, the rule being that marriages must take place between the two groups into which the community is divided. The totemic clan grouping does not come into play until the break-up of the dual organization, when the rule is that marriages must be outside the clan. In the final stage, when the clan grouping is disintegrating, marriage is forbidden within certain degrees of kinship. The first form of exogamy, that of the dual organization, bears every trace of artificiality ; certain groups of relatives are possible mates, while others are forbidden ; the children of brother and sister, cross-cousins, may marry, while those of two brothers or of two sisters may not marry. Such a rule is not founded on any prohibition of incest ; it is obviously a secondary derivative from a rule devised for some other purpose. The rule of exogamy in the dual organization simply divided the whole community into two groups, possible mates and forbidden mates, and this grouping has nothing whatever to do with proximity or relationship or propinquity of habitation. It is entirely artificial, and this artificiality is evident when the dual organization disintegrates.

[1] I shall not discuss this matter. Cf. Sethe vi.
[2] See pp. 481 e.s. for a consideration of the possibility of speculation on the part of people such as the Maori.
[3] Westermarch II. 162 e.s.

For then the restriction holds with regard to relatives on one side, according to whether descent is matrilineal or patrilineal, and no real account is taken of proximity. It is only when the clan restriction disappears that marriage is directly forbidden to relatives.

It is stated definitely, in the case of Gowa of South Celebes, that the interrelationship between the rulers of Tallo and of Gowa was a source of strength to the State, and led to its great influence in that part of the archipelago.[1] Since the form of the exogamous principle changed in the course of time, it is easy to believe that, in its inception, it was due to a compact between the two sides of the ruling group, whereby intermarriage took place. When the question of the origin of the archaic civilization is mooted, it will be found that this is the explanation suggested by the facts.

[1] Eerdmans 66.

CHAPTER XXIV

GIVERS OF LIFE

ONE of Elliot Smith's greatest services to knowledge has been his recognition of the rôle of man's search for " life-giving " substances in the development of civilization. In a striking passage in " The Evolution of the Dragon " he says :—
" In delving into the remotely distant history of our species we cannot fail to be impressed with the persistence with which, throughout the whole of his career, man (of the species *sapiens*) has been seeking (in response to the prompting of the most fundamental of all instincts, that of the preservation of life) for an elixir of life, to give added ' vitality ' to the dead (whose existence was not consciously regarded as ended), to prolong the days of active life to the living, to restore youth, and to protect his own life from all assaults, not merely of time, but also of circumstance. In other words, the elixir he sought was something that would bring ' good luck ' in all the events of his life and its continuation. Most of the amulets, even of modern times, the lucky trinkets, the averters of the ' Evil Eye,' the practices and devices for securing good luck in love and sport, in curing bodily ills or mental distress, in attaining material prosperity, or a continuation of existence after death, are survivals of this ancient and persistent striving after those objects which our earliest forefathers called collectively ' givers of life.' "[1]

That is, I am convinced, one of the most important generalizations ever made in the study of human society, and, as evidence is daily being acquired, it becomes increasingly more certain that Elliot Smith has here put his finger upon one of the prime causes of the development of our civilization, namely, the " desire for life " in its broadest sense.

Space makes it inadvisable to enter upon a discussion of the origins of the use of " Givers of Life," and the inquiring reader is referred to the work of Elliot Smith for more details. This chapter will be devoted simply to showing that the archaic civilization was much more potent in the practices connected with givers of life than those that followed it ; moreover, that the later civiliza-

[1] Elliot Smith xx. 145 : See also xviii. : Cf. Weston 75, n. 2.

tions derived magical practice from the archaic civilization. In order to support this thesis, it will be shown that the peoples of the later civilizations use for their magical operations certain objects left behind them by the people of the archaic civilization, and that traditions point to the people of the archaic civilization as a potent source of magic.

One example of this use of ancient objects is well known. The work of Andrée, Blinkenberg and others shows that polished stone implements are considered, in those countries where they are no longer used, to be " thunderstones," " thunderteeth," " god's axes " and so forth, and to have magical powers. The belief can hardly be of spontaneous growth, for it is not attached to palæolithic implements. The choice of a particular group of implements by peoples in widely separated regions points to a uniform cause ; it suggests that in these places the makers of the implements were accredited with great magical powers.

In India the peoples have a widespread belief in the magical properties of polished stone implements, which, as has been seen, are not now made or used by them. The Naga tribes of Assam look upon polished stone implements as thunderbolts ; the Sema Naga say that the fall of these implements from the sky is marked by forked lightning.[1]

In the East Indian Archipelago polished stone implements are not made, and are universally looked upon as " thunderbolts " or " thunderteeth." This belief exists wherever the implements are discovered.[2] Among the Kenyah tribe of Borneo they are called the teeth of the war- and thunder-god Balingo ;[3] a Madang chief, Tama Kajan Odoh, who claims descent from Balingo, the same war-god, possesses many such " teeth " as heirlooms.[4] Kruyt mentions that the chiefs of West Sumba, the part of the island with megaliths, irrigation, dual grouping of villages and other signs of the archaic civilization, possess polished stone implements and similar implements of bronze,[5] which are looked upon as very sacred and as belonging to their ancestors, He mentions also that these objects are found in Central Celebes on hill-sides, in cracks of rocks and elsewhere. The Kolaka district of South-East Celebes is ruled over by chiefs descended from sky-beings called Sangia. The original Sangia were two brothers, who divided the land between them. This suggests the dual organization. One of these Sangia, Konawe, is said to have given stone hammers to the four head chiefs of his district, as tokens that these chiefs were his direct descendants.[6] This information with regard to the association between chiefs of

[1] Hutton i. 196, 252, ii. [2] Perry vii. 133–4.
[3] Hose and McDougall II. 124. [4] Id., II. 11, n. 3.
[5] Kruyt viii. 545.
[6] Kruyt vi. 696–7. Some Californian tribes likewise possess obsidian blades as heirlooms ; they are sacred and objects of wealth, but not like objects in a sacred " bundle " (Rust, 688 e.s.).

Borneo, Sumba and Celebes, and polished stone implements is important. The possession of these sacred objects is a token of descent from beings of the sky-world, or of the ancestry of chiefs ; the Borneo chiefs of the Madang claimed descent from Balingo, and possessed a large number of his teeth ; in Sumba the implements were sacred tokens of ancestors ; in Celebes they were given to chiefs by beings from the sky-world. The information thus agrees in associating these implements with the people of the archaic civilization, and, what is more important, in connecting the ancestors of chiefs with the rulers of the archaic civilization, and thus in providing another link between early and late in Indonesia, a region where such links are all too rare. This further accession of information makes it possible to understand still more clearly the past history of the islands east of Timor. For, in these islands, especially in Wetar, the chief treasures, which, as in Sumba, are kept in the village temples, are small stones in which the ghosts of ancestors are supposed sometimes to live. In the case of Wetar it seems especially clear that these small stones are polished stone implements.[1] If so, the people of the region from Sumba to Timorlaut are evidently preserving implements of the archaic civilization as precious links with the past. The fact that these implements are foreign to the peoples, that they do not know their use, makes any evidence gained from them of peculiar importance : they serve as an unconscious witness to the connexion of these peoples with the archaic civilization, and help to show that in several parts of the region the continuity between past and present has never really been broken.

The magical practices of peoples of the lower culture in Indonesia, Melanesia and elsewhere, tend to centre round a few substances. This is evident from an enumeration of the magical paraphernalia of various peoples. The Punan of Borneo, food-gatherers who have been influenced by their more highly civilized neighbours, make use of charms : " The Punan has great faith in charms, especially for bringing good luck in hunting. He usually carries, tied to his quiver, a bundle of small objects which have forcibly attracted his attention for any reason, e.g. a large quartz crystal, a strangely shaped tusk or tooth or pebble, etc., and the bundle of charms is dipped in the blood of the animals that fall to his blow-pipe." [2] The use of blood and animal's teeth can be left on one side for the present, and attention fixed on the use of quartz. The Punan are not alone in regarding this substance as a " giver of life," for the Kayan and other tribes use it. Kenyah houses usually possess a bundle of charms : " This bundle, which is the property of the whole household or village, generally contains hair taken from the heads that hang in the gallery ; a crocodile's tooth ; the blades of a few knives that have been used in special ceremonies ; a few crystals or pebbles of strange shape ; pig's teeth of unusual shape (of both wild and domestic pig) ;

[1] Perry vii. 45, 57.　　　　　[2] Hose and McDougall II. 190.

25

feathers of fowls (these seem to be substitutes for Bali Flaki's feathers, which they would hardly dare to touch); stone axe-heads, called the teeth of Balingo ; and isang, i.e. palm leaves that have been put to ceremonial use." [1]

It may be asserted that quartz is used for magical purposes on account of its colour ; that it has attracted attention and come to acquire magical power. Such a possibility must be borne in mind, but there is much evidence against it.

The magical practices of the peoples of British New Guinea make it more reasonable to ascribe the use of quartz (the matrix of gold) to the influence of the archaic civilization than to the attraction that its properties may have had for primitive man. In British New Guinea it is possible to connect the archaic civilization with the magical practices of the present-day peoples. The evidence collected by Mr. Chinnery shows that the distribution of stone pestles and mortars, stone circles, and other cultural elements foreign to the present population, coincides so closely with that of gold and pearls, as to leave no room to doubt as to what those responsible for the remains were seeking. The natives are ignorant of the nature of the remains, but they use them in their magic : Mr. Chinnery mentions that they had a circular stone mortar ; they had no idea of its use, but would not part with it " lest harm should come to them." In another case a sorcerer had a small stone mortar, which gave potency to his magic, and he was killed because so many people died. Small stone pestles are looked upon as charms. A small stone image was used by the natives of one village to place in the ground in order to get good crops. Neuhass describes and figures some stone human figures with remarkable heads collected in Bukaua, that were used by the natives as charms.[2] That is to say, the present-day population look upon the implements and ceremonial objects from the archaic civilization as " givers of life."

Other evidence reveals the profound influence of this vanished population upon native thought and practice. The peoples of British and German New Guinea look upon the previous peoples as their superiors in power, and this is enough to account for the regard that they have for their remains. This influence goes very deep into their magical practice, and is betrayed by their choice of varieties of stone for charms. The gold-miners made their implements of mica-schist, sandstone, volcanic rock, diabase, diorite, granite, quartz, hornblende, clay-stone, ophicalcite, obsidian and jade. Professor Seligman describes the agricultural charms of the Koita people of British New Guinea : "Yam stones are rounded, oval or oblong, and almost always water-

[1] Hose and McDougall II. 124.

[2] Chinnery 272, 273, 279. Similarly the natives of California regard mortars found in gold-bearing gravels as magical. "They were acquainted with these mortars, but knew nothing about the makers of them, and held them in such superstitious dread that on no account could they be induced to touch one" (Skertchly 332–5).

worn; they usually consist of a volcanic or highly metamorphic rock, or a basic tuff. More rarely yam charms consist of pieces of trachytic lava, waterworn fragments of vein quartz, or even the large irregular hollow blisters' which probably arise in the giant clam (*Tridacna gigas*). When these blisters are removed they are used as charms, they are sometimes reddened, and water is left in them for a few minutes before being sprinkled on the yams.

" Among the yam charms sent by Mr. Ballantine to the British Museum are waterworn pebbles of the following minerals: Serpentine, a diorite or hornblende schist, ophitic diabase, augite, andesite, iron pyrites and a not obviously waterworn piece of chert." Among banana charms are fossil coral, crystalline calcite, limestone, beekite, metamorphic rock, Cassis shell, resin, titaniferous iron ore. The fishing charms seem to have been mainly of quartz: one consisted of an irregularly fractured piece of quartz connected by a short piece of string with a string knot to which are attached five small netted string bags containing various charms, a piece of resin and an irregularly fractured piece of jasper-like rock. The five netted bags contain respectively a highly polished pebble, a clam (Tridacna) pearl, two clam pearls, fragments of resin, a fragment of quartz.[1]

The similarity between the list of stones and other objects used for charms, and that of stones used by the gold-workers in their craft, is striking enough to suggest that the natives attach magical power to these varieties of stone because of their associations. The occurrence of pearls and resin certainly strengthens this suggestion, for it can hardly be doubted that the people of the archaic civilization included pearl-diving among their activities; and the use of resin was extremely important in such countries as Egypt.[2]

Quartz evidently is the most prized of all: " Certain charm stones—as far as my knowledge goes these are always of quartz—are so highly charged with magical power that it is not considered safe for them to be touched with the hand, even by the man who is about to bring their power into play. One charm of this sort which I saw was kept in a small bamboo cylinder, out of which it was lifted by means of a bone fork, the pointed end of which was thrust through the loosely netted covering which surrounded the stone."[3] The stone pestle and mortars left behind in the gold-diggings suggest quartz-grinding. It is therefore significant that the kind of rock that the old gold-seekers sought above all others should have been the most potent in magic for the natives.

The study of the magical practice of British New Guinea suggests that the peoples of Borneo owe their use of quartz to the

[1] Seligman i. 176–8.
[2] Mr. A. R. Brown notes the importance of resin in the lives of the Andamanese. Cf. " The Andaman Islanders." Cambridge, 1922.
[3] Seligman i. 174.

people who left behind them the carved stone bulls in the centre of the island, as well as those who made the polished stone implements. I have already urged that the search for gold, pearls and other substances led the people of the archaic civilization to Indonesia, and this search for gold-bearing quartz may have so impressed the natives that they adopted the use of quartz as a principal giver in life.[1]

The case now being argued will gain in strength if it can be shown that the people of the archaic civilization themselves regarded gold, pearls and quartz as magical. This was certainly so in Egypt. Gold was identified with Hathor, the great mother goddess, the Lady of Nubia, whence came the metal. The room in the temple where the king was born was called the " House of Gold." The god Ptah is said to have made the first statues of the kings and gods, and to have covered them with gold. He was called " Lord of the Gold Smithy," and the place where he was supposed to perform the act of creating the new king was called the " Gold Smithy in the Temple of Dendereh."[2] Quartz was a favourite material for making amulets among the Egyptians, and pearls were " givers of life."

In Sumeria, Ea and Inlil were called Lords of Gold.[3] In India the Asuras were credited by the Aryans with magical powers : they could bring the dead to life and perform many wonderful feats. They were said to have vast stores of treasures, among them gold and jewels and pearls. The following extracts show how the Indians regarded gold and pearls :—

Gold as an Amulet for Long Life

1. The gold which is born from fire, the immortal, they bestowed it upon the mortal. He who knows this deserves it ; of old age he dies who wears it.

2. The gold (endowed by) the Sun with beautiful colour, which the men of yore, rich in descendants, did desire, may it gleaming envelop thee in lustre. Long-lived becomes he who wears it.

3. (May it envelop) thee unto (long) life, unto lustre, unto force, and unto strength, that thou shalt by the brilliancy of the god, gold, shine forth among people.

4. (The gold) which king Varuna knows, which god Brihaspati knows, which Indra, the slayer of Vrita, knows, may that become for thee a source of life, may that become for thee a source of lustre.[4]

Gold is constantly compared with the gods, and claimed as a giver of life : " Gold, doubtless, is Agni's seed " ; " Gold, doubtless,

[1] The Fijians have magic crystals (Kunz ii. 304–5).
[2] Lippmann 267. See Chapter X for other instances of the divine nature of gold in Egypt. [3] *Id.*, 521.
[4] Bloomfield XIX. 26.

is a form of the gods " ; " Gold, indeed, is fire, light, and immortality." [1]

Again the pearl is looked upon as a giver of life.

THE PEARL AND ITS SHELL AS AN AMULET BESTOWING LONG LIFE AND PROSPERITY

1. Born of the wind, the atmosphere, the lightning, and the light, may this pearl shell, born of gold, protect us from straits.
2. With the shell which was born in the sea, at the head of the bright substances, we slay the Rakshasas and conquer the Atvins (devouring demons).
3. With the shell (we conquer) disease and poverty ; with the shell, too, the Sadanvas. The shell is our universal remedy ; the pearl shell protects us from straits.
4. Born in the heaven, born in the sea, brought on from the river (Sindhu), this shell, born of gold, is our life-prolonging amulet.
5. The amulet, born from the sea, a sun, born from Vritra (the cloud), shall on all sides protect us from the missiles of the gods and the Asuras.
6. Thou art one of the golden substances, thou art born from Soma (the moon). Thou are sightly on the chariot, thou art brilliant on the quiver. (May it prolong our lives.)
7. The bone of the gods turned into pearl ; that, animated, dwells in the waters. That do I fasten upon thee unto life, lustre, strength and longevity, unto a life lasting a hundred autumns. May the (amulet) of pearl protect thee.[2]

Mr. Donald A. Mackenzie, in his latest work, has shown that the ancient Mexicans held ideas with regard to the life-giving powers of certain substances, exactly similar to those of the Egyptians and peoples of India. He mentions gold, silver, pearls, precious stones, jade and so forth. " Withal, they were used in precisely the same way and connected with similar beliefs and practices." [3]

Not only did the communities nearest in culture to the archaic civilization possess ideas regarding the supposed life-giving powers of gold, pearls and so forth ; but, it can be shown, in one case at least, that such ideas have been handed down directly from the archaic civilization. Mr. Skeat, in his work on "Malay Magic," has some remarkable information with regard to the mining charms of the people of the Malay Peninsula.[4] The Malays possess some of the cultural elements of the archaic civilization, such as mother-right ; they have spread from the Menangkabau Plateau of Sumatra, and, as the following quotation from Marsden shows, their movements have been controlled by the presence of gold. He says : " Beside those articles of trade

[1] Satapatha-Brahmana V. 187, 203, 215, 236, 239, 303, 304.
[2] Bloomfield xlii.
[3] D. A. Mackenzie ii. Chapter I. [4] Skeat 23–9.

afforded by the vegetable kingdom, Sumatra produces many others, the chief of which is gold. This valuable metal is found mostly in the central parts of the island, none (or with few exceptions) being observed to the southward of Limun, a branch of Jambi River, nor to the northward of Nalabu, from which port Achin is principally supplied. Menangkabau has always been esteemed the richest seat of it ; and this consideration probably induced the Dutch to establish their head factory at Padang, in the immediate neighbourhood of that kingdom. Colonies of Malays from thence have settled in almost all the districts where gold is procured, and appear to be the only persons who dig for it in mines, or collect it in streams ; the proper inhabitants or villagers confining their attention to the raising of provisions, with which they supply those who search for the metal. Such at least appears to be the case in Limun, Batang Asei, and Pakalang jambu, where a considerable gold-trade is carried on." [1] Their movements, therefore, are like those of the Gonds, who also have spread over gold-bearing formations.

One important circumstance makes it probable that the Malays have derived their ideas concerning the life-giving powers of tin, gold and so forth from the archaic civilization. The Malay rulers owe much of their great sanctity to their regalia. They are divine beings : " The theory of the king as the Divine Man is held perhaps as strongly in the Malay region as in any other part of the world, a fact which is strikingly emphasized by the alleged right of Malay monarchs ' *to slay at pleasure, without being guilty of a crime.*'[1] Not only is the king's person considered sacred, but the sanctity of his body is believed to communicate itself to his regalia, and to slay those who break the royal taboos. Thus it is firmly believed that anyone who seriously offends the royal person, who touches (even for a moment) or who imitates (even with the king's permission) the chief objects of the regalia, or who wrongfully makes use of any of the insignia or privileges of royalty, will be kena daulat, i.e. struck dead, by a quasi-electric discharge of that Divine Power which the Malays suppose to reside in the king's person, and which is called ' Daulat ' or ' Royal Sanctity.' " [2]

Professor van den Berg has made it clear that the great sanctity attaching to regalia belongs to the early stratum of kingship in Indonesia, to the rulers who are nearest in culture to the archaic civilization. For he says : " Although the institution of Regalia exists in the Javanese and Malay States, it nowhere has such a significance as in South Celebes. The superstitious reverence for regalia, which elsewhere is sporadic, is there a regular practice." [3] He says further that this custom is non-Mohammedan, and that a ruler must have possession of the regalia

[1] Marsden 165.
[2] Skeat 23–4. Egyptian kings were possessed of much magical power.
[3] Berg 74.

before he can reign;[1] which recalls the case of a Mekeo chief, who, when deposed, handed the royal lime-gourd to his successor. Not only must each ruler come into possession of the regalia, but, more important still, " native tradition connects the origin of the earliest States with the finding, discovery, or acquisition in some other manner, of an ornament, for instance a stone, a piece of wood, a fruit, a weapon and so forth, all of a particular shape or of a particular colour, in a word of a strange object, that according to tradition appears to have superhuman powers." [2]

This quotation recalls the fact that rulers of States in Sumba and South Celebes possess polished stone implements that have magic power. A detailed study of regalia would reveal much important information, and would help to the understanding of many problems connected with givers of life. It would seem, from what has been said, that the institution comes down directly from the archaic civilization.[3]

Another fact makes it probable that the Malay kings of the Malay Peninsula derive their sanctity from the archaic civilization, directly or indirectly, and that is the magical use of iron. The Sacred Lump of Iron forms part of the regalia of several rulers, and it is regarded with " the most extraordinary reverence, not unmingled with superstitious terror." Iron does not occur in the Malay Peninsula, so that its use must have come from elsewhere. The people of the archaic civilization worked iron in India, and presumably in places such as Central Celebes, where, as Kruyt has shown, iron is much used in magic.[4] Once again, therefore, a substance is used for magic that has been associated with the archaic civilization.

To turn to the mining practices of the peoples of the Malay Peninsula. These have been described chiefly by Mr. A. Hale, whose paper is quoted *in extenso* by Mr. Skeat. Tin and gold are the chief minerals sought in this region, and both are worked to the accompaniment of much ceremony, carried on by a mining wizard, generally a Malay, sometimes a Sakai (that is, a man speaking an Austronesian language).[5] Mr. Hale says : " The Malay pawang, or medicine-man, is probably the inheritor of various remnants and traditions of the religion which preceded Muhammadanism, and in the olden time this class of persons derived a very fair revenue from the exercise of their profession, in propitiating and scaring those spirits who have to do with mines and miners." [6] Again he says : " The Malay miner has peculiar ideas about tin and its properties ; in the first instance, he believes that it is under the protection and command of certain spirits whom he considers it necessary to propitiate ; next he considers that the tin itself is alive and has many of the pro-

[1] Berg 72. [2] *Id.*, 77.
[3] Cf. Samoa, where the insignia and magical power of the earliest rulers came from the sky-world (Chapter X, p. 140). [4] Kruyt i. 150 e.s.
[5] Skeat 250. [6] *Id.*, 253.

perties of living matter, that of its own volition it can move from place to place, that it can reproduce itself, and that it has special likes—or perhaps affinities—for certain people and things, and vice versa. Hence it is advisable to treat tin ore with a certain amount of respect, to consult its convenience, and what is, perhaps, more curious, to conduct the business of mining in such a way that the tin-ore may, as it were, be obtained without its own knowledge." [1] Mr. Skeat gives a quotation from the ideas associated with gold, from Denys' "Descriptive Dictionary" (which is not accessible to me) :—

" Gold is believed to be under the care and in the gift of a dewa, or god, and its search is therefore unhallowed, for the miners must conciliate the dewa by prayers and offerings, and carefully abstain from pronouncing the name of God or performing any act of worship. Any acknowledgment of the sovereignty of Allah offends the dewa, who immediately ' hides the gold,' or renders it invisible." [2]

It may be asserted that it is " natural " for people working tin or gold to " imagine " that the mineral is protected by a spiritual being. It must, however, be remembered that the working of tin or gold is not itself " natural " in any sense of the term, and that native populations have left such metals undisturbed for untold centuries. When, therefore, the present-day seekers after tin and gold in the Malay Peninsula accompany their craft with magical practices, it is possible to claim that, on the basis of the other signs of continuity with the archaic civilization, these ideas and practices have been derived from the same source.

The facts adduced form a coherent system. Evidently the people of the archaic civilization looked upon gold, pearls and other things as Givers of Life, and sought them wherever they could. That being the case, it is likely that such ideas would be handed on to their successors. It would thus be expected that, wherever signs exist of old gold-workings of the people of the archaic civilization, the natives would look upon quartz as a giver of life.

We turn now to study the magic of Australia, Melanesia and Torres Straits. The magic of Torres Straits Islanders shows traces of the influence of the past. Stones, often in the form of carved human images, play an important part in magical ceremonies, especially those for the production of rain and yams. [3] It has already been stated that the communities of the western group of Torres Straits have exercised strong cultural influences upon those of the eastern group. This is manifest in the magic of the easterners ; for " so many of the natural and worked sacred stones in the Murray Islands, are of foreign origin, and there can be no doubt that the majority of these must have come from the

[1] Skeat 259–60.
[2] *Id.*, 271–2. Cf. Perry vii. 173–4, for ceremonies in Timor connected with gold. [3] Torres Straits Report VI. 193 e.s.

Western Islands."[1] In the Western Islands magic is largely centred round stones. "Certain stones from their shape, or from other causes, were regarded as potent and were employed for magical purposes." It is also said that: "Stones rudely carved and painted were formerly frequent, but unfortunately very little information is to hand about them."[2] So the magic of Torres Straits rests upon the past, and is centred round objects associated with the archaic civilization. The Torres Straits Islanders also use the shells of the giant clam, which yield pearls, as well as others, in their magic.[3]

Melanesia is a classical home of magic, but the different parts of the region vary in the proportion of magic to religion. The nature of this magic is well known to students, and the Melanesian word for magical power has become a commonplace in ethnological literature. In the words of Codrington, who first described the belief in detail :—

"The Melanesian mind is entirely possessed by the belief in a supernatural power or influence, called almost universally mana. This is what works to effect everything which is beyond the ordinary power of men, outside the common process of nature ; it is present in the atmosphere of life, attaches itself to persons and to things, and is manifested by results which can only be ascribed to its operation. . . . But this power, though itself impersonal, is always connected with some person. If a stone is found to have a supernatural power, it is because a spirit has associated itself with it. . . ."[4] Beyond doubt stones play the most conspicuous part in the magical beliefs and practices of the Banks Islands and New Hebrides. It is to be noted that, in the region where magic is so prominent, the cults are centred round spirits, called vui, which are not the ancestral spirit of the present inhabitants. These vui spirits have already been mentioned, and brought into relationship with the ruling class of the archaic civilization of Southern Melanesia. The vui were supposed to be possessed of mana in a great degree.[5] They are also closely associated with stones, and, in the Banks Islands and the New Hebrides, sacrifices are made to them. "The spirits who are approached with these offerings are almost always connected with stones on which the offerings are made. Such stones have some of them been sacred to some spirit from ancient times, and the knowledge of the way to approach the spirit who is connected with them has been handed down to the man who now possesses it." A man can himself get a stone of unusual shape, and, by trial, find whether or not it contains a spirit.[6] Again, it is said of these vui : "In the Banks Islands and in the Northern New Hebrides the purely spiritual beings who are incorporeal are innumerable, and unnamed. These are they whose representative

[1] *Id.*, VI. 243. [2] Torres Straits Reports V. 363.
[3] *Id.*, V. 347 ; VI. 211, 303.
[4] Codrington 119. [5] *Id.*, 123. [6] *Id.*, 140.

form is generally a stone, who haunt the places that are sacred because of their presence, and who connect themselves with certain snakes, owls, sharks and other creatures," and thus in this respect bring themselves into line with the archaic people.[1] In this region stones and sacred places are intimately associated : " Sacred places have almost always stones in them ; it is impossible to treat separately sacred places and sacred stones." [2]

The custom exists in Southern Melanesia of choosing stones for their shapes and using them for magical purposes. " In the Banks Islands a man would happen upon a boulder of volcanic or coral rock, and would be struck with a belief that a spirit was connected with it. The stone was then rongo, and the place wherein it lay was rongo ; the man constituted himself the master of the sanctuary ; it was his marana within which none but himself, or those brought in by him, could come." [3]

To these remarks from Codrington may be added some of Mr. Hocart's, whose competence in such matters is unquestionable. He comments as follows upon the uses of the word mana in the Pacific : " So far from being præanimistic, the word is out and out spiritualistic ; it is almost, if not entirely, confined to the action of ghosts and spirits, who, whatever their origin, now go under the same name as the ghosts ; tomate in Mandegusu, kalou in Fiji, 'atua in Uvea, aitu in Samoa. It would seem that the word is simply a technical term belonging to a spiritualistic doctrine which it is now the task of Ethnology to reconstruct, and that it has been carried all over the Pacific as part of that doctrine by a people whom we have to identify." [4]

What is the meaning of the attitude of Melanesians to the givers of life that possess the mysterious power of Mana ? The current interpretation of the facts starts from the well-known occurrence of a man choosing a stone because of its peculiar shape, say like a yam, and then applying that stone for some useful purpose. Throughout Melanesia stones have come to be looked upon as the seats of spirits or as possessed of mana because of their shape. Does the admission of that fact lead to the origin of the custom of choosing these stones ? Not a bit. It is quite true that the man chose the stone because of its shape. But do we choose a fantail pigeon because of its shape ? Does the fact that this pigeon has certain " points " strike us with an idea of its superiority over other pigeons ; or have we in our minds certain ideas that incline us to choose one pigeon rather than another ? That is the real question at issue. It is the difficulty that is inherent in all questions of this same type. It may be perfectly true that a man chooses a stone because of its shape, but that act need have nothing whatever to do with the origin of the custom, or with the development of Melanesian magic. As a study in

[1] Codrington 151. See also 140, 143. [2] Id., 175. [3] Id., 181.
[4] Hocart i. Cf. Best vi. 489.

pure psychology the act of choosing the stone is obscure, and any interpretation is simply of the form of a guess. At least two distinct and contrary causes can force a man to choose some particular stone. In the first place, he may, in some unknown manner, spontaneously originate the idea that the stone is like a yam, and therefore can help in growing yams. On the other hand, he may have come under the influence of a social institution in which certain stones are looked upon as the source of magic power, as givers of life, and this may cause him to choose a stone for himself. The only possible manner of solution is by the application of the historical method.

An inquiry into the history of Melanesia ultimately will reach the times when men made the stone buildings that are scattered here and there throughout the region. According to the folk-tales the beings associated with these remains are called vui, and are potent as " givers of life " : they are full of mana. Moreover, they made stone images. The study of New Guinea and the Torres Straits shows that carved stone images are important " givers of life," and are used for all sorts of purposes similar to those to which the Melanesians of the Banks Islands and the Northern New Hebrides put stones. Also, these stone images are associated with a previous people powerful in magic, from whom they derive their potency. The present-day natives of British New Guinea not only make use of the stone images that the ancients left behind them, but they also use stone pebbles of the kinds of stone of which the ancients made implements for use in gold-mining and agriculture. Thus, before it can be claimed that the mana of Southern Melanesia is a product of the present-day population, it is necessary to discount all these facts, and to prove that a residuum remains that is incapable of explanation on the hypothesis of inheritance from the archaic civilization. This task would not be easy. On the other hand, if the builders of the stone remains were people who thought themselves able to control the weather, and to animate and transmit magical powers to stone images, then the practices of the present-day peoples receive an explanation in accordance with the facts.

The Australian tribes have no religious cults, but much magic associated with certain material objects. Of these Howitt says : " In all the tribes I refer to (these cover the whole of the south-east part of the continent) there is a belief that the medicine-men (the magicians of the tribes) can project substances in an invisible manner into their victims. One of the principal projectives is said to be quartz, especially in the crystallized form. Such quartz crystals are always, in many parts of Australia, carried as part of the stock-in-trade of the medicine-man, and are usually carefully concealed from sight, especially of women, but are exhibited to the novices at the initiation ceremonies." [1] What could have persuaded a group of tribes, scattered over a vast continent,

[1] Howitt 357-8.

that the chief cause of disease was the presence in the body of quartz, or that certain men could project these crystals into other men? To assume that they came to these beliefs independently is risky, for the beliefs are so outrageously at variance with fact. It seems impossible on such lines to suggest any explanation of how the Australians could have elaborated such a belief, especially if it be supposed to have happened independently over the whole continent.

Among the Dieri tribe the medicine-men are supposed to have communication with supernatural beings called Kutchi, as well as with their culture-heroes, the Mura-muras. These medicine-men are believed to have the power to fly up to the sky-land, whence came the culture-heroes. " It is said that they drink the water of the sky-land, from which they obtain the power to take the life of those they doom." "The medicine-men were everywhere credited with the ability to fly through the air—perhaps ' being conveyed ' would be a better term—either to distant places, or to visit the ' sky-land,' where dwelt, according to a widespread belief, their allies the ghosts and supernatural beings, such as Daramulun, from whom, in some tribes, their magical powers were supposed to be derived." [1]

Howitt sums up his lengthy discussion of the medicine-men of the Australians in the following terms : " The general belief as to the powers of the medicine-man are much the same in all the tribes herein spoken of. He is everywhere believed to have received his dreaded power from some supernatural source, or being, such as Baiame, Daramulun, or Bunjil, or the ancestral ghosts.

" In all cases he is credited with being able to see men in their incorporeal state, either temporarily as a wraith, or permanently separated from their body as a ghost, which is invisible to other eyes. He can ascend to ghost-land beyond the sky, or can transport himself, or be transported by the ghosts, from one spot of earth to another, at will, much after the manner of the Buddhist Arhat. The powers thus conferred upon him he can use to injure or to destroy men, or to preserve them from the secret attacks of other medicine-men. He can, it is also thought, assume animal forms and control the elements.

" In these beliefs there is a striking resemblance to those which have been recorded concerning wizards, sorcerers and witches in other parts of the earth, as well as to the beliefs of savages the world over, nor can it be said that they have together died out in the most civilized countries.

" Some of the practices described are found all over the Australian continent, locally, if not generally. For instance, the use of human fat, and the belief in the magical properties of the quartz crystal. But as to the latter, the use of the crystal globe is still with us also, and may have been handed down from the distant times when our ancestors were savages." [2]

[1] Howitt 358, 359, 388. [2] Id., 410.

It is striking that the magic of the Australians should centre round two forms of givers of life in which the people of the archaic civilization were evidently interested ; for human sacrifice and cannibalism, according to the evidence, belong to the archaic civilization, and the aim of both these practices was to get life from the human body itself. The traditions of these peoples also point to the archaic civilization as the source of their magic, for their practitioners come and go from the sky-world, the land of their culture-heroes, whence they obtain their powers. Every reason thus exists to ascribe Australian magic wholly to the influence of the archaic civilization.

It is significant that the Australians do not use stone for their magic. This cannot be due to the absence of stones of the required shape for the purpose. If peculiarly shaped stones inspired the people of the Torres Straits and Melanesia, why did they not inspire those of Australia ? From the point of view of those who would claim that the shape of the stone was in itself the causative agent for the Melanesian, the same shape should inevitably inspire the Australian. Since it does not, it is evident that this mode of reasoning is false. In Torres Straits, New Guinea and Melanesia, stone images of unknown origin are found, and certain stones are regarded as givers of life. The coincidence of these distributions suggests that the magic is centred round the remains of the archaic civilization, and will vary according to the character of these remains. Moreover, another difference exists between the magical practices of Australia and New Guinea. In New Guinea, the kinds of stone used for implements by the old gold-seekers are now regarded as givers of life : Australian natives make stone implements, but do not regard them as magical, for quartz is their giver of life. This suggests that artifacts can only be regarded as magical when contact has been broken between the peoples of the archaic civilization and their successors.

Possibly the use of magical objects is not always common among communities in which there are beings who are themselves givers of life, that is, incarnate deities. In Egypt, magic and religion were inseparable. It may be that in other communities the magical procedure is centred mainly round people associated with the sky-world. In this connexion the remarks of Rivers about the distribution of magic in Oceania are interesting. He compares the Banks Islands and Tikopia. He says : " While the practices of the Banks Islands would by almost universal consent be regarded as magical, there can be none who will doubt the essentially religious character of the rites of Tikopia. In this island benefits are obtained for the individual and the community, calamities are averted and injuries inflicted, by means of direct appeal to atua, beings who are believed to possess the power of conferring or withholding that for which appeal is made." [1] In the Banks Islands magical practice really depends upon objects

[1] Rivers ix. II. 404.

associated with the vui spirits, who are connected, it would seem, with the archaic civilization, and are not related in any way to the present-day population. In Tikopia, on the other hand, the rites practised for exactly the same purposes are centred round atua. Who are these atua ? We turn again to Rivers for information. He says : " All the sacred beings are called atua and many of them are clearly the ghosts of ancestors. Others are the animals connected with the different divisions or reverenced by the people as a whole. . . . Whatever other atua there may have been, there is little doubt that so far as ceremonial is concerned those derived from ancestors are the most important." [1]

The Tikopians came from Tonga, a place with sacred chiefs, and therefore connected more or less intimately with the archaic civilization. So, in a community that has a continuous connexion with the archaic civilization, the " givers of life " are pre-eminently ancestral ghosts. On the other hand, in communities where connexion has been definitely cut off from the archaic civilization, such as the Banks Islands, the givers of life are objects left behind by the archaic civilization. Rivers states also that " though magic exists in the Solomons, it is less important and far less malignant there than in the Banks and Torres Islands." [2] This may be due to the fact that the Solomons contain many peoples with chieftainship.

Evidence from Ponape of the Carolines explains the relationship, in magical practice, between the archaic civilization and the later peoples. The founders of Ponape are supposed to have come from Yap on stones that swam on the water, and to have made Ponape where these stones stranded. It is said in Ponape that certain spirits came from the sky and changed into stones ; and the gods cannot be approached except through these stones, which are only found in certain places ; if they are lacking in any place, so is the cult of gods. These stones are not only used in connexion with offerings made to gods, but also possess magical power and healing properties.[3] When, for example, men wish to go fishing, they drop a holy stone into the sea.[4]

This information from Ponape is important in connexion with what has been learned in Melanesia, for it shows that the use of stones as givers of life can be connected both with the religion and with the magic of a community. Through the stones the gods are approached, and by means of them magical effects are produced. The stones themselves are petrified sky-beings. Ponape is closely connected with the archaic civilization, and the priesthood show signs of being derived from that part of the population which has remained from that civilization after the conquest ; for the priests belong to the commoners, and not to the royal family, which is immigrant in origin. The priesthood is also

[1] Rivers ix. I. 315. [2] *Id.*, ix. II. 407.
[3] Hahl, 2. [4] *Id.*, 3.

matrilineal in succession.[1] In every respect, therefore, the stones of Ponape seem to be connected with the archaic civilization.

It is claimed that the people of Ponape came originally from Yap, where are remains of archaic civilization, on stones that swam on the water. This custom of transportation of stones can be paralleled in Polynesia. I have already mentioned that Mr. Percy Smith gives, in one of his writings, a fascinating peep into the past history of the Pacific. Speaking of the Polynesians he says, " There was a time in the history of the race when the old beliefs and history were taught at great gatherings, when chiefs and priests collected from the far-distant isles of the Pacific to a central spot, and there the history was recited, and a vast number of ceremonies performed the faint recollection alone of which remains. . . . Here were found the whare-kariori or houses of amusement, in which, no doubt, originated the Areoi societies of Tahiti. . . . This gathering place in Eastern Polynesia was at Raiatea, of the Society Group. Here came lordly chiefs within their gaily decked canoes, with flying streamers and drums beating, accompanied by large retinues of chiefs, warriors, priests, and servitors. Tradition says that from far Uea, or Wallis Island, in the western Pacific, to Rapa-nui, or Easter Island, in the Far East, the people gathered to these meetings. They took place at Opoa in Raiatea, the most sacred marae, or temple, in all Polynesia, and from whence stones were taken to other islands with which to found other maraes, to serve as visible connecting links with this most holy of places." Opoa, in Raiatea, was the Polynesian Mecca.[2] In those far-off days evidently close communication was maintained between the various parts of Polynesia, and the stones served as connecting links between the settlements. This goes far to show the unity of the Polynesian race, and to explain the importance of stones in Oceania.[3]

The practice of transportation of stones serves still further to throw light on the continuity existing between the settlements of the archaic civilization and those that followed. The quotations just made show that the Polynesian settlements were connected, perhaps universally, by the possession of sacred stones derived from some pre-existing settlement.[4] The identical practice exists in Indonesia, as is evident from the facts collected in

[1] Hahl 3.
[2] P. Smith v. 257–8 ; vii. 23.
[3] Cf. also the great talisman-mauri of the Maori, a tree supposed to have grown from a branch brought from Hawaiki. This ensured the wealth and prosperity of the country. " When the Kumara, or sweet potato, was first obtained by the old-time people of Whakatame they were advised by the islanders from whom they obtained it to slay one Taukata and sprinkle or besmear his blood on the door-frame of the storehouse in which the Kumara was placed. This rite was for the purpose of preventing the mauri or life-principle of the tribe from returning to Hawaiki." (Goldie 7–8.)
[4] Pieces of stone are said to have been taken from " Avaiki " to Rarotonga, and from " Hawaiki " to New Zealand (Browne 3, 10).

" The Megalithic Culture of Indonesia." [1] In all parts of the region where stone is used, those who found new villages take with them stones from the former site, in order, evidently, to preserve continuity with the ancestral home. Not only is stone used, but earth is also carried in many cases from one place to another. It is thus possible to regard the whole of the settlements of the archaic civilization in Indonesia and Polynesia as probably linked together by the custom of transportation of stones, or even of earth, from one place to another. [2]

The distribution of the archaic civilization in North America probably results from the desire for certain materials, such as gold, pearls, turquoise, jade and so forth. [3] If the people of the archaic civilization attached magical powers to these substances, and placed them in the forefront in that respect, if, further, the post-Columbian tribes are the descendants of these people, then the results obtained elsewhere would suggest that the later tribes would place great stress on quartz, pearls, pearl-shell, turquoise, and so on, as givers of life. This does not mean that these substances would be used exclusively : far from it. But, as in Australia, Borneo and New Guinea, quartz should play an important part in the magic of the tribes.

This can be easily shown to be so. The Huichol of Mexico, living in a country with a long history of people of the archaic civilization, attach high importance to rock crystals. " Small rock crystals, supposed to be produced by the shamans, are thought to be dead or even living—a kind of astral bodies of the Theosophists. Such a rock crystal is called Tevali (plural tevali's) or grandfather—the same name is given to the majority of the gods. But it may, however, represent any person or relative, in accordance with the directions of the shaman." [4] The same author says in another place, that the shaman can catch a certain sort of god, in votive bowls, in the form of small crystals. " Rock crystals are said to be mysterious people, dead or alive, who at the shaman's bidding come flying through the air as tiny white birds, which afterwards crystallize. They are called grandfather, and are thought to bring special luck in hunting deer. . . . The conditions necessary for living people becoming rock-crystals is that they must be true husbands and wives, therefore such rock crystals are rare." [5]

The Zuni Indians connect quartz crystal with the Sun, and say that he has a shield of that stone. The Hopi in their ceremonies represent the sun on altars by a piece of quartz crystal. The sacred objects of the Navaho include rock crystal, and in

[1] Perry vii. 46–8.

[2] The Maori carried with them, on their wanderings, small pieces of stone which ensured communication with their deities. In their new homes these were set in larger stones, and both were put in the great wooden or stone pillar in the sacred place (Tregear TZNI 30, 1899, 63–4).

[3] Cf. D. A. Mackenzie ii. Chaps. I., II. : Brasseur de Bourbourg cliii.

[4] Lumholtz i. 63. [5] *Id.*, ii. II. 187–8.

their creation legend they speak much of the Youth and Maiden of the Rock Crystal; also the First Man and Woman made the sun out of a clear stone and the moon out of a kind of crystal.[1]

The Cherokee of the Eastern States regard a crystal as the great talisman of the tribe. They believe in great beings shaped like snakes, corresponding to the dragons of other peoples. The Uktena is a great snake with horns on its head and a bright blazing crest like a diamond on its forehead and scales glittering like sparks of fire. The blazing diamond is the Ulunsuti, "transparent," and he who can win it may become the greatest wonder-worker of the tribe. Only one man ever succeeded in getting it, and this crystal is now in the possession of the eastern Cherokee. It is a large transparent crystal nearly the shape of a cartridge bullet, with a blood-red streak running through its centre from top to bottom. Its owner keeps it secretly wrapped up in a deerskin in a cave in the mountains. Every seven days he rubs it over with the blood of small game, and twice a year with the blood of deer or some large animals. " Should he forget to feed it at the proper time it would come out from its cave at night in the shape of fire and fly through the air to slake its thirst with the life blood of the conjurer or some one of his people. He may save himself from this danger by telling it, when he puts it away, that he will not need it again for a long time. It will then go quietly to sleep and feel no hunger until it is again brought out to be consulted. Then it must be fed again with blood before it is used." When the owner dies the stone must be buried with him; if not, it will come out of its cave night after night for seven years like a blazing star to look for him, when, if not able to find him, it will return to the cave and sleep for ever. The owner of the crystal can bring to his aid certain spiritual beings called Little People.[2]

There are many crystals in the old Cherokee country, the Southern Alleghanies,[3] which is a famous gold-mining region. So, as among the Mexican and Pueblo Indians, supernatural powers are ascribed to the stone associated with gold. The crystal played an important part in connexion with the mounds that the Cherokee formerly made. They had a clan of hereditary priests, who were exterminated because they became so haughty and overbearing. These priests are said to have made mounds. They placed a circle of stones on the ground, lit a fire in the centre, and near it put the body of some prominent chief or priest who had lately died. Some say that they put seven bodies of chief men from the seven clans; together with the Ulunsuti stone, that is, the great crystal; a scale or horn of the Uktena, on whose head is the crystal; a feather from the right wing of an eagle; and beads, red, white, black, blue, purple, yellow, and grey-blue. The mound was then built up with earth, and a chimney was left in

[1] Matthews ii. 452; iv. 243, 79–82. [2] Mooney vii. 296 e.s., 459–60.
[3] *Id.*, vii. 460.

the middle to help the fire.[1] The use of crystals thus goes right back into the past history of the Cherokee, being associated with their former class of hereditary priests, with the building of mounds and therefore, presumably, with the mound-builders themselves.

The importance paid to crystals by the Cherokee and the association of the crystal with a water-monster is of great interest in view of some facts regarding the Omaha, who have migrated into the plains, presumably from some region near to the ancestral home of the Cherokee. They have lost most of their rites pertaining to religion, but have retained some practices that are of interest. They have a secret society called the Pebble Society, membership being open to those who have had a vision of water, or its representative, the water monster, a huge creature that lashed the water with its tail. The opening ritual of the society deals with creation and the cosmic forces ; it speaks of a primal rock called the Aged One ; and the steam from the water in the sweat lodge of the society represents the mighty water whence issued life and the power to wash away all impurities. The members of the society acquire magical powers.[2]

The Dakota branch of the Sioux also have magic stones, the more important of which are white, " resembling ice or glass." [3] " The Dakotas regard certain small stones or pebbles as mysterious, and it is said that in former days a man had one as his helper or servant. There are two kinds of these mysterious stones (i.e. pebbles, not rock). One white, resembling ice or glass (i.e. probably translucent) . . . the other resembles ordinary stones. It is said that one of them entered a lodge and struck a man, and people spoke of the stones sending in rattles through the smoke hole of a lodge." [4] Both the Omaha and the Dakota have thus retained ideas regarding crystals which possibly have originally been derived, like those of the Cherokee, from the archaic civilization.

The Omaha have another sacred giver of life that plays a part in the ceremonial of their secret societies—the Sacred Shell. " No one knows what it stood for, but every one held it in superstitious dread ; in all the tribe there was not a person exempt from fear of this shell. The superstition that clung about it indicated that its rites related to the cosmic forces and to fundamental beliefs relative to life and death." Among the Osage branch of the Omaha the shell was associated with the introduction of life on the earth.

This shell is a specimen of Unio Alatus, the pearl-bearing mussel, a species known to occur only in the Ohio, Missouri and Northern Mississippi, and in the Great Lakes.[5]

[1] Mooney vii. 395–6. [2] Fletcher and La Flèsche 565 e.s.
[3] J. O. Dorsey i. 153. [4] *Id.*, ii. 447.
[5] Fletcher and La Flèsche 454–7. Cf. Hoffman i. for similar beliefs concerning cowries.

The mound-builders were busily engaged in exploiting the pearl-beds of the United States, for many thousands of pearls have been found with their burials. In Mexico pearls were looked upon as givers of life of the first order. It is thus significant that the most sacred object of the Omaha should be a shell of the pearl-bearing mussel. The fact that the Omaha cannot account for the origin of this shell makes it necessary to seek elsewhere for the explanation, and the assumption that the early mound-builders held such ideas with regard to pearls as were held in Mexico solves the problem. That the mound-builders looked upon pearls in this manner is made probable by the fact that they placed so many of them in their graves, for that is a sign that they were givers of life. Thus the magical objects of the Omaha are explained in the region east of the Mississippi.

The importance attached to quartz the whole way from India to America, by tribes who do not work gold, can be explained on the hypothesis that the people of the archaic civilization sought for gold, and looked upon it as a giver of life, and that the peoples who followed have continued to use quartz in their magical practice. It is the rule to find that quartz is the most important giver of life, which harmonizes with the claim that the search for gold was the main cause of the distribution of the archaic civilization. Although pearl oysters and mussels have added to the equipment of the magician, usually in the form of pearl-shells, gold certainly has occupied more attention than any other substance, and it is not remarkable that the obsession of the people of the archaic civilization has made so deep an impression on the natives of so many places.

This survey shows that the people of the archaic civilization have had a profound effect upon the magical practice of the later peoples, which has shown itself in manifold ways. Moreover, they were looked upon by their successors as powerful in magic; for, in the whole region, magical powers are invariably ascribed to gods and culture-heroes, as has already been seen in the case of the Australians. In a recent work Mr. F. C. Cole has analysed the folk-tales of the Tinguian of Luzon in the Philippines, and has shown that they were formerly in contact with a much higher civilization, with people credited with great powers over nature, who, it is said, could transport themselves at will to a distant spot in an instant of time; could create men; could make crops grow in an instant; could control the weather; and could kill people and bring them to life by means of magical practices.[1] Mr. Cole contrasts these early folk with the later Tinguian: " Magic was practised extensively in ' the first time,' but it is by no means unknown to the people of the present day. They cannot now bring a dead person to life, or create human beings out of bits of betel-nut; but they can and do cause sickness and death to their foes by performing certain rites or directing actions

[1] Cole 17–18.

against garments or other objects recently in their possession." [1]

The Polynesians formerly also had wonderful magicians. The Maori have a tradition of a former priest Kiki, whose shadow withered plants and shrubs. Two celebrated wizards of Maori tradition had a magical head, and slew hundreds by the power of its enchantment.[2] These ancient priests could bring the dead to life, perform the " mango trick," and do other wonderful feats.[3]

The powers that in certain places are accredited to the people of the archaic civilization, such as bringing the dead to life, changing shape, transporting themselves to distant spots, causing plants to grow with great speed, are not entirely mythical, but have, in certain cases, a substantial historical basis. No one who has read the descriptions of the powers of the members of the fraternities of the North American Indians, can doubt that these well-authenticated accounts of marvellous feats performed by these men have some basis in fact.[4] I do not for a moment pretend that these men did what they are supposed to have done ; that they cured men hopelessly wounded, or caused maize plants to come to fruition in a few minutes ; what I do claim is that they had the power of deluding people into believing that they had done so, and, in so far as they possessed this power, they must be looked upon as remarkable men. It is highly significant that in Egypt, India, Polynesia, and North America similar powers are claimed by magicians. I do not know whether any systematic examination has been made of these magical fraternities ; but it seems certain that the traditions of their magical powers have an historical basis that readily accounts for the tremendous influence that these men of old have exerted on their successors. The great amount of magic practised in the communities of the archaic civilization readily accounts for the practice among the native populations with which they have come in contact.

Although the discussion of the use of givers of life throughout the region has not been exhaustive, yet it seems, to me at least, to lead to the formulation of the following working hypothesis : [5] The magic of any people without a ruling class centres round those objects that have acquired magical power from their association with the people of the archaic civilization ; so that, in a place such as Australia, where the people of the archaic civilization, who presumably were seeking for gold, suddenly retired, and left no stone images behind them, the people have centred their magic round two features of the culture of the strangers—their cannibalism and human sacrifice, and their appreciation of quartz. In Torres Straits, on the other hand, where there is no quartz, but where these strangers, presumably engaged in pearl-

[1] Cole 24–5. [2] Goldie ii. 31. See p. 191.

[3] P. Smith v. 32. [4] Grinnell 374 e.s.

[5] The discussion of Chapter XXVII, which deals with the general problem of the manner in which the archaic civilization was built up on the psychological side, has an important bearing on this matter.

fishing, made stone images, the pearl-bearing giant clam and stone images play a prominent part in magic. Similarly, in Melanesia as a whole, the greater part of the magic is centred round stones, because the people of the archaic civilization made, and presumably animated, stone images, as in San Cristoval at the present day. North American tribes have a similar regard for crystals and the shells of pearl-bearing mussels, as well as for the pearls themselves. In the Pueblo region likewise, turquoise is much valued as a giver of life, which agrees with the suggestion of an earlier chapter, that the search for turquoise was the cause of the first settlement of this inhospitable region.

Although this by no means completes the catalogue of givers of life, yet it is enough to lend support to the suggestion that the magical ceremonies of any tribe whatever will be centred round certain " givers of life," which derive their power from their historical associations ; and that, if it be possible to trace the matter far enough, the inquiry in every case would lead back to the archaic civilization ; so that any given community regards an object as a " giver of life " simply because it was associated with the wonderful people of old.[1]

This generalization can be put forward the more freely because it is readily capable of refutation by facts. If it can be shown that any people, in any part of the world, regards, as a giver of life, an object that has no possible association with the people of the archaic civilization, then it will be necessary to modify the hypothesis, and to conclude that magical practices can spontaneously originate.

[1] Cf. Rivers xiii. for an extended examination of magic in Oceania, together with a discussion of problems of transmission.

CHAPTER XXV

THE ORIGIN OF THE ARCHAIC CIVILIZATION

THE discussion of the past twenty-three chapters has been concerned with the elaboration of the theory that the first food-producing civilization in the region was characterised by the following cultural elements :—

1. Agriculture by means of irrigation.
2. The use of stone, typically for pyramids, dolmens, stone circles, and rock-cut tombs.
3. The carving of stone images.
4. Pottery-making.
5. Metal-working and pearl-fishing.
6. The use of polished stone implements.
7. A ruling class in two divisions :—
 (a) The Children of the Sun, connected with the sky-world, born of theogamies, who practise incestuous unions.
 (b) A class associated with the underworld, who survive as war-chiefs.
8. The sun-cult.
9. The practice of mummification.
10. The great mother goddess.
11. Human sacrifice, connected with agriculture and the cult of the mother goddess.
12. Mother-right.
13. Totemic clans.
14. The dual organization.
15. Exogamy.

This archaic civilization gave rise to others, which differed from it in lacking some of these elements. Now that this process has been discussed, I propose to turn to the question of the origin of the archaic civilization itself.

The maps show that the cultural elements just given in the list are not scattered haphazard throughout the region, although their distribution may seem, at first sight, sporadic. I have already claimed that the evidence connects the settlements of the archaic civilization with sources of gold, pearls, copper, iron, turquoise, obsidian, and so forth, the inference being that the desire for these things led the people of the archaic civilization

hither and thither, so that they settled where they found supplies. Since this conclusion runs counter to much modern thought, it is desirable to recount briefly the reasons why it alone fits the facts ; and to examine in detail some objections that may be urged to the contrary.

The cultural elements of the archaic civilization which did not survive, are grouped in places noted as important sources of certain raw materials. In India megalithic monuments, irrigation, polished stone implements, metal-working and other signs of the archaic civilization are grouped closely round the gold, copper, iron, and diamond districts of that country. Human sacrifice, the cult of mother goddesses, totemic clans, the sun-cult, are all characteristic of the civilization that is so closely linked with these cultural elements. Signs of the dual organization are also more notable in those parts of the country where other elements of the archaic civilization are plentiful.[1] In Indonesia the sources of gold and pearls are associated closely with polished stone implements, megalithic monuments and stone-work in general, human sacrifice, matrilineal institutions and the dual grouping. These cultural elements are, as a rule, either all present in any given place or all absent ; they are not distributed haphazard.

The distribution of cultural elements of the archaic civilization is marked in Oceania. Micronesia possesses practically all of them in a marked manner, which is but fitting for a region containing such vast ruins as those on Ponape and other islands. In British New Guinea, in the Solomons, in the New Hebrides, and other parts of Southern Melanesia, the old order has much disintegrated ; nevertheless, the distribution of known remains of the archaic civilization, and of cultural elements such as the dual organization, mother-right, and so forth agrees well with that of pearls and gold.

In Polynesia the cultural elements of the archaic civilization are not invariably present. From the beginning of the inquiry it became evident that the places that mattered were the groups of Fiji, Samoa and Tonga in the west, and Tahiti in the east. Outlying groups, such as Hawaii, the Gilberts, the Ellice group, the Phœnix group, among others, have played practically no part in the history of Polynesia, but have been colonized by secondary movements from Samoa and other places. During the process of colonization the old order broke up, and the wanderers went to places not noteworthy for stores of pearls or minerals. New Zealand offers an apparent exception to this rule, for the Maori went there as a secondary movement from Rarotonga. But the Maori were not attracted by the gold : perhaps they went there for the jade. The existence of a former population shows that people in the past may have gone there for the gold, but the evidence is not of much weight.

In North America the peoples who have emerged latest, the

[1] Sketch Maps Nos. 2, 3, 4, 5, 6 ,7, 8, 14, 15 will illustrate this argument.

tribes of the western Plains, such as the Arapaho, Cheyenne, Pawnee, and others, show the least signs of the culture of the archaic civilization. The cultural elements associated with the archaic civilization are grouped in the regions possessing gold, pearls, turquoise, and other such things.

The sum total of the survey of the region is to show that the cultural elements of the archaic civilization have, on the whole, similar distributions ; if one of these elements be reported in any place, most, if not all, of the others are also recorded. Since the distribution of the archaic civilization is not uniform, it is evident that some cause or causes must have determined why some localities were favoured, while others have been rejected, or have been occupied in later times.

The suggestion has already been made that the cause of the distribution was the search for valuables. Putting that suggestion on one side for the moment, and treating the problem as a general one, it is possible to frame more than one hypothesis to account for the distribution, and to assert that, either the people of the archaic civilization deliberately chose certain spots, or else that the conditions in such places favoured the growth of civilization, and caused the various arts and crafts to be developed. A third possibility is a combination of the two ; namely, that the people of the archaic civilization were determined in their choice of settlement by the natural conditions of certain localities, and settled there with their cultural baggage. These three hypotheses really reduce to two : either the people of the archaic civilization settled in certain places because they so wished, or else they were forced by natural conditions, climatic or otherwise, to settle in some places and avoid others.

This question involves important principles in human geography, so it will be threshed out in detail. It necessitates the elaboration of a theory of colonization on the basis of the facts already accumulated.

The problem is to decide what are the underlying modes of thought of the people of the archaic civilization. Why did they choose the Carolines rather than the Gilberts ? Why did they choose Tahiti rather than Hawaii ? Why were Tikal and Copan chosen for the first Maya sites, rather than any other sites in America, or even in Guatemala ?

An argument that carries much weight at the present moment is that of climatic influence. It is held that the natural conditions of any place will determine, in some measure, what will be the culture of the people of that place. As a good instance, the case of the early Maya settlements may be mentioned. In his work on Climate and Civilization, Professor Huntingdon maintains that when Copan and the other early cities of America were built, the climate was much more bracing than at present, and the rainfall less. He holds that it is possible to correlate climatic cycles with the rise and fall of the successive Maya civilizations.

According to him, man is, as it were, a plastic material in the hands of forces that decide where and when he shall build up his civilizations, like a nest of ants under observation of a scientist who is conducting experiments. Such students as Professor Huntingdon, when asked to explain why the Plains of North America were left alone by food-producers when the ravines of the Pueblo region were thickly populated, would probably maintain that the climate had much altered since those days, and that probably when the Pueblo settlements were first made the country was more habitable than at present.

Such arguments as these sound plausible when viewed from a general standpoint. But when inquiry is made with regard to particulars, it is not so easy to understand how the process works. For instance, it is well known that the Maya made first of all a few cities, half a dozen at the most, Copan, Tikal, and so forth. No signs exist of any previous development of culture in that region, on which fact further emphasis will be laid at the end of this chapter. Does Professor Huntingdon seriously argue that climatic conditions can cause people, in the food-gathering stage, to invent, without any previous experience, the arts and crafts that were possessed by the builders of Copan and a few other cities ? It is quite possible to understand that climatic influences may be at work when a civilization is seen to develop from one stage to another, as, for instance, in Egypt. But when it is argued that the climatic conditions of Copan led certain people living there to build a wonderful city without any previous experience that can be detected, then it is time to call a halt. However bracing the climate may have been, the concentration of effort on a few sites, and the result of the first experiments at building up a civilization, cannot be so explained.

The cultural conditions of North America forbid any speculations as to the cause of the growth of civilization anywhere outside Mexico and the Maya country : for, as has been seen, the agriculture of the whole region depends upon maize-growing, which must have come from Mexico. The only claim that can be put forward, therefore, with regard to North America, is that the conditions determined where the culture connected with maize-growing should be planted. The climate had no causative effect whatever in places other than Mexico ; for all the other civilizations are clearly derivative. Moreover, it must not be forgotten that no signs have as yet been detected of any cultural development in North America and Mexico subsequent to the time of the early cities of the Maya. On the contrary, since that time culture has gone downhill. Huntingdon's hypothesis therefore has to bear a terrific weight, for its implications are that, at one place and time, the climatic conditions were such, in North America, as to cause the generation of a civilization, and that subsequently no such conditions ever recurred. That is incredible. If climate causes men to create civilizations, surely, in North

America, a great variety of cultures should have been elaborated, a culture of the woodlands, another of the plains, all sorts of cultures of different kinds. When inquiry is made it is found that this climatic diversity has done nothing at all ; which there-fore warrants complete scepticism with regard to the hypothesis that the cities of Copan and elsewhere owe anything whatever to climatic influences.

In order to drive this matter home, attention is called to the problem of the Pacific. In this case climatic circumstances have had nothing whatever to do with the production of civilization ; for the ancestors of the Polynesians brought their foodplants with them, and thus made the region fit for habitation. The climate of this region cannot have altered during the past two thousand years or so that the Polynesians have been there, or not enough to matter. It is therefore difficult, on any ground, to see in what way climatic conditions can be brought forward to account for the culture of the Polynesians. On the contrary, all the facts show that it was brought from the west. The existence of remains in British New Guinea, in the midst of inhospitable country far less habitable than the regions of the coasts, is further evidence against any climatic or environmental hypothesis.

The general hypothesis of climatic and natural conditions fails also to account in any way for the abrupt discontinuities displayed in the distribution of the archaic civilization. Why should these people have concentrated on a few spots in India, round Bellary and a few other places, and have ignored the rest of the country ? Why, going north from Hyderabad, has this civilization left no traces until Chota Nagpur is reached ; and, then, again, why should certain parts only of that region be chosen ? This hypo-thesis likewise fails to account for abrupt discontinuities in Polynesia, where the climatic conditions are practically uniform, and no excuse is afforded for arguing about soils, temperature and so forth.

The agriculture of the archaic civilization was based on irriga-tion. It might be claimed, on the climatic hypothesis, that irrigation was installed because of its utility in any place. This argument really is twofold, and either aspect is used according to circumstances. When it is pointed out that irrigation has not been installed in countries where it obviously was necessary, such as Australia, California, and elsewhere, it would be answered that perhaps the people were not yet advanced enough in culture, they had not yet come to cultivate the soil, and thus could not be expected to think of irrigation. When, on the other hand, irrigation is present, it is claimed that the natural conditions necessitated it, and thus the people came to practise it. It is significant that the Pueblo Indians were expert irrigators, instal-ling terraces on the walls of the canyons where they had their dwellings ; while, in California, the Indians had no agriculture

at all. In this case irrigation evidently forms part of a culture. For, if it be argued that the Pueblo people originated irrigation, then it is obvious that they must previously have reached a certain stage of culture. Otherwise, if they developed their own agriculture, how came they to practise irrigation, while their Californian neighbours, who needed it as much as they, never thought of it ? Since the Pueblo Indians grow maize, they evidently got their agriculture, and presumably their irrigation, from Mexico, so that natural conditions, in this case, had nothing to do with the origin of irrigation.

This argument applies likewise to the early Maya settlements. Given that they evolved their civilization on the spot, how did they come to invent irrigation ? They surely could not have needed it as much as the Indians of California, Utah and elsewhere ; the rainfall must certainly have been more, whatever climatic cycles can be postulated, especially in the past two thousand years, which is the period of development of American civilization. Any theory of the indigenous origin of American irrigation must account for the contrast between the Indians of California and those of Pueblo regions and elsewhere, and in such a case the climatic hypothesis fails.

In British New Guinea the installation of irrigation systems by some unknown people in the past at places such as Bartle Bay does not suggest climatic influence. The irrigation of Polynesia was obviously brought there by the ancestors of the Polynesians from their home in India.

The most hardened exponent of the climatic hypothesis would probably not venture to assert that at any time the climate of Borneo differed greatly from that of Java, Lombok, Bali, and other islands of that region ; or that the climate of Java differed from that of the islands east of Timor. Yet irrigation in that part of Indonesia is confined to Java, Bali, Lombok, Sumba, Roti, and Timor. The island of Sumba is divided into two parts, east and west ; irrigation is practised in the west part, and is accompanied by many cultural elements of the archaic civilization, while the east end of the island is devoid of these elements and of irrigation.

Java is remarkable in that it possesses a great rainfall, which suggests that only one explanation can be given of the presence of a form of cultivation involving the storage of great supplies of water, namely, that it is due to a cultural influence. But for the existence of irrigation in Java the great rainfall of Borneo could be used to account for the absence there of irrigation. In Assam, again, the rainfall is immense, and much irrigation is practised, but abrupt discontinuities are observable. Some Naga tribes, for instance, practise irrigation, while their kinsmen and neighbours have dry cultivation.

These remarks show that great difficulties meet the exponents of the doctrine that irrigation owes its existence to climatic influences.

It is possible to give the argument another turn, and to consider the custom of erecting stone monuments. Since it is hard to see how climatic influences could have caused men to invent irrigation independently in several places, it may be urged that perhaps the distribution of the settlements of the archaic civilization can be explained by supposing that people, possessing the craft of irrigation, were led to settle because they found stone for their constructions. A glance at the distribution of megalithic monuments in India shows that this hypothesis will not stand criticism.

Even if the hypothesis of climatic influence could explain the growth of civilization in certain places, it would utterly fail to account for the unity of the archaic civilization. This unity cannot be doubted ; for, in contrast with those civilizations that followed, the archaic civilization stands unique. Right across the region, from one end to the other, extends a chain of settlements possessing cultures so alike that the idea of unity must force itself on the most sceptical mind. Given that the climate of different regions, for various reasons, caused men to adopt irrigation, the same conditions, which obviously differed greatly in various places, could not explain why the same communities possessed mother-right, practised human sacrifice and sometimes cannibalism, produced a class of Children of the Sun, looked on gold and pearls as givers of life, and possessed in common several other cultural elements. This is unthinkable, unless appeal be made to the doctrine of the similarity of the working of the human mind, in the form in which it is usually stated, namely that men, once started on the upward path, tend to develop their civilizations on parallel lines, and thus to invent similar cultural elements in the most diverse places. If reliance be made on that hypothesis, it is hard to account for the great diversity among the civilizations that followed the archaic civilization. What caused men to diverge from the path that they trod in step for so long ? How again, is the fact of degradation to be explained ? A hypothesis such as this has therefore to bear a great weight. It must, nevertheless, be treated with respect ; but before considering it attention must be paid to the relationships between the archaic civilization and its successors.

Several lines of argument converge upon the conclusion that food-producing peoples all over the region owe their origin to the communities of the archaic civilization. The first consideration of this matter showed that, from the point of view of geographical distribution, this conclusion was satisfactory : for the boundary line between the food-producers and the food-gatherers was also the boundary between the archaic civilization and the food-gatherers ; and in many places it was evident that the food-producers of the lower culture were living in regions previously tenanted by the people of the archaic civilization, and probably were derived, directly or indirectly, from them. Subsequent

discussions have supported this conclusion : the culture-heroes who have civilized so many tribes have been identified with the ruling class ; the origin myths of later peoples derive them from it ; magical practices are largely concerned with objects connected with the old wanderers : in short, the later peoples are living on culture derived from the past.

The discussion has not dealt with every tribe or community in the region. Enough, however, have been considered to show that the form of culture possessed by any one community can be accounted for when its manner of derivation from the archaic civilization is known. That is to say, uniformity has produced diversity, owing to the various historical circumstances accompanying the transformation of the original civilization. Theories, such as those of the influence of natural circumstances, or of the similarity of the working of the human mind, can be set on one side, and the whole problem may be treated as historical.

Attention must be paid to another important feature of the relations between the archaic civilization and its successors. If natural conditions exerted any influence, it should be noticeable in the culture of the derived civilizations. But, far from improving on the past, they have, in all parts of the region, lost much that they formerly had. The study of culture-sequences has shown, in case after case, that two entirely different forms of culture can succeed one another in the same place : a people building megaliths, seeking gold, and practising irrigation can be succeeded by another that never uses stone, has rough and ready methods of cultivation, and attaches no importance to gold ; the dual organization can be followed by local exogamy or by totemic clans, mother-right gives place to father-right ; while natural conditions remain the same, and are seemingly powerless to exert any influence whatever on the course of development.

When the great diversity of culture that has been reviewed is recalled, the conviction gains in strength that the process under review has its own peculiar nature. Of late years students of human society have tended to treat man as a plastic material in the hands of an unknown potter. Sir James Frazer comments upon this attitude of mind when dealing with Professor Westermarck's theory of exogamy, and his remarks are so pertinent that they are well worth quoting : " It may be observed that Dr. Westermarck's theory of the origin of exogamy appears to suffer from a weakness which has of late years vitiated other speculations as to the growth of human institutions. It attempts to explain that growth too exclusively from physical and biological causes without taking into account the factors of intelligence, deliberation and will. It is too much under the influence of Darwin, or rather it has extended Darwin's methods to subjects which only partially admit of such treatment. Because, in treating of the physical evolution of man's body and his place in the animal creation, Darwin rightly reckoned only with physical and biological

causes, it has seemed to some inquirers into the history of man's social evolution that they will best follow his principles and proceed most scientifically if they also reckon with nothing else! They forget the part that human thought and will have played in moulding human destiny. They would write the history of man without taking into account the things that make him a man and discriminate him from the lower animals. To do this, to adopt a common comparison, is to write the play of Hamlet without the Prince of Denmark. It is to attempt the solution of a complex problem while ignoring the principal factor which ought to come into the calculations. It is, as I have already said, not science but a bastard imitation of it. For true science reckons with all the elements of the problem which it sets itself to solve, and it remembers that these elements may differ widely with the particular nature of the problem under investigation. It does not insist on reducing the heterogeneous at all costs to the homogeneous, the multiformity of fact to the uniformity of theory. It is cautious of transferring from one study the principles and methods which are appropriate to another. In particular the science which deals with human society will not, if it is truly scientific, omit to reckon with the qualities which distinguish man from the beasts." [1]

The consideration of the phenomena of degradation that bulk so largely in the cultural history of the region shows that the hypothesis of the uniformity of the working of the human mind, as propounded by certain students, will not work. In America it is necessary to account for the rise of the Maya civilization, and the subsequent steady cultural degradation throughout that continent; and this is impossible on a hypothesis of spontaneous development of culture in all places, for such a hypothesis fails to take account of the movements of culture that obviously have taken place.[2]

Human society is a human product. It is thus best to look first of all to causes that are peculiarly human when dealing with problems presented by human society, and not to expect unthinking natural forces to have played a determining part in the production of the vast organism with which we have been concerned. If the continuity between the communities of the archaic civilization and those that followed be as definite as I claim, then it is evident that the process at work must be regarded as mental. That is to say, the mind of man must have been of predominating importance, both in the production of the archaic civilization and also in the determination of its distribution. The archaic civilization being a human product, its distribution must be expressed in terms of that civilization itself, and not in terms of barometric pressure or rainfall. If any explanation on such

[1] J. G. Frazer ii. 98.
[2] It will be apparent later that, rightly formulated, it supports the general thesis of this book.

lines be not practicable, it will then be time to turn elsewhere for help.

The introduction to Chapter VII showed that the gold of California, Australia and elsewhere was untouched until the arrival of men who valued it, and were prepared to undergo any hardship in order to possess it. It stands beyond doubt that the reason for the colonization of new countries is especially to be found in the presence there of desired substances.[1] No one in his senses would claim that climatic conditions had anything whatever to do with the foundation of Dawson City in Alaska, or with the building of the ruins on the Yukon River that belonged to some unknown gold-washing or pearl-fishing folk of the past ; or that the gold-diggers who went out to Australia were forced there by anything but a mad desire for wealth. That being so, what justification has anyone for denying that the only possible reason that could have led men to the inhospitable mountains of New Guinea was the presence there of alluvial gold ? It is the only rational explanation of the facts, and no amount of argument can account otherwise for the sudden appearance of people with a distinctive civilization in such a region : in late years it is this very motive that has led civilized men once again to brave the terrors of New Guinea. That the Polynesians of old were seeking pearls stands beyond doubt ; for, ever since Europeans have known of them, they have been engaged in pearl-fishing, and there is no reason for believing that they have ever done otherwise. Given that the appearance of the archaic civilization in British New Guinea and Polynesia is due to the search for gold and pearls, we can interpret similarly the facts in Indonesia and India, where sites of the archaic civilization bear so obvious a relationship to sources of various kinds of wealth. In America, again, the desire for gold, copper, turquoise, and pearls can well explain the peculiar distribution of early civilization. Such a hypothesis as this accounts, as none other will, for sites such as Copan, and for the localization of Pueblo villages in the canyons of the Colorado River basin, and elsewhere in the south-west. It is possible in this way to see what led the culture-heroes to Australia ; they evidently were wandering about seeking gold. Perhaps their sudden departure, which is recounted in Australian folk-lore, was consequent upon the evacuation of the New Guinea gold-fields. It is certain that connexions between the Pacific and the West were cut at some past time : that was evident from the study of food-plants. Such interruptions were probably due to the break-up of archaic civilization, consequent on the intensification of warfare. The coming of warlike peoples to British New Guinea will readily explain the sudden abandonment of the gold-fields and the departure of the culture-heroes from Australia. This is probably why they missed the pearl-beds of Broome, on the west coast of Australia.

[1] Such instances as those of the Pilgrim Fathers and others are sporadic.

Another argument is that derived from the study of Givers of Life. The great store set by later peoples on gold, or quartz, or iron, pearls and so forth, gives an inkling of the intensity of the powers accredited to such objects by the early folk. This desire for givers of life is enough to account for a world-wide search for such objects. For, as I have shown elsewhere, it has certainly led, in historical times, to many expeditions in search of earthly paradises, where givers of life were supposed to exist. With so powerful a motive, it is readily understood why the people of the archaic civilization scattered themselves far and wide on the face of the earth.

Another line of approach to the same conclusion is through the study of the movements of peoples who migrated from settlements of the archaic civilization. Tribes like the Gonds of the Central Provinces, the Kayan of Borneo, and the Toradja of Central Celebes, apparently settled where they found iron for their industry. In the case of the Gonds, however, the prime cause of their movements has been the search for gold.

In the case of the Toradja, the migration was into entirely new country, so that the choice of position for settlement was practically free. The wanderers chose sites where iron existed, and have installed in some cases irrigation works, which goes to show that the determining factor was the presence of iron ; for even the most convinced supporter of climatic and other influences would hardly venture to show that one river valley was any better than another in this part of Celebes. This secondary movement in search of iron fits in readily with that of the archaic civilization in search of such things as gold and pearls : it is the result of the selection, by people such as the Toradja, of certain cultural elements, and of the concentration of their attention on those elements.

Finally, it is improbable that climatic and other natural conditions have co-operated to produce similar civilizations in places which in practically every case are sources of various desired objects : such a coincidence does not fall within the limits of probability. The distribution of communities of the archaic civilization can only be due to the deliberate choice of settlement by people possessing an uniform culture.

Given that continuity exists between the archaic civilization and those that followed, the inference is that the process at work is continuous. The communities of the archaic civilization in more than one instance have produced others, some of them destined to grow to great size. Sometimes the growth of a group of tribes from one original settlement can be watched, and, doubtless, if knowledge were available, such instances could be multiplied : the Polynesians have made a far-flung line of settlements, all related to one another : in Australia it would seem that many tribes are derived from one original tribe : several people of India, such as the Naga tribes of Assam, show an underlying

unity. To this unity of settlements can be added the unity of culture such as is especially evident in North America. No signs exist of anything approaching independent origin. The better the facts are known, the more apparent is the continuity between one settlement and another, between one tribe and another.

When the Polynesians are considered as a whole, it is evident that their cultural similarities are due to filiation, to a definite interrelationship existing between the most widely-scattered communities : in Assam the cultural similarities of the Nagas are put down to similar cultural history ; and so on throughout the region. When this knowledge is applied to the communities of the archaic civilization, the inference can only be that all these communities, with their similar cultures, owe their existence to derivation from one original source. This is evident when the possible mode of formation of settlements is considered. Settlements ruled over by the Children of the Sun must have been founded by members of that family : it is unthinkable that commoners from one place could go to another and reproduce the culture of their homeland : the whole of the evidence vetoes that view. It is known, in the case of the Polynesians, that the expeditions were led by men of noble blood, which makes it impossible for commoners to have usurped their place ; it has been found, also, that when the Children of the Sun die out, they are replaced by the other side of the ruling class, the chiefs connected with the underworld ; moreover, when the ruling class has disappeared, it is not replaced by another. Any given community lives on what it has got from the archaic civilization ; it does not add to the original capital, but tends rather to squander t . The invariable result of the disappearance of the Children of the Sun has been for the sky-world to lose its place in the religious system of the community. In that case, how can it be asserted that men not belonging to that family have arrogated to themselves divine honours ? The prestige of the Children of the Sun makes that impossible. The only conclusion that can be accepted is that any settlement of Children of the Sun must have been derived from some settlement of that family, and this conclusion is universally borne out by native tradition from one end of the region to the other, which says that men came from the sky, from a place where there was a sun-cult. This may be interpreted as invention to explain the fact. But the results of the study of tradition throughout this book will not support such an assumption for a moment.

Given that the archaic civilization is a unity, and that the successive settlements have been derived from preceding settlements, it is natural to ask where was the original settlement. The laws of probability make it incredible that the archaic civilization, as it is known in various parts of the region, could have originated more than once. The entire failure of any subsequent people to develop independently any cultural elements of the

27

archaic civilization is sufficient warrant for that supposition. A study of the direction of movement should therefore point at once to that of the original home ; and it can hardly be doubted that this home was in the Ancient East.

This can readily be shown by the consideration of such a cultural element as the use of a script. The possession of a script by any people is a sign of a high stage of civilization. The earliest script in Egypt and Sumer was certainly prior to 3000 B.C. : in India a script apparently arrived about 700 B.C. : the Polynesians are said to have left India about 450 B.C., and to have arrived in the Pacific about the beginning of our era, which suffices roughly to fix the date of the script of the Carolines ; a Phœnician script is known in south-west Sumatra, the date is uncertain, but probably is not earlier than 1500 B.C. : the foundation of the Maya civilization is put at about the beginning of our era, with a possible margin of 200 years either way. This rough measure suggests that writing moved in an easterly direction, for it appeared in various countries at dates progressively later in proportion to the remoteness from the Ancient East. No one maintains that civilization existed in the northerly part of America before 200 B.C. Since all the arts and crafts of the Maya people, including writing, had been possessed by other peoples for thousands of years before that time, it seems reasonable to suppose that the movement of culture has been towards America.

In any attempt to understand the origin of the civilization of North America it must constantly be remembered that it contains a group of communities whose cultures are fundamentally similar. With the exception of the horse-riders, who can be put on one side, for reasons previously stated, as playing no part in the argument, the food-producers are divided by a great cultural gap from the food-gatherers, who represent the early population of the continent. The culture of the food-producers, as is constantly said by American ethnologists, is fundamentally a unity. All the facts point to the Maya as the earliest civilized people in North America, and to them is owed the civilization of the other peoples. The question is : whence came the Maya civilization ?

It will be well to inquire, first of all, of the American archæo-logists who have had this matter in hand. I quote from a recent authority, Mr. S. C. Morley, whose bulky monograph on "The Inscriptions at Copan" has lately been published by the Carnegie Institute of Washington. He devotes some pages to the question of the origin of the Maya civilization. According to him : "The Maya themselves have been variously derived from the ancient Egyptians ; from the Ten Lost Tribes of Israel ; from the Javanese ; and even from the visionary folk of fabled Atlantis." [1] And he goes on to say that "unfortunately these highly improbable hypotheses have not entirely disappeared before the advance of the science since the Egyptian connexion has been revived

[1] Morley ii. 28.

recently by (Elliot) Smith on the basis of erroneous identifications and purely superficial similarities." [1] He continues : " Such extravagant hypotheses would scarcely merit even passing notice were it not for the fact that their very superficiality renders them peculiarly attractive to the general public. It is, therefore, perhaps not superfluous to repeat that the Maya civilization was a native American product, developed in its entirety in the New World, and probably not far from the region where its extensive remains are now to be found." [2] Mr. Morley is very emphatic in his assertions, and his language suggests that presumptuous folk, such as Elliot Smith, will be thoroughly castigated when it comes to a discussion of the evidence. His colleague, Mr. Spinden, writing in 1913, is even more emphatic. He says : " The writer does not care to dignify by refutation the numerous empty theories of ethnic connexions between Central America and the Old World." [3] These and other American authorities are very impatient of any comparison between America and Asiatic civilization. This for example : " Except in the matter of stairways and methods of construction the pyramids of Assyria were not dissimilar from those of Mexico and Central America. Superficial resemblances might also be noted in the assemblages of rooms in the palace structures and in the marked use of inclosed courts." [4]

I do not propose to enter on an argument with American archæologists, I shall simply inquire where and how they imagine the Maya civilization to have originated. In spite of wholesale condemnation of their opponents, they are unable to produce a single fact in favour of its indigenous origin. Listen to the authorities just quoted. First Mr. Spinden, who begins by scolding those who seek an outside origin : " No reasonable excuse can now be found for writers who, on the strength of this or that authority, cheerfully leap the bounds of space, time and reason to derive the religious and artistic conceptions of the Mayas from Egypt, India or China. The evidence these writers present is always insufficient, and usually wrong. Where real similarities exist they probably can be explained by pure chance or by psychic unity.[5]

" In determining origins, however, account may well be taken of the single outlying group of the Maya-speaking peoples, the Huasteca, who inhabit the low coast region north of Vera Cruz, and in whose territory many remains of cities as yet undescribed are known to occur. It is possible but not likely that a careful study of this disconnected group will indicate a northern origin for Maya arts. An origin to the south of the stated limits (of the Maya civilization) is hardly conceivable, owing to the great and

[1] Id., 402. [2] Id., 28, n. 4.
[3] Spinden i. 231–2. [4] Id., i. 232.
[5] In a later chapter (see p. 485) it will be seen to what conclusion this hypothesis of " psychic unity " really leads.

sudden falling off in handicrafts and ideas once the southern frontier has been crossed. Such similarities as do exist may easily be accredited to the Nahua colonies, which, in the last centuries before the coming of Europeans, were planted even farther south than Lake Nicaragua. No matter, however, to what other region fuller investigation may refer the humble beginnings of Maya art, the indisputable fact remains that in all essential and characteristic features it was developed upon its own ground." [1]

In view of these assertions some evidence would be expected to show that the elaborate civilization of the Maya was a local product. A careful examination of the arguments brought forward by Mr. Morley, the latest writer on the subject, who is fully aware of what has been written, makes it clear, to any fair-minded reader, that the claim is groundless ; and that no evidence whatever exists to point to the origin of the Maya civilization in America. It seems to spring full-blown from the ground, to use the candid words of Mr. Joyce. This is the sort of explanation that we are tendered : " At some remote epoch sufficiently prior to (their earliest date) for them to have developed such a complex calendar, chronology, and hieroglyphic writing as they possessed at that early date (about 100 B.C.), the Maya may have lived somewhere north of their habitat during the Old Empire ; and since a Maya-speaking people still inhabit such a region between Tuzan and the Panuco River, this may possibly have been the place.

" Before developing their calendar, chronology, hieroglyphic writing, and distinctive civilization, by which they were characterized in later times, the great mass of the stock moved south, leaving behind, perhaps, the more backward elements, who later developed a far lower and different culture but who continued to speak the mother Maya tongue, and who later became the Huastecs of historic times. [2]

" Somewhere between the above region and San Andreas Tuxtla, if our hypothesis be correct, the Maya civilization had its origin, and their calendar and chronology had been perfected to such a point that by (their earliest date) they were able to carve upon a very hard stone . . . the earliest date yet found in their hieroglyphic writings.

" How long prior to this date it took them to make and record the necessary astronomical observations on the sun and moon, upon which their calendar is based, and having at last sufficient data at hand, how long it took them to perfect their remarkable chronological system, is of course impossible to say. The first process, however, would appear, a priori, to have been much the longer of the two, since, once certain astronomical facts, such as the apparent revolutions of the sun and moon around the earth, had been determined, the invention of the whole elaborate calendar and chronology, including the arithmetical and notational

[1] Spinden i. 2. [2] This argument is rejected by his colleague, Spinden.

systems, might have been the work of a single individual. Such highly complex and arbitrary inventions, while based upon data slowly and laboriously acquired over long periods of time, are apt to flower quickly once a certain stage is reached [1]—a sudden liquidation of long-accumulated intellectual investments ; and so the actual construction of the Maya calendar and chronology may have come swiftly, once the astronomical data upon which they were based had been accumulated in sufficient quantities to establish therefrom certain dependable astronomical laws. And possibly this invention may have taken place not long prior to . . . the date on the Tuxtla Statuette, since no certain earlier contemporaneous date has yet been found in the Maya writing." [2] This quotation will show the reader what form of argument is used by the utterers of the strong opinions with regard to those who would claim foreign origin for the Maya civilization. These students have not a single fact to explain the origin of any of the features of Maya civilization. The bankruptcy of facts is complete, and in order to buttress their position the invention of all sorts of arts and crafts is taken for granted as something not needing explanation, which is as good an example as could be desired of the time-honoured practice of " begging the question." [3]

Something is known about the history of civilization in North America in pre-Columbian times. Can any reason be adduced to support the belief that a people of that continent elaborated any civilization at all ? What did the study of culture-sequence reveal ? It showed that, wherever it was possible to establish a sequence, the earlier civilization was the more developed. This was true in comparing the Plains Indians with those east of the Mississippi ; the Indians east of the Mississippi with the Mound Builders ; the Mound Builders with the Mexicans (if this be allowed as a legitimate culture-sequence) ; the early Pueblo Indians with their descendants ; the later branch of the Zuni with the Elder Brethren ; the tribes of Mexico with the ancient Mexicans ; the later Maya with the early Maya. The evidence was always unhesitating. Therefore, if a certain tribe speaks a Maya tongue, and is culturally lower than the early Maya, then it can only be assumed, on the basis of what really is known in North America, and not what is postulated, that this tribe must have been later in time than the Maya. Going backward in time, in America, is like the ascent of a series of cultural steps, at the summit of which stands unchallenged the earliest civilization of all, that of the Maya.[4] How, therefore, can such claims be made

[1] As if this sort of process could be watched at work in all parts of the earth.
[2] Morley ii. 408.
[3] I may perhaps mention that this attitude is not adopted by all Americanists. See, for instance, Holmes iii. 35–6, for an appreciation of the cultural similarities between America, Cambodia, Java, and elsewhere. Also Z. Nuttall ii. 135 e.s. and other writings.
[4] Long. Man, 1918, 70. " If the theory put forward in this paper as to the origin of the zero point of Maya chronology is sound, it will show a remarkable

as those that are put forward with so much confidence and vigour by Spinden and Morley and some of their colleagues ? Is it credible that, in the space of a few decades or centuries, the Maya invented their civilization and brought it to its highest development, and that subsequently the whole history of the continent has been one of uninterrupted cultural degradation ?

One loophole may be suggested to those who support this claim. It has been stated that the coming of warlike peoples ruined the archaic civilization. This may be held responsible, as it certainly could, for the degeneration of culture among the other peoples of North America. It may be claimed that the Maya elaborated their civilization in peace, and that the subsequent degeneration was the result of the introduction of warfare. The evidence put forward shows that warfare must have been responsible for much of the cultural degeneration in this continent. But it does not explain everything. For large areas are inhabited by people who have never at any time elaborated any sort of civilization. The theory that warfare has destroyed civilization is plausible when applied to civilization already in existence. But the existence of that civilization has to be accounted for, so, before applying the solution of war, it is essential to explain how it is that civilization appeared first in certain spots, particularly in southern Mexico and the surrounding countries. What in that region made it so different from the whole of the rest of the continent, that men there began to elaborate arts and crafts, even though subsequently they have shown no tendency to follow the same example ? The colonization of the United States areas can be explained by a spread from Mexico of maize-growing people, and this explanation is the only one that accounts for the facts. These people went in search of substances that they needed, pearls, copper, gold, turquoise, and so forth. In Guatemala and Southern Mexico they were likewise in an area full of precious substances. Why therefore refuse to believe that the founders of the Maya civilization came in search of such things and settled where they found them ? The mere presence of the gold and other substances cannot account for the civilization, for they also exist in California, the natives of which have never displayed the slightest interest in them.

The fact is that the Maya civilization springs from nowhere, so far as America is concerned. Giving due weight to all the data, is it credible that this miracle was accomplished by the Maya people entirely independently of any outside influence ? What is the real situation ? After the archaic civilization had been in

parallel to the Hindu Kali Yuga era of 3102 B.C., which has been shown also not to be a historical date, but one arrived at by calculating back till a date was reached which would be the commencement of a cycle harmonizing lesser cycles (Dr. J. F. Fleet, in Journal Roy. Asiatic Soc., April 1911). It is curious that another parallel can be found between the Hindu method of reckoning by ' expired ' instead of current time periods and the Maya reckoning by elapsed time.''

existence for nearly three thousand years, a civilization, in all essentials its exact copy, suddenly springs up in a part of America where existed supplies of precious substances. The direction of culture-movement across the region as a whole is from west to east ; so that, logically speaking, the wave of culture should, in time, have impinged on the American coast. In support of that contention it is urged that it is possible to establish some distributions that run continuously throughout the region from one end to the other. The distribution of polished stone implements is continuous ; so are those of mummification, pyramid-building, the dual organization, the sun-cult, relationship with animals, theogamy and so on. The continuity is only broken in any part of the region as the result of the decay of the archaic civilization, and even in such cases traces of the old order still persist. Thus was spread over the whole region a civilization which did not repeat itself in subsequent times : the new civilizations always deviate from it, thus showing that there is no inherent necessity about this civilization, that men do not inevitably make polished stone implements of trap rocks, work obsidian, build pyramids, elaborate a dual organization of society, and so on. The facts, on the contrary, all go to show that the archaic civilization was a thing in itself, put together once and for all, and only preserved in special circumstances. Is it to be believed, therefore, that, in circumstances that would suggest the spread of the archaic civilization to America, the Maya people independently elaborated a civilization that, as it were, finished off the process and completed the extension of the archaic civilization ? To believe that involves the denial of the traditions of American peoples, who all claim that they got their civilization from culture-heroes, and have elaborated ideas about these culture-heroes identical with those held in other parts of the region.

It has been shown that, in America as elsewhere, the use of stone, the carving of stone images, the practice of irrigation and the working of precious metals constitute definite cultural elements that are found only in certain circumstances. The presence of precious metals has nothing whatever to do with their use, for in several parts of North America are great deposits of gold, that were not worked until the middle or end of last century. The peoples of North America were, on the whole, indifferent to the use of stone for building and for images : they sometimes dropped the making of pottery. Anyone who would choose to insist that the Maya invented all these cultural elements will, in the face of these facts, have to produce definite evidence to show how and where they were invented. It must be remembered that no evidence has yet turned up of the origin in America of any one cultural element that has figured in the discussion. The only place where, as yet, signs of beginnings can be detected, is the Ancient East. To accept the use of stone, irrigation, the working of metals, as axiomatic, is to run counter to the known facts.

These cultural elements belong to the archaic civilization in all parts of the region, and disappear with that civilization. On them may be based in the first instance, the challenge to those who claim the American origin of the Maya civilization.

Certain objections can be raised against the theory that the civilization of America was of exotic origin. One, upon which emphasis is laid, is that of food-plants. If the strangers came in, why did they not bring some food-plant with them, such for example as rice ? Fortunately what is known of the results of a long movement of culture disposes of the difficulty. The ancestors of the Polynesians came from a country where rice was grown, and they seem to have known of it. Why did they not take it out into the Pacific ? The answer is given by their own traditions : they found the breadfruit in Indonesia and took that instead. So a migrating people can drop one plant and take up another. This is what apparently happened in America. As has been seen, the first colonizers of the Pacific were clever agriculturists, and would have a good knowledge of plants. Evidently they found the maize plant in America, and adopted it, and grafted on to its cultivation a group of ceremonies and ideas that are common to the agriculture of the archaic civilization from one end of the region to the other. The maize mother is exactly analogous to the rice mother of Indonesia. The calendrical system of the Maya was centred round agriculture, as were those of the Egyptians and others ; their great festivals were also mainly agricultural : they had human sacrifice in connexion with their agriculture, which was closely associated with mother goddesses. The only thing that differs is the plant itself, and it is only natural that it should. What value, therefore, has an objection that selects one element of a complex and ignores the others ?

The language difficulty is also brought forward. How is it that the strangers, if they came from Asia, did not bring with them a language or a script that shows signs of affinity with those of their homeland ? As in the case of food-plants, this difficulty is specious. It is not confined to America ; for in Micronesia and Easter Island scripts exist that cannot be deciphered. No one claims that the Easter Islanders elaborated their civilization. So, before the difficulty of America be brought up, those of the Pacific should be considered. When it is realized that exactly the same process has been at work, in the Pacific as in America, the objection based on language vanishes, for it is not proper to America.

It is possible that the strangers were expert agriculturlists who soon discovered maize and started to grow it : that they learned the language of the natives, and that they elaborated a hieroglyphic system to express this new language.

Another group of cultural elements will have to be explained on the basis of the hypothesis of the indigenous origin of American civilization. Apart from stone-working, irrigation and the work-

ing of precious metals, many less material elements demand elucidation. First and foremost is the class system.

It is admitted by American archæologists that the Maya people elaborated their civilization in a short space of time. In addition to inventing various arts and crafts, they evolved a ruling class headed by Children of the Sun, who belonged to a sky-world, and including other rulers connected with the underworld. At death the Children of the Sun went to the sky, and the rest of the community went underground, to be ruled over by the mother goddess and a king, representative, it has been concluded, of the other branch of the ruling class. How is this extraordinary condition of affairs to be explained on the hypothesis of the American origin of the Maya civilization ?

Again, how did the Maya come to elaborate the dual organization with all its ramifications, producing thereby a form of society with an uncanny resemblance to that of the archaic civilization of the rest of the region ? Not in one, but in a number of ways, does the dual organization of North America reproduce that of the Pacific and India. Then can be added the organization into totemic clans, the institution of exogamy, all of which run continuously through the archaic civilization from one end of the region to the other.

The practice of building pyramids presents another serious difficulty. Archæologists are fond of stating that the dolmen was the favourite form of stone building for " primitive " man. When the Maya began to work stone they built vast stone pyramids. The civilization of Egypt had been in existence for many centuries before this step was taken ; and the Egyptians began their pyramids with one made of brick. It seems incredible that the Maya in a few short decades jumped cultural gaps that needed centuries in the Ancient East, and that they left out some of the steps. The pyramid of Egypt was a development either of the mastaba or else of the top stone of the obelisk. It is not a simple natural obvious structure, as is evident from its history in Egypt (see p. 437).

Innumerable such difficulties could be put, which are simply insoluble on the hypothesis of the indigenous origin of the Maya civilization.

What is the real position as regards North America ? It seems to be this. The Maya civilization stands at the summit of American culture, and it precedes all others in that area ; it displays, in itself, or in its derivatives, exact parallels to other branches of the archaic civilization, with which it is continuous in distribution, and of which it can be treated as an integral part ; it resembles the civilization of the Ancient East more than that of any other part of the region, excepting perhaps India ; and its origins in America cannot be traced. It is reasonable to suggest, therefore, that the origins of this civilization must be sought elsewhere than in America.

In Oceania the current of civilization has flowed in the past from west to east, and little opposition can be maintained to the view that the culture of this region came from India by way of Indonesia. The study of food-plants is enough to settle that point : the Polynesians made their islands habitable by bringing with them the breadfruit, the banana and other fruit-bearing trees, and these trees in the great majority of cases came from India. It is therefore in India that must be sought the origin of the civilization of Polynesia, and presumably of the rest of Oceania.

There is nothing to show that the peoples of Indonesia elaborated their civilizations. They themselves claim to have been civilized by strangers, often from the sky-world. And the evidence indicates that the people of the archaic civilization came to the region and settled where they found substances not previously valued by the native populations, except when under the influence of people of higher civilization. The whole history of Indonesia is that of civilization by strangers.

Then comes the problem of the origin of the civilizations of India. Evidently, in the present state of the study of the history of that country, any direct attack on this problem would be futile. Any attempt to penetrate far into the past is bound, sooner or later, to come up against a wall of fog, through which it is as yet impossible to penetrate.[1] Nevertheless, it is possible to urge good reasons for believing that the people of the archaic civilization in India were strangers : they evidently knew where to settle, for they chose places yielding gold, copper, and so forth ; and they were masters of the mining craft, able to work quartz reefs to a depth of 600 ft. They practised irrigation. No evidence whatever exists in India to show that either of these crafts originated there ; they seem to have been introduced, together with pottery-making. This is negative evidence, but it is significant.

Then another and more serious argument can be adduced against the theory of the independent origin, in India, of the archaic civilization. This argument goes right to the foundations of the problem of the origin of civilization. In a paper already quoted, in connexion with the search for gold and other desired substances, I have claimed that the paleolithic people of Western Europe, like their successors, chose to live in the localities where they found raw materials for their industries. This paper was confined to the discussion of the problem in England and Wales, where it was shown that the river drift implements mentioned by Sir John Evans had been found in places situated in close proximity to the chalk formations, and particularly in those providing ample supplies of flint, of which paleolithic implements were chiefly made. So far as I can see, the drama of the paleolithic age was played out on the geological formations producing flint

[1] Pargiter has, in his latest work, made a good start along these lines.

and other allied substances of which paleolithic man made his implements, as well as in the limestone regions, where later on he lived in caverns; so that the fundamental problem of the origin of civilization is that of discovering what caused man to settle on other formations. That problem will be considered once again in the next chapter; for the present attention will be confined to India.

Numbers of paleolithic implements, chiefly quartzite, are found in India. As to the distribution of these remains, Bruce Foote is well aware of the relationship with geological formations, for he says : " There are far more traces of the paleolithic race around the great quartzite yielding groups of hills forming the Cuddapah series of the Indian geologists and the great quartzite shingle conglomerates of the Upper Gondwana system in the Chingleput (Madras), North Arcot and Nellore districts, than in other regions. In diminishing quantities traces of paleolithic man are found to the northward of the Kistna valley, where quartzite becomes a much less common rock. So also to the southward of the Palar valley, where quartzite becomes a rare material ; to the westward on the Deccan plateau, where the same stone chippers finding no quartzite in the Bellary district had recourse to the banded jasper hæmatite rocks (of the Dharwar system) ; and farther north in the valley of the Kistna, where recourse was had in one instance to hard siliceous limestone." [1] The men of the paleolithic age thus left their remains on quite different geological formations from those of the archaic civilization. That is to say, the later folk had entirely different ideas from their forerunners, and no traces can be detected of the transition from one stage of culture to the other. It is more reasonable to seek for such traces on a geological formation which possesses a raw material common to the food-gathering and food-producing stages of culture, such as the flint-bearing formations which supplied the peoples of Egypt and Western Europe with raw material for their industries.

[1] Foote 36.

CHAPTER XXVI

EGYPT

THIS chapter constitutes the climax of the argument. Having discussed the possible origin of the archaic civilization in North America, Oceania and India, we have found no good reason for believing that it developed in any of those areas. There remain but Sumer and Egypt, and it is in Egypt that, as I shall try to show, the archaic civilization came into being.

The nature of the problem must clearly be understood. By asserting that the archaic civilization originated in Egypt, I do not mean that every element was necessarily invented by the Egyptians : I mean that it took shape in Egypt and was propagated thence. To establish my contention, therefore, it will be necessary to show how and why these cultural elements originated, and to explain what caused Egyptian culture to begin its journey across the earth.

In the last chapter a list was made of the principal elements of the archaic civilization (see p. 406). The surveys of the various chapters have shown that these elements were present in Egypt : it now remains to show how the Egyptians came to possess them. Egypt is peculiarly fitted to be the home of the archaic civilization, or of any food-producing culture, for it has been inhabited continuously since the early days of the Paleolithic Age.[1] The reason for this occupation lies in the presence of large quantities of excellent flint for the manufacture of implements, in which craft the Egyptians were unequalled. In consequence of the elaboration of fresh needs, the Egyptians moved out from this district, and began to live on other geological formations. But when still in their homeland they made the first step towards the production of civilization as we know it : they discovered the craft of irrigation. Irrigation is certainly one of the most important cultural elements of the archaic civilization, for on it the settlements depended for food. The recent work of Prof. Cherry has made it beyond reasonable doubt that this craft—and with it agriculture—must have originated in Egypt.[2] He shows that the Nile has a perfect irrigation cycle, the like of which is not found in any other river valley of the world. The inundation takes place at the end of the hot, dry summer, so that the water,

[1] de Morgan i. [2] Cherry.

428

by flooding the land on either bank, causes any plant seeds that may be lying there to germinate, and provides the mud in which they can thrive. When the flood recedes the plant has the cool winter months in which to grow, and the crop, in the case of cereals, can be harvested at the end of the winter. Thus, before man cultivated food, ripe grains of barley and millet would lie on the ground throughout the hot Egyptian summer without sprouting or mildewing, and would be ready for the flood at the end of the summer. The Nile was the first cultivator of the cereals by irrigation. Men lived in Egypt for many thousands of years before they learned the lesson that they were yearly being taught. They were seed-gatherers, beyond doubt, who lived on the barley and millet that the Nile grew for them. Eventually, however, they probably began to scoop out small channels to help the water to cover more ground, and thus came to practise artificial irrigation. In Mesopotamia, on the other hand, the flood-cycle does not serve to grow crops without artificial control. For the flood comes at the beginning of the summer, which means that any sprouting plants would be at the mercy of the hot sun, and would inevitably die. Consequently, as Prof. Cherry observes, those who inaugurated the irrigation system of Mesopotamia must have proceeded with deliberate intent. He discusses also the problems connected with barley, so favourite a food with the pre-dynastic Egyptians, and argues that the valley of the Nile must have been the place where it evolved.

The Egyptians of these early days possessed other elements of the archaic civilization, the origin of which is not yet decided ; spinning and weaving ; pottery-making ; and the cult of the Mother Goddess common to the peoples of the upper paleolithic age, and revealed in Egypt by the presence of small feminine images of grotesque shape. The Egyptians had also discovered the use of copper for tools, probably as the result of their employ-ment of malachite as a pigment. Various Givers of Life were also in use. The country had territorial divisions, called by the Greeks " nomes," each having as ensign an animal, plant or material object. These nomes were in two groups, constituting respectively Upper and Lower Egypt. In the earliest days no signs existed of stone for construction, of the sun-cult as the state cult, of the Children of the Sun, of pyramids, dolmens and so forth, or of several other cultural elements of the archaic civilization.

The most important date for our purpose is that of the unifica-tion of Egypt under the First Dynasty, which took place about 8300 B.C., according to some, or earlier, according to others. Before the dynastic period there were kings ; and, in late pre-dynastic times, and at the beginning of the dynastic period, these kings seem to have had similar titles ; which serves, it is claimed, to establish a continuity between the two groups. The evidence for this is late, but, according to Sethe, it goes to show that the " Followers of Horus " or " Worshippers of Horus " (Horus-

diener), who are said to have existed in Egypt in the days before the country was united under Menes, the first king of the First Dynasty, were actual men. They corresponded, he thinks, to the king of Upper Egypt at Hieraconpolis, and the king of Lower Egypt at Buto.[1] Sethe says that the kings of the first historical dynasties seem to have considered themselves to be the successors of the Upper Egyptian " Followers of Horus " of Hieraconpolis, and that they were especially worshippers of this god.[2] The kings of the Sixth Dynasty still retained traditions of the days of the " Followers of Horus " of Hieraconpolis and Buto, to whom reached back the annals. In the royal annals of the first two dynasties mention is made of a feast called " Worship of Horus," which was held every two years.[3] It is thus possible that the foundation of united Egypt was the work of one of the " Followers of Horus."

The connexion between the nomes and animals has already been mentioned. The royal families of late pre-dynastic times were also connected with animals : rulers are represented with jackal standards and as jackal-headed :[4] the ruling family of Hieraconpolis was connected with the hawk, the bird of Horus, and this connexion was clearly shown in the coronation ceremony of the king of united Egypt.

Whether or not Egypt was united in the pre-dynastic period under one king, to fall again into two kingdoms, it is certain that the First Dynasty united two distinct kingdoms. The first king of the First Dynasty was Menes, a native of Thinis near Abydos in Upper Egypt, who is said to have built Memphis at the boundary of Upper and Lower Egypt so as to preserve order.[5] He was thus ruler of a double kingdom, each part including a number of territorial groups, closely connected, certainly so far as their rulers were concerned, with certain animals, plants and material objects. Thus Egypt at the beginning of the First Dynasty already had begun to take on the aspect of the typical community of the archaic civilization.

Other cultural elements became attached to the dual grouping. The conquest of Lower Egypt by a king of Upper Egypt produced hostility between the peoples of Upper and Lower Egypt. The king of Upper Egypt had continually to enforce law and order in the Delta : and Sethe claims that the Memphite feast in the month of Choiak had a relationship to the forcible union of the two kingdoms. " The anniversary of the coronation of the Egyptian kings, which was also that of the coronation of Horus, was the day on which Menes seated himself on the throne of Egypt." On this day was the feast held. On the previous day a preliminary ceremony was performed which Sethe claims to be a sign of triumph. A pillar, called the " dad " pillar, was erected.

[1] Sethe iii. 20. [2] *Id.*, 16.
[3] Breasted iv. 46 ; ii. I. §§ 91–167.
[4] Sethe iv. 20. [5] Breasted iv. 91.

" The ceremony of the erection of the dad pillar, which took place on the day before this important festival day for the king, must have had a particular meaning for the king besides its religious and mythological importance, because of the singular mock-fight that was fought with plant-stalks. When we read over the heads of the two struggling priests the words, ' I take Horus so-and-so,' it seems as if a new king is concerned, about whom the adversaries struggle. More important still are the two groups of combatants, who are distinguished from the others by their clothing " (they evidently are people of Lower Egypt). " We seem to have to do with a fight between citizens, which took place among those of Buto, the capital of the king of Lower Egypt. When could this struggle have been fought in Buto, that it should have such importance for the Egyptians as a whole ? Probably on the occasion of the union of the two lands, for Buto was then still of importance. If at that time any part of the population of Buto had declared itself for the Upper Egyptian king, then that would have been doubly welcome, because by this means the union would not have appeared quite so involuntary as it actually was from the standpoint of the Lower Egyptians. The phrase, ' I take Horus so-and-so,' which was uttered during the strife between the priests, gains thereby particular importance." [1]

This ceremony serves to throw light on the hostility between the two sides of the dual organization, especially as characterized in the ball-game.[2]

Horus and Set in Egyptian mythology are usually represented as hostile, though in some of the Pyramid Texts they are friendly. These two beings are connected with Upper and Lower Egypt respectively, and evidently the hostility between them has some historical significance. One reason for this hostility has already been suggested, namely, the dispossession of Set by Horus. It is said also that Set was lord of Ombos in Upper Egypt, and Horus was lord of Buto in Lower Egypt.[3]

The duality of the organization of dynastic Egypt has already been described : it pervaded most departments of the State. The king himself might have a dual personality : [4] he had a dual

[1] Sethe iii. 6, 137.

[2] It is remarkable that a ceremony similar to that of the erection of the dad-pillar takes place on the occasion of the Sun Dance of the Plains Indians of North America, a feature strangely reminiscent of the rites of Attis and other mystery heroes. The Sun Dance is performed in the spring. On the day before the real ceremony certain warriors go to the forest and get a pine tree, which they bring home in triumph and erect in the lodge made for the purpose. While bringing it home a mock fight takes place. It is entirely impossible to explain the fight in America, but it certainly is more in place in Egypt.

[3] Sethe v. 5. I do not propose to enter here on a discussion of the problem of the hostility of Horus and Set in connexion with the hostility between the twins in other parts of the region.

[4] Breasted iv. 42. Perabsen of the Third Dynasty had the signs of Horus and Set (Weill).

palace; his coronation ceremony was dual; his titles bore witness to the fact that he was the ruler of a dual kingdom; his high officials were often two in number for each office, as in the case of the High Priests of Heliopolis and Memphis; his crown was dual; in short, in every way it was made evident that the unification of Egypt under one crown had left an indelible impression on the whole organization of the State.

The duality of the early state was the direct result of the unification of Upper and Lower Egypt under one throne. Thus the process of development of the typical community of the archaic civilization has advanced another step.

In early dynastic times other cultural elements came into being; the practice of mummification, together with its correlative, the making and animation of stone statues. The pre-dynastic Egyptians buried their dead in the hot dry sand, in consequence of which the bodies were preserved in the likeness of the living. " The burying of valuable objects with the corpse led to frequent rifling of the graves (by the deceased's contemporaries), and this repeated desecration must have familiarized the people with the knowledge that in Egypt the bodies of the dead were often preserved in a marvellously incorrupted state by the action of the forces of nature. The hot dry sand in which the early pre-dynastic graves were scooped out, often produced such rapid desiccation that the whole corpse was preserved indefinitely without change." [1] But the customs of the later Egyptians tended to prevent this process of desiccation from taking place : " Even in the earliest known pre-dynastic period the Proto-Egyptians were in the habit of loosely wrapping their dead in linen—for the art of the weaver goes back to that remote time in Egypt—and then protecting the wrapped corpse from contact with the soil by an additional wrapping of goat-skin or matting." This practice was developed and varied as the wealth of the Egyptians increased, until, finally, after the discovery of the use of copper, the dead were, in the case of the rich, placed in stone coffins. This had a noteworthy consequence : " For in the course of time the early Egyptians came to learn, no doubt again from the discoveries of their tomb-robbers, that the fate of the corpse, after remaining for some time in a roomy rock-cut tomb or stone coffin, was vastly different from that which befell the body when simply buried in the hot, dry, desiccating sand.[2] They evidently set themselves to counteract these natural forces, and to preserve the dead in the likeness of the living." [3] " From the outset the Egyptian embalmer was clearly inspired by two ideals : (a) to preserve the actual tissues of the body with a minimum disturbance of its superficial appearance ; and (b) to preserve a likeness of the deceased as he was in life." [4] The earliest known attempt at mummification dates from the First Dynasty. In the Second Dynasty attempts the

[1] Elliot Smith ix. 9 e.s. ; xii. 32 e.s. [2] Id., xii. 33–5.
[3] Id., xii. 36. [4] Id., xx. 15.

corpse was swathed in a large series of bandages which were moulded into shape to represent the form of the body. In the earliest instances, endeavours were made to mould the features so as to preserve the likeness of the deceased ; so that the mummy was evidently intended to be a portrait as well as the actual bodily remains of the dead. " A discovery made by Mr. J. E. Quibell in the course of his excavations at Sakkara suggests that, as an outcome of these practices, a new procedure may have been devised in the Pyramid Age, the making of a death-mask. For he discovered what may be the mask taken directly from the face of the Pharaoh Teta." [1] At the same time the practice originated of making a life-size portrait statue of the deceased which was left in the tomb along with the mummy.

" All these varied experiments were inspired by the same desire, to preserve the likeness of the deceased. But when the sculptors attained their object, and created those marvellous life-like portraits, which must ever remain marvels of technical skill and artistic feeling, the old ideas that surged through the minds of the pre-dynastic Egyptians as they contemplated the desiccated remains of the dead, were strongly reinforced. The earlier people's thoughts were turned more specifically than heretofore to the contemplation of the nature of life and death, by seeing the bodies of their dead preserved whole and incorruptible ; and, if their actions can be regarded as an expression of their ideas, they began to wonder what was lacking in these physically complete bodies to prevent them from feeling and acting like living beings. Such must have been the results of their puzzled contemplation of the great problems of life and death. Otherwise the impulse to make more certain the preservation of the body of the deceased by means of a sculptured statue remains inexplicable. But when the corpse had been rendered incorruptible and the deceased's portrait had been fashioned with realistic perfection the old ideas would recur with renewed strength. The belief then took more definite shape that if the missing elements of vitality could be restored to the statue, it might become animated and the dead man would live again in his vitalized statue. This prompted a more intense and searching investigation of the problems concerning the nature of the elements of vitality of which the corpse was deprived at the time of death. Out of these inquiries in course of time a highly complex system of philosophy developed." [2]

The practices of mummification and of the making of portrait statues thus in all probability developed simultaneously, in response to the desire to preserve both the body and also a likeness of the deceased, and as the outcome of certain climatic and economic causes.

Mummification and the making of portrait statues evidently played an important part in the development of ideas regarding

[1] Elliot Smith xx. 17. [2] Id., xx. 19.

28

the soul. When the portrait statue had been made, it was a lifeless object until it had been animated. In order to animate it, certain ritual procedures were followed, such as the use of libations and the burning of incense, and the ceremony of the "Opening of the Mouth."[1]

Dr. A. M. Blackman has discovered the significance of libations and incense in Egyptian funerary ritual. His quotations from the Pyramid Texts show that the Egyptians considered that the deceased had lost his bodily fluids and odours, and that they must be restored to him. For example, "These thy libations, Osiris; these thy libations, O Unas, which have come forth before thy son, which have come forth before Horus. I have come, I have brought to thee the Horus-eye that thy heart may be cool possessing it. . . . I offer thee the moisture that has issued from thee, that thy heart may not be still possessing it." And again, "The offering of libations. Thy water belongs to thee, thy flood belongs to thee, the fluid that issued from the god, the exudation that issued from Osiris." Dr. Blackman quotes from a later ritual text, the Ritual of Amon, which states that "The grains of incense are the exudations of a divinity, the fluid which issued from his flesh, the god's sweat descending to the ground." Incense was used for purification, and also to communicate with the gods by means of the smoke that rises to the sky. Incense and libations were both intended to restore the bodily fluids to the deceased : "The general meaning of these passages is quite clear. The corpse of the deceased is dry and shrivelled. To revivify it, the vital fluids that have exuded from it must be restored, for not until then will life return and the heart beat again. This, so the texts show us, was believed to be accomplished by offering libations to the accompaniment of incantations."[2]

The animation of the portrait statue was not complete until the chief ceremony of all had been accomplished, that of "The Opening of the Mouth." This was performed by touching with a metal chisel the mouth, ears, eyes, and nose of the statue, after which it was supposed to live.[3]

The act of making a portrait statue was regarded by the Egyptians as essentially creative. I quote an extract from Elliot Smith recording a note given him by Dr. Alan Gardiner : "That statues in Egypt were meant to be efficient animate substitutes for the person or creatures they portrayed has not been sufficiently emphasized hitherto. Over every statue or image were performed the rites of ' Opening of the Mouth '—magical passes made with a kind of metal chisel in front of the mouth. Besides the up-re, ' mouth-opening,' other words testify to the prevalence of the same idea ; the word for ' to fashion a statue ' (ms) is to all appearance identical with ms, ' to give birth,' and the term for the sculptor was sankh, 'he who causes to live.' "[4]

[1] Elliot Smith 20. [2] Blackman i. 69–70. [3] Elliot Smith xii. 42. [4] *Id.*, 42.

The importance attached by the Egyptians to the portrait statues, and the ideas that they possessed with regard to the process of animation of these statues can, as Elliot Smith has already insisted, well explain the origin of the world-wide idea of the creation of men from images.

The practice of mummification was closely connected with Anubis, the jackal god of Upper Egypt. Osiris, the prototype of early Egyptian kings, was closely associated with the ritual, for all ceremonies of mummification centred round him. The dead king was identified with Osiris, and his son, the reigning king, was identified with Horus, the son of Osiris, who performed the ceremony of mummification of his father. The making of portrait statues was connected with Ptah, the god of Memphis, his high priest being called the Chief Artificer.[1] At Memphis Ptah was regarded as the creator of the earth : he was also the " Lord of Life," who performed the ceremony of " Opening the Mouth " for images of the gods.[2]

It is now possible to approach the study of the origin of the use of stone and of the different stone monuments. Elliot Smith has given a clear account of the development of the Egyptian tomb. He says :—

" In the Pre-dynastic Age in Egypt the corpse was buried lying flexed upon the *left* side, with the head *south* ; it was protected from contact with the soil by linen, mats or skins, or in the larger tombs by a palisade of sticks or a wooden frame in the grave. The small graves were shallow pits of an oval or nearly round form ; the larger graves were deeper rectangular pits, roofed with branches of trees.

" At the end of the pre-dynastic period the practice was introduced of lining the grave with brickwork to prevent the sand falling in and also to support a roof of branches, logs with layers of bricks upon them, or, later, corbel vaults, which were certainly invented about this time in Egypt."

Elliot Smith goes on to say : " When the Proto-Egyptian had learned efficiently to line the grave, either with wood or brickwork (with or without a definite coffin made of wood, pottery, or, later, of stone), the skins and matting previously employed to protect the corpse from direct contact with the soil were no longer considered necessary, though the loose linen wrapping was still retained. Quite early in the dynastic period the wooden coffin, the pottery coffin and the stone sarcophagus were invented to overcome the special difficulties that appealed to the Proto-Egyptians."

In the course of time the graves of the richer classes became more elaborate. Whole suites of rooms were made underground, and the grave became so deep that a flight of steps had to be made down into it. Also the pile of earth or stones on the top of the grave was enclosed by a wall of mud-brick, thus forming

[1] E. Meyer iii. I. 2, § 247. [2] Erman 942, 947.

the mud-brick mastaba. On the side that faced the Nile a court-yard was made by means of a low wall which was floored with beaten mud. In this period the shape of the grave altered, and from being round, circular or elliptical, became definitely rectangular. Thus was evolved in Egypt the mastaba, which is described by Elliot Smith in the following terms|: it is "a type of tomb consisting of (a) a multi-chambered subterranean grave, to which a stairway gave access ; (b) a brickwork superstructure in the shape of four walls enclosing a mass of earth or rubble ; and (c) an enclosure for offerings in front of (i.e. facing the river) the brick mastaba." [1]

Then came a remarkable development. "As the material prosperity of Egypt rapidly increased and the arts and crafts began to feel the powerful impetus of the invention of metal tools, the process of aggrandisement of the tomb, which we have now followed through the first two dynasties, received a further tremendous stimulus. Bigger, deeper and grander tombs were being made. Before the end of the Second Dynasty the gradual deepening of the burial chamber involved the necessity of cutting into the solid rock, and when the workmen realized that it was possible to overcome this difficulty, a process which the invention of the copper chisel had now greatly facilitated, a great innovation was made in the tomb-constructor's technique." Thus came the practice of making rock-cut tombs, which, as Elliot Smith states, were on the same plan as the former underground grave. Stone was used to some extent in grave construction in the First and Second Dynasties, but not regularly till the Third Dynasty. "At this time (early part of the Third Dynasty), although the subterranean burial chamber was often carved out of the solid rock, the superstructure was still constructed of mud-brick. But eventually the mud-brick mastaba was replaced by a stone building. At first the mud-brick model was more or less slavishly followed in the stonework, but the stairway rapidly atrophied and gave place to a simple shaft ; and the many-chambered subterranean house soon dwindled into a small burial chamber." [2]

It is from the mastaba that Elliot Smith derives the dolmen and the stone circle. He says, " If my arguments are valid we must regard the dolmen, not as the whole of the Egyptian mastaba-tomb but as its core, so to speak, greatly overgrown and stripped of all its unessential parts. The parts which are constantly represented in every dolmen represent the serdab (the chapel) and the burial chamber, often merged into one. The ' holed-stone ' found in dolmens so widely separated as India, the Caucasus and various parts of Western Europe is a striking witness to the reality of the serdab-conception in the dolmen ; and the great masses of stone that go to the making of the dolmen represent

[1] Elliot Smith ix. 9, 12, 13, 14, 19. [2] *Id.*, ix. 22.

not the visible parts of the mastaba, but the greatly overgrown lining slabs of the serdab." [1]

The Third Dynasty opens with Zoser, one of the most remarkable kings of Egypt. His accession to the throne marks the rise of Memphis, which was his capital.[2] In his reign appears the first pyramid. " Until his reign the royal tombs were built of sun-dried bricks, only containing in one instance a granite floor, and in another a chamber of limestone." Zoser built a brick mastaba in which the passage into the burial chamber was closed by five portcullis stones. " In all probability Zoser himself never used this tomb, built so near those of his ancestors ; but assisted by Imhotep (one of his advisers) undertook the construction of a mausoleum on a more ambitious plan than any of his ancestors had ever attempted. In the desert behind Memphis he laid out a tomb, very much like that at Bet Khallaf, but the mastaba was now built of stone ; it was nearly 38 ft. high, some 227 ft. wide, and an uncertain amount longer from north to south. As his reign continued he enlarged it upon the ground, and increased its height also, building five rectangular additions superimposed upon its top, each smaller than its predecessor. The result was a terraced structure, 195 ft. high, in six stages, the whole roughly resembling a pyramid. It is often called the ' terraced pyramid,' and does indeed constitute the transitional form between the flat-topped rectangular superstructure or mastaba first built by Zoser at Bet Khallaf and the pyramid of his successors, which immediately followed. It is the first large structure of stone known in history." [3]

The great Pyramid Age has now set in. The last king of the Third Dynasty, Snefru, made a pyramid at Medum, between Memphis and the Fayum. It began with a limestone mastaba with the tomb beneath it. The builder " enlarged it seven times to a terraced structure," and filled in the steps from top to bottom so as to produce the smooth slope of the later pyramids. From the time of Snefru onward the power of the state waxed, and this development went on until the beginning of the Fifth Dynasty, when signs of decay set in. The Fourth Dynasty, during which pyramid-building reached its zenith, was founded by Khufu, or Khnum-Khufu, a noble from the neighbourhood of Beni-Hasan.[4] " It has now become the chief project of the state to furnish a vast, impenetrable and indestructible resting-place for the body of the king, who concentrated upon this enterprise the greatest resources of wealth, skill and labour at his command. How strong and effective must have been the organization of Khufu's government we appreciate in some measure when we learn that his pyramid contains some two million three hundred

[1] *Id.*, 42–3. His contentions are fully borne out by Professor Seligman, who mentions (ii.) several localities in Egypt and the Sudan possessing dolmens.
[2] Breasted v. 111 e.s. [3] *Id.*, 113–14. [4] *Id.*, v. 116.

thousand blocks, each weighing on the average two and a half tons. The mere organization of labour involved in the quarrying, transportation and proper assembly of this vast mass of material is a task which in itself must have severely taxed the public offices." [1] It is significant that this tremendous work was accomplished in a kingdom where the whole of the power was in the hands of a single man. " It will be evident that all the resources of the nation were completely at his disposal and under his control ; his eldest son, as was customary in the Fourth Dynasty, was vizier and chief judge ; while the two ' treasurers of the God ' who were in charge of the work in the quarries were undoubtedly also sons of the king, as we have seen. The most powerful offices were kept within the circle of the royal house, and thus a great state was swayed at the monarch's slightest wish, and for many years held to its chief task, the creation of his tomb." [2]

At this point the king stood at the summit of human power, a condition of affairs the like of which the world has not since seen. It is a striking commentary on mankind that all this man could do with his power was to concentrate on the building of a tomb that should help him to immortality. The colossal folly of the building of pyramids is typical of man's desire for his own preservation, and also of the ruthlessness with which he will encompass that desire if only he possess the power.

Thus from the simple pre-dynastic grave there developed, along with the growing wealth of Egypt and the increasing power of the kingship, the pyramid, a monument of stone that is a witness of the futility of selfish human aspiration. The pyramid of stone was therefore the result of a long period of development ; the first example was in all probability a variation of the mastaba tomb, due to Zoser, who, by setting one mastaba on another, produced the embryonic pyramid. Further, the use of stone for building was not begun in Egypt until a comparatively late date, the Third Dynasty marking the real beginning of this practice. It is obvious, therefore, that the mere presence of stone in any place does not constitute any reason why it should be used for construction. On the contrary, the practice probably resulted from the making of tombs in the rock, which may have suggested the idea of cutting slabs of stone for other purposes. The sequence of ideas provides a logical transition from brick to stone by way of the rock-cut tomb.

The assembling of the archaic civilization has thus advanced : the use of stone, the building of pyramids, and possibly the building of dolmens and stone circles, have been added to the complex. Evidently the causes giving rise to the pyramid were entirely different from those that produced the dual kingship, the dual grouping of the people, and the hostilities between Set and Horus and Upper and Lower Egypt. The development of the stone pyramid and the stone mastaba depended upon the invention of

[1] Breasted v. 117. [2] *Id.,* v. 119.

the copper chisel, and the use of stone for construction probably arose as the result of the systematic cutting out of stone in the process of making rock-cut tombs.

What were the real causes that led to the transformation from mastaba tombs to pyramids? According to Elliot Smith: " The pyramid itself may be regarded as a divergent development of the First Dynasty grave, in which the sloping passage on the northern aspect is retained (the great development of the temple on the river side prevented the retention of the stairway or incline of the Proto-Dynastic grave in the alternative—i.e. eastern side— as well as the many chambers in the subterranean grave). The pyramid itself is a monstrously overgrown but elaborately built cairn." [1]

The pyramid differed in another respect from the mastaba; in that the set of dwelling-rooms for the dead, that were included in the mastaba, were, in the case of the pyramid, removed to a temple outside the tomb itself. The pyramid thus was a funerary monument surrounding a small chamber containing the coffin.

The point to be explained is how and why it came about that the kings of Egypt gave up the habit of building mastabas, and made pyramids instead, while the rest of the ruling class went on using mastaba tombs. Such divergences cannot simply be ascribed to chance. A new idea has a history that serves to account for its genesis. It may be true, as is asserted, that the act of placing one mastaba on another led to the idea of the pyramid, but it is not wise to rely on such methods of surmise; for the pyramid is more than a modification of the mastaba; it signifies the coming of new ideas into Egyptian religious thought. The texts in the mastaba tombs are concerned with the old gods of Egypt, such as Anubis, Osiris, Hathor, and Ptah. The texts found in the pyramids of the Fifth and Sixth Dynasties, on the other hand, are full of solar theology. What is the origin of the solar theology that seems to emerge with the building of pyramids? The answer to this question reveals one of the most important events in the history of the world. The sun-cult became the state cult at the beginning of the Fifth Dynasty.[2] In this same dynasty the kings for the first time called themselves the *Children of the Sun*; and this marks the entrance of the actors who were destined to play so important a part in the drama of the archaic civilization. At this moment the archaic civilization assumes its typical shape, and henceforth, in Egypt, the Children of the Sun dominate the situation.

Before the sun-cult became the state cult, it was established in Heliopolis, where, as I hope to show, it originated. But, although the sun-cult did not become prominent until the Fifth Dynasty, there are signs of the influence of the solar theology before the construction of pyramids. Some of the kings of the Second, Third and Fourth Dynasties called themselves by names com-

[1] Elliot Smith ix. 30-1. [2] Breasted ii.

pounded of Re : Reneb was a king of the Second Dynasty ; the third and fifth kings of the Third Dynasty were Nebkere and Neferkere ; and in the Fourth Dynasty the second, third and fourth kings were Dedefre, Khafre and Menkure.[1] The inclusion of Re in the royal name points unmistakably to the influence of Heliopolis, the home of the sun-cult, which influence was destined ultimately to cause the transference of the ruling power from Memphis, the capital of the first four dynasties, to Heliopolis, the home of the Children of the Sun, who appeared at the beginning of the Fifth Dynasty. The early ruling families had been associated, by virtue of their relationship to Osiris, with the moon, and no signs exist of any connexion with the sun apart from the use of Re in the early dynasties. The problem, therefore, is to account for the elaboration of a sun-cult at Heliopolis. Men do not naturally elaborate sun-cults ; rather do they ignore them, as was seen throughout the region.

One reason for the unique position of Heliopolis is to be found, I am convinced, in the fact that it is the home of the Sothic or solar calendar. " The most important cultural achievement which dates from the old Lower Egyptian kingdom, which at the same time confirms our previous results and fixes them chronologically, is the calendar. That the Egyptians originally reckoned time in months varying from twenty-nine to thirty days cannot be doubted, the influence of which has been preserved in the celebration of lunar festivals and in the word for month, ebot, for a sub-division of the year. For an agricultural people the succession of the seasons was a matter of importance. In the case of the Egyptians it was of supreme importance that the date of the Nile rising should be known, for the whole of their agricultural operations depended upon this event. Apparently the difficulties and confusions attending the use of the lunar calendar led some one in Egypt to invent a calendar based on the date of the rising of Sirius. Thus came the great stride forward, that of abandoning the consideration of the moon altogether with regard to the calendar, and of proceeding to a pure solar year, or perhaps one ought to say more correctly, to an agricultural year of uniform length."[2]

[1] Appended is a list of the chief kings of the Third to Sixth Dynasties for the convenience of the reader :—

Third.	Fourth.	Fifth.	Sixth.
Zoser I	Khufu	Userkaf	Teti
Zoser II	Dedefre	Sahure	Userkere
(Teti I)	Khafre	Neferirkere	Pepi I
Nebkere	Menkure	Shepseskere	Mernere I
Sezes	Shepseskaf	Khaneferre or Isi	Pepi II
Neferkere		Nuserre	Mernere II
Hu		Menkuhor	
Cha-ba		Dedkere-Isesi	
Ka-hor		Unis	
Sneferu			

[2] E. Meyer iii. 98–9.

This great step forward was taken at Heliopolis ; and in time the use of the new form of calendar was adopted throughout Egypt. " Of course we must not assume that the new calendar was accepted immediately throughout the whole country, but it will have been first of all introduced in one principality and thence, partly owing to political events and partly owing to its eminent advantages, it will have spread throughout the whole of Egypt. But there is one fact of particular importance which also adds considerably to our historical knowledge, and that is the date of the rising of (Sirius) on the 19th of July, which shows that the home of the calendar is to be sought in Lower Egypt in the territory of Heliopolis and Memphis. The monuments of the most ancient period which exist in such abundance in Upper Egypt fail us completely as regards these territories, up to the present, at least, in spite of the great importance of Heliopolis and of the Delta. By the calendar, however, Lower Egypt set up a monument which, as even we can see, makes it, even in early times, equal, even superior, to the centres of culture of Upper Egypt at Hieraconpolis and Abydos." [1]

The height of the Nile is determined by Nilometers. Such monuments are mentioned in the First Dynasty. The oldest Nilometer was at Rodah, the old capital of the Heliopolitan nome ; and thence were derived the other Nilometers of Egypt.[2] Thus for yet another reason it is probable that the calendar was invented at Heliopolis.

If the priests of Heliopolis were the inventors of the calendar based on Sirius, if also they were the inventors of the Nilometer, they would evidently stand high in Egypt. The invention of a calendar of such a kind is a tremendous achievement, and the Heliopolitans were entitled to their share of influence in Egyptian affairs, since they gave to mankind one of its greatest possessions.

The power of the solar ideas that manifested itself in the early dynasties by the inclusion of Re in royal names, may rest on a still broader basis. As was pointed out at the end of Chapter XV, the custom of offering a subject in place of the king himself appears to be connected with Re, the sun-god, for it is in the tale of the Destruction of Mankind that this incident first appears. If the Heliopolitans had thought out a way for the king to escape his fate, their power would be immensely strengthened, and I suggest that they were responsible for this great mental feat.

What were the consequences of the introduction of the new form of calendar ? The priests of Heliopolis must constantly have been engaged in making astronomical observations in connexion with it ; corrections have to be made, and predictions verified. The practical identity of the Sothic and the Solar year must have been observed by the Heliopolitans at an early date ; and it is possible that this led these men to make observations with regard to the sun. This would explain the presence of

[1] E. Meyer i. 41. [2] Borchardt i. 41.

obelisks at Heliopolis, the city of the sun-cult. The obelisk, casting as it does a sharp shadow, is an ideal instrument for observing the altitude of the sun, and this in all probability was the end for which it was designed.[1] This preoccupation with the observations of the sun's movements I take to be one of the prime causes of the elaboration of the sun-cult by the priests of Heliopolis. Probably another important factor in the situation was the existence of a definite moon-cult in connexion with the royal family ; for Hathor, Osiris and Isis were definitely connected with the moon. Indeed the most common feature of mother goddesses was their connexion with the moon. I shall have more to say later on that point : at the present it is enough to note that the existence of ideas connected with the moon may have led the Heliopolitan priests towards the elaboration of a sun-cult. The moon, the central element of the former calendar, was closely connected with deities ; it is significant, therefore, that the sun should become the centre of a new theological system. It is fair to argue that the preoccupation with the calendar gave the direction to the new ideas, while the existence of a lunar theology helped to give them their expression.

The sun-god born of Heliopolitan speculation was closely connected with the irrigating activities of Egypt. Re himself was born of the primeval ocean, Nun, or from an egg made by Ptah or Khnum, that came out of the primeval ocean. Moreover, the birthday of Re was the day of the Nile flood, the New Year's Day of the Egyptian calendar.[2] Re therefore is a product of composition, for he is expressed in terms of ideas and practices already in existence in Egypt. Khnum and Ptah were old gods ; the primeval ocean was evidently the Nile flood ; and the fact that the birthday of Re was the New Year's Day suggests that he was invented after the inauguration of the new calendar.

It can easily be explained why, although the influence of the Heliopolitans was at work behind the scene in royal circles, the solar cult was not the state cult before the Fifth Dynasty. The evidence gathered from other parts of the region shows that the chief criterion of the existence of the sun-cult in any community is the existence of the Children of the Sun. In Egypt, in the days before the Fifth Dynasty, the sun-god was evidently an abstraction, a being with no real connexion with the earth. If, as seems certain, cults of deities are ancestor cults, it follows that such a deity could not receive a cult until he became the ancestor of kings.

This was the situation with which the Heliopolitan priests were faced. Their power was growing ; their ideas had been accepted by the kings ; but the relationship between the king and Re, the sun-god, would have to be made definite before any real advance was possible. Re was no natural father of a king, as was Osiris,

[1] Breasted claims that the pyramid was an imitation of the top stone of the obelisk, which seems probable.
[2] E. Meyer iii. I. 2 § 197 ; ii. 14.

so he had to be made into a father. Obviously the ordinary method was impossible ; but the priests of Heliopolis were equal to the occasion, for they elaborated a fiction that places them on a pinnacle among mankind : they made Re into the actual father of the king.

The story runs that Khufu, the first king of the Fourth Dynasty, " was enjoying an idle hour with his sons, while they narrated wonders wrought by the great wise men of old. When thereupon Prince Harzozef told the king that there still lived a magician able to do marvels of the same kind, the Pharaoh sent the prince to fetch the wise man. The latter, after he had offered some examples of his remarkable powers, reluctantly told the king, in response to questions, that the three children soon to be born of the wife of a certain priest of Re were begotten of Re himself, and that they should all become kings of Egypt. . . . In this folk-tale we have what is now the state fiction ; every Pharaoh is the bodily son of the sun-god, a belief which was thereafter maintained throughout the history of Egypt." [1] The title first appears in the case of the eighth king of the Fifth Dynasty, which is the first known mention of the Children of the Sun.[2]

The claim to physical fatherhood on the part of the sun-god will bear examination, for it serves to show how the idea was probably built up by the Heliopolitan priests.

The first complete text dealing with the act of birth of a new sovereign is that concerning Hatshepset, the sister or aunt, and probably wife, of Thutmose III of the Eighteenth Dynasty.[3] Her father was, according to the inscriptions, Amon-Re, the god of Thebes.

In the Texts it is said that the god himself takes on the form of the king and visits the queen in her apartments. He has an interview with Thoth, and announces his intention of becoming the father of Hatshepset. The first part of the text implies that he is the father of the queen by the ordinary sexual act. Then, it is said, Amon-Re calls in the aid of Khnum. The text runs :

Instructions of Amon

Utterance of Amon, presider over Karnak : " Go, to make her, together with her ka, from these limbs which are in me ; go, to fashion her better than all gods ; (shape for me) this my daughter, whom I have begotten. I have given to her all life and satisfaction, all stability, all joy of heart from me, all offerings, and all bread, like Re, for ever."

Reply of Khnum

" I will form this (thy) daughter (Makare) (Hatshepset), life, prosperity and health ; offerings . . . love for all good things. Her form shall be more exalted than the gods, in her great dignity of king of Upper and Lower Egypt.

[1] Breasted v. 123. [2] Cf. Petrie i. I. 69 e.s. [3] Breasted ii. II. 87 e.s.

V. Khnum Fashions the Child

Scene

Khnum is seated before a potter's wheel, upon which he is fashioning two male children, the first being Hatshepset, and the second her ka. The frog-headed goddess Heket, kneeling, on the right, extends the symbol of life to the two children.

Inscription

Khnum repeats the instructions he has received from Amon, putting them down in the first person.

Utterance of Khnum, the potter, lord of Hirur : " I have come to thee (fem.), to fashion thee better than all gods. I have given to thee (fem.) all life and satisfaction, all stability, all joy of heart with me ; I have given to thee (fem.) all health, all lands ; I have given to thee (fem.) all offerings, all food ; I have given to thee (fem.) to appear upon the throne of Horus like Re, for ever ; I have given to thee (fem.) to be before the Kas of all the living, while thou (fem.) shinest as king of Upper and Lower Egypt, of South and North, according as thy (fem.) father who loves thee (fem.) has commanded."

The interest of this account lies, of course, in the part played by Khnum. He was the potter god, and obviously in the Eighteenth Dynasty was credited with powers of creating human beings on his potter's wheel. It would be important to discover when Khnum was first credited with these powers. In the Westcar Papyrus it is said that Khnum gives health to a child already born, and no mention is made of the manufacture of the embryo. Apparently, in such a case, the god Re is the actual father of the child by his own powers. If so, the conception of Khnum as a creator must have been introduced into the story at a later date.

It would be interesting to determine how Khnum came to be the fashioner of the child in its mother. The idea seems to be old ; for it can hardly be thought that, once the notion had arisen of Re as a creator by virtue of his own power, an idea which deputes the power to another could have originated. It is easier to think that the Heliopolitans adopted wholesale a view already existing, or else that these men gave a peculiar twist to current thought and induced the belief that Khnum could actually make a child.

Khnum belongs to an early and obscure period of human thought on the subject of creation. He corresponds to Enki of Eridu. Both were ram-headed, and both controlled the waters of irrigation ; both were creators ; Enki made out of potter's earth the chief gods of the Sumerian guilds of carpenters, jewellers

[1] I owe this information to Prof. Peet.

[2] The bearing of this question on the problem of the origin of totemism is obvious.

and so forth; he also created towns and ruled over the first race of men.[1] It is important to note that the first men created by Enki were animated by means of blood mixed with clay. The blood was that of members of the earlier race that he had destroyed by the flood. If the evidence with regard to Enki be taken as witness to the manner of early thought, it seems that the idea of creation by the potter's wheel is not the first. It may thus be that the notion of creation in this later way was the result of the thought of the Heliopolitans. It is natural for them to use the idea of Khnum as a creator for the son of Re, since Khnum made the egg out of which Re himself emerged.

Probably the notion that Khnum made the child was an early Egyptian belief that became incorporated in the doctrine of theogamy as put forward by the Heliopolitan priesthood. Whether the Heliopolitans originated this thought, or whether they used, in later accounts, ideas that were current in Egypt, seems uncertain. Whatever be the upshot, the claim to the divine birth of the king was a stroke of genius. It evidently was the means whereby the Heliopolitan priests managed to gain power. They had solved the great problem that lay before them. They had established a connexion between the king and the sun-god, which was absolutely essential if the sun-cult was to become the state religion of Egypt. Once direct filiation was established the rest was easy.

A fraternity that elaborated the calendar of Egypt was capable of this piece of reasoning, and scored thereby one of the greatest triumphs of history; these Heliopolitans provided ruling families with a trump card that served them for thousands of years. The doctrine of theogamy is the lynch-pin of the group of ideas centring round the early kingship; by means of it kings reached a far greater height than they previously had attained, and all over the world the Children of the Sun have been accepted as divine kings, far removed from ordinary mortals, by virtue of their tremendous claim to divine parentage.

The story of the rise of the power of the Heliopolitan priesthood suggests an explanation of the origin of ruling classes. Elliot Smith was the first to call attention to the close connexion between the earliest kings and irrigation : " One of the earliest pictures of an Egyptian king represents him using the hoe to inaugurate the making of an irrigation-canal. This was the typical act of benevolence on the part of a wise ruler. It is not unlikely that the earliest organization of a community, under a definite leader, may have been due to the need for some system-atized control of irrigation. In any case the earliest rulers of Egypt and Sumer were essentially the controllers and regulators of the water supply and as such the givers of fertility and pros-perity." Again : " It is no mere coincidence that the ' god ' should have been a dead king, Osiris, nor that he controlled the

[1] Langdon v. 29, 58, 60.

waters of irrigation and was especially interested in agriculture." [1]
All the evidence goes to support the contention of Elliot Smith,
that the earliest kings and gods were intimately associated with
irrigation.

What was the manner of association between the ruling family
of Egypt and the irrigation system ? According to Cherry the
Egyptians began their irrigation by digging small channels to
help the water to reach fresh places. In course of time this
system became more complicated, and thus needed organization ;
but it is hard to see how any ruling family could have developed
on such lines. The evidence with regard to village and clan
councils shows that the existence of a ruling group is not at all
necessary for the proper maintenance of an irrigation system.
The Bontoc of Luzon in the Philippines, the Mundas of Chota
Nagpur, and many other irrigating peoples of the present day,
maintain vast and complicated systems of terraced irrigation
solely by means of village councils, which decide the allotment of
water to each field. Indeed, the necessity for the maintenance
of irrigation systems may have led to the foundation of village
councils ; but it is certainly hard, if not impossible, to conceive
how the continuously developing process of elaboration of irri-
gation systems in Egypt could have led one group to have raised
itself above the others, and to have maintained that position
without challenge for so many centuries. The explanation surely
cannot lie in that direction.

The rise to power of the Heliopolitan kings suggests the means
whereby the first kings of Egypt gained their position. The
first step taken by the Heliopolitan priests towards their ultimate
goal was the elaboration of the Sothic Calendar, and with that
source of power they were ultimately able to dominate Egypt.
When the ruling power that they dispossessed is considered, it
is evident that this ruling group may have owed its position to a
similar process, namely the invention of the lunar calendar. The
early kings, and the great mother goddess Hathor, were closely
connected with the moon. If it be assumed that some genius
began to calculate, by means of the phases of the moon, the date
of the next flood time, then the rise to power of a ruling group is
explained. This man would be in possession of knowledge of
inestimable value for the community as a whole, which would
place him on a pedestal. The benefits that he and his descendants
would confer on the community would be of the same order as
those that gave Heliopolis its power ; namely, the means of pre-
dicting the seed time.

How the connexion between the ruling group and the great
mother goddess and the moon came into existence does not enter
into this question. It may be that the great mother had become
connected with the moon, for reasons stated by Elliot Smith ;
or it may be that the institution of the lunar calendar gave the

[1] Elliot Smith xx. 29–30. Cf. Boylan 23, n. 4.

ideas that led to the elaboration of the lunar theology. But what seems to have given the ruling family its original power was the elaboration of the lunar calendar, and the retention by that group of the necessary knowledge that enabled them to predict the date of the flood. Along such lines as these the origin and persistence of ruling groups is easy to understand.[1]

The Heliopolitans, by their accession to power in the Fifth Dynasty, brought about a bisection in the ruling power that must be explained. The older ruling group was, in the beginning, connected with the moon, while the Heliopolitans were connected with the sun. All the evidence, moreover, points to the latter as the inventors of the idea of a world in the sky. Re himself, when old, was lifted up on the back of the Great Cow in the form of the Mother Goddess, Nut, and there he made the sky-world for the gods. A remarkable passage in the Pyramid Texts suggests that the Heliopolitans themselves in the Sixth Dynasty were well aware that the sky-world was entirely of their invention, for they speak of " one of the great bodies of gods formerly born at Heliopolis, who were subject to no king, who were ruled by no prince . . . when neither the sky nor the earth yet existed." [2] Although this text states that the earth did not exist, and thus tends to diminish the value of the statement about the sky ; yet it does seem that the Heliopolitans recognized a time when the sky-world itself did not exist, when the gods lived only at Heliopolis. This is entirely in harmony with the native traditions recorded in "The Megalithic Culture of Indonesia," to the effect that in a bygone time the sky-world had not yet come into existence.[3] The elaboration of the cult associated with the sky at Heliopolis can constitute a fixed point in human history from which to date all ideas concerning the sky-world. All through the region it is evident that ideas concerning the sky have not persisted ; they have tended to disappear together with the Children of the Sun. It is entirely fitting that these ideas should have been elaborated in the place where the Children of the Sun originated.

An examination of the literature and the monuments suggests that the land of the dead was formerly not in the sky. "It is not improbable that the history of the early sequence of these

[1] This important topic requires investigation throughout the region. It would seem that the knowledge of the determination of the time for planting has been preserved by the ruling groups. For instance, Kruyt, in his MSS. on Sumba states that throughout the island one man looks after the regulation of agriculture. In Central and East Sumba this is always the ratœ, or priest. In the west part of the island the office seems to be sometimes held by men other than the ratœ. "When I asked what showed that the time was come for the beginning of operations, the answer usually was : We watch for the first rains." It is only the ratœ who has the knowledge of the movements of the stars, and he keeps it to himself. This knowledge certainly constitutes a source of strength to this class. A wide survey of the practices connected with the determination of the date for the beginning of agriculture is necessary in order to establish the truth of my contention.

[2] Moret i. 7, n. 1. [3] Perry vii. 167 e.s.

beliefs was thus : we should begin with a primitive belief in a subterranean kingdom of the dead which claimed all men. As an exclusive privilege of kings at first, and then of the great and noble, the glorious celestial hereafter . . . finally emerged as a solar kingdom of the dead." [1] Again, according to Moret, in the Memphis period (Third Dynasty onwards) it was certainly believed that the soul lived in the tomb or did not go outside its precincts.[2] Breasted says : " The early belief that the dead live in or at the tomb, which must therefore be equipped to furnish his necessities in the hereafter, was one from which the Egyptian never escaped entirely, not even at the present day. . . . The common people doubtless still thought of their dead either as dwelling in the tomb or at best as inhabiting the gloomy realm of the west, the subterranean kingdom ruled over by the old mortuary gods eventually led by Osiris. But for the great of the earth, the king and his nobles at least, a happier destiny had now dawned. They might dwell at will with the sun-god in his glorious celestial kingdom. In the royal tomb we henceforth discern the emergence of this solar hereafter." [3]

The Pyramid Texts show clearly the bisection of the community produced by the elaboration of the solar theology and the accession to power of the Children of the Sun. They contain no mention of the old land of the dead. The king goes to the sky : " He has freed King Teti from Kherti, he has not given him over to Osiris." Horus " puts not this Pepi over the dead, he puts him among the gods, he being divine." [4] In these texts Osiris and his cycle of deities are even said to be hostile, ceremonies being performed to keep them from the pyramid tomb of the king.

Even when pyramid-building was in full swing, the nobles continued to be buried in mastaba tombs, which contain no trace whatever of a solar cult. This means that the old ideas connected with Osiris still persisted among the nobles, although the royal family had introduced the solar theology. The land of the dead associated with the older ruling groups was either underground or else on the horizon : in later times it certainly was underground. Thus the ruling group possessed two entirely different theologies, and had distinct homes after death. The king went to the sky, where he was separated from his subjects : the nobles went to the land of the dead, where they would find all their subjects, to the old world ruled over by Osiris, who had ruled over the dead from time immemorial. Thus was produced, in Egypt, by the coming to power of the Heliopolitan family, the bisection of the community that was noted from one end of the region to the other.

To turn now to another problem connected with the assembling of the archaic civilization.[5] Although the evidence

[1] Breasted iv. 141. [2] Moret iv. 85.
[3] Breasted iv. 51, 69. [4] Id., iv. 99, 143.
[5] The data on which the following discussion of the Viziers of the Pyramid

regarding the political events of the days following the rise to power of the Children of the Sun is scanty, yet enough is known to show that it caused a dislocation of the state machinery, and led finally to internal convulsions from which Egypt never really recovered. As the result of the accession to power of the Heliopolitans, the ruling function, formerly in the hands of the family of the king, was divided : the Heliopolitan family supplied the sacred king, who theoretically was the head of the State, and the administrative power was in the hands of other families. In order to understand the formation of the archaic civilization it is necessary to determine as closely as possible the conditions under which this change took place.

In the Fourth Dynasty the ruling power was fixed at Memphis. The king was supreme, and was assisted in the government by his heir, who acted as vizier, and controlled for his father the administration of the State. " The century and a half during which the Fourth Dynasty maintained its power was a period of unprecedented splendour in the history of the Nile valley people, and, as we have seen, the monuments of that time were on a scale of grandeur which was never later eclipsed." [1] The royal family held all power in their hands. They even controlled Heliopolis ; for some of the high priests of Heliopolis in this dynasty are known by name : Merib, son of Khufu ; [2] Kanefer, son of Sneferu ; [3] and Rehotep, who was the son of a king. [4] These men were very closely connected with the royal power, for they bore the title of " king's son of his body." They married women called " royal acquaintances," who were thus probably of the royal family, and their children were also " royal acquaintances." The viziers were also in this dynasty " king's sons," married " royal acquaintances," and had children called " royal acquaintances." The vizier and the high priest of Heliopolis were members of the royal family : Kanefer held both offices. One high priest of Memphis of this dynasty is known, Renefer, of the reign of Sneferu or Khufu. [5] His name suggests Heliopolitan influence.

It seems impossible at present to understand the nature of the events that established the sun-cult as the state religion of Egypt. The royal family of the Fourth Dynasty evidently had complete control over the State, and supplied the high priest of Heliopolis. The actual transition may have come about because of an intrigue among the priests attached to Heliopolis, the result of which was the overthrow of the royal high priest. The story of theogamy

Age is based have been supplied by Miss W. M. Crompton, Keeper of Egyptian Antiquities of the Manchester Museum, to whom I express my obligations. The bulk of the facts have been derived from original sources, so are probably free from serious error. Although Miss Crompton has provided the material, the conclusions are mine, and I accept full responsibility for them. See also Weil and Murray v.

[1] Breasted v. 121.　　　　　　　　[2] Lepsius II. 18–22.
[3] Hieroglyphic Texts I. Pl. 4.　　　[4] Petrie v. 37.
[5] Petrie v. : Mariette i. 125.

29

may have supplied the means whereby the conspirators incited the others to action. This, however, is a dark place in Egyptian history, and it seems too much to hope that it will ever be illuminated.

It is fairly obvious that some of the princes and high officials of the dispossessed dynasty reconciled themselves to the change. Thus Ptahshepses, brought up with the children of King Menkure, and married to the oldest daughter of King Shepseskaf, last king of the Fourth Dynasty, received, or apparently continued to hold, during the new regime, the High Priesthood of Memphis, and lived to add to his titles that of priest of the solar temple of Neuserre, seventh king of the Fifth Dynasty. This man, husband of the eldest daughter of a king, might have claimed the throne. Again Sekhemkere, son of a Fourth Dynasty king, and a vizier, is recorded in his tomb to have been " worthy before " Kings Khafre and succeeding kings up to Sahure, second king of the Fifth Dynasty.[1] Whether or no Prince Sekhemkere acted as vizier after the deposition of the royal house to which he belonged, it is certain that with the succeeding viziers comes a complete change in the situation. They are no longer king's sons, and they usually bear names compounded with Ptah, as is shown by the list :—

VIZIERS OF THE FIFTH DYNASTY

Vizier.	Chief Titles.	Wife's Titles.	Reign.
Sekhemkere[2] . .	King's eldest son	Royal acquaintance	Khafre to Sahure
Ptahhetep[3]. . .	Not royal . .	Not known . .	?
Ptahhetepdesher } [4] Ptahhetep	Erpa, Ha . .	,, ,, . .	?
Ptahhetepdesher[5].	—	,, ,, . .	?
Ptahwesh[6] . . .	Not royal, Ha .	,, ,, . .	Neferirkere
Pahniwka[7] . ,	,, ,, ,, .	No titles . . .	Neferirkere, or later
Ptahshepses[8] . .	,, ,, ,, .	King's daughter .	Neuserre
Minnefer[9] . . .	—	Not known . .	,,
Ptahhetep[10] . .	Not royal . .	,, ,, . .	Dedkere-Isesi
Ikhethetep [11] .	Not royal, Ha .	,, ,, . .	,, ,,
Senezemib Inti [12] .	Erpa, Ha . .	Royal acquaintance	,, ,,

[1] Mariette C. 1 ; H. 14.
[2] Lepsius II. 41–2.
[3] Id., II. 101–4. Weil places this and the next three viziers after Minnefer, in order to bring together all those of the same name, but Davies (i. II. 21) assigns some to the earlier date.
[4] Mariette i. C. 6, 7 : Murray vi. I. Pl. 6 (Double Tomb).
[5] Mariette i. 434. [6] Sethe vii. I. 40–5 : Mariette i. D. 38.
[7] Lepsius II. 45–8. Two of his sons have names compounded with Ptah.
[8] Borchardt ii. 31, 127–8, 144–5. [9] Id., 74.
[10] Mariette i. D. 62 : Murray vi. I. 8–18.
[11] Mariette i. D. 64 : Davies i. 21.
[12] Lepsius II. 76–8 : Mariette i. I. 2.

Vizier.	Chief Titles.	Wife's Titles.	Reign.
Senezemib Mehi [1]	Erpa, Ha . .	King's Daughter .	Unas
Tepemankh [2] . .	Ha	No titles . . .	Unas, or later
Henku [3] . . .	Erpa, Ha . .	Royal acquaintance	?
Rehem Isi [4] . .	,, . .	,, ,,	?

Probably the viziers with Ptah names belonged to a Memphite family, for Ptah was god of Memphis. Ptahshepses was son-in-law to King Neuserre, but the wives of the others are not mentioned. Such names continue until the time of the eighth king of the dynasty, Dedkere-Isesi, the first king known to have borne the title of " Son of the Sun," [5] but the exception of Ptahshepses, who married a king's daughter, prevents the formulation of any generalization as to the absence of evidence of marriage relationships with the royal family. Two viziers late in the dynasty, both named Senezemib, father and son, married—in one case, a " royal acquaintance," and, in the other, a " king's daughter." This suggests a closer connexion between the vizier of the royal family than in the case of most of the early viziers of the period.

During this dynasty the high priests of Heliopolis seem to have been unimportant, for they are unknown. That is natural, for the king himself theoretically filled the office. Throughout the dynasty one of the high priests of Memphis, a position held concurrently by two men, generally bore the name of Ptahshepses : the first was the husband of the eldest daughter of Shepseskaf, the last king of the Fourth Dynasty, and probably held the office in that reign. The high priest of Memphis during the reigns of Unas, the last king of the Fifth Dynasty and Teti of the Sixth Dynasty, married a " royal acquaintance." [6] Thus the high priests of Memphis, although apparently Memphite, since they bear the name of Ptah, are closely connected by marriage with the royal family.

The events of this dynasty are obscure. The sun-cult has become the state religion, but not until the reign of Dedkere-Isesi is the king known on good evidence to have called himself Son of the Sun. [7] Before this king's reign the viziers were presumably Memphites, as, apparently, also were the high priests of Memphis throughout the dynasty. Thus it seems that the ruling power was divided between families of Heliopolis and of Memphis :

[1] Lepsius II. 73–75 : Mariette I. 2.
[2] Mariette i. H. 11 (D. 10a). [3] Davies ii. II. Pll. 22–26.
[4] Davies ii. Pll. xvii–xxi. This and the following may belong to the time of King Isi, predecessor of Neuserre, or they may be placed at the end of the Sixth Dynasty.
[5] In this reign the two titles of " Governor of the South " and " Governor of the King's Palace " first appear (Sethe ii. 48). Do they correspond to the Bruderhauptling of Samoa, or the Tomailaring of South Celebes ? (see pp. 286, 301).
[6] Mariette i. C. 1, 9 ; H. 14 ; E. 1, 2 : Murray vi. I. P. 1, 26, 28, 31.
[7] Burchardt and Pieper 12–14. The evidence for the earlier use of the title depends only on two scarabs.

the Heliopolitan family provided the sacred king; and certain families of Memphis acted as viziers and as high priests of Memphis.

It is important to note that the viziers of the early part of the Fifth Dynasty often lack the hereditary title of erpa, and their wives are seldom mentioned. Sekhemkere, the first vizier, a king's " eldest " son, who married a " royal acquaintance," is an apparent exception, but he carried on from the Fourth Dynasty. The first known high priest of Memphis likewise married a princess, but the others apparently had no high titles.

The case of the early viziers of the Fifth Dynasty is therefore remarkable. Presumably the Heliopolitan family, on gaining power, chose a family of Memphis to act in that capacity. They probably had to compromise with the former administration, and were forced to agree to a division of power. It is hard to understand the apparent lack of titles among the early viziers of this dynasty. But, whatever were the arrangements, it is clear that they did not persist; for the seventh king, Neuserre, had a vizier who married into the royal family.

The situation changed at the end of the Fifth Dynasty. The kings began to call themselves Son of the Sun. Their viziers were of noble blood, having the erpa and ha titles, and this form of designation persisted throughout the Sixth Dynasty.[1] The following table shows the viziers of the Sixth Dynasty:—

VIZIERS OF THE SIXTH DYNASTY

Vizier.	Chief Titles.	Wife's Titles.	Reign.
Neferseshemseshet [2]	King's son	Not known. . .	Last king of V, or early VI
Neferseshemre [3] . .	Erpa, Ha . .	No titles . . .	Teti, or later
Gemnikai [4] . . .	,, ,, . .	King's daughter .	,, ,,
Sesi [5]	Ha . .	Not known . .	Pepi I ?
Zau [6]	Erpa, Ha . .	—	Pepi II
Meri [7]	,, ,, . .	King's daughter .	Pepi II
Teti Meri [8] . . .	King's son .	Royal acquaintance	Pepi II, or later
Idi [9]	—	Not known . .	Pepi II
Pepynekht [10] . .	Erpa, Ha . .	,, ,,	,,
Iuu [11]	,, ,, . .	,, ,,	,,
Thenty [12] . . .	,, ,, . .	,, ,, . . .	Possibly much earlier

[1] Sethe says that, from the time of Senezemib, the viziership was no longer hereditary, but was given at choice. I find it hard to understand the reason for this statement : the two Senezemib were father and son ; as were Meri and Teti Meri ; and Idi was probably brother to Zau.

[2] Mariette i. E. 11.　　　　　[3] Capart ii. II. Pl. VIII e.s.

[4] Bissing Pl. X.　　　　　[5] Mariette i. E. 16. Sethe vii. 94.

[6] Mariette ii. 523 : Sethe vii. I. 117.

[7] de Morgan ii. 523 e.s.

[8] de Morgan ii. 562, 569–70 ; Teti Meri was the son of Meri ; his maternal grandfather was a king.

[9] Mariette ii. 526 : Cairo 1575.　　　[10] Mariette ii. 531 : Cairo 1573.

[11] Mariette ii. 540 : Cairo 1576 : Lepsius Text 176.

[12] Mariette i. C. 18.

Not only are noble titles commoner in the Sixth Dynasty, but two of the viziers, Neferseshemseshet and Teti Meri, held the exalted title of King's Son. The viziers of this dynasty, therefore, appear to be more closely connected with the royal family than most of those of the Fifth Dynasty. When, therefore, the Fourth, Fifth and Sixth Dynasties are compared, a remarkable series of changes become evident. In the Fourth Dynasty the viziers are all king's sons, and one of them seems to carry over into the Fifth Dynasty. Then no apparent royal connexion can be witnessed until the reign of Dedkere-Isesi, a time when the king calls himself " Son of the Sun," and two new offices, those of " Governor of the South " and " Governor of the King's Palace" are first mentioned. Henceforth the royal family and the viziers appear to be closer associated. But it seems certain that, whatever else happened, the old system of the Fourth and preceding dynasties was abandoned, so that the crown prince never acts as vizier. Thus was produced, by some means not yet fully understood, the bisection of the ruling group into two distinct portions, each with separate functions, and this condition persisted in Egypt. We have found that the two sides of the ruling group throughout the archaic civilization appear to have intermarried regularly, which custom has evidently been imposed on the rest of the community, so that exogamy forms a definite part of the dual organization of society. If, as is urged, the dual ruling group originated in Egypt, the practice of intermarriage should also have begun in that country.[1]

With the exception of Sekhemkere at the beginning, who carried on from the Fourth Dynasty, and Ptahshepses, the early viziers of the Fifth Dynasty married women whose titles are unknown. Those viziers had no exalted titles. This is suggestive when it is noted that, when the hereditary erpa title comes again into common use, under Dedkere-Isesi, the Son of the Sun, the viziers' wives at once are mentioned as of high rank. This may be fortuitous. As it stands, the evidence suggests that the earlier viziers did not marry princesses. Whether that be so or not, it is evident that the viziers and the royal family were more closely connected from the time of Dedkere-Isesi onwards. Two daughters of Teti, named Heruatetkhet and Seshseshet, married Meri and Gemnikai ; while a third daughter, also named Seshet, married Neferseshem Ptah, the brother of the vizier Neferseshemre. The son of Meri and Heruatetkhet, named Teti Meri, who was a vizier, married Nebt, a " Royal Acquaintance." Thus the viziers were closely connected by marriage with the royal family in the early part of the Sixth Dynasty, in that they married princesses. On the other hand, one king of this dynasty, and possibly two, married into a family of viziers. For Pepi I, or Meryre as he is also called, married two sisters of Zau, and was by them the

[1] Cf. Elliot Smith's article in Anthropology and Archæology in the supplementary volumes of the "Encyclopædia Britannica" (11th Edition).

father of Mernere I and Pepi II (Neferkere). Zau was vizier for his nephew Pepi II, and one Ibi, probably his son,[1] was " Governor of the South," thus filling an important office, that came into existence with Dedkere-Isesi, the eighth king of the Fifth Dynasty.

It is possible that in another case the king married into the family of a vizier, but the evidence is not certain. The father of Zau, the vizier of Pepi II, and brother of the wives of Pepi I, was named Khui. The wife of King Teti was Khuit,[2] the feminine form of Khui. This suggests that Khui and Khuit were related. If that be so, the family of Zau and the royal family intermarried. The wife of Khui was royal. The conditions thus suggest that the relationships between the royal family and the family of the vizier were precisely similar to those obtaining in such places as Ponape, and the Pelews, in which the ruling group is divided into two intermarrying families.

We can go still farther in the matter; for Zau belonged to Abydos in Upper Egypt, while the king lived at the other end of the country, at Memphis, on the border of Upper and Lower Egypt. The son of Zau was also the Governor of the South, and thus held an office in Upper Egypt. It is consequently claimed that the marriage of Pepi I into a family of Abydos " not improbably had a political end in view " and that " it may have been both custom and policy that the king as king of Upper Egypt should marry an heiress of the south, and vice versa." [3]

The family of Zau is well known. An examination of the marriages contracted by its members suggests that this family constantly married royal princesses. Zau's two sisters, who married Pepi I, were called Pepy-ankhnes or Meryre-ankhnes, names evidently derived from those of their husband.[4] It seems to have been usual in those times for daughters to take the names of their mothers, and sons the names of their fathers ; often the names of grandparents were taken. So when Zau-shmaa, the grandson of Zau, married a woman named Pepy-ankhnes,[5] it sounds as if he were marrying a daughter or granddaughter of the wife of Pepi I. This surmise is strengthened by the fact that Zau-shmaa and Pepy-ankhnes had a daughter named Pepy-ankhnes.[6]

The family tree of Zau provides yet another possible instance of a marriage between the royal family and that of the vizier and other important officials. Aba or Ibi, the son or grandson of Zau, married a woman named Rehem Hemi.[7] Through this marriage he became lord of the Twelfth Nome. He was also " real Governor of the South." Possibly the parents of Rehem Hemi were Rehem-Isi and Rehem. Rehem-Isi evidently had taken the name of his wife, and had come into her property.

[1] Davies ii. I. 30. [2] Gauthier 150.
[3] Davies ii. I. 30. [4] Gauthier 161-2. [5] Davies ii. II. Pl. VI.
[6] Davies ii. II. pl. IX. [7] Davies ii. I. pl. XII.

Rehem-Isi was vizier. Thus two viziers' families, those of Zau and of Rehem-Isi, seem to intermarry with the royal family. The available evidence suggests that a close relationship of inter-marriage existed between the royal family and the families of viziers and " Governors of the South " : and, if it be permissible to generalize on such a scanty basis of fact, these two families formed at that time an intermarrying group similar to those found in Micronesia. The remarks of Davies suggest that the actual stage of affairs was that in which, as a rule, the king married a woman of the vizier's family, and also a royal princess, but the evidence in favour of this is scanty.

From the time of the Fifth Dynasty onwards, therefore, the ruling power in Egypt was bisected ; the royal family carried on the state cult of the sun-god and the king was closely connected with the sky, where he went at death ; the civil administration was carried on by another family. In the Fifth Dynasty this family lived at Memphis, and does not seem to have had any close relationship with the royal family. But in the early Sixth Dynasty the family of the vizier lived at Abydos, and members of that family act as Governors of the South ; while the king lived at Memphis on the border of Upper and Lower Egypt. The conditions thus approximate closer to those of the dual organiza-tion of the Pacific and other parts of the region. In the late Fifth and early Sixth Dynasties the royal family seems constantly to have intermarried with that of the vizier, thus producing a close co-operation and alliance. In this the conditions approach still closer to those of the archaic civilization in Micronesia. But it has been found, in Samoa, that the king probably married women of both sides of the dual grouping. The prevalence of incestuous unions in Egypt suggests that this may have been the case in that country : the king would marry his sister, mother or perhaps daughter, and thus gain possession of the throne ; he, or one of his sons, would also marry a member of the other family : the heads of the vizier's family would marry royal princesses. In that way the royal family and the vizier's family would approxi-mate to the ruling families of the archaic civilization in all parts of the region.

Although the evidence on this point is not yet entirely satis-factory, yet it is possible to see, on a broad survey of the whole situation, that the varieties of the practice of intermarriage between two branches of the ruling group probably had a common origin in one place. For it is probable that, in Egypt, as in the rest of the region, the vizier was not necessarily always a member of a family that intermarried with the royal family. Indeed, it is found, for instance in Indonesia, in the case of certain com-munities ruled over by Mohammedan chiefs, that the vizier is the heir to the throne, and that only the ruling groups most closely connected with the archaic civilization have the vizier chosen from a distinct family, which is closely connected at the same

time with the royal family.[1] In later times, in Polynesia and elsewhere, the office of vizier disappeared. In Egypt, also, the vizier was definitely chosen, in subsequent dynasties, and was not necessarily a member of a family that intermarried with royalty. It is significant that, in Egypt, and elsewhere, only in certain circumstances do the royal family and the family of the vizier or war-chief form an intermarrying group. This close correspondence in circumstances argues strongly for a relationship between these various intermarrying groups, and goes to support the contention that the alliance made in Egypt, probably for purely political ends, survived in the rest of the region for a time, and then disappeared, as in Egypt itself.

Another important process was at work in Egypt as the consequence of the emergence of the Heliopolitan ruling group. The rulers of the nomes, formerly appointed by the king, took the opportunity of making themselves independent, and introduced hereditary succession to their office. The power of the throne was thus undermined, and it is easy to understand that the king was forced to make alliance with his powerful nobles in order to rule the country. This process of consolidation of power in the hands of the nobles of the nomes produced the condition of affairs found in Samoa, where the independent nobles form a council that has great power in the state.

An important question now arises. Is there evidence of a movement from Egypt similar to that which led the people of the archaic civilization across the world ? Although the presence of flint caused the early inhabitants of Egypt to live in the valley of the Nile, there is ample evidence that some sort of intercourse was maintained, even in those early times, with other regions. The presence, in the Grimaldi caves of Mentone in the south of France, of Indian Ocean cowrie shells is proof of wide connexions. Egypt has a peculiarity that makes it unique in the region : it is the only country with no valuable natural products. In being an exception to the rule laid down in Chapter VII, it is peculiarly fitted to be the home of the archaic civilization, and the centre whence it spread. The process of cultural spread was doubtless due to several causes. But since gold has played so important a part in the spread of the archaic civilization, since, moreover, it was probably the first metal used by the Egyptians, it will be well to understand how it came to acquire its value. The origin of the Egyptian appreciation of this metal has been traced by Elliot Smith to superstitions connected with the cowrie shell, which the ancient Egyptians were getting from the Red Sea. He says : " The evidence which has been collected by Mr. J. Wilfrid Jackson seems to suggest that the shell-cults originated in the neighbourhood of the Red Sea.

" With the introduction of the practice of wearing shells on girdles and necklaces and as hair ornaments the time arrived

[1] Berg 35-6.

when people living some distance from the sea experienced difficulty in obtaining these amulets in quantities sufficient to meet their demands. Hence they resorted to the manufacture of imitations of these shells in clay and stone. But at an early period in their history the inhabitants of the deserts between the Nile and the Red Sea (Hathor's special province) discovered that they could make more durable and attractive models of cowries and other shells by using the plastic yellow metal which was lying about in these deserts unused and unappreciated. This practice first gave to the metal gold an arbitrary value which it did not possess before. For the peculiar life-giving attributes of the shells modelled in the yellow metal came to be transferred to the gold itself. No doubt the lightness and especially the beauty of such gold models appealed to the early Egyptians, and were in large measure responsible for the hold gold acquired over mankind. But this was an outcome of the empirical knowledge gained from a practice that originally was inspired purely by cultural and not æsthetic motives. The earliest Egyptian hieroglyphic sign for gold was a picture of a necklace of such amulets ; and this emblem became the determinative of the Great Mother Hathor, not only because she was originally the personification of the life-giving shells, but also because she was the guardian deity both of the Eastern ways where the gold was found and of the Red Sea coasts where the cowries were obtained." [1]

It is probable that Elliot Smith is not correct in all his statements, but this does not matter in the present instance : what is important is his clear and logical explanation of the possible manner in which gold came to acquire an arbitrary value, and subsequently, as he shows, was used as currency. The desire for gold and for cowries must have led men away from Egypt down to the Red Sea, that is to say, on to other geological formations. The enormous extent of Nubian gold-mining activity in ancient times certainly supports this theory.

The development of gold-mining in Nubia in pre-dynastic times may explain a remarkable fact connected with polished stone implements. Although widespread throughout the region, and certainly belonging to the archaic civilization, they are very rare in Egypt. But there is another remarkable fact with regard to them, as is shown by the following statement by Professor Seligman : " I have been unable," he says, " to find any record of their discovery in a tomb group or undisturbed burial in Egypt ; so that considering the number of prehistoric burials that have been examined, it can be said that they were scarcely if at all known in pre-dynastic Egypt. On the other hand, they are common in Nubia, where a number have been found in pre-dynastic and early dynastic tombs." [2]

Egypt was, from very early times, in close connexion with Nubia, so that, if the Nubians had invented the use of polished

[1] Elliot Smith xx. 221-2. [2] Seligman ii.

stone implements, it is hard to understand, especially on the basis of the fashionable theories of " trade " and " barter," how the Egyptians lacked them so completely, especially when it is perfectly well known that, in our own country for instance, such implements are found far from localities possessing basic rocks. But if the case of the bronze and copper chisels of Celebes be borne in mind, if it be remembered that the use of polished stone implements can survive that of metal implements, it is easy to see that people such as the Egyptians, going out into a fresh country, could have imitated their copper chisels in stone ; or else that, finding no flint in Nubia, they began to use the local stone, but did not import them to Egypt, because they preferred their flint and copper implements. Some such explanation as this will account without difficulty for the facts in Egypt and Nubia. It does more than that : it explains, for instance, why the mound-builders made beautiful " Solutrean " blades of flint identical with those of the Egyptians, as well as polished stone implements like those of the rest of the region. Moreover, the pre-dynastic Egyptians knew well how to work diorite and other basic rocks, and therefore were quite capable of manufacturing polished stone implements. The hypothesis that the outward spread of civilization was that of the Egyptians, a people well versed in the manufacture of " Solutrean " blades, who were attracted to geological formations containing basic rocks because they found there gold and other minerals, thus provides a satisfactory explanation of the peculiarities of the use of polished stone implements.[1]

In like manner it is possible to explain the use of obsidian, so common in the Admiralty Islands, New Guinea, Mexico, and North America, as a result of the search in the islands of the Ægean for emery and corundum, which the Egyptians used for working hard stones. [2]

The growing complexity of Egyptian civilization led to expeditions to surrounding lands for desired substances. At the beginning of the Fifth Dynasty the Egyptians were undertaking considerable foreign enterprises. " Sahure, who followed Userkaf (the founder of the Fifth Dynasty), continued the development of Egypt as the earliest known naval power in history. He dispatched a fleet against the Phœnician coast, and a relief just discovered in his pyramid temple at Abusir shows four of the ships with Phœnician captives among the Egyptian sailors. This is the earliest surviving representation of sea-going ships, and the oldest known picture of Semitic Syrians. Another fleet was sent by Sahure to still remoter waters, on a voyage to Punt, as the Egyptians called the Somali coast at the south end of the Red Sea, and along the south side of the Gulf of Aden. From this

[1] I need not stress here the bearing of these facts on the problem of the origin of the so-called " Neolithic " civilization of Europe.
[2] Melos 216 e.s.

region, which like the whole east he termed the ' God's Land,'
he obtained the fragrant gums and resins so much desired for the
incense and ointments indispensable in the life of the oriental.
Voyages to this country may have been made as early as the First
Dynasty, for at that time the Pharaohs already used myrrh in
considerable quantities, although this may have been obtained
in trade with the intermediate tribes who brought it overland
down the Blue Nile, the Atbara and the Upper Nile. In the
Fourth Dynasty a son of Khufu had possessed a Puntite slave,
but Sahure was the first Pharaoh whose records show direct com-
munication with the country of Punt for that purpose. His
expedition brought back 80,000 measures of myrrh, probably
6,000 weight of electrum (gold-silver alloy), besides 2,600 staves of
some costly wood, presumably ebony." [1] King Isesi of the Fifth
Dynasty, the first king known to have used the title of the Son
of the Sun, sent an expedition to Punt. In the Sixth Dynasty
expeditions were being sent to that land. [2] The best account of the
expeditions to Punt is that of the inscriptions of Queen Hatshepsut
of the Eighteenth Dynasty, on the walls of her temple at Deir-el-
Bahri. [3] These inscriptions give details of the venture, and of the
traffic with the natives, and enumerate the treasures that were
acquired. " The loading of the ships very heavily with marvels of
the country of Punt ; all goodly fragrant woods of God's Land,
heaps of myrrh-resin, with fresh myrrh trees, with ebony and
pure ivory, with green gold of Emu, with cinnamon wood, khesyt
wood with ihmut-incense, sonter-incense, eye-cosmetic, with apes,
monkeys, dogs, and with skins of the southern panther, with
natives and their children. Never was brought the like of this
for any king who has been since the beginning." [4]

This list shows that the Egyptians went far to obtain products
also attractive to the people of the archaic civilization throughout
the region. In the peninsula of Sinai they worked copper and
turquoise, the latter of which was so closely connected with Hathor,
the Lady of Turquoise. [5] A name for Punt, " God's Land," shows
the real nature of the search ; the expeditions to that land reveal
the innermost desires of the Egyptian rulers—the need for " Givers
of Life," for magical substances. In thus setting out to procure
the materials for mummification, and for other ritual purposes,
the Egyptians set a process at work that still persists, a process
that has formed the theme for the literature of the ages, the search
for the Isles of the Blest, the earthly Paradise, where eternal
youth, perfect health, and all the desirable things of life are to be
found. [6] Their intense desire for life-giving substances has been
transmitted to native populations in all parts of the earth, who
use objects left behind by the old seekers for Givers of Life in their

[1] Breasted v. 127. [2] *Id.*, I. 351, 360, 361.
[3] *Id.*, II. 246–8. [4] *Id.*, ii. 265.
[5] Like the turquoise mother of the Pueblo Indians.
[6] Meyer and Nutt : Yetts : Perry xi.

magical practice, and thus carry on a process the origin of which
is unknown to them, but the mainsprings of which they themselves
possess, the desire for " Life " in all its manifestations.

The period of the Sixth Dynasty was one in which a great out-
ward movement from Egypt was probable. Breasted remarks
that "The foreign policy of Pepi was more vigorous than that
of any Pharaoh of earlier times. He sent expeditions out to Nubia
and Palestine. When he died his son Mernere retained a great
measure of power. He employed the services of the great family
of nobles who lived at Elephantine, Harkhuf and his relatives,
to maintain order in Nubia and the Sudan, whence Egypt derived
gold, ostrich feathers, ebony logs, panther skins, and ivory." [1] " It
was upon Harkhuf and his relatives, a family of daring and
adventurous nobles, that the Pharaoh now depended as leaders of
the arduous and dangerous expeditions which should intimidate
the barbarians on his frontiers and maintain his prestige and his
trade connexions in the distant regions of the south. These men
are the earliest known explorers of inner Africa and the southern
Red Sea. The responsibility for the development of Egyptian
commerce with the land of Punt and the region of the southern
Red Sea also fell upon the lords of Elephantine. Evidently they
had charge of the whole south from the Red Sea to the Nile." [2]

It has been concluded that Ibi, a " Governor of the South "
in the reign of Pepi II, was probably the son of the vizier, Zau, of
the same king.[3] Zau's sisters married Pepi I, and Zau's son
married a " Royal Acquaintance " named Rahem. This close
relationship between the two groups makes it significant that in
the reign of Mernere, the son of Pepi I, a noble named Harkuf,
who was pushing out into the Sudan and the lands on the south
of the Red Sea, was also a " Governor of the South," and pre-
sumably connected by marriage with the royal family.

To sum up : At the beginning of the Sixth Dynasty in Egypt,
about 2625 B.C.[4] and onwards, the social, political, economic, and
religious features of Egyptian society resembled those of the
archaic civilization in other parts of the region. The kingdom
was based on the dual organization, the ruling power was in the
hands of two families that intermarried, one family being at
Memphis, and the other in the south ; the state religion was the
sun-cult, and the king called himself the Son of the Sun ; he was
mummified after death and buried in a pyramid ; he went to the
sky as a special privilege, while the rest of the community went
underground ; the Egyptians were expert metal-workers ; they
practised irrigation ; they used, in Nubia and the Sudan, polished
stone implements : the cause of their outward expansion was the
search for gold and other substances such as incense, fragrant
woods and other Givers of Life, which led them to southern
Arabia. Presumably members of the ruling families set up

[1] Breasted v. 136. [2] *Id.*, v. 136, 138.
[3] Davies ii. I. 30. [4] Breasted v. 131.

independent kingdoms outside Egypt, say in southern Arabia, Somaliland or Abyssinia, which kingdoms were the forerunners of others still farther afield.

The movement from Arabia to India is natural when it is remembered that trade had been going on round south Arabia since the First Dynasty, about 3300 B.C. This trade was flourishing in the time of the Romans. Men who went down in ships to the land of Punt would be certain to try their fortunes farther afield ; for they were driven on by one of the strongest desires that have possessed men. Moreover, the fact that the boats of India and the East are often exact reproductions of Egyptian boats of the Sixth and succeeding dynasties, is further strong evidence, as Elliot Smith has insisted, of the preponderating influence of Egypt on early navigation in all parts of the world.[1]

The hypothesis of an early movement out from Egypt, which resulted in the translation of the civilization of the Sixth Dynasty to the uttermost parts of the earth, will gain enormously in strength if it can be shown that a community with the culture of the archaic civilization has actually been in close contact with Egypt. I do not propose to discuss this matter at any length here, as I dealt with it briefly at the end of the last chapter, where it is mentioned that the Phœnicians probably supply a close link between Egypt and the external world, and that their culture possesses the fundamental traits of the archaic civilization, including the dual organization. In every respect they satisfy the necessary conditions postulated as determining the spread of the archaic civilization ; their close interrelationship with Egypt is well known ; so for these reasons it is possible to claim that an outward movement from Egypt is an established fact, and that what happened in the case of the Phœnicians certainly must have happened before their time. Moreover, the reputed homeland of the Phœnicians, in the Persian Gulf, is a fitting place for their origin, since it is the site of extensive pearl-fisheries. Thus these people supply an important link in the chain ; their origin in the Persian Gulf serves to establish the dual organization on a chain of pearl-beds extending from the Red Sea, by way of the Persian Gulf, right across the Pacific, in continuous succession to the valley of the Ohio.

The archaic civilization in all parts of the region tended to break up shortly after its appearance in any place. This also happened in Egypt at the end of the Sixth Dynasty. During the Fourth Dynasty (2900–2750 B.C.) the power of the kings was at its summit. " The century and a half during which the Fourth Dynasty maintained its power was a period of unprecedented splendour in the history of the Nile valley people, and as we have seen, the monuments of the time were on a scale of grandeur which was never later eclipsed." [2] But with the coming of the Heliopolitan Fifth Dynasty the office of grand vizier remained in the

[1] Elliot Smith xvii. : Hornell. [2] Breasted v. 121.

families of the old regime, the kings now had to reckon with the power of their nobles. The rulers of the nomes, formerly local governors, now began to rule on their own behalf, and hereditary succession became prevalent.[1] Evidence of the increasing power of the official class is shown by the fact that, in this dynasty, under King Isesi, mention is made, for the first time, on a relief recounting the triumphs of the king over his enemies, of the name of the official who carried out the campaign. Another sign of the weakening power of the kings of the Fifth Dynasty is shown in their pyramids. "Their limestone pyramids ranged along the desert margin south of Gizeh, at Abusir and Sakkara, are small— less than half as high as the great pyramid, and the core of such poor construction, being largely loose blocks, or even rubble and sand, that they are now in complete ruin, each pyramid being a low mound with little semblance of the pyramid form. The centralized power of the earlier Pharaohs was thus visibly weakening, and it was indeed in every way desirable that there should be a reaction against the totally abnormal absorption by the Pharaoh's tomb of such an enormous proportion of the national wealth."[2]

The growing power of the local nobles, the rulers of the nomes, finally produced the downfall of this dynasty. "We have the first example traceable in history of the dissolution of a centralized state by a process of aggrandisement on the part of local officials of the crown, like that which resolved the Carlovingian empire into duchies, land-graviates or petty principalities."[3]

It is significant that the kings of Egypt, no longer complete masters at home, began to look to the neighbouring countries round Egypt for the exercise of their power. So long as Egypt was ruled over by absolute monarchs, the king concerned himself mainly with state functions, which is natural when he is the high priest of the state cult. When the monarch is faced with a powerful nobility in a condition of semi-independence, this new relationship in the state often expresses itself in the foreign policy of the king. In the Sixth Dynasty Pepi I, who managed to hold his nobility more or less in hand, maintained an attitude towards the realm different from that of his predecessors. "Pepi I . . . strove to single out men of force and ability with whom he might organize a strong government, closely attached to his fortunes and to those of his house. He also launched a strong foreign policy and brought the Nubian tribes under his power, so that they could be made to fight for him in his struggles against his nobles."[4] But the end was not far off. The successors of Pepi I were not able to maintain his position and power, and the dynasty was doomed. "When it had ruled something over 180 years the power of the landed barons became a centrifugal force which the Pharaohs could no longer withstand and the dissolution of the state resulted. The nomes gained their

[1] Breasted v. 128. [2] Id., 129.
[3] Id., 131. [4] Id., 134–5.

independence, the Old Kingdom fell to pieces, and for a time was thus resolved into the petty principalities of prehistoric times. Nearly a thousand years of unparalleled development since the rise of a united state, thus ended, in the twenty-fifth century B.C., in political conditions like those which had prevailed in the beginning."[1] Thus fell the Old Kingdom, the culminating point of early Egyptian civilization.

The subsequent history of Egypt is that of the education in warfare of a peaceful people. In the Eleventh Dynasty the king had to reckon with the power of small states or petty principalities, the heads of which owed him their loyalty, but were not his officials or his servants. Some of these local nobles were " Great Lords " or nomarchs; others were only " counts " of a smaller domain with its fortified town.[2] Under such conditions the Pharaoh could not but surround himself with the necessary power to enforce his will when obliged to do so. A class of military " attendants " or literally " followers of his majesty " arose, professional soldiers, the first known in ancient Egypt. But Egyptian warfare was still but a petty business : " As in the Old Kingdom, war continues to be little more than a series of loosely organized predatory expeditions, the records of which clearly display the still unwarlike character of the Egyptians." [3]

The Middle Kingdom continued for nearly 400 years (2160–1788 B.C.). During the reign of the founder of the Twelfth Dynasty, Amenemhet I, the country enjoyed great prosperity, for he had reduced his nobles to order. But here again, curiously enough, the king seems to have looked outside Egypt for his reward. He no longer had complete control of the resources of the state ; the most he could expect to do was to keep the nobility quiet. " It is doubtless true that the circumstances in which these kings of the feudal period found themselves forced them to seek new sources of wealth outside the country." The nobles were taking their share of the wealth, and the kings had to use their armies to help them to exploit other peoples. At the same time the country itself was raised to a pitch of unexampled prosperity.[4] " The pyramids of the Twelfth Dynasty kings are eloquent testimony to the fact that the construction of the royal tomb was no longer the chief office of the state. More wholesome views of the function of the kingship have now gained the ascendancy and the resources of the state nation are no longer absorbed in the pyramid as in the Old Kingdom. In the Eleventh Dynasty the Theban kings had already returned to the original material of the royal tomb and built their unpretentious pyramids of brick. Amenemhet I followed their example in the erection of his pyramid at Lisht ; the core was of brick masonry and the monument was then protected by casing masonry of limestone." [5] The custom was continued by all the kings of the dynasty with

[1] *Id.*, 143. [2] *Id.*, 157–8. [3] *Id.*, 167–8.
[4] *Id.*, 191. [5] *Id.*, 198.

one exception. This was the end of pyramid building. "Henceforward, with the exception of a few small pyramids at Thebes, we shall meet no more of these remarkable monuments, which, stretching in a desultory line along the margin of the western desert for 65 miles, are the most impressive surviving witnesses to the grandeur of the civilization which preceded the Empire." [1] In the Middle Kingdom all the arts and crafts were flourishing, but perhaps not at quite so high a level as in earlier times. Nevertheless, "Little ever produced by the later goldsmith of Europe can surpass either in beauty or in workmanship" the "regal ornaments worn by the daughters of the house of Amenemhet nearly 2000 years before Christ." [2] The theological developments of the Twelfth Dynasty also bear witness to the weakening of the royal prestige. In the Pyramid Age, the time of the greatest power of the kingship in early Egypt, the royal scribes managed to persuade themselves that the king went to the sky, and that Osiris was an enemy, yet the Solar theologians were forced ultimately to bow to popular superstition, and to raise Osiris to the sky, there to become inextricably confused with Re as the ruler of that realm. Further, in the Twelfth Dynasty, the ideas concerning Osiris had become very powerful. The Heliopolitan priests apparently were forced constantly to modify their doctrines, to add yet one element after another to their compilation; and in the end they were defeated by sheer weight of popular prejudice.

Then came the Thirteenth Dynasty, in which the succession to the throne was soon interrupted by usurpers. "Rapid dissolution followed, as the provincial lords rose against each other and strove for the throne. Pretender after pretender struggled for supremacy; now and again one more able than his rivals would gain a brief advantage and wear his ephemeral honours, only to be quickly supplanted by another. Private individuals contended with the rest and occasionally won the coveted goal, only to be overthrown by a successful rival. Foreign adventurers took advantage of the opportunity, and one of the pretenders who achieved a success may have been a Nubian." [3] During these struggles, the Hyksos, a line of foreign shepherd kings, dominated the country for a long period, finally turning it into a warlike state by educating its people in warfare, and teaching them the advantage of an army. The Hyksos were expelled and the Empire was founded about 1580 B.C. by Ahmose I of Thebes, whose military experience thoroughly fitted him for the task of reorganizing the nation after the disorganization caused by the downfall of the Middle Kingdom and the incursion of the Hyksos. [4]

"The task of building up a State, which now confronted Ahmose I, differed materially from the reorganization accomplished at the beginning of the Twelfth Dynasty by Amenemhet I.

[1] Breasted 200. [2] Id., 203.
[3] Id., 211–12. [4] Id., 225–6.

The latter dealt with social and political factors no longer new in his time, and manipulated to his own ends the old political units without destroying their identity, whereas Ahmose had now to begin with the erection of a fabric of government out of elements so completely divorced from the old forms as to have lost their identity, being now in a state of total flux. The course of events, which culminated in the expulsion of the Hyksos, determined for Ahmose the form which the new state was to assume. He was now at the head of a strong army, effectively organized and welded together by long campaigns and sieges protracted through years, during which he had been both general in the field and head of the state. The character of the government followed involuntarily out of these conditions. Egypt became a military state. It was quite natural that it should remain so, in spite of the usually unwarlike character of the Egyptian. The long war with the Hyksos had now educated him as a soldier, the large army of Ahmose had spent years in Asia and had even been for a longer or shorter period among the rich cities of Syria. Having thoroughly learned war and having perceived the enormous wealth to be gained by it in Asia, the whole land was roused and stirred with a lust of conquest, which was not quenched for several centuries. The wealth, the rewards and the promotion open to the professional soldier were a constant incentive to a military career, and the middle classes, otherwise so unwarlike, now entered the ranks with ardour." [1] Naturally the king was once again in possession of supreme power, and had been educated in war and conquest. No one could oppose him with his army at his back. The landed nobility had disappeared, and local districts were administered by petty officials of the crown ; the nation had come back by a different route to the condition of the Old Kingdom. Thus opened the period of the New Empire, which witnessed a revival of Egyptian culture. This period began with the Eighteenth Dynasty, and ended about 1150 B.C., with the close of the Nineteenth Dynasty. Finally, internal struggles of various kings brought this new state tottering to its fall.[2] Thebes developed into an independent sacerdotal principality, and caused the destruction of the Empire and the end of the unity of the kingdom.[3] The king once more had to deal with the rising power of the nobles, and, as always, they beat him in the end, and brought the fabric of the state crashing to the ground.

From Egypt to America, therefore, the end of the complex of belief and practice, social, economic, political, and religious, built up in Egypt during the first six dynasties, was ruin and decay. According to local circumstances, the length of time before the catastrophe varied, but in no case did this unstable conglomeration last for many centuries. It is evident that the day when the Heliopolitan priests first sat on the throne of Egypt marked the beginning of the end. From that day onwards the power of the

[1] Breasted iv. 233. [2] *Id.*, 505 e.s. [3] *Id.*, 522.

30

king grew weaker, and that of his nobles increased, so that finally they were able to control the destinies of the state. This great wave of civilization that swept over the earth carried with it the seeds of decay, which soon grew up and strangled the parent growth ; in all parts of the region the Children of the Sun, who imposed themselves in the beginning in an artificial manner, disappeared for ever, and their place was taken by the representatives of the old society in Egypt, the nobles who were connected with the old underworld, the first land of the dead that man ever knew. The destruction of the archaic civilization revealed fresh potentialities in man ; mother-right gave place to father-right, military aristocracies came into being, war-gods emerged, and the world began to take on a shape that we all recognize. The exposition of the story of the coming of the modern world is a task for the future ; it is enough to have recognized the former order of society and its manner of origin.

CHAPTER XXVII

CONCLUSION

THE last chapter ended a long inquiry into the historical problem of the origin and development of the civilizations of the region from Egypt to North America. The conclusion reached was that the food-producing peoples owed their culture to the direct or indirect influence of the archaic civilization, which took its shape in Egypt. It now remains to consider what bearing this conclusion has on the general problem of the origin and development of civilization.

The only sound method of study, in the case of human society, is to ascertain what has happened before considering why it happened. It is also necessary to be sure that the basis of facts is wide enough to make it possible to determine cause and effect ; otherwise the end will be disaster. The scope of this book satisfies this last requirement, since North America, Oceania, Indonesia, India, and Egypt have come under survey, with their immense variety of cultures, ranging from food-gatherers to Egyptians of the Pyramid Age.

Current speculation as to the origin and development of culture, from the food-gathering stage upwards, has been much influenced by the views of what may be termed the *Evolutionary School* of thought, which sprang up in the latter half of the last century, mainly under the influence of Darwin and Herbert Spencer. Reasoning from the obvious facts of the evolution of various forms of life on this planet, it was assumed that, since the most elementary forms of life appeared first, since also the elementary forms of human society preceded those more advanced in type, what is termed " savagery " represents an early stage of development of civilization, so that human society has, in all parts of the world, gradually developed from the food-gathering stage to that of high civilization, the process on the whole being one of advance. Such reasoning is implicit or explicit in most works on the development of any aspect of human society. It is assumed without question that people such as the Iroquois of North America, or the Australians, can be taken as representing, in their culture, something primitive in human thought and doings. Sir James Frazer attempts to derive the origin of Totemism and Exogamy from peoples such as the natives of Australia, and but little

opposition is maintained to his general position, although he is much criticized in detail.

The general attitude and methods of this school of thought have been well summarized by Rivers in his small pamphlet on " History and Ethnology," which should be universally read by those interested in these studies. He speaks of the time, ten years or more ago, when the historical method of study began under the influence of himself and Elliot Smith. " At this more remote period anthropology—I use the term anthropology advisedly—was wholly under the domination of a crude evolutionary standpoint. The aim of the anthropologist was to work out a scheme of human progress according to which language, social organization, religion, and material art had developed through the action of certain principles or laws. It was assumed that the manifold peoples of the earth represented stages in this process of evolution, and it was supposed that by the comparative study of the culture of these different peoples it would be possible to formulate the laws by which the process of evolution had been directed and governed. It was assumed that the time-order of different elements of culture had been everywhere the same ; that if matrilineal institutions preceded patrilineal in Europe and Asia, this must also have been the case in Oceania and America ; that if cremation is later than inhumation in India, it has also been later everywhere else. This assumption was fortified by attempts to show that there were reasons, usually psychological in nature, according to which there was something in the universal constitution of the human mind, or in some condition of the environment, or inherent in the constitution of human society, which made it necessary that patrilineal institutions should have grown out of matrilineal, and that inhumation should be earlier than cremation. Moreover, it was assumed as an essential part of the general framework of the science that, after the original dispersal of mankind, or possibly owing to the independent evolution of different main varieties of Man, large portions of the earth had been cut off from intercourse with others, so that the process of evolution had taken place in them independently. When similarities, even in minute points of detail, were found in these regions, supposed to have been wholly isolated from one another, it was held that they were due to the uniformity in the constitution of the human mind, which, working on similar lines, had brought forth similar products, whether in social organization, religion, or material culture." [1]

This position is now being hotly contested, as is evident to any reader of this book. As Rivers says in the pamphlet just quoted, when speaking of the rise of the historical school, and of its attitude towards the older " Evolutionary " school of thought : " The adherents of the recent movement to which I have referred regard the whole of this construction with its main supports of mental uniformity and orderly sequence as built upon the sand.

[1] Rivers xvii. 4.

It is claimed that there has been no such isolation of one part of the earth from another as has been assumed by the advocates of independent evolution, but that means of navigation have been capable, for longer periods than has been supposed, of carrying Man to any part of the earth. The widespread similarities of culture are, it is held, due in the main, if not wholly, to the spread of customs and institutions from some centre in which local conditions favoured their development." [1] This group challenges the other to show that it is right in using evidence indiscriminately from all over the earth without regard to time or place, and demands stricter canons of evidence. It asserts that it can be shown that certain less advanced communities are derived from those more advanced, and wants to know where such a process stops.

The quarrel, therefore, between the two schools centres round culture degradation. Tylor recognized the importance of this process. [2] He remarks that : " It would be a valuable contribution to the study of civilization to have the action of decline and fall investigated on a wider and more exact basis of evidence than has yet been attempted. The cases here stated are probably but part of a long series which might be brought forward to prove degeneration in culture to have been, by no means the primary cause of the existence of barbarism and savagery in the world, but a secondary action largely and deeply affecting the general development of civilization. It may perhaps give no unfair idea to compare degeneration of culture, both in its kind of operation and in its immense extent, to denudation in the geological history of the earth." [3] Tylor thus realized the importance of degradation of culture. He was also aware of the importance of the historical method : " It is always unsafe to detach a custom from its hold on past events, treating it as an isolated fact to be simply disposed of by some plausible explanation." [4] It is fair to claim that neither of these canons has been generally respected ; degradation has been largely ignored ; and facts have been collected wholesale from all parts of the earth, and put together to support some thesis or other, without any attention being paid to their history.

While it is certain that civilization has developed, it is equally certain that no community can be taken as a type of an elementary or primitive stage of culture, except when it has been demonstrated beyond doubt that its history lends support to such an assumption. Thus, for instance, there is little reason to doubt that the Dene of the Mackenzie River basin in Canada, the Punan of Borneo, the Veddas of Ceylon are really primitive, although they have acquired some elements of culture from their more highly civilized neighbours. But, in the case of food-producing peoples as a whole, it can safely be said that not one is evidence for the early stage of mankind, except in so far as it can be shown that such customs as they possess could not have been

[1] Rivers xvii. 4–5. [2] Tylor I. 27, 32.
[3] Tylor I. 48. [4] Tylor I. 20.

derived from some pre-existing community. Thus the arguments for the primitiveness of Australian totemism are really baseless ; they are founded on the assumption that culture belonging to people of a low stage of civilization must of necessity be of lowly origin, forgetting that Australian natives sometimes use matches and other products of European civilization, and so, in bygone ages, may have acquired elements of the culture of sojourners in a higher state of civilization.

The fount and source of the opposition is " The History of Melanesian Society," in which Rivers made the first attempt to range cultures in an historical sequence, and to determine their interrelationships. It is true that Graebner and other German students had previously worked out certain culture distributions, and formulated sequences ;[1] but their methods were entirely different from those of Rivers, whose work may be regarded as a new development of thought.

Once it is evident that the historical aspect is of importance, the position held by the followers of Tylor becomes precarious. The prosecution of the line of thought opened up by Rivers leads to a position in direct conflict with that generally adopted. It reveals the important fact that, in the region under consideration, especially in North America, Oceania and Indonesia, the earliest form of civilization was more advanced than those that followed ; also that the later communities had, with the exception of the food-gatherers, acquired their culture, directly or indirectly, from this original civilization, which was, broadly speaking, uniform throughout the region. In so far as the communities of these outlying parts of the region are concerned, leaving Egypt and India on one side for the present, this is the basis on which the old point of view is held to be unsound.

This theory of continuity is open to attack from more than one side. One possible objection, that based on the doctrine of the influence of climatic and other geographical circumstances on the development of civilization, has already been met. The consideration of the distribution of certain cultural elements did not seem to afford any support to the notion that men had, in the outlying parts of the region, been plastic material in the hands of unintelligent forces, but rather that they had been wilful, desiring beings, with aims of their own that they sought to satisfy, and for the satisfaction of which they were willing to undergo considerable hardship.

Criticism can also be directed towards the numerous gaps in the evidence, which will certainly be considered by some readers to constitute a formidable difficulty in the way of my enterprise. It is therefore imperative that the method of inquiry should enable anyone, who does not agree with the conclusions, readily to control the evidence on which the argument is founded. The

[1] Graebner.

method adopted, that of culture-sequence, seems to provide a simple test to effect this control. It is only necessary, in any instance, to produce one well-founded contrary example, in order to shake the whole structure. The theory of the growth and spread of culture has not been built up on any suppositions regarding the manner in which man acts in society ; it has been erected, so far as personal proclivities will permit, on the basis of the facts adduced. It is patent to anyone that the whole ground has not been covered ; it is unnecessary to state that India has not been studied in complete detail ; such facts are undeniable ; but it is unreasonable to urge that as damning the general conclusions of the book. All that is claimed is that the study of culture-sequences has invariably given the same results throughout the region ; that, for instance, mother-right precedes father-right ; sun-gods precede war-gods, and so on. The process may be likened to that of throwing a fine web of argument from one point to another, and then adding to those in position fresh strands derived from new inquiries, so as finally to produce a fabric capable of sustaining some weight, the amount borne depending on the number of strands. The method of production of these threads, usually that of culture-sequence, is simple, its results are easily controlled, and, on that account, it is reasonable, I claim, to rely on the final conclusions.

It is possible, in the study of culture-sequences, to take one element of culture, say the sun-cult, and to show that the sun-god is followed in all parts of the region by a war-god ; or to show that mother-right gave way to father-right. If the survey be made on a wide scale, it then can be said that the region has had two civilizations, the earlier characterized by the sun-cult and mother-right, the later by a cult of war-gods and father-right, although, in certain instances, elements of the first civilization survived into the second civilization. It might consequently be argued that mankind has naturally and independently in all parts of the world gone through the stage of the sun-cult before developing the notion of war-gods ; that the process was natural and inevitable ; or that the transition from mother-right to father-right was a natural sequence. But when inquiry shows that the sun-cult is also accompanied by a ruling class claiming descent from the sun-god, and that when this class disappears the sun-gods disappear also, the theory of spontaneous origin meets with difficulties. For, not only has it to be shown how men came to elaborate a sun-cult, and then to give it up ; it is also necessary to explain the origin of a ruling class that looked upon the sun-god as a father. It must be remembered that the doctrine of probability cannot be forgotten in such cases as this. If the chance of any cultural element existing in any community be one in two, then the chance of ten elements existing in that community will be one in one thousand and twenty-four ; that is, provided the elements are independent. Although the uniform presence in the archaic civilization of one

cultural element may therefore not be important, it is vastly different when ten such elements are present.

On this basis it is possible to deal with the problem of gaps. If it be found, in any place, that subsequent events have obliterated most traces of the past, and have left some characteristic features of the archaic civilization, then filiation can be claimed for that reason alone. As an instance, in the Jataka Tales in India, mention is made of two princes with similar names. When Kamsa or Sagara came to the throne, his brother, Upukamsa or Upusagara, became viceroy. This can be interpreted as evidence of a former dual grouping of the ruling class, one side of which supplied the king, and the other the viceroy or vizier, and, consequently, of the dual organization of society.

It must be remembered, however, that this form of assertion can only be made on the basis of the invariability of the culture-sequence. Once any serious exceptions to the rule are established, the possibility of such confident predictions immediately vanishes.

The problem of gaps may be treated in another way. In only one country in the region was it possible to watch the archaic civilization coming into existence. It is evident, from the discussions in the chapter on Egypt, that the compilation of the archaic civilization was the result of events which, it might be said, were fortuitous : the process of mummification had nothing to do with the sun-cult ; the doctrine that Khnum could make children was not directly connected with either of these things ; the dual division of the ruling power, and the form in which intermarriages took place between the family of the king and that of the vizier, were due to purely historical causes ; and so on for the rest of the story of Egypt of the Pyramid Age. In face of the process of accumulation of the various cultural elements of the archaic civilization, a process vastly intricate in its workings, and often directly the result of certain natural features of the country, such as the annual flood of the Nile, and of the ambitions of certain groups of the community, is it seriously argued that processes entirely different, that may have taken place in other parts of the earth, could have given rise to results that are so similar ? In the whole region out of Egypt the rule was that of degradation of culture ; in Egypt alone can growth be witnessed. Therefore Egypt must have been the originating place of the archaic civilization. Anyone who denies this will be faced with a question in probability that surely would daunt the most determined exponent of the doctrine of independent origin. He would have to explain how, in other countries, where the conditions were vastly different, men came to elaborate a heterogeneous collection of beliefs and practices entirely similar to those collected by the Egyptians ; he would have to interpret all the stories of culture-heroes on an entirely different basis ; he would have to deny the historical value of tradition ; he would have to face the question as to why this civilization, spontaneously originated in all parts

of the world, and entirely alike in its content, gave rise, in all parts of the region, to diversity, and, ultimately, to the wholesale loss of culture.

This manifold task would, I feel certain, prove insuperable. In fact, it is only by constantly ignoring tradition that it has been possible to work along the lines followed for so many years. Once native tradition is taken seriously, and an attempt is made to understand what it really means, the mind is forced, I feel assured, to travel along the lines followed here and in " The Megalithic Culture of Indonesia " ; and the ultimate production of a rational scheme is but the outcome of reliance on native tradition allied to an historical method of treatment of the evidence.

Given that the process by which the civilization of the food-producers has appeared in all parts of the region has been continuous, it evidently has two different aspects. The introduction of agriculture to various places has caused an increase in the population, and fresh communities have budded off, carrying with them some measure of culture from the parent settlement. On the other hand, the civilization itself, the collection of arts, crafts and beliefs, is the result of the addition of one cultural element to another.

The spread of the archaic civilization is not hard to understand. The bearers of this civilization have moved, say from India to Indonesia ; perhaps from Arabia, or even Egypt itself, to India, Indonesia, and farther east. As in the case of the Kayan and the Punan, they have civilized the native populations. They have carried with them their culture, and the natives have provided the bulk of the population. Certain interesting problems arise concerning the identity of the carriers of the culture in any case. The native population can have played but little part in the process of culture-transmission ; they simply provided the background for the immigrants. The circumstances attending the presence of the Children of the Sun, with their consanguineous marriages, suggest that some continuity may have existed in the ruling families of the archaic civilization ; but, in the case of commoners, there is no reason for this belief. The essential condition for the transplantation of the civilization is simply the movement of men of all grades of society from a place where it was in full bloom. The Children of the Sun of any community must have been derived from those of some other community, which means that the ruling groups of all the chief settlements of the archaic civilization must have been interrelated, and their distribution throughout the region must be the result of a continuous process.[1] This argument probably holds with the other branch of the ruling group, the underworld people ; but this is not so certain. In any case the institution of the secular branch

[1] The widespread custom of adoption in royal families will produce racial mixture.

of the ruling group has certainly been handed on from one community to another.

It is possible that the principle of continuity may serve to account for the disappearance of boat-building and stone-working in Polynesia and elsewhere in the region. These crafts were in the hands of families, usually of noble birth. If the family died out, so would the craft. When it is remembered that the archaic civilization was a complicated organization with various grades of society, with hereditary occupations, it is not extraordinary that this civilization failed to stand the shocks to which it was subjected by the struggle set up in the ruling group from one end of the region to the other.

In the last chapter an account was given of the manner in which the ancient Egyptians built up their civilization, adding one cultural element after another to those already in their possession. I now propose to discuss this process from a general point of view, so as to determine, in some measure, how the mind of man works in society ; and at the end of this chapter a theory will be propounded to account for the phenomena that have already been described.

The contrast between Egypt and the rest of the region is striking. In New Guinea, Indonesia, Polynesia, and North America crafts such as stone-working, pottery-making, disappeared, and were never re-introduced, except as the result of the arrival of fresh groups of men possessing those crafts. In like manner pyramids degenerate into earthen mounds ; earthen mounds never grow into pyramids. Once the thread of continuity in any craft is dropped, it is not picked up again ; the craft can only be re-introduced by some one who knows it. In Egypt, on the other hand, new ideas were constantly being added to the common store.

The most important step taken by man was when the Egyptians first scooped out small channels in the sand to allow the Nile to flow over fresh patches of land ; for they were forced to think of problems connected with the sizes and shapes of fields, and to study hydraulics. The annual incidence of the flood led to observations of the moon's movements, and the institution of a lunar calendar, and in this lies, perhaps, the secret of the origin of ruling groups. The man who discovered that it was possible, by calculating the months, to predict the annual rise of the Nile, possessed valuable knowledge, and it is reasonable to believe that he and his family were allowed to live at the expense of the community in return for the services that they rendered. In this way was set in motion a process of terrific import for mankind, the full significance of which is only now beginning to be realized. This group produced an entirely new situation in human society ; the first vested interest was produced, and those who benefited by it were not slow to take advantage of it. In like manner the invention of the new calendar also caused men to attain to

positions of power. Thus the annual flood of the Nile has had effects on human society that are felt to this day with the keenest intensity.

When attention is paid to the method by which the Egyptians elaborated their thought, it is found, in the case of the Helio-politan theology, for instance, that they were using elements of thought already in existence. It has been pointed out that the god Re was composite, and was hardly original in his nature. Ideas of creation were based, after the invention of pottery-making and stone-carving, on those crafts.

It is possible to show that cultural elements, apparently simple in nature, are really the products of a long process of development. In the early chapters of this book, for instance, all forms of stone-work were grouped together without consideration of type. That is to say, the craft itself was the fundamental reality, and varia-tions in the product were ignored. In Egypt the use of stone was applied to the mastaba and the pyramid, and followed the use of brick. Therefore it was a new cultural element added to others already existing. The pyramid, again, owed its origin to several causes, among them being the elaboration of the Helio-politan solar theology, itself the result of a complicated process. The conditions accompanying the introduction of the use of stone in Egypt for purposes of construction therefore support the attitude adopted, when all sorts of stonework were taken to-gether without consideration of variety. This attitude has already been justified in the case of Indonesian stone-work, where it was found that the use of stone, for any purposes of construction whatever, occurred in circumstances that suggested the influence of the archaic civilization.[1] When, therefore, it is claimed that the existence of variant forms of stone-work in the Pacific means variant cultural influences, it is evident that the premise is wrong. There may be trilithons and dolmens and pyramids of stone ; but these monuments do not necessarily mean variant cultural influences. They are all stone monuments, and for that reason it can be claimed that they represent one cultural influence. The use of stone dies out in the region, except under the influence of the archaic civilization. When, therefore, stone is used, it can be claimed that this practice is due to the influence of the archaic civilization. That being admitted, the next problem would be that of inquiring into shape and ornamentation.

I claim, therefore, that it is wrong to assert that the existence of different forms of stone-work means that men have indepen-dently invented the use of stone, and applied it in different ways. This is a fundamental question that faces every student of the growth of civilization. What happens in the case of the stone pyramid is that this monument did not originate as a stone pyramid, but that it is the result of the grouping of various ideas which can ultimately be analysed into their fundamental elements.

[1] Perry vii. 48–9.

So when stone pyramids are found in Mexico and elsewhere in America, there can hardly be any doubt that they owe their origin, ultimately, to Egypt. For the monument is the expression of several cultural elements that tend to disappear. That two widely separated communities invented a complicated monument in entirely different circumstances is incredible. Similarly with pottery-making and metal-working. The fundamental question is that of the presence or absence of the craft, not of the form of production.

It is easy to see that civilization may ultimately have been built up out of a few original elements, which, by their combinations, and the subsequent addition of fresh elements, have produced a richly variegated fabric. In this way it is possible to regard human culture as a whole, every element being dependent on others for its existence, and organically related to the body of ideas in possession of the people. It is thus easy to understand how readily arts and crafts disappear when transplanted into new surroundings.

Having tentatively suggested that the existence of cultural elements is not the result of spontaneous development in the minds of different peoples, but rather is due to a long process of accretion of one idea to another, it is possible to go farther. What, it may be asked, is the way in which the original ideas came into man's possession ? The Egyptians were surrounded by manifold phenomena, capable of being worked up into a system of ideas and made part of their organized system of thought. They did not, however, choose out elements at random. For some reason or other, they speculated about the moon before the sun, and in many other ways their thought shows signs of a selective attitude of mind. I suggest that throughout this process of elaboration of thought ran a single principle, that the Egyptians derived their ideas in the first instance directly from facts of concrete experience, and that these ideas had, in their inception, no element of speculation or of symbolism. Although he is not consciously arguing this theory, Elliot Smith, in his " Evolution of the Dragon " and other writings on the origins of Egyptian culture, adduces numerous instances that entirely support it. Time after time he shows that ideas, at first sight of a highly speculative nature, are derived from the most homely of human experiences, and are literal statements of fact. He shows, for instance, that the idea of the double of man was derived directly from the phenomenon of the placenta ; so that the fravashi of the Persians, the guardian spirit, apparently the product of human speculation about the relationships between man and the unknown, is a very material thing, prosaic in its first shape.[1] Again, he remarks that the magic wand, known from one end of the world to the other, is supposed to have been, in Egypt, nothing more than a conventionalized uterus :[2] " The Great Mother wields a magic wand which the ancient Egyptian

[1] Elliot Smith xx. IX. e.s. [2] Id., 45.

scribes called the ' Great Magician.' It was endowed with the twofold powers of life-giving and opening, which from the beginning were intimately associated the one with the other from the analogy of the act of birth, which was both an opening and a giving of life. Hence the ' magic wand ' was a key or ' opener of the ways,' wherewith, at the ceremonies of resurrection, the mouth was opened for speech and the taking of food, as well as for the passage of the breath of life, the eyes were opened for sight, and the ears for hearing. Both the physical act of opening (the ' key ' aspect) as well as the vital aspect of life-giving (which we may call the ' uterine ' aspect) were implied in this symbolism. Mr. Griffith suggests that the form of the magic wand may have been derived from that of a conventionalized picture of the uterus, in its aspect as a giver of life." [1]

In other important departments of thought, Elliot Smith shows how Egyptian ideas were originally direct, literal statements of fact. Speaking of the origin of the idea of gods, he says that—" It is essential to realize that the creation of the first deities was not primarily an expression of religious belief, but rather an application of science to national affairs. It was the logical interpretation of the dominant scientific theory of the time for the practical benefit of the living ; or in other words, the means devised for securing the advice and active help of wise rulers after their death. It was essentially a matter of practical politics and applied science. It became ' religion ' only when the advancement of knowledge superseded these primitive scientific theories and left them as soothing traditions for the thoughts and aspirations of mankind to cherish. For by the time the adequacy of these theories of knowledge began to be questioned they had made an insistent appeal, and had come to be regarded as an essential prop to lend support to man's conviction of the reality of a life beyond the grave. A web of moral precept and the allurement of hope had been so woven around them that no force was able to strip away this body of consolatory beliefs ; and they have persisted for all time, although the reasoning by which they were originally built up has been demolished and forgotten several millennia ago." [2] He goes on to explain how " some scientific theorist, interpreting the body of empirical knowledge acquired by cultivating cereals, propounded the view that water was the great life-giving element," [3] and how that in consequence of the elaboration of this theory, the ideas of deity were made more complex, and the ritual was enriched by the invention of libations and other procedures. " The symbolism so created has had a most profound influence upon the thoughts and aspirations of the human race. For Osiris was the prototype of all the gods ; his ritual was the basis of all religious ceremonial ; his priests who conducted the animating ceremonies were the pioneers of a long series of ministers who for more than fifty

[1] *Id.*, 190. [2] *Id.*, 30–1. [3] *Id.*, 31.

centuries, in spite of the endless variety of details of their ritual and the character of their temples, have continued to perform ceremonies that have undergone remarkably little essential change. Though the chief functions of the priest as the animator of the god and the restorer of his consciousness have now fallen into the background in most religions, the ritual acts (the incense and libations, the offerings of food and blood, and the rest) still persist in many countries ; the priest still appeals by prayer and supplication for those benefits which the Proto-Egyptian aimed at securing when he created Osiris as a god to give advice and help." [1] Elliot Smith then proceeds to comment on the terms " god " and " religion " : " I have already said that in using the terms ' god ' and ' religion ' with reference to the earliest form of Osiris and the beliefs that grew up with reference to him, a potent element of confusion is introduced.

" During the last fifty centuries the meanings of those two words have become so complexly enriched with the glamour of a mystic symbolism that the Proto-Egyptian's conception of Osiris and the Osirian beliefs must have been vastly different from those implied in the words ' god ' and ' religion ' at the present time. Osiris was regarded as an actual king who had died and been reanimated. In other words, he was a *man* who could bestow upon his former subjects the benefits of his advice and help, but could also display such human weaknesses as malice, envy and all uncharitableness. Much modern discussion completely misses the mark by the failure to recognize that these so-called ' gods ' were really men, equally capable of acts of beneficence and of outbursts of hatred, and as one or the other aspect became accentuated the same deity could become a Vedic deva or an Avestan daeva, a deus or a devil, a god of kindness or a demon of wickedness.

" The acts which the earliest ' gods ' were supposed to perform were not at first regarded as supernatural. They were merely the boons which the mortal ruler was supposed to be able to confer, by controlling the waters of irrigation and rendering the land fertile. It was only when his powers became apotheosized with a halo of accumulated glory (and the growth of knowledge revealed the insecurity of the scientific basis upon which his fame was built up) that a priesthood, reluctant to abandon any of the attributes which had captured the popular imagination, made it an obligation of belief to accept these supernatural powers of the gods for which the student of natural phenomena refused any longer to be a sponsor. This was the parting of the ways between science and religion ; and thenceforth the attributes of the ' gods ' became definitely and admittedly superhuman." [2]

These quotations show how strongly Elliot Smith's work supports the thesis now being argued, that thought was in the

[1] Elliot Smith 32. [2] *Id.*, 32–3.

beginning empirical, that ideas were concrete, based on actual human experience, consisting of literal expressions of fact, without the slightest admixture of speculation or symbolism. His statements would require qualification on minor points, but his main contention is clear, and, to my mind, entirely correct.

Support can be gained from other quarters for this position. Mr. Donald Mackenzie has just published, in the "Journal of the Folk-Lore Society," a paper on Colour Symbolism that exactly bears out the statements of Elliot Smith with regard to early Egyptian thought, and supports the thesis that symbolism is founded, in the beginning, on concrete ideas, and not on any innate tendency of the human mind.[1] He has also accumulated a large mass of material, which shows how the idea of milk, so common in Egypt, has been carried round the world, and given rise to an immense accumulation of symbolic thought, by its application to trees, shells, and so forth.

Another scholar, Dr. Alan Gardiner, in his article on "Egyptian Philosophy" in the 'Hastings' Encyclopædia of Religion and Ethics," states that the whole basis of Egyptian thought was concrete. "Most scholars would agree with the verdict that the Egyptians show no real love of truth, no desire to probe into the inner nature of things. Their minds were otherwise oriented : a highly gifted people, exhibiting talent in almost every direction, their bent was towards material prosperity and artistic enjoyment ; contemplation and thought for their own sake—necessities to peoples of Greece and India—were alien to the temperament of the Egyptians." Breasted also says : "The Egyptian . . . always thought in concrete terms and in graphic forms." [2]

These quotations and remarks serve to open up the general question of the growth and development of civilization from the mental side. I have claimed that the archaic civilization was put together, and that it spread, by a continuous process ; that, in fact, the growth of communities and of cultural elements proceeded by definite steps, each of which was the consequence of those that preceded it. I have, further, claimed that most of the elements of the archaic civilization were built up in Egypt. In the domain of ideas, so far as can be told at present, the Egyptians went from one idea to another as the organized body of thought in their possession led them. (This refers, of course, to the Egyptians who possessed these ideas, usually the priests.) Given that this is true, and that Egyptian thought was built up ultimately from concrete facts of everyday experience, and that it has, in its inception, no element whatever of speculation, it is obvious that communities which derived their culture from Egypt would adopt a different attitude towards the ideas originated in Egypt from that of the Egyptians themselves. The peoples influenced by the archaic civilization rejected large parts of the culture, and, in fact, chose those elements that harmonized with

[1] Mackenzie i. 136 e.s. [2] Breasted iv. 246.

their own experience. They selected, for instance, the ceremonies connected with agriculture, leechcraft, burials, house-building, because they understood, from the people of the archaic civilization, that without these ceremonies things would go wrong. The sun was to them a matter of indifference, simply because, it may be argued, nothing had ever occurred in their experience to cause them to elaborate ideas with regard to it. The sun had risen and set daily for untold years, and was accepted as a matter of course, as was the rest of nature. Only when men arrived with an organized system of ideas built up round the sun was any attention at all paid to it. And, what is more, it would seem that after the disappearance of the Children of the Sun, the sky-world only remained in men's thoughts because of the life that it was supposed to contain. Otherwise, it would evidently have disappeared from thought all through the region, as it has in the case of the Pueblo Indians, where the life, in the form of the " breath-body," goes to the underground land of the dead.

The study of Givers of Life, so far as it went, showed that the ideas concerning magic held by the peoples that followed the archaic civilization were largely based on empirical facts. They chose for their magical objects things closely identified with the strangers of old, and seem to have shown little signs of inventiveness. It is probable that, as further inquiry goes nearer to the root of things, it will be found that, prior to the coming of this civilization, the native peoples were devoid of any magical or religious practices or ideas.

It may be contested that this statement is going too far, that we do not know what may or may not have happened. That is true, but such an argument cuts both ways. It is not possible for those who postulate a spontaneous development of thought in various parts of the world, to rely on negative evidence to support their arguments. The only practical basis on which to found conclusions is that of actual ascertained fact. The study of Givers of Life shows that it is possible to point to the magical practice of a large number of peoples, and to say, with confidence, that these people are using, in their magic, objects associated with the archaic civilization. The people of the archaic civilization were well aware of the magical craft : therefore, as a working hypothesis, it may be claimed that the whole of the magic of the peoples outside Egypt was ultimately derived from ideas elaborated in Egypt, or derived by the Egyptians from a pre-existing source. If this working hypothesis be rejected, it will be necessary to point to a body of magical ideas and magical practice that could not possibly have been derived from the archaic civilization, and that task will be difficult, if not impossible.

Another task will have to be faced by the objector to this hypothesis. Elliot Smith has shown with considerable certainty that the beginnings of the ideas underlying magical and religious practice were bound up with shells, which were used by the people

of Upper Paleolithic times for necklaces and in burial ceremonies. He has pointed out the relationship between the shape of the opening of the cowrie shell and the portal by which we all enter this world ; he and Mr. Jackson have shown the immense ramifications of this primordial idea. One class of objects after another has been incorporated in the body of ideas concerning Givers of Life ; so that, ultimately, vast categories are included in the scheme, all originally deriving their potency in thought from the homely cowrie shell. Similarly it may be argued with regard to the use of blood-red substances as Givers of Life. On this basis of reasoning, therefore, the objector to the theory that all ideas have been transported from Egypt to the uttermost parts of the earth, will have to show not only that local ideas are of local growth, but also how these ideas arose from facts of concrete experience, what was the train of thought that led men to argue that such and such an object had potency for good or evil, to help or hinder man in his various activities. It is easy to harmonize the facts with the doctrine of the similarity of the working of the human mind, if it be accepted that the ideas of any community are ultimately based on their experience, and are not due to an innate tendency to speculation.

One of the most prominent results of the inquiries conducted in the preceding pages has been, I hope, the realization of the intimate relationship between all aspects of the life of a community. This interrelationship extends to mythology, for, in more than one instance, it has been found possible to explain the stories of beginnings in terms of the actual experience of the ancestors of that community.

This seems to be true for all the communities that have come under review. The fundamental unity of the Polynesian mythology, or that of the peoples of North America, can, in both cases, be put down to unity of experience. The ideas that the Polynesians and Indians of North America express with regard to the world and their relationship to it, are, in both cases, confined to a relatively narrow circle of thought, so that certain themes recur with regularity. In the case of the Polynesians it is well known, from irrefutable evidence, that of the genealogical tables, that the various groups are but shoots from one original stem ; in the case of the North American Indians the common possession of maize-growing and other elements of culture points to a uniform experience in the past. The unity of mythology, so far as it exists, corresponds therefore to actual unity of former experience on the part of these peoples.

In other cases, such, for instance, as that of the Toradja of Central Celebes, ideas of creation are expressed in terms of contact with the people of the archaic civilization, who left images lying about in various places. Again, peoples such as the Omaha of the United States, the Maori of New Zealand, and the Bugi and Macassar peoples of South Celebes, have tales of origin which

31

suggest the dual organization as formerly existing in the communities from which they were derived. The stories of fishing up of islands in the Pacific by Maui, the Polynesian hero, are probably descriptions, compounded of various elements, of the actual colonization of the islands, of the pearl-fishing, and so on. Many other instances could be adduced to suggest that the origin tales of the communities of the archaic civilization and its successors have a definite historical basis. That being so, a similarity exists between the cases of the peoples just quoted, and that of Egypt. In all instances the tales of origin are compounded of ideas based on experience, but the experience is of a different kind.

This is seen by comparing the stories of origin of the Egyptians and Sumerians with those already recounted. The Sumerian tales of Paradise and the Flood, collected and edited by Mr. Langdon, contain ideas that can be expressed in empirical terms. The stock of ideas is small : the mother goddess creates men out of blood and bone ; the first settled community is a place where irrigation is practised ; Tag-tug, the Sumerian Noah, works in a garden ; and the thought is so elementary that the notion of immortality is absent, the greatest boons attainable for man being good health and long life ; Tammuz, like Osiris, was an actual king. Ideas associated with the animation of images were absent in the earliest texts ; the sky-world was not yet. The only abstract ideas are those centring round the notion of deity ; and these, as Elliot Smith has claimed, are ultimately to be explained in terms of human experience.

What, therefore, is to be said of the creation stories of the peoples, say, of the Eastern States of North America, in which the sky-world existed before the earth, a world tenanted by semi-human, semi-animal ancestors, who fished up the earth from the bottom of the waters ? These peoples account for their origin as the result of the coming to earth of a woman of the sky-world, who became pregnant in a mysterious manner and gave birth to twins. Their origin stories wind through a series of incidents, most of which are, in themselves, wholly unintelligible without an historical investigation into the relationship between each community and the archaic civilization.

What attitude is to be maintained towards these stories, now that it is suggested that human thought is not free to wander where it pleases through the realms of fancy ? Using a story such as that just sketched out as typical for the great bulk of origin tales, is it claimed that, while the first known civilizations, those of Sumer and Egypt, had origin stories based directly on experience of a homely kind, other peoples, who have shown no signs of elaborating arts and crafts such as stone-working and pottery-making, had a faculty of inventing, independently, such manifold and symbolic ideas as those contained in the story of the origin of people from the sky-world ?

The story of the peoples of the Eastern States is unintelligible if taken by itself. These peoples could have had no such experience themselves of the ocean as to warrant the idea that at first only water existed.[1] Even were they coast dwellers, why should they elaborate such an idea ? But when it is remembered that the idea of emergence from the primordial ocean of land or of the sun-god is found from America to Egypt, it becomes evident that the best explanation is that of assuming that the primordial ocean, which, in Egypt, can well be equated to the Nile flood, has formed part of the creation story of these peoples because it has been carried over the earth. The idea is anchored down in concrete fact in one place : in the other it is purely speculative. Again, the notion of the sky-world has, in Egypt, a definite history, which can, in part, be traced. Yet the story of origin of the peoples of the Eastern States claims that the sky-world existed before the earth. Since the Egyptians and Sumerians were concerned, in their early forms of thought, solely with this earth, it is hard to believe that men, who interpret their origins in terms of the sky-world, could independently make this great step forward, that took the Egyptians so much time to perform, and indeed was only accomplished by one group of men in that country. Similarly in the case of the semi-human, semi-animal denizens of the sky-world. How are they to be interpreted in terms of native thought ? Why should they be in the sky-world ? It is evident that the history of this idea leads closer to reality the farther it is followed ; the semi-animal folk correspond to the clan chiefs with their animal associations ; and their super-human nature corresponds to that of the rulers of the archaic civilization. Their rôle of culture originators is fitting.

It is not necessary to labour this point. The discussions that have preceded make it plain that the culture of the peoples of the Eastern States can be interpreted in terms of the archaic civilization, and that the origin tales of the tribes rest on an historical basis. The point insisted on is that the origin tales suggest, in themselves, that they must have had a long history, since they are so divorced from reality. In this they contrast definitely with the origin tales of Egypt and Sumer, where, in the early stages, even the idea of creation from images apparently was non-existent. This reasoning applies well to cases such as those of the Australian All-Fathers, beings who live in the sky, and are credited with the power of creation from images. This mythology possesses at least three ideas that were comparatively late in Egyptian and Sumerian thought—residence in the sky, creation from images, and animation by means of breath. Is it seriously claimed that the Australians independently evolved these ideas, even if, for the moment, abstraction be made of the rest of their culture, which shows such strong traces of the

[1] It is unnecessary to remind the reader of the ridiculous ideas of the Freudians on this topic.

influence of the archaic civilization ? What facts of their experience could have led them to think of creation from images, or of animation by breath, or of creation itself ? Is it not easier to think of Biaame, Bunjil, and the rest, as legacies from the archaic civilization, bereft of many characteristics, and deprived of cults because of the disappearance of their descendants ?

Throughout the region mention is made of gods. The first gods in Egypt and Sumer were certainly men ; and, throughout the region, the earliest rulers, the Children of the Sun, were closely connected with the gods of the sky-world. When, therefore, any community without a god-descended class possesses ideas concerning gods, is it to be believed that they have made a jump that enables them to overleap the steps up which toiled the best thinkers of the highest civilizations of antiquity ? Is it credible that they displayed such powers of abstract thought ? Is it not easier to believe that such peoples have derived their ideas of gods from the archaic civilization, and that they are dealing with notions the origins of which they do not understand ?

The study in Chapter XIII of the ideas with regard to gods and the knowledge of them exhibited by the different social classes, supports the contention that such ideas are divorced from their original context of fact. For, as has been said, the commoners in various communities know nothing whatever of their gods, and therefore could not have imagined them. The idea of a god is something alien to their experience, their history has not brought them to think on such lines, and thus, when the idea is presented to them, they tend to reject it.

The implications are obvious. It can be shown that the stories of origins, in Sumer and Egypt, are founded ultimately on concrete human experience, and that they have grown up by an orderly process of accretion of one idea to another, so that ultimately organized systems of thought have emerged. It is found, also, that communities outside the Ancient East invariably express their origins in terms of systems of ideas similar to those ultimately elaborated in the Ancient East, systems of ideas which, moreover, are often, in such cases, divorced from any facts of actual experience, and are not evidently parts of an organized system of thought. In these circumstances it is possible to claim, with confidence, that all these communities must have derived their systems of thought from other communities. That is to say, the mythologies of the peoples of India and the region to the east, represent the traditional accounts of the beginnings of those communities ; and these accounts, because of the use of ideas detached from their original context, and therefore symbolical, show clearly that the members of these communities have no notion whatever of the real origin of civilization, but are using ideas at second-hand.

If this conclusion be contested, it is necessary to show how and why the Egyptian and Sumerians have systems of thought based

so near to actual fact, while those of peoples such as the North American tribes, have fantastic stories of origins that obviously are false in many respects. It will be necessary to explain why the Egyptians founded their ideas on experience, while the Maori of New Zealand held symbolical notions about the sexual distinctions of the sky and earth, notions which cannot possibly have been founded directly on experience, but can only have come into existence at the end of a long train of thought.

As in other instances, it is found that the later developments in Egypt were parallel to those of the communities supposed to have derived their culture from Egypt. Early Egyptian thought evidently was empirical and concrete, but Dr. Alan Gardiner states that " The religious literature of Egypt shows a stronger leaning to speculation than the secular works, due to a confusion of contradictory myths and attributions which must have been intolerable to the more learned priests. Cosmogony has the same purpose as philosophy—an explanation of the universe ; and in Egypt it might, under more favourable circumstances, have resulted in true philosophy." That is to say, various groups of priests, each with their own body of doctrine founded on their varied intellectual histories, had come to amalgamate their ideas, which in the process necessarily became separated from their context in fact, and thus gave rise to speculation, or reasoning on ideas the origins of which are unknown.

It can therefore be claimed that the doctrine of the similarity of the working of the human mind provides an explanation of the facts. For, as the Egyptians founded their systems of theology, mythology and philosophy on experience, so also did the communities supposed to have derived their culture from Egypt. But, in their case, the basis of experience was far different : they had been civilized by men who had inherited a culture based on long experience, they had come into possession of ideas the real meaning of which was unknown to them ; and they were forced to reason on the basis of these ideas, and thus produced mythological systems, stories of beginnings so far as they knew of them. It has been seen, in more than one instance, that these ideas were capable of rational explanation when the relationship between the community in question and the archaic civilization had been explained ; that, in fact, an increase in historical knowledge led often to the complete rationalization of the story.

The conclusion of the matter is this : The growth of civilization is attained through the development of an organized system of thought, founded in the beginning on direct experience, and consisting of empirical ideas concerning matters that interested early man. Once this process has begun, the original themes begin to influence one another, and to bring into existence fresh ideas, and thus ultimately to produce speculative and abstract thought. Applying this conclusion to communities derived from the archaic civilization, it will be seen that they had an entirely different

experience from Egypt and Sumer, in that they inherited a cultural equipment already elaborated, and acquired ideas of the concrete origin of which they were ignorant. Their initial capital, partly composed of the results of the experience of pre-existing communities, was modified in transmission to conform to the experience of the communities themselves ; and thus it happens that the derived communities expressed their origins in terms of ideas that had been produced in the original communities as the result of a long experience. The thought of the derived communities therefore tends to be more speculative, being detached from the experience from which it was originally derived, and, in India for instance, has elaborated a world for itself, as is seen in the speculations of the Brahmanas and Upanishads. None the less, it seems that all elements of thought, of whatever community, can ultimately be expressed in terms of the empirical experience of that, or some other community, so that human thought is anchored in human experience.

CHAPTER XXVIII

CONCLUSION—*Continued*

L ITTLE thought is needed in order to realize that the behaviour of man is largely moulded by the social institutions that he has elaborated in the course of the development of civilization. He has come to live with his fellows in communities, all of which have distinct personalities, so to speak, due to their varied histories. The behaviour of the members of these communities can, as has been seen in the case of warfare, differ profoundly, according to the mode of origin of the community, and the circumstances in which it finds itself. A review of the region seems to reveal communities in a constant state of flux, each apparently living its own life more or less independently of the others. The idea of independence, plausible as it may seem, is, as has been found, profoundly false ; for the various communities are really all linked together by innumerable ties ; and all, from the point of view of culture, derive their capital from one original source. These communities, therefore, are but the expression of a process at work ; and one of the fundamental tasks of the historian, taking that term in its widest sense, is to express that process in its simplest terms, so that the whole range of civilization from beginning to end may be grasped without any serious difficulty.

It is commonly thought that the only hope for the student of society is the acquisition of knowledge ; more facts, and still more facts, is a common catch-phrase. But what is really needed is more insight into what facts have been gained. The mere accumulation of knowledge in itself is of little use : what really is needed is some means of using that knowledge. The student should constantly try to group his facts into still wider generalizations, he should learn what is more and what is less essential, what is primary and what is derived ; for he will only be able to acquire the necessary economy of thought by confining himself to what is really essential in the growth and development of human society.

The question of what is primary and what is secondary in human institutions is of the utmost importance for all students of society. An example will probably explain my meaning. It is possible for anyone to have a detailed knowledge of human warfare in all ages,

and yet to be totally ignorant of the real meaning of that institution in human society. He may know all about the conquests of Genghis Khan and his descendants, he may be able to tell of the triumphs of Alexander the Great, or of Napoleon, he may have a detailed knowledge of the war of 1914. But what will that knowledge really avail him? Nothing, unless he tries to understand what is the essential meaning of that form of social activity. Is war a primary social institution? That is to say, is it, like the family, something rooted deep down in human history, resting perhaps upon inherited mental traits, and certain to persist whatever forms civilization may assume, and in itself a potent factor in the development of civilization? Or is it but the expression of something else? That is to say, does civilization possess a social institution that expresses itself by a warlike mode of behaviour? If so, then it is possible to eliminate warfare from our minds, and to think simply of the institution which gives rise to it. For, if that institution be eliminated or modified, then the mode of expression, the warfare, will disappear. Further, the institution of which warfare is an expression may itself possibly be derived from some other institution, and so on. The law of growth holds with social institutions, as with ideas and elements of culture, and this fact must constantly be held in mind.

In this chapter I shall indicate briefly some of the more general instances of the relationships between social institutions and human behaviour that have come under notice, and shall discuss shortly some of the larger consequences of the appearance of ruling groups.

In food-gathering communities the family groups live in juxtaposition, with no signs of the superposition of one group on another. If what has gone before be correct, it follows that civilization, meaning the possession of the fundamental craft of agriculture, has, from its beginnings, been characterized by the phenomenon of superposition of certain family groups on others. In the earliest times in Egypt a power-holding hereditary group seems to have existed, and such groups have persisted throughout the region, only disappearing in cases like those of the Omaha of the Plains of North America, but even then leaving strong traces behind them.

It is possible to think of the great group of communities throughout the region as consisting of people using givers of life, or possessing some other fundamental element of culture, but such a formula does not express the existence of different communities with definite personalities, with traditions, religious systems, and all sorts of variations that make them into separate entities. The needed formula is one that will make it possible to think of the communities of the whole region as the expressions of a process. In the case of the food-gatherers the communities were family groups; they were simply the expression of the fundamental

instinctive tendencies of men, the sexual, maternal instincts, and the sentiments that grow up in the family circle. But the food-producing communities are more than that ; they are the expression of something beyond the instinctive tendencies of men. They result from the combination of cultural elements that have been elaborated by men in the course of the development of society.

It is commonly asserted that men possess a gregarious instinct, that causes them to accumulate in communities ; and that the possession of this instinct has helped in the process of development of civilization. If that be the case, it is remarkable that all the food-gathering peoples show no traces of this process at all, for they live in family groups.[1] And, moreover, as has been seen, the process of development of civilization is of an entirely different order from that of the mere expression of some uniform instinctive tendency of man. No traces exist, throughout the region, of the working of an instinctive tendency to live in groups, except in the case of groups of relatives. The clan system itself, on which the archaic civilization is built up, is simply a variation, produced by agriculture, of the same habit. Once agriculture is introduced, it is possible for family groups to live in closer contact, but that is not evidence of their innate desire to do so.

Reasoning on the lines of the instinctive tendency of men to live in communities leads nowhere ; least of all does it explain the means whereby one group of families is able to dominate others, and often to cause various clan groups, that is, various enlarged families, to live in juxtaposition. That is the fundamental problem of the political organization of society : and, in view of its importance, the cultural element of which it is the expression itself attains to importance.

What cultural element expresses itself throughout the region in the form of society in which family groups, clans or otherwise, are amalgamated into a state ? The class system supplies the answer. In the analysis of the dual organization of society, the form of society of the archaic civilization, it was found that the distinctive features of both sides of the dual grouping were derived ultimately from the ruling group itself—the hostility, the contrast of light and dark colours, superior and inferior, elder and younger, sacred chief and war chief, were all derived from peculiar features of the dual ruling group of the archaic civilization. The communities of the archaic civilization were presumably formed, in all cases, from others, as daughter settlements, which, by a continuous process, transplanted the constitution of society into a new place. That is to say, the ruling group of one community transferred itself partly to another place, and thus the process continued. Without the ruling group, the archaic civilization, as it is known, would have been extinguished, as it was, for instance, in the Malay Peninsula. The whole of the ideas con-

[1] Perry xiii. 515 e.s. : Speck iv.

cerning the sky-world, cults of deities, the doctrine of theogamy, and other cultural elements, were definitely linked on to this other cultural element. As has been seen in Egypt, the power-holding group formed a focus of attraction for other cultural elements. The existence of a ruling group induced the rulers to invent all sorts of cultural elements to keep it in existence. The motive was selfish, but it provided the necessary stimulus. Although the life of the community must have gone on more or less undisturbed throughout the region, yet the formation of states, with their varying personalities, is ultimately to be ascribed to the institution of the class-system. How many communities in the region have no ideas connected with the sky-world ? Very few. Very few, therefore, have escaped the influence of the Children of the Sun. Every community, with the possible exception of the food-gatherers, has some sort of a religious system, some ideas concerned with deities—that is, every community is, in some way or other, the expression of the class-system as it sprang up in Egypt.

It is legitimate to claim, therefore, that the process of expansion of the archaic civilization all over the region was really that of the growth of the power-holding group from one place to another, each community that consisted of groupings other than those of families pure and simple, being but the expression of the existence of a ruling group. It is thus not necessary to think of a series of communities from one end of the region to the other : it is only necessary to think of the continuous development of a process. The break-up of the archaic civilization, and the production of new communities, can likewise be expressed in terms of the same process. The fundamental element of these societies, the ruling group, modified itself, and gave rise to fresh groups, which produced new communities that were the expression of the modification of the ruling group.

The study of ruling groups leads to the question of warfare and other modes of human behaviour. Food-gathering communities, in their primordial state, are entirely peaceful, not only, it seems, towards the members of other family groups, or towards the members of different tribes, but in all relations inside the group itself. That is to say, violence and cruelty are apparently rare.[1] How far this is strictly accurate further investigation only will show ; but the published accounts of the behaviour of peoples of the food-gathering stage, and also of certain of those of the food-producing stage, go to show that cruelty and violent behaviour are not universal characteristics of men. This is not the place to enter upon a detailed investigation of the problem of violence ; but a few suggestions may be allowed on the basis of the discussions carried out in previous chapters.

The people of the region underwent a process of education in

[1] Even in more highly developed communities this is often mainly true. See, for instance, Huguenin (p. 40).

violent behaviour : this was seen in Egypt, Babylonia and else-where. Fighting forces developed from militias to professional armies. Throughout the region the first form of warfare was connected with human sacrifice ; and, so far as the evidence goes at present, it can be said that warfare in the first instance was but the expression of the pre-existing cultural element of human sacrifice, which itself was founded upon certain ideas concerning the necessity of human blood for agriculture, for the rejuvenation of the king and so on, and thus was, in itself, a complicated element of culture. Ignoring other elements that complicate the problem, the consideration of human sacrifice shows that this form of cruelty depends for its existence on a developed cultural environment. Throughout the region it was intimately associated with the cult of the great mother and the sun, and with agriculture. It has other associations, but these need not be considered at present. It was found that, when human sacrifice was introduced to places such as Indonesia, where the archaic civilization was not deeply rooted, it soon became transformed into the more humane practice of head-hunting, and also into animal sacrifice. The form of cruelty exhibited in human sacrifice was only possible in the case of people who possessed the civilization of which it was an integral part.

This is well seen in the contrast between Mexico and the region to the north. The Mexicans, under the Aztecs, practised human sacrifice on an immense scale, as well as ceremonial cannibalism. Both these practices die out in the United States as the cultural stage of the Mexicans recedes, presumably because the general breakdown of the archaic civilization caused men to lose that particular form of induced behaviour.[1] Human sacrifice, there-fore, provided the communities that practised it with an education in cruelty that, in Mexico for instance, led them to great excesses. Other peoples, who had not inherited the culture of the archaic civilization, were less educated in this form of behaviour, and did not exhibit it in so definite a manner.

In another way it can be seen that the communities of the archaic civilization were educated in violent and cruel modes of behaviour. The dual organization, from one end of the region to the other, was characterized by the exhibition of an hostility between the two sides of the community, in spite of the fact that they intermarried, and were united in ceremonial performances. This hostility was a disruptive force that ultimately smashed the archaic civilization, and gave rise to fresh communities of a war-like nature. In several places, such as New Guinea, the whole of the warfare apparently consists of struggles between communities on either side of the dual organization. As in the case of human sacrifice, the amount of violence displayed depends upon the

[1] It is interesting to note that the Kiowa of the Plains do not permit the self-mutilation that is so prominent a feature of the Sun Dance among other tribes (Scott 345).

degree to which the culture of the archaic civilization has been received. In Australia the fighting is not serious : in Polynesia it was deadly. In proportion as the various native peoples were influenced by the archaic civilization so did they begin to fight.[1] The great development of fighting that took place at the break-up of the archaic civilization, in which new communities with war-gods and warlike organizations came into existence, was the result of events that took place in the ruling groups of the archaic civilization themselves. Thus the modern form of warfare, that of fighting for domination, is the direct result of a process of education in violence that men experienced during the development of civilization.

Since human sacrifice, and the hostility between the two sides of the dual organization, are so intimately connected with the ruling groups, it can safely be said, as a working hypothesis, that warfare, in the beginning, was a secondary result of the existence of ruling groups, which, for various reasons, gradually educated themselves and their followers in violent and cruel modes of behaviour. It is interesting to note that the communities which developed the more violent forms of warfare to a great extent gave up human sacrifice. That is but another instance of the phenomenon that a cultural element can only survive in the proper environment, particularly in that in which it originated, and that it tends to disappear when its environment is altered.

The education in cruel modes of behaviour that can be witnessed in action throughout the region is an excellent instance of the interaction between social institutions and human behaviour. Given that the behaviour of the food-gatherers constitutes the normal type, it follows that any deviation has been caused by some human institution. A constant interaction is proceeding between institutions and human beings, institutions are constantly being modified, and in their turn are constantly influencing human behaviour.

The cruel behaviour of men in the time of the archaic civilization was centred mainly round two institutions : one connected with ritual human sacrifice, the foundation of which was the supposed necessity for human blood as an elixir of life ; the other, ordinary fighting as we know it, in which two groups of men are pitted against each other. The cruelty involved in human sacrifice is understandable. The necessity for blood caused men to perform acts which were, in all probability, abhorrent to them. The performance of these acts would, nevertheless, provide an education in cruelty. The decadence of human sacrifice among warlike peoples shows that this form of cruelty is on a different plane from that involved in ordinary combat. The great development in warfare consequent on the break-up of the archaic civilization

[1] Heer Kruyt tells me that, in Central Celebes, the warlike behaviour of peoples diminishes in proportion to the remoteness of their culture from that of the archaic civilization.

was accompanied by some profound political changes. Judging from the culture-sequences in Indonesia, the later rulers were not so restricted in their actions as their predecessors ; the councils had fallen more or less into decay, and chiefs were able to do much as they pleased. In the archaic civilization the war-chief was subordinate to the sacred chief, and thus had less power. His actions were circumscribed, and as he was only in authority when fighting began, he evidently could not wield such powers as a warlike king. That is to say, when the sacred king disappeared, and the warrior aristocracy took his place, the aims of the ruling class were entirely different, and they gave themselves up to fighting on a large scale. It seems certain that this education in violent modes of behaviour has had repercussions on all phases of social life, which will need detailed study in all stages of civilization. It can be shown, beyond doubt, that the increasingly militaristic and violent spirit that has been acquired by man has resulted in the subjection of women. The sexes in the food-gathering communities are on a stage of perfect equality, the normal condition of things.[1] Such was also the case in early Egypt, Sumer and Babylonia ; in communities such as the Khasi, the Bugi and Macassar States of Southern Celebes ; in Micronesia ; and among the Iroquois of North America. But when warfare became a prominent occupation, woman's manifest incapacity for violent modes of behaviour, and the increasing attention paid to fighting by ruling classes, tended, among other things, to put her in a position of inferiority, and man became predominant. Polygyny is also an expression of this transformation.

The process has not stopped here. For, as can be shown beyond doubt, the treatment of children in food-gathering communities is vastly better than in our own communities. Savage children are, as a rule, treated with all kindness, and are petted and spoiled.[2] It is only in communities that have adopted violent modes of behaviour that cruel methods of education of children are thought to be necessary. This topic can only be brought to notice in this place. It is evident that it is of the utmost importance for mankind, and one that needs the most intensive study in the future, if it is to be possible to order society on right lines. It is permissible, perhaps, to stray beyond bounds, and to note that, in our own days, a profound change is coming over the face of society. The great democratic movement that is taking place is accompanied by the continual adoption of less violent modes of behaviour. It is only necessary to compare, in our country, the penal laws of the eighteenth and the twentieth centuries to understand how men are modifying their views. If the results gained in this book be true, it should follow that this transformation of behaviour, this reluctance to use violence that is becoming so apparent, is accompanied by social and political

[1] Cf. Perry vi.
[2] See for instance A. R. Brown (p. 51) in the case of the Andamanese.

changes, and that all have to be studied as a whole, and not piece-meal. I mention this as an instance of the way in which the study of early forms of society can throw light on modern problems.

Another instance of the education of mankind in certain ideas and modes of behaviour may be mentioned. In the course of the discussion on exogamy, it was claimed that this social rule went through certain stages, in which the restriction of marriage to people not related by ties of blood became more and more evident. In the dual organization, the rule of exogamy could only, by the greatest stretching of terms, be claimed as a restriction of incest ; for it marked certain groups of relatives as possible mates, and ruled out other relatives, equally nearly related, as impossible. Moreover, it led finally to the idea that the most desired marriage of all was that between actual first cousins, the children of a brother and sister. This notion is widespread, being found, in India, among the Dravidian peoples, in Timor, among the royal family of Boni in Celebes, and elsewhere. The rule of exogamy, in these circumstances, has no pretence whatever to be a rule of prohibition of incest. Everything points to it as a positive injunction to marry into another group, not a prohibition against marriage in a certain group. As the dual organization broke down the rule became that the members of all other clans were possible mates. Finally marriage was only forbidden to blood relatives. This line of development suggests that the idea of incest was taught men by means of the marriage rules of the dual organization, and that, previously, no rule existed. It may have been that, as is claimed by Westermarck and others, men prefer to choose their mates among strangers, owing to the great attraction that novelty has in sexual matters ; but no evidence exists, so far as I am aware, to show that this preference was elevated into a rule, especially if it be claimed that the rule was to avoid incest. Preference for strangers, and avoidance of incest, are poles apart, and no amount of argument can bring them together. The matter is not yet quite clear, for the forms of marriage of the Children of the Sun complicate the question ; but it would seem that, in the archaic civilization, the rule usually was that the royal family practised incestuous unions, and the commoners were bound by the rule of marriage into the other side of the community. In Indonesia and elsewhere, tales tell of the prohibition of incest by beings who are said to have practised incest themselves. The punishments meted out by the sky peoples, the traditional representatives of the people of the archaic civilization, show that the injunction was something strange to the natives. What the real injunction was can only be surmised : probably it was that marriage had to be exogamous. The natives found that the very people who enjoined this form of marriage, practised incest, and may have come to interpret the positive command as a prohibition against incestuous practices ; so that,

when the dual organization broke down, the practice was remembered in terms, both of the incest of the Children of the Sun, and of the exogamy of the dual grouping, and this duality of thought was realized in the incest prohibition. Those communities that had gone through the previous stages then came to interpret the rule as meaning that no marriages must be practised between people who were related on either side of the family.

Incest was a common feature of Egyptian life. The attitude of the Egyptians towards incest, as stated by Sethe, well exemplifies the process just outlined. He says that " the notion of incest, in the strong sense in which the Hebrews, Greeks and Romans understood it, and also as Christendom understands it, seems to have been foreign to the Egyptians, at least in ancient times, even if already at that time the people may have avoided marriages between parents and children because of natural feelings and on natural grounds." [1] The Greeks, Hebrews and Romans have demonstrably gone through a process of development similar to that experienced by the communities of the archaic civilization, and they have all gained possession of the feeling of incest. It is thus probable that the scheme just outlined for the people of the region under consideration is correct in its essential features. The earliest feeling may have been that of the greater desirability of marriages with strangers, partly because of their greater sexual attractiveness, partly, perhaps, for other reasons. The innovation of the arrangement of intermarriage between the two sides of the ruling group in Egypt brought to men's minds for the first time the conception of a marriage regulation. This regulation, in time, owing to the working of more than one cause, tended to become restrictive, and to take on the ultimate form of incest prohibition. [2]

These few instances are brought forward as examples of the sort of problem that emerges from the study of culture-sequences. The vicissitudes through which the archaic civilization has gone may be described in terms both of history and of psychology. The historical description must, of course, come first, and, in this book, the great bulk of the attention of the reader is occupied with such problems. But it is impossible to ignore the psychological aspects of the process, and the examples just considered serve to indicate the problems that confront the student of society.

It is not possible here to do more than indicate what appear to be the main lines of development of society as the result of the interaction of men and the social institutions that they have brought into being. The formulation of the historical scheme of development is but the prelude to the more fundamental problem of assigning causes to the various phenomena. It will

[1] Sethe v. 60.

[2] I owe to Professor Elliot Smith the realization of the real meaning of incest.

be necessary to study the behaviour of human societies in detail before this branch of inquiry is firmly established. Nevertheless, it is permissible to sketch, in broad outlines, what appear, at the present, to be some of the principal forms of interaction between men and social institutions. So far as this line of inquiry has proceeded, it seems probable that the institution of the class system has been fraught with great consequences to civilization. The great development of religious systems has taken place within ruling groups ; the political systems of states owe their origin to the interactions of ruling groups, and, finally, the important institution of warfare seems to be entirely centred round ruling groups. Thus they have played a part of supreme importance in the growth and spread of civilization.

The demonstration of the truth, or the falsity, of the thesis, that human warfare is the outcome of the existence of the class-system, whereby the members of the ruling group, on account of their subjection to the influences of certain social institutions, develop a cruel mode of behaviour, will have to be attained on the basis of an extensive exposition of the facts.

The problem of the warlike behaviour of mankind is inextricably bound up with another important problem, that of the conditions in which advances in culture are made. It has already been stated that the development of new cultural elements seems to be dependent on the existence of the proper cultural environment. When a civilization is transplanted to a new region, and thereby undergoes transformations more or less fundamental, the equilibrium between the various cultural elements is upset, ideas become detached from their contexts, and the civilization tends to break down. What is the principal cause of this break-up ? Or, in other words, what is the social element that is most destructive of culture ? If that question can be answered, then it is possible that the first step may have been taken towards the foundation of a study of the necessary conditions for the advance of culture.

Beyond any reasonable doubt, the principal cause of the break-up of the archaic civilization was the existence of hostility between the two sides of the dual organization. It is remarkable that this hostility was carried from one end of the region to another ; and that, in places where the old ruling group persisted, this ruling group ultimately destroyed itself, more or less completely, owing to this cause. The hostility owed its origin, as has been seen, to the actions of ruling groups, to the struggles of the rulers of Upper and Lower Egypt for supremacy, which makes it, therefore, a secondary result of the existence of ruling groups. When these ruling groups began to struggle for supremacy, the arts and crafts declined with great rapidity, and many cultural elements disappeared, including, sometimes, that of writing. That is to say, the existence of a ruling group possessed of the necessary warlike behaviour, is a very destructive element

of society. Evidently its influence does not merely confine itself to producing a warlike mode of behaviour in the community ; it also prevents the invention of fresh elements of culture.

In Egypt it seems certain that practically all the arts and crafts were invented before the end of the Third Dynasty. Weaving, metal-working, pottery-making, house-building, and so forth were invented long before historical times. Although the conditions in which these inventions were made were not known, it would seem probable, judging from the pre-dynastic Egyptian graves, that the ruling group, even if one existed, had but little power, compared with what it had in the Third Dynasty, when it was possible for the king to build enormous pyramids. It may therefore be urged that the growing power of the rulers, and their absorption in the problem of getting enough supplies for their temples, prevented the Egyptian people from turning their minds to the invention of fresh arts and crafts, and caused all attention to be centred round the supposed welfare of one small group of the community in this life and in the world to come. The struggles within this group culminated, as has been seen, in the ruin of the country for centuries : at the end of the Sixth Dynasty Egypt was given over to anarchy, directly as the result of the struggles between the various branches of the ruling group. What happened in Egypt happened in other parts of the region ; the archaic civilization was transplanted with a ruling group that held so much power that further advance in civilization was practically impossible. Evidently the archaic civilization was, in itself, an unfavourable medium for the production of new elements of civilization.

What happens when, in a favourable environment, the archaic civilization is broken up to some extent, but not completely ? What happens, for instance, with the elimination of certain elements connected with the ruling groups ?

From time to time in the history of the world a genius has arisen, who has seen through the mist, and has perceived that man, in order to attain to greater perfection and happiness, must throw away many of the institutions with which he has surrounded himself. One of the most important of these great teachers was Buddha. He preached that men should rely, in their life, not on hypotheses but on facts, on reason not on authority, and thus he struck, at one blow, at the very foundations of the civilization of his time. The aim of Buddhism is, it is said, " to produce in every man a thorough internal transformation by self-culture and self-conquest." [1] Buddha entirely rejected the caste system. " Between ashes and gold there is a marked difference, but between a Brahmin and a Chandala there is nothing of the kind. A Brahmin is not produced like fire by the friction of dry wood ; he does not descend from the sky nor from the wind, nor does he arise piercing the earth. The Brahmin is brought forth from the

[1] Narasau 32.

32

womb of woman in exactly the same way as the Chandala."
Buddhism, in fact, preached equality of mankind, and also the
equality of woman and men.[1] The Buddhist doctrines, therefore,
were entirely subversive of those that must have been held
previously in India. Freed, therefore, from many of the ideas
that had grown up in the archaic civilization in the course of ages,
and forced,once again, to base reasoning and conduct on experience,
what was the form of behaviour manifested by the Buddhist
monks, and what part did Buddhism play in the development of
civilization ? The Buddhist monks were great civilizers. " It
was often the monks who encouraged the people in the cultivation
of the arts of peace and life. Often they themselves led the
people in the transformation of waste lands into rice-fields."[2]
That Buddhism was a great civilizing agency is made clear from
the following quotation, which could be supported by many
others. "A tangible way in which a religion manifests its actual
influence upon civilization is art. The great glory of Buddhism
is that it has always ministered to the satisfaction of æsthetic
aspirations. Wherever Buddhism has prevailed, artistic pagodas,
vast viharas, beautiful stupas have come into existence. The
finest buildings in Japan are the Buddhist temples. The beauty
and charm of the frescoes of Ajanta caves serve as monumental
proofs of the wonderful inspiration which the religion of the
Tathagata imparted to art. Brahminism has no art of its own
in India, and the plastic arts of later Vaishnavism and Saivaism
are the bastard children of the sculpture of the bhikshus. . . .
The best era of Indian medicine was contemporary with the
ascendancy of Buddhism . . . the true schools of Indian medicine
arose in the public hospitals established by Asoka and other
Buddhist kings in every city. . . . All sciences and arts were
studied in the chief centres of Buddhist civilization, such as the
great Buddhist university of Nalanda. According to the great
orientalist, Theodore Benfrey, the very bloom of the intellectual
life of India, whether it found expression in Buddhist or Brah-
minical works, proceeded substantially from the Dharma, and
was contemporaneous with the period in which Buddhism
flourished."[3]

It is possible to argue that new cultural influences were coming
into India at the time when Buddhism was promulgated, that
new ideas were at work like a ferment in men's minds, causing
them to strike out in new directions. The rise of Buddhism may,
therefore, be put down to a " cultural influence." But until
such a term is strictly defined, it is meaningless, and simply tends
to confuse thought. It is becoming the fashion to speak of " cul-
tural influences," and to use this phrase as a " catch-phrase,"
which can be applied to any problem. But, in India, the question
is to understand how and why, at one period, and one period only,

[1] Narasau 71, 88, 93. [2] Id., 114, 115.
[3] Narasau 34-7.

that of the rise and spread of Buddhism, the intellectual life of India was immensely stimulated, so that, later on, with the rise of Brahminical influence and the spread of the caste-system, all signs of creative activity disappeared. In India of the time of Buddhism, activity was shown in all aspects of life. The stimulus did not merely act in one direction but in all. It seems as though some repressing factor has been removed which allowed the intellectual faculties full play. This is true, it seems to me, of all times in the history of the world when great advances have been made. A country is not active in one direction, it is active in all.

It is plausible to argue that the teaching of Buddha himself, whatever be its antecedents, formed the first impulse towards the new development of thought, to claim that he removed some of the mental factors that repressed original thought, and allowed the minds of men once more to have free play. Before his time thought was conventionalized and stereotyped, owing to certain social causes : he freed it, allowed the mind to return to concrete ideas, and the consequences were great. It is significant that his doctrines were essentially democratic ; he preached equality of men and women, he denied the basis of the caste system, that is to say, he denied the basis on which rested the class system. This he did successfully for a time, and at the same time men's minds were free to advance in all directions.

Every one is familiar with the presence, in this country, and elsewhere in western Europe, of megalithic monuments and other cultural elements that suggest the presence of the archaic civilization. It is necessary, however, to remember that the problems presented by Europe will differ somewhat from those for the region just examined. For, as is known, the Ancient East was radiating influences towards western Europe at very early dates, and probably long before the time of the Fifth Dynasty of Egypt. A perusal of the works of Sir Arthur Evans, Siret, Déchelette and others, shows that Egypt was probably in relationship with Europe as early as the First Dynasty, if not before, either directly or by way of Crete. It is therefore not necessary to expect that the first civilized people to visit western Europe should display all the cultural elements of the archaic civilization, for several of them demonstrably originated at a later date. At the same time they should display some of them ; and, if the general principles arrived at be correct, the successive waves of influence that swept over Europe should approximate more and more closely to that of the archaic civilization.

In one respect the conditions controlling the spread of civilization from the Ancient East to western Europe should be identical with those controlling the distribution of the archaic civilization in the Pacific and elsewhere in the region—the earliest settlements should be situated near sources of raw materials. This, I take

it, is a fundamental general principle of human geography that cannot be upset. Man, from the earliest times of which there is knowledge, has lived near his supplies of raw materials, and has got his food locally. He has never, so far as can be told, occupied a new country because he was pressed for food. This supposition is baseless, and the sooner it is abandoned the better for science. I have already shown, as has been insisted on more than once in this book, that the earliest food-producing people in England and Wales settled near the sources of flint, gold, tin, and so forth, and thus exhibited desires identical in nature with those of the archaic civilization elsewhere. Throughout the whole range of the Paleolithic Age certain favoured spots of France, and northern Spain, and of the Rhine and Danube valleys, have been inhabited by successive waves of peoples, presumably because of the supplies of flint or the limestone caverns that existed there.[1] Similarly, in this country, round Brandon and Dunstable, successive cultures, from the paleolithic onwards, have chosen these flint-bearing localities for settlement.[2] And as the needs of civilized men increased, so did their choice of locality become more varied. The fundamental principle holds from the beginning to the end of human history, so that, at the present day, the distribution of coal in this country mainly determines that of population.

Since the Egyptians and others were setting out to seek raw materials before the archaic civilization had been fully developed, it follows that the earliest food-producing settlements in Europe should display a simpler culture than those, say, of India. This is so, for the so-called " Neolithic " stage of culture in Europe lacks many of the fundamental elements of the archaic civilization. Nevertheless, the aims of these men were to seek out raw materials. It is only on the arrival of the use of stone for construction that signs appear of the archaic civilization. As to the exact date of megalithic monuments in Europe it is not easy to lay down any general rule ; but it would seem that it is best to think that they were the work of men who knew of metals, of gold, copper and tin, for their distribution strongly suggests mining activities. But it is certain that there suddenly appeared in Europe several new cultural elements that strongly suggest the archaic civilization ; bronze daggers, solar symbols, a new form of grave and a great use of gold for personal ornament. The solar symbols suggest at once the Children of the Sun ; and the daggers suggest warfare, of which, it must be noted, no signs whatever exist previously, in connexion with the " neolithic " phase of civilization. The facts suggest that ruling groups were gradually spreading across Europe, beginning in Egypt and moving out by way of Crete and Mycenæan Greece.[3] I shall discuss this matter in my forthcoming work on the "Growth of Civilization."

[1] Cf. the various maps in Osborn.
[2] See Sketch Map No. 6 in Perry xii., which is based on J. Evans.
[3] Cf. A. J. Evans i. for evidence with regard to the spread from Egypt of

Although it is not possible to say much with regard to the social and political conditions of Europe in the days of the coming of the Children of the Sun, who have survived in Greek, Celtic and other mythologies, yet it seems certain that the archaic civilization has, at one period, been transplanted bodily into the basin of the Mediterranean. For a people, known as the Phœnicians, who, according to their traditions, originated in the Persian Gulf, on the Behrein Islands the seat of famous pearl-fisheries, came over and settled on the Syrian coast, and forthwith proceeded to spread all over the basin of the Mediterranean, and probably into the Atlantic. The ruling class of these people were Children of the Sun, who practised mummification and human sacrifice. The Phœnicians were skilful metal-workers, great sailors and traders, who ransacked the countries for treasures, as may be seen from the Twenty-Seventh Chapter of Ezekiel. They were expert stone-workers, and built the Temple for Solomon. They were skilful irrigators.[1] What is more, their culture exhibits strong traces of the dual organization. Tyre and Sidon seem to have formed a dual grouping of cities, with constant rivalry and hostility between them, but the evidence is somewhat obscure on this point. Each city had two harbours, north and south.[2] It is not said whether these were associated with different functions, but that of Carthage was also dual, and was divided into the military and commercial harbours.[3] These harbours were artificial, and were formed by breakwaters, just like those of Ponape. The stone-work was megalithic. "The construction of the central pier is remarkable. It is formed of massive blocks of sandstone, 16 ft. long by 7 ft. wide and deep, which are placed transversely, so that the lengths form the thickness of the pier, and their ends the wall on either side. On both sides of the wall are quays of cement."[4] Tyre was a double city, with seaward and landward parts, as probably was also Carthage. The seaward part was built on an island just near the coast, just as in the Carolines. This was built first, and then another city was built on the land opposite, the two constituting a dual group, like those of the archaic civilization from one end of the region to the other.[5] Little is known of political organization, but what is known goes to link the Phœnicians still closer to the communities of the archaic civilization in Polynesia and elsewhere. For the families of the king and the high priest of Melcarth at Tyre apparently formed an intermarrying group.[6] The government was largely carried on by an aristocratic council, as throughout the archaic civilization. Carthage and its colonies were governed by two

the sun-cult, and therefore, according to the principles worked out here, of the Children of the Sun, to Crete in the Mycenæan period.

[1] See Rawlinson, Movers, Kenrick, for an account of the Phœnician civilization : R. B. Smith, Meltzer, Church, and Bötticher for the Carthaginians.
[2] Rawlinson, 65, 68, 69, 70.
[3] "Ency. Brit.", Art. Carthage, vol. V. 427.
[4] Rawlinson 75. [5] Rawlinson 69. [6] R. B. Smith 15.

Suffetes, kings elected from certain clans, who had priestly functions. The nobility of Carthage is said to have formed two hostile factions, another prominent trait of the archaic civilization. Moreover, civil strife is said to have led to the break-up of the old Phœnician society. Enough has been said to show that a stable foundation probably exists for the theories so lucidly discussed by Dr. Rendel Harris regarding Twin Cults in Europe.[1] When it is remembered that the Phœnicians, the Spartans and the Romans had, in their social and political organization, so much that characterizes the dual organization in India, the Pacific, North America, and, of course, Egypt, it is evident that these beliefs in all probability have, as elsewhere, a direct historical basis, the reconstruction of which will, I am convinced, throw considerable light on the manner of growth and development of the civilization of Europe. When it is remembered, too, that the Phœnicians admittedly depended largely on Egypt for their culture, it is evident that they constitute a typical example of the hypothetical communities, originated in the Indian Ocean, as the result of Egyptian enterprise, which, by continuous segmentation, produced a long chain of daughter settlements, all situated near the sources of raw materials, and all destined to break up as the result of internal instability and external aggression.

[1] Rendel Harris.

LIST OF AUTHORITIES

A	. . .	" L'Anthropologie," Paris.
AA	. .	" The American Anthropologist," Washington, New York, Lancaster.
AAAS	. .	" Report of the Australian Association for the Advancement of Science."
AE	. .	" Ancient Egypt."
AKAW	.	" Königliche-Preussische Akademie der Wissenschaften zu Berlin," Abhandlungen.
ARBE	.	" Annual Reports of the Bureau of American Ethnology," Washington.
ASI	. .	" Archæological Survey of India."
BBE	. .	" Bulletin of the Bureau of Ethnology," Washington.
BTLV	. .	" Bijdragen tot de taal-land-en volkenkund van Nederlandsch-Indie," 's Gravenhage.
ERE	. .	" Hastings' Encyclopaedia of Religion and Ethics."
FL	. . .	" Folk-Lore," London.
IAE	. .	" Internationales Archiv für Ethnographie," Leiden.
ICA	. .	" International Congress of Americanists."
JAFL	. .	" The Journal of American Folk-Lore," Boston and New York.
JASB	. .	" Journal of the Asiatic Society of Bengal," Calcutta.
JBORS	.	" Journal of the Bihar and Orissa Research Society," Patna.
JES	. . .	" Journal of the Ethnological Society of London."
JPS	. .	" Journal of the Polynesian Society."
JRAI	. .	" Journal of the Royal Anthropological Institute."
JRAS	. .	" Journal of the Royal Asiatic Society," London.
JRSNSW	.	" Journal of the Royal Society of New South Wales."
MASB	.	" Memoirs of the Asiatic Society of Bengal," Calcutta.
MGMB		" Bulletin of the Madras Government Museum," Madras.
MGSI	. .	" Memoirs of the Geological Survey of India."
PASB	. .	" Proceedings of the Asiatic Society of Bengal," Calcutta.
PSBA	. .	" Proceedings of the Society of Biblical Archæology," London.
PRIA	. .	" Proceedings of the Royal Irish Academy."
TES	. .	" Transactions of the Ethnological Society of London."
TNAG	. .	" Tijdschrift van het (koninklijk) Nederlandsch Aardrijkskundig Genootschap," Amsterdam, Leiden.
TNZI	. .	" Transactions of the New Zealand Institute."
TRAI	. .	" Transactions of the Royal Anthropological Institute," London.
TRAS	. ,	" Transactions of the Royal Asiatic Society," London.

TTLV . . " Tijdschrift voor indische taat, land-en volkenkunde,"
Batavia and 's Gravenhage.
USGS . . " United States Geological Survey."
VBG . . " Verhandelingen van het Bataviaasch Genootschap
van kunsten en wetenschappen," Batavia.
VKAW . . " Verhandelingen van het (koninklijk) Akademie der
wetenschappen," Amsterdam.
VMKAW . " Verslagen en mededeelingen van het . . . (konink-
lijk) Akademie der wetenschappen," Amsterdam.
ZAS . . " Zeitschrift für Aegyptische Sprache," Leipzig.
ZFE . . " Zeitschrift für Ethnologie," Berlin.

ADRIANI, N. : " Indonesische Priestertaal," VMKAW, Ser. 5, IV,
1920.
ALLEN, W. : " Rotuma and the Rotumans," AAAS, 6, 1895.
ANDERSON, C. W. : " Notes on Prehistoric Stone Implements found
in the Singhbhum District," JBORS, 3, 1917.
ANDREE, R. : " Ethnographische Parallelen und Vergleiche," Neu
Folge, Leipzig, 1889.
ARCHAMBAULT : " Les mégaliths neo-caledoniens," A, 12, 1901.
" Assam Census Report," 1891.
" Atharva Veda " : see Whitney, Bloomfield.
AVALON, A. : " Tantra of the Great Liberation," London, 1913.
AYMONIER, E. : " Le Camboge," Paris, 1900.

BAESSLER, A. : " Marae und Atu auf den Gesellschafts-Inseln,"
IAE, X, 1897.
BAKKERS, J. A. :
 (i) " Tanette en Barroe (Celebes)," TTLV, XII, 1862.
 (ii) " De eilanden Bonerate en Kalao," ibid.
 (iii) " De afdeeling Sandjai (Celebes)," ibid.
 (iv) " Het leenvorstendom Boni," id. XV, 1866.
BALL, V. :
 (i) " On Stone Implements found in Bengal," PASB, 1865.
 (ii) " Geology of the Rajmahal Hills," MGSI, XIII, 1867.
 (iii) " Note on Stone Implements found in Bengal," PASB, 1867.
 (iv) " Note on some Stone Implements found in the District of
Singhbhum," PASB, 1868.
 (v) " On the Ancient Copper Mines of Singhbhum," PASB, 1869.
 (vi) " Remarks on Stone Implements in Singhbhum," PASB,
1870.
 (vii) " On some Stone Implements of the Burmese Type, found
in Pargana Dalbhum, District of Singhbhum, Chota Nagpur
Division," PASB, 1875.
 (viii) " On Stone Implements found in the Tributary States of
Orissa," PASB, 1876.
 (ix) " On the Forms and Geographical Distribution of Ancient
Stone Implements in India," PRIA, Second Ser. I, 1879.
 (x) " On the Mode of Occurrence and Distribution of Gold in
India," Jourl. Roy. Geol. Soc. of Ireland, V, 1880.
BANCROFT, H. H. : " Native Races of the Pacific States of North
America," New York, 1883.
BANDELIER, A. F. : " On the Art of War and Mode of Warfare of the
Ancient Mexicans," 10th Ann. Rep. Peabody Museum, 1877.

BARBEAU, C. M. :
 (i) " Supernatural Beings of the Huron and Wyandot," AA, New Ser. XVI, 1914.
 (ii) " Huron and Wyandot Mythology," Geological Survey, Ottawa. Memoir 80, Ottawa, 1915.
 (iii) " Iroquoian Clans and Phratries," AA, New Ser. XIX, 1917.
BARNETT, L. D. : " Antiquities of India," London, 1913.
BARTH, A. : " The Religions of India," London, 1882.
BARTON, G. A. : " A Sketch of Semitic Origins," New York, 1902.
BASTIAN, A. : " Indonesien," Berlin, 1884–94.
BECKER, G. K. : " Reconnaissance of the Gold Fields of the Southern Appalachians," 16th AR, USGS, 1894–5.
BECKWITH, M. W. : " The Hawaiian Romance of Laieikawai," 33rd ARBE, 1911–12.
BERG, L. W. C. VAN DEN : " De Mohammedansche Vorsten op Neder-landsch-Indie," BTLV, 6th Ser. IX, 1901.
BERGAIGNE, A. : " La religion védique d'après les hymnes du Rig-Veda," 1878–83.
BEST, E. :
 (i) " Spiritual Concepts of the Maori," JPS, IX, 1900.
 (ii) " The Whanga-nui-a-Tara," JPS, X, 1901.
 (iii) " Maori Marriage Customs," TNZI, 36, 1903.
 (iv) " Notes on Ancient Polynesian Migrants or Voyagers to New Zealand," TNZI, 37, 1904.
 (v) " Maori Eschatology," TNZI, 38, 1905.
 (vi) " Maori Religion," AAAS, XII, 1909.
 (vii) " Prehistoric Civilization in the Philippines," JPS, 1.
 (viii) " Maori Forest Lore," TNZI, 42, 1909.
 (ix) " The Cult of Io," Man., 1913, 57.
 (x) " The Peopling of New Zealand," Man., 1914, 37.
 (xi) " Ceremonial Performances Pertaining to Birth, as Per-formed by the Maori of New Zealand in Past Times," JRAI, 44, 1914.
 (xii) " Maori Voyagers and their Vessels," TNZI, 48, 1915.
 (xiii) " Maori and Maruiwi," ibid.
 (xiv) " The Maori Genius for Personification ; with Illustrations of Maori Mentality," TNZI, 53, 1921.
BEUCHAT, H. : " Manuel d'Archéologie Américaine," Paris, 1912.
BHANDARKAR, R. G. : " The Aryans in the Land of the Assurs (Skr-Asura)," JRAS (Bombay), 25, 1917–18.
BISSING, F. W. VON : " Die Mastaba des Gemnikai," Berlin, 1911.
BLACKMAN, A. M. :
 (i) " The Significance of Incense and Libations in Funerary and Temple Ritual," ZAS, 50, 1912.
 (ii) " The Pharaoh's Placenta and the Moon God Khons," JEA, 3, 1916.
 (iii) " The House of the Morning," JEA, 5, 1918.
BLAGDEN, H. O. :
 (i) JRAS, 1902.
 (ii) " Siam and the Malay Peninsula," JRAS, 1906.
BLAKE, W. P. : " The Chalchihuitl of the Ancient Mexicans," Am. Jour. Sc., 2nd Ser. XXV, 1858.
BLANDFORD, W. T. :
 (i) " On the Geology of the Taptee and Nerbadda Valleys and some Adjoining Districts," MGSI, VI, 1869.

(ii) " On the Traps and Intertrappean Beds of Western and Central India," *ibid.*
BLINKENBERG, C. : " The Thunderweapon in Religion and Folk-lore," Easton, 1916.
BLOOMFIELD, M. : " Hymns of the Atharva Veda," Sacred Books of the East, Vol. 42, Oxford, 1897.
BLUMENTRITT, F. :
(i) " Der Ahnencultus und die religiosen Anschauungen der Malaier des Philippinen-Archipels."
(ii) " Gaddanes, etc., des Valle de Cagayan," Mitt. Anth. Ges. Wien., 14, 1884.
BLYTH, W. H. : " The Whence of the Maori," TNZI, XIX, 1886.
BORCHARDT, L. :
(i) " Nilmesser und Nïlstandmarken," AKAW, 1906.
(ii) " Das Grabdenkmal des Königs Neuserre," Leipzig, 1907.
BOTANIC GARDENS, ROYAL : " Bulletin of Miscellaneous Information," Add. Ser. VI, Selected Papers from the Kew Bulletin. II, " Species and Principal Varieties of Musa," London, 1906.
BÖTTLICHER, W. : " Geschichte der Carthager," Berlin, 1827.
BOYLAN, P. : " Thoth the Hermes of Egypt," Oxford, 1922.
BRABROOK : " On the Tombs in the Island of Rotumah," JRAI, VI, 1877.
BRASSEUR DE BOURBOURG : " Popol Vuh," Paris, 1861.
BREASTED, J. H. :
(i) " The Philosophy of a Memphite Priest," ZAS, 39, 1904.
(ii) " Ancient Records of Egypt," London, 1907.
(iii) " A History of the Ancient Egyptians," London, 1908.
(iv) " Development of Religion and Thought in Ancient Egypt," London, 1912.
(v) " A History of Egypt," London, 1919.
BRENNER, J. FRHR. v. : " Besuch bei Kannibalen Sumatras," Würzburg, 1894.
BRIGHAM, W. T. : " Stone Implements and Stone Work of the Ancient Hawaiians," Honolulu, 1902.
BRINTON, D. G. : " American Hero Myths," Philadelphia, 1882.
BROUWER, J. J. v. L. : " Steenen beitels in 't museum van 't Bataviaasch Genootschap," TTLV, XVIII, 1872.
BROWN, A. R. : " The Andaman Islanders," Cambridge, 1922.
BROWN, J. C. :
(i) " Note on Two Copper Axes," JBORS, I, 1915.
(ii) " Note on a Copper Celt found in the Palamau District," *ibid.*
BROWN, MACMILLAN :
(i) " A New Pacific Ocean Script," Man., 1914, 43.
(ii) " Notes on a Visit to New Caledonia," Man., 1916, 66.
BROWNE, A. H. : " An Account of some Early Ancestors of Rarotonga," JPS, 6, 1897.
BRUGSCH, H. : " Mythologica," ZAS, 24, 1886.
BUDGE, E. A. W. : " Legends of the Gods," London, 1912.
BURCHARDT and PIEPER : " Handbuch der Königsnamen," Leipzig, 1912.
BURMA : " Note on the Occurrence of Celts in British Burma," PASB, 1865.
BUSHNELL, D. J., jun. : " Myths of the Louisiana Choctaw," AA, New Ser. 12, 1910.

CABATON, A. : " Java, Sumatra and the other Islands of the Dutch East Indies," London, 1911.

CAIRO : " Exhibits in the Museum at Cairo."

CAMPBELL, R. E. M. : " Traces of Ancient Human Occupation in Pelorus Sound," JPS, 5, 1896.

CANDOLLE, A. DE : " Origin of Cultivated Plants," London, 1884.

CAPART, J. :
(i) " Primitive Art in Egypt," London, 1905.
(ii) " Une rue des Tombeaux," 4to Brussels, 1907.

CAREY, B. S., and TUCK, H. N. : " The Chin Hills," Rangoon, 1896.

CARNOY, A. J. : " Iranian Views of Origins in Connection with Similar Babylonian Beliefs," Jourl. Amer. Oriental Soc. 36, 1916.

CHERRY, T. : " The Discovery of Agriculture," AAAS, 1921.

CHEVALIER, M. : " Remarks on the Production of the Precious Metals, and on the Depreciation of Gold," translated by D. F. Campbell, London, 1853.

CHINNERY, E. W. P. : " Stone-work and Goldfields in British New Guinea," JRAI, 49, 1919.

CHRISTIAN, F. W. :
(i) " Notes on the Marquessans," JPS, IV, 1895.
(ii) " On the Distribution and Origin of some Plant- and Tree-names in Polynesia," JPS, VI, 1897.
(iii) " Notes from the Caroline Islands," ibid.
(iv) " The Caroline Islands," London.

CHURCH, A. J. : " Carthage," London, 1886.

CHURCHILL, W. : " Easter Island," Washington, 1912.

CLAYTON, A. C. : " The Paraiyan," MGMB, V, 2, 1906.

CLIFFORD, H. : " Further India," London, 1905.

CODRINGTON, R. H. : " The Melanesians," Oxford, 1891.

COLE, F. C. : " Traditions of the Tinguian," Field Columbian Museum, 14, No. 1, Anth. Sect., Chicago, 1915.

COLE, R. A. : " On the Discovery of Cromlechs in Southern India," TES, 7, 1869.

COMAN, K. : " Economic Beginnings of the Far West : How we won the land beyond the Mississippi," New York, 1912.

COWELL, E. B. C. : " The Jataka or Stories of the Buddha's Former Births," Cambridge, 1895–1907.

CRANE, W. R. : " Gold and Silver," New York, 1908.

CRAWFURD : " On an Ancient Hindu Sacrificial Bell with Inscription found in the Northern Island of the New Zealand Group," TES, 5, 1867.

CROOKE, W. : " Primitive Rites of Disposal of the Dead with Special Reference to India," JRAI, 1900.

CUNNINGHAM, A. : " Archæological Survey of India," Vol. XIV.

CUSHING, F. H. :
(i) " Zuni Fetiches," 2nd ARBE, 1883.
(ii) " Outlines of Zuni Creation Myths," 13th ARBE, 1891–2.
(iii) " Zuni Folk Tales," New York, 1901.

DALEY, C. : " Remains of the Stone Age in Victoria," AAAS, 12, 1910.

DALTON, E. T. : " Rude Stone Monuments in Chutia Nagpur and Other Places," JASB, 42, 1873.

DANKS, B. : " New Britain and its People," AAAS, 4, 1892.

DANKS, S. : " Some Notes on Savage Life in New Britain," AAAS, 12 ,1910.

DARMESTETER, J. : " Ormazd and Ahriman," Paris, 1876.
DAVIDS, T. W. RHYS : " Buddhist India," London, 1903.
DAVIES, N. DE G. :
 (i) " The Mastaba of Ptahhetep and Akhethetep at Saqqarah,"
 Arch. Surv. of Egypt, Memoir IX, Vol. II, London, 1901.
 (ii) " The Rock Tombs of Deir el Gebrawi," id., Memoir XI,
 London, 1902.
DEANE, W. : " Fijian Society," London, 1921.
DÉCHELETTE, J. : " Manuel d'archéologie préhistorique, celtique et
 gauloise," Paris, 1908.
DEHON, P. : " Religion and Customs of the Uraons," MASB, 9, 1906.
DEUSSEN, P. : " The Philosophy of the Upanishads," Edinburgh, 1906.
DIXON, R. D. : " The Mythology of the Central and Eastern
 Algonkins," JAFL, 22, 1909.
DORSEY, G. A. :
 (i) " Traditions of the Caddo," Carnegie Institute, Publ. No. 41,
 Washington, 1905.
 (ii) " The Cheyenne," Field Columbian Museum, Anthr. Sect.
 IX, 1, 1905.
DORSEY, J. O.
 (i) " Teton Folk-Lore," AA, II, 1889.
 (ii) " A Study of Siouan Cults," 11th ARBE, 1894.
 (iii) " Siouan Sociology," 15th ARBE, 1897.
DUFF, U. F. : " Some Exploded Theories Concerning South-Western
 Archæology," AA, New Ser. 6, 1904.
DUNBAR, G. DUFF-SUTHERLAND : " Abors and Galangs," MASB,
 V, Extra No., 1915.
DUNN, S. C. : " Ancient Gold Mining in the Sudan."
DU PRATZ : " Histoire de la Louisane," 1758.

EERDMANS, A. J. A. F. : " Het landschap Gowa," VBG, 50, 1897.
ELIOT, C. N. G. : " Hinduism in Assam," JRAS, 1910.
ELLA, S. :
 (i) " Samoa," AAAS, 4, 1892.
 (ii) " The Ancient Government of Samoa," ibid., 6, 1895.
 (iii) " 'O le tala le taema ma na-fanua," JPS, 6, 1897.
ELLIS, W. : " Polynesian Researches," London, 1832–6.
EMERSON, E. R. : " The Book of the Dead and Rain Ceremonials,"
 AA, 7, 1894.
ERKELENS, B. : " Geschiedenis van het rijk Gowa."
ERMAN, A. : " Ein Denkmal memphitischer Theologie, Sitzungs-
 berichte der Königlich Preussischen Akademie der Wissen-
 schaften," 1911.
ES, L. J. C. VAN : " Inlandsche Kopererstontginningen op Timor,"
 TNAG, 2nd Ser. 38, 1921.
EVANS, A. J. :
 (i) " Mycenaean Tree and Pillar Cult."
 (ii) " The Palace of Minos," Vol. I, London, 1921.
EVANS, I. H. N. :
 (i) " On a Collection of Stone Implements from the Tempassuk
 District, British New Guinea," Man., 1913, 86.
 (ii) " A Grave and Megaliths in Negri Sembilan with an Account
 of some Excavations," Journal of the Federated Malay
 States Museum, 9, 1921.

EVANS, J. : " The Ancient Stone Implements, Weapons and Ornaments of Great Britain," 2nd ed., London, 1897.

FAWCETT, F. :
 (i) " Notes on some of the People of Malabar," Bull. Madras Govt. Mus., 3, 1900.
 (ii) " Nayars of Malabar," *ibid.*, 1901.

FERGUSSON : " Rude Stone Monuments in all Countries," London, 1872.

FEWKES, J. W. :
 (i) " A Study of Certain Figures in a Maya Codex," AA, 7, 1894.
 (ii) " On Certain Personages who appear in a Tusayan Ceremony," *ibid.*
 (iii) " Tusayan Snake Ceremonies," 16th ARBE, 1897.
 (iv) " The Group of Tusayan Ceremonies called Katcinas," 15th ARBE, 1897.
 (v) " Archæological Expedition to Arizona," 17th ARBE (1895–6), 1898.
 (vi) " Hopi Katcinas," 21st ARBE (1899–1900).
 (vii) " An Interpretation of Katcina Worship," JAFL, 14, 1901.
 (viii) " Two Summers' Work in Pueblo Ruins," 22nd ARBE (1900–1), 1904.
 (ix) " Antiquities of the Mesa Verde, National Park Spruce Tree House," BBE, 41, 1909.
 (x) " Ancient Zuni Pottery," Putnam Anniversary Volume, New York, 1909.
 (xi) " Mesa Verde, National Park Cliff Palace," BBE, 51, 1911.
 (xii) " Preliminary Report on a Visit to the Navaho National Monument, Arizona," BBE, 50, 1911.
 (xiii) " Antiquities of the Upper Verde River and Walnut Creek Valleys, Arizona," 28th ARBE (1906–7), 1912.
 (xiv) " Casa Grande, Arizona," *ibid.*
 (xv) " Sun-worship of the Hopi," BBE, 1921.

FISON, L. : " Tales from Old Fiji," London, 1907.

FLETCHER, A. C. :
 (i) " Star Cult Among the Pawnee," AA, New Ser. 4, 1902.
 (ii) " The Hako, a Pawnee Ceremony," 22nd ARBE, Pt. 2, 1904.
 (iii) " Tribal Structure : A Study of the Omaha and Cognate Tribes," Putnam Anniversary Volume, New York, 1909.

FLETCHER, A. C., and LA FLÈSCHE, F. : " The Omaha Tribe," 27th ARBE, 1911.

FOOTE, R. B. :
 (i) " The Geological Features of the South Mahratta Country and Adjacent Districts," MGSI, 12, 1876.
 (ii) " Indian Prehistoric and Protohistoric Antiquities," Madras, 1916.

FORBES, H. O. : " A Naturalist's Wanderings in the Eastern Archipelago," London, 1885.

FORNANDER, A. : " An Account of the Polynesian Race," London, 1878.

FOX, A. LANE : " Remarks on Mr. Westropp's Paper on Cromlechs," JES, New Ser. 1, 1869.

FOX, C. E. : " Social Organization in San Cristoval, Solomon Islands," JRAI, 49, 1919.

FOX, C. E., and DREW, F. H. : " Beliefs and Tales of San Cristoval, Solomon Islands," JRAI, 45, 1915.

FRASER, J. :
 (i) " Some Folk Songs and Myths from Samoa," JRSNSW, 29, 1895.
 (ii) " Folk-Songs and Myths from Samoa," JPS, 5, 1896.
 (iii) " Folk-Songs and Myths from Samoa," *ibid.*, 6, 1897.
FRAZER, J. G. :
 (i) " Adonis, Attis Osiris," London, 1906.
 (ii) " Totemism and Exogamy," London, 1910.
FREIRE-MARRECO, B. : " Tewa Kinship Terms from the Pueblo of Hano, Arizona," AA, New Ser. 16, 1914.
FRIEDERICH, R. : " Voorloopig verslag van het eiland Bali," VBG, 23, 1850.
FURNESS, W. H., 3rd : " The Stone Money of Uap," Univ. of Penn. Trans. of Dept. of Arch., I, 1904.

GAIT, E. A. : " A History of Assam."
GANN, T. W. F. : " The Maya Indians of Southern Yucatan and Northern British Honduras," BBE, 54, 1918.
GARDINER, A. H. :
 (i) " The Goddess Nekhbet at the Jubilee Festival of Rameses III," ZAS, 48, 1910.
 (ii) " Some Personifications : I. Hike', the God of Magic," PSBA, 38, 1915.
 (iii) Review of J. G. Frazer, " Adonis, Attis Osiris," Journal of Egyptian Archæology, 2, 1915.
GATSCHET, A. S. : " Some Mythic Stories of the Yuchi Indians," AA, 6, 1893.
GAUTHIER, H. : " Le Livre des Rois à l'Egypte," Cairo, 1908-10.
" Genealogies and Notes from Rarotonga," JPS, 1.
GERINI, G. E. :
 (i) " Siamese Archæology," JRAS, 1904.
 (ii) " Researches on Ptolemy's Geography of Eastern Asia," Asiatic Soc. Researches, 1, 1909.
GIFFORD, E. W. : " Dichotomous Social Organization in South Central California," Univ. of California Publications in American Archæology and Ethnology, 11, 1911-16.
GILL, W. W. :
 (i) " Myths and Songs from the South Pacific," London, 1876.
 (ii) " The Genealogy of the Kings and Princes of Samoa," AAAS, 2, 1890.
 (iii) " The Genealogy of the Kings of Rarotonga and Mangaia," AAAS, 2, 1890.
 (iv) " The Story of Tu and Rei," AAAS, 4, 1892.
 (v) " From Darkness to Light in Polynesia," London, 1894.
 (vi) " Remarks on the Legend of Honoura," JPS, 5, 1896.
GILMORE, M. R. : " Uses of Plants by the Indians of the Missouri River Region," 33rd ARBE (1911-12), 1919.
GLAUMONT, M. :
 (i) Usages moeurs et coutumes des Neo-Caledoniens," Rev. d'ethn. 7, 1888.
 (ii) " La culte de l'igaune et du taro en Nouvelle-Caledonie," A, 8.
GOLDIE, W. H. : " Maori Medical Lore," TNZI, 38, 1904.
GOUDSWAARD, A. : " De Papoea's van de Geelvink-Baai," Schiedam, 1863.

GRAEBNER, P. : " Die melanesische Bogenkultur und ihre Verwandten," Anthropos, 4, 1909.
GRAY, W. : " Notes on the Tannese," AAAS, 4, 1892.
GREY, G. : " Polynesian Mythology," London (no date).
GRIERSON, G. A. :
 (i) " Linguistic Survey of India," Vol. 2, Mon-Khmer and Siamese-Chinese Families, 1904.
 (ii) *Ibid.*, Vol. 4, " Munda and Dravidian Languages," 1906.
GRIGNARD, F. J. : " The Oraons and Mundas," Anthropos, 4, 1909.
GRINNELL, G. B. : " Pawnee Hero Stories," London, 1893.
GROENENVELDT, W. P. : " Notes on the Malay Archipelago and Malacca, Compiled from Chinese Sources," VBG, 39, 1877.
GRYZEN, H. J. : " Mededeelingen omtrent Belu of Midden-Timor," VBG, 54, 1904.
GUDGEON : " The Maori Tribes of the East Coast of New Zealand," JPS, 3, 1894.
GUPPY, H. B. :
 (i) " The Solomon Islands and their Natives," London, 1887.
 (ii) " The Solomon Islands, their Geology, etc.," 1887.
 (iii) " Observations of a Naturalist in the Pacific between 1896 and 1899.
 Vol. I. " Vanua Levu, Fiji," London, 1903.
 Vol. II. " Plant Dispersal," London, 1906.
GURDON, P. R. : " The Khasis," London, 1914.

HAAST, J. VAN :
 (i) " On Certain Prehistoric Remains Discovered in New Zealand, and on the Nature of the Deposits in which they Occurred," JES, New Ser. 2, 1870.
 (ii) " Notes on some Ancient Rock Paintings in New Zealand," JRAI, 8, 1879.
HADDON, A. C. (see also Torres Straits) :
 (i) " The Religion of the Torres Straits Islanders," Anthropological Essays presented to E. B. Tylor, Oxford, 1907.
 (ii) " The Wanderings of Peoples," Cambridge, 1911.
 (iii) " The Outriggers of Indonesian Canoes," JRAI, 50, 1920.
HAGAR, S. :
 (i) " Izamal and its Celestial Plan," AA, New Ser. 15, 1913.
 (ii) " The Maya Zodiac of Acanceh," *ibid.*, 16, 1914.
HAGEN : " Beitrage zur Kenntniss der Battareligion," TTLV, 28, 1883.
HAHL : " Mittheilungen über Sitten und rechtliche Verhaltnisse auf Ponape, Ethnologisches Notizblatt herausgegeben von der Koniglichen Museums für Volkerkunde in Berlin," II, 2, 1901.
HALE, A. : " Notes on Stone Implements from Perak," JRAI, 17, 1887.
HALL, R. N., and NEAL, W. G. : " The Ancient Ruins of Rhodesia," London, 1904.
HAMILTON, A. : " On Rock Pictographs in South Canterbury," TNZI, 30, 1897.
" Hand-Book of American Indians."
HANDY, E. S. : " Some Conclusions and Suggestions Regarding the Polynesian Problem," AA, New Ser. 22, 1920.
HARRINGTON, J. P. : " The Ethnogeography of the Tewa Indians," 29th ARBE (1907–8), 1916.

HARRINGTON, M. R. : " A Preliminary Survey of Lenape Culture,"
 AA, New Ser. 15, 1913.
HARRIS, RENDEL :
 (i) " The Cult of the Heavenly Twins."
 (ii) " Boanerges," Cambridge.
HARTMAN : JAFL, 20, 1907.
HASZARD, H. D. M. : " Notes on some Relics of Cannibalism,"
 TNZI, 22, 1889.
HAUGHTON, J. C. : " Memorandum on the Geological Structure and
 Mineral Resources of the Singhbhoom Division," JASB, New
 Ser. 20, 1854.
HESSLING, T. VON : " Die Perlmuscheln," Leipzig, 1859.
HEWETT, E. L. : " Antiquities of the Jemez Plateau, New Mexico,"
 BBE, 32, 1906.
HEWITT, J. N. B. : " Iroquoian Cosmology," 21st ARBE, 1899–1900.
HEWITT, J. P. : " Notes on the Early History of Northern India,"
 JRAS, New Ser., 1888, 1890.
HICKSON, S. J. : " A Naturalist in North Celebes," 1889.
"Hieroglyphic Texts from Egyptian Stelae (British Museum)."
HILL, J. M. : " The Mining Districts of the Western United States,"
 USGS, Bull., 507, 1912.
HILL-TOUT, C. : " British North America," London, 1907.
HOCART, A. M. :
 (i) " Mana," Man., 1914, 46.
 (ii) " Note on the Dual Organization in Fiji," Man., 1914, 2.
 (iii) " Chieftainship and the Sister's Son in the Pacific," AA,
 New Ser. 17, 1915.
 (iv) " The Dual Organization in Fiji," Man., 1915, 3.
 (v) " The Common Sense of Myths," AA, New Ser. 18, 1916.
 (vi) " Early Fijians," JRAI, 49, 1919.
HODSON, T. C. : " The Naga Tribes of Manipur," London, 1911.
HOFFMAN, W. J. :
 (i) " The Mide'wiwin or Grand Medicine Society of the Ojibwa,"
 7th ARBE, 1885–6.
 (ii) " Mythology of the Menomini Indians," AA, 3, 1890.
HOLLAND, T. H. : " Remarks on Crushing Mills used by Ancient
 Gold Miners in Chota Nagpur," PASB, 1903.
HOLMES, W. H. :
 (i) " The Obsidian Mines of Hidalgo, Mexico," AA, New Ser.
 2, 1900.
 (ii) " Traces of Aboriginal Operations in an Iron Mine near
 Leslie, Missouri," AA, New Ser. 5, 1903.
 (iii) " Bearing of Archæological Evidence on the Place of Origin
 and on the Question of the Unity or Plurality of the American
 Race," AA, New Ser. 14, 1912.
 (iv) " Handbook of Aboriginal American Antiquities, Part I,
 Introductory and Lithic Industries," Washington, 1919.
" Honoura, The Legend of," JPS, 4, 1895.
HOPKINS, E. W. : " The Religions of India," London, 1895.
HORNELL, J. : " The Origins and Ethnological Significance of Indian
 Boat Designs," MASB, 7, 1920.
HORST, D. W. : " De Rum-Serams op Nieuw-Guinea of het Hinduisme
 in het oosten van onzen archipel," Leiden, 1893.
HOSE, C., and MCDOUGALL, W. : " The Pagan Tribes of Borneo,"
 London, 1912.

HOUGH, W. : "Antiquities of the Upper Gila and Salt River Valleys in Arizona and New Mexico," BBE, 35, 1907.

HOWITT, A. W. : "The Native Tribes of South-East Australia," London, 1904.

HUETING, A. : "De Tobeloreezen in hun denken en doen," BTLV, 77, 1921.

HUGUENIN, P. : "Raiatea la sacrée," Bull. de la Société Neuchateloise de Géographie, 14, 1902–3.

HUNTINGTON, E. : "The Climatic Factor," Washington, D.C., 1914.

HUTTON, J. H. :
(i) "The Sema Nagas," London, 1921.
(ii) "The Angami Nagas," London, 1921.

"Imperial Gazetteer of India."

"India, Census of," 1901 :
(i) Part I, Report.
(ii) "Ethnographic Appendices."

INDONESIA : "Encyclopædie van Nederlandsch-Indie," Second Edition, 's Gravenhage and Leiden, 1919.

JACKSON, J. W. : "Shells as Evidence of the Migrations of Early Culture," Manchester, 1917.

JAMESON, H. L. : "On the Identity and Distribution of the Mother-of-Pearl Oyster," Proc. Zool. Soc., London, 1901.

JASTROW, M., jun. : "Die Religion Babyloniens und Assyriens," Giessen, 1905.

JATAKAS : See COWELL.

JENKS, A. E. :
(i) "The wild Rice Gatherers of the Upper Lakes," 19th ARBE, 1901.
(ii) "The Bontoe Igorot," Manila, 1905.

JONES, W. : "Episodes in the Culture-Hero Myth of the Sauks and Foxes," JAFL, 14, 1901.

JOSKE, A. B. : "The Nanga of Viti Levu," IAE, 2, 1889.

JOYCE, T. A. (see also C. G. SELIGMAN) :
(i) "British Museum," Handbook to the Ethnographical Collections, London, 1910.
(ii) "Mexican Archæology," London, 1914.

JUYNBOLL, H. H. : "Katalog des Ethnographischen Reichsmuseums, Band V, Javanische Altertümer," Leiden, 1909.

KATE, H. TEN : "Verslag eener reis in de Timorgruppe en Polynesie," TNAG, Sec. Ser. 2, 1894.

KENRICK, J. : "Phœnicia," London, 1855.

KERN, H. :
(i) "Een spaansch schrijver over den godsdienst der heidensche Bikollen," BTLV, 1897.
(ii) "Dravidische Volksnamen op Sumatra," BTLV, 55, 1903.
(iii) "Austronesisch und Austroasiatisch," BTLV, 60, 1908.

KIDDER, A. V. : "Prehistoric Cultures of the San Juan Drainage," 19th ICA.

KING, L. W. : "A History of Sumer and Akkad," London, 1910.

KRÄMER, A. :
(i) "Hawaii, Ostmicronesien Samoa," Stuttgart, 1906.

33

(ii) " Palau, Ergebnisse der Südsee-Expedition," 1908–1910. Hamburgische Wissenschaftliche Stiftung, Hamburg, 1917–1919.

KRÄMER, F. : " Die Samoa-Inseln," Stuttgart, 1902.

KRAUSE, G. : " Bali," Hagen i. W., 1920.

KRIEBEL, D. J. C. : " Het eiland Bonerate," BTLV, 76, 1920.

KROEBER, A. L. : " The Arapaho," Bull. Amer. Mus. Nat. Hist., 18, 1902.

KROEBER, H. R. (Mrs.) : " Pima Texts," AA, New Ser. 10, 1908.

KRUYT, A. C. :
(i) " Het IJzer in Midden-Celebes," BTLV, 53, 1901.
(ii) " De rijstmoeder in den Indischen Archipel," VMKAW, Atd. Lett., 4th Ser. 5, 1903.
(iii) " Het Animisme in den Indischen Archipel," 's Gravenhage, 1906.
(iv) " Measa, eene bijdrage tot het dynamisme der Bare'e-sprekende Toradja's en enkele omwonende volken," BTLV, 74, 1918 ; 75, 1919 ; 76, 1920.
(v) " De To Rongkong in Midden-Celebes," BTLV, 76, 1920.
(vi) " De To Seko in Midden-Celebes," ibid.
(vii) " Verslag van een reis over het eiland Soemba," TNAG, Sec. Ser. 38, 1921.
(viii) " Verslag van een reis naar Kolaka," ibid.
(ix) " Verslag van een reis door Timor," ibid.
(x) " De Roteneezen," TTLV, 60, 1921.

KRUYT, A. C., and ADRIANI, N. : " De Bare'e-sprekende Toradja's van Midden-Celebes," 's Gravenhage, 1912.

KRUYT, A. C., and KRUYT, J. : " Een reis door het Westelijk deel van Midden-Celebes, Mededeelingen, Tijdschrift voor Zendingswetenschap," 64, 1920, Oegstgeest.

KUBARY, J. : " Ethnographische Beiträge zur Kenntniss der Karolinischen Inselgruppe und Nachbarschaft, Heft 1, Die Sociale Einrichtungen der Pelauer," Berlin, 1885.

KUNZ, G. E. :
(i) " The Magic of Jewels and Charms," London, 1915.
(ii) " Gems and Precious Stones of North America," New York, 1890.

KUNZ, G. F., and STEVENSON, C. H. : " The Book of the Pearl," London, 1908.

LA FLÈSCHE : " Omaha and Osage Traditions of Separation," 19th ICA.

LAMBERT : " Moeurs et Superstitions des neo-Caledoniens," Noumea, 1900.

LANGDON, S. :
(i) " Tammuz and Ishtar," Oxford, 1914.
(ii) " Sumerian Liturgical Texts," Univ. of Penn., Univ. Mus., Publ. Baby. Sect. X, 2, 1917.
(iii) " The Epic of Gilgamesh," ibid.
(iv) " Three New Hymns in the Cults of Deified Kings," PSBA, 40, 1918.
(v) " Le poème sumérien du paradis, du déluge et de la chute de l'homme," 1919.
(vi) Article, " Mysteries (Babylonian) " in " Hastings,' Encyclopædia of Religion and Ethics."

LA TOUCHE, T. H. D. : " A Bibliography of Indian Geology and Physical Geography with an Annotated Index of Minerals of Economic Value," Calcutta, 1917.

LECLÉRE, A. : " Histoire du Camboge," Paris, 1914.

LEGGATT, T. W. : " Malekula, New Hebrides," AAAS, 4, 1892.

LEPSIUS, C. R. : " Denkmäler aus Aegypten und Aethiopien," Leipzig.

LETOURNEAU, C. J. M. : "La guerre dans les div. races humaines," 1895.

LIEFRINCK, F. A. : " Bijdrage tot de kennis van het eiland Bali," TTLV, 21, 1875.

LINDGREN, W. (i), and GRATON, L. : " A Reconnaissance of the Mineral Deposits of New Mexico," Contributions to Economic Geology, USGS, Bull. 285, 1906.

LINDGREN, W. (ii), GRATON, L. C., and GORDON, C. H. : " The Ore Deposits of New Mexico," USGS, Professional Paper, 68, 1910.

LIPPMANN, E. O. VON : " Entstehung und Ausbreitung der Alchemie," Berlin, 1919.

LOCK, A. G. : " Gold," London, 1882.

LOISY, A. : " Essai historique sur le Sacrifice," Paris, 1920.

LONG, R. C. E. : " The Maya and Christian Eras," Man., 1918, 70.

LUMHOLTZ, C. :
 (i) " Symbolism of the Huichol Indians."
 (ii) " Unknown Mexico," London, 1903.

LYALL, A. C. : " Asiatic Studies," London, 1899.

MACCAULEY : " The Seminole Indians of Florida," 5th ARBE, 1887.

MACDONALD, D. : " The New Hebrides," AAAS, 4, 1892.

MACKENZIE, D. A. :
 (i) " Colour Symbolism," FL, 1922.
 (ii) " Myths of Pre-Columbian America."

MACLAREN, J. M. : " Gold," London, 1908.

MACLEAN, J. P. : " The Mound Builders," Cincinnati, 1885.

MACPHERSON, S. C. : " An Account of the Religion of the Khonds in Orissa," JRAS, 13, 1852.

MADRAS : " Bulletin of the Madras Government Museum."

MAHABHARATA : See RAY.

MALCOLM, J. : " Essay on the Bhills," TRAS, 1, 1827.

MALINOWSKI, B. : " Baloma; The Spirits of the Dead in the Trobriand Islands," JRAI, 46, 1916.

MANDHAR (CELEBES) : " Mededeelingen betreffende eenige Mandharsche Landschappen," BTLV, 62, 1909.

MARIETTE :
 (i) " Mastabas."
 (ii) " Catalogue d'Abydos."

MARINER, W. : " An Account of the Natives of the Tonga Islands," London, 1818.

MARSDEN, W. : " A History of Sumatra," London, 1811.

MASPERO, G. :
 (i) " Un manuel de hiérarchie égyptienne, Études Egyptiennes," Vol. 2, Paris, 1888.
 (ii) " The Dawn of Civilization."

MATEER, S. : " Native Life in Travancore," London, 1883.

MATHEW, J. : " The Origin of the Australian Phratries and Explanations of some of the Phratry Names," JRAI, 40, 1910.

MATTHES, B. F. : " Over de Ada's of gewoonten der Makassaren en Bœgineezen," VMKAW, Af. Lett., 3rd Ser. 2, 1885.

MATTHEWS, W. :
 (i) " Ethnology and Philology of Hidatsa Indians," Misc. Publ. No. 7, U.S. Geol. and Geog. Survey, Washington, 1877.
 (ii) " The Mountain Chant, a Navajo Ceremony," 5th ARBE, 1887.
 (iii) " The Prayer of a Navajo Shaman," AA, 1, 1888.
 (iv) " Navaho Legends," New York, 1897.
 (v) " Myths of Gestation and Parturition," AA, New Ser. 4, 1902.

MAZUMDAR : " Durga, Her Origin and History," JRAS, 1906.

McDONALD, Rev. Dr. : " Early Arabia and Oceania," AAAS, 10, 1910.

McDOUGALL, W. : See HOSE.

McGEE, W. J. : " The Seri Indians," 17th ARBE, 1898.

McLELLAN, J. F. : " Studies in Ancient History."

MELOS : " Excavations at Phylakopi in Melos," Society for the Promotion of Hellenic Studies, Supplementary Paper Number 1, London, 1904.

MELTZER, O. : " Geschichte der Karthager," Berlin, 1879.

MEYER, E. :
 (i) " Aegyptische Chronologie," AKAW, Phil.-Hist. Klasse, 1904.
 (ii) " Nachträge zur aegyptischen Chronologie," id., 1907.
 (iii) " Geschichte des Altertums," I, 2, 1909.

MEYER, K., and NUTT, A. : " The Voyage of Bran," London, 1895–7.

MICHELSON, T. : " Menominee Tales," AA, New Ser. 13, 1911.

MINDELEFF, C. :
 (i) " A Study of Pueblo Architecture, Tusayan and Cibola," 8th ARBE (1886–7), 1891.
 (ii) " Aboriginal Remains in Verde Valley, Arizona," 13th ARBE (1891–2), 1896.
 (iii) " The Cliff Ruins of Canyon de Chelly, Arizona," 16th ARBE (1894–5), 1897.

" Mineral Resources of the United States," USGS (Annual).

MITRA, P. : " Prehistoric Cultures and Races of India," Univ. of Calcutta, Jour. of Dept. of Letters, 1920.

MOONEY, J. :
 (i) " The Sacred Formulas of the Cherokee," 7th ARBE, 1889.
 (ii) " Cherokee Mound-Building," AA, 2, 1889.
 (iii) " The Cherokee Ball Play," AA, 3, 1890.
 (iv) AA, 1890.
 (v) " The Siouan Tribes of the East," BAE, 22, 1894.
 (vi) " Calendar History of the Kiowa Indians," 17th ARBE, 1898.
 (vii) " Myths of the Cherokee," 19th ARBE, 1900.
 (viii) " The Cherokee River-Cult," JAFL, 13, 1900.
 (ix) 20th ARBE, 1901.

MOORHEAD, W. K. : " Prehistoric Implements," Cincinnati, Ohio, 1900.

MORET, A. :
 (i) " Du caractère religieux de la royauté Pharonique," Ann. du Musée Guimet, Bibl. d'Études, 20, 1902.
 (ii) " Mystères egyptiens," Conf. au Musée Guimet, Ann. de Mus. Guimet, Bibl. de Vulgarisation, Paris, 1912.
 (iii) " La royauté dans l'Egypte primitive : Totem et Pharaon," Ann. de Musée Guimet, Bibl. de Vulg., 38, 1912.

(iv) " Les Statues d'Egypte, ' images vivantes,' " Ann. de Mus. Guimet, Bibl. de Vulg., 41, 1916.

MORGAN, J. DE :
(i) " Recherches sur les Origines de l'Egypte," Paris, 1896–7.
(ii) " Mastaba de Mera."
(iii) " Délégation en Perse," Vol. 13, 1912.

MORGAN, L. H. : " Ancient Society," 1877.

MORLEY, S. G. :
(i) " The Rise and Fall of the Maya Civilization in the Light of the Monuments and the Native Chronicles," 19th ICA.
(ii) " The Inscriptions at Copan," Washington, 1920.

MORRIS, E. H. : " Preliminary Account of the Antiquities of the Region between the Mancos and La Plata Rivers in South-Western Colorado," 33rd ARBE (1911–12), 1919.

MORRIS, F. BRAM : " Het landschap Loehoe, getrokken uit een rapport van den Gouverneur van Celebes," TTLV, 32, 1889.

MOSZKOWSKI, JRAS, 1909.

MOULTON, J. H. : " Early Zoroastrianism," London, 1913.

MOVERS, F. E. : " Die Phönizier," Bonn, 1841.

MUIR, J. : " Original Sanskrit Texts," London, 1872.

MÜLLER, S. : " Reizen en onderzoekingen in den Indischen Archipel," Amsterdam, 1857.

MÜLLER (WISMAR), W. : " Yap, Ergebnisse der Südsee Expedition," 1908–10. Hamburgische Wissenschaftliche Stiftung, Hamburg, 1917–18.

MUNN, L. : " Ancient Mines and Megaliths in Hyderabad," Mem. Proc. Manchester Lit. and Phil. Soc. 54, 1921.

MURRAY, M. A. :
(i) " Priesthoods of Women in Egypt," Trans. Third Int. Cong. Hist. Rel., Oxford, 1908.
(ii) " The Cult of the Drowned in Egypt," ZAS, 51, 1913.
(iii) " Evidence for the Custom of Killing the King in Ancient Egypt," Man., 1914, 12.
(iv) " Royal Marriage and Matrilineal Descent," JRAI, 45, 1915.
(v) " Index to Names and Titles of the Old Kingdom."
(vi) " Saqqara Mastabas," Egyptian Research Account, London, 1905.

NARASAU, P. L. : " The Essence of Buddhism," Madras, 1907.

" Necker Island, Stone Idols from," JPS, 3.

NEWBERRY, J. S. : " Report of the Exploring Expedition from Santa Fé, New Mexico, to the Junction of the Grand and Green Rivers of the Great Colorado of the West in 1857," Washington, 1876.

NEWBERRY, P. E. :
(i) " The Life of Rekhmara," London, 1900.
(ii) " The Horus-Title of the Kings of Egypt," PSBA, 26, 1904.

NEWBOLD, CAPT. : " Ancient Sepulchres of Panduvaram Dewal, in Southern India," JRAS, 13, 1852.

NEWELL, J. E. : " Notes on Tokelau, Gilbert and Ellice Islanders," AAAS, 6, 1895.

" Nova Guinea."

NUTTALL, Z. :
(i) " Chalchihuitl in Ancient Mexico," AA, New Ser. 3, 1901.

(ii) " Some Unsolved Problems in Mexican Archæology," AA, New Ser. 8, 1906.

OLDEN, C. : " Notes on a Discovery of Ancient Copper Smelting Apparatus at Rakkhan in the Dalbhum Pargana of Singbhum," JBORS, 5, 1919.

OLDHAM, C. F. : " The Sun and the Serpent," London, 1905.

OPPERT, G. : " The Original Inhabitants of Bharatavarsa or India," London, 1893.

ORR, R. B. : " Pre-Columbian Copper in Ontario," 18th ICA, 1912, London.

OSBORN, H. F. : " Men of the Old Stone Age," London, 1921.

OWEN, J. A. (Mrs.) : " The Story of Hawaii," London, 1898.

OWEN, M. A. : " Folk-Lore of the Musquakie Indians of North America," London, 1904.

PAHANG : " Notes on Stone Implements from Pahang," Man. 1904, 34.

PARGITER, F. E. :
(i) " Ancient Indian Genealogies and Chronology," JRAS, 1910.
(ii) " The Purana Text of the Dynasties of the Kali Age," Oxford, 1913.
(iii) " Ancient Indian Genealogies : Are they Trustworthy ? " Commemorative Essays presented to Sir R. G. Bhandarkar, Poona, 1917.
(iv) " Ancient Indian Historical Tradition," Oxford, 1922.

PARKER, A. C. :
(i) " Iroquois Sun Myths," JAFL, 23, 1900.
(ii) " Iroquois Tree Myths and Symbols," AA, New Ser. 14, 1912.
(iii) " The Origin of the Iroquois as suggested by their Archæology," id., 18, 1916.

PEARCE, J. E. : " Indian Mounds and other Relics of Indian Life in Texas," AA, New Ser. 21, 1919.

PEET, T. E. : " New Light on Mining in Sinai," Jourl. Manchester Egy. and Orien. Soc. (1918–19), 1920.

PERRY, W. J. :
(i) " The Orientation of the Dead in Indonesia," JRAI, 44, 1914.
(ii) " Myths of Origin and the Home of the Dead," FL, 26, 1915.
(iii) " The Relationship between the Geographical Distribution of Megalithic Monuments and Ancient Mines," Mem. and Proc. Manchester Lit. and Phil. Soc., 1915. [See Rep. Brit. Ass., 1915.]
(iv) " The Geographical Distribution of Terraced Cultivation and Irrigation," id., 1916.
(v) " An Ethnological Study of Warfare," id., 1917.
(vi) " The Peaceful Habits of Primitive Communities," Hibbert Journal, Oct., 1917.
(vii) " The Megalithic Culture of Indonesia," Manchester, 1918.
(viii) " War and Civilization," Manchester, 1918.
(ix) " The Significance of the Search for Amber in Antiquity," Jourl. Manchester Egy. and Orien. Soc. (1918–19), 1920.
(x) " The Development and Spread of Civilization," Nature, March 31, 1921.
(xi) " The Isles of the Blest," FL, 32, 1921.
(xii) " The Problem of [Megalithic Monuments and their Distribution in England and Wales," Mem. Proc. Manchester Lit. and Phil. Soc., 1921.

(xiii) " The Relation of Class Distinctions to Social Conduct,"
Hibbert Journal, 1922.
PETRIE, W. F. :
(i) " History of Egypt," London, 1894–1901.
(ii) " Egyptian Beliefs in a Future Life," AE, 1914.
(iii) " The Geography of the Gods," AE, 1917.
(iv) " Prehistoric Egypt," London, 1920.
(v) " Medum," London, 1892.
PATTERSON, R. H. : " The New Golden Age, and the Influence of
the Precious Metals upon the World," Edinburgh, 1882.
PHAYRE, A. P. : " On the History of Pegu," JASB, 1873.
PINCHES, T. E. :
(i) " Notes on the Deification of Kings, and Ancestor-Worship,
in Babylonia," PSBA, 37, 1915.
(ii) " The Legend of the Divine Lovers, Entil and Ninlil,"
JRAS, 1919.
PLEYTE, C. M. : " Singa Mangaradja, de heilige koning der Bataks,"
BTLV, 55, 1903.
POGUE, J. E. : " The Aboriginal Use of Turquoise in North America,"
AA, New Ser. 14, 1912.
POSEWITZ, T. : " Borneo," London, 1892.
POWELL, J. W. :
(i) " Wyandot Government," 1st ARBE.
(ii) " Linguistic Families of America North of Mexico," 7th
ARBE, 1885–6.
POWELL, T., and PRATT, G. : " On Some Folk-Songs and Myths
from Samoa," JRSNSW, 24, 1890.
PRATT, G. : (See also POWELL, T.)
(i) " Genealogy of the Sun : A Samoan Legend," AAAS, 1, 1888.
(ii) " Some Folk-Songs and Myths from Samoa," JRSNSW, 25,
1891.
(iii) " Some Folk-Songs and Myths from Samoa," JRSNSW,
26, 1892.
PRATZ : see DU PRATZ.
PRESCOTT, W. H. : " The Conquest of Mexico," Everyman Library,
London.

RADAU, H. : " Early Babylonian History," New York, 1900.
RADIN, P. : " The Clan Organization of the Winnebago," AA, New
Ser. 12, 1910.
RATZEL, F. : " History of Mankind," London, 1897.
RAY, P. C. : " The Mahabharata," Calcutta, 1892.
RAWLINSON, G. : " History of Phœnicia," London, 1889.
RAWLINSON, H. G. : " Foreign Influences in the Civilization of
Ancient India, 900 B.C.–400 A.D.," JRAS (Bombay), 23, 1912.
REA, A. :
(i) " Some Prehistoric Burial-places in Southern India," JASB,
57, 1888.
(ii) " Pallava Inscriptions," ASI, Ser. 34, 1909.
RICHARDS, F. J. :
(i) " Cross Cousin Marriage in South India," Man., 1914, 97.
(ii) " Some Dravidian Affinities and their Sequel."
RIGGS, S. R. : " Dakota Grammar Texts, and Ethnography." U.S.
Geological and Geographical Survey of the Rocky Mountain

Region. Contributions to North American Ethnology, Vol. 9, 1893.

RISLEY, H. H. : " Caste, Tribe and Race," Chapter 11 of Census of India Report, Vol. 1, Part 1, Calcutta, 1903.

RIVERS, W. H. R. : (See also Torres Straits Reports.)
 (i) " The Todas," London, 1906.
 (ii) " On the Origin of the Classificatory System of Relationships," Anthropological Essays presented to E. B. Tylor, Oxford, 1907.
 (iii) " The Marriage of Cousins in India," JRAS, 1907.
 (iv) Presidential Address, Section H, Brit. Ass., 1911 ; Nature, 1911.
 (v) " The Disappearance of Useful Arts," Festsscrift Tillägnad Edward Westermarck, Helsingfors, 1912.
 (vi) " Survival in Sociology," Sociological Review, 1913.
 (vii) " The Contact of Peoples," Essays and Studies presented to William Ridgeway, Cambridge, 1913.
 (viii) " Is Australian Culture Simple or Complex ? " Rep. Brit. Ass., 1914 ; Man., 1914.
 (ix) " The History of Melanesian Society," Cambridge, 1914.
 (x) " Sun-Cult and Megaliths in Oceania," AA, New Ser. 17, 1915.
 (xi) " Sociology and Psychology," Sociological Review, 1916.
 (xii) Art. " New Hebrides," ERE.
 (xiia) " Irrigation and the Cultivation of Taro," Nature, 1916.
 (xiii) Fitzpatrick Lectures, 1915 ; " Medicine, Magic, and Religion," Lancet, 1916.
 (xiv) " The Statues of Easter Island," FL, 1920.
 (xv) Art. " Mother-right," ERE.
 (xvi) " History and Ethnology," London, 1922.

ROTH, H. LING :
 (i) " The Aborigines of Tasmania," Halifax, 1890.
 (ii) " The Natives of Sarawak and British North Borneo," London, 1896.

ROTH, W. E. : " North Queensland Ethnography," Bull. No. 9, Burial Ceremonies and Disposal of the Dead, Records of the Australian Museum, Vol. 6, 1907.

ROUAFFER, G. P. :
 (i) " Waar kwamen de radselachtig Moetisalah'a (Aggri-kralen) in de Timor-groep oorsprongkelijk van daan ? " BTLV, Ser. 6, 6.
 (ii) " Zijn er nog Hindoe-Oudheden in Midden-Borneo aan de Boven-Sekadan," TTLV, 51, 1909.

ROULIN : " Rapport sur une collection d'instruments en pierre découverts dans l'ile de Java, et remontant à une époque anteriéure à celle où commence pour ce pays l'histoire proprement dite." Comptes Rendus des Séances de l'academie des Sciences, Vol. 67, 1868.

ROUTLEDGE, K. (Mrs.) : " The Mystery of Easter Island, the Story of an Expedition." 2nd Ed., London, 1920.

ROY, S. C. :
 (i) " The Mundas and their Country," Calcutta, 1912.
 (ii) " Magic and Witchcraft on the Chota Nagpur Plateau," JRAI, 44, 1914.
 (iii) " The Oraons of Chota Nagpur," Ranchi, 1915.

(iv) " A Note on some Remains of the Ancient Asuras in the Ranchi District," JBORS, 1915.

(v) " Notes on some Prehistoric Stone Implements found in the Ranchi District," JBORS, 1916.

(vi) " Relics of the Copper Age found in Chota Nagpur," JBORS, 1916.

(vii) " A Find of Ancient Bronze Articles in the Ranchi District," JBORS, 1916.

RUSSELL, F. : " The Pima Indians," 26th ARBE, 1908.

RUSSELL, R. V. : " The Tribes and Castes of the Central Provinces of India," London, 1916.

RUST, H. N. : " The Obsidian Blades of California," AA, New Ser. 7, 1905.

RUTLAND, J. :

(i) " Ancient Human Occupation in Pelorus District," JPS, 3, 1894.

(ii) " On some Ancient Stone Implements, Pelorus District, Middle Island, New Zealand," JPS, 5, 1896.

(iii) " Traces of Civilization," TNZI, 29, 1896.

(iv) " Did the Maori discover the Greenstone ? " TNZI, 30, 1897.

(v) " On the Ancient Pit Dwellings of Pelorus District, South Island, New Zealand, JPS, 6, 1897.

SAFFORD, W. E. : " Guam and its People," AA, New Ser. 4, 1902.

SAHAGUN, B. DE : " Histoire générale des Choses de la Nouvelle-Espagne," Paris, 1880.

SALDANHA, J. A. : " Philology and Ethnology and their bearing on Customary Law in the Bombay Presidency," JRAS (Bombay), 25, 1917–18.

" Samoa : Prehistoric Remains in Samoa," JPS, 3.

SASTRI, H. K. : " South Indian Images of Gods and Goddesses," Madras, 1916.

" Satapatha-Brahmana," SBE, 44, 1900.

SCHMIDT, P. W. :

(i) " Die Sprachen der Sakei und Semang auf Malacca und ihr Verhältnis zu den Mon-Khmer-Sprachen," BTLV, 52, 1901.

(ii) " Grundzuge einer Lautlehre der Mon-Khmer-Sprachen," Denkschriften der Kaiser 1. Akad. d. Wiss. in Wien. phil.-hist. Kl. Bd. III.

(iii) " Grundzuge einer Lautlehre der Khasi-Sprache, in ihren Beziehungen zu derjenigen der Mon-Khmer-Sprachen," Abh. der Kön. Bayer. Akad. d. Wiss. Kl. I, Bd. 22, Abt. 3.

(iv) " Die Gliederung der australischen Sprachen," Anthropos. 13, 1917–18.

SCHOFF, W. : " The Periplus of the Erythraean Sea," 1912.

SCHOOLCRAFT, H. R. : " Information resp. the hist., condition, etc., of the Indian Tribes of the United States," Philadelphia, 1853–7.

SCHWARZ, J. A. T. : " Tontemboansche Teksten," Leiden, 1907.

SCOTT, H. L. : " Notes on the Kado or Sun Dance of the Kiowa," AA, New Ser. 13, 1911.

SELER, E. : " Einiges über die natürlichen Grundlagen mexicanischer Mythen," ZFE, 39, 1907.

SELIGMAN, C. G., and B. Z. : " The Veddas," Cambridge, 1911.

SELIGMAN, C. G., and JOYCE, T. A. : " On Prehistoric Objects in

British New Guinea," Anthropological Essays presented to E. B. Tylor, Oxford, 1907.

SELIGMAN, C. G. :
 (i) " The Melanesians of British New Guinea," Cambridge, 1910.
 (ii) Presidential Address, Section H, British Association, 1915 (Manchester).

SEMPLE, E. C. : " Influences of Geographical Environment, on the Basis of Ratzel's System of Anthropo-geography," London, 1911.

SETHE, K. :
 (i) " Die Heiligthumer des Re' im alten Reich," ZAS, 27, 1889.
 (ii) " Geschichte des Amtes (Vizier) im alten Reich," ZAS, 28, 1890.
 (iii) " Beitrage zur Ältesten Geschichte Ägyptens. I. Die Horusdiener. Untersuchungen zur Geschichte und Altentumskunde Aegyptens," Leipzig, 3, 1905.
 (iv) " Die Namen von Ober- und Unterägypten und die Beziehungen für Nord und Sud," ZAS, 44, 1907.
 (v) " Das Fehlen des Begriffes der Blutschande bei den alten Ägypten," ZAS, 50, 1912.
 (vi) " Zur altägyptischen Sage von Sonnenauge das in der Fremde war," Leipzig, 1912.
 (vii) " Urkunden des alten Reichs," Leipzig, 1903.

SHAKESPEAR, L. W. :
 (i) " The Lushei Kuki Clans," London, 1912.
 (ii) " History of Upper Assam, Upper Burma and North-Eastern Frontier," London, 1914.

SHAND, A. : " The Moriori People of the Chatham Islands," JPS, 3.

SHERRING, M. A. : " The Bhar Tribe," JRAS, 1881.

SHORTT, J. : " The Fishermen of Southern India," TES, 5, 1867.

SIMPSON, C. T. : " Synopsis of the Naiades, or Pearly Fresh-Water Mussels," Proc. U.S. Nat. Mus., 22, 1900.

SIRET, L. : " Questions de chronologie et d'ethnographie ibériques," Paris, 1913.

SKEAT, W. W. : " Malay Magic," London, 1900.

SKEAT, W. W., and BLAGDEN, H. O. : " Pagan Races of the Malay Peninsula," London, 1906.

SKERTCHLY, J. B. J. : " On the Occurrence of Stone Mortars in the Ancient (? Pliocene) River Gravels of Butte County, California," JRAI, 17, 1887.

SKINNER, H. D. : " Evolution in Maori Art," JRAI, 46, 1916.

SMITH, G. ELLIOT :
 (i) " A Contribution to the Study of Mummification in Egypt," Memoires présentes à l'Institut Egyptien, Tome 5, Fasc. 1, 1906.
 (ii) " The History of Mummification in Egypt," Proc. Roy. Phil. Soc. of Glasgow, 1910.
 (iii) " The Ancient Egyptians," London and New York, 1911.
 (iv) " The Influence of Egypt under the Ancient Empire," Rep. Brit. Ass., 1911 ; Man., 1911.
 (v) " The Royal Mummies," Catalogue Général des Antiquités Egyptiennes du Musée du Caire, 1912.
 (vi) " The Earliest Evidence of Attempts at Mummification in Egypt," Rep. Brit. Ass., 1912.
 (vii) " Megalithic Monuments and their Builders," Rep. Brit. Ass., 1912 ; Man., 1912.

(viii) " The Origin of the Dolmen," Rep. Brit. Ass., 1913 ; Man., 1913.
(ix) " The Evolution of the Rock-Cut Tomb and the Dolmen," Essays and Studies presented to William Ridgeway, Cambridge, 1913.
(x) " Early Racial Migrations and the Spread of Certain Customs," Rep. Brit. Ass., 1914 ; Man., 1914.
(xi) " Discussion on Influence of Ancient Egyptian Civilization on the World's Culture," Rep. Brit. Ass., 1915, p. 667.
(xii) " The Migrations of Early Culture," Manchester, 1915.
(xiii) " Pre-Columbian Representations of the Elephant in America," Nature, 1915, 1916.
(xiv) " The Origin of the Pre-Columbian Civilization of America," Science, New Ser. 44, 1916.
(xv) "Primitive Man," Proc. Brit. Accd., 1917.
(xvi) " The Influence of Ancient Egyptian Civilization in the East and in America," Manchester, 1916. [Bull. of John Rylands Library, 1916.]
(xvii) " Ships as Evidence of the Migrations of Early Culture," Manchester, 1917.
(xviii) " The Giver of Life," Journal of the Manchester Egyptian and Oriental Society, 1917–18.
(xix) " Ancient Mariners," Jourl. Manchester Geogr. Soc., 1917.
(xx) " The Evolution of the Dragon," Manchester, 1919.
SMITH, R. B. : " Carthage and the Carthaginians," London, 1879.
SMITH, S. P. :
(i) " Tongareva, or Penrhyn Island," TNZI, 22, 1889.
(ii) " Uea ; or Wallis Island and its People," JPS, 1.
(iii) " Stone Implements from the Chatham Islands," JPS, 1.
(iv) "The Tahitian ' Hymn of Creation,' " JPS, 2.
(v) " The Tohunga-Maori," TNZI, 32, 1899.
(vi) " Hawaiki : the Original Home of the Maori," London, 1910.
(vii) " The Polynesians in Indonesia," JPS, 30.
SMITH, W. R. :
(i) " Kinship and Marriage in Early Arabia," 1885.
(ii) " Lectures on the Religion of the Semites," Sec. Ed., London, 1894.
SMYTH, H. W. : " Notes on a Journey to some of the South-Western Provinces of Siam," Geogr. Jourl., 6, 1895.
SOUTHALL, J. : " On Pliocene Man in America," Jourl. Victoria Inst., 15, 1882.
SPECK, F. G. :
(i) " Notes on Chickasaw Ethnology and Folklore," JAFL, 20, 1907.
(ii) " Ethnology of the Yuchi Indians," Univ. of Penn., Anth. Publ. of the Univ. Museum, Vol. 1, No. 1, 1909.
(iii) " Creek and Yuchi Ceremonial Songs," id., 1911.
(iv) " The Family Hunting Band as the Basis of Algonkian Social Organization," AA, New Ser. 17, 1915.
SPENCE : " Myths of Mexico and Peru."
SPENCER, B. : " Blood and Shade Divisions of Australian Tribes," Proc. Roy. Soc. Victoria, 24, 1921.
SPENCER, B., and GILLEN, F. J. : " The Northern Tribes of Central Australia," London, 1904.

SPENCER, J. : " Shawnee Folk-Lore," JAFL, 22, 1909.
SPINDEN, H. J. :
 (i) " A Study of Maya Art," Mem. Peabody Museum, Harvard, 1913.
 (ii) " The Origin and Distribution of Agriculture in America," 19th ICA.
STAIR, J. B. :
 (i) " O le Fale-o-le-Fe'e, or, Ruins of an Old Samoan Temple," JPS, 3, 1894.
 (ii) " Samoa, whence Peopled ? " JPS, 4, 1895.
 (iii) " Early Samoan Voyages and Settlements," AAAS, 6, 1895.
 (iv) " Flotsam and Jetsam from the Great Ocean," JPS, 4, 1895.
 (v) " Jottings on the Mythology and Spirit-lore of Old Samoa," JPS, 6, 1897.
 (vi) " Old Samoa," London, 1897.
STEMPELL : " Die Tierbilder der Mayahandschriften," ZFE, 40, 1908.
STEVENSON, M. C. (Mrs.) :
 (i) " The Sia," 11th ARBE, 1894.
 (ii) " The Zuni Indians, their Mythology, Esoteric Fraternities and Ceremonies," 23rd ARBE, 1904.
SUAS, J. :
 (i) " Mythes et Légendes des Indigénes des Nouvelles-Hébrides," Anthropos., 7, 1912.
 (ii) " Notes ethnographiques sur les indigénes des Nouvelles-Hébrides," id., 9, 1914.
 (iii) " I Talu Tuei, les hommes d'autrefois, ou les premiers Hébredains," id., 12–13, 1917–18.
SWANTON, J. R. :
 (i) " Indian Tribes of the Lower Mississippi," BBE, 1911.
 (ii) " A Foreword on the Social Organization of the Creek Indians," AA, New Ser. 14, 1912.
 (iii) " The Creek Indians as Mound Builders," AA, New Ser. 14, 1912.

TAHITI : " The Quest and Occupation of Tahiti," Vol. 3, Hakluyt Society, Sec. Ser. 43, 1918.
TAUTAIN, DR. :
 (i) " Sur l'anthropophagie et les sacrifices humains aux iles Marquises," A, 7, 1896.
 (ii) " Notes sur les Constructions et Monuments des Marquises," A, 8, 1897.
TAYLOR, MEADOWS :
 (i) " On Prehistoric Archæology of India," JES, New Ser. 1, 1869.
 (ii) " Descriptions of Cairns, Cromlechs, Kistvaens, and other Celtic, Druidical, or Scythian Monuments in the Dekhan," TRIA, 24, 1873.
TAYLOR, R. : " Te Ika a Maui, or New Zealand and its Inhabitants," London, 1870.
THEOBALD, W. :
 (i) " Notes on the Stone Implements of Burma," PASB, 1869.
 (ii) " On the Geology of Pegu," MGSI, 10, 1873.
THOMAS, C. :
 (i) " Curious Customs and Strange Freaks of the Mound-Builders," AA, 1, 1888.

(ii) "Report on the Mound Explorations of the Bureau of Ethnology," 12th ARBE (1890–1), 1894.
(iii) "Introduction to the Study of North American Archæology," Cincinnati, 1898.
THOMSON, B. :
(i) New Guinea : Narrative of an Exploring Expedition to the Louisiade and D'Entrecasteaux Islands," PRGS, 11, 1889.
(ii) "Notes upon the Antiquities of Tonga," JRAI, 32, 1902.
(iii) "The Fijians," London, 1908.
THURSTON, E. :
(i) "Castes and Tribes of Southern India," Madras, 1909.
(ii) "The Madras Presidency," Cambridge, 1913.
TIDEMANS, J. : "De Batara Gowa op Zuid-Celebes," BTLV, 61, 1908.
TOD, J. : "Annals and Antiquities of Rajasthan," 3rd Ed., 1880.
Torres Straits : "Report of the Cambridge Anthropological Expedition to Torres Straits," Vols. 5 and 6, Cambridge, 1904, 1908.
TOY, C. H. : "Mexican Human Sacrifice," JAFL, 18, 1905.
TREGEAR, E. :
(i) "Polynesian Folk-Lore : Hina's Voyage to the Sacred Isle," TNZI, 19, 1886.
(ii) "The Track of a Word," id.
(iii) "Ancient Alphabets in Polynesia," id., 20, 1887.
(iv) "Polynesian Folk-Lore : 2. The Origin of Fire," id.
(v) "Thoughts on Comparative Mythology," TNZI, 30, 1898.
TURNER, G. : "Samoa a Hundred Years Ago and Long Before," London, 1884.
TYLOR, E. B. : "Primitive Culture," 4th Ed., 1903.

VISHNU PURANA : see H. H. WILSON.
VISSER, M. W. DE : "The Dragon in China and Japan," VKAW, Afd. Lett., New Ser. 13, 1913.
VOTH, H. R. :
(i) "The Traditions of the Hopi," Field Mus. of Nat. Hist. Anthr., Ser. 8, 1905.
(ii) Brief Miscellaneous Hopi Papers, id., 11, 1912.

WADDELL, L. A. : "A Trilingual List of Naga Rajas," JRAS, 1894.
WAKE, C. S. : "Traits of an Ancient Egyptian Folk-Tale compared with those of Aboriginal American Tales," JAFL, 17, 1904.
WALHOUSE, M. J. : "Notes on the Megalithic Monuments of the Coimbatore District, Madras," JRAS, 1875.
WALLACE, A. R. : "The Malay Archipelago," 3rd Ed., London, 1890.
WALLACE, D. B. : "Notes on Manihaki Island," JPS, 29, 1920.
WAUGH, R. W. : "Iroquois Foods and Food Preparation," Ottawa, 1916.
WEIL, A. : "Die Veziere des Pharaonen Reiches."
WEILL, R. : "Les Origines de l'Egypte Pharonique," Ann. du Musé Guimet, Bibliothèque d'Études, XXV, Paris, 1908.
WESTERMARCK, E. : "The History of Human Marriage," 5th Ed., London, 1921.
WESTMAN, S. : "Notes on Great Barrier Island," TNZI, 22, 1889.
WESTON, J. M. (Miss): "From Ritual to Romance."
WESTROPP, H. M. : "Cromlechs and Megalithic Structures," JES, New Ser. 1, 1869.

WEULE, K. : Art. in Helmholt's " History of the World," Vol. II.

WHITNEY, W. T. : " Atharva-Veda Samhita," Translated by W. D. Whitney, 1905.

WIEDEMANN, A. : " Religion of the Ancient Egyptians," London, 1897.

WILKEN, G. A. : " Handleiding voor de Vergelijkende Volkenkunde van Nederlandsch-Indie," Leiden, 1893.

WILKINS, W. J. :
 (i) " Modern Hinduism," London, 1887.
 (ii) " Hindu Mythology," Calcutta, 1892.

WILLIAMS, J. : " A Narrative of Missionary Enterprises in the South Sea Islands," London, 1837.

WILLOUGHBY, C. C. : " The Virginia Indians in the Seventeenth Century," AA, New Ser. 9, 1907.

WILSON, H. H. :
 (i) " The Vishnu Purana," London, 1840.
 (ii) " On the Sacrifice of Human Beings as an Element of the Ancient Religions of India," JRAS, 13, 1852.

WILSON, T. :
 (i) " Prehistoric Art," Ann. Rep. U.S. Nat. Mus. for 1896 ; Washington, 1898.
 (ii) " Arrowpoints, Spearheads, and Knives of Prehistoric Times," Ann. Rep. U.S. Nat. Mus., 1899.

WINSHIP, G. P. : " The Coronado Expedition, 1540–1542," 14th ARBE (1892–3), 1896.

WISSLER, C. :
 (i) " Material Cultures of the North American Indians," AA, New Ser. 16, 1914.
 (ii) " The Influence of the Horse on the Development of Plains Culture," id., 16, 1914.
 (iii) " Comparative Study of Pawnee and Blackfoot Rituals," 19th ICA.
 (iv) " The American Indian."

WRAY, L. : " The Cave Dwellers of Perak," JRAI, 26, 1897.

YARROW, H. C. : " Mortuary Customs of the North American Indians," 1st ARBE (1879–80), 1881.

YETTS, H. P. : " The Chinese Isles of the Blest," FL, 30, 1919.

INDEX

(The numbers that appear in brackets after certain names of tribes and of places refer to the maps in which these names occur.)

LOST CITIES OF ATLANTIS, ANCIENT EUROPE & THE MEDITERRANEAN
by David Hatcher Childress

Atlantis! The legendary lost continent comes under the close scrutiny of maverick archaeologist David Hatcher Childress in this sixth book in the internationally popular *Lost Cities* series. Childress takes the reader in search of sunken cities in the Mediterranean; across the Atlas Mountains in search of Atlantean ruins; to remote islands in search of megalithic ruins; to meet living legends and secret societies. From Ireland to Turkey, Morocco to Eastern Europe, and around the remote islands of the Mediterranean and Atlantic, Childress takes the reader on an astonishing quest for mankind's past. Ancient technology, cataclysms, megalithic construction, lost civilizations and devastating wars of the past are all explored in this book. Childress challenges the skeptics and proves that great civilizations not only existed in the past, but the modern world and its problems are reflections of the ancient world of Atlantis.
524 PAGES. 6x9 PAPERBACK. ILLUSTRATED. BIBLIOGRAPHY & INDEX. $16.95. CODE: MED

LOST CITIES OF CHINA, CENTRAL INDIA & ASIA
by David Hatcher Childress

Like a real life "Indiana Jones," maverick archaeologist David Childress takes the reader on an incredible adventure across some of the world's oldest and most remote countries in search of lost cities and ancient mysteries. Discover ancient cities in the Gobi Desert; hear fantastic tales of lost continents, vanished civilizations and secret societies bent on ruling the world; visit forgotten monasteries in forbidding snow-capped mountains with strange tunnels to mysterious subterranean cities! A unique combination of far-out exploration and practical travel advice, it will astound and delight the experienced traveler or the armchair voyager.
429 PAGES. 6x9 PAPERBACK. ILLUSTRATED. FOOTNOTES & BIBLIOGRAPHY. $14.95. CODE: CHI

LOST CITIES OF ANCIENT LEMURIA & THE PACIFIC
by David Hatcher Childress

Was there once a continent in the Pacific? Called Lemuria or Pacifica by geologists, Mu or Pan by the mystics, there is now ample mythological, geological and archaeological evidence to "prove" that an advanced and ancient civilization once lived in the central Pacific. Maverick archaeologist and explorer David Hatcher Childress combs the Indian Ocean, Australia and the Pacific in search of the surprising truth about mankind's past. Contains photos of the underwater city on Pohnpei; explanations on how the statues were levitated around Easter Island in a clockwise vortex movement; tales of disappearing islands; Egyptians in Australia; and more.
379 PAGES. 6x9 PAPERBACK. ILLUSTRATED. FOOTNOTES & BIBLIOGRAPHY. $14.95. CODE: LEM

LOST CITIES OF NORTH & CENTRAL AMERICA
by David Hatcher Childress

Down the back roads from coast to coast, maverick archaeologist and adventurer David Hatcher Childress goes deep into unknown America. With this incredible book, you will search for lost Mayan cities and books of gold, discover an ancient canal system in Arizona, climb gigantic pyramids in the Midwest, explore megalithic monuments in New England, and join the astonishing quest for lost cities throughout North America. From the war-torn jungles of Guatemala, Nicaragua and Honduras to the deserts, mountains and fields of Mexico, Canada, and the U.S.A., Childress takes the reader in search of sunken ruins, Viking forts, strange tunnel systems, living dinosaurs, early Chinese explorers, and fantastic lost treasure. Packed with both early and current maps, photos and illustrations.
590 PAGES. 6x9 PAPERBACK. ILLUSTRATED. FOOTNOTES. BIBLIOGRAPHY. INDEX. $16.95. CODE: NCA

LOST CITIES & ANCIENT MYSTERIES OF SOUTH AMERICA
by David Hatcher Childress

Rogue adventurer and maverick archaeologist David Hatcher Childress takes the reader on unforgettable journeys deep into deadly jungles, high up on windswept mountains and across scorching deserts in search of lost civilizations and ancient mysteries. Travel with David and explore stone cities high in mountain forests and hear fantastic tales of Inca treasure, living dinosaurs, and a mysterious tunnel system. Whether he is hopping freight trains, searching for secret cities, or just dealing with the daily problems of food, money, and romance, the author keeps the reader spellbound. Includes both early and current maps, photos, and illustrations, and plenty of advice for the explorer planning his or her own journey of discovery.
381 PAGES. 6x9 PAPERBACK. ILLUSTRATED. FOOTNOTES. BIBLIOGRAPHY. INDEX. $16.95. CODE: SAM

LOST CITIES & ANCIENT MYSTERIES OF AFRICA & ARABIA
by David Hatcher Childress

Across ancient deserts, dusty plains and steaming jungles, maverick archaeologist David Childress continues his world-wide quest for lost cities and ancient mysteries. Join him as he discovers forbidden cities in the Empty Quarter of Arabia; "Atlantean" ruins in Egypt and the Kalahari desert; a mysterious, ancient empire in the Sahara; and more. This is the tale of an extraordinary life on the road: across war-torn countries, Childress searches for King Solomon's Mines, living dinosaurs, the Ark of the Covenant and the solutions to some of the fantastic mysteries of the past.
423 PAGES. 6x9 PAPERBACK. ILLUSTRATED. FOOTNOTES & BIBLIOGRAPHY. $14.95. CODE: AFA

ANCIENT SCIENCE

THE GIZA DEATH STAR
The Paleophysics of the Great Pyramid & the Military Complex at Giza
by Joseph P. Farrell

Physicist Joseph Farrell's amazing book on the secrets of Great Pyramid of Giza. *The Giza Death Star* starts where British engineer Christopher Dunn leaves off in his 1998 book, *The Giza Power Plant*. Was the Giza complex part of a military installation over 10,000 years ago? Chapters include: An Archaeology of Mass Destruction, Thoth and Theories; The Machine Hypothesis; Pythagoras, Plato, Planck, and the Pyramid; The Weapon Hypothesis; Encoded Harmonics of the Planck Units in the Great Pyramid; High Freqquency Direct Current "Impulse" Technology; The Grand Gallery and its Crystals: Gravito-acoustic Resonators; The Other Two Large Pyramids; the "Causeways," and the "Temples"; A Phase Conjugate Howitzer; Evidence of the Use of Weapons of Mass Destruction in Ancient Times; more.
290 PAGES. 6x9 PAPERBACK. ILLUSTRATED. $16.95. CODE: GDS

THE GIZA DEATH STAR DEPLOYED
The Physics & Engineering of the Great Pyramid
by Joseph P. Farrell

Physicist Joseph Farrell's amazing sequel to *The Giza Death Star* which takes us from the Great Pyramid to the asteroid belt and the so-called Pyramids of Mars. Farrell expands on his thesis that the Great Pyramid was a chemical maser, designed as a weapon and eventually deployed—with disastrous results to the solar system. Includes: Exploding Planets: The Movie, the Mirror, and the Model; Dating the Catastrophe and the Compound; A Brief History of the Exoteric and Esoteric Investigations of the Great Pyramid; No Machines, Please!; The Stargate Conspiracy; The Scalar Weapons; Message or Machine?; A Tesla Analysis of the Putative Physics and Engineering of the Giza Death Star; Cohering the Zero Point, Vacuum Energy, Flux: Synopsis of Scalar Physics and Paleophysics; Configuring the Scalar Pulse Wave; Inferred Applications in the Great Pyramid; Quantum Numerology, Feedback Loops and Tetrahedral Physics; and more.
290 PAGES. 6x9 PAPERBACK. ILLUSTRATED. BIBLIOGRAPHY. INDEX. $16.95. CODE: GDSD

PIRATES & THE LOST TEMPLAR FLEET
The Secret Naval War Between the Templars & the Vatican
by David Hatcher Childress

The lost Templar fleet was originally based at La Rochelle in southern France, but fled to the deep fiords of Scotland upon the dissolution of the Order by King Phillip. This banned fleet of ships was later commanded by the St. Clair family of Rosslyn Chapel (birthplace of Free Masonry). St. Clair and his Templars made a voyage to Canada in the year 1398 AD, nearly 100 years before Columbus! Chapters include: 10,000 Years of Seafaring; The Knights Templar & the Crusades; The Templars and the Assassins; The Lost Templar Fleet and the Jolly Roger; Maps of the Ancient Sea Kings; Pirates, Templars and the New World; Christopher Columbus—Secret Templar Pirate?; Later Day Pirates and the War with the Vatican; Pirate Utopias and the New Jerusalem; more.
320 PAGES. 6x9 PAPERBACK. ILLUSTRATED. BIBLIOGRAPHY. $16.95. CODE: PLTF

CLOAK OF THE ILLUMINATI
Secrets, Transformations, Crossing the Star Gate
by William Henry

Thousands of years ago the stargate technology of the gods was lost. Mayan Prophecy says it will return by 2012, along with our alignment with the center of our galaxy. In this book: Find examples of stargates and wormholes in the ancient world; Examine myths and scripture with hidden references to a stargate cloak worn by the Illuminati, including Mari, Nimrod, Elijah, and Jesus; See rare images of gods and goddesses wearing the Cloak of the illuminati; Learn about Saddam Hussein and the secret missing library of Jesus; Uncover the secret Roman-era eugenics experiments at the Temple of Hathor in Denderah, Egypt; Explore the duplicate of the Stargate Pillar of the Gods in the Illuminists' secret garden in Nashville, TN; Discover the secrets of manna, the food of the angels; Share the lost Peace Prayer posture of Osiris, Jesus and the Illuminati; more. Chapters include: Seven Stars Under Three Stars; The Long Walk; Squaring the Circle; The Mill of the Host; The Miracle Garment; The Fig; Nimrod: The Mighty Man; Nebuchadnezzar's Gate; The New Mighty Man; more.
238 PAGES. 6x9 PAPERBACK. ILLUSTRATED. BIBLIOGRAPHY. INDEX. $16.95. CODE: COIL

THE CHRONOLOGY OF GENESIS
A Complete History of the Nefilim
by Neil Zimmerer

Follow the Nefilim through the Ages! This is a complete history of Genesis, the gods and the history of Earth — before the gods were destroyed by their own creations more than 2500 years ago! Zimmerer presents the most complete history of the Nefilim ever developed — from the Sumerian Nefilim kings through the Nefilim today. He provides evidence of extraterrestrial Nefilim monuments, and includes fascinating information on pre-Nefilim man-apes and man-apes of the world in the present age. Includes the following subjects and chapters: Creation of the Universe; Evolution: The Greatest Mystery; Who Were the Nefilim?; Pre-Nefilim Man-Apes; Man-Apes of the World—Present Age; Extraterrestrial Nefilim Monuments; The Nefilim Today; All the Sumerian Nefilim Kings listed in chronological order, more. A book not to be missed by researchers into the mysterious origins of mankind.
244 PAGES. 6x9 PAPERBACK. ILLUSTRATED. REFERENCES. $16.95. CODE: CGEN

LEY LINE & EARTH ENERGIES
An Extraordinary Journey into the Earth's Natural Energy System
by David Cowan & Anne Silk

The mysterious standing stones, burial grounds and stone circles that lace Europe, the British Isles and other areas have intrigued scientists, writers, artists and travellers through the centuries. They pose so many questions: Why do some places feel special? How do ley lines work? How did our ancestors use Earth energy to map their sacred sites and burial grounds? How do ghosts and poltergeists interact with Earth energy? How can Earth spirals and black spots affect our health? This exploration shows how natural forces affect our behavior, how they can be used to enhance our health and well being, and ultimately, how they bring us closer to penetrating one of the deepest mysteries being explored. A fascinating and visual book about subtle Earth energies and how they affect us and the world around them.
368 PAGES. 6x9 PAPERBACK. ILLUSTRATED. BIBLIOGRAPHY. INDEX. $18.95. CODE: LLEE

ANCIENT SCIENCE

THE LAND OF OSIRIS
An Introduction to Khemitology
by Stephen S. Mehler

Was there an advanced prehistoric civilization in ancient Egypt? Were they the people who built the great pyramids and carved the Great Sphinx? Did the pyramids serve as energy devices and not as tombs for kings? Independent Egyptologist Stephen S. Mehler has spent over 30 years researching the answers to these questions and believes the answers are yes! Mehler has uncovered an indigenous oral tradition that still exists in Egypt, and has been fortunate to have studied with a living master of this tradition, Abd' El Hakim Awyan. Mehler has also been given permission to present these teachings to the Western world, teachings that unfold a whole new understanding of ancient Egypt and have only been presented heretofore in fragments by other researchers. Chapters include: Egyptology and Its Paradigms; Khemitology—New Paradigms; Asgat Nefer—The Harmony of Water; Khemit and the Myth of Atlantis; The Extraterrestrial Question; 17 chapters in all.

272 PAGES. 6X9 PAPERBACK. ILLUSTRATED. COLOR SECTION. BIBLIOGRAPHY. $18.95. CODE: LOOS

A HITCHHIKER'S GUIDE TO ARMAGEDDON
by David Hatcher Childress

With wit and humor, popular Lost Cities author David Hatcher Childress takes us around the world and back in his trippy finalé to the Lost Cities series. He's off on an adventure in search of the apocalypse and end times. Childress hits the road from the fortress of Megiddo, the legendary citadel in northern Israel where Armageddon is prophesied to start. Hitchhiking around the world, Childress takes us from one adventure to another, to ancient cities in the deserts and the legends of worlds before our own. Childress muses on the rise and fall of civilizations, and the forces that have shaped mankind over the millennia, including wars, invasions and cataclysms. He discusses the ancient Armageddons of the past, and chronicles recent Middle East developments and their ominous undertones. In the meantime, he becomes a cargo cult god on a remote island off New Guinea, gets dragged into the Kennedy Assassination by one of the "conspirators," investigates a strange power operating out of the Altai Mountains of Mongolia, and discovers how the Knights Templar and their off-shoots have driven the world toward an epic battle centered around Jerusalem and the Middle East.

320 PAGES. 6X9 PAPERBACK. ILLUSTRATED. BIBLIOGRAPHY. INDEX. $16.95. CODE: HGA

CLOAK OF THE ILLUMINATI
Secrets, Transformations, Crossing the Star Gate
by William Henry

Thousands of years ago the stargate technology of the gods was lost. Mayan Prophecy says it will return by 2012, along with our alignment with the center of our galaxy. In this book: Find examples of stargates and wormholes in the ancient world; Examine myths and scripture with hidden references to a stargate cloak worn by the Illuminati, including Mari, Nimrod, Elijah, and Jesus; See rare images of gods and goddesses wearing the Cloak of the illuminati; Learn about Saddam Hussein and the secret missing library of Jesus; Uncover the secret Roman-era eugenics experiments at the Temple of Hathor in Denderah, Egypt; Explore the duplicate of the Stargate Pillar of the Gods in the Illuminists' secret garden in Nashville, TN; Discover the secrets of manna, the food of the angels; Share the lost Peace Prayer posture of Osiris, Jesus and the Illuminati; more. Chapters include: Seven Stars Under Three Stars; The Long Walk; Squaring the Circle; The Mill of the Host; The Miracle Garment; The Fig; Nimrod: The Mighty Man; Nebuchadnezzar's Gate; The New Mighty Man; more.

238 PAGES. 6X9 PAPERBACK. ILLUSTRATED. BIBLIOGRAPHY. INDEX. $16.95. CODE: COIL

LEY LINE & EARTH ENERGIES
An Extraordinary Journey into the Earth's Natural Energy System
by David Cowan & Anne Silk

The mysterious standing stones, burial grounds and stone circles that lace Europe, the British Isles and other areas have intrigued scientists, writers, artists and travellers through the centuries. They pose so many questions: Why do some places feel special? How do ley lines work? How did our ancestors use Earth energy to map their sacred sites and burial grounds? How do ghosts and poltergeists interact with Earth energy? How can Earth spirals and black spots affect our health? This exploration shows how natural forces affect our behavior, how they can be used to enhance our health and well being, and ultimately, how they bring us closer to penetrating one of the deepest mysteries being explored. A fascinating and visual book about subtle Earth energies and how they affect us and the world around them.

368 PAGES. 6X9 PAPERBACK. ILLUSTRATED. BIBLIOGRAPHY. INDEX. $18.95. CODE: LLEE

THE ORION PROPHECY
Egyptian & Mayan Prophecies on the Cataclysm of 2012
by Patrick Geryl and Gino Ratinckx

In the year 2012 the Earth awaits a super catastrophe: its magnetic field reverse in one go. Phenomenal earthquakes and tidal waves will completely destroy our civilization. Europe and North America will shift thousands of kilometers northwards into polar climes. Nearly everyone will perish in the apocalyptic happenings. These dire predictions stem from the Mayans and Egyptians—descendants of the legendary Atlantis. The Atlanteans had highly evolved astronomical knowledge and were able to exactly predict the previous world-wide flood in 9792 BC. They built tens of thousands of boats and escaped to South America and Egypt. In the year 2012 Venus, Orion and several others stars will take the same 'code-positions' as in 9792 BC! For thousands of years historical sources have told of a forgotten time capsule of ancient wisdom located in a mythical labyrinth of secret chambers filled with artifacts and documents from the previous flood. We desperately need this information now—and this book gives one possible location.

324 PAGES. 6X9 PAPERBACK. ILLUSTRATED. BIBLIOGRAPHY. $16.95. CODE: ORP

ALTAI-HIMALAYA
A Travel Diary
by Nicholas Roerich

Nicholas Roerich's classic 1929 mystic travel book is back in print in this deluxe paperback edition. The famous Russian-American explorer's expedition through Sinkiang, Altai-Mongolia and Tibet from 1924 to 1928 is chronicled in 12 chapters and reproductions of Roerich's inspiring paintings. Roerich's "Travel Diary" style incorporates various mysteries and mystical arts of Central Asia including such arcane topics as the hidden city of Shambala, Agartha, more. Roerich is recognized as one of the great artists of this century and the book is richly illustrated with his original drawings.

407 PAGES. 6X9 PAPERBACK. ILLUSTRATED. $18.95. CODE: AHIM

ANCIENT SCIENCE

MAYAN GENESIS
South Asian Myths, Migrations and Iconography In Mesoamerica
by Graeme R. Kearsley

India in the Americas? Did the ancient Buddhists, Hindus and Jains transfer cultural influences into Mesoamerica? Were the Maya also in India? Who were the Mandaeans and were they among the enablers and traders who influenced the Maya? Packed with over 1200 illustrations, this book is an instant classic that will rock the academic world. Chapters include Climatic Causes of Early Migrations; Myths and Legends of the Kwakiutl; Mariners, Missions, Traders and Sea Voyages; Myths and Legends of Migration; Tula—Bearded Gods and Monoliths; The Mysterious Zapotecs of Oaxaca; The Maya and the Pacific; Mayan Collapse? or a Return to the Land of the Ancestors; Indonesia and Cultural Diffusion; Architectural and Iconographical References Originating from India Found Among the Maya; Calendrical Rounds; Spider Deities and Star Demons; Sky Pillars; The Cosmic Tree-Megalithics and Monoliths to Planted Pillars; Pauahtuns—"Sons of the Wind" Sacred Symbols of the Mariner Gods; The Turban—The Mariner's Crown; Symbol of Authority—the Vajra/Dorje/Trident; Giants and Wind Gods; The Mandaeans; Reed Bundles of the Mayan, Aztec and in Asia; The Realm of the Peacock Angel and the Red-Haired Mandaeans; tons more. Imported from Britain.

1098 PAGES. 7x9 PAPERBACK. ILLUSTRATED. INDEX. $39.95. CODE: MGEN

SOLOMON: FALCON OF SHEBA
The Tomb and Image of the Queen of Sheba Discovered
by Ralph Ellis

The Queen of Sheba, King Solomon and King David are still household names in much of the Western and Middle Eastern world, so how is it possible that all of these influential monarchs are completely missing from the archaeological record? The reality of this omission has perplexed theologians and historians alike for centuries, but maverick archeologist Ralph Ellis, author of *Jesus, Last of the Pharaohs* and *Tempest & Exodus*, has rediscovered their lost tombs and sarcophagi. The reason that Ralph has succeeded where generations of archaeologists have failed is that the latter were looking in the wrong location—surprisingly enough, the tombs of these monarchs are not to be found in either Israel, Ethiopia or Yemen. While the discovery of the tombs of King Solomon, King David, Hiram Abif and the Queen of Sheba may in itself be a startling and dramatic revelation, the precise historical identities of these monarchs serves to completely rewrite the whole of the Biblical Old Testament and much of our secular history, too. In short, history was not as we know it...

360 PAGES. 6x9 PAPERBACK. ILLUSTRATED. BIBLIOGRAPHY. $20.00. CODE: SFOS

THOTH
Architect of the Universe
by Ralph Ellis

This great book, now available in paperback, is on sacred geometry, megalithic architecture and the worship of the mathematical constant pi. Ellis contemplates Stonehenge; the ancient Egyptian god Thoth and his Emerald Tablets; Atlantis; Thoth's Ratios; Henge of the World; The Secret Gate of Knowledge; Precessional Henge; Royal Planisphere; Kufu's Continents; the Ma'at of the Egyptians; ancient technological civilizations; the Ark of Tutankhamen; Pyramidions; the Pyramid Inch and Pi; more. Well illustrated with color photo sections.

236 PAGES. 6x9 PAPERBACK. ILLUSTRATED. BIBLIOGRAPHY. $16.00. CODE: TOTH

K2—QUEST OF THE GODS
by Ralph Ellis

This sequel to *Thoth, Architect of the Universe* explains the design of the Great Pyramid in great detail, and it appears that its architect specified a structure that contains a curious blend of technology, lateral thinking and childish fun—yet this design can also point out the exact location of the legendary 'Hall of Records' to within a few meters! The 'X' marks the spot location has been found at last. Join the author on the most ancient quest ever devised, a dramatic journey in the footsteps of Alexander the Great on his search for the legendary Hall of Records, then on to the highest peaks at the top of the world to find the 'The Great Pyramid in the Himalayas'; more.

280 PAGES. 6x9 PAPERBACK. ILLUSTRATED. COLOR SECTION. BIBLIOGRAPHY. $16.00. CODE: K2QD

TEMPEST & EXODUS
by Ralph Ellis

Starts with the dramatic discovery of a large biblical quotation on an ancient Egyptian stele which tells of a conference in Egypt discussing the way in which the biblical Exodus should be organized. The quotation thus has fundamental implications for both history and theology because it explains why the Tabernacle and the Ark of the Covenant were constructed, why the biblical Exodus started, where Mt. Sinai was located, and who the god of the Israelites was. The most dramatic discovery is that the central element of early Israelite liturgy was actually the Giza pyramids, and that Mt. Sinai was none other than the Great Pyramid. Mt. Sinai was described as being both sharp and the tallest 'mountain' in the area, and thus the Israelite god actually resided deep within the bowels of this pyramid. Furthermore, these new translations of ancient texts, both secular and biblical, also clearly demonstrate that the Giza pyramids are older than the first dynasty—the ancestors of the Hyksos were writing about the Giza pyramids long before they are supposed to have been constructed! Includes: Mt. Sinai, the Israelite name for the Great Pyramid of Egypt; the biblical Exodus inscribed on an Egyptian stele of Ahmose I; the secret name of God revealed; Noah's Ark discovered, more.

280 PAGES. 6x9 PAPERBACK. ILLUSTRATED. COLOR SECTION. BIBLIOGRAPHY & INDEX. $16.00. CODE: TEXO

JESUS, LAST OF THE PHARAOHS
Truth Behind the Mask Revealed
by Ralph Ellis

This book, with 43 color plates, traces the history of the Egyptian royal family from the time of Noah through to Jesus, comparing biblical and historical records. Nearly all of the biblical characters can be identified in the historical record—all are pharaohs of Egypt or pharaohs in exile. The Bible depicts them as being simple shepherds, but in truth they were the Hyksos, the Shepherd Kings of Egypt. The biblical story that has circulated around the globe is simply a history of one family, Abraham and his descendants. In the Bible he was known as Abram; in the historical record he is the pharaoh Maybra—the most powerful man on Earth in his lifetime. By such simple sleight of hand, the pharaohs of Egypt have hidden their identity, but preserved their ancient history and bloodline. These kings were born of the gods; they were not only royal, they were also Sons of God.

320 PAGES. 6x9 PAPERBACK. ILLUSTRATED. $16.00. CODE: JLOP

MYSTIC TRAVELLER SERIES

THE MYSTERY OF EASTER ISLAND
Katherine Routledge

THIS RARE ARCHAEOLOGY BOOK ON
EASTER ISLAND IS BACK IN PRINT!

THE MYSTERY OF EASTER ISLAND
by Katherine Routledge
The reprint of Katherine Routledge's classic archaeology book which was first published in London in 1919. The book details her journey by yacht from England to South America, around Patagonia to Chile and on to Easter Island. Routledge explored the amazing island and produced one of the first-ever accounts of the life, history and legends of this strange and remote place. Routledge discusses the statues, pyramid-platforms, Rongo Rongo script, the Bird Cult, the war between the Short Ears and the Long Ears, the secret caves, ancient roads on the island, and more. This rare book serves as a sourcebook on the early discoveries and theories on Easter Island.
432 PAGES. 6X9 PAPERBACK. ILLUSTRATED. $16.95. CODE: MEI

MYSTERY CITIES
OF THE MAYA
by Thomas Gann

Archaeology and Adventure in Central America!
Mystic Travellers Series

MYSTERY CITIES OF THE MAYA
Exploration and Adventure in Lubaantun & Belize
by Thomas Gann
First published in 1925, *Mystery Cities of the Maya* is a classic in Central American archaeology-adventure. Gann was close friends with Mike Mitchell-Hedges, the British adventurer who discovered the famous crystal skull with his adopted daughter Sammy and Lady Richmond Brown, their benefactress. Gann battles pirates along Belize's coast and goes upriver with Mitchell-Hedges to the site of Lubaantun where they excavate a strange lost city where the crystal skull was discovered. Lubaantun is a unique city in the Mayan world as it is built out of precisely carved blocks of stone without the usual plaster-cement facing. Lubaantun contained several large pyramids partially destroyed by earthquakes and a large amount of artifacts. Gann shared Mitchell-Hedges belief in Atlantis and lost civilizations (pre-Mayan) in Central America and the Caribbean. Lots of good photos, maps and diagrams.
252 PAGES. 6X9 PAPERBACK. ILLUSTRATED. $16.95. CODE: MCOM

IN SECRET TIBET
T. Illion

MYSTIC TRAVELLER SERIES

IN SECRET TIBET
by Theodore Illion
Reprint of a rare 30s adventure travel book. Illion was a German wayfarer who not only spoke fluent Tibetan, but travelled in disguise as a native through forbidden Tibet when it was off-limits to all outsiders. His incredible adventures make this one of the most exciting travel books ever published. Includes illustrations of Tibetan monks levitating stones by acoustics.
210 PAGES. 6X9 PAPERBACK. ILLUSTRATED. $15.95. CODE: IST

DARKNESS OVER TIBET
by Theodore Illion
In this second reprint of Illion's rare books, the German traveller continues his journey through Tibet and is given directions to a strange underground city. As the original publisher's remarks said, "this is a rare account of an underground city in Tibet by the only Westerner ever to enter it and escape alive! "
210 PAGES. 6X9 PAPERBACK. ILLUSTRATED. $15.95. CODE: DOT

Danger My Ally

The true life adventure of
F.A. Mitchell-Hedges

DANGER MY ALLY
The Amazing Life Story of the Discoverer of the Crystal Skull
by "Mike" Mitchell-Hedges
The incredible life story of "Mike" Mitchell-Hedges, the British adventurer who discovered the Crystal Skull in the lost Mayan city of Lubaantun in Belize. Mitchell-Hedges lived an exciting life: gambling everything on a trip to the Americas as a young man, riding with Pancho Villa, questing for Atlantis, fighting bandits in the Caribbean and discovering the famous Crystal Skull.
374 PAGES. 6X9 PAPERBACK. BIBLIOGRAPHY & INDEX. $16.95. CODE: DMA

IN SECRET MONGOLIA

HENNING HASLUND
AUTHOR OF
'MEN AND GODS
IN MONGOLIA'

MYSTIC TRAVELLER SERIES

IN SECRET MONGOLIA
by Henning Haslund
First published by Kegan Paul of London in 1934, Haslund takes us into the barely known world of Mongolia of 1921, a land of god-kings, bandits, vast mountain wilderness and a Russian army running amok. Starting in Peking, Haslund journeys to Mongolia as part of the Krebs Expedition—a mission to establish a Danish butter farm in a remote corner of northern Mongolia. Along the way, he smuggles guns and nitroglycerin, is thrown into a prison by the new Communist regime, battles the Robber Princess and more. With Haslund we meet the "Mad Baron" Ungern-Sternberg and his renegade Russian army, the many characters of Urga's fledgling foreign community, and the last god-king of Mongolia, Seng Chen Gegen, the fifth reincarnation of the Tiger god and the "ruler of all Torguts." Aside from the esoteric and mystical material, there is plenty of just plain adventure: Haslund encounters a Mongolian werewolf; is ambushed along the trail; escapes from prison and fights terrifying blizzards; more.
374 PAGES. 6X9 PAPERBACK. ILLUSTRATED. BIBLIOGRAPHY & INDEX. $16.95. CODE: ISM

MEN and GODS
IN MONGOLIA

This rare 1935 book is back in print!
Mystic Traveller Series

MEN & GODS IN MONGOLIA
by Henning Haslund
First published in 1935 by Kegan Paul of London, Haslund takes us to the lost city of Karakota in the Gobi desert. We meet the Bodgo Gegen, a god-king in Mongolia similar to the Dalai Lama of Tibet. We meet Dambin Jansang, the dreaded warlord of the "Black Gobi." There is even material in this incredible book on the Hi-mori, an "airhorse" that flies through the sky (similar to a Vimana) and carries with it the sacred stone of Chintamani. Aside from the esoteric and mystical material, there is plenty of just plain adventure: Haslund and companions journey across the Gobi desert by camel caravan; are kidnapped and held for ransom; witness initiation into Shamanic societies; meet reincarnated warlords; and experience the violent birth of "modern" Mongolia.
358 PAGES. 6X9 PAPERBACK. ILLUSTRATED. INDEX. $15.95. CODE: MGM

24 hour credit card orders—call: 815-253-6390 fax: 815-253-6300
email: auphq@frontiernet.net www.adventuresunlimitedpress.com www.wexclub.com

ATLANTIS STUDIES

MAPS OF THE ANCIENT SEA KINGS
Evidence of Advanced Civilization in the Ice Age
by Charles H. Hapgood

Charles Hapgood's classic 1966 book on ancient maps produces concrete evidence of an advanced world-wide civilization existing many thousands of years before ancient Egypt. He has found the evidence in the Piri Reis Map that shows Antarctica, the Hadji Ahmed map, the Oronteus Finaeus and other amazing maps. Hapgood concluded that these maps were made from more ancient maps from the various ancient archives around the world, now lost. Not only were these unknown people more advanced in mapmaking than any people prior to the 18th century, it appears they mapped all the continents. The Americas were mapped thousands of years before Columbus. Antarctica was mapped when its coasts were free of ice.
316 PAGES. 7X10 PAPERBACK. ILLUSTRATED. BIBLIOGRAPHY & INDEX. $19.95. CODE: MASK

PATH OF THE POLE
Cataclysmic Pole Shift Geology
by Charles Hapgood

Maps of the Ancient Sea Kings author Hapgood's classic book *Path of the Pole* is back in print! Hapgood researched Antarctica, ancient maps and the geological record to conclude that the Earth's crust has slipped in the inner core many times in the past, changing the position of the pole. *Path of the Pole* discusses the various "pole shifts" in Earth's past, giving evidence for each one, and moves on to possible future pole shifts. Packed with illustrations, this is the sourcebook for many other books on cataclysms and pole shifts.
356 PAGES. 6x9 PAPERBACK. ILLUSTRATED. $16.95. CODE: POP.

ATLANTIS & THE POWER SYSTEM OF THE GODS
Mercury Vortex Generators & the Power System of Atlantis
by David Hatcher Childress and Bill Clendenon

Atlantis and the Power System of the Gods starts with a reprinting of the rare 1990 book *Mercury: UFO Messenger of the Gods* by Bill Clendenon. Clendenon takes on an unusual voyage into the world of ancient flying vehicles, strange personal UFO sightings, a meeting with a "Man In Black" and then to a centuries-old library in India where he got his ideas for the diagrams of mercury vortex engines. The second part of the book is Childress' fascinating analysis of Nikola Tesla's broadcast system in light of Edgar Cayce's "Terrible Crystal" and the obelisks of ancient Egypt and Ethiopia. Includes: Atlantis and its crystal power towers that broadcast energy; how these incredible power stations may still exist today; inventor Nikola Tesla's nearly identical system of power transmission; Mercury Proton Gyros and mercury vortex propulsion; more. Richly illustrated, and packed with evidence that Atlantis not only existed—it had a world-wide energy system more sophisticated than ours today.
246 PAGES. 6x9 PAPERBACK. ILLUSTRATED. $15.95. CODE: APSG

ATLANTIS IN AMERICA
Navigators of the Ancient World
by Ivar Zapp and George Erikson

This book is an intensive examination of the archeological sites of the Americas, an examination that reveals civilization has existed here for tens of thousands of years. Zapp is an expert on the enigmatic giant stone spheres of Costa Rica, and maintains that they were sighting stones similar to those found throughout the Pacific as well as in Egypt and the Middle East. They were used to teach star-paths and sea navigation to the world-wide navigators of the ancient world. While the Mediterranean and European regions "forgot" world-wide navigation and fought wars, the Mesoamericans of diverse races were building vast interconnected cities without walls. This Golden Age of ancient America was merely a myth of suppressed history—until now. Profusely illustrated, chapters are on Navigators of the Ancient World; Pyramids & Megaliths: Older Than You Think; Ancient Ports and Colonies; Cataclysms of the Past; Atlantis: From Myth to Reality; The Serpent and the Cross: The Loss of the City States; Calendars and Star Temples; and more.
360 PAGES. 6x9 PAPERBACK. ILLUSTRATED. BIBLIOGRAPHY & INDEX. $17.95. CODE: AIA

FAR-OUT ADVENTURES *REVISED EDITION*
The Best of World Explorer Magazine

This is a compilation of the first nine issues of *World Explorer* in a large-format paperback. Authors include: David Hatcher Childress, Joseph Jochmans, John Major Jenkins, Deanna Emerson, Katherine Routledge, Alexander Horvat, Greg Deyermenjian, Dr. Marc Miller, and others. Articles in this book include Smithsonian Gate, Dinosaur Hunting in the Congo, Secret Writings of the Incas, On the Trail of the Yeti, Secrets of the Sphinx, Living Pterodactyls, Quest for Atlantis, What Happened to the Great Library of Alexandria?, In Search of Seamonsters, Egyptians in the Pacific, Lost Megaliths of Guatemala, the Mystery of Easter Island, Comacalco: Mayan City of Mystery, Professor Wexler and plenty more.
580 PAGES. 8X11 PAPERBACK. ILLUSTRATED. REVISED EDITION. $25.00. CODE: FOA

RETURN OF THE SERPENTS OF WISDOM
by Mark Amaru Pinkham

According to ancient records, the patriarchs and founders of the early civilizations in Egypt, India, China, Peru, Mesopotamia, Britain, and the Americas were the Serpents of Wisdom—spiritual masters associated with the serpent—who arrived in these lands after abandoning their beloved homelands and crossing great seas. While bearing names denoting snake or dragon (such as Naga, Lung, Djedhi, Amaru, Quetzalcoatl, Adder, etc.), these Serpents of Wisdom oversaw the construction of magnificent civilizations within which they and their descendants served as the priest kings and as the enlightened heads of mystery school traditions. *The Return of the Serpents of Wisdom* recounts the history of these "Serpents"—where they came from, why they came, the secret wisdom they disseminated, and why they are returning now.
400 PAGES. 6x9 PAPERBACK. ILLUSTRATED. REFERENCES. $16.95. CODE: RSW

24 hour credit card orders—call: 815-253-6390 fax: 815-253-6300

email: auphq@frontiernet.net www.adventuresunlimitedpress.com www.wexclub.com

One Adventure Place
P.O. Box 74
Kempton, Illinois 60946
United States of America
•Tel.: 1-800-718-4514 or 815-253-6390
•Fax: 815-253-6300
Email: auphq@frontiernet.net
http://www.adventuresunlimitedpress.com
or www.adventuresunlimited.nl

10% Discount when you order 3 or more items!

ORDERING INSTRUCTIONS

✓ Remit by USD$ Check, Money Order or Credit Card
✓ Visa, Master Card, Discover & AmEx Accepted
✓ Prices May Change Without Notice
✓ 10% Discount for 3 or more Items

SHIPPING CHARGES

United States

✓ Postal Book Rate { $3.00 First Item / 50¢ Each Additional Item
✓ Priority Mail { $4.50 First Item / $2.00 Each Additional Item
✓ UPS { $5.00 First Item / $1.50 Each Additional Item
 NOTE: UPS Delivery Available to Mainland USA Only

Canada

✓ Postal Book Rate { $6.00 First Item / $2.00 Each Additional Item
✓ Postal Air Mail { $8.00 First Item / $2.50 Each Additional Item
✓ Personal Checks or Bank Drafts MUST BE
✓ USD$ and Drawn on a US Bank
 Canadian Postal Money Orders in US$ OK
✓ Payment MUST BE US$

All Other Countries

✓ Surface Delivery { $10.00 First Item / $4.00 Each Additional Item
✓ Postal Air Mail { $14.00 First Item / $5.00 Each Additional Item
✓ Checks and Money Orders MUST BE US$
 and Drawn on a US Bank or branch.
✓ Payment by credit card preferred!

SPECIAL NOTES

✓ RETAILERS: Standard Discounts Available
✓ BACKORDERS: We Backorder all Out-of-
 Stock Items Unless Otherwise Requested
✓ PRO FORMA INVOICES: Available on Request
✓ VIDEOS: NTSC Mode Only. Replacement only.
✓ For PAL mode videos contact our other offices:

European Office:
Adventures Unlimited, Pannewal 22,
Enkhuizen, 1602 KS, The Netherlands
http: www.adventuresunlimited.nl
Check Us Out Online at:
www.adventuresunlimitedpress.com

Please check: ☑
☐ This is my first order ☐ I have ordered before ☐ This is a new address

Name	
Address	
City	
State/Province	Postal Code
Country	
Phone day	Evening
Fax	Email

Item Code	Item Description	Price	Qty	Total

Please check: ☑
☐ Postal-Surface
☐ Postal-Air Mail (Priority in USA)
☐ UPS (Mainland USA only)

Subtotal ➡	
Less Discount-10% for 3 or more items ➡	
Balance ➡	
Illinois Residents 6.25% Sales Tax ➡	
Previous Credit ➡	
Shipping ➡	
Total (check/MO in USD$ only) ➡	

☐ Visa/MasterCard/Discover/Amex

Card Number

Expiration Date

10% Discount When You Order 3 or More Items!

Comments & Suggestions	Share Our Catalog with a Friend